A–Z OF MODERN AMERICA

An *A–Z of Modern America* is a comprehensive cultural dictionary which defines contemporary America through its history and civilization. The book includes entries on:

- key people from Presidents to Babe Ruth
- American life, customs, clothing and education
- legal, religious and governmental practices
- multiculturalism, minorities and civil rights

An *A–Z of Modern America* offers accessible and lively definitions of over 3,000 separate items. The book is cross-referenced and thus provides associated links and cultural connections while the appendixes contain essential extra information on American institutions, structures and traditions.

Alicia Duchak has taught courses in English Language and American Cultural Studies in the United States, Japan, and Belgium. She is currently studying Cultural Studies in a PhD program at the University of Antwerp. She lives and works in Belgium.

REFERENCE

A–Z OF MODERN AMERICA

Alicia Duchak

London and New York

WB

First published 1999
by Routledge
11 New Fetter Lane, London EC4P 4EE
Simultaneously published in the USA and Canada
by Routledge
29 West 35th Street, New York, NY 10001
© 1999 Alicia Duchak

Typeset in Baskerville by Routledge
Printed and bound in Great Britain by TJ International Ltd, Padstow,
Cornwall

British Library Cataloguing in Publication Data
A catalogue record for this book is available from the British Library

Library of Congress Cataloging in Publication Data
Duchak, Alicia, 1968–
A–Z of modern America / Alicia Duchak,
p. cm.
Includes bibliographical references and indexes.
1. United States–Civilization-1945–Miscellanea–Dictionaries.
2. United States–History–1945–Miscellanea–Dictionaries.
I. Title.
E169.12.D83 1999
973.92–dc21 98–34384CIP

ISBN 0–415–18755–9 (hbk)
ISBN 0–415–18756–7 (pbk)

8/31/01

Contents

Acknowledgements

This book was completed while working on a Fulbright Scholarship at the Katholieke Vlaamse Hogeschool, Antwerp, Belgium, 1995–1996 and 1996–1997; as well as a scholarship from the John F. Kennedy-Institut für Nordamerikastudien at the Freie Universität in Berlin, Germany, during summer 1997. I appreciate the support provided by the various individuals who were working with these fine groups during these times.

Many have provided me assistance in the process of writing this book, most of whom know who they are and have already heard my words of gratitude. However, I would like to extend special thanks to a few individuals: to Erik Hertog who started the proverbial ball rolling; to Francine Lercangée and Myriam Lodeweyckx of the Center for American Studies in Brussels, Belgium, for their help; to Luc Herman for e-mail support; to Maggie Nicholson of the Fulbright Scholarship Program; to Heather McCallum, Gillian Kay and Ruth Jeavons for being a wonderful team of editors; to Joost Verschaeve, the computer guru, who created macros and zipped many files; to Kathleen and John Duchak for support and information. To Wim Bien for much appreciated computer assistance and the drawings as well as for supporting and believing.

Abbreviations

A.D.	Anno Domini (the year that Jesus Christ was born, marking the beginning of the common era)
a.m.	after 12:00 midnight and before 12:00 noon
B.C.	Before (the birth of) Christ; meaning before the common era
c.	circa, around the date of; used when the precise date or year is not known
e.g.	"for example"
ha.	hectare
i.e.	"that is to say; in other words"
km	kilometer
lb	pound
mi.	mile
p.m.	after 12:00 noon and before 12:00 midnight
sq.	square
St.	Saint
TV	television
v.	versus; used in legal court cases to indicate the two parties. The name before the "v." is the party introducing or appealing the lawsuit

Nickname abbreviations

Look up under this full name

AA	Alcoholics Anonymous
AAA	Agricultural Adjustment Administration or American Automobile Association (see also Triple A)
AAAS	American Association for the Advancement of Science
AAIA	Association on American Indian Affairs
AAU	Amateur Athletic Union
ABA	American Bar Association
ABCL	American Birth Control League
ACE	Accelerated College Enrollment Program
ACLU	American Civil Liberties Union
ACM	Academy of Country Music
ADA	Americans with Disabilities Act
AEC	Atomic Energy Commission
AFC	American Football Conference
AFDC	Aid to Families with Dependent Children
AFL	American Football League
AFT	American Federation of Teachers
AFS	American Field Service
AHL	American Hockey League
AID	Agency for International Development
AIRFA	American Indian Religious Freedom Act
AIM	American Indian Movement
AJC	American Jewish Congress
AL	American League
AMA	American Medical Association
AMEX	American Stock Exchange
AMPAS	Academy of Motion Picture Arts and Sciences
AP	Associated Press or Advanced Placement
APP	Advanced Placement Program
ASL	American Sign Language
ATP	Association of Tennis Professionals
BBQ	barbecue/barbeque
BIA	Bureau of Indian Affairs

BLS	Bureau of Labor Statistics
BP	Black Panthers
BPP	Black Panthers (Black Panthers Party)
BYU	Brigham Young University
C&W or C and W	Country and Western Music
Cal Tech	California Institute of Technology
CBC	Congressional Black Caucus
CBO	Congressional Budget Office
CBT	Chicago Board of Trade
CCC	Civilian Conservation Corps
CCC-ID	Civilian Conservation Corps-Indian Division (see Civilian Conservation Corps)
CDCP	Center for Disease Control and Prevention
CDF	Children's Defense Fund
CIA	Central Intelligence Agency
CMA	Country Music Association
COLA	cost-of-living adjustment
CORE	Congress of Racial Equality
Corp.	corporation
CPA	Certified Public Accountant
CPB	Corporation for Public Broadcasting
CPI	Consumer Price Index
CRS	Congressional Research Service
CSA	Confederate States of America
CWM	Catholic Worker Movement
DA	District Attorney
DC	Washington D.C.
DEA	Drug Enforcement Administration
DH	designated hitter
DJIA	Dow Jones (Industrial Average)
DNC	Democratic National Committee
DOC	Department of Commerce
DOD	Department of Defense
DOE	Department of Energy
DOI	Department of the Interior
DOT	Department of Transportation
DP	displaced person
EEOC	Equal Employment Opportunity Commission
EF	Earth First!
EPA	Environmental Protection Agency
ERA	Equal Rights Amendment
ESA	Endangered Species Act
ESEA	Elementary and Secondary Education Act
EST	Eastern (Standard Time)
FAA	Federal Aviation Administration
FAP	Federal Arts Project
FBI	Federal Bureau of Investigation

FCC	Federal Communications Commission
FDA	Food and Drug Administration
FDIC	Federal Deposit Insurance Corporation
FDR	Franklin Delano Roosevelt
FEC	Federal Election Commission
FECA	Federal Election Campaign Act of 1972
FFA	Future Farmers of America
FLSA	Fair Labor Standards Act
FOI	Fruit of Islam
FTC	Federal Trade Commission
FWP	Federal Writers' Project (see Federal Arts Project)
GA	General Assistance
GP	General Practitioner
HHS	Department of Health and Human Services
HMO	Health Maintenance Organization
HUAC	House Un-American Activities Committee
HUD	Department of Housing and Urban Development
IAA	Indian Appropriations Act
ICC	Indian Claims Commission, or Interstate Commerce Commission
IGRA	Indian Gaming Regulatory Act
IHS	Indian Health Service
INS	Immigration and Naturalization Service
IRA	individual retirement account or Indian Reorganization Act
IRCA	Immigration Reform and Control Act
IRS	Internal Revenue Service
IU	Indiana University
IWW	Industrial Workers of the World
JACL	Japanese American Citizens League
JAMA	*Journal of American Medical Association*
JCC	Jaycees
JFK	John Fitzgerald Kennedy
JP	justice of the peace
JV	junior varsity
K	kindergarten
K of C	Knights of Columbus
KKK	Ku Klux Klan
LA	Los Angeles
LBJ	Lyndon Baines Johnson
LHJ	*Ladies' Home Journal*
LLDL	Lamda Legal Defense Fund
LOC	Library of Congress
LPGA	Ladies' Professional Golfers' Association
LULAC	League of United Latin American Citizens
LWV	League of Women Voters
MBA	Master's of Business Administration

MBDA	Minority Business Development Agency
MFN	most-favored nation
MIA	Montgomery Improvement Association
MIT	Massachusetts Institute of Technology
MLA	Modern Language Association (of America)
MLK	Martin Luther King, Jr.
MPAA	Motion Picture Association of America
MST	Mountain (Standard Time)
MWM	March on Washington Movement
NAACP-LDF	NAACP Legal Defense and Education Fund
NAGPRA	Native American Graves Protection and Repatriation Act
NARF	Native American Rights Fund
NAS	National Audubon Society
NASCAR	Nascar (National Association of Stock Car Racing)
Navy	United States Naval Academy or Navy
NBA	National Basketball Association
NBCC	National Book Critics Circle Award
NCAA	National Collegiate Athletic Association
NCAI	National Congress of American Indians
NCCJ	National Conference of Christians and Jews
NEA	National Education Association or National Endowment for the Arts
NFC	National Football Conference
NFL	National Football League
NFWA	National Farm Workers Association
NHL	National Hockey League
NIH	National Institutes of Health
NIRA	National Industrial Recovery Act
NIT	National Invitational Tournament
NL	National League
NLRB	National Labor Relations Board
NMB	National Mediation Board
NMS	National Merit Scholarship
NOW	National Organization for Women
NPC	National Press Club
NPR	National Public Radio
NRA	National Rifle Association (of America)
NRC	Nuclear Regulatory Commission
NSF	National Science Foundation
NTCA	National Tribal Chairman's Association
NWPC	National Women's Political Caucus
NYC	New York City
NYSE	New York Stock Exchange
OAAU	Organization of Afro-American Unity
OMB	Office of Management and Budget
OSHA	Occupational Safety and Health Administration
OSU	Ohio State University

OTS	Office of Thrift Supervision
PB&J	peanut butter and jelly sandwich
PC	Political Correctness
PGA	Professional Golfers' Association
PSA	public service announcement
PST	Pacific (Standard Time)
PTA	Parent Teacher Association
PTO	Parent Teacher Organization
PWA	Public Works Administration
PWAP	Public Works of Art Project
QB	quarterback
R&B or R and B	Rhythm and Blues or room and board
R 'n' R or R and R	Rock and Roll or Rest and Relaxation
R v. *Wade*	*Roe* v. *Wade*
RFK	Robert ("Bobby") Francis Kennedy
RN	Registered Nurse
RNC	Republican National Committee
RSV	Revised Standard Version
RUP	La Raza Unida Party
S&L	Savings & Loan Association
S&P	Standard & Poor's Stock Price Index
SAG	Screen Actors Guild
SCLC	Southern Christian Leadership Conference
SDI	Strategic Defense Initiative
SDS	Students for a Democratic Society
SEC	Securities and Exchange Commission
SNCC	Student Nonviolent Coordinating Committee
SNL	*Saturday Night Live*
SSA	Social Security Administration
SSI	Supplemental Security Income
SSN	Social Security number
State	Department of State
TANF	Temporary Assistance to Needy Families
TD	touchdown
TFA	Teach for America
UAW	United Auto Workers
UC	University of California
UFW	United Farm Workers of America
UMWA	United Mine Workers of America
UNCF	United Negro College Fund
UNIA	Universal Negro Improvement Association
U of M	University of Michigan
UPI	United Press International
US	United States
USA	United States of America or United States Army
USDA	United States Department of Agriculture
USGA	United States Golf Association

USMC	United States Marine Corps
USN	United States Navy
USPHS	United States Public Health Service
USTA	United States Tennis Association
USTR	United States Trade Representative
USWA	United Steelworkers of America
UVA	University of Virginia
VA	Department of Veterans Affairs
VFW	Veterans of Foreign Wars (of the US)
WCTU	Women's Christian Temperance Union
WNBA	Women's National Basketball Association
WPA	Works Progress Administration
WRA	War Relocation Authority
WTC	World Trade Center
WWI	World War I
WWII	World War II
YLO	Young Lords Organization

How to use this dictionary – sample page

Initial **emboldened word(s)** is/are the vocabulary term

Emboldened **1** is the first definition

In the definition, the words in SMALL CAPITALS are cross-referenced vocabulary terms (which can be found in this dictionary)

Emboldened **2** is the second definition

In second definitions, a second **emboldened** term indicates that this spelling/form is different from that of the initial/first definition

Italics indicates the title of a magazine or book; or the name of a film, movie, television show, radio program or a legal court case or decision

Items between (...) indicate that area or field of American culture in which this term is used; each field is preceded by a number which matches its respective numbered definition

After the definition, *see* introduces other vocabulary term(s) related to this term (shown in SMALL CAPITALS) that can be found in this dictionary

"..." provide a fixed expression based on this term

After the definition, [...] brackets and '...' provide information about the derivation and/or history of the term

After the definition, *compare* introduces another entry which contrasts with this term

Superscript numbers directly after a term indicate that that term has more than one definition

If the item has a *nickname* (often an abbreviation), it is listed between (...) after the field and before the definition

An **emboldened item** within a definition, but not preceded by an emboldened number, indicates that this is a different, but related, form of the original item

Stars and Stripes, the (1 customs and traditions; 2 media) **1** The name of the official national flag of the UNITED STATES. It has 13 red and white 'stripes' (representing the original THIRTEEN COLONIES) and a blue rectangle in the upper corner which is covered in 50 white 'stars' (each star represents one of the total 50 STATES). The Stars and Stripes is celebrated on FLAG DAY. Often, it is flown on all FEDERAL HOLIDAYS. **2 *Stars and Stripes*** A daily newspaper prepared for members of the US ARMED FORCES and US government families who are currently not stationed in the UNITED STATES. It contains American news and sports articles, as well as local news, sports, comics and entertainment information.

bar (1 daily life; 2 legal system) **1** An establishment that sells alcoholic drinks (e.g., beer, whiskey, wine) and may serve some snacks (e.g., pretzels, peanuts) or SHORT ORDER dishes to customers. It may contain pool tables, a dance floor and/or televisions for watching sports. Its hour of closing is determined by the STATE or local government. However, all clients must be at least 21 years of age to enter and drink. *See* DRINKING AGE, BOUNCER, DRY, ID CARD, BLUE LAWS. **2 the bar** A general, collective term for the profession of ATTORNEYS. "Members of the bar" are LAWYERS who have passed the BAR EXAMINATION for that STATE and practiced law for a certain period of time. [From the wooden railing, or 'bar', traditionally used in courtrooms in England to separate the ATTORNEYS, JURY and judge from the public.] *See* BAR ASSOCIATION, DISBAR; *compare* BENCH[1,2,3].

Congressional Research Service (government) (CRS) A part of the LIBRARY OF CONGRESS that researches information for individual members of CONGRESS and the CONGRESSIONAL COMMITTEES to use.

Gotham (geography) A nickname for NEW YORK CITY; **Gothamites** are New Yorkers.

A

à la King (food and drink) Describing a manner of serving cooked meat, usually chicken or turkey; the meat is cooked, chopped into cubes and then mixed into a cream sauce with mushrooms, green pepper and pimento pepper then served in a pastry shell (e.g., chicken à la King). [French, meaning "in the style of".]

à la mode (food and drink) Describing a dessert (especially, apple PIE) served with a scoop of ice cream. [From French *à la mode*, meaning "according to the fashion".]

A+ (education) The highest GRADE² in the A–F LETTER GRADE system. By association, "excellent". *See* GRADING SYSTEM, REPORT CARD.

AA (education) A type of ASSOCIATE'S DEGREE. [Abbreviation of 'A'ssociate of 'A'rts.]

AARP (society) A private organization founded in 1958 for people aged 50 years and older who are working or retired, its current membership is 32 million. It provides various services as efforts to improve all aspects of life for its members, namely: pre-retirement planning, retirement savings plans, health insurance, special hotel and travel rates, discount coupons and the publication of *MODERN MATURITY*. It is an active LOBBY group and is especially concerned with any Congressional legislation concerning SOCIAL SECURITY. [Abbreviation of 'A'merican 'A'ssociation of 'R'etired 'P'ersons.]

AAS (education) A type of ASSOCIATE'S DEGREE. [Abbreviation of 'A'ssociate of 'A'pplied 'S'cience.]

Amateur Athletic Union (sports and leisure) (AAU) The organization founded in 1888 to promote non-professional sports and to prevent abuses in them. It operates the JUNIOR OLYMPICS but is not associated with the NCAA.

Abbey, Edward (people) (1927–1989) Writer, NATIONAL PARK ranger and leader of the ENVIRONMENTAL MOVEMENT. His books of fiction are set in beautiful areas of the WEST and the humorous characters often are radical environmentalists who like enjoying nature (e.g., camping, white-water river rafting) and believe in preserving natural places at all costs, even blowing up government dam projects and other illegal activities as in *The Monkey Wrench Gang* (1966) and *The Journey Home* (1977). His nonfiction book *Desert Solitaire* (1968) is recognized for supporting the national parks; especially ARCHES NATIONAL PARK, where he once worked.

ABC (1 media; 2 minorities) **1** One of the major COMMERCIAL¹ networks (originally founded in 1943), which provides TV and radio programs nationwide. It is one of the major NETWORK TELEVISION companies. [Abbreviation of 'A'merican 'B'roadcasting 'C'ompany.] *See* NETWORK TELEVISION, BIG THREE; *compare* CBS, NBC. **2** A person who was born in the UNITED STATES and who has Chinese ancestors and/or family heritage. An Asian American. [From the abbreviation 'A'merican-'b'orn 'C'hinese.]

ABD (education) The unofficial acronym used to describe a GRADUATE² student who has completed all of the coursework in a PHD program but who has not researched, not written nor officially defended the DISSERTATION before the DEPARTMENT¹. [Abbreviation of 'A'll 'B'ut 'D'issertation.]

Abolition/abolition (history) An important nineteenth century movement of individuals, whites and blacks (free-born and escaped slaves), and organizations, mostly in the NORTH, that wanted to end, 'abolish', SLAVERY by passing federal legislation making it illegal in the UNITED STATES. It began in full force in the 1830s, engaging speakers, distributing pamphlets and lobbying CONGRESS to end slavery. It ended in 1865 with the THIRTEENTH AMENDMENT. From 1865 to 1870, some **abolitionists** promoted land rights and voting rights for blacks, and the FIFTEENTH AMENDMENT. Also known as the "abolitionist movement"; *see* FREDERICK DOUGLASS, CIVIL WAR, LOBBY, SECOND GREAT AWAKENING, UNDERGROUND RAILROAD, HARRIET TUBMAN, HARPER'S FERRY, "JOHN BROWN'S BODY".

absentee ballot (politics) A vote recorded on an official BALLOT¹ or in an official way and submitted through the mail or via computer technology. In order

for it to be counted, it must be received before or on ELECTION DAY.

Abstract Expressionism (the arts) A unique, post-modern style of oil painting characterized by: using large canvasses and spaces; mixing a combination of various colors and textures; and having no recognizable human shapes or forms. It was active during the 1950s and was centered in NEW YORK CITY. It was promoted by JACKSON POLLOCK, Willem de Kooning (1904–1997), Mark Rothko (1903–1970) and others. *See* ACTION PAINTING.

Abyssinian Baptist Church (religion) A congregation of the BAPTIST faith known for its many African-American members, talented chorus which sings GOSPEL MUSIC and its enthusiastic worship services held on Sundays. It is located on West 138th Street in HARLEM. From the 1930s through the 1960s its members were particularly politically active promoting CIVIL RIGHTS and working opportunities for AFRICAN AMERICANS as well as in the CIVIL RIGHTS MOVEMENT. Many of its members were represented in the US CONGRESS by their dynamic preacher, Adam Clayton Powell, Jr. (1908–1972).

Abzug, Bella (1920–1998, born Bella Savitsky) (people) LAWYER, DEMOCRATIC politician from NEW YORK CITY and FEMINIST. She served in the US CONGRESS (1970–1974) and promoted women's rights, peace in Vietnam, the end of the VIETNAM WAR, as well as the rights of MINORITIES. She was a co-founder of the NATIONAL WOMEN'S POLITICAL CAUCUS in 1971 and supported the EQUAL RIGHTS AMENDMENT. During her political career, she voiced her strong LEFT opinions and was easily recognized by her independent, dynamic personality and her penchant for wearing big-brimmed hats. She is best known for stating: "A woman's place is in the HOUSE – the HOUSE OF REPRESENTATIVES".

academe (education) A collective term referring to the academic environment, PROFESSORS and scholars at a UNIVERSITY and the scholarly life led by them, especially those in the LIBERAL ARTS and sciences. It is commonly used in the expression "in the Halls of Academe".

academic year (education) The period of formal academic instruction, including classes and exams, offered at a SCHOOL[5], COLLEGE[3] or a PROFESSIONAL SCHOOL. It usually runs from late August or September to May or June. It can be divided into TERMS[2] of either two SEMESTERS, three TRIMESTERS or four QUARTERS. Also known as "SCHOOL YEAR".

academy (1, 2 education; 3 the arts) **1** A private, usually elite, HIGH SCHOOL or BOARDING SCHOOL[1] (e.g., PHILIPS EXETER ACADEMY). **2** A COLLEGE[1] where special skills are taught (e.g., the UNITED STATES AIR FORCE ACADEMY). **3 the Academy** a collective term for a society, group or organization of learned persons or professionals in some field. (e.g., ACADEMY OF MOTION PICTURE ARTS AND SCIENCES).

Academy Awards, the (the arts) The popular name for the "Motion Picture Arts and Sciences Awards", a prize of outstanding achievement given to an individual in the film entertainment industry. The many categories of prizes include: "best picture" (i.e., movie), "best actor", "best actress", "best director", "best soundtrack" (i.e., movie music), "best foreign film" and others. Also, honorary awards are given to important individuals, from the past and present, in the history and development of the movie industry. The winners of the awards are selected by a vote of the members of the ACADEMY OF MOTION PICTURE ARTS AND SCIENCES. The award (commonly known as an "OSCAR") is a gold-colored statuette of a bald man standing on a round reel of film. All the awards for a particular year are presented at the ACADEMY AWARDS CEREMONY.

Academy Awards Ceremony, the (the arts) The large, annual, lavish ceremony attended by elegantly-dressed movie stars and celebrities at which ACADEMY AWARDS are presented to nominated winners and song and dance performances are given. The event, which is sponsored and attended by members of the ACADEMY OF MOTION PICTURE ARTS AND SCIENCES, is held every March at the large Shriner Auditorium or other large venues in LOS ANGELES. The first ceremony was held in 1928 honoring those films released in 1927 and early 1928. Today, this event is tele-

vised and is known for being extremely lavish and very long; on COMMERCIAL American television broadcasts, the event stretches to some 3.5 or 4 hours. Also, informally known as "The Oscars"; *see* OSCAR, EMCEE.

Academy of Country Music, the (the arts) (ACM) An organization, founded in 1964, which supports and promotes COUNTRY MUSIC and country music artists, especially in the WEST. It is based in the city of HOLLYWOOD[1], California and presents annual awards to talented artists. *Compare* COUNTRY MUSIC ASSOCIATION.

Academy of Motion Picture Arts and Sciences, the (the arts) (AMPAS) The organization for movie producers, directors, actors, actresses and technicians that sets standards for the movie entertainment industry. It publishes the *Academy Players' Directory* which is a list of the actors and actresses available for casting in movies. Further, it votes on and presents the ACADEMY AWARDS CEREMONY. Its membership is limited to those individuals who have already won ACADEMY AWARDS. It is popularly referred to as "the ACADEMY[3]", especially by its members. It was founded in 1927 and is based in BEVERLY HILLS, California; current membership is over 5,200.

Accelerated College Enrollment Program (education) (ACE) A program sponsored by the COLLEGE BOARD for academically motivated HIGH SCHOOL students to take UNDERGRADUATE-level courses on a COLLEGE[1] CAMPUS for CREDIT while still enrolled in SECONDARY SCHOOL. After enrolling in COLLEGE[1], the CREDITS earned are automatically added to the student's UNIVERSITY transcript. *Compare* ADVANCED PLACEMENT PROGRAM.

accreditation (education) The formal process of judging the quality of educational programs and recognizing SCHOOLS[5] as meeting a certain minimum of standards. It helps to stabilize the CREDIT system nationwide and recognizes the degree that a SCHOOL[5] awards. Members of an accrediting group may be educators and/or private citizens. Public ELEMENTARY SCHOOLS and SECONDARY SCHOOLS are usually accredited by STATE BOARDS OF EDUCATION. PRIVATE SCHOOLS and COLLEGES[3] are accredited by regional organizations (e.g., MIDDLE STATES ASSOCIATION OF COLLEGES AND SCHOOLS), while PROFESSIONAL SCHOOLS are accredited by specialized national organizations in that field (e.g., AMERICAN MEDICAL ASSOCIATION). Also known as "certification"; *see* PUBLIC SCHOOLS.

acculturation (minorities) A process in which an immigrant group, religious group or MINORITY practices and retains aspects of its unique culture and/or language while still being active in the larger community. It is considered more respectful and tolerant of different cultures and the differences which exist between groups. It is an important part of MULTICULTURALISM. *Compare* ASSIMILATION.

accused, the (legal system) In CRIMINAL LAW, the generic name for that individual whom a PROSECUTING ATTORNEY is prosecuting in a legal suit; a DEFENDANT in a CRIMINAL TRIAL.

acquittal (legal system) In CRIMINAL LAW, the official act releasing someone who is charged and tried for a crime. A person is **acquitted** if the DECISION of the judge and/or JURY is "not guilty" or if there is any doubt about the DEFENDANT'S guilt. Receiving an acquittal means that the defendant cannot be tried for that crime again. *See* FIFTH AMENDMENT, DOUBLE JEOPARDY.

ACT (education) A standardized MULTIPLE-CHOICE test taken by HIGH SCHOOL JUNIORS who want to apply for admission to a COLLEGE[1] or UNIVERSITY. It is created, administered and graded by a private company. Test questions are in four areas: English, math, reading and reasoning. The total maximum points to be earned is 36. The score a student receives on this exam is one factor of an application to a COLLEGE[1]. [Abbreviation of 'A'merican 'C'ollege 'T'esting.] *Compare* SAT.

ACT UP (minorities) An active, militant group which uses DIRECT ACTION tactics to promote all issues concerning AIDS (Acquired Immune Deficiency Syndrome) and HIV (Human Immunodeficiency Virus), namely, more money to fund research and pay for the treatment of these patients. Its most well-known tactic was covering government buildings in red-colored tape to

symbolize the government delays in help-ing those with AIDS and HIV. It was established in 1987 and its headquarters are in NEW YORK CITY. [Acronym from 'A'IDS 'C'oalition 'T'o 'U'nleash 'P'ower.]

action painting (the arts) In the AB-STRACT EXPRESSIONISM movement, an un-preconceived manner of painting works in which the painter does not plan or think about the art work either before or during his or her creation of it; rather, the painter uses free hand gestures and materials to create the works frequently dripping, dropping or pouring paint on a canvas without a plan. It was used and promoted by JACKSON POLLOCK.

Actor's Equity Association (the arts) A UNION[1], founded in 1913, for profes-sional theater performers which sets pay-ment rules and regulations for its members, actors and actresses. It is based in NEW YORK CITY and is a member of the AFL-CIO. Currently, it has some 39,000 members.

Adams, Ansel (people) (1902–1984) A photographer whose professional career focused on making images of nature. He used black and white film to capture the unique shapes and textures of wild land-scapes, especially those of the WEST.

Adams, Samuel (people) (1722–1803) A political leader, revolutionary and colonial patriot who promoted the American fight for independence from Great Britain. His nickname is "Father of the Revolution" because he planned the BOSTON TEA PARTY, wrote newspaper articles support-ing American independence and organized a local group of militia men known as the "Sons of Liberty" to fight against the British Army. After the AMERICAN REVO-LUTION, he served Massachusetts in the CONTINENTAL CONGRESS and as STATE governor. Today, there is a popular com-mercial bottled beer named after him.

Adirondack chair (sports and leisure) A comfortable, deep-seated chair designed to be used outdoors. It is made of thick wooden slats and has wide arm rests. [After the ADIRONDACK MOUNTAINS, the region where it was originally made and popularized.]

Adirondack Mountains, the (geogra-phy) A region of forests and lakes in northeastern New York STATE. It is a popular winter and summer resort area, especially for middle-class and upper-class residents of MANHATTAN[1]. The winter resort, Lake Placid, and the horse race-track, Saratoga Springs, are located in this region. [After the former local INDIAN TRIBE.]

adjournment (1, 2 government) **1** The formal end of the year-long SESSION[2] of CONGRESS; the exact date is voted on by CONGRESSMEMBERS and thus changes from year to year (but is usually in November or December). All legislative business must be finished by this date. **2** The extended period of time (lasting from one to several weeks) between ADJOURNMENT[1] and the beginning of a new SESSION[2,3]. Legislators use this time to return to their voting districts in order to work, meet people or relax as a sort of vacation. *See* CONSTITU-ENCY.

administration, the (1, 2 government) **1** A collective term for the CHIEF EXECUTIVE and his or her appointed advisers who develop and enforce policy. *See* CABINET. **2 Administration**, a collective term for the entire executive branch of government during those years when a particular chief executive is in office (e.g., the Clinton Administration).

admissions department (education) The official DEPARTMENT[1] of a SCHOOL[5], especially a COLLEGE[1], that reviews the applications of potential students, en-forces SCHOOL[5] standards for accepting new students and informs applicants if that school accepts them as new students or not. However, in most GRADUATE[2]-level programs, students apply directly to the DEPARTMENT[2] of their field (e.g., English Department).

adobe (housing and architecture) A type of building made of clay that has been mixed with straw or grass and then "baked" in the sun. Traditionally, it was a form and method of architecture of those INDIANS living in the SOUTHWEST; namely the NAVAJO. Today, it is still used in this region to make low-budget private residences, huts and storage areas. *See* PUEBLO[1].

adult contemporary (media) A format for music radio stations, playing current,

popular music (e.g., TOP-40), but not hard ROCK music.

adult education (education) A system of programs usually offered part-time in the evenings to provide people over eighteen years of age with education or special training. Originally the courses offered knowledge and skills that people did not receive in SECONDARY SCHOOL (e.g., remedial math, English language literacy, GED certification). Now, the curriculum includes many other courses (e.g., ESL, arts and crafts and foreign languages). Also known as "evening school", "night school"; *see* REMEDIAL EDUCATION; *compare* CONTINUING EDUCATION.

Advanced Placement Program (education) (AP or APP) A program sponsored by the COLLEGE BOARD that encourages motivated SECONDARY SCHOOL students to study at a higher level in HIGH SCHOOL to earn COLLEGE[1] CREDIT in the fields of English, math, the sciences and foreign languages. Afterwards, COLLEGE[1]-enrolled students take a PLACEMENT TEST which can exempt them from taking introductory UNDERGRADUATE courses in a particular subject. *Compare* ACCELERATED COLLEGE ENROLLMENT PROGRAM.

adversary system (legal system) The American judicial system of rules and methods allowing persons or groups having a dispute with each other to argue it before a THIRD PARTY[2] (e.g., judge or JURY) and receive a DECISION. *See* COMMON LAW.

advice and consent (government) The power that the CONSTITUTION gives the SENATE to review and approve (or disapprove) actions of the PRESIDENT, specifically concerning TREATIES and presidential appointments. *See* APPOINTMENT POWER, CHECKS AND BALANCES.

adviser/advisor (education) A teacher or staff person who is assigned to help students make choices about which classes to take, EXTRACURRICULAR ACTIVITIES to participate in, SCHOLARSHIPS to apply for and COLLEGES[3] to attend. Also known as "guidance counselor"; *see* DEPARTMENT[1].

affidavit (legal system) An official written document concerning a legal or financial issue that a person (known as an **affiant**) swears is true and correct. It is prepared by a LAWYER or NOTARY PUBLIC.

affiliate (1 work; 2 media) **1** Any independent organization (e.g., it has its own leaders, own BYLAWS) that is, as a group, a member of a larger organization in order to receive more protection, more widespread bargaining rights, national visibility and other benefits. The AFL-CIO has many **affiliated** members. **2** A local radio or television station which agrees to carry the programs of the network. **Affiliated** stations may be owned by the network, but usually are independent. *Compare* FRANCHISE.

affirmative action (minorities) Any policy or program that offers women and MINORITIES better opportunities in education (e.g., admission), employment (e.g., hiring), business and industry (e.g., DEFENSE CONTRACTS). It began in 1965 and is supported by the CIVIL RIGHTS ACT (of 1964) and the FOURTEENTH AMENDMENT as a method of making up for past DISCRIMINATION against women and minorities and to protect them from current discrimination in educational and/or work opportunities. Individual SCHOOLS[5], private companies and businesses and government institutions develop and practice their own affirmative action policies; most of which use the QUOTA SYSTEM. Complaints about affirmative action policies are presented to the EQUAL EMPLOYMENT OPPORTUNITY COMMISSION and the legal courts. Recently, its validity and continuance have been questioned by critics and the legal case of the *REGENTS OF THE UNIVERSITY OF CALIFORNIA v. ALLAN BAKKE*. Beginning in 1998 in California, the ADMISSIONS DEPARTMENTS in SCHOOLS[5] no longer practiced affirmative action programs. *See* REVERSE DISCRIMINATION, EQUAL EMPLOYMENT OPPORTUNITY COMMISSION.

AFL, the (work) A federation of various craft UNIONS[1] which worked together to promote workers' benefits; especially WORKER COMPENSATION. It was founded with 25 unions in 1886 by Samuel Gompers (1850–1924) who promoted the idea of "BREAD AND BUTTER UNIONISM" and encouraged the organization to remain apolitical. In 1955, it merged with the CIO to form the AFL-CIO. [Abbreviation of 'A'merican 'F'ederation of 'L'abor.]

AFL-CIO (work) The largest group of labor UNIONS[1]. Because its AFFILIATES[1] include over 100 national unions and over 500 regional unions (a total 13.1 million workers), it is considered the voice and spokesperson of organized labor. It includes the following UNIONS[1]: UAW, ACTOR'S EQUITY ASSOCIATION, AMERICAN FEDERATION OF TEACHERS, UNITED STEELWORKERS OF AMERICA, UNITED FARM WORKERS OF AMERICA, UNITED AUTO WORKERS and the TEAMSTERS. It formed in 1955 from the MERGER of the AFL and the CIO; its headquarters are located in WASHINGTON D.C. Its full name is "American Federation of Labor and Congress of Industrialized Organizations". *See* BIG LABOR.

African American (minorities) An American whose ancestors (some or all of whom) originally came from Africa. This term has been used since the 1980s and the movement for MULTICULTURALISM to refer to black people because this term more accurately reflects the dual history and culture of blacks living in the UNITED STATES than other terms. It is another, but more accurate name for a black person. [From 'Africa' + 'America'.] Further, it replaces both "NEGRO" (a term used after RECONSTRUCTION, during the CIVIL RIGHTS MOVEMENT and until the BLACK POWER movement of the 1960s) and it replaces the term "Afro American" (a term used during the Black Power movement until the early 1980s).

African-American Studies (education) An academic field at the COLLEGE[1] level which includes courses in the history, politics, economics, society and culture of the black people of North America and the Caribbean. It developed as a separate field during the CIVIL RIGHTS MOVEMENT and BLACK POWER movement of the 1960s. Also known as "Black Studies" or "Afro-American Studies"; *see* CULTURAL/ETHNIC/AREA STUDIES.

age of consent (legal system) The age at which a person is considered mature enough to decide for him or herself if he or she wants to have sexual intercourse or to get married. It is established by the different STATES, but generally, it is between the ages of 14 and 18. *Compare* (age of) MAJORITY.

Agency for International Development (foreign policy) (AID) A federal agency that designs and operates various educational, health, technical and economic programs to help people in less-developed countries, especially in: Africa, Latin America, South Asia, Israel and Turkey. These programs are financed through money GRANTS and technical assistance given to particular projects. It was established in 1961 by the Federal Assistance Act and until 1979 was a part of the DEPARTMENT OF STATE; now it is a part of the US International Development Corporation Agency. *Compare* PEACE CORPS.

aggravated (legal system) Describing something that is particularly mean, harsh, brutal or criminal. It is used to describe different crimes in CRIMINAL LAW (e.g., aggravated theft, aggravated ASSAULT).

Agricultural Adjustment Administration (history) (AAA) During the NEW DEAL, the federal agency that helped stabilize and fix the prices of crop produce by paying farmers to limit the amount of land farmed and crops produced; further, it used federal money to assure a solid price for farmers' produce. It was established and modified by the Agricultural Adjustment Act of 1933 and 1938; in 1942, it became part of the DEPARTMENT OF AGRICULTURE.

Aid to Families with Dependent Children (health) (AFDC) The federal program, commonly known as "WELFARE", active from 1935 until 1996 which gave a gift of money to those poor families that had a child aged 18 years or younger; for each additional child, the family received more money. This program was operated by the federal government with some help from the STATES but because of debates over the effectiveness of the program, complaints about the unwillingness of money recipients to work, and the high costs of the program, it was permanently replaced in 1996 by the TEMPORARY ASSISTANCE TO NEEDY FAMILIES (TANF).

Air Force (military) The division of the ARMED FORCES which uses airplanes to

conduct military procedures. It was established as part of the ARMY in 1907, and was reorganized as a separate division in 1947. Its highest commissioned ranking official is a general. It is headed by a Department of the Air Force which is overseen by the DEPARTMENT OF DEFENSE. By association, it is also a nickname for the UNITED STATES AIR FORCE ACADEMY. *See* NATIONAL SECURITY ACT, Appendix 7 Military Ranks.

Air Force One (government) One of several large, private Boeing 747 airplanes meant for the PRESIDENT to use for traveling and official business. Each aircraft is equipped with telephones, televisions, computers and other office equipment and space as well as sleeping space for the President, ADMINISTRATION staff and FIRST FAMILY. Whichever plane the President is flying in is called "Air Force One". *Compare* AIR FORCE TWO.

Air Force Two (government) The private Boeing 747 airplane operated by the government which the VICE PRESIDENT uses for official business and which is equipped in a similar manner to AIR FORCE ONE. The PRESIDENT and the Vice President never ride the same aircraft or vehicle with each other, for security reasons.

Alamo, the Battle of the (history) A bloody battle in which a group of Texans defended and held off the trained Mexican army for 13 days; the battle ended on March 6, 1836, when the entire group of 189 Texans was killed by the victorious Mexicans. Although the Texans lost this battle, they won their independence from Mexico and established the REPUBLIC OF TEXAS. By association, the expression "Remember the Alamo" means: "remember the courage of your fellow countrymen and do not give up". [After the mission established by the Spanish missionaries *Pueblo del 'Alamo'*, which today is a small town in southern Texas with a current population of 8,000.] *See* DAVY CROCKETT.

Alamogordo (science and technology) The site of the first planned detonation of the nuclear bomb on July 16, 1945. The actual explosion took place outside the limits of this small town (current population 25,500) in the STATE of New Mexico. *See* ROSENBERG CASE.

Alaska Native (minorities) A general name for the four groups of native peoples who live in the STATE of Alaska. It includes: the Aleut people (who live on the Aleutian Islands and traditionally had underground homes and hunted whales, seals and other sea animals); the Athabascans (the traditionally nomadic group which hunted bear, elk and other land animals); the Tlingit (who live along the warmer southern coast near present-day Fairbanks and traditionally fished and hunted); and the Inuit, formerly known as the "Eskimos" (who traditionally lived on the cold Northwest coast in igloos and wooden houses and fished and hunted). All of these people live and are organized into "villages" (i.e., not TRIBES). This term has officially been used since the 1990 US CENSUS for these people; before then, they were officially known as "American Indians". A "federally recognized Alaska Native" is a group that the federal government considers a sovereign group and with which it enters into agreements. There are 210 different federally-recognized governments of Alaska Natives.

Alcatraz (legal system) The federal prison (active from 1934 to 1963) located on the small, rocky Alcatraz Island in San Francisco Bay which used high security and enforced the strictest rules in order to deter criminals; the meanest criminals (e.g., AL CAPONE) served prison sentences here. During this period, it was nicknamed "the Rock". From 1969 to 1971, it was occupied for 19 months by members of various Indian groups who claimed it for Native American peoples and demanded that the US government acknowledge Indian rights. Although INDIANS did not gain ultimate control of the island, this ALCATRAZ OCCUPATION became a symbol for the demand of Indian rights. Since 1973, the island and its buildings have functioned as a museum of the former prison. [Spanish for "gannet".]

Alcatraz (occupation) (minorities) The peaceful seizure and occupation of the former federal penitentiary, ALCATRAZ, by a group of young people and students from various Indian TRIBES from November 1969 until June 1971. The group wished to gain title ownership to the

island, build an Indian cultural center and make that place the base for a major pan-Indian movement. The group chose that site because, previously in the 1960s, some SIOUX INDIANS had occupied the island and went to court to claim rights to the island but they were forcibly removed and the claims case was dismissed. *See* AMERICAN INDIAN MOVEMENT; *compare* WOUNDED KNEE II.

Alcoholics Anonymous (health) (AA) A self-help and group support organization designed for people who are alcoholic and want to stop drinking and end their alcohol addiction. Members promise not to drink alcohol and try to encourage others not to drink by meeting in group sessions. The motto of the members is to live "one day at a time". It was founded in 1935, is headquartered in NEW YORK CITY and counts over 2 million members. Also known as "Al-Anon".

Alcott, Louisa May (people) (1832–1888) A writer whose best-known works are her series of popular, moralistic books for young people, namely, *Little Women*, *Jo's Boys* and *Little Men*. These books treat the daily lives of young people in the nineteenth century.

Alger, Horatio (people) (1832–1899) A fiction writer who wrote over 130 different books popular with young white people. His books treated the theme of poor boys who begin with no material wealth but who earn financial success and happiness by working hard and having a positive attitude. This is often called the process of going from "rags to riches". *See* AMERICAN DREAM.

Algonquin Hotel (the arts) A luxurious hotel located on West 44th Street in MANHATTAN[1], which was the regular meeting place of the ROUND TABLE, a literary discussion group of the 1920s. *See* ROARING TWENTIES.

Ali, Muhammad (people) (born Cassius Clay in 1942) A talented professional heavyweight boxer known for his speed and light step in boxing and self-boasting and proud rhymes (e.g., "I'm the greatest"; I "Float like a butterfly", I "Sting like a bee"). He became controversial in the 1960s because of his independence; he joined the NATION OF ISLAM and refused to

be drafted into the US ARMY during the VIETNAM WAR (for which his boxing title of "heavyweight champion" was taken away from him). However, today, he is widely respected for his individuality and personal strength. He developed Parkinson's Disease in the 1970s. *See* DRAFT[1].

Alien and Sedition Acts (immigration) Four federal acts (passed in 1798) which limited the rights guaranteed to people by the CONSTITUTION: specifically they include the rights of: freedom of the press and freedom of speech of all immigrants and American citizens. Also, they made it more difficult for immigrants to become citizens by requiring them to live in the US for 14 years (no longer five). These laws were supported by many FEDERALIST[2] members in CONGRESS. In 1801, when the Congress had many DEMOCRATIC-REPUBLICAN PARTY members, most of these unfair laws were reversed by the NATURALIZATION ACTS OF 1795 AND 1802. However, they remain a symbol of UNCONSTITUTIONAL laws, NATIVISM and offending the CIVIL LIBERTIES of individuals. *See* FIRST AMENDMENT.

Alien Land Laws (minorities) One of any restrictive STATE laws that did not permit immigrants from Asia (e.g., Chinese, Japanese) from owning or leasing agricultural land and/or prohibited them from leasing land for more than three years, all on the premise that they were not US citizens. Between 1913 and 1923, 13 different states in the WEST and SOUTHWEST (including California, Washington and Oregon) passed these laws. These laws seriously hurt the presence and prosperity of Asian immigrants in these areas. These laws were only repealed after 1956. *See* NATIVISM, YELLOW PERIL.

"all men are created equal" (government) The principle that the government and law courts will treat no person (i.e., male or female) better or worse than any other person. This important element of American democracy was established in the DECLARATION OF INDEPENDENCE and is the basis for EQUAL OPPORTUNITY. *Compare* INALIENABLE RIGHTS.

"All Things Bright and Beautiful" (religion) A common Christian prayer which children often say before going to

bed or after awaking. It goes: "All things bright and beautiful/All creatures great and small/All things wise and wonderful/ The Lord God made them all".

All-American (1 sports and leisure; 2 customs and traditions) **1** Describing a COLLEGE[1] student-athlete who has received the honor of being chosen as one of several outstanding players in a particular sport in a given year. Players are chosen by the voting of sports writers, sports commentators and other members of the press, especially from; the ASSOCIATED PRESS and UNITED PRESS INTERNATIONAL. **2 all-American** Describing someone or something that represents the best values of the UNITED STATES; especially patriotism, honesty, being hard-working and humble. *See* "AMERICAN AS APPLE PIE".

All-Star (sports and leisure) Describing a professional sports athlete chosen in a given year to play a single game with other talented professional players (who normally play for other teams) against a team similarly composed of members. *See* ALL-STAR GAME; *compare* ALL-AMERICAN[1].

All-Star Game (sports and leisure) One game pitting the best professional players of a sport against each other. It is played by two professional teams, each of which is composed of ALL-STAR players. It does not count in the regular season records of any organized teams. The MAJOR LEAGUE has sponsored a mid-season game since 1933; the NBA in February since 1951; and the NFL one week after the SUPER BOWL since 1947. *See* PRO BOWL.

Allen, Woody (people) (born in 1935) A film director, scriptwriter and actor. He is known for making films concerning the friendships, loves, marriages and divorces of adults living in NEW YORK CITY. In many of his own films, he frequently portrays a character similar to his real life person: a JEWISH-American writer. Some films include *Annie Hall* (1977) and *Crimes and Misdemeanors* (1989). He is also a talented JAZZ MUSIC clarinetist. His relationship and 1997 marriage to Soon-Yi (born in 1970), the adopted daughter of his former girlfriend, Mia Farrow (born in 1945), caused some controversy.

allotment (minorities) The general, federal policy (active from 1887 to 1934) in which the community-owned RESERVATION of an Indian TRIBE was divided into separate units and a piece given to each Indian family, adult and/or child for individual ownership. It was an attempt to solve the "Indian problem" and to make INDIANS farmers and more capitalistic. It also allowed Indians to then sell their land to white settlers and American citizens. It was enforced through various different federal laws; the DAWES SEVERALTY ACT (1887), Curtis Act (1898), Dead Indian Land Act (1902) and Burke Act (1906). This policy did not help the ASSIMILATION of Indians to American society; further, it reduced Indian lands from 138 million acres to 48 million acres.

allowance (daily life) The amount of money that a child or teenager receives from a parent, usually weekly, and which the young person uses to pay for his or her social expenses and small purchases. Usually, it does not entail the child doing any work in exchange for receiving the money. *See* CHORES.

alma mater (1, 2 education) **1** The SECONDARY SCHOOL, COLLEGE[1] or UNIVERSITY from which a person graduated. **2** **"Alma Mater"** The song that students or ALUMS sing in respectful honor of their SCHOOL[5]; usually at sporting events, COMMENCEMENT ceremonies and CLASS reunions. [Latin, meaning, "fostering mother".] *Compare* FIGHT SONG.

aloha (language) In Hawaii, the single word which is used to say "hello", "greetings" and "good-bye". [Hawaiian, meaning "love".]

alum/alums (education) A GRADUATE[1] of a particular SCHOOL[1], COLLEGE[3] or PROFESSIONAL SCHOOL. Alums are also known as "alumni". [Shortened from the Latin *alumnus* (meaning "male student") and *alumna* (meaning "female student").]

Alvin Ailey American Dance Theater (the arts) An individualistic, modern dance company which is committed to exploring issues and themes concerning AFRICAN AMERICANS and blacks from the Caribbean and to express this information in new, unique expressions of dance. It was founded in 1958 by Alvin Ailey (1931–1989) and is based in NEW YORK CITY.

AM (media) Describing a radio station that receives and sends signals through a broadcasting system of 'Amplitude Modulation' (a long direct wave that travels the surface of the earth). Since the quality of sound is less clear (i.e., has more static) than FM, AM often carries news programs, talk shows and live broadcasts of sporting events. There are some 5,300 COMMERCIAL radio stations which can be found from 540 through 1600 megahertz AM on the radio dial.

Amateur Sports Act (sports and leisure) The federal act of 1978 requiring each amateur sport that is an Olympic sport to maintain its own independent, national organization to make rules and set standards for that sport.

"Amazing Grace" (religion) A popular, solemn GOSPEL MUSIC song written in 1789 by Englishman John Newton (1725–1807). It is commonly sung in a steady, solemn manner during Christian religious services, in times of sadness or pressing difficulties. The first verse follows: "Amazing grace! How sweet the sound/That saved a wretch [unhappy person] like me/ I once was lost and now am found/Was blind, but now I see".

amendment (government) An official change or addition to a document (e.g., BILL2, the CONSTITUTION). *See* BILL OF RIGHTS.

America (1, 2 customs and traditions) A term referring to the UNITED STATES OF AMERICA; it is used when referring to the history and society which took place on the North American continent during the COLONIAL PERIOD and until just following the AMERICAN REVOLUTION. It is also used to refer to the history and conditions of European and Asian immigration to and settlement in this region; especially with idealistic, hopeful undertones. Today, it is frequently used to refer to the US in a patriotic, idealistic, pride-full and/or traditional way. Further, it serves as a collective term for the "American people". *Compare* COLUMBIA1. **2 "America"** A traditional, popular, up-beat, patriotic song which glorifies the beautiful natural areas and freedoms in the UNITED STATES as well as the development of white settlement. The first verse follows: "My country, 'tis of thee/Sweet land of liberty, Of thee I sing/Land where my fathers died!/Land of the Pilgrims' pride!/From every mountainside/Let freedom ring!" It was written in 1831 by REVEREND Samuel Francis Smith, a BAPTIST preacher. Smith wrote the lyrics to match a German tune he had found in a book of songs; the tune happened to be the same one as the British anthem "God Save the Queen/King".

America Enterprise Institute (economy) An organization that studies the effects of economic policies and reports this information to the public. It is based in WASHINGTON D.C. and awards the annual Frances Boyer prize to world leaders influential in economics.

"America the Beautiful" (customs and traditions) A traditional song celebrating the natural beauty and special-ness of the UNITED STATES OF AMERICA. It was written in 1893 by Katherine Lee Bates (1859–1929), an educator and poet, while she was traveling through the ROCKY MOUNTAINS. The first verse is: "O beautiful for spacious skies/For amber waves of grain/For purple mountain majesties/Above the fruited plain/America! America! God shed his grace on thee/And crown thy good with brotherhood from sea to shining sea."

America's Cup, the (sports and leisure) An international yacht race between two national teams in which a yacht crew must win four races out of a series of seven possible races. A country's team crew challenges the previous winner to the contest which, according to custom, is held once every three or four years. It was first held in 1851 between the United Kingdom and the UNITED STATES. Between the first race in 1851 and the one held in 1995, US yachts won 28 of the 30 contests. The winner is awarded the temporary guardianship of the tall, silver-colored metal trophy standing two feet three inches high (68.6 cm). Formerly known as the "Hundred Guinea Cup" [after the first yacht to win the race, the *'America'*, and the 'cup'-like winner's trophy.]

American Academy of Arts and Letters, the (the arts) An organization, founded in 1898, for those artists, writers,

composers who have been honored in their profession for high achievement. It is based in NEW YORK CITY and currently counts some 250 members.

"American as apple pie", "as" (customs and traditions) A popular phrase used to describe someone or something with strong, traditional values, especially honesty, simplicity and wholesomeness. [From the traditional, overall popularity of PIE made of apples, a perennial favorite dessert.] *See* ALL-AMERICAN[2].

American Association for the Advancement of Science (science and technology) (AAAS) The largest organization for general science, promoting the work and researches of current scientists as well as young people and future scientists. It was founded in 1948 and now includes some 300 scientific societies. It currently has some 135,000 members.

American Automobile Association (transportation) (AAA) The organization, established in 1902, providing travel services and information (e.g., hotel guides, city and STATE maps), car insurance and emergency car services (e.g., towing) to its 3.7 million members. It also functions as a LOBBY to improve car and road safety. It is popularly known as "TRIPLE A".

American Bandstand (media) A popular television program designed for a teenage audience and playing ROCK AND ROLL and POP MUSIC weekdays (1957–1963) and Saturdays (beginning in 1963). From 1963 to 1989, it was popularly hosted by Dick Clark (born in 1929). Also known as "*BANDSTAND*".

American Bar Association (legal system) (ABA) The most important nationwide professional organization for ATTORNEYS of any STATE. It is concerned with all aspects and changes to the civil and criminal justice system. It also works to conduct research and educational projects in order to encourage the professionalism of LAWYERS and to provide legal services to the public. It was founded in 1878, its headquarters are in Chicago and currently, it has some 380,000 members. *See* BAR[2], CIVIL LAW[1], CRIMINAL LAW.

American Birth Control League (minorities) (ABCL) The organization founded in 1921 by MARGARET SANGER which was the first to promote those forms of birth control that women could control. In 1942, it became PLANNED PARENTHOOD.

American cheese (food and drink) A yellow-colored processed cheese with a mild flavor. Often, it is sold in thin, precut slices and frequently eaten on cheeseburgers and sandwiches.

American Civil Liberties Union, the (legal system) (ACLU) An organization which protects the rights and CIVIL LIBERTIES of people and groups in the UNITED STATES by providing legal advice and LAWYER services in all cases, from local courts to the SUPREME COURT. Since it was organized in 1920, it has been involved with cases concerning religious freedom, DESEGREGATION and FREEDOM OF SPEECH. Some groups find the ACLU controversial because it defends all people (eg. it has supported a group of American Nazis in Illinois wanting to hold a parade in a local JEWISH neighborhood). *See Engel* v. *Vitale.*

American Colonization Society (minorities) A privately operated organization which believed the race problem could be solved with the BACK-TO-AFRICA MOVEMENT for blacks. It was active from 1817 to 1912 and helped blacks emigrate to Africa, established the city of Monrovia in Liberia and took care of this new settlement and population in Liberia. Before the CIVIL WAR, from 1822–1862, it helped over 11,000 former American slaves emigrate. *See* BLACK NATIONALISM, ABOLITION.

American Dilemma, An (history) An important book (published in 1944) which discussed race relations in the UNITED STATES, namely, it addressed the theory of American "equality" and blamed the US government for the fact of AFRICAN AMERICANS' inequality in society. It was written by a Swedish social scientist, Gunnar Myrdal (1898–1987); RALPH BUNCHE helped do research for it. It was confident that the situation would improve; it led to the CIVIL RIGHTS MOVEMENT.

American Dream, the (customs and traditions) The political, social, and economic idea that if a person works hard and obeys the rules in AMERICA[1] he or she will be rewarded with financial wealth and

other successes. Usually, it supports the family unit, EQUAL OPPORTUNITY and the system of CAPITALISM in the US. It generally includes the idea that one becomes more successful than one's parents. Also spelled "American dream"; *see* PURITAN WORK ETHIC, HORATIO ALGER; *compare* FAMILY VALUES, PROTESTANT WORK ETHIC, "I HAVE A DREAM".

American Federation of Teachers (education) (AFT) The major national labor UNION[1] for teachers. It was established in 1916 and is now an AFFILIATE[1] of the AFL-CIO. *Compare* NATIONAL EDUCATION ASSOCIATION.

American Field Service (education) (AFS) An intercultural, educational exchange program that gives American SECONDARY SCHOOL students the opportunity to live overseas for an ACADEMIC YEAR to attend HIGH SCHOOL and live with families. In return, American families welcome high school-aged international children and teenagers into their homes to live and attend SCHOOL[1] for a year. It was established in 1914 and now has exchanges with over 60 different countries.

American Film Institute Life Achievements Awards, the (the arts) A respected, honorary award presented to any individual for a long period of important, quality work in the fields of film (e.g., director, actor, actress) or television. Only one is presented each year (first in 1973) by the American Film Institute.

American Football Conference (sports and leisure) (AFC) One of the two parts of the NFL. It consists of 15 professional FOOTBALL teams which are organized into three, largely geographical divisions: Eastern Division, Central Division and Western Division. The winner of this conference plays the winner of the NATIONAL FOOTBALL CONFERENCE in the SUPER BOWL. Originally, it was founded as the AMERICAN FOOTBALL LEAGUE. *See* Appendix 3 Professional Teams.

American Football League (sports and leisure) (AFL) A professional FOOTBALL league active from the 1960 to 1969 which was separate from the NFL; although its best team did play against the best team of the NFL in the post-season SUPER BOWL tournament (beginning in 1967). In 1970,

it became the AMERICAN FOOTBALL CONFERENCE and thus, a part of the NFL.

American Gothic (the arts) A finely detailed oil painting created in 1930 by the regional artist Grant Wood (1892–1942). It depicts an older, balding man holding a pitchfork and a younger, blond-haired woman; both are wearing dark, sober looking clothes. They are standing in a farmyard before an off-white colored farmhouse which has a 'gothic' shaped window. Because it is a symbol of the MIDWEST, farming, rural communities, conservativism and traditional values, it is often used to mock these American elements. Further, because it is considered very American, the images of contemporary figures in society may be placed in the same setting to show that those figures behave like or represent Americans. *See* CONSERVATIVE.

American Hockey League (sports and leisure) (AHL) An organization founded in 1936 for semi-professional ice hockey which manages season rules and marketing for its 13 member teams all of which are based in the UNITED STATES and Canada. It is an AFFILIATE[1] of the NHL.

American in Paris, An (1, 2 the arts) **1** The upbeat classical music (1928), inspired by popular, contemporary JAZZ MUSIC, that was written by GEORGE GERSHWIN. **2** A musical using the songs and music of GEORGE GERSHWIN to relate the story of a frustrated American artist living in Paris, France, the center of painting. It was made into a colorful movie in 1951 starring the dancer, Gene Kelly (1912–1996).

American Independent Party (politics) A THIRD PARTY[1] supporting STATES' RIGHTS[2], lower taxes, law and civil order in the UNITED STATES and victory in the VIETNAM WAR. It was active only in the elections of 1968 in which it nominated George Wallace (born in 1919) of Alabama for PRESIDENT. Most of its supporters were in the SOUTH. *See* Appendix 2 Presidents.

American Indian Movement (minorities) (AIM) An activist organization active in helping INDIANS receive those rights that they had been promised but were then not receiving (i.e., TREATY rights). It was

founded in Minneapolis, Minnesota in 1968 by DENNIS BANKS and others; and it served as the main organization of the RED POWER Movement. It worked to protect NATIVE AMERICANS from unnecessary arrest and police department brutality; and to improve the quality and number of federal, STATE and local programs providing social, anti-poverty and (Indian-oriented) education services to INDIANS (especially those living in urban areas). After it had sponsored other more radical events, namely, the TRAIL OF BROKEN TREATIES and WOUNDED KNEE II, several of its leaders were arrested which left a vacuum of leadership. In 1979, the organization dissolved at the national level.

American Indian Religious Freedom Act (religion) (AIRFA) The first federal law (passed in 1978) that protects and supports the inherent right of INDIANS to practice their religious traditions and beliefs, specifically; using traditional objects and PEYOTE and visiting traditionally sacred sites. *See* NATIVE AMERICAN CHURCH; *compare* GHOST DANCE, WOUNDED KNEE, BLACK HILLS.

American Institute of Architects Gold Medal (the arts) The very prestigious award given to honor an architect, of any nationality, and his or her life work; sometimes it is awarded after an artist's death. It is overseen by the American Institute of Architects; it was first presented in 1907, but is not awarded every year.

American Jewish Congress (religion) (AJC) A private organization that defends the political and social rights of JEWISH peoples in the UNITED STATES and throughout the world. It includes the AJC's Commission on Law and Social Action which works to legally abolish DISCRIMINATION and ANTI-SEMITISM practices. It was founded in 1918, is headquartered in NEW YORK CITY and currently has 50,000 members. *Compare* ANTI-DEFAMATION LEAGUE.

American League (sports and leisure) (AL) In professional BASEBALL, the organization founded in 1901 that regulates the rules and policies for its 14 member teams which are organized into three largely geographical Divisions (i.e., East, Central, West). All of its teams use a DESIGNATED

HITTER. It sponsors the LEAGUE CHAMPIONSHIP SERIES and is one of the two MAJOR LEAGUES. *See* PENNANT, WORLD SERIES; *compare* NATIONAL LEAGUE.

American Legion, the (military) The largest organization for American veterans of the ARMED FORCES. It lobbies for veterans and veteran-related causes as well as organizes social and charitable activities for veterans and the local community. Frequently, members participate in parades and services on VETERANS' DAY and MEMORIAL DAY. Currently, it has some 3 million members organized into 15,000 local groups. *See* LOBBY.

American Medical Association (health) (AMA) The largest organization in the UNITED STATES for physicians and doctors (currently some 300,000 members). It distributes scientific information concerning the private medical profession. It sets standards for medical SCHOOLS[5] and residency programs and lobbies CONGRESS on health-related issues; it does not support a national health care plan. It was founded in 1847 and publishes the *JOURNAL OF THE AMERICAN MEDICAL ASSOCIATION* (*JAMA*). Its current headquarters are in CHICAGO and it has an active PAC.

American Renaissance, the (the arts) The collective name for the busy literary and lecturing period beginning in the 1830s and lasting until 1860 (i.e., the CIVIL WAR) which was active in NEW ENGLAND, especially in the BOSTON area. The subject matter treated those things uniquely American, namely, American nature (e.g., the mountains, rivers) and Americans' relationship to nature, as well as American history (e.g., of the Puritans, of New England, whalers) and types of people found in and shaped by America (e.g., INDIANS, frontiersmen, independent individuals). The artists included: writers EDGAR ALLAN POE, RALPH WALDO EMERSON, NATHANIEL HAWTHORNE, HERMAN MELVILLE, HENRY DAVID THOREAU, Oliver Wendell Holmes (1809–1894), social reformer Margaret Fuller (1810–1850) and poets Henry Wadsworth Longfellow (1807–1882), James Russell Lowell (1819–1891) and John Greenleaf Whittier (1807–1892) as well as others. It included the movement of TRANSCENDENTALISM.

See MOBY DICK, UNCLE TOM'S CABIN, WALDEN, PURITAN.

American Revolution, the (history) The war fought between the THIRTEEN COLONIES and Great Britain from 1775 to 1783. It began at the battles of LEXINGTON AND CONCORD and ended with the surrender at YORKTOWN. The issues of the war stemmed from the colonists' wish to be taxed by the British Parliament only if the colonists had colonial representatives in that Parliament. The British refused to give up voting Parliament seats to colonials; therefore Americans wanted their own independent government. The Americans were victorious in the war and gained their independence and land concessions via the TREATY OF PARIS. Also known as "REVOLUTIONARY WAR" and "War for Independence"; *compare* DECLARATION OF INDEPENDENCE, "NO TAXATION WITHOUT REPRESENTATION", *COMMON SENSE*.

American Sign Language (language) (ASL) A communication system of hand and facial movements that people with hearing disabilities use. Because it has its own grammar rules (i.e., not those of the English language), it is considered a separate language from English. The common acronym for it is "AMESLAN".

American Stock Exchange (economy) (AMEX) The second largest and second busiest stock exchange in the US (*compare* NEW YORK STOCK EXCHANGE) which lists the stocks of some 1,000, mostly medium-sized and small businesses and provides a space for them to be traded. It was established in 1911 and is now one of the major financial institutions of WALL STREET. Also known as "LITTLE BOARD" and "CURB EXCHANGE".

Americana (customs and traditions) Any thing or information relating to the UNITED STATES, especially folklore items, FOLK ART objects, FOLK MUSIC, historical objects (e.g., books, maps) and other objects. The SMITHSONIAN[1] has large collections of Americana.

Americans with Disabilities Act (minorities) (ADA) The important federal law (passed in 1990) which prevents DISCRIMINATION against DISABLED people in employment because of their disability.

Namely, it makes business and public accommodations (e.g., restaurants, theaters, bathrooms) and telephone services become HANDICAPPED ACCESSIBLE. *Compare* CIVIL RIGHTS ACT.

AmeriCorps (education) A national service program that promotes full-time or part-time community service in education, public safety, human needs and the environment in exchange for federal help in paying for HIGHER EDUCATION. A program participant must be over 17 years of age and either a HIGH SCHOOL GRADUATE[1] or a GED holder. It was created in 1994 by PRESIDENT BILL CLINTON through the National Service Movement bill. *Compare* PEACE CORPS, TEACH FOR AMERICA, TEACHER CORPS.

AMESLAN (language) a popular name for AMERICAN SIGN LANGUAGE. [Acronym from 'Ame'rican 'S'ign 'Lan'guage.]

Amish, the (religion) A PROTESTANT religious group/division of the Mennonite Church which believes in living a traditional and simple way of life (e.g., not owning; cars, electrical appliances, telephones, contemporary or fancy clothing) in order to be closer to its God. It developed during the seventeenth century in Europe by growing out of a Mennonite group and was brought to America through immigration in the 1720s. The Amish do not have church buildings but hold their religious services in their homes and farmhouses. Today, most of the 80,000 members practice farming (with horses and wagons) in the MIDWEST, as well as and especially in the STATE of Pennsylvania, where, because of their religious beliefs and practices, they have become tourist attractions. Their first language is PENNSYLVANIA DUTCH[2]; although some do speak German as well. They refer to all non-MENNONITES (Americans and non-Americans) as "the English". [After founder Jakob 'Ammann', a Swiss preacher of the seventeenth century.]

Amtrak (transportation) The popular name for the National Railroad Passenger Corporation and its passenger train service offering transportation between some cities and STATES. It was created by the Rail Passenger Service Act of 1970 and

includes over 24,000 miles (38,400 km) of track.

anchor (media) The person who leads a television news program by reading news reports and introducing other reporting correspondents. Two people who share this job are "co-anchors". [From the steady support that a ship's 'anchor' gives to the ship.]

Angel Island (immigration) The federal immigration and detention center in SAN FRANCISCO which was active from 1910 to 1940 processing mostly Asian (especially some 200,000 Chinese) immigrants to the US. It is popularly known as "the ELLIS ISLAND of the WEST". [After the name of the island on which it stands in San Francisco Bay.]

Angelou, Maya (people) (born Marguerite Johnson in 1928) An author and poet who spent the first 16 years of her career as a dancer. She is known for writing her autobiography in five different best-selling books that trace her life as an African-American woman in the twentieth century. Her writing style is admired for its eloquence and oral-sounding narration. Her most famous book is *I Know Why the Caged Bird Sings* (1970). She read a poem at the INAUGURATION DAY ceremonies in 1992. *See* BESTSELLER.

antebellum south, the (history) A collective name for the STATES in the SOUTH before the CIVIL WAR which practiced the plantation crop economy and the legal institution of SLAVERY. *See* APOLOGIST.

Anthony, Susan B. (people) (1820–1906) A SUFFRAGIST and strong supporter of the WOMEN'S RIGHTS movement. Her organizational skills and circulation of petitions for women's property rights, women's rights to child custody and the right to vote encouraged the STATE of New York to pass laws giving women more rights. Her birthday, February 15, is recognized in some states, although it is not a FEDERAL HOLIDAY.

Anti-Defamation League (of B'nai B'rith) (religion) A respected, private organization formed in 1913 by B'NAI B'RITH to fight ANTI-SEMITISM and unfair DISCRIMINATION against all MINORITIES by using the legal court system. In particular,

it has supported those cases involving education in PUBLIC SCHOOLS and the SEPARATION OF CHURCH AND STATE. Further, it lobbies and promotes new laws to protect the CIVIL RIGHTS of all minorities. *See* LOBBY, FIRST AMENDMENT; *compare* NAACP, AMERICAN JEWISH CONGRESS.

Anti-Federalists (politics) A group of FOUNDERS[1] and other people in the CONSTITUTIONAL CONVENTION who believed the CONSTITUTION gave the government too much power and did not protect the rights of individuals. They refused to support and adopt the Constitution unless the BILL OF RIGHTS was added to it. [From their opposition to the FEDERALISTS[1].]

anti-imperialism (foreign policy) An organized political movement (1870–1900) that did not want the UNITED STATES to gain or buy colonies overseas. In addition, its followers, **anti-imperialists**, did not support the SPANISH-AMERICAN WAR nor did they support the REPUBLICAN PRESIDENT William McKinley (1843–1901) for re-election. By association, any person who does not support any US military action or acquisition of property overseas. *See* ANTI-WAR MOVEMENT.

anti-miscegenation laws (minorities) Local or STATE laws that prevent people from different races to mix or socialize with each other, especially preventing a white person and a non-white person from marrying and living with each other. These laws were passed and enforced with the "SEPARATE BUT EQUAL" doctrine. Since the CIVIL RIGHTS MOVEMENT, these laws have been OVERRULED and forbidden by the SUPREME COURT.

anti-Semitism (religion) An official or personal policy of DISCRIMINATION against JEWISH people because of their religion or culture. ['anti' + originally from Hebrew, '*Shem*', the name of the oldest son of Noah, an early Old Testament Jewish figure.] *See* ANTI-DEFAMATION LEAGUE.

Anti-Terrorism Act (immigration) A federal law (passed in 1996) which tries to reform the policy of immigration to the UNITED STATES, namely, by limiting the rights of ILLEGAL ALIENS and permitting the federal government to deport those individuals who have a record for terrorist activities. It was passed after the bombing

of the WORLD TRADE CENTER in 1993. *See* DEPORTATION DRIVE.

anti-war movement, the (history) The movement of various organized and spontaneous events carried out by UNIVERSITY students, members of the COUNTERCULTURE, HIPPIES, YIPPIES, members of the NEW LEFT, members of the STUDENTS FOR A DEMOCRATIC SOCIETY (SDS) and other concerned citizens, demonstrating their strong wish for the UNITED STATES government to end its military violence in Southeast Asia and to stop the VIETNAM WAR and to bring US troops back home to America. It included namely: the March on Washington to End the War in Vietnam (April 15, 1967); the March on the PENTAGON (October 21 to 22, 1967); the Jeanette Rankin Brigade March (thousands of women protested the war November 1967); the Stop The Draft Week (1967); the Women's March (January 15, 1968); the student takeover and occupation of COLUMBIA UNIVERSITY (April and May, 1968); the CHICAGO RIOT (August 26 to 29, 1968); the Anti-Vietnam "Moratorium Day demonstration" (October 15, 1969); March on Washington (November 16 to 19, 1969); the protests which ended in the KENT STATE MASSACRE/INCIDENT; the National Mobilization Committee to End the War in Vietnam (known as "The Mobe"); and draft resistance. Also known as "the Anti-Vietnam War movement"; *see* DRAFT[1], WOODSTOCK, SIT-INS, SUMMER OF LOVE, FLOWER CHILDREN, CHICAGO EIGHT.

Antiquities Act, the (environment) The federal law (passed in 1906) which permits the PRESIDENT to create or establish NATIONAL MONUMENTS on those lands which are under the control of the federal government.

antitrust laws (economy) Laws designed to protect trade, businesses, low prices and competition in the UNITED STATES. They prevent MONOPOLIES, price discrimination (i.e., charging different prices to different customers for the same product) or any other business activity that tries to limit competition. Federal antitrust laws include: SHERMAN ANTITRUST ACT, Federal Trade Commission Act and the CLAYTON ANTITRUST ACT.

They are enforced by the Antitrust Division of the US DEPARTMENT OF JUSTICE. *See* MA BELL.

Apollo Project (science and technology) The mostly successful research and space program that developed the spacecraft that carried crews to the moon from 1967 to 1972. The most important trip was Apollo 11 on July 20, 1969, in which the astronaut NEIL ARMSTRONG became the first person to walk on the moon. This first moon walk fulfilled a 1961 promise of PRESIDENT JOHN F. KENNEDY to the American people to land an American on the moon before the end of the decade. It was formally known as "Project Apollo". *See* NASA.

Apollo Theater, the (the arts) In NEW YORK CITY, the famous club presenting live music entertainment located on 125th Street in HARLEM. It is known, since the 1930s, for showcasing black musicians and singers and has helped many of these performers develop their careers. *Compare* COTTON CLUB.

Apologist/apologist (history) Before the CIVIL WAR and especially in the SOUTH, a person who supported the use of SLAVERY (for political, economic or religious reasons) and believed in STATES' RIGHTS[2] and property rights. *Compare* ABOLITION.

Appalachia (geography) A general name for those rural regions of the APPALACHIAN MOUNTAINS in the present-day STATES of West Virginia, North Carolina, Virginia, Ohio and Pennsylvania. It is characterized as being a region where heavy coal mining was done in the early twentieth century as well as having long been home to mostly poor, white people.

Appalachian Mountains, the (geography) The longest and oldest mountain range in the eastern UNITED STATES, extending for 1,600 miles (2,570 km), from Maine to Georgia. During the eighteenth century, it served as a natural western boundary prohibiting white migration out WEST. Today, it is a popular summertime recreation, resort and conservation area. *See* APPALACHIAN TRAIL.

Appalachian Trail (sports and leisure) A footpath for leisure and intensive hiking which extends 2,050 miles (3,300 km) from

Mount Springer in the southern STATE of Georgia to Mount Katahdin in the northern state of Maine.

appeal (legal system) A request by the DEFENSE or PLAINTIFF that all or part of a case which was decided in a LOWER COURT be re-examined in a higher court. A higher court has the authority to hear the case and decide to change the DECISION of that case that is **appealed**. *See* US COURT OF APPEALS, SUPREME COURT, CERTIORARI.

appellate court (legal system) A general name for any court which hears a case on APPEAL; especially the US COURT OF APPEALS. *See* SUPREME COURT.

appetizer (1, 2 food and drink) **1** A small portion of food prepared with ingredients (e.g., small pieces of meat, fish or vegetables) designed to stimulate a person's interest in eating; it is served either hot or cold. **2** The first course of an evening meal or DINNER. *See* HORS D'OEUVRE; *compare* ENTREE, FINGER FOOD.

apple pandowdy (food and drink) A deep-dish dessert made of thin slices of apples, cinnamon and molasses topped with a crumbly pastry dough crust. It is served warm with cream. [From the 'apple' ingredients and the sloppy, not-fancy (i.e., 'dowdy') pastry crust.] Also, sometimes known as "Apple Jonathan" in the NORTHEAST.

appointment book (daily life) A small book of bound pages printed with the month, days and dates of a particular year as well as space for an individual to write in the times and locations of meetings, DATES[1] and other personal or business plans. Also known as "schedule" or "calendar"; *compare* DIARY.

appointment power (government) The responsibility and ability of the PRESIDENT to select and nominate individuals to hold official positions and work for the federal government in the executive branch (e.g., SECRETARIES of DEPARTMENTS[2], members of the FEDERAL RESERVE BOARD, FEDERAL TRADE COMMISSION) as well as the judicial branch (e.g., judges for the SUPREME COURT, US DISTRICT COURT, US COURT OF CLAIMS) and all US ambassadors. All presidential **appointees** must be approved of by the US SENATE, usually after

HEARINGS[2]. *See* ADVICE AND CONSENT; *compare* SPOILS SYSTEM, CIVIL SERVICE.

Appomattox Court House (history) General ROBERT E. LEE surrendered his Confederate Army of Northern Virginia to US General ULYSSES S. GRANT, head of the UNION[3] Army, on April 9, 1865, which effectively ended the CIVIL WAR. Further, it ensured that the US would accept those areas of the former CONFEDERATE STATES OF AMERICA back in to the UNITED STATES and become one country again. [From the rural village (named 'Appomattox Court House') where the two generals met. The actual signing of the terms of surrender took place in the private residence of a local villager.] *See* FORD'S THEATER.

appropriations (government) Money that is planned to be spent (e.g., in the budget of the federal government) according to the laws that the legislature or executive makes.

April 15 (economy) The deadline day on which all federal tax forms must be completed and all taxes for the previous year must be paid to the INTERNAL REVENUE SERVICE. The official deadline is 12 o'clock midnight on April 15. *See* TAX SEASON.

April Fools' Day (customs and traditions) April 1, the day on which people tell jokes and play practical jokes on each other at school, at home and at work. If the listener believes the joke, the joke-teller calls him or her an "April Fool", meaning that the listener was foolish enough to believe the joke. [After a similar traditional day in French-speaking countries known as "*poisson d'avril*", meaning "April fish".]

Arbor Day (customs and traditions) The last Friday in April, a day reserved to celebrate trees and nature and for increasing the public's interest in forestry and planting trees. It was first celebrated in 1872 and is a LEGAL HOLIDAY only in the STATE of Nebraska. However, it is OBSERVED[2] by many other people and states by planting trees and holding outdoor, educational events concerning trees and the environment.

Arches National Park (environment) A unique NATIONAL PARK in the dry, eastern part of the state of Utah. The park has a

moon-like, desert landscape containing over 1,800 natural red-, orange- and gold-colored sandstone 'arches'. *See* ED-WARD ABBEY, WEST.

area code (daily life) A three-digit number used before a local telephone number when calling that number from a different city or STATE.

Arlington National Cemetery (military) The national cemetery of the UNITED STATES in which common soldiers as well as famous figures are buried. The land and mansion belonged to the wife of ROBERT E. LEE, Mary Custis Lee and were dedicated to the US after the CIVIL WAR. It includes the graves of hundreds of soldiers (each grave indicated with a white marker: white crosses for Christians; white Stars of David for Jews) from various US wars, the TOMB OF THE UNKNOWNS and the graves of JOHN F. KENNEDY (marked by an eternally-lit flame), ROBERT KENNEDY and Jacqueline Kennedy Onassis (1929–1994). It is the site of special ceremonies on VETERANS' DAY and MEMORIAL DAY. [After its location on land in 'Arlington', Virginia which is across the Potomac River from WASHINGTON D.C..] *See* DEPARTMENT OF VETERANS' AFFAIRS.

ARM! (environment) A radical animal rights organization and LOBBY that lobbies to create laws to stop the abuse of animals, especially to cease the use of animals in laboratory testing and to end the animal fur industry. It was founded in 1981 and has 30,000 members.

armed forces, the (military) A collective name for the different branches of the UNITED STATES military, namely, the US ARMY, US NAVY, US AIR FORCE, and US MARINES. All of these groups are parts of and under the command of the DEPARTMENT OF DEFENSE. The armed forces also include the US COAST GUARD. They have been officially desegregated (mixed whites and blacks in the same squads) since 1954. They have accepted female personnel since 1973, and since 1993, women can fly combat planes and serve aboard warships, but they still cannot serve in ground combat. *See* DRAFT[1].

Armed Forces Day (military) The third Saturday in May, the day established to honor the current, active members of the US ARMED FORCES. It usually entails parades at the national service academies (e.g., WEST POINT) and at military bases throughout the UNITED STATES and its territories. *Compare* MEMORIAL DAY.

Armory Show, the (the arts) The popular name for the controversial "International Exhibition of Modern Art", which included works from European and American artists and was held from February 17 to March 15, 1913, in NEW YORK CITY. Many of the paintings made by Europeans shocked American audiences because the artworks were not realistic-looking and they experimented with the human figure, different forms and colors. Most notably, Frenchman Marcel Duchamp's *Nude Descending a Staircase* did not appear to be a woman but a geometric group of triangles and other shapes. This show introduced Americans and American artists to the new European styles of Cubism and Post-Impressionism. It is considered the birth of modern art in America. [After the exhibition's location at New York's Sixty-Ninth Regiment 'Armory' building.]

Armstrong, Louie (people) (1901–1971) A popular, talented JAZZ MUSIC performer and entertainer known for his skill at playing the trumpet (with a band or as a soloist), innovation and improvisation in the music and his distinctive deep, "scat" voice. Other artists and singers called him "Pops"; his popular nickname was "Satchmo", a clipped form of "Satchelmouth", because he had enormous cheeks which could hold a lot of air to play the instrument. Before 1925, he played the coronet.

Army (military) A branch of the ARMED FORCES serving in land maneuver combat in wartime situations and serving in domestic emergencies and relief measures. It was established in 1775 and today is overseen by the Department of the Army which is part of the DEPARTMENT OF DEFENSE. Its highest commissioned ranking official is a general. By association, it is also a nickname for the United States Military Academy at WEST POINT. *See* GREEN BERETS, PURPLE HEART, Appendix 7 Military Ranks.

Arnold, Benedict (people) (1741–1801) A traitor and American-born US ARMY

general who led colonial troops during the AMERICAN REVOLUTION. Because of his personal greed, he sold colonial military information to the British in 1780 hoping to earn money. His plan was soon discovered by American authorities, but he escaped to the British army and later to England. He is a symbol of treason; the opposite of patriotism.

arroyo (environment) A dry, narrow ditch that carries away water caused by flash floods. Arroyos are found in the SOUTHWEST and are dry most of the year.

"arsenal of democracy", "the" (foreign policy) A slogan used by PRESIDENT FRANKLIN ROOSEVELT to encourage the UNITED STATES (even though it was a neutral country) to supply democratic European nations with military weapons to help those countries fight and retain their democratic systems of government and business. This slogan encouraged CONGRESS to support the LEND-LEASE ACT. *See* ISOLATIONISM.

Articles of Confederation, the (government) The unsuccessful, first written plan of the national American government which was in effect from 1781 to 1778. It was written and adopted by the CONTINENTAL CONGRESS and failed because it gave the individual STATES more powers than the central government (e.g., states could choose to pay taxes to the federal government or not; all states must agree to all TREATY agreements for them to become law). In 1789, it was replaced by the UNITED STATES CONSTITUTION. *See* SHAY'S REBELLION, WHISKEY REBELLION.

Arts and Crafts movement (the arts) A movement of the late nineteenth century which promoted making and using traditional handmade handicrafts (e.g., wooden furniture) because it feared that these older skills would be lost because of the cheaper prices and popularity of new, machine-made and industrial products.

AS (education) A type of ASSOCIATE'S DEGREE. [Abbreviation of 'A'ssociate of 'S'cience.]

ASCAP (the arts) The largest representative organization, founded in 1914, to help protect the rights of artists to their works. It works to collect the royalties on the songs and music of its member artists and then pays the respective artists their respective royalty amounts. It currently has over 33,000 members. [Abbreviation of 'A'merican 'S'ociety of 'C'omposers, 'A'uthors and 'P'ublishers.]

Ashcan School, the (the arts) An artistic movement of oil paintings and sketches which depicted realistic urban scenes containing poverty and dirtiness from the human perspective. It often depicted the sadness or happiness of members of the working class, crowds and the daily life of people living in the slums. It was centered in Philadelphia, the city where it began, and NEW YORK CITY during the period from 1891 to 1914. It was not accepted by critics, and because it was so real looking, it dissolved after the ARMORY SHOW. It was led by Robert Henri (1865–1929) and included George Luks (1867–1933), George Bellows (1882–1925) and others. It is an example of REALIST PAINTING in art.

Ashe, Arthur (people) (1943–1993) A talented tennis player and the first AFRICAN AMERICAN to win the US OPEN (1968) and to play with the American DAVIS CUP team (1964). After having heart surgery, he contracted AIDS (Acquired Immune Deficiency Syndrome) and later died. Also, he is remembered for supporting talented, young black athletes.

Aspen (geography) The chic and elite ski resort in the ROCKY MOUNTAIN region of Colorado which since the 1960s has also been a popular destination and winter home for famous stars and celebrities. It has a strong LOBBY against wearing animal fur. The town was originally founded in 1936 and currently has strict ZONING REGULATIONS to preserve the small western-town atmosphere.

Aspen Institute, the (politics) A multinational, private cultural organization which tries to solve important social problems by organizing WORKSHOPS and conferences between leaders in business, education and culture to address these problems. It was founded in 1948 and is based in Queenstown, Maryland.

assault (legal system) The legal name for some intentional action (or some threat to do some action) that could physically harm another person. Usually,

this is a minor type of crime. "Criminal assault" is a more serious type of assault because it causes serious harm to an individual. "Assault and battery" refers to assault and physical touching/hitting (i.e., battery). All types of assault can be tried in one of various different legal courts.

Assembly, the (government) In many STATES, the name of the larger chamber in the legislature; especially the lower house. "Assemblymembers" meet in the STATE-HOUSE. *See* BICAMERAL LEGISLATURE; *compare* HOUSE OF REPRESENTATIVES.

asset (economy) Anything owned by a person or a business that has value and that can earn value in the future (e.g., land, cars, building, equipment, COPY-RIGHT).

assimilation (minorities) The idea and process of a group or MINORITY abandoning its native culture (i.e., morals, values, religious practices, language, etc.) in order to become an individual member of the mainstream white, American culture. This was the official, federal goal (enforced by the BUREAU OF INDIAN AFFAIRS) toward NATIVE AMERICANS during the nineteenth century and until 1934. **Assimilationist** policies included the program of ALLOT-MENT and the extension of US citizenship to INDIANS. Although Indians who were MIXED-BLOOD or lived in the city supported assimilation, those Indians living on the RESERVATIONS did not want to adopt white American culture. Sometimes known as "integration"; *see* MELTING POT, *Worchester v. Georgia*, INDIAN CITIZENSHIP ACT; *compare* BLACK NATIONALISM, ACCOMMO-DATION, MULTICULTURALISM, ACCULTURA-TION, CAPITALISM.

assistantship (education) A paid position in teaching, research or administration for a full-time GRADUATE[2] that pays for tuition and other SCHOOL[4] costs. The position usually requires 10 to 20 hours of work a week. A student who has this position is called a "Graduate Assistant" or "Graduate Associate" (GA) or "Teaching Assistant" (TA). *Compare* PROFESSOR.

assisted living (health) Describing the medical and resident care provided to elderly patients, especially those too old or disabled to live (e.g., cook, shop, walk)

alone without special care. They live in an especially equipped residence center and are cared for by trained care givers and nurses. This type of care is often provided in a NURSING HOME.

Associate Justice (legal system) The title given to eight (of the nine) judges of the SUPREME COURT. Each one is appointed by the PRESIDENT *see* APPOINT-MENT POWER) to this position and serves a TERM[1] for life or until retirement. *Compare* CHIEF JUSTICE.

associate's degree (education) A degree awarded to a student who has completed the courses and exams of a two-year, HIGHER EDUCATION program, at a COMMUNITY COLLEGE or JUNIOR COLLEGE. There are three types: the AAS is earned in a technical or semi-professional field; the AA is earned in LIBERAL ARTS and sciences, the AS is earned in a scientific field. Both the AA and AS permit the student to transfer to a LIBERAL ARTS COLLEGE or other UNDERGRADUATE program at a UNI-VERSITY. *Compare* BACHELOR'S DEGREE.

Associated Press (media) (AP) A news service selling and sending news stories and SYNDICATED news items by wire to newspapers, magazines, on-line services and TV and radio broadcasts. It was founded in 1848 and is the largest wire service in the world. Further, its sports writers nominate amateur athletes to the status of ALL-AMERICAN. *Compare* UNITED PRESS INTERNATIONAL.

Association of Tennis Professionals (sports and leisure) (ATP) The organization founded in 1972 that sets standards for professional tennis and sponsors over 70 tournaments worldwide for professional male tennis players. It consists of two divisions: Division I is for the top 200 tennis players in singles, and top 100 doubles teams; Division II is for the top 500 tennis players in singles, and top 250 doubles teams.

Association on American Indian Affairs (minorities) (AAIA) The organization which works to support Indian TRIBES by giving them legal advice (in the US federal government and STATE government systems) as well as other more technical advice. It was established in 1923, is head-quartered in South Dakota and currently

has 40,000 members. Traditionally, it was operated by people who were not INDIANS.

at bat (sports and leisure) In BASEBALL, in general when one team is on the offensive. Specifically, when an offensive player is standing at the HOME PLATE, holding a bat and ready to hit the ball. By association, a person or group who is ready and/or in a position to perform.

athletic director (sports and leisure) The person in a SECONDARY SCHOOL or COLLEGE[3] who is responsible for organizing the sporting schedules of that SCHOOL'S[5] teams and enforces the rules of an athletic CONFERENCE. See NCAA.

Atlanta (geography) The capital city of Georgia originally founded in 1847. During the CIVIL WAR, it served as a very important supply center for the Army of the Confederacy and was burned to the ground on November 16, 1864, by US General WILLIAM T. SHERMAN. Today, it is a thriving city of business and communications (the headquarters of CNN are here); it has over 2.5 million inhabitants and hosted the summer Olympic games in 1996. It is considered the economic center and unofficial "capital city" of the SOUTH; it is the center of the "New South". See CONFEDERATE STATES OF AMERICA, MARCH TO THE SEA, Appendix 3 Professional Teams.

"Atlanta Compromise", "the" (minorities) The popular nickname for the philosophy of BOOKER T. WASHINGTON which accepted racial SEGREGATION and encouraged blacks to accept academic, social and political inferiority to whites. This philosophy was first articulated in a speech presented by Washington to white REPUBLICANS in 1895 at the Cotton States Exposition in ATLANTA, Georgia. In this speech, Washington encouraged blacks to "cast down your bucket where you are" and work to get economic self-reliance (i.e., not political and social equality with whites), specifically by studying in VOCATIONAL SCHOOLS (i.e., not UNIVERSITIES) and working in industries and factories. Washington encouraged blacks never to fight for political power or social equality in America. These ideas were contrary to those held by W.E.B. DU BOIS.

Atlantic City (geography) A coastal city of some 38,000 people, noted for its summer seaside resort, long boardwalk (seven miles; 11 km) and for being the host city of the MISS AMERICA PAGEANT. Since 1976 when gambling was legalized in this area, it has become known for being the gambling and casino center of the EAST COAST. Compare LAS VEGAS.

Atlantic Monthly, The (media) A monthly magazine containing well-written articles and commentary on politics, public affairs and contemporary social issues. Each issue also includes a story of fiction, an essay and poetry. It was founded in BOSTON in 1857 by RALPH WALDO EMERSON, HENRY DAVID THOREAU and others. Its current circulation is 500,000.

atom bomb, the (foreign policy) A military weapon developed by the MANHATTAN PROJECT. It was used militarily only twice: first on Hiroshima, a city in Japan, on August 6, 1945, and second on the town of Nagasaki, Japan on August 9, 1945. Although it encouraged the Japanese to surrender and end the fighting in the Pacific during WORLD WAR II, it has not been used since because of its terrible, destructive and lasting effects noticed on the Japanese people in those cities (e.g., large death toll, severe burns, birth defects). Also known as "the A-bomb"; see ALAMOGORDO.

Atomic Energy Commission (science and technology) (AEC) It was replaced by the NUCLEAR REGULATORY COMMISSION in 1974.

attorney (legal system) A person who has studied law (usually for three years at a law SCHOOL[4]) and is a member of the BAR[2] of that STATE. He or she works for clients by giving them legal advice outside of court, making OUT-OF-COURT SETTLEMENTS or representing a client in court during a CRIMINAL TRIAL or a CIVIL TRIAL. This term is often used interchangeably with LAWYER. See LSAT; compare ATTORNEY-AT-LAW, BAILIFF, PARALEGAL.

Attorney General (1, 2 government) **1** The title and position of the highest official of the DEPARTMENT OF JUSTICE of the UNITED STATES. This person is appointed to the position by the PRESIDENT and also may provide legal advice to the

PRESIDENT. This individual is an important member of the CABINET. compare SECRETARY. **2** The title and position of the head official of the Justice Department in any of the fifty STATES.

attorney-at-law (legal system) A somewhat formal title for an ATTORNEY who works representing clients only in court lawsuits. Most often, it is only used in writing (e.g., on the sign advertising a lawyer's office and/or PRACTICE or on a BUSINESS CARD).

Audubon, John James (people) (1785–1851) Self-taught painter, ornithologist, hunter and naturalist. His keen observations and knowledge about wild birds helped him create his masterpiece work, *BIRDS OF AMERICA* (1827). Although his habit was to kill birds, he did this to examine them more closely in order to paint them accurately. After this work met with success he started, but did not finish, the paintings of mammals for the project known as *The Viviparous Quadrupeds of North America*. *See* NATIONAL AUDUBON SOCIETY.

"Auld Lang Syne" (customs and traditions) The title and part of the refrain (meaning "time long past") of the old, traditional song sung to remember old friends and old experiences; according to tradition, it is sung in a solemn manner on NEW YEAR'S EVE after the bells have chimed twelve o'clock midnight. The words were written down by the Scottish poet, Robert Burns (1759–1796) and they thus contain dialect words unique to Scotland (e.g., the title itself); the music dates to an even earlier century. The first verse follows: "Should auld [old] acquaintance be forgot and never brought to mind?/ Should auld acquaintance be forgot and days of auld lang syne?/For auld lang syne, my dear, for auld lang syne/We'll take a cup of kindness yet, for auld lang syne".

Australian ballot (politics) A type of BALLOT[1] designed for voters to mark in secret. It consists of a piece of paper printed by the government that lists the names of all the nominated candidates for a public office, as well as an empty space to write in the name of a candidate not listed. It was first used in the UNITED STATES in 1888 and was later modified by the MASSACHUSETTS BALLOT and INDIANA BALLOT. [It was created in 1858 and originally used in 'Australia'.]

Avon (work) A commercial cosmetic and beauty care company which employs sales people to travel DOOR-TO-DOOR selling its cosmetic and beauty care products to customers. As payment, the sales person receives a percentage of the total sales made.

awakening (religion) In general, a term referring to any increased interest in religion and/or religious faith. It may also be used to refer to a REVIVAL. Specifically, the GREAT AWAKENING or the SECOND GREAT AWAKENING.

away team (sports and leisure) Any team that comes to another playing field or court to play. Usually, it is from a different town or from another geographical area. Because fans usually cheer for the HOME TEAM, sometimes it is difficult for away teams to win. Also known as "visitor".

AWOL (military) In the ARMED FORCES, describing a military personnel member who has temporarily left the camp or base without receiving formal permission from some higher-ranking officer. In most cases, this is a minor offense. It does not mean that the person has "deserted" the military. By association, any person who is not present or has left a position without giving an explanation. [Acronym from 'A'bsent 'W'ithout 'O'fficial 'L'eave.]

B

B movie (the arts) A film made on a small financial budget and thus characterized by having poor special effects, starring unknown actors and focusing on unreal or fantastical subjects (e.g., creatures from outerspace). By association, anything which is done in an amateur or cheap manner.

B'nai B'rith (International) (religion) An important, international charity organization for Jews which works to fight ANTI-SEMITISM through community programs as well as by the legal work of its ANTI-DEFAMATION LEAGUE. Further, it helps new JEWISH immigrants to the UNITED STATES adjust to life here in the US by giving them legal, financial and language assistance. It was founded in 1843 by and for Jewish men; today, it now accepts women members and counts some 500,000 total members. Its headquarters are in WASHINGTON D.C. [Hebrew meaning "the sons/brotherhood of the Covenant".] "B'nai B'rith Women" (also known as "Jewish Women International") was founded in 1897 and "B'nai B'rith Youth Organization" founded in 1924 provide similar, but less comprehensive services. *See* HILLEL FOUNDATION.

BA (education) A type of BACHELOR'S DEGREE. [Abbreviation of 'B'achelor of 'A'rts.]

baby boomer (society) Any person born between the years 1945–1965 who came to MAJORITY (AGE OF) from 1963 to 1983 during which time many of them were interested and active in political issues, the ANTI-WAR MOVEMENT and the COUNTERCULTURE. Generally, these people are considered as interested in social issues, having strong opinions and feeling the need to publicly express these opinions and their feelings. Today, baby boomers are specifically concerned with their health, looking young and keeping fit, making investments, living a financially comfortable life and developing retirement plans. Because this group consists of some 70 million members (36% of the total US population), the interests and desires of its many members are reflected in the economy, politics and social life of the country. [From the marked rise, or 'boom', in the birth of babies after WORLD WAR II.]

Baby Doe (legal system) The name used to refer to a young child or MINOR who is involved in a legal court case in order to protect him or her from unwanted media attention. *Compare* JOHN DOE[2], JANE DOE[2].

bachelor party (customs and traditions) A party held in honor of a man who is soon to be married. It is sponsored by the male friends of the guest of honor and usually consists of drinking alcohol, telling stories and celebrating the last few days/hours of being single before the wedding. Traditionally, a large cake is ordered from which an attractive woman jumps out. Sometimes, the men rent a female stripper to perform for the groom-to-be. *Compare* BACHELORETTE PARTY.

bachelor's degree (education) A general term for an UNDERGRADUATE degree awarded by a COLLEGE[1] or UNIVERSITY to a student who has earned the required number of CREDITS. It usually takes a student four years to earn and is necessary for admission to a POST-GRADUATE program. A BA is earned in a HUMANITIES program; a BS is earned in a hard science program (e.g., chemistry, engineering); and a BFA for the performing arts (e.g., acting, opera singing). Also known as "bachelor's", "baccalaureate"; *compare* MASTER'S DEGREE, PhD.

bachelorette party (customs and traditions) A party held in honor of a woman who is soon to be married. It is sponsored by the female friends of the guest of honor and it usually consists of drinking alcohol, telling stories and celebrating the last few days/hours of being single before the wedding. Sometimes, the women rent a male stripper to perform for the bride-to-be. *Compare* BACHELOR PARTY.

Back-to-Africa Movement (minorities) A movement, consisting of three major waves, among AFRICAN AMERICANS to free themselves of American SLAVERY, racism and DISCRIMINATION by physically and permanently returning to West Africa, their traditional homeland, to live. First, the idea originated with Paul Cuffe (1759–1817) who encouraged blacks to emigrate back to Africa even transporting some on his boat to Africa in 1815. The second wave (from 1876 to 1915), was led by Henry McNeal Turner (1834–1915), a black bishop in the METHODIST CHURCH. The third wave (during the 1920s), was led by MARCUS GARVEY who even started a transatlantic transportation company, the Black Star Steamship Line, to carry blacks

to Africa. *See* AMERICAN COLONIZATION SOCIETY.

bacon and eggs (food and drink) A traditional, heavy breakfast dish of strips of thin bacon served with eggs prepared "sunny-side up" (i.e., fried on one side only), "over" (i.e., flipped and fried long enough to make the yolk firm), "over easy" (i.e., flipped and fried very briefly) or "scrambled" (i.e., broken yolk mixed with cream or milk). It is served with buttered toast with jelly. *Compare* EGGS BENEDICT.

Badlands, the (environment) A general name for that empty, moonlike, rocky area of lands, canyons and ridges in North Dakota and South Dakota. Neither trees nor shrubs can grow here. The region includes the Badlands National Park and the PINE RIDGE INDIAN RESERVATION. [From SIOUX *Mako Sica* literally meaning "land bad".] *See* GREAT PLAINS, NATIONAL PARK.

Baez, Joan (people) (born in 1941) A FOLK MUSIC singer and composer known for writing and singing songs especially designed to promote political or social issues. Most of her songs have been written for guitar and require a vocal effort. Her long career first began in the 1960s; she performed at WOODSTOCK.

bagel (food and drink) A thick, round bread roll having a firm texture which is cut widthwise and eaten toasted for breakfast or filled with meats, cheeses and lettuce as a LUNCH-time sandwich. It may be made with different flavors (e.g., raisin, cinnamon, blueberry, onion). [Yiddish *beygl* from German *boug* meaning "ring".] *See* DELICATESSEN, LOX.

bail (legal system) The amount of money (i.e., cash) that is paid to release a person who is currently being held in jail because of his or her connection to a crime. Usually, "bail is posted" (i.e., the money is paid) by a relative, friend or the ATTORNEY of the individual being held.

bailiff (legal system) The person, often a member of the police department and wearing a police officer's uniform, who provides order in a local or COUNTY courtroom. During a trial he or she protects and escorts the JURY to and from the courtroom and announces when the judge enters the room (all people must stand when judges enter and leave the courtroom). *Compare* FEDERAL MARSHALS.

bake sale (daily life) A type of sale in which a NONPROFIT ORGANIZATION or group makes and sells (for a small fee) COOKIES, BROWNIES, QUICK BREADS and other sweet snacks and desserts. The money earned is given to a special cause, BOOSTER, athletic team or charity. Usually, it is sponsored by students or volunteers and is held at a SCHOOL[1] or in religious meeting places.

baked Alaska (food and drink) A sweet dessert of baked cake covered in a layer of vanilla ice cream topped with whipped egg whites which is put into a hot oven briefly to brown the egg-white topping. [Probably for the use of white ice cream and egg whites which are reminiscent of the snow found in the STATE of Alaska.]

baked beans (food and drink) A dish of small pea or navy beans cooked with tomato paste, brown sugar, molasses and salted pork. It may be served hot or cold and frequently is eaten at picnics and while TAILGATING. Also known as "Boston baked beans".

Baker, Josephine (people) (1906–1975) An African-American dancer and entertainer who spent most of her adult life living and performing in France because racist policies then permitted her from performing much in the UNITED STATES. She is known for her beauty, glamour and sexiness.

Bakke* v. *University of California (minorities) The name of the LOWER COURT case concerning REVERSE DISCRIMINATION. The final, formal name of the SUPREME COURT case is *REGENTS OF THE UNIVERSITY OF CALIFORNIA* v. *ALLEN BAKKE*.

balanced budget (government) An economic budget where the government does not spend (e.g., on MEDICARE, defense projects) more money than it collects (e.g., from income taxes, property taxes).

balancing the ticket (politics) A method of appealing to a wide range of citizens. A candidate for PRESIDENT **balances the ticket** by choosing a RUNNING-MATE with a different geographical, educa-

tional, religious and experiential background from his or her own. *See* TICKET.

bald eagle (customs and traditions) The official national symbol of the UNITED STATES OF AMERICA. It is found on many official documents and objects (e.g., its image decorates the GREAT SEAL). It is also the national bird of the United States. [Actually, this bird only appears to be 'bald' because its head is covered in white feathers.]

Baldwin, James (people) (1924–1987) A popular African-American writer and playwright known for his works which explore the themes of blacks, racism and homosexuality. He spent most of his adult life living and working in France. Well-known works include the novels *Go Tell it on the Mountain* (1953) and *Notes of a Native Son* (1955) and the collection of essays, *The Fire Next Time* (1963). Also, he served on the board of CONGRESS OF RACIAL EQUALITY.

ballot (1, 2 politics) **1** In the voting booth, the piece of paper listing the candidates that a citizen uses to record his or her vote. **2** The total number of votes cast in an election; it may be figured by STATE, region or across the nation.

ballpark (1, 2, 3 sports and leisure) **1** Any place where a BASEBALL game is played; usually, in a stadium. **2** Describing a guess or estimate (e.g., **ballpark** figure). **3**"In the ballpark" describes something reasonable or acceptable.

Bandstand (media) A popular nickname for *AMERICAN BANDSTAND*.

bandwagon (politics) A temporary movement or issue that is currently popular and thus sure to win, especially in an election. A PRESIDENT or other person who "jumps on the bandwagon" supports those movements or issues that are most likely to win.

banjo (the arts) A musical instrument with a long neck and a small round body which is covered with goat or sheep skin. It is played with the fingers and often has five or three strings. It is an important instrument in BLUEGRASS MUSIC and COUNTRY MUSIC.

banker's hours (work) The period of 10:00 a.m. to 2:00 p.m. on Mondays through Fridays; that is, those traditional hours when a bank is open and active for customer service. By association, a short work day.

Banks, Dennis (people) (born in 1932) A member of the Chippewa (Anishinabe) TRIBE and a Native American activist. He was a co-founder and leader of AIM, participated in the occupation of WOUNDED KNEE II and has organized long-distance "sacred" runs for young people. He is known for lobbying to improve Indian rights (especially, STATE laws to protect old graves and sites of NATIVE AMERICANS) and encouraging young INDIANS to become interested in their heritage.

Baptist (religion) A member of a BAPTIST CHURCH.

Baptist Church (religion) The largest PROTESTANT DENOMINATION in the US (currently with 36.6 million total members) which is particularly popular in the SOUTH among whites and AFRICAN AMERICANS. It began during the PURITAN movement of the seventeenth century in England and was founded in 1609 by Englishman John Smyth (1554–1612); its first American Church was started in 1639 by Roger Williams (1603–1683) in Rhode Island. Its members, BAPTISTS, believe in the importance of reading the Bible, the SEPARATION OF CHURCH AND STATE, CONGREGATIONALISM[1] and that only people can become full members by being 'baptized' as adults. Usually, Baptist religious services follow an informal format where members speak out to voice their agreement as well as use GOSPEL MUSIC songs to get members involved. Currently, the largest Baptist Churches are the Southern Baptist Convention (15.6 million mostly white members) and the National Baptist Convention, USA (8.2 million African-American members). The ABYSSINIAN BAPTIST CHURCH is a well-known, but single Baptist CHURCH[1].

bar (1 daily life; 2 legal system) **1** An establishment that sells alcoholic drinks (e.g., beer, whiskey, wine, mixed drinks) and may serve some snacks, (e.g., pretzels, peanuts) or SHORT ORDER dishes to customers. It may contain pool tables, a dance floor and/or televisions for watching sports. Its hour of closing is determined

by the STATE or local government. However, all clients must be at least 21 years of age to enter and drink. *See* DRINKING AGE, BOUNCER, DRY, ID CARD, BLUE LAWS. **2 the bar** A general, collective term for the profession of ATTORNEYS. "Members of the bar" are LAWYERS who have passed the BAR EXAMINATION for that STATE and practiced law for a certain period of time. [From the wooden railing, or 'bar', traditionally used in courtrooms in England to separate the ATTORNEYS, JURY and judge from the public.] *See* BAR ASSOCIATION, DISBAR; *compare* BENCH[1,2,3].

bar association, the (legal system) A STATE or national group of professional LAWYERS who are licensed to practice law. The best-known one is the AMERICAN BAR ASSOCIATION. Each state has at least one bar association, which is then responsible for writing the BAR EXAMINATION of a state. *See* BAR[2], DISBAR.

bar examination (legal system) A written test that an ATTORNEY must pass to receive permission to practice law legally in a STATE. It is prepared by the BAR ASSOCIATION of the state where the person wants to work. *See* BAR[2].

bar mitzvah (religion) In the JEWISH faith, a special, festive ceremony held to honor a boy 13 years of age and meant to welcome him into this faith as a full adult member. **Bar mitzvahing** is held on a WEEKEND and is sponsored by the boy's parents who invite many adult guests and colleagues. A **bar mitzvahed** boy usually wears special clothing and a YARMULKE; he receives gifts, usually money, from his family, friends' parents and the other guests. This is considered one of the most important events of a Jewish man's religious life as well as a major RITE OF PASSAGE[1]. [Aramaic *bar* meaning "son" + Hebrew *miswah* meaning "divine commandment".]

Baraka, Imamu Amari (people) (born LeRoi Jones in 1934) A versatile African-American poet, playwright, political activist and teacher. He began his career as LeRoi Jones publishing poetry during the BEAT GENERATION. Through the CIVIL RIGHTS MOVEMENT, he became politically active publishing poems and plays which explored relationships between blacks and whites, namely; *Dutchman* (1964) and *The Slave* (1964). During the late 1960s and 1970s he was controversial for his active support of the BLACK POWER movement and encouraging violence. Today, he is recognized as helping young black people; namely by founding the Black Arts Repertory Theatre in HARLEM to help young blacks develop their artistic skills (which then launched the BLACK ARTS MOVEMENT). Currently, he teaches COLLEGE[3] courses in Afro-American Studies *see* AFRICAN-AMERICAN STUDIES) and promotes African-American culture and history. [He adopted this current Muslim name when he converted to Islam in 1966.]

barbecue (1 food and drink; 2 customs and traditions) (BBQ) **1** pieces of meat (e.g., beef, pork, chicken, mutton) basted in a spicy tomato sauce (known as "barbecue sauce") and roasted over an open fire. **2** An outdoor meal and social event where barbecued meats and other food items are eaten. [From Spanish *barbacoa* meaning "frame of sticks" which NATIVE AMERICANS in the Caribbean used to grill meat.] Also spelled "barbeque".

barn dance (customs and traditions) A type of social event popular in the MIDWEST and WEST at which guests dance, participating in SQUARE DANCING and LINE DANCING. Originally, this event was held in a barn or on a farm; sometimes, guests take a ride on a slow-moving trailer full of hay, which is pulled by a tractor, around the farm.

Barnard College (education) A member of the SEVEN SISTERS and a well-respected, private LIBERAL ARTS COLLEGE for women which is located in NEW YORK CITY, New York. Founded in 1889, it was one of the first institutions to provide post-SECONDARY SCHOOL education to women. Since 1900 when it became an independent AFFILIATE[1] of COLUMBIA UNIVERSITY, its GRADUATES[1] have received BACHELOR'S DEGREES from COLUMBIA; but it still retains its own BOARD OF TRUSTEES, own faculty and all female student population of 2,200 UNDERGRADUATES. It is an NCAA member and its teams compete at the INTERCOLLEGIATE level. *See* PRIVATE SCHOOL.

Barnum, P(hineas) T(aylor) (people) (1810–1891) A circus owner, publicity

creator and publicist. He owned the Ringling Brothers and Barnum and Bailey Circus and is responsible for creating the three-ring circus (i.e., where three different events are occurring simultaneously). He is remembered for his talent in creating publicity around an event or person which succeeded in attracting many other people and making money. A **P. T. Barnum** is a person who promotes himself or herself.

barrio, el (geography) A section of a city and/or community where HISPANICS live and work. It has a close, Spanish-speaking community and usually is economically poor. In NEW YORK CITY, SPANISH HARLEM is commonly known as "el barrio". [Spanish meaning "the district".] *Compare* LITTLE HAVANA.

Barry, Dave (people) (born in 1947) A humorist and writer. He writes a regular, SYNDICATED newspaper column in which he treats, in a funny way, the everyday issues and the daily aspects of: having and raising babies, romantic relationships, buying and caring for houses and aging, as well as cyberspace, history and travel. Many of his popular books (some twenty different volumes usually containing his name, "Dave Barry" in the title – *Dave Barry in Japan*) deal with similar topics in a similar, humorous manner.

base hit (sports and leisure) In BASEBALL, the success of a batter who has hit a ball (which is not a FOUL[1]) and run to a base.

baseball (sports and leisure) A popular sport played between two teams in which the object of the game is for individual members of the offensive team to score using a bat to hit a ball and run around the field (in a counter-clockwise direction) physically touching all the bases (i.e., first, second, third and HOME PLATE) in order to score one point. Each game consists of nine INNINGS each of which allows both teams to play offensively and defensively. Games have no time limit; rather, when a team gets three OUTS[2], it loses its opportunity to score and must then play defensively. The season begins in April and ends in September; although the professional leagues do play the WORLD SERIES in October. Professional teams play some 162 games each season. Teams are organized at different levels, namely: LITTLE LEAGUES; in SECONDARY SCHOOLS; COLLEGES[1]; the MINOR LEAGUES; and MAJOR LEAGUES. Before all games, the NATIONAL ANTHEM is played and sung by team members and spectators. It is a popular SPECTATOR SPORT and has long been considered 'America's "NATIONAL PASTIME"'. *See* PITCHER, CATCHER, THREE STRIKES, YOU'RE OUT, BLACK SOX scandal, SPRING TRAINING.

bases loaded (sports and leisure) In BASEBALL, describing a condition in which an offensive team has a player on each base and a fourth player is AT BAT. This offensive team is in a very good position to score. The maximum number of points that can be scored is four; the minimum is zero (which can happen if the batter STRIKES OUT). By association, a positive condition in which great advances or gains can be made.

basic cable service (media) The fixed set of cable television channels and programs provided to SUBSCRIBERS of PAY-TV without an additional fee (e.g., M-TV, C-SPAN).

Basie, Count (people) (1904–1984, born William Basie) An influential and popular African-American JAZZ MUSIC pianist and orchestra leader. He is remembered for developing and popularizing the SWING MUSIC style of jazz in the 1930s and 1940s which combined BLUES[1] and jazz with a danceable beat. His band's theme song was "One O'Clock Jump". His nickname was the "Count of Swing".

basketball (sports and leisure) A popular team sport in which players try to advance the round leather ball down the court (e.g., indoor or outdoor) by dribbling and passing, and then score by putting or throwing the ball through the metal ring of the 'basket'. Each team consists of five players who are responsible for offensive and defensive maneuvers. The players include: two guards (who pass and control the ball from the middle of the court); two forwards (who try to score and block scoring); and one center (who is usually quite tall and important for REBOUNDS and scoring). At the HIGH SCHOOL and COLLEGE[1] level, the game consists of two periods or "halves" and the season

begins in late November. At the professional level the game is divided into four periods or "QUARTERS³"; and the regular season runs from December through the spring. All games are officiated by a referee and one or two UMPIRES. It was invented by JAMES NAISMITH. *See* NBA, NCAA, MARCH MADNESS, HOOPS, SPRINGFIELD.

bat mitzvah (religion) In the JEWISH faith, a special, festive ceremony held to honor a young woman (aged 12 to 15) and to recognize her as a full adult member of the community. *Compare* BAR MITZVAH.

batting average (sports and leisure) In BASEBALL, the percentage of times that a batter hits a ball and gets to base (e.g., first base). It is figured by dividing the number of hits by the number of official times a player has been AT BAT. It is an important indicator of the talent of an offensive player. In professional baseball, batting over .300 is a very good batting average.

Bay Area, the (geography) The cities and areas around San Francisco Bay and the Bay Bridge: the "East Bay" includes BERKELEY, which is home to the UNIVERSITY OF CALIFORNIA, BERKELEY and Oakland; the "South Bay" or "Peninsula" includes SILICON VALLEY; to the North lies Marin County, a wealthy region of SUBURBS.

Bay of Pigs Invasion, the (foreign policy) The April 17, 1961, military invasion of Cuba that the US supported and PRESIDENT JOHN KENNEDY had approved, but which failed. The invasion was attempted by exiled Cuban soldiers who did not believe in communism and wanted to overthrow the Cuban, communist leader Fidel Castro (born in 1923). These soldiers had been trained and supported by the CIA. This failure embarrassed the US government (Kennedy accepted responsibility for the failure), and caused the Cuban government to temporarily prohibit REFUGEE emigration from Cuba to the US. [From Spanish *Bahía de Cochinos*, the site of the planned invasion landing.]

bayou (environment) A body of water which moves very slowly, or not at all. It is found particularly in the Deep South, especially in the STATE of Louisiana. [From Choctaw *bayuk*.] *See* SOUTH.

Beale Street (the arts) An entertainment and tourist district in DOWNTOWN Memphis, Tennessee, known as one of the birthplaces of the BLUES¹ (in the period 1900 to 1920). Currently, it has many BARS¹ where musicians perform JAZZ MUSIC and the blues live. *See* B. B. KING.

Bean Town (geography) The popular name for the city of BOSTON. [Traditionally, Christian Bostonians used to eat BAKED 'BEANS' on Sundays because it could be prepared on Saturday, and thus they would not offend the BLUE LAWS.]

bear (economy) On the STOCK MARKET, a person who sells stocks and bonds expecting a fall in price and who then plans to rebuy them, but at the lower price. A bear makes a profit in a BEAR MARKET. [From the old expression "selling the 'bear' skin before catching the bear".] *Compare* BULL.

bear market (economy) A decline in the prices of stocks, bonds or commodities, which lasts for an extended period. In a bear market, BEARS buy back stocks and thus make money and prosper.

Beat Generation, the (the arts) (the Beats) The collective name for the group of writers and poets who developed then wrote from a philosophy promoting self-love, freedom, poverty, spontaneity and experimentation, especially with travel, drinking, drugs and sex. It began in the mid-1940s in GREENWICH VILLAGE and COLUMBIA UNIVERSITY (where several members attended courses); later spreading to North Beach in SAN FRANCISCO; it dissolved about 1970. The defining works were the book *On the Road* (1957) by JACK KEROUAC and the long poem "Howl" (1956) by ALLEN GINSBERG. The literary style was colloquial, containing daily speech; the works expressed anxiousness and restlessness. The movement contradicted the settled lives of the SUBURBS. Some FEMINIST critics complain that it was too male-oriented; other critics complain that it was very commercialized. [From Jack Kerouac who described the characters as 'beat'en down or 'beat'ified.] *See* BEATNIKS; *compare* COUNTERCULTURE.

beatniks (the arts) Teenage followers and supporters of the BEATS. [After the 'Beat' Generation + the Soviet space craft,

Sput'nik' which had recently been launched (1957).]

beauty contest (1, 2 politics) **1** A type of PRIMARY ELECTION that a political party holds for itself to measure which presidential candidates from its party are the most popular with voters. Although it is usually done early in the year of a presidential election, it does not affect choosing DELEGATES. **2** By association, any public gathering of a certain group of people hoping and trying to make a good impression on the public (e.g., candidates for PRESIDENT, students).

Bebop (the arts) A style of JAZZ MUSIC popular throughout the 1950s and early 1960s which used a wider range of notes than NEW ORLEANS JAZZ by experimenting with and adding chords, not melodies. It is characterized by having a fast tempo and being very frenetic or very relaxed. It was popularized by MILES DAVIS, LESTER YOUNG and Dizzy Gillespie (1917–1993). It was also known as "Bop" and "bop"; originally known as "Rebop". "Hard Bop" was a type of Bebop during the 1950s characterized by having a strong, pronounced rhythm which conveyed optimism and emotion. COOL JAZZ is a second type of Bebop.

Bedford-Stuyvesant (geography) (Bed-Stuy) A working-class and middle-class section of Northern BROOKLYN, which has the second largest black community in the UNITED STATES. *See* WILLIAMSBURG[2]; *compare* SOUTH SIDE.

Beggars' Night (customs and traditions) The particular day designated by the local community or STATE as the day when young children go TRICK-OR-TREATING. Often, it is not on the same day as HALLOWEEN.

Beige Book, the (economy) The informal name for the report on current national economic conditions and thus the most recent and accurate appraisal of the American economy. The FEDERAL RESERVE prepares it and releases it publicly once every six weeks. It is used to decide monetary policy and INTEREST RATES.

believer (religion) A person who accepts the existence of a God and practices a religion. Usually, it is used by some PROTESTANT groups to refer to those persons who believe in the same DENOMINATION of Christianity.

Bellow, Saul (people) (born in 1915) A fiction writer and, currently, a UNIVERSITY professor. His works are characterized by their realism, modernity and treatment of sociological issues. He has often presented JEWISH-American characters and situations in his books (e.g., *Herzog* 1964). He has won the NATIONAL BOOK AWARD three separate times as well as the Nobel Prize (1976) and PULITZER PRIZE (1976).

bellwether (economy) On the STOCK MARKET, a specific stock that is strong and thus can lead or indicate the overall direction (i.e., up or down) of the market. By association, describing something that leads something and/or can indicate some condition. [From the 'bell' used to lead a flock of sheep and 'wether', a castrated male sheep known for following the flock.] *Compare* BENCHMARK.

belly up (economy) Describing a company that is facing bankruptcy.

Belmont Stakes, the (sports and leisure) The annual horse race of 1.5 miles (2.4 km) for three-year-old thoroughbred horses and the third race of the TRIPLE CROWN[1]. It is held every June (first in 1867), at Belmont Park in New York STATE, three weeks after the PREAKNESS.

beltway, the (1 geography; 2 government) **1** A highway which encircles and bypasses a city. **2 the Beltway** The popular nickname for the city of WASHINGTON D.C. and, by association, the politics of the federal government, especially the CONGRESS. [After the highway that encircles the city.] *See* POTOMAC FEVER; *compare* LOOP.

bench, the (1, 2, 3 legal system) **1** The general, collective name for the profession of being a judge. **2** The collective name for the judge(s) hearing a particular case. **3** The general name for courts and courtrooms where judges hear cases. [From the 'bench', or long wooden seat, traditionally used by judges in courts in England.] *Compare* BAR[2].

benchmark (economy) On the STOCK MARKET, a standard, solid quality stock by which others are measured. *Compare* BELLWETHER.

Berkeley (geography) A city located in western California in the BAY AREA. It is the location of the branch CAMPUS of the UNIVERSITY OF CALIFORNIA, BERKELEY and is largely influenced by the students and teachers of this UNIVERSITY. This town is characterized by its good climate, academic emphasis and the liberal-minded attitude of the residents; its current population is 104,000. By association, the University of California at Berkeley. [After George 'Berkeley' (c. 1685–1753), an Irish philosopher and bishop.]

Berkeley, University of California (education) *See* UNIVERSITY OF CALIFORNIA, BERKELEY.

Berkshire Hills (environment) A hilly, forested district of the western half of the STATE of Massachusetts which is a popular summertime NEW ENGLAND tourist resort area. Every year it hosts outdoor musical events at TANGLEWOOD.

bestseller/best-seller (the arts) A type of current, popular book which has officially recorded high sales (i.e., the number of copies shipped and billed) in a given week. This information is compiled on the top twenty books in each category and presented weekly by the magazine *PUBLISHER'S WEEKLY*. **Best-selling** books may be in one of several categories, namely, hardback, paperback, fiction, nonfiction and poetry. The *NEW YORK TIMES* and some other large newspapers compile their own best-selling lists.

Better Homes and Gardens (media) A monthly magazine designed for women, carrying articles and photos on home decoration, gardening and traveling. Also, each month it features an article and photographs of an attractive house and/or garden often owned by a celebrity. It was founded in 1922 and its current circulation is 7.6 million.

Betty Crocker (food and drink) A female cook who provides tips for successful, quality cooking in the home; especially through *The Betty Crocker Cookbook* (first published in 1950) a popular recipe book which helped first make cooking scientific by standardizing measurements. (Actually, "she" is a fictional figure whom the General Mills food company created to promote its products). *compare* JULIA CHILD.

Betty Ford Center, the (health) An expensive, private and elite rehabilitation center to help patients stop drinking alcohol and/or stop taking drugs. It is located in Palm Springs, California and is known for its high success rate. Often, it is frequented by film stars and celebrities who want to end their alcohol or chemical addictions. [After founder and former FIRST LADY, 'Betty Ford' (born in 1918), who had an alcoholic addiction.] *See* GERALD FORD; compare ALCOHOLICS ANONYMOUS.

Beverly Hills (geography) The wealthy city (population some 32,000 people) located west of DOWNTOWN LOS ANGELES and famous for the expensive shopping district, RODEO DRIVE, and for having the luxury homes of film stars and celebrities.

BFA (education) A type of BACHELOR'S DEGREE. [Abbreviation of 'B'achelor of 'F'ine 'A'rts.]

Bible Belt, the (religion) A general, collective name for certain regions in the UNITED STATES where CONSERVATIVE and/or FUNDAMENTALIST Christian groups have a strong power over local politics, culture and community ethics and morals. These geographical areas are found in the SOUTH, SOUTHWEST and MIDWEST. It was first used by a northern reporter, H. L. Mencken (1880–1956) to describe the religious local population in Tennessee during the SCOPES MONKEY TRIAL. [From 'Bible' + 'belt' (meaning "a region").]

Bible camp (religion) A special type of SUMMER CAMP in which people – adults, or more usually, children – take lessons in reading and understanding the importance of the Bible and participate in group activities and sports. It is sponsored by a particular PROTESTANT group. Also known as "CAMP".

bicameral legislature (government) A legislature that has two parts, or 'chambers'. It is a method of providing CHECKS AND BALANCES in this branch of the government. The CONGRESS and all the STATES (except Nebraska; it has a unicameral legislature) use this sysyem.

Bicentennial (customs and traditions) July 4, 1976, the 200th anniversary of

American independence which was cele-
brated throughout the county with extra
fireworks, festivals and other patriotic
displays.

bid (1 work; 2 customs and traditions) **1**
A formal offer by a company to work on a
project or product. *See* DEFENSE CON-
TRACT. **2** A formal invitation given to an
UNDERGRADUATE by a GREEK LETTER OR-
GANIZATION to join a FRATERNITY or SOR-
ORITY.

Big Apple, the (geography) Since 1971,
the self-promoted, popular nickname for
NEW YORK CITY. [Originally, only the slang
word used by African-American JAZZ
MUSIC musicians in the 1920s and 1930s
to refer to the success and 'big' opportu-
nity of performing live in the clubs in New
York City.]

Big Band/big band (music) (the arts)
Another name for SWING MUSIC. During
that epoque, this term was used by whites
to refer to Swing music. The "Big Band
Era" refers to the period from 1935 until
1950 when this music was very popular
among the public. [From the large number
of performing orchestra musicians (at
least 10) in one 'band'.] *See* BENNY GOOD-
MAN, GLEN MILLER.

Big Blue (economy) The popular nick-
name for the large, powerful, private
computer company formally known as
"International Business Machines"
(IBM). [From the company's self-chosen,
official color 'blue' which it uses in its
official letterhead and other materials.] By
association, any large, powerful company
may be temporarily given the nickname
"Big + (some self-identifying color)" when
its own stocks are doing well or when it
experiences growth or great control in the
marketplace, STOCK MARKET or employ-
ment.

Big Board (economy) A nickname for
the NEW YORK STOCK EXCHANGE. [After
the large number of large companies
whose stocks and bonds are traded here,
all of which are listed on the large electro-
nic display 'board'.]

Big Brothers/Big Sisters (of America)
(health) A nationwide organization
founded in 1904 with various local
branches which pairs up a child from a
single-parent family with an older, unre-

lated adult in order to have a one-on-one
relationship providing the youngster with
friendship, support and guidance.

big business (economy) A collective
term for the large, privately owned com-
panies that manufacture products or pro-
vide services and have large ASSETS.
Because of their product(s) and/or services
and employment of many employees, these
companies have a 'big' effect on the
national economy. Some federal govern-
ment laws try to limit the power of big
business. *See* ANTITRUST LAWS; *compare*
BIG GOVERNMENT, BIG LABOR.

big government (government) A nega-
tive phrase referring to a government
which exercises a strong, central power,
usually has high tax rates (e.g., INCOME
TAX, PROPERTY TAX) and spends a lot of
that money on social programs. *See* LIB-
ERAL; *compare* BIG BUSINESS, BIG LABOR.

big hair (clothing) Long, usually wo-
men's, hair that has been treated with
artificial products, namely, curl perma-
nents, teasing and hair gel to give the hair
extra and/or unusual height and volume.

big labor (work) A general term refer-
ring to strong organized labor organiza-
tions. Specifically, it refers to the AFL-CIO
and its union AFFILIATES[1]. *Compare* BIG
BUSINESS, BIG GOVERNMENT.

big league(s), the (sports and leisure) A
nickname for the MAJOR LEAGUES and
professional BASEBALL. By association,
describing any group that performs in a
professional or quality way.

"Big Rock Candy Mountains", "The"
(customs and traditions) A popular hobo
song that glorifies the WEST and the easy
life there because of the rich natural
resources and ability to live off the land
without, seemingly, too much work. It
became popular during the GREAT DEPRES-
SION. The refrain follows: "Oh the birds
and the bees and the cigarette trees/The
rock rye springs where the whang-doodle
[fictional kind of bird] sings in the Big
Rock Candy Mountains". *See* AMERICAN
DREAM, FRONTIER.

"big stick" (foreign policy) A method of
foreign policy in which one group receives
support from other groups by using the
threat of force (e.g., military action or
economic sanctions) against those other

groups. It was the policy of THEODORE ROOSEVELT. [From a statement made by Roosevelt, but based on an African saying: "Speak softly and carry a 'big stick', you will go far."]

Big Ten, the (sports and leisure) The INTERCOLLEGIATE athletic CONFERENCE of a group of large STATE UNIVERSITIES that share similar standards of ACADEME[1], GRADUATE[2] level research and UNDERGRADUATE NCAA sports. The athletic rivalries are long-standing and especially fierce in FOOTBALL and BASKETBALL. The ten original member UNIVERSITIES are: University of Illinois, INDIANA UNIVERSITY, University of Iowa, UNIVERSITY OF MICHIGAN, Michigan State University, University of Minnesota, Northwestern University, OHIO STATE UNIVERSITY, Purdue University and UNIVERSITY OF WISCONSIN. In 1992, Penn[sylvania] State University joined the conference making eleven members. It was founded in 1895 and was originally known as "Western Conference".

Big Three, the (economy) The three largest American car and truck makers – Chrysler, Ford and General Motors – which, together, compose the majority of the US new automobile sales market. By association, any collection of three powerful, large businesses, networks or people. *See* HENRY FORD.

Bilingual Education Act (education) The federal legislation (passed in 1968) that provided for bilingual education programs (e.g., English-Spanish) in public ELEMENTARY SCHOOLS and SECONDARY SCHOOLS. *See* PUBLIC SCHOOL.

bill (1 economy; 2 government; 3 daily life) **1** A paper DOLLAR bill. **2** A legislative act before it becomes law; that is, a piece of legislation that has been introduced and is being discussed in any legislature or CONGRESSIONAL COMMITTEE. Sometimes, even after the bill becomes a law, it is still referred to as a "bill" (e.g., "BRADY BILL"). **3** A listing of items or services and their amounts which are to be paid by a customer (e.g., in a restuarant).

Bill of Rights, the (legal system) The first ten AMENDMENTS to the UNITED STATES CONSTITUTION (added in 1791) which together list the specific, basic rights

of the people that the government promises to protect, namely: the freedoms of religion, speech, press, and the right for people to hold meetings; in CRIMINAL TRIALS, the right of the DEFENDANT to a quick JURY trial, protection against BAIL that is too expensive or any other type of CRUEL AND UNUSUAL PUNISHMENT. These rights must also be protected by the STATES according to the FOURTEENTH AMENDMENT. *See* FIRST, SECOND, THIRD, FOURTH, FIFTH, SIXTH, SEVENTH, EIGHTH, NINTH, TENTH AMENDMENTS, INCORPORATION, *FEDERALIST PAPERS*, ANTI-FEDERALISTS.

Billboard (media) A weekly magazine containing the TOP-40 rankings and other information and articles about music, movies, television programs and videos which are written for professionals in these fields. Its development and method of categorizing the different types of music (e.g., COUNTRY MUSIC and COUNTRY AND WESTERN MUSIC) has given many different and similar musical styles different names over the years. It is the source which compiles and publishes the CHARTS. It was originally founded in 1894; it reorganized in 1958 and has a current circulation of 200,000. *Compare PUBLISHERS WEEKLY.*

Biltmore house, the (housing and architecture) The lavish mansion, located in Ashville, North Carolina and the largest private residence in the UNITED STATES, containing some 255 rooms. Its exterior design is after a French chateau from the Loire Valley and its interiors are decorated in the Victorian style. It is surrounded by formal gardens and spacious green lawns and was commissioned (in 1888) and owned by the railroad millionaire George Vanderbilt. Today, it is a museum.

bipartisan (government) Describing anything (e.g., a group, an action) where the two major political parties, DEMOCRATS and REPUBLICANS, agree to work together. In the CONGRESS, it often means that the two parties work together on a particular issue, especially when writing and passing BILLS[2]. *See* BOTH SIDES OF THE AISLE; *compare* MODERATE.

birder (sports and leisure) A person who engages in the pastime of watching wild birds and identifying different wild bird species. Also known as a "birdwatcher".

Birds of America (the arts) A folio of 435 large sheets (sized 40 x 30 inches; 102 cm x 76 cm) unbound, engraved prints depicting many of the wild birds of the UNITED STATES, especially those east of the MISSISSIPPI RIVER; it was originally published in 1821 and is an exceptional collection because all the birds are painted life-size, in natural poses, in natural habitats and engaged in realistic activities (e.g., nest building, feeding). The prints are based on the watercolor works of JOHN JAMES AUDUBON and were originally sold by subscription.

Birmingham Church Bombing (minorities) The violent bomb attack on September 15, 1963, that was made during SUNDAY SCHOOL[1] on the all African-American Sixteenth Street Baptist Church in Birmingham, Alabama that killed four black fourteen-year-old girls and injured others. MARTIN LUTHER KING, JR. presided over the funerals of three of them. A KU KLUX KLAN member, Robert "Dynamite Bob" Chambliss, was charged with the crime, however, due to a claim by the FBI that it had lost many of the records concerning the case, Chambliss was only tried and convicted in 1977 of first degree murder. At the time, the violence, the religious location and the young age of the victims of the bombing shocked the American public as did the lenient type of justice given to the bomber.

Birth of a Nation, The (the arts) The silent, popular dramatic movie and the first feature-length film (1915). It was based on the novel *The Clansman* (1905) by Thomas Dixon and related a story about the CIVIL WAR and RECONSTRUCTION. It was controversial at the time because it presented the idea that AFRICAN AMERICANS naturally are born to serve white people; upon its release, the NCAAP protested it. It was produced and directed by D(avid) W. Griffith (1875–1948) a self-proclaimed promoter of whites and WHITE SUPREMACY. Today, it is regarded as a blatant example of racist propaganda.

biscuits (food and drink) A type of bread in the form of small, soft patties, often made with buttermilk or sour cream

and eaten for breakfast, LUNCH or DINNER. *See* BISCUITS AND GRAVY.

biscuits and gravy (food and drink) A popular dish from the SOUTH in which a thick sauce made from herb spices and the fat and juices from cooked meat is poured over BISCUITS. *See* SOUTHERN COOKING.

bivouac (sports and leisure) A type of simple, open-air camping done with very little shelter (i.e., no tent) and without cooking, toilet or shower facilities. In some NATIONAL PARKS and NATIONAL MONUMENTS, **bivouacking** is permitted. [From Swiss German *bei* + *wacht* meaning "side" or "auxiliary patrol".]

Black Arts Movement, the (the arts) An artistic, political and literary movement by and for AFRICAN AMERICANS which lasted from the mid-1960s to the mid-1970s. Many of the books, poems and plays created treated the themes of black culture, black pride, problematic black–white interpersonal relations as well as the political ideas of BLACK POWER and BLACK NATIONALISM. Works include those by AMIRI BARAKA, JAMES BALDWIN, STOKELY CARMICHAEL and *The Autobiography of Malcolm X. See* ALEX HALEY; *compare* HARLEM RENAISSANCE, BEAT GENERATION.

Black Belt, the (environment) A band of rich farming land in the SOUTH which, during the nineteenth century, was important for producing cotton; today, it produces peanuts and vegetables. [From the rich, dark-colored band, or 'belt', of soil running through this region.]

Black Caucus (government) A popular name for the CONGRESSIONAL BLACK CAUCUS.

Black Codes (minorities) The collective name for the repressive laws passed by the white STATE legislatures of the SOUTH to regulate the housing and work opportunities and freedom of speech of blacks; these laws resembled SLAVERY conditions and severely limited blacks' freedoms. They stipulated that blacks could only rent rural land (i.e., could not buy urban property), must not break work contracts, could not preach or lecture in public without a license and could not "insult" whites. They were first passed in 1865 by Mississippi and South Carolina and then spread throughout the region; however,

they became void after CONGRESS passed the Civil Rights Act (of 1866), the FOURTEENTH AMENDMENT and approved the use of US military rule during RECONSTRUCTION. *Compare* JIM CROW.

black college (education) One of over 100 institutions that was originally founded (with help from the FREEDMEN'S BUREAU) to offer HIGHER EDUCATION to AFRICAN AMERICANS, some include: Howard University (1867) in WASHINGTON D.C.; MOREHOUSE COLLEGE (1867) for men and Spelman College (1881) for women, both in ATLANTA, Georgia. During the nineteenth century, these institutions were called "seminaries" and their goal was to teach reading and writing to freed SLAVES. The second MORRILL ACT (1890) helped establish COLLEGES[3] for blacks in the SOUTH although many of them lacked ACCREDITATION. Between 1896 and 1965 these COLLEGES[3] increased black student enrollments and added some GRADUATE[2]-level programs. Currently, black colleges are open to students of all races. Also known as "Historically Black Colleges and Universities" (HBCU); *see* SEGREGATION, GI BILL, UNITED NEGRO COLLEGE FUND.

Black English (language) A variety of American English spoken by some AFRICAN AMERICANS, especially by those who live in urban areas of the NORTH and the SOUTH, when communicating in a familiar manner with family and friends. formerly called "Black Vernacular English"; *compare* "EBONICS".

Black Hawk (people) (1767–1838) A leader of the Native American group Sack and Fox remembered for bravely trying to retain his TRIBE's lands in present-day Illinois and attempting to stop the settlement of white people in that area. He supported the plans of TECUMSEH, fought with the British in the WAR OF 1812 and led his people against the American military in the conflict known as "Black Hawk's War" (1832), after which he lost their lands.

Black Hills, the (environment) A pine and spruce tree forested mountain region rich in gold, petroleum and silver. It has long been sacred to the SIOUX people; and in the Fort Laramie Treaty of 1868, the US government promised that the Sioux would have all property rights to that land. However, property rights have been in dispute since 1874 when gold was discovered in this region. This GOLD RUSH attracted many whites who moved permanently into this area and the US government refused to protect the Black Hills from being seized by whites from the Sioux in 1877. In the 1970s, the Sioux sued the US government for the return of the land (according to the TREATY rights). Although the SUPREME COURT awarded the INDIANS $122.5 million in DAMAGES for the land, the Sioux refuse to accept the money; they want the return of the sacred land. *See* MOUNT RUSHMORE, GREAT PLAINS, BADLANDS.

Black History Month (minorities) February is designated as the month to highlight and celebrate the contributions of AFRICAN AMERICANS to American history and society. Many ELEMENTARY SCHOOLS and SECONDARY SCHOOLS plan special classes, events and FIELD TRIPS to teach all students the importance of blacks in American history. *Compare* WOMEN'S HISTORY MONTH.

"black is beautiful" (minorities) A slogan promoting racial, cultural and historical pride among AFRICAN AMERICANS which was first used during the BLACK POWER movement. It was expressed by blacks by wearing their hair long, curly (i.e., unstraightened) or in braids, wearing African-inspired clothing (e.g., bright colors, patterns, DAISHIKIS) as well as studying black history and culture. *See* AFRICAN-AMERICAN STUDIES.

Black Jews (religion) A general name for several small, independent African-American religious sects which combine elements of Judaism with BLACK NATIONALISM. The JEWISH groups in the US and Israel do not recognize the Black Jews groups as followers of Judaism.

Black Lung Program (health) The federal program which gives money to those coal miners who are disabled by the 'black lung' disease or to the spouses and/or DEPENDENTS of those coal miners who have died from this disease. Miners get the disease (formally known as "pneumoconiosis") from working in the coal mines.

This is a type of SOCIAL SECURITY program which was established by federal law in 1969. It is funded by a tax on coal companies.

Black Monday (economy) October 16, 1987, on the STOCK MARKET, the day when the DOW JONES INDUSTRIAL AVERAGE dropped 508 points (or 22.6%, the biggest drop in the history of the NEW YORK STOCK EXCHANGE). This drop occurred because of a price imbalance between NYSE stocks and options on the Chicago Board of Options Exchange. After this, the SECURITIES EXCHANGE COMMISSION established a limit for trading in a working day; if the DJIA rises or falls 50 points in one single day, all orders for trading must stop immediately. Sometimes referred to as the "Crash of 1987"; *see* CRASH OF 1929.

Black Muslims (religion) The popular name for members of the NATION OF ISLAM. [The religion, which is for 'blacks' only, uses some 'Muslim' ideas although it is not a DENOMINATION of the Muslim religion.] *See* LOUIS FARRAKHAN, MALCOLM X.

Black Nationalism (minorities) A general African-American theory which promotes political, social and cultural self-determination for blacks. It states that blacks will only be free of DISCRIMINATION by whites when all blacks unite and hold political and economic power. It has been interpreted differently by various different black leaders, namely: the BACK-TO-AFRICA MOVEMENT, MARCUS GARVEY, MALCOLM X, the NATION OF ISLAM and the BLACK POWER Movement.

Black Panthers (minorities) (BP) A militant BLACK NATIONALISM organization, political party and leading radical group of the BLACK POWER Movement. It tried to improve the housing, economic and political conditions of poor AFRICAN AMERICANS through "self-defensive" violence against the police and whites in various large cities throughout the country. It was founded in 1966 by HUEY NEWTON and Bobby Seale (born in 1937) in Oakland, California and evolved many of its ideas from the aggressive speeches and writings of MALCOLM X and the Chinese Communist leader, Mao Tse-tung

(1893–1976). Its motto was: "All Power to the People" and its members carried and used guns; they wore black-colored berets and leather jackets. It was supported by many young, urban, mostly poor blacks and other radical organizations (e.g., the WEATHERMEN). In 1968, it nominated candidates for elections in the STATE of California and for US PRESIDENT; however, without success. Its use of violence and shootings against police forces left many of its leaders in prison or dead; it went into decline after 1971 and then dissolved about 1976. Formally known as "Black Panther Party" (BPP); *compare* CHICAGO EIGHT, STOKELY CARMICHAEL, BROWN BERETS.

Black Power (minorities) Specifically, a form of BLACK NATIONALISM and a term for the militant activism of blacks in politics, economics and culture from 1966 to 1975. It encouraged AFRICAN AMERICANS to create or to take economic and political power by remaining separate from white people and developing their own all-black political and economic power through all-black organizations and businesses. This term was made popular by STOKELY CARMICHAEL in 1966 during the MEREDITH MARCH AGAINST FEAR and conflicted sharply with the NONVIOLENT ACTION practices of the CIVIL RIGHTS MOVEMENT. Its main ideas were black self-defense with weapons and violence as well as black self-pride. Its symbol and salute was a raised arm and clenched fist. It promoted the development of AFRICAN-AMERICAN STUDIES. Its most important group was the BLACK PANTHERS. It encouraged other MINORITIES to aggressively fight for themselves, namely, RED POWER, GAY RIGHTS MOVEMENT, CHICANO MOVEMENT and the WOMEN'S MOVEMENT. By association, a general term that refers to self-reliance, racial self-love and economic and political power of and for AFRICAN AMERICANS to achieve equality with whites. [Perhaps, from the book entitled *Black Power* (1954) by RICHARD WRIGHT.] *Compare* FEMINIST MOVEMENT.

Black Sox scandal, the (sports and leisure) A scandal concerning the guilt of professional BASEBALL players of purposefully trying to lose games that they were

playing in order to make money for themselves. It concerned the WORLD SERIES of 1919 in which the better team, the Chicago White Sox (of the AMERICAN LEAGUE), played very poorly and lost to the Cincinnati Reds (of the NATIONAL LEAGUE) 3 games to 5 games. In 1920, eight active members of the White Sox team were accused of conspiring with gamblers and bookies in order to purposefully make their team lose the World Series if the bookies would pay the players money. In 1920, after the players' court trial, the players were found to be "not guilty" of the charges, largely because several important documents and written player confessions to the crime disappeared. These events greatly hurt the public's confidence in baseball. Afterwards, therefore, professional baseball hired a special judge to review the case and make a stronger decision; the judge, Kenesaw Mountain Landis, banished the eight players from professional baseball (i.e., playing, managing, owning, becoming a member of the HALL OF FAME) forever. These events symbolize the greed of players, the power of the baseball owners and the disappointment of fans who had believed that the sport of baseball was an honest game. It is commonly considered the lowest point in the history of professional baseball. [From the public's perception of the guilt ('black') of the White 'Sox' players.] *See* "NATIONAL PASTIME".

Black Studies (education) A UNIVERSITY academic program available at the BA, MA and PhD levels that treats the history, literature and culture of blacks in the UNITED STATES, the Caribbean as well as other courses in the history, philosophies and languages of Africa. *Compare* AFRICAN-AMERICAN STUDIES.

black tie (clothing) The bow tie (e.g., colored black, white or printed in a pattern) worn by a man with a TUXEDO. By association, it is commonly used in invitations (i.e., oral or written) as an indication to men to wear SEMIFORMAL[1] clothing, especially a tuxedo; the bow tie may be of any color.

Black Tuesday (economy) October 29, 1929, on the STOCK MARKET, the day when a record number of 16 million shares were traded although there were very few buyers, which led to very low prices. All of this affected the DOW JONES INDUSTRIAL AVERAGE which reacted in a panic by falling 11.7% (until then, its biggest drop in one single day). This day marked the beginning of the CRASH OF 1929 and the GREAT DEPRESSION, the worst economic depression in the history of the UNITED STATES.

blacklist (work) A list composed of the names of those individuals to be punished or companies which are to be boycotted for performing in an unacceptable (e.g., anti-labor) manner. By association, **to blacklist** means to punish someone or some group for betraying or offending the larger group. *See* HOLLYWOOD BLACKLIST.

Blair House (government) In WASHINGTON D.C., the house used by official guests of the PRESIDENT of the UNITED STATES, especially foreign ministers and presidents. From 1948 to 1952, PRESIDENT HARRY TRUMAN and the FIRST FAMILY lived here while the WHITE HOUSE was being repaired. The house was built in 1824 and is on Pennsylvania Avenue. [After Francis Preston 'Blair' (1791–1876), an earlier owner of the house who happened to be a member of the KITCHEN CABINET of ANDREW JACKSON.]

blazer (clothing) A suit coat (for men or women) with lapels, metal buttons and patch pockets. Often, it is made in a blue-colored material and is a sign of a CONSERVATIVE or PREPPY dressing style. A blazer with an academic crest or monogram on the left breast pocket is part of the uniform for some elite BOARDING SCHOOLS[1] or ACADEMIES[1].

block (1, 2 geography; 3 housing and architecture) **1** In a city, the square or rectangle of land that is enclosed by streets. **2** The narrow width of one side of that block; also known as a "city block". Often, it is used for figuring distances to and from locations in a city. **3** A large building divided into separate living units (e.g., "apartment block").

block grant (government) A type of GRANT given to a STATE, group, TRIBE, SCHOOL[1] and which that group decides how to spend. *Compare* GRANT-IN-AID.

Blue and the Gray, the (history) The popular name for the two opposing armies in the CIVIL WAR. Those fighting for the UNITED STATES OF AMERICA wore 'blue'-colored uniforms; those fighting for the CONFEDERATE STATES OF AMERICA wore 'gray'-colored uniforms.

blue book (education) A blue-covered booklet measuring $8\frac{3}{8} \times 6\frac{3}{4}$ INCHES (21 cm × 17 cm) containing 16 lined pages that is used by students to write essay exams for COLLEGE[1] and UNIVERSITY.

blue chip (economy) On the STOCK MARKET, a phrase describing those major companies well known for their high-quality products and/or services. Blue chip stocks are low risk because they give buyers a modest profit and dependable return. [From the 'blue chips' used in poker, which are worth more than the red or white chips.]

blue collar (work) Describing a worker who does physical, manual labor (e.g., factory worker, car mechanic). [From the heavy, 'blue'-colored denim work clothing or uniforms originally worn by these workers.] *See* LOWER CLASS, MIDDLE CLASS; *compare* WHITE COLLAR.

blue laws (religion) STATE or local laws forbidding certain activities on SUNDAY, especially selling alcohol, retail shopping and gambling because, according to Christians' interpretation of the Bible, that day is the day of the week reserved for religion and rest. Today, most of these laws are no longer in effect because they offend the FIRST AMENDMENT; although, they are still practiced in parts of NEW ENGLAND (e.g., Massachusetts). [From the 'blue'-colored paper on which the original 'laws' were printed in New England in the seventeenth century.] Also known as "Sunday blue laws"; *see* DRY.

blue note (1, 2, 3 the arts) **1** A type of "off-pitch" musical note which is actually a lowered third, fifth or seventh degree of a major scale. It is an important, distinctive element used in the BLUES[1] and JAZZ MUSIC and stems from African music. It was formerly known as "blue node"; "to play blue note" or **blue node** means not to play in the major scale or minor scale. [From its use in the 'blues'.] **2 Blue Note** an influential, respected jazz LABEL

founded in 1939 which has helped promote jazz music. **3** A well-respected, premiere club in GREENWICH VILLAGE for live jazz bands and jazz singers.

blue plate special (food and drink) In a restaurant or DINER, a set meal consisting of some prepared meat, vegetables and potatoes or rice that has a special, economical price. [After the 'blue' color of the 'plate' upon which this meal was originally served.]

blue ribbon (sports and leisure) A blue-colored satin band which is awarded to the winner of a contest or event; often it is embossed with the words "first place" in gold letters. By association, describing something that is done very well. *See* STATE FAIR, COUNTY FAIR.

bluegrass music (the arts) A style of COUNTRY MUSIC in which high-pitched voices are highlighted and supported by the skillful musical accompaniment and playing of string instruments, namely, the FIDDLE[1], guitar, mandolin and BANJO. It employs traditional songs and originated in the region of the APPALACHIAN MOUNTAINS about 1950, although it had been played in that area during the 1940s and even earlier. [From the typical type of 'blue'-colored grass grown in Kentucky, an area of APPALACHIA.]

blues, the (1 the arts; 2 military) A unique, subtle, unassuming type of music developed by black singers and performers which uses the BLUE NOTE[1] and strong, steady rhythms. It originated among AFRICAN AMERICANS in rural areas of the SOUTH about 1900 by growing out of the work songs that blacks used to sing during SLAVERY. Its themes usually include; loss, sadness, regret and a hard life. "Classic blues" has a 12-bar form with three lines for each four bars. Blues may also be played with a 13-bar form. "Urban blues" and "electric blues" both refer to blues music played since the 1940s with electric guitars and sung with microphones and with city themes in the lyrics. In general, the blues is less European (i.e., more African and American) than JAZZ MUSIC; and was a very important influence on twentieth-century music, especially because it affected jazz music, COUNTRY MUSIC, RHYTHM AND BLUES and POP MUSIC.

It was played by B. B. KING a popular performer, Robert Johnson (1912–1938) and many others. **2 blues** The formal dress military uniforms worn by members of the ARMED FORCES for special occasions. *Compare* WHITES, KHAKIS[1].

Board of Directors (work) The group of members appointed or elected to oversee the governing, investment and administrative duties of a private company, CORPORATION or NONPROFIT ORGANIZATION. It is headed by the "Chairman (Chairwoman or Chair) of the Board", the most powerful person of this group.

board of education (education) The body of members elected to govern and administer the PUBLIC SCHOOLS in a particular SCHOOL DISTRICT. It is responsible for approving, financing and evaluating the educational programs of the SCHOOLS[1] in a particular STATE or local district. Each state board of education appoints and employs the SUPERINTENDENT OF SCHOOLS for a district. Also known as "SCHOOL BOARD" and "the Board"; *compare* BOARD OF TRUSTEES.

Board of Governors (economy) The group of seven people making monetary policy for the FEDERAL RESERVE SYSTEM, especially the budgets and maintenance of federal banks. Members are appointed by the PRESIDENT for TERMS[1] of 14 years. The "Chairman of the Federal Reserve Board" serves a renewable, four-year term. Sometimes known as "the FED"; *see* APPOINTMENT POWER.

board of trustees (education) The committee that decides on the principal internal and financial policies of a COLLEGE[1] or UNIVERSITY. It appoints a president, vice president and other administrators to oversee the daily workings of the institution. Its members may serve limited TERMS[1] or they may be appointed for life. In a public COLLEGE[3] or STATE UNIVERSITY, the members are elected or appointed by the STATE governor. In religiously-affiliated and PRIVATE SCHOOLS, the members are usually representatives of the institution's founders or religious leaders. Also known as "the Board", "Board of Regents", "the Regents"; *compare* BOARD OF EDUCATION, BOARD OF DIRECTORS.

boarding school (1, 2 education) **1** A private, religious or sometimes elite, PREP SCHOOL at the SECONDARY SCHOOL level (GRADES[1] seven through 12) that provides ROOM AND BOARD to its students. Usually, the students remain on the CAMPUS most of the ACADEMIC YEAR only seeing their families during religious or academic holidays and SUMMER VACATION. *See* Appendix 4 Educational Levels, PRIVATE SCHOOL, PREPPIE[1], PHILLIPS EXETER ACADEMY; *compare* ACADEMY[1]. **2** A type of boarding school operated by religious missionaries who taught Indian students and children English and other academic courses. During the late nineteenth century and the early twentieth century, it was an important form of ASSIMILATION of NATIVE AMERICANS.

boat people (immigration) Specifically, some 1.5 million REFUGEES, mostly poor, who immigrated to the UNITED STATES from Vietnam, Laos and Cambodia after the VIETNAM WAR (from 1975 to the late 1980s). By association, a general term for any group of people, usually poor and desperate, hoping to immigrate and traveling to the United States by boat. [From the crowded 'boats' that those 'people' originally used to flee Southeast Asia.]

bobbing for apples (customs and traditions) A game traditionally played at HALLOWEEN parties in which players must use their mouths (i.e., not their hands) to lift an apple from a deep tub filled with water and some 10 to 20 floating apples. Lifting an apple out of the tub without getting one's face wet is very difficult to do.

bolo tie (clothing) A type of decorative tie in which a thin cord encircles the neck and is clasped at the throat with an ornamental clip. It is the official neckwear of the STATE of Arizona and is associated with the WEST. [From Spanish *bola*, a thick cord with a ball attached at either end, which was a tool used by COWBOYS[1] to capture cattle.]

bomb, the (sports and leisure) In FOOTBALL, a long forward pass from one offensive player (e.g., the QUARTERBACK) to another (e.g., the receiver).

bonus (checks) (work) An extra sum of money (i.e., not part of the normal salary)

given to an individual for exceptional service or outstanding work. A "Christmas bonus" or "holiday bonus" is a bonus customarily given in December to many employees to thank them for work and services and to help them celebrate the HOLIDAY SEASON. *See* OFFICE PARTY.

boom–bust (economy) A term describing a process in a business or the economy. First a 'boom' occurs (i.e., a fast increase in the economy) which causes a need for employment, increasing prices and a high demand for well-made goods. It is then followed by a 'bust' (i.e., a serious, fast drop in business activity) which causes a climate of economic depression.

Boone, Daniel (people) (1734–1820) A frontiersman and outdoorsman. He helped whites settle the land of the STATES of present-day Kentucky (1771–1799) and Missouri (1799–1820) by exploring land, building forts and towns there and defending these from various local Indian TRIBES. His adventures on the edges of white civilization and the FRONTIER made him the model of frontiersman for JAMES FENIMORE COOPER's "Leatherstocking Tales". *See* NATTY BUMPO.

booster club (sports and leisure) A local group organized to help amateur sport teams, usually in EXTRACURRICULAR ACTIVITIES, by raising money to pay for team expenses (e.g., uniforms, equipment, travel expenses). Popularly known as "boosters"; *see* BAKE SALE.

Booth, John Wilkes (people) (1838–1865) Actor and assassin. The southerner who was so unhappy about the surrender of the SOUTH in the CIVIL WAR that he assassinated ABRAHAM LINCOLN at FORD'S THEATER in WASHINGTON D.C. on April 14, 1865. He himself died on April 26 from a gunshot wound. *See* APPOMATTOX COURT HOUSE.

bop (the arts) A shortened, alternative name for BEBOP.

Border, the (geography) The international boundary between the UNITED STATES and Mexico, especially that part delineated by the RIO GRANDE. "South of the Border" refers to Mexico, its people and customs; "north of the Border" refers to the US, its peoples and customs.

border crosser (immigration) A common name for an illegal immigrant (e.g., from Mexico, Latin America). [After the method of some Mexican people entering the US by walking 'across' the international 'border' between the two countries, that is, not at an official border checkpoint.]

border patrol (immigration) A special type of federally-supported police force which enforces immigration policies along the international borders, especially with Mexico. Its responsibilities include preventing ILLEGAL ALIENS from entering the country and for operating DEPORTATION DRIVES. It was established in 1924 by CONGRESS and is overseen by the IMMIGRATION AND NATURALIZATION SERVICE. Several incidents in the 1970s concerning this group's harsh physical treatment of non-Americans caused the public to criticize and question this group's methods and purpose. *See* RIO GRANDE; *compare* TEXAS RANGERS.

born-again Christian (religion) A person who is committed to or has rediscovered Christianity after having had a strong emotional and/or personal religious experience. *See* REVIVAL, EVANGELICAL, BELIEVER.

borough (1, 2 geography) **1** In NEW YORK CITY, one of the five separate political units which compose the city. **2** In the STATE of Alaska, the name for a COUNTY.

Boston (geography) The capital city of the STATE of Massachusetts and largest city in NEW ENGLAND (3.8 million people). It was first settled by English settlers in 1630 and because of its busy port, played an important role in the AMERICAN REVOLUTION. In the nineteenth century, it was the intellectual and literary center of the country. Today, it remains a fishing port and is a major financial and education center; the academic institutions of HARVARD UNIVERSITY, MASSACHUSETTS INSTITUTE FOR TECHNOLOGY and BARNARD COLLEGE as well as several others are located here. Popularly known as "BEAN TOWN"; *see* Appendix 3 Professional Teams; BOSTON TEA PARTY, MASSACHUSETTS BAY COLONY, ISABELLA STEWART GARDNER MUSEUM, SAMUEL ADAMS,

GREAT MIGRATION[1], PATRIOTS' DAY, AMER-ICAN RENAISSANCE.

Boston cream pie (food and drink) A dessert cake consisting of two layers separated by a thick filling of cream or custard and topped with a chocolate ICING.

Boston Globe, The (media) The daily newspaper which, since the 1960s, has become an influential paper, publishing well-researched articles designed to expose problems and public abuse in the community. It has a noted SUNDAY EDITION and a current circulation of about 500,000. It was first published in 1872 and was acquired by THE NEW YORK TIMES in 1993.

Boston Marathon, the (sports and leisure) The oldest marathon race (26.2 miles; 42 km) in the US; it was first held in 1897 (for men) and was opened to women in 1972. It is held every year in the city of Boston on the third Monday of April, that is, on PATRIOTS' DAY, a legal holiday in the state of Massachusetts. Runners begin the course at Hopkinton in West BOSTON and finish in the city center of Boston at the John Hancock Tower. The winners receive prize money and a traditional pot of beef stew.

Boston Tea Party, the (history) An organized but undercover protest (December 16, 1773) against British taxation policies in which colonists of Massachusetts, disguised as INDIANS, boarded three British ships docked in Boston Harbor and dumped their contents (over 340 crates of tea, intending to be sold with a high tax to the colonists) into the water of Boston Harbor. This event symbolized American colonists' rebelliousness against the ruling British. *See* AMERICAN REVOLUTION.

both sides of the aisle (government) In the legislature, cooperation between the two political parties; an informal expression, meaning "BIPARTISAN". [From the main 'aisle' in the legislative chambers which separates the seating section for DEMOCRATS from the seating section for REPUBLICANS.]

bottom of the (inning) (sports and leisure) In BASEBALL, the second part of an INNING when team A, which has already played defensively, is now playing offensively; and team B plays defensively. Often, it is used with the number of the inning (e.g., "bottom of the ninth"). *Compare* TOP OF THE (INNING).

bottomless cup of coffee (food and drink) A policy in a restaurant in which a customer pays for one cup of coffee and thereafter during the meal receives free refills. [The cup is never empty because it is always refilled.]

bouncer (work) At a night club or BAR[1], the worker who is stationed at the establishment's entrance and is responsible for checking the ID CARDS of all those entering, preventing underage people from entering and ejecting any disorderly people from the premises. Usually, this person is male and has a large, muscular body.

bourbon (food and drink) A type of straight whiskey that is distilled from a mash consisting of corn (at least 51%) plus malt and rye which is then aged for two years in wooden barrels. [After 'Bourbon' COUNTY, Kentucky where it originally was and continues to be made; only whiskey made in this county may be called "bourbon".]

Bourbon Democrats (politics) After 1865 and especially during RECONSTRUCTION, a nickname for those white, mostly wealthy, DEMOCRAT politicians from the SOUTH who tried to pass legislation which represented policies of the Old South (e.g., large-scale farming, crop subsidies), and not the very weakened South which existed after the CIVIL WAR (i.e., which needed new infrastructure and needed to employ millions of freed blacks and which had no bargaining power in the CONGRESS). By association, any old-fashioned, very CONSERVATIVE member of the DEMOCRATIC PARTY living in or representing the South.

Bourbon Street (geography) In NEW ORLEANS, a street running through the FRENCH QUARTER which is known for its cheap BARS[1], strip tease clubs and tacky signs. It is the site of many festivities during MARDI GRAS.

Bourbons (society) A group of white people living in the SOUTH which is characterized by having very CONSERVATIVE social and political views and supporting the DEMOCRATIC PARTY. Before the

CIVIL RIGHTS MOVEMENT, this group promoted and enforced JIM CROW and SEGREGATION.

Bowers v. Hardwick (minorities) The SUPREME COURT DECISION (1986) which does not support GAY RIGHTS. It does not give two homosexuals the protection of privacy; that is, it does not allow them to have sex with each other or engage in other related activities even while on private property. The case concerned a homosexual man who was arrested in the bedroom of his own house because he was having sex with another man. *See* NINTH AMENDMENT.

Bowery, the (geography) The street and surrounding area of lower MANHATTAN[1]. During the second half of the nineteenth century, it was part of the theater district. Since the 1870s and up to today, it has been known as a poor area of slums and corruption. [From Dutch '*bouwerij*', meaning "farm".]

bowl game (sports and leisure) In COLLEGE[1] FOOTBALL, a major post-season football game held between different INTERCOLLEGIATE teams. These games usually are held in late December or on NEW YEAR'S DAY; all are televised. The most famous one is the ROSE BOWL. All the games are preceded by parades, MARCHING BANDS and other festivities. *See* other bowl games listed in Appendix 6 Bowl Games. *Compare* PRO BOWL.

box lunch (food and drink) A cold, light meal usually eaten for LUNCH (i.e., consisting of a sandwich, fruit and/or salad or other non-hot items) which is packed in a cardboard box and presented in a pleasing or elegant way. *Compare* LUNCH BOX.

box social (the arts) An elegant social or society event designed to raise funds for an artistic project or charity through the audience's (often female) bidding and the auction of BOX LUNCHES and/or tickets to a dinner event. All profits go to the designated causes and arts projects.

boxscore (sports and leisure) The results and summary of statistics of a sports game (especially BASEBALL) which is published in newspapers, on computer and on television sports broadcasts.

boy scout (sports and leisure) A member of the Boy Scouts of America (BSA), an organization which teaches boys, aged 11 through 18, practical skills about the environment, especially first aid, hiking and camping as well as the social skills of helpfulness, responsibility, patriotism and leadership. The group oath is to "Be Prepared". It was established in the UNITED STATES in 1910 and currently has 5.4 million members. It was originally founded in Great Britain in 1908. Members wear distinctive khaki-colored uniforms which they may decorate with any of various badges which they can earn through successfully completing various activities. *See* CUB SCOUT; *compare* GIRL SCOUT.

Boys' Town (health) A private organization which sponsors a type of BOARDING SCHOOL[1], VOCATIONAL SCHOOL and training center for homeless or troubled teenage boys and (now) girls from fifth GRADE[1] through HIGH SCHOOL. It is supported by private donations and is located in Omaha, Nebraska. It was founded in 1917 by Edward Flanagan (1886–1948) a Catholic priest, as an orphanage for boys. *See* ROMAN CATHOLIC CHURCH.

bracero (immigration) An unskilled, manual laborer from Mexico who participated in the BRACERO PROGRAM from 1942 to 1964. [Spanish, meaning "a person who works with his hands"; from *brazo*, meaning "arm".]

Bracero program (immigration) A mutual contract labor program between the UNITED STATES and Mexico that brought Mexican manual workers (i.e., BRACEROS) to the US to work temporarily on US farms picking ripe fruit and vegetables, mostly in the SOUTHWEST and MIDWEST. It was designed to fill US jobs (which needed to be done), provide work to Mexican laborers (who needed work) and control the flow of illegal immigration to the US from Mexico (which was a problem for the two governments). It was operated by the US federal government which gave the workers short-term work contracts that provided the worker with housing, medical care, MINIMUM WAGE and transportation to and from Mexico. It began in 1942 because of the lack of laborers in the US due to WORLD WAR II and the INTERNMENT CAMPS; it ended in 1964. Although it

satisfied the worker shortage during that period, it produced negative aspects in the economies of both countries, namely, it still encouraged illegal immigration to the US and caused a BRAIN DRAIN in Mexico.

Bradford, William (people) (1590–1657) A PILGRIM leader and the popular, elected governor of the PLYMOUTH COLONY (largely from 1622 to 1656). He is remembered for having helped write the *Mayflower Compact* and for providing solid, tolerant leadership of the colony. *See* MAYFLOWER.

Brady Bill (legal system) The federal law (passed in 1993) which tries to control the sale of guns to individuals. It demands that after a person requests to purchase a gun, he or she wait for a period of five days, during which time the police have time to check that potential purchaser's personal criminal history. If that purchaser has a history of criminal activities or mental disabilities, he or she may not buy the gun. This BILL[2] proved very controversial because it was protested against by the NRA (NATIONAL RIFLE ASSOCIATION). [After James 'Brady' (born in 1944) the former WHITE HOUSE press secretary who was paralyzed during the March 30, 1981, gun-shooting attempt against PRESIDENT RONALD REAGAN's life. The gunshooter, John Hinckley, Jr., bought the gun even though he had a personal history of mental instability.]

Brady, Matthew (people) (*c.* 1823–1896) A photographer who is best known for recording the reality of daily life in camp for UNION[3] soldiers as well as battle scenes during the CIVIL WAR. Several of his brown/black and white photographs show ABRAHAM LINCOLN among the troops in camp and as CHIEF EXECUTIVE.

brain drain (immigration) A negative term describing the loss of educated persons, professionals or intellectuals from a company, regional area or country to some other company or area.

Brandeis University (education) An accredited, private UNIVERSITY located west of BOSTON. It was founded in 1948 as the first JEWISH-sponsored university which is not religious nor sectarian. Today, it has a COED population of 3,000 UNDERGRADUATES and 1,000 GRADUATES

and is known for its research programs. [After Jewish US ASSOCIATE JUSTICE of the SUPREME COURT, Louis Dembitz 'Brandeis' (1856–1941).] *See* ACCREDITATION.

Branson (geography) Since the 1960s, a resort town and center for COUNTRY MUSIC and family-oriented entertainment. Many entertainers own their own theaters and perform and live in this town from May through October. It is located in the STATE of Missouri in the OZARK MOUNTAINS. *compare* NASHVILLE.

"bread and butter unionism" (work) A philosophy of organized labor in which the labor UNION[1] does not try to change the system of society, but rather works for members' benefits within the existing system of CAPITALISM. Usually it uses STRIKES[1] and SIT-INS to achieve its goals of higher wages, shorter work days for members. It was first popularized by the AFL. *Compare* INTERNATIONAL WORKERS OF THE WORLD.

Breeders' Cup, the (sports and leisure) The richest and most glamorous day of thoroughbred racing which consists of seven different horse races held at the same track on the same Saturday. The races differ according to distance, type of surface (e.g., grass, dirt turf) and sex of the horse; each race winner receives at least $1 million in prize money. It was first held in 1984 and its location rotates every year.

Briar Rabbit (the arts) The main character in the *UNCLE REMUS STORIES* who is noted for his cleverness and mental skills. Also spelled "Br'er Rabbit" [After the thorny branches of these 'briar' plants which provide good protection to small 'rabbits'.]

Brigham Young University (education) (BYU) A large, independent, COEDUCATIONAL accredited UNIVERSITY. It was founded in 1877 in Provo, Utah by the CHURCH OF JESUS CHRIST OF LATTER-DAY SAINTS and is one of the largest church-related private UNIVERSITIES in the UNITED STATES. Its aims include teaching the Bible, providing a LIBERAL ARTS education and/or PROFESSIONAL SCHOOL instruction. Its COED population includes some 25,000 UNDERGRADUATES and 4,000 GRADUATES[2]. It is an NCAA member and its teams compete at the INTERCOLLEGIATE level. Its

mascot is the Cougar. [After BRIGHAM YOUNG (1801–1877), a founder.] *See* PRIVATE SCHOOL, ACCREDITATION.

"British invasion", "the" (the arts) The collective name for that hectic, exciting period in 1964 when the British music band, The Beatles, was making a successful performance tour of the UNITED STATES. The group was extremely popular among American audiences, especially female teenagers, who wanted to know everything about the handsome, young Englishmen. By association, any excitement caused by something or person that is British. Similarly, any nationality adjective + "invasion" can be used to express similar ideas and effects in the US caused by any other country or its people.

Broadway (the arts) Specifically, a collective name for any of the large, live, premiere theaters in NEW YORK CITY (located between West 41st and 55th Streets) which stage professional productions of popular MUSICALS and already established plays. When a theatrical production is showing or an actor is performing in one of these theaters it/he/she is "on Broadway". Generally, these shows are more commercial than OFF-BROADWAY productions. By association and in general, a collective term for the respected art of live (i.e., not movie) acting. [After the street, 'Broadway', in MANHATTAN[1] which originally housed many theaters in the early twentieth century.] *See* TONY AWARDS; *compare* OFF-OFF-BROADWAY, BOWERY.

Brooklyn (geography) In NEW YORK CITY, the residential working-class BOROUGH[1] with the largest total population (2.3 million **Brooklynites**). Many of its residents are black, JEWISH or recent immigrants. It is linked to MANHATTAN[1] by the BROOKLYN BRIDGE and is home to CONEY ISLAND and Bensonhurst, a particularly rough neighborhood. [After the Dutch city, '*Breuckelen*'.] *See* BEDFORD-STUYVESANT, BROOKLYN DODGERS, BROOKLYN BRIDGE, BROOKLYNESE, WILLAMBURG[2]; *compare* HARLEM.

Brooklyn Bridge, the (transportation) A suspension bridge extending over the East River from MANHATTAN[1] Island to BROOKLYN meant to carry cars, trucks and pedestrians. In the nineteenth century, it was the first suspension bridge of its kind (built 1869–1893 with steel cables) and became a symbol of progress and was recognized for its elegance and beauty; it was repaired during the 1990s.

Brooklyn Dodgers (sports and leisure) The NATIONAL LEAGUE BASEBALL team which formed in BROOKLYN in 1884 and played there through the 1957 season. It was the favorite team of Brooklynites who were enthusiastic, loyal fans. From 1915 to 1957, EBBETS FIELD was its HOME TEAM BALLPARK. It had a long-standing rivalry with the New York Yankees; during the 1940s and 1950s, these two teams played each other in seven different WORLD SERIES championships, during which time the DODGERS won this world championship only once, in 1955. In 1957 when the owner, Walter O'Malley, announced that the Dodgers team was to move from Brooklyn to LOS ANGELES, many loyal local fans were angry and sad. This announcement and subsequent move are considered low points in baseball history. [From "trolley 'dodger'", a nickname used by Manhattanites to refer to Brooklynites because of the need to avoid, or 'dodge', many 'trolley' car tracks in that BOROUGH[1] in the late nineteenth century.] *See* JACKIE ROBINSON, YANKEES[4], Appendix 3 Professional Teams.

Brooklynese (language) A popular name for the American English accent used by those people born and raised in NEW YORK CITY. It is characterized by replacing a vowel + "r" by a long vowel sound; and for substituting "d" or "t" for "th". For example, the standard phrase "in the park" becomes "in de pak".

Brooks, Garth (people) (born in 1962) COUNTRY MUSIC songwriter and performer. He is known for being a very successful and popular singer. His songs have been popular on both the country music CHARTS and the POP MUSIC charts. In 1997, he gave a free concert in CENTRAL PARK which attracted over 200,000 fans.

"Brother, Can You Spare a Dime?" (the arts) The title and refrain of a popular FOLK MUSIC song popular during the 1930s which became the theme song of the GREAT DEPRESSION; the poor, penniless

narrator tells about all the work and fighting (in WORLD WAR I) that he has done for the UNITED STATES and asks passers-by to give him some small change because he has no money nor job due to the Depression. The first lines are: "Once I built a railroad, I made it run/I made it run against time/Once I built a railroad, now its done/Brother can you spare a dime?/Once in khaki suits, gee we looked swell/Full of that Yankee-Doodly-dum/Half a million boots went slogging through Hell/And I was the kid with the drum"/.../"Brother, can you spare a dime?" See KHAKIS[1].

Brotherhood of Sleeping Car Porters (work) The first African-American labor UNION[1] in the UNITED STATES which worked to get work contracts for black workers on trains. Its successes included decreasing the hours of work per week, increasing wages and providing its members with job security. It joined the AFL in 1937 and served as an active voice in the struggle for CIVIL RIGHTS. It was founded in 1925 by A. PHILIP RANDOLPH who served as its dynamic president. See MARCH ON WASHINGTON MOVEMENT, MARCH ON WASHINGTON OF 1963.

Brothers, Joyce, Dr. (people) (born in 1928) A psychologist and SYNDICATED columnist known for presenting psychological information and advice concerning relationships between spouses, families and partners in popular, open, easy-to-understand articles and personal interviews.

Brown Berets (minorities) During the CHICANO MOVEMENT, a militant hispanic organization which worked in the BARRIOS to improve the conditions for poor HISPANICS, especially, the opportunities for housing and jobs. Further it worked to encourage young people not to take drugs. It was founded in 1967 in LOS ANGELES and it was supported by many urban, hispanic young people from the barrio, especially, HIGH SCHOOL DROP-OUTS. Members wore 'brown'-colored 'berets', FATIGUES and military boots. Although it supported the BLACK PANTHERS in the elections of 1968, it itself was not a political party. It dissolved in the mid-1970s.

Brown v. Board of Education of Topeka, Kansas (education) The unanimous SUPREME COURT decision (of 1954) that decided that the SEGREGATION of blacks and whites in PUBLIC SCHOOLS was illegal because it denied black students equal educational opportunity. This very important decision reversed the law of "SEPARATE BUT EQUAL" in public school education which was established with *PLESSY* v. *FERGUSON* in 1896. [After the student, Linda 'Brown' (born in 1946), whose father brought the case to court on her behalf.] See CONSTITUTION, WHITE ACADEMY[1].

brownie (1 food and drink; 2 sports and leisure) **1** A small, chewy, cake-like sweet cookie made from chocolate, butter, eggs and sugar and usually chopped nuts eaten as a snack or for dessert. **2 Brownie** A young member (aged six through eight) of the lower division of the GIRL SCOUTS (i.e., first, second and third GRADE[1]).

brownstone (housing and architecture) A tall, narrow urban building (usually three stories tall) designed as a single family's private residence during the nineteenth century in cities of the NORTHEAST. Today, it may consist of different apartments or professional offices or it may contain a single private residence. [After the 'brown'-colored sand'stone' material used to decorate the façade of this building.]

BS (education) A type of BACHELOR'S DEGREE. [Abbreviation of 'B'achelor of 'S'cience.]

buckskin (clothing) The soft yellow or grayish-tan colored deer leather used to make pants, shirts, moccasins and shoes. By association, any clothing made from this material. Traditionally, it is associated with those people living on the FRONTIER and is a sign of independence. [From the leather 'skin' of a male deer, a 'buck'.]

"buck stops here", "the" (government) A phrase, meaning that an individual takes responsibility for all his or her actions – good and bad. In government, this belief includes a CHIEF EXECUTIVE taking credit and blame for the actions of his or her ADMINISTRATION. [From the personal motto of HARRY TRUMAN, US PRESIDENT (from 1945 to 1953). It is an

alteration of an earlier phrase, "pass the buck", meaning to deny one's own responsibility for some action that one has committed.]

budget deficit (government) The debt the government acquires in any FISCAL YEAR when the government spends more money (e.g., on SOCIAL SECURITY, defense projects) than it earns (e.g., from income taxes, PROPERTY TAXES). There was a large national BUDGET DEFICIT throughout most of the Reagan ADMINISTRATION[2] and Bush ADMINISTRATION[2]. *See* RONALD REAGAN; *compare* BALANCED BUDGET.

bull (economy) A person who expects or acts like he or she is expecting the overall price of stocks, bonds or commodities to increase and therefore buys them before they increase. A bull makes money in a BULL MARKET. *Compare* BEAR.

bull market (economy) On the STOCK MARKET, a long-term rise in the prices of stocks, bonds or commodities. The bull market's rise in prices help bulls make money and prosper. It is good for the national economy. *Compare* BEAR MARKET.

Bull Mooser (politics) The nickname for a member of the PROGRESSIVE PARTY[1] of 1912. The bull moose was the mascot of this party. [From a comment by THEODORE ROOSEVELT who said he felt like a 'bull (male) moose', which is a large, powerful mammal living in the northwestern UNITED STATES, Alaska and Canada.]

Bull Run, the Battles of (history) During the CIVIL WAR, the site of two different battles both of which the Confederacy won. In the first battle (July 21, 1861), the Confederate troops fought very well (especially STONEWALL JACKSON) making the UNION[3] realize that its own leadership was poor and that the war would not be over quickly. In the second battle (August 28 and September 1, 1862), the Confederate troops led by ROBERT E. LEE, were again successful, this time by pushing the UNION[3] troops north out of Northern Virginia. [After the location of the fighting at 'Bull Run' Creek in the present-day STATE of Virginia.] In the SOUTH, they are also known as "First and Second Manassas"; *see* MANASSAS.

bullpen, the (sports and leisure) In BASEBALL, specifically a place reserved for the RELIEF PITCHERS to practice and warm up before going on the field to play. Generally, a collective name for the relief pitchers. By association, any small, crowded area.

bun (food and drink) A small, soft yeast cake. It may have a light flavor and be made to hold a HAMBURGER or HOT DOG for LUNCH or DINNER. Or it may be sweetened with fruits, nuts or cinnamon which is then eaten with the hands for breakfast or with coffee. A "sticky bun" is a type of bun basted with an outer, 'sticky' layer of butter and syrup.

Bunche, Ralph (people) (1904–1971) African-American scholar and promoter of the CIVIL RIGHTS MOVEMENT, human rights and peace. He helped research the book *AN AMERICAN DILEMMA* (1944), was an active member in the NAACP and participated in the MARCH ON WASHINGTON OF 1963. He is remembered for his work as United Nations Under-Secretary General and for being the first black person to win the Nobel Peace Prize (in 1950).

Bunker Hill, the Battle of (history) During the AMERICAN REVOLUTION, the battle (June 17, 1775) near BOSTON in which the success of the Americans (killing some 1,000 British soldiers) greatly encouraged the colonists to fight on for independence. (Actually, the battle was fought on the nearby Breed's Hill.)

Bunyan, Paul (customs and traditions) A fictional male character from white folklore who worked as a lumberjack (i.e., cutting trees down) in the WEST and was the central character of various heroic stories. He was depicted as a very tall, large strong man wearing a plaid shirt and blue JEANS. His companion was a female, blue-colored ox named "Babe, the Great Blue Ox". He and Babe were attributed with creating several special natural places; in one story he carved the GRAND CANYON with his ax; in another story, the large footprints left by him and Babe filled with water and became the "10,000 lakes" of the STATE of Minnesota. Today, he is also a symbol of lumberjacks and foresters.

Buppie/buppie (society) An African-American YUPPIE. [Acronym from 'B'lack 'U'rban 'P'rofessional + 'ie'.]

Bureau of Indian Affairs (minorities) (BIA) The federal agency responsible for overseeing all issues concerning NATIVE AMERICANS and ALASKA NATIVES (e.g., the rights for tribal lands and RESERVATIONS, education and water rights). Currently, it is a part of the DEPARTMENT OF THE INTERIOR and is headed by the "Commissioner of Indian Affairs". Its headquarters are in WASHINGTON D.C. but it operates 12 area offices throughout the UNITED STATES. Originally, it was founded in 1819 as part of the federal Department of War. During those years, this agency was severely criticized for enforcing federal programs which did not respect NATIVE AMERICANS nor their cultures, namely, during much of the nineteenth century, it enforced the reservation system and ASSIMILATION techniques (e.g., prohibited the performance of the SUN DANCE and GHOST DANCE RELIGION, enforced government BOARDING SCHOOLS[2] and English language teaching); during most of the twentieth century, it enforced TERMINATION. However, it did help Indians by promoting the INDIAN NEW DEAL. Today, its goal is to continue to provide the necessary health and education services while encouraging the tribes to govern themselves; most of its CIVIL SERVANTS are Indians. It still receives a budget from the federal government; however, since the 1970s, most of this money is directly given to the tribes to fund different programs operated by the tribes. It is popularly referred to as the "BIA" or "The Bureau". Formerly, during the nineteenth century, it was known as the "Office of Indian Affairs"; see GAMING, INDIAN SELF-DETERMINATION AND EDUCATION ASSISTANCE ACT.

Bureau of Labor Statistics (economy) (BLS) The agency of the DEPARTMENT OF LABOR, which collects, analyzes and reports information about current employment. Every month it publishes the CONSUMER PRICE INDEX.

Burger Court, the (legal system) The popular nickname for the SUPREME COURT from 1969 to 1986 during which time it practiced a limited JUDICIAL ACTIVISM. Its DECISIONS concerned many different issues: it supported AFFIRMATIVE ACTION but limited the policy of the racial QUOTA SYSTEM; it increased women's protection from SEXUAL HARASSMENT and approved legal abortion in the decision ROE V. WADE. Other decisions concerned CIVIL RIGHTS, equality, personal privacy, religious freedom and the separation of government power between the executive and legislative branches. This Court was purposefully more CONSERVATIVE than its predecessor, the WARREN COURT, which the Burger Court believed had exercised too much JUDICIAL ACTIVISM. [After Warren E. 'Burger' (1907–1995), CHIEF JUSTICE during this period.]

Burlingame Treaty (immigration) A TREATY agreed to in 1868 by the US government and the Ch'ing Dynasty of China, which established free migration between the two countries. It helped guarantee enough Chinese workers for the Central Pacific Railroad link of the TRANSCONTINENTAL RAILROAD. [After American diplomat Anson 'Burlingame' (1820–1870), who helped arrange the treaty.] See CHINESE EXCLUSION ACT OF 1882.

bus boy/girl (daily life) In a restaurant, the person who cleans tables, clears the dishes from the tables and helps the waiter and serve food orders. He or she is usually paid less than a waiter and earns smaller TIPS. [Shortened from omni'bus'.] Also known as "busser"; see SERVICE INDUSTRY.

bush league (sports and leisure) In BASEBALL, a nickname for the MINOR LEAGUE. By association, something that is amateur or unprofessional.

Bush, George (people) (born in 1924) US PRESIDENT (1989–1993) with MODERATE REPUBLICAN beliefs. As COMMANDER IN CHIEF, he sent American forces to the Persian Gulf which led to the GULF WAR and helped to successfully organize the United Nations military coalition. In his domestic program, he permitted new taxes and he vetoed federal legislation which supported: abortion rights; the MINIMUM WAGE; and anti-DISCRIMINATION. He served as the VICE PRESIDENT during the presidency of RONALD REAGAN (1981–1989). He also served as Director of the CIA (1976–1977). See Appendix 2 Presidents.

business card (work) A small rectangular piece of stiff paper upon which is written an individual's name, that person's business title, the name and logo of the business, address, telephone and/or fax numbers and e-mail address and/or website. Frequently, a person refers to it as "my card".

busing (education) A SUPREME COURT-mandated attempt to eliminate SEGREGATION in PUBLIC SCHOOLS by mixing black and white students in the same SCHOOL[1]. Since most blacks lived in different neighborhoods than whites, they were transported across the SCHOOL DISTRICT by SCHOOL BUS to attend the white SCHOOLS[1] and white children were bussed to black SCHOOLS[1]. This practice began in 1971 with *SWANN V. CHARLOTTE-MECKLENBURG BOARD OF EDUCATION* (also known as the "busing decision"), but was very controversial because it was a judicial decision (not legislative) and also although many adults approved of the program in theory, white parents did not want their own children bussed. *See BROWN v. BOARD OF EDUCATION OF TOPEKA, KANSAS*, WHITE ACADEMY[1], WHITE FLIGHT, JUDICIAL ACTIVISM; *compare* MAGNET SCHOOL.

"buy American" (economy) A business strategy and unofficial foreign policy urging the public to buy American products, especially those made in the UNITED STATES, in order to improve the American business market.

buy-out (economy) Buying the majority of stocks in a company so that the buyer can take control of that company's decisions and its ASSETS.

bylaw (government) A rule or law adopted by a CORPORATION, a business, SCHOOL[5], a UNION[1] or any of its LOCALS for governing its own meetings or affairs.

C

C-SPAN (media) The cable television channel that broadcasts government events live, especially daily SESSIONS[1] of the SENATE and the HOUSE OF REPRESENTATIVES and press conferences by the PRESIDENT, SECRETARIES of DEPARTMENTS[2] and other officials. It has 70 million SUBSCRIBERS. [Acronym of 'C'able-'S'atelite 'P'ublic 'A'ffairs 'N'etwork.]

Cabinet, the (government) The official group of appointed officers the PRESIDENT chooses to advise him or her on making decisions and developing public policy. The Cabinet members include the CHIEF OF STAFF, the ATTORNEY GENERAL and the 13 SECRETARIES of the DEPARTMENTS[2] of: AGRICULTURE; COMMERCE; DEFENSE; EDUCATION; ENERGY; HEALTH AND HUMAN SERVICES; HOUSING AND URBAN DEVELOPMENT; THE INTERIOR; LABOR; STATE; TRANSPORTATION; THE TREASURY; and VETERANS AFFAIRS. Some presidents choose to increase the Cabinet size by including other members, namely: the US TRADE REPRESENTATIVE, the DRUG CZAR; the Director of CENTRAL INTELLIGENCE (AGENCY); the Administrator of the ENVIRONMENTAL PROTECTION AGENCY; and the Ambassador to the United Nations among others. *See* APPOINTMENT POWER; *compare* KITCHEN CABINET.

Cabrini-Green (housing and architecture) In the city of CHICAGO, the large federal public housing project consisting of some 90 different buildings which was designed to provide housing to poor people. It soon became the site of gang violence and crimes; today, it is a symbol of poor planning and an unsuccessful federal housing policy. [After Mother 'Cabrini' (1850–1917), Italian-born American Catholic saint who worked for the poor.] *See* DEPARTMENT OF HOUSING AND URBAN DEVELOPMENT.

caddy/Caddy (transportation) An affectionate name used to refer to one's CADILLAC. [Clipped from 'CADI'LLAC + 'ie'.]

Cadillac (transportation) The brand name of an expensive well-made automobile admired for its smooth-running engine, comfortable passenger seats, interior and exterior elegance and overall luxuriousness. It comes in a variety of styles and colors; namely the two-seater coupe and the four- or five-seat sedan car. It is affectionately known as a "CADDY". By

association, the best of some thing or class; something of the highest class. [After Antoine de la Mothe 'Cadillac' (1658–1730), French explorer and the founder of DETROIT.]

Caesar salad (food and drink) A salad of romaine lettuce tossed with a dressing of garlic, grated cheese, olive oil and raw egg. It is topped with croutons and sometimes anchovies. [After the restaurant named 'Caesar's' in Tijuana, Mexico which first created and popularized this salad.]

Cajun Country (geography) A popular name referring to that southern, rural part of the STATE of Louisiana where, since 1765, CAJUNS, descendants of Acadians, have lived. The regional capital of this area is Lafayette. See CAJUN COOKING.

Cajun food (food and drink) A country-style of cooking developed by CAJUNS containing the key ingredients of tomatoes, pork, parsley, garlic and green onions. Characteristic dishes include *boudin* (i.e., a type of pork sausage), GUMBO and foods covered in *roux* (i.e., a spicy brown sauce). See CAJUN COUNTRY, JAMBALAYA; *compare* CREOLE CUISINE.

Cajuns (people) A collective name for the groups of traditionally bilingual (i.e., French and English), Roman Catholic, mostly white people currently living in rural areas in Louisiana. Originally, they were French and lived in "Acadia", that is, the present-day eastern Canadian province of Nova Scotia; after the English won the right from the French to control that area of land in Canada, the Cajuns immigrated to the Louisiana colony from 1755 to 1763. Because of a US government law in 1916, ELEMENTARY SCHOOL-aged **Cajun** students were no longer permitted to be taught in the French language; currently, most Cajuns speak English as a native language. Today, they are recognized for their unique style of speaking English with French vocabulary, music playing and cooking . [From a corruption of A'cadian' or 'Canadian'.] See CAJUN COOKING.

Cal Tech (education) The popular name for the CALIFORNIA INSTITUTE OF TECHNOLOGY.

Calamity Jane (people) (1852–1903; original name, Martha Jane Cannary Burk) Figure of the "Wild West" (*see* WEST). She was skilled in shooting guns and riding horses and developed a reputation for unusual, wild behavior (for women during that period of time) by drinking alcohol in public, wearing men's clothing and fighting INDIANS. She was a friend of the gunfighter James Butler "Wild Bill" Hickock (1837–1876). Her activities, real or imagined, were popularized in many books and newspapers of the nineteenth century.

Caldecott Medal, the (housing and architecture) The prestigious award given to the illustrator of a children's picture book. It is awarded annually (first in 1938) by the American Library Association to books published in the UNITED STATES during the previous year. [After Randolph 'Caldecott' (1846–1886) an early illustrator of English language books.]

Calhoun, John C[aldwell] (people) (1782–1850) VICE PRESIDENT (1825–1832) from the DEMOCRATIC-REPUBLICAN PARTY and US SENATOR from SOUTH CAROLINA (1833–1850). He was a very strong supporter of SLAVERY and the plantation-farming system then practiced in the SOUTH as well as STATES' RIGHTS[2]. *See* Appendix 2 Presidents.

California Institute of Technology (education) (CAL TECH) A small, elite, independent leading research UNIVERSITY famous for its graduate engineering SCHOOL[4] and strong BACHELOR'S DEGREE programs. It runs the Jet Propulsion Laboratory (JPL) which was responsible for the *Voyager* SPACE SHUTTLE. The CO-EDUCATIONAL student population is composed of 1,000 UNDERGRADUATES and 500 GRADUATES[2]. It is located in Pasadena, California, hosts the ROSE BOWL and considers MIT its academic rival. Its students have a tradition of staging humorous, sophisticated, but harmless pranks. For example, during the Rose Bowl game of 1984, students rewired the scoreboard to replace the names of the competing teams "UCLA" and "University of Illinois" with "Cal Tech" and "MIT". *See* PRIVATE SCHOOL.

call letters (media) The four letters used to identify a COMMERCIAL or public radio or TV station in the UNITED STATES. "K"

is used as the first letter in stations located west of the MISSISSIPPI RIVER; "W" for those east of the river.

call-in (media) A type of radio or TV program that broadcasts the telephone 'call' conversations or questions of the listeners or viewers to a program host.

caller (sports and leisure) In a BARN DANCE, the person who stands with the live band and sings the songs and gives the dancing partners the commands and orders for their steps (e.g., "Swing your partner"). The caller is an important person in SQUARE DANCING and is associated with COUNTRY AND WESTERN MUSIC.

calling card (daily life) A plastic card issued by a long-distance telephone company to a registered customer which lists the name and special access number (usually 14 or 15 digits) of that customer. To use the card, the customer types the access number and the desired telephone number into the telephone key pad. The customer pays for all phone calls made once a month after receiving the BILL[3] from the telephone company. *Compare* CHARGE CARD.

Calvinism (religion) A type of PROTESTANT, religious view of life believing in a very powerful God who has already chosen a group of special people who, after dying, will live with their God in the next life. It also promotes strict, CONSERVATIVE morals in religious and daily life and opposes the SEPARATION OF CHURCH AND STATE. In America, it influenced the PURITANS, CONGREGATIONALISM[1,2], the Congregationalist Church and the PRESBYTERIAN CHURCH. [After French religious thinker, Jean Chauvin (1509–1564) who is remembered by his anglicized name, John 'Calvin'.]

Camelot (1 the arts; 2 history) **1** A popular MUSICAL in two acts by LERNER AND LOWE which relates the English legend of King Arthur, his wife and Queen, and the knights of the Round Table all of whom had an enthusiastic desire to create and preserve their new special kingdom. The title song, "Camelot", related these ideas. It first opened on BROADWAY in 1960. **2 Camelot** After the death of JOHN F. KENNEDY, a name used to refer to the Kennedy ADMINISTRATION and

the NEW FRONTIER. [After Kennedy's strong liking for the musical and the title song, 'Camelot'.]

cameo (the arts) In a movie or play, a small, but noteworthy part, played by a well-known person; often, it is only one scene. Also known as "cameo role".

camouflage (military) A collective name for a type of military clothing (e.g., shirts, pants, baseball caps) made from a fabric with a special pattern designed to hide military personnel in the outdoors. A green-brown colored **camouflage** was used during the VIETNAM WAR; a tan, white and brown camouflage was used during the GULF WAR. By association, the clothing and face make-up especially used by military soldiers on undercover-missions during combat. Also known as "FATIGUES".

camp (sports and leisure) A general name for a variety of different camps, namely, SUMMER CAMP, BIBLE CAMP. Also, it is a popular name for SPRING TRAINING.

Camp David (government) The official US presidential retreat where the current PRESIDENT relaxes or can hold meetings or host conferences. It is located in the STATE of Maryland some 70 miles (113 km) northwest of WASHINGTON D.C. [After DWIGHT EISENHOWER'S grandson, 'David'.]

campaign (politics) A series of planned efforts or activities (e.g., debates, TV SPOTS, radio speeches) aimed to influence people to support a political party candidate. The election campaign for PRESIDENT formally begins after the NATIONAL CONVENTIONS and runs until ELECTION DAY. *See* FEDERAL ELECTION CAMPAIGN ACT OF 1972, CANDIDATE IMAGE, PAC.

campaign manager (politics) The person who organizes and directs the CAMPAIGN of a candidate for public office. Traditionally, he or she receives a position in the ADMINISTRATION if the candidate wins the election.

campus (education) The land on which the SCHOOL[1], COLLEGE[3], or PROFESSIONAL SCHOOL buildings are located including academic buildings, libraries, research laboratories, DORMS, cafeterias, INTERCOLLEGIATE stadiums, recreation centers, INTRAMURAL playing fields and sometimes

GREEK LETTER ORGANIZATION houses or meeting halls. Most SCHOOL[5]-sponsored events take place "on-campus"; while other events take place on property not pertaining to campus, that is "off-campus". Many STATE UNIVERSITIES have more than one campus: a large "main campus" houses the COLLEGE[1] administration and main SCHOOL[6] and a smaller "branch campus" located in another city of the STATE offers only classes. *See* OHIO STATE UNIVERSITY.

candidate image (politics) The presentation of the candidate's personal aspects (e.g., physical appearance, clothing, body language), especially in television appearances and SPOTS which help attract or take away the support of voters during a CAMPAIGN.

Candlestick Park (sports and leisure) The former name for today's 3Com Park at Candlestick Point, a sports stadium in SAN FRANCISCO. It was built in 1960 as an uncovered stadium; however due to cold winds from San Francisco Bay, a roof covering was added in 1970. It seats 70,270 people and is the home field of the San Francisco 49ers NFL team and the San Francisco Giants team of the NATIONAL LEAGUE. *See* Appendix 3 Professional Teams.

candy striper (health) A person, usually a teenager, who volunteers to work in a hospital to gain experiences. [After the distinctive uniforms worn which have red and white 'candy' cane-like 'stripes' on them.] *Compare* INTERN[1].

Canton (sports and leisure) Since 1963, the site of the Professional Football HALL OF FAME. This city, located in the STATE of Ohio, was one of the first areas where organized FOOTBALL clubs played. By association, the beginning of professional football.

canvassing (politics) A method of encouraging the public's support in which CAMPAIGN workers and volunteers talk to voters in a CONSTITUENCY (e.g., by knocking on the door, by telephone) asking them to support a candidate or issue. *See* DOOR-TO-DOOR; *compare* POLLING.

cap and gown (customs and traditions) The traditional, ceremonial clothing that students wear at the formal COMMENCE-

MENT exercises from a SECONDARY SCHOOL, COLLEGE[3] or PROFESSIONAL SCHOOL. The head piece is a cap fitting close to the head with a flat board on top (known as the "mortarboard") from which a tassel hangs. The gown is a loose, flowing robe which is worn over regular clothing. Both cap and gown are usually in black, however the tassel is in the color of the particular SCHOOL[2] or COLLEGE[2] (e.g., that of LIBERAL ARTS is white). Students wear the cap tassels on the right-hand side of their cap and, once they have graduated, they move the tassel to the left to indicate that they are GRADUATES[1] (this action is done during the ceremony).

Cape Canaveral (science and technology) In Florida, the location of the KENNEDY SPACE CENTER, which is used for launching missiles and spacecraft and the SPACE SHUTTLES. *See* NASA.

Cape Cod (geography) A land peninsula of the STATE of Massachusetts surrounded by the Atlantic Ocean; it is a popular vacation, beach and summertime resort area. [After the large number of 'cod' fish that used to be caught here.] *See* MARTHA'S VINEYARD.

capital gains (economy) Any profit that a person or company makes by selling business-related ASSETS (e.g., land, buildings, equipment). A "capital gains tax" is the federal tax that one pays on these profits. Conversely, a "capital loss" is a loss on the sale of these goods.

capital punishment (legal system) A punishment of death given to a person who has been found, usually by a JURY, to be guilty of a serious crime listed in the CRIMINAL LAW. The most common methods used for killing prisoners include: lethal injection, electrocution by the electric chair and lethal gas. Currently 39 STATES legally permit capital punishment; however, only 26 states have used these methods since 1977. Also known as the "death penalty"; *see* DEATH ROW.

capitalism (economy) The economic system in the US which is based on the theory that individuals work and achieve to earn a profit and that profit gives people reason to work and achieve. In the American **capitalistic** society, most property and businesses are privately

owned, profits from companies go to the owners, individuals and businesses are free to compete with each other and the government does very little to regulate the economy, except for managing some fiscal and monetary policies. *See* FEDERAL RESERVE SYSTEM, ANTITRUST LAWS; *compare* NEW DEAL.

Capitol (Building), the (government) The building of CONGRESS where the SENATE, HOUSE OF REPRESENTATIVES and CONGRESSIONAL COMMITTEES hold their SESSIONS[1,2], debates and voting. It was designed in the classical style in 1793 and the large dome (made of cast iron) was added during the CIVIL WAR. It is the central part of CAPITOL HILL[2]. By association, it functions as the symbol of CONGRESS, American government, democracy and WASHINGTON D.C. .

Capitol Hill (1, 2, 3 government) **1** In WASHINGTON D.C., the raised plateau of land on which the CAPITOL BUILDING sits, as well as the US SUPREME COURT and the main building of the LIBRARY OF CONGRESS. **2** By association, a nickname for CONGRESS. **3** A nickname for the federal government. Popularly known as "the HILL"; *see* MALL.

Capone, Al (people) (1899–1947, born in Italy) The influential, powerful gangster in CHICAGO who became wealthy from the illegal sale and distribution of alcohol during PROHIBITION. He ordered the ST. VALENTINE'S DAY MASSACRE in 1929 to kill members of the rival "Bugs" Moran gang. He was imprisoned by the US government (1931–1939) at ALCATRAZ because he had not paid his federal income taxes. His nickname was "Scarface Al".

Capra, Frank (people) (1897–1991, born in Italy) The American movie director and producer known for making moralistic movies containing the theme of innocence winning over evil, especially in the films: *It Happened One Night* (1934), for which he won an OSCAR, and *It's a Wonderful Life* (1946).

card-carrying (1 work; 2 politics) **1** Describing a person who is a loyal member of a trade UNION[1]. [From the habit of this person carrying, and being prepared to display, his or her union membership card.] **2** Describing a person who enthu-

siastically supports some political party, idea or belief.

cardinal (1 religion; 2 environment) **1** In the ROMAN CATHOLIC CHURCH, a high-ranking, male member of the clergy. Traditionally, he wears long, red robes. The US (including PUERTO RICO) has a total of nine native-born CARDINALS to oversee issues and represent the Pope in America. *See* PAROCHIAL SCHOOL, PRO-LIFE, CATHOLIC WORKER MOVEMENT. **2** A wild bird with a bubbling song native to North America and usually living in woods, city parks and natural areas. The male has distinctive red-colored feathers.

Carmichael, Stokely (people) (born in Trinidad and Tobago in 1943) Black CIVIL RIGHTS MOVEMENT student leader, author and political activist. As a student member of SNCC, at first he promoted the ideas of NONVIOLENT ACTION in order to win rights for AFRICAN AMERICANS. However, he is best remembered for enthusiastically promoting the idea of BLACK POWER and violence to achieve black equality; both as SNCC director (1966–1967) and as the Prime Minister of the BLACK PANTHERS (1967–1969). He wrote about these ideas in the book *Black Power: the Politics of Liberation in America* (1967). After resigning from the Black Panthers in 1969, he moved to Guinea in Africa, changed his name to "Kwame Toure", married the South African singer Miriam Makeba (born in 1932) and organized the All Afrikan People's Revolutionary Party. *See* BLACK ARTS MOVEMENT.

Carnegie Hall (the arts) The prestigious theater for live music and singing performances known for its superior acoustics. It was built for and served as the home stage of the New York Philharmonic Orchestra until that group moved to LINCOLN CENTER. In 1959, it was threatened to be torn down, but through the efforts of many musicians it was spared and remains an important performance space. To "play (at) Carnegie Hall" is a sign that a musician has reached a certain high level of success and recognition in a particular field of music. [After ANDREW 'CARNEGIE' (1835–1919), the benefactor.]

Carnegie, Andrew (people) (1835–1919) An ENTREPRENEUR and philanthropist who earned large sums of money in the steel industry and through wise investments in the STOCK MARKET. After he sold his steel company in 1901 for $250 million, he donated millions of dollars to artistic and educational causes, namely, building CARNEGIE HALL in NEW YORK CITY, a hall for the performing arts. *See* ROBBER BARONS.

carol (customs and traditions) A song sung during the HOLIDAY SEASON in expectation of CHRISTMAS DAY. Originally, these songs only treated religious themes. Now there are many secular carols, for example "Jingle Bells". Also known as "Christmas carol"; *see* CAROLING, SECULARISM.

caroling (customs and traditions) A CHRISTMASTIME practice in which a group of people walk through a neighborhood and stop at individual houses to sing songs (without instruments) for those neighbors. Often afterward, the singers, **carolers**, are offered warm drinks (e.g., hot chocolate, EGG NOG) and/or TIPS by the listening neighbors. [After 'CAROL'.]

carpetbagger (history) During RECONSTRUCTION, any REPUBLICAN from the NORTH who migrated to the SOUTH to establish businesses and to help southern blacks improve their positions in the "New South". Usually, they were UNION[3] soldiers, teachers, businessmen and FREEDMEN'S BUREAU agents. Although they often worked with SCALAWAGS and blacks, they were not accepted by the majority of the DEMOCRATS in the South. [After the type of 'carpet'-covered luggage they carried.]

Carson, Rachel (people) (1907–1964) A writer, biologist and researcher whose works helped the ENVIRONMENTAL MOVEMENT. She is best known for her book *SILENT SPRING* (1964) in which she revealed the heavy use of pesticides, especially DDT (dichloro-diphenyl-trichloroethane) by farmers and the harmful effects of these pesticides on the water supplies and in turn on birds, animals and fish. She also wrote *The Sea Around Us* (1951), a BESTSELLER.

Carter, Jimmy (people) (born James Earl Carter in 1924) US PRESIDENT (1977–1981) DEMOCRAT from Georgia. As CHIEF EXECUTIVE, he was committed to CIVIL RIGHTS, the ENVIRONMENTAL MOVEMENT and was influential in developing a peace treaty between the countries of Israel and Egypt; although, he was weak in other aspects of foreign policy, namely not being able to gain the release of Americans held hostage in Iran (1979–1980). Since his presidency, he has been active working for HABITAT FOR HUMANITY, mediating international disputes, monitoring democratic elections in foreign countries and writing poetry. *See* MARIEL BOATLIFT, Appendix 2 Presidents.

case law (legal system) The body of laws consisting of all written DECISIONS made in legal court cases. Because these decisions of 'cases' help other judges make future decisions about similar lawsuits, they create a system of laws. It was used most often before the late nineteenth century. It is one element of COMMON LAW. *See* PRECEDENT; *compare* STATUTORY LAW.

"Casey at the Bat" (sports and leisure) A moralistic, rhyming poem about the overly-proud BASEBALL player, 'Casey', who refuses to swing his bat the first two times that the ball is pitched to him; then on the third and last throw, he misses and STRIKES OUT; which makes his team lose the game and disappoints all the fans in his HOME TEAM's town of Mudville. The last line of the poem is: "There is no joy in Mudville, mighty Casey has struck out." Its moral is "don't be too proud, or you will disappoint yourself and others". It was written by Ernest Lawrence Thayer in the nineteenth century. *See* "THREE STRIKES, YOU'RE OUT".

Castro, the (geography) A residential and commercial district of shops and restaurants in SAN FRANCISCO. Most of the residents belong to the gay and lesbian community who, since the 1970s, have worked to promote CIVIL RIGHTS and GAY RIGHTS for gay people. It is considered the center of the homosexual and lesbian neighborhood in that city and of the WEST.

catalog shopping (daily life) A method of shopping for merchandise by using a book of items for sale containing pictures, a written description of the item and a price and ordering those items by telephone or through the mail with a CREDIT CARD or computer transfer of money. "Online shopping" is when the catalog is found via a computer network and orders are placed through that network. All goods are delivered by mail or delivery service. Both methods facilitate shopping because people do not have to leave their homes to purchase goods. See L.L. BEAN CATALOG.

catch-22 (language) Describing a two-part, senseless situation. By association, it means a difficult dilemma. [From the book by Joseph Heller (born in 1923), *Catch-22* (1961) which tells of a US bomber pilot in WORLD WAR II who wants to be discharged from his duties and leave the war, and thus pretends to be insane. However, the AIR FORCE 'catch-22' rules state that all bomber pilots must be insane to perform their work; and if they ask to be removed from their work, they are not insane. By this "logic", the bomber pilot cannot be insane and therefore he is not discharged from the military.]

catcher (sports and leisure) In BASEBALL, the defensive player who squats behind HOME PLATE and is responsible for catching all the balls that the hitter does not hit. This player wears special equipment (e.g., metal face mask, padded chest protector, plastic shinguards) as protection from balls.

Catholic Worker Movement (religion) (CWM) A radical LAY group of Roman Catholics and other Christians that currently works to improve society by feeding and housing the poor, especially in urban areas and exposing the causes of poverty. Its members take vows of poverty and pacifism and practice NONVIOLENT ACTIONS to promote these causes. It was founded in 1933 by Dorothy Day (1897–1980) and Peter Maurin (1877–1949) to support workers; it helped thousands of needy people during the GREAT DEPRESSION. Although in the past it supported communist ideas, today, it does not support Communism, CAPITALISM nor any

other political idea. See ROMAN CATHOLIC CHURCH, SOCIAL ACTION.

caucus (politics) A meeting for members which is closed to all non-members. [From Algonquin, meaning "elder" or "counselor".] See PRESIDENTIAL CAUCUS, IOWA CAUCUS, CONGRESSIONAL CAUCUS.

CBS (media) One of the largest COMMERCIAL networks (founded in 1927) broadcasting news and entertainment programs on television and the radio. It is one of the major NETWORK TELEVISION companies. [Abbreviation of former name 'C'olumbia 'B'roadcasting 'S'ystem.] See BIG THREE.

CD (economy) A safe way to invest money and earn interest on that money. It is a type of IOU, issued by a commercial bank. A person buys the CD and after a fixed period of waiting (lasting from weeks to years), the investor receives the value of the CD back, plus the interest it earned. [Abbreviation of 'C'ertificate of 'D'eposit.]

census (immigration) An official count of residents in each STATE of the US. It also records economic and social information (e.g., job, native language, ethnic status, MINORITY group). It has been taken every ten years since 1790 by the Bureau of the Census, which is a division of the DEPARTMENT OF COMMERCE. This information helps STATE legislators determine REAPPORTIONMENT and a variety of other organizations track trends in the American population including: work, migration and immigration.

Center for Disease Control and Prevention (health) (CDCP) A federal agency concerned with protecting the health of the general public by providing information to the public about preventing or controlling health conditions such as AIDS (Acquired Immune Deficiency Syndrome), Lyme's Disease, immunization and other infectious diseases. It was created in 1973 and is located in ATLANTA, Georgia.

Central Intelligence Agency (government) (CIA) The federal agency that works both in the US and overseas collecting and organizing information concerning US national security (e.g., spying, drug trafficking). Based on this information, it advises the PRESIDENT and NATIONAL SECURITY COUNCIL. The "Director of Central

Intelligence" is appointed by the President and is a member of the CABINET. Its headquarters are located in WASHINGTON D.C. It is popularly known as the "CIA". *Compare* FEDERAL BUREAU OF INVESTIGATION.

Central (Standard Time) (daily life) (CST) The clock time of those geographical areas located west of the GREAT LAKES and APPALACHIAN MOUNTAINS but east of the ROCKY MOUNTAINS (it includes St. Louis and CHICAGO). It corresponds to the Central time zone. It is one hour later than EASTERN STANDARD TIME.

Central Park (geography) In NEW YORK CITY, the large, green grassy public park located near the center of MANHATTAN[1], west of FIFTH AVENUE. It consists of 840 acres (340 hectares) and contains a zoo, a lake, several small ponds, as well as paths for walking and running. Further, in the winter the Wollman Rink is used for ice skating. It was designed by FREDERICK LAW OLMSTEAD and Calvert Vaux and officially opened in 1876. Today, it is a much beloved open space in the city and a popular place for daytime walks, picnics, INTRAMURAL sports and both small and large amateur and professional musical concerts. Although, at night it can be more dangerous because of thefts.

Century of Dishonor, A (minorities) The book (published in 1881) which severely criticized the UNITED STATES government's policies and treatment of INDIANS in the nineteenth century. This book, written by Helen Hunt Jackson (1830–1885), a white female novelist, informed the public of the wrongs inflicted on Indians, produced public concern for Indian issues and helped to encourage some members of CONGRESS to re-examine federal policies concerning Indian affairs.

CEO (work) The title of the head working and/or managing leader of a company. [Abbreviation for 'C'hief 'E'xecutive 'O'fficer.]

Certified Public Accountant (economy) (CPA) An accountant who is licensed by a STATE to prepare corporate taxes, personal TAX RETURNS as well as doing other accounting work. A CPA must pass certain exams and acquire experience before receiving license from the state.

certiorari, writ of (legal system) An order from a higher court asking that a LOWER COURT send it the full written record of a case because the higher court wants to review and maybe hear that case on APPEAL. For example, the US SUPREME COURT can send the California STATE Supreme Court a writ of certiorari in order to prepare for the higher court's case. If the writ of certiorari is refused (i.e., "Cert. denied") then the US Supreme Court no longer wants the record because it respects the decision reached by the lower court.

chain (economy) A general term for a number of stores or restaurants, all of which carry the same name and products and/or services, and which are owned by one company. *Compare* FRANCHISE.

Challenger disaster, the (science and technology) The fiery explosion of the US SPACE SHUTTLE *USS Challenger* on January 28, 1986, only 74 seconds after its take-off at CAPE CANAVERAL. All seven crew members died in the explosion, including a non-astronaut, the SCHOOL[1] teacher, Christa McAuliffe. Because the entire take-off, brief ascent and fall were broadcast live on television, the entire nation including SCHOOL[1] students watched the unexpected explosion with shock and great sadness. The causes for the explosion were a busy schedule which caused NASA to overlook its regular safety checks. It is recognized as the worst accident in the US space program.

chamber of commerce (economy) A group of local business people and political leaders, organized to promote their local economy, usually through developing new businesses and tourism in a particular STATE or community.

chambers (legal system) In general, the official working office of a judge, his or her LAW CLERK, PARALEGAL, and other staff members. Specifically, a judge's office and work space. Usually, they are located in the same building as the courtrooms or near the courtrooms. *See* SUPREME COURT BUILDING.

chamois shirt (clothing) A long-sleeved, collared shirt with buttons up

the front made of a very soft, warm cotton material. Sometimes spelled "shammy" or "chammy".

Channel 1 (education) A FOR-PROFIT news program about national and international news especially designed for HIGH SCHOOL students and classroom use. It was developed in 1990 by Whittle Communications and has raised SECONDARY SCHOOL student awareness about world events; it now has over 8 million student viewers. However, it is controversial because the broadcasts contain COMMERCIALS.

chaps (clothing) The one-sided leather leggings worn over JEANS, protecting the front side of the leg; they fit snugly around the thigh and flare out below the knee. They are worn by working COWBOYS[1] to protect their legs from the animals with which they are working.

Chapter 11 (bankruptcy) (economy) A method in which a debtor or bankrupt party (e.g., an individual, CORPORATION) receives help from a court of law to pay personal or company debts. "Filing Chapter 11" freezes the debtor's amount of debts and prohibits creditors from asking for payment while still allowing the debtor to continue doing its normal, daily business. A panel of court-appointed individuals then develops and oversees a repayment plan for the debtor of the "frozen" debts until all the debts are paid off. Also written "Chapter XI".

charge card (economy) A small, rectangular card which a company or store issues to a customer to allow that customer to purchase that company's products (e.g., clothing, gasoline) immediately and to pay for them later; usually the BILL[3] is sent to the customer's private residence once a month and is then paid by PERSONAL CHECK or a computer transfer. The card shows the person's name and an account number. Often, it is used as a type of ID CARD. *Compare* CREDIT CARD.

charts, the (the arts) The collective name for the list of the most popular songs (i.e., 40 songs, 100 songs) which is based on the record or album sales during a given week. It is the most accurate barometer of the popularity of songs. It is compiled and presented by *BILLBOARD* magazine. Currently, its major musical

categories of music include: for albums; ROCK, JAZZ MUSIC, black, COUNTRY MUSIC, classical music, Top POP MUSIC and others. Categories for individual songs include: country, Pop music, black music, ADULT CONTEMPORARY and others. Previous categories included COUNTRY AND WESTERN MUSIC (1950s–1970s), RHYTHM AND BLUES (1949–1969) and SOUL (1969–1970s). A **charted** song has been or is listed "on the charts". A recording artist who **has charted** has had a song on the charts. The "country charts" register the most popular COUNTRY MUSIC songs; the "pop charts" register the most popular POP MUSIC songs. Sometimes a hit song on the country charts can "cross over" and become popular on the pop charts. Sometimes, the term "the charts" can also refer to popular-selling books and videos.

Chautauqua movement (education) A movement to provide cultural and religious education and popular entertainment to adults, especially those living in rural areas. It did this by organizing live speakers and artistic and musical entertainment which then traveled throughout the MID-ATLANTIC region and the MIDWEST, especially to the small towns in these areas. It was started in 1874 and organized by the METHODIST CHURCH; it was strongest just before WORLD WAR I. It ended in 1932 after being replaced by the radio. [After the movement's headquarters located at Lake 'Chautauqua' in UPSTATE New York.]

Chávez, César Estrada (people) (1927–1993) Mexican-American migrant worker and organized labor leader. He founded the UNITED FARM WORKERS (originally known as the "NATIONAL FARM WORKERS' ASSOCIATION") in 1962 which organized poor, migrant workers into a powerful force which could then bargain with management. He promoted the idea of LA CAUSA, NONVIOLENT ACTION and organized workers' STRIKES[1] and marches. His work encouraged the CHICANO MOVEMENT.

check (economy) An official piece of paper issued by a bank to a person or a company, which is then used to make personal or company payments. It is a very common method for individuals and

companies to make payments and pay bills. A check is drawn from a "checking account". *See* PERSONAL CHECK.

checkout counter (work) The counter in a store where customers pay for purchases and the SALES TAX is figured.

checks and balances (government) A major principle of American democracy which limits governmental power and prevents its abuse by not focusing too much power in any one person or group of persons; because different branches of government are assigned different responsibilities and tasks to do. The CONSTITUTION divides the government into three branches (i.e., legislature, executive, judiciary) and gives each branch its own responsibilities as well as some methods to restrain the power of another branch when that branch grows too powerful. [From a stop, or 'check', of power which equalizes, or 'balances', the power.] *See* CONGRESS, PRESIDENT, US SUPREME COURT, ADVICE AND CONSENT, JUDICIAL REVIEW.

cheerleader (sports and leisure) A person, usually a woman, who performs routine steps and acrobatic movements while leading the audience in organized chants, cheers and songs at athletic events especially FOOTBALL, soccer, BASKETBALL and BASEBALL. A group, or "squad", of six women usually performs on the sidelines during the game and on the field or court during halftimes. Cheerleading is an EXTRACURRICULAR ACTIVITY at many SCHOOLS[1] and COLLEGES[1]; it is also performed at professional sporting events. At the college level, male students are also members of the squad. *See* POM POM, LETTER; *compare* DRILL TEAM.

cheesecake (food and drink) A popular dessert PIE consisting of a rich filling of CREAM CHEESE in a crumbly crust made of crumbled sugar COOKIES or GRAHAM CRACKERS and often garnished with fresh fruit (e.g., strawberries, blueberries or sweetened cranberries).

chemo(therapy) (health and technology) The medical therapy for patients suffering from cancer in which special toxic chemicals are used to kill the cancer cells in the human body. These chemicals are so strong that they cause a patient exposed to them to lose his or her body, facial and head hair.

Cherokee Nation (of Oklahoma), the (people) A Native American TRIBE known for being removed from their original homeland (in the southern part of the APPALACHIAN MOUNTAINS) to the MIDWEST by the TRAIL OF TEARS. It is one of the FIVE CIVILIZED TRIBES; and was the first Indian tribe to develop a system of writing, and to develop a constitution (1827, rewritten in 1975) to promote self-governance, to practice large-scale farming and to hold slaves. Today, the tribe controls 61,000 acres of tribal land located in the STATE of Oklahoma; its capital city is Tahlequah. It is involved in the GAMING and bingo industry and is one of the wealthiest tribes in the US. This Oklahoma part of the tribe counts over 122,000 members. Also known as the "Western Band (of the Cherokee Nation)". *See CHEROKEE NATION v. GEORGIA, WORCHESTER v. GEORGIA.*

Cherokee Nation v. Georgia (minorities) An important SUPREME COURT DECISION (of 1831) that stated that the CHEROKEE NATION was a "domestic, dependent nation". (Until 1831, all TRIBES had been considered foreign, independent nations within North America). The decision further stated that the governing laws for tribes were to be made by the tribes, however, the US government and its laws could protect non-Indians living in INDIAN COUNTRY. Further, TREATIES between the US and tribes still could be made. The case concerned the STATE of Georgia which wanted to dissolve the tribe of Cherokees then living in Georgia. This decision protected tribes from being controlled by states and local governments. However, it did not prevent the INDIAN REMOVAL ACT nor the TRAIL OF TEARS. *See* INDIAN CITIZENSHIP ACT.

Chicago (geography) The largest city in the MIDWEST (population 2.7 million), which is characterized by its tall SKYSCRAPERS and location on the west end of Lake Michigan. It was founded in 1779 as a fur trading post and since the nineteenth century has been an important center for processing and shipping agricultural products and beef production throughout the

country. It has a reputation for very modern, tall skyscrapers, notably the SEARS TOWER; and for having the CHICAGO BOARD OF TRADE. Further, it has a large Mexican-American population. [From Algonquin, meaning "strong smell of swamp plants".] Popularly known as the "WINDY CITY"; *see* LOOP, EL, GREAT LAKES; MRS. O'LEARY'S COW, MICHIGAN AVENUE, MAGNIFICENT MILE, UNIVERSITY OF CHICAGO, CABRINI-GREEN, SOUTH SIDE, *CHICAGO TRIBUNE,* Appendix 3 Professional Teams.

Chicago Board of Trade (economy) (CBT) The largest exchange in futures COMMODITIES in the US. The majority of trading in futures of grain, gold and silver is conducted here. It is regulated by the Commodity Futures Trading Commission. It is located in a large building decorated in the Art Deco style within the LOOP of CHICAGO. Also known as the "Board of Trade"; *compare* NEW YORK STOCK EXCHANGE.

Chicago Eight (history) A group of eight young men brought to trial for their involvement in causing the CHICAGO RIOT during the NATIONAL CONVENTION of the DEMOCRATIC PARTY (August 26 to 29, 1968). These men were members of either an ANTI-WAR MOVEMENT organization, the YIPPIE party and/or the BLACK PANTHERS. The trial was held in CHICAGO in the US DISTRICT COURT and began in September 1969; however, the judge had difficulty establishing order in the courtroom and the DEFENDANTS acted purposefully disrespectful and impertinent. Then Bobby Seale (born in 1937) of the BLACK PANTHERS asked to defend himself in the case (his ATTORNEY was unable to); when that was denied him he was gagged and bound (a very unusual procedure) for being too loud in the courtroom; and then ejected from the case. The trial of the **Chicago Seven** then continued with the judge finding the men guilty of trying to incite the riot. However, in February 1971 most of the men received ACQUITTALS; the charges against Seale were later also dropped. This trial represented the active position young people were taking during the anti-war movement against the government, the circus-like quality of the trial and demonstrated the inability of the legal system to adequately contain, reprimand and control them.

Chicago Riot (history) During the NATIONAL CONVENTION of the DEMOCRATIC PARTY (August 26 to 29, 1968), a riot occurred outside of the CONVENTION[1] when protesting young political radicals, white middle-class LIBERALS and some blacks, who wanted to enter the building, were attacked by the police. The Walker Report, which studied the violence of this event, blamed the police for initiating it, calling it a "police riot". *See* ANTI-WAR MOVEMENT, CHICAGO EIGHT.

"Chicago Style" jazz (the arts) A method of jazz performance, where within a song, a small group of jazz musicians rotates between performing together as an ENSEMBLE, and then as individual soloists. It was popularized in the jazz clubs of CHICAGO but does not work with BIG BAND MUSIC.

Chicago Tribune, The (media) The daily newspaper published for the metropolitan area of CHICAGO since 1847. Traditionally, it has CONSERVATIVE opinions on national news; further, it is recognized for its articles on foreign and local issues. It has a popular SUNDAY EDITION and a current circulation of 680,000. It is popularly known as the "*Trib*".

Chicano/Chicana (minorities) In general, a man/woman of Mexican descent. Specifically, a man (chicano) or woman (chicana) of Mexican descent who supported the CHICANO MOVEMENT. [Originally from Nahuatl, an Indian language of Mexico, *mechicano*, meaning a person from this region.] It has had various referents in the past; "Chicano" referred to a lower-class Mexican immigrant worker (*c.* 1920s); a slang term for a "Mexican person" (1940s–1950s); a person of Mexican-American heritage since the mid-1960s. *Compare* HISPANIC, LATINO.

Chicano Movement (minorities) A social and cultural movement by people of Mexican-American heritage to promote the CIVIL RIGHTS, Spanish language and status of CHICANOS in the UNITED STATES. It worked to glorify and praise the traditional Chicano culture of farmers and laborers as well as improve the sociocultural position of this group of people

in American society. It began with the labor UNION[1] successes achieved by CÉSAR CHÁVEZ and the NATIONAL FARM WORKERS' ASSOCIATION which resulted in awarding better economic and working conditions to Mexican-American farm workers. It then spread to the CAMPUSES of UNIVERSITIES in California and the SOUTHWEST, developing into a type of cultural movement which was centered in that geographical region and being most active in the 1960s and 1970s. This cultural element of the movement promoted the unique history, themes and language(s)-use of Mexican Americans in various literary works, poetry and theater pieces, many of which were written about, but not for, the poor. Its theater was the TEATRO CAMPESINO and the central character in many of these works was the poor peasant farmer or worker. The movement succeeded in increasing awareness of chicano culture and encouraged "Chicano Studies", a type of CULTURAL STUDIES about this group of people. *See* BROWN BERETS.

chichi (clothing) Describing clothing, a manner or a person that is excessively fashionable and overly elegant.

chicken (sports and leisure) A kind of contest that puts all players in danger unless one person or party chooses to stop (and therefore lose). By association, a coward.

chicken wings (food and drink) A popular FINGER FOOD of chicken wing meat dipped in breading, fried in oil then served with a sauce for dipping. "Buffalo (chicken) wings" are chicken wings served with sticks of celery and a blue-cheese sauce. [After the city of 'Buffalo', New York, where they were first served in the 1960s.]

chief executive (government) The title (i.e., Chief Executive) and role of the head of the executive branch of government. Duties include appointing people to fill positions in the CABINET and in federal courts and initiating legislation and BILLS[2]. The US PRESIDENT and STATE governors are all chief executives. *Compare* CHIEF OF STATE.

Chief Justice (legal system) The title of the head judge of the UNITED STATES SUPREME COURT who oversees the work of the court and the ASSOCIATE JUSTICES. He or she is appointed by the PRESIDENT and serves a TERM[1] for life or until retirement. *See* APPOINTMENT POWER, JOHN MARSHALL.

Chief of Staff (government) The top aide to the PRESIDENT and manager of the WHITE HOUSE OFFICE responsible for keeping contact with the CABINET, CONGRESS, the press, and the American people. He or she can have a large influence over the CHIEF EXECUTIVE. The President chooses the person to fill this role without the ADVICE AND CONSENT of the SENATE. *Compare* JOINT CHIEFS OF STAFF.

Chief of State (government) The PRESIDENT'S title and role as the ceremonial leader of the government of the UNITED STATES OF AMERICA. Role duties include entertaining official guests and foreign presidents and ministers in the UNITED STATES at the WHITE HOUSE and when overseas, representing the American people. In addition, he or she throws out the FIRST PITCH, lights the National CHRISTMAS TREE, and presents the NATIONAL MEDAL OF THE ARTS and the PRESIDENTIAL MEDAL OF HONOR. The governors hold similar roles and perform similar duties in their own STATES. *Compare* CHIEF EXECUTIVE.

child support (health) A monthly sum of money given by a birth parent to the other parent on behalf of his or her child to help pay the expenses of raising that child (e.g., education, food, clothing). Usually, it is provided by the parent with whom the child does not live full time. Establishing the amount of this sum and ensuring its payment is an important element when two parents decide not to live together (e.g., in case of divorce or legal separation of a couple). *See* JUVENILE COURT.

Child, Julia (people) (born in 1912) Chef. She has made a career out of cooking and making the preparation of meals seem easy and enjoyable, namely through several cookbooks, television programs and numerous television guest appearances.

Children's Defense Fund, the (health) (CDF) An active, private organization, established in 1973, concerned with the health, safety, education and opportunities

for children and teenagers. As an INTEREST GROUP, it compiles information about the condition of young people in America and lobbies the government to pass legislation to help them. *See* LOBBY.

chili con carne (food and drink) A spicy TEX-MEX[1] dish of ground beef, kidney beans, chopped onions in a tomato sauce garnished with chopped hot chilies or chili powder. [Spanish for "chili (peppers) with meat".]

Chinatown (geography) An area of a city owned and controlled by the Chinese community and where many Chinese immigrants and Chinese Americans live, work, shop and socialize. Usually, most or all the communication is in the Chinese language. The first Chinatown was established in SAN FRANCISCO in 1847. Others exist in LOS ANGELES, NEW YORK CITY, CHICAGO and other cities. Usually, it is the site of the various festivities of the Chinese New Year celebration held annually in January or February.

Chinese Consolidated Benevolent Association (minorities) The independent federation of organizations founded and operated by Chinese Americans to help and provide services to its members and other new immigrants from China. These services include: finding work and housing, as well as providing LEGAL COUNSEL, group insurance plans and burial services. The first group was founded in SAN FRANCISCO in the 1850s. It has served as a powerful force in the Chinese community in various cities (e.g., it was established in NEW YORK CITY in 1890) and serves as a spokesperson organization for people of Chinese descent in America. In many cities, it sponsors annual festivities to celebrate the Chinese New Year. In Chinese, its official name is *Chung Wah Kung Saw*. The popular nickname is the "CHINESE SIX COMPANIES".

Chinese Exclusion Act (immigration) The Congressional law (passed in 1882) that stopped the immigration of Chinese people to the US (from 1882 to 1902) and denied US citizenship to Chinese immigrants then living in the UNITED STATES. It was the first major law that limited immigration based on a person's country of birth and is a symbol of racism. *See* NATIVISM.

Chinese Six Companies (minorities) The popular name for the CHINESE CONSOLIDATED BENEVOLENT ASSOCIATION.

chinos (clothing) Trousers made of a heavy, twilled cotton fabric. Originally they were only available in a "khaki" color *see* KHAKIS[2]); now they are offered in other, various colors (e.g., blue, plaid). They are worn by men and women for leisure wear.

chips and salsa (food and drink) A popular FINGER FOOD consisting of thin, deep-fried corn wafers designed to be dipped into a spicy tomato, onion, jalapeño pepper and chili pepper sauce. [*salsa* is Spanish for "sauce".] Also known as "nacho chips"; *see* TEX-MEX[1].

chitterlings (food and drink) The small intestines of hogs cooked in a batter and eaten as a LUNCH or DINNER dish. Mostly, this dish is served in the SOUTH or as a type of SOUL FOOD. Colloquially known as "chitlins".

chocolate chip cookies (food and drink) A round baked COOKIE of semi-sweet chips of chocolate with butter, sugar, chopped nuts which is a popular snack food (especially for SCHOOL[1]-aged children) or a dessert for LUNCH.

Chomsky, Noam (people) (born in 1928) An intellectual, linguist and LIBERAL political thinker. He started his career in 1957 by developing linguistic theories of grammar and language learning in human languages (known as "Transformational Generative Grammar"). He has published many books criticizing the policies of the UNITED STATES government and its foreign and international business policies (especially in Latin America, the Developing World and the Middle East). He also believes the media has too much power over shaping people's opinions.

chores (work) The regular work (e.g., cleaning, mowing the lawn) that a person does at home. Children may receive an ALLOWANCE in exchange for doing chores. *Compare* NEWSPAPER ROUTE.

Christian Coalition (religion) A CONSERVATIVE, FUNDAMENTALIST organization and GRASSROOTS-level PAC which promotes the election of politicians and political

office holders who support conservative causes and FAMILY VALUES. It was founded in 1989 by PAT ROBERTSON and its headquarters are in Virginia. Currently, it is the largest CHRISTIAN RIGHT organization with over 1.5 million members.

Christian Right (religion) Another name for the RELIGIOUS RIGHT.

Christian Science (religion) A popular name for the CHURCH OF CHRIST, SCIENTIST. Likewise, members are popularly known as **Christian Scientists**.

Christian Science Monitor, The (media) The daily newspaper (Monday through Friday) focusing on reporting and analyzing, in depth, the news from WASHINGTON D.C., other US regions as well as foreign news. Its editorial viewpoint is independent and CONSERVATIVE. It also carries articles on art, literature and religion. [Established in BOSTON in 1908 by the CHRISTIAN SCIENCE CHURCH which wanted to focus on "positive news".]

Christie's (the arts) An auctioneer firm known for offering various quality items to bidders at its auctions, especially paintings, furniture, silver, musical instruments and other items. It originally was founded in London, England in 1766; it established its American division in NEW YORK CITY in 1977. [After Englishman James 'Christie' (1730–1803), the founder.] *Compare* SOTHEBY'S.

Christmas cards (customs and traditions) During the HOLIDAY SEASON, a GREETING CARD sent to wish one's friends and family a "Merry Christmas" and "Happy New Year". Most people personally address, prepare, sign and send more than several cards. Other people prefer to prepare a sort of typed newsletter in which they report their family's events of the year, photocopy it and mail it by US post or e-mail to others. These cards may be Christian religious or secular. When they are sent in celebration of HANUKKAH they are "Hanukkah cards" or for KWANZA, "Kwanza cards". *See* SECULARISM.

Christmas cookies (customs and traditions) Any type of colorful COOKIE cut in any of a variety of seasonal shapes (e.g., snowman, SANTA CLAUS, CHRISTMAS TREE) and decorated in ICING, chocolate flakes and other special sweets. They may be made in a variety of flavors, but sugar, chocolate and GINGERBREAD are the most traditional. Making them is a popular CHRISTMASTIME activity that a parent and children can do together. Frequently, they are served at TREE-TRIMMING PARTIES or used to decorate the tree itself.

Christmas Day (customs and traditions) December 25, the most important day of CHRISTMASTIME. It marks the second most important religious holiday for Christians (*compare* EASTER) who celebrate the birth of Jesus Christ on this day by attending religious services. Also, it is a festive, secular event when families of all religious backgrounds (i.e., Christian and non-Christian) gather in their respective homes in order to share a large meal, exchange gifts with each other and in general, think of other people. It is a favorite holiday among children who find and unwrap presents which SANTA CLAUS left for them under the CHRISTMAS TREE. It is a FEDERAL HOLIDAY; when it occurs on a Saturday or on a Sunday, the previous Friday or the following Monday is considered the LEGAL HOLIDAY. *See* CHRISTMAS TREE, SECULARISM.

Christmas Eve (customs and traditions) December 24, the last day of CHRISTMASTIME shopping, decorating, cooking and other preparations before CHRISTMAS DAY. Some Christian families attend "midnight mass", a religious service which begins close to midnight on this day and ends in the early hours of Christmas Day.

Christmas play (customs and traditions) In SCHOOLS[1], an annual event in which students, with the help and guidance of their teachers, stage and perform a play before an audience made up of their parents and fellow students. Usually, the play's subject matter concerns the HOLIDAY SEASON, Jesus Christ, or some other story about love and sharing decided upon by the SCHOOL[1] authorities. PAROCHIAL SCHOOLS often choose religious plays and themes; PUBLIC SCHOOLS do not. *See* SEPARATION OF CHURCH AND STATE.

Christmas stocking (customs and traditions) A long, decorated, fabric cloth sock designed to be hung from the mantel at CHRISTMASTIME to receive gifts from SANTA CLAUS.

Christmas tree (customs and traditions) An evergreen tree (real pine tree or artificial plastic) which is placed inside the home and decorated with strings of electric lights, ribbons, tinsel and other bright ornaments. SANTA CLAUS leaves presents under it for children and adults leave their gifts for each other under it, too. It is the central secular symbol of CHRISTMASTIME and most cities display one in public during this period; a tall one is set up in ROCKEFELLER CENTER in NEW YORK CITY. The "National Christmas tree" is set up across from the WHITE HOUSE and its lights are first turned on by the PRESIDENT. *See* TREE-TRIMMING PARTY, SECULARISM; *compare* CRECHE, MENORAH.

Christmastime (customs and traditions) The busy period of several weeks before CHRISTMAS DAY when people prepare for that holiday by shopping for gifts; decorating their homes inside and outside (with white and colored lights) and CHRISTMAS TREES; sending CHRISTMAS CARDS; making CHRISTMAS COOKIES, decorating GINGERBREAD cookies and other foods; going CAROLING; taking children to visit SANTA CLAUS; and attending SEMI-FORMAL[1] Christmas parties and OFFICE PARTIES. Employees usually receive a BONUS at this time. This is the most important money-making period of the year for stores and shops. Traditionally, it begins the DAY AFTER THANKSGIVING; however, every year it begins earlier (e.g., early November, late October), critics complain that this period, and CHRISTMAS DAY itself, are over-commercialized by businesses and stores. Its traditional decorative colors are green and red. Also known as the "Christmas Season"; *see* NUTCRACKER, SALVATION ARMY, CRECHE, MISTLETOE; *compare* KWANZA, HANUKKAH.

Christopher Street (geography) In GREENWICH VILLAGE, that street, its shops, clubs and surrounding residential buildings considered the center of the homosexual community in the "Village" and in NEW YORK CITY. The STONEWALL INN is located here.

Chronicle of Higher Education, The (media) A FOR-PROFIT weekly periodical that covers the developments, events, PROFESSORS, DEANS and administrators of COLLEGES[1] and UNIVERSITIES in the US. It was founded in 1966, is published in WASHINGTON D.C. and currently has a subscription of 94,000.

Chrysler Building, the (housing and architecture) The decorative SKYSCRAPER designed by William Van Alen, measuring 1,110 feet tall (338.3 m; counting the spire) to praise and promote the automobile; it is decorated with seven step-like arches resembling car wheels as well as by shiny chrome car parts and radiator caps. It is located in Midtown MANHATTAN[1] and was formally opened in 1930. It is a symbol of the Art Deco buildings and skyscrapers of NEW YORK CITY and it is widely recognized for its attractiveness. [It was designed as the headquarters of the 'Chrysler' car company.]

church (1, 2, 3 religion; 4 legal system) **1** Any single group or congregation of worshipping members of some Christian religious belief. *See* CONGREGATIONALISM[1]. **2** The building(s) where religious services are held for Christian religions. **3 the Church** A term for any organized, Christian religion (e.g., the ROMAN CATHOLIC CHURCH). **4** A general, legal term for any religious organization (e.g., in the expression "SEPARATION OF CHURCH AND STATE").

Church of Christ, Scientist (religion) A religious organization established in 1879 by Mary Baker Eddy (1821–1910) that is based on both the Bible and Baker's books *Science and Health* (1875) and *Key to the Scriptures* (1883) which provide methods for spiritual and physical healing. Its members, "Christian Scientists", believe that all sins and physical pains can be eliminated by healing the spirit and eating a healthy diet; that is, they do not take medication nor any help from medical doctors (e.g., surgery, CHEMOTHERAPY). They believe that Jesus Christ was the first Christian Scientist and that both men and women can be CHURCH[3] ministers. Its world headquarters and "Mother Church" are located in BOSTON. It publishes the *CHRISTIAN SCIENCE MONITOR.* Also known as "CHRISTIAN SCIENCE".

Church of Jesus Christ of Latter-day Saints (religion) A populous (currently 4,620,000 members) religious group established in 1830 by Joseph Smith, Jr.

(1805–1844) in UPSTATE New York. The religion in built upon three books. First, MORMONS believe that Smith found golden tablets containing information (e.g., that NATIVE AMERICANS are descended from Jews and that Jesus Christ also lived in North America) which he translated and presented in the English language as *The Book of Mormon* (1824). Second, Smith then wrote *The Book of Commandments* (1835) which presents members with methods of how to live. Mormons follow these two books and, in addition, they follow the Bible. In the nineteenth century, Mormon husbands were permitted to have more than one wife and were disliked by Christian groups because of this and other differences. From 1846 until 1847 and under the leadership of BRIGHAM YOUNG, Mormons migrated cross-country to SALT LAKE CITY, Utah where they established their community without persecution and world headquarters. Today, Mormons practice CONSERVATIVE morals, FAMILY VALUES (i.e., husbands have only one wife, parents do not practice artificial birth control), self-reliance, missionary work and healthy diets (e.g., they drink no coffee, no tea with caffeine, no alcohol). [From Smith's idea that members, the 'saints' of God, were living in the last (i.e., 'latter') days before the return of Jesus Christ to earth.] Also known as "the MORMONS"; *see* SECOND GREAT AWAKENING, MORMON TABERNACLE CHOIR, MORMON TRAIL, BRIGHAM YOUNG UNIVERSITY.

Cinco de Mayo (customs and traditions) May 5, the national holiday of Mexico which is celebrated with local parties and parades by many Mexican Americans living in the UNITED STATES. It commemorates the victory of the Mexican army (composed of indigenous-born soldiers) over the invading French army in Puebla, Mexico on May 5, 1862. It is not a LEGAL HOLIDAY in the US.

CIO (work) A federation of industrial labor UNIONS[1] especially for unskilled workers or workers in the manufacturing industries; especially the car-making industry. It was originally founded in 1937 by splitting from the AFL because of disagreements over representation and was led by John Lewis (1880–1969). In 1955, it permanently reunited with the AFL to form the AFL-CIO. [Abbreviation of 'C'ongress of 'I'ndustrial 'O'organizations.] *See* DETROIT.

Citizenship Day (immigration) September 17, since 1952, a day to recognize American citizenship and its duties (e.g., JURY DUTY, VOTER REGISTRATION). Often, many immigrants take their oath of American citizenship on this day. It is not a FEDERAL HOLIDAY.

City Beautiful movement (the arts) A collective, urban movement of engineers, architects and landscape architects which promoted removing old inner-city buildings and slums in order to create well-designed, attractive civic and private buildings and gardens. It believed that beautiful buildings could positively inspire people. It was part of the PROGRESSIVE ERA and active during the 1890s in cities of the EAST COAST.

"City on a Hill" (history) A key phrase in a sermon given in 1630 by JOHN WINTHROP, a PURITAN leader and founding governor of the MASSACHUSETTS BAY COLONY, in which he instructed his fellow colony members to conduct themselves properly and to create good institutions in the new colony because their new community was to be an example for other colonies and people to imitate. During the nineteenth and twentieth centuries and by association, it grew into a widespread, self-conscious American idea that Americans must be responsible role-models for other regions and countries by encouraging social reform, global democracy and American CAPITALISM. [From the original seventeenth-century sermon; "We shall be as a 'City upon a Hill', the eyes of all people. . . upon us".] *Compare* MANIFEST DESTINY.

civic/civil religion (religion) A collective, theoretical term used to refer to the non-religious, somewhat exaggerated, American citizens' patriotic belief in and support for the actions, ideals and policies of the modern nation and government of the UNITED STATES. It manifests itself in strong feelings of US patriotism by Americans, especially in times of war and national defense. Further, it greatly values

certain FEDERAL HOLIDAYS (e.g., LABOR DAY, VETERANS DAY) and certain American documents (e.g., the US CONSTITUTION, DECLARATION OF INDEPENDENCE). [After the idea developed by Frenchman Jean Jacques Rousseau (1712–1778) in his book *The Social Contract* (1762) about the rise of the modern nation-state and the collapse of theological religion.]

civil disobedience (legal system) A deliberate, peaceful violation of government laws which participants consider unjust or unmoral in order to show their disapproval of them and to try to achieve changes in those laws. It usually employs NONVIOLENT ACTION tactics; common techniques include not paying government taxes and not registering for the DRAFT[1]. It was used frequently during the CIVIL RIGHTS MOVEMENT (e.g., SIT-INS, marches, FREEDOM RIDES) and was popularized by CORE and MARTIN LUTHER KING, JR. [From HENRY DAVID THOREAU's essay entitled "Civil Disobedience" (1849) which first introduced and promoted this type of behavior.] *See* JAMES FARMER; *compare* DIRECT ACTION.

civil law (1, 2 legal system) **1** The group of laws which establish how civil problems (e.g., divorce, child custody, minor car accidents, wills, business contracts) and SETTLEMENTS will be solved legally. Usually there is no guilt, only LIABILITY and the need to pay money in DAMAGES. *See* CIVIL TRIAL; *compare* CRIMINAL LAW. **2** A system of laws treating civil aspects (e.g., marriage, property ownership) which is based on ancient Roman law and the French *Code Napoléon* (c. 1804). It lists laws and legal conditions which often are different from CIVIL LAW[1] in the other STATES. This system of CIVIL LAW[2] is used in the state of Louisiana and does not require a JURY. [From French *code civil*.] Also known as "civil code"; *compare* COMMON LAW.

civil liberties (legal system) Freedoms to which a person has a natural right (e.g., freedoms of religion, speech, press, having children, owning property) without any interference from the government or its laws. They protect individuals from arbitrary actions of the government.

See AMERICAN CIVIL LIBERTIES UNION; *compare* CIVIL RIGHTS.

civil rights (legal system) The privileges, protections and legal rights that all US citizens are entitled to by the CONSTITUTION and the BILL OF RIGHTS, especially those rights which guarantee full legal, social and economic equality to an individual (e.g., voting, EQUAL OPPORTUNITY, property possession). MINORITIES have not always enjoyed their civil rights in the US. *See* CIVIL RIGHTS MOVEMENT, CIVIL RIGHTS ACT, THIRTEENTH AMENDMENT; *compare* CIVIL LIBERTIES.

Civil Rights Act (minorities) The important piece of legislation (passed in 1964) that included 11 parts (known as "titles") that protected the CIVIL RIGHTS of blacks and other MINORITIES established by previous acts and granted many more. Most importantly, it prohibited DISCRIMINATION in the workplace, prohibited racial segregation in public buildings (e.g., hotels, restaurants) and public facilities (e.g., parks, swimming pools). In addition, it provided federal funds to help desegregate PUBLIC SCHOOLS, protected voting rights and encouraged the ATTORNEY GENERAL to file LAWSUITS against violators of any of these parts. Finally, it established the EQUAL EMPLOYMENT OPPORTUNITY COMMISSION to enforce these rights. The passage of this important law was a high point and great success of the CIVIL RIGHTS MOVEMENT; further, it encouraged the WOMEN'S MOVEMENT and the RED POWER Movement. *Compare* VOTING RIGHTS ACT, *BROWN* v. *BOARD OF EDUCATION OF TOPEKA, KANSAS*, AMERICANS WITH DISABILITIES ACT.

Civil Rights Movement (minorities) The legal and popular struggle of AFRICAN AMERICANS to achieve their legal CIVIL RIGHTS as well as integration and equality with whites in American society by abolishing DE JURE SEGREGATION and DISCRIMINATION (from 1954 through 1965). The legal struggle was based upon the THIRTEENTH AMENDMENT, FOURTEENTH AMENDMENT and FIFTEENTH AMENDMENT but truly began in 1954 with the NAACP victory in the legal case *BROWN* v. *BOARD OF EDUCATION OF TOPEKA, KANSAS* which outlawed segregated public facilities. The

popular struggle began in 1955 with Rosa Parks and the Montgomery bus boycott led by Martin Luther King, Jr. This popular struggle was led mostly by black-led organizations, namely, CORE, SNCC, SCLC all of which followed King's teachings of nonviolent action, specifically; sit-ins, Freedom Rides and voter registration drives. High points of the movement included the March on Washington of 1963 and the new federal laws, Civil Rights Act and Voting Rights Act of 1965. Its popular theme song and motto was "We Shall Overcome", which was often sung in groups by the protesters and marchers. The success of this movement encouraged the Women's Movement, Chicano Movement, Gay Rights Movement and the Red Power Movement. From 1966, the seemingly slow pace of this movement and its use of nonviolent action encouraged Black Power. See Feminist Movement; compare Black Nationalism, Malcolm X, Nation of Islam, Black Panthers.

civil service (government) A collective term for the employees of a government (e.g., federal, state, local) but who are not members of the military or armed forces. Usually, **civil servants** are not appointed to the position, but hired and promoted. See civil service reform; compare appointment power.

civil service reform (government) An employment idea and movement of hiring, promoting and firing people in the civil service according to workers' skills and experiences, not their personal or political influence. It has been a concern since 1881 when an angry former campaign worker assassinated the new President, James Garfield (1831–1881), after not receiving an appointment to a job in the new Administration[2]. See appointment power, Appendix 2 Presidents.

civil trial (legal system) A court case that settles disagreements concerning the civil law[1] between two different persons or groups. Each person or group hires an attorney to represent them and usually the judge (i.e., not a jury) makes the decision about a settlement. See liability, out-of-court settlement, damages.

Civil War, the (history) It began as a war between the United States and the Confederate States of America to preserve the Union[3] of the United States and resulted in ending legalized slavery. It lasted from 1861 to 1865 and was the bloodiest and most destructive war in America. Over 2.2 million men served in the Union army (the official troop numbers in the Confederate army are not known) and a total of some 800,000 men (including both armies) died. The war succeeded in destroying the social, economic and political systems that had been long-established in the South; further, it is recognized as an emotional war because it was fought on home lands and affected so much of the population: soldiers and civilians; whites and blacks; men, women and children. It is also known as the "War between the States". See Robert E. Lee, U.S. Grant, Fort Sumter, Bull Run, Manassas, Gettysburg, Gettysburg Address, William T. Sherman, March to the Sea, Appomattox Court House, Emancipation Proclamation, Reconstruction.

Civilian Conservation Corps (environment) (CCC) A federal program (active from 1933–1941) created by the first round of New Deal programs of President Franklin Roosevelt to help provide work to some 3 million unemployed men. The **CCC** operated under the authority of the US Army working to plant trees, build dams and prevent soil erosion, especially out West. Often, the men lived in camps while serving a contract of six months or one year. It was popularly known as the "tree army". One of its divisions was the Indian Emergency Works Program (known as the **CCC-ID**) in which Indian workers helped build dams and prevent soil erosion out West, especially on reservations. See conservation movement.

clam chowder (food and drink) A thick seafood soup made with clams, chopped celery and onions. "New England clam chowder" is white colored because it is made with a base of milk. "Manhattan[1]-style clam chowder" is red colored because it has a base of tomatoes.

clambake (customs and traditions) An outdoor, social gathering at a beach and at which various types of seafood (e.g., clams, lobsters), CORN ON THE COB and other vegetables are cooked either over a fire and covered with dry seaweed or in a large cooking pot and are eaten. *Compare* BARBECUE.

Clarence Thomas/Anita Hill Hearings (minorities) The emotional televised SENATE hearings over a political appointment which increased the public's awareness of SEXUAL HARASSMENT in the workplace. The Senate's Judiciary Committee held these hearings from October 12 to 14, 1991, as part of the confirmation hearings of the new presidential appointee to the SUPREME COURT, CLARENCE THOMAS, a REPUBLICAN African-American judge. Thomas's suitability for the presidential appointment was questioned by ANITA HILL (born in 1956), a female black law professor. Hill claimed that from 1981 to 1983 while she, as an employee, and Thomas, as director of the EQUAL EMPLOYMENT OPPORTUNITY COMMISSION, had worked together in that office, he had sexually harassed her and therefore would not be fit to serve as an ASSOCIATE JUSTICE. Despite the negative publicity, Thomas was eventually, appointed to the Supreme Court. These hearings are a symbol of the difficulty of proving sexual harassment; as well as the difficulties experienced by women who work in the workplace. *See* APPOINTMENT POWER.

class (education) A group of students or alumni that shares the same graduation year from a SCHOOL[5] (e.g., the JUNIOR class; or the class of 1999, in which case, only the last two digits are used, '99). This year is frequently noted on a student's LETTER JACKET and/or CLASS RING. *See* CLASS RANK, ALUMS.

class action (legal system) A type of LAWSUIT or other legal action that one or more persons start(s) (for themselves and others who have the same complaints) against some other person or group. For example, a person who bought a certain car model which had defects can bring a **class-action suit** on behalf of all the buyers of that car model against the car company that made the defective cars. If

successful, the car buyers divide up the total amount of the DAMAGES among themselves.

class rank (education) A number, ratio or percentage, based on the GPA, that shows a student's academic standing in the CLASS. This can be stated in a number (e.g., a student who has the highest GPA in a CLASS of 100 students would hold rank 1/100, or first; and the student with the lowest GPA would rank 100/100, or last) or in a percentage (e.g., a student ranking 10/100 is in the top 10% of the class). Class rank is one of several factors considered in COLLEGE[1] or UNIVERSITY admissions; others include, SAT or ACT scores, HIGH SCHOOL GRADES[2], EXTRACURRICULAR ACTIVITIES and personal essays. *See* ADMISSIONS DEPARTMENT.

class ring (education) A piece of jewelry decorated with the crest, motto and CLASS year of a HIGH SCHOOL or COLLEGE[3] which is worn by students and ALUMS of a SCHOOL[5]. Sometimes a male student gives this ring to his girlfriend who wears it on her finger or on a chain around her neck to show that they are DATING.

classified ad(vertisement)s (media) Advertisements which are listed under different headings or 'classes' (e.g., job positions that are open, products to buy or sell) and printed in a newspaper or magazine. Also known as the "classifieds"; *compare* PERSONALS.

Clayton Antitrust Act (economy) A major national ANTITRUST LAW (passed in 1914) designed to stop MONOPOLIES from developing and to encourage the free market economy. It amended the SHERMAN ANTITRUST ACT. In particular it: prohibited businesses from having prices that were too low (which drove competitors out of business); prohibited business leaders from serving on the BOARD OF DIRECTORS of two or more competing firms; and prohibited business leaders from purchasing too much stock in competitors' firms.

Clean Air Act (environment) A federal law (first passed in 1963) and its AMENDMENTS (of 1965, 1967, 1970, 1977, 1990) which have developed air quality standards in an effort to protect and improve

the public's health from the effects of smog and air pollution.

clerk (legal system) A shortened, alternative name for a LAW CLERK.

Clinton, Bill (people) (born William Jefferson Clinton in 1946) Governor of Arkansas (1979–1981, 1983–1993) and UNITED STATES PRESIDENT (elected 1992; re-elected in 1996). DEMOCRAT of MODERATE positions. During his presidency, he supported the NAFTA treaty, a raise in the MINIMUM WAGE, increased legal rights for women in the workplace and a limitation in federal funding of WELFARE by restructuring the welfare system. In 1994, his major plan to overhaul the current American health care system, in order to provide nationwide health care to all Americans, did not pass CONGRESS. He married HILLARY RODHAM CLINTON in 1975; his only child is his daughter, Chelsea Clinton (born in 1980). *See* TEMPORARY ASSISTANCE TO NEEDY FAMILIES.

Clinton, Hillary Rodham (people) (born in 1947) LAWYER and mother. She was an active lawyer with the Rose Law Firm in Little Rock, Arkansas (1977–1992). She served as First Lady after her husband was elected PRESIDENT (1992; re-elected 1996); during this period she promoted children's issues, breast cancer research and a failed effort to nationalize the American health care system. She married BILL CLINTON in 1975 with whom she has one daughter, Chelsea Clinton (born in 1980).

closed primary (politics) The most common type of PRIMARY ELECTION in a PRESIDENTIAL PRIMARY. Voters can cast a BALLOT[1] only in that primary of the POLITICAL PARTY with which they are registered. *See* VOTER REGISTRATION; *compare* OPEN PRIMARY.

closed shop (work) A labor practice in which a business only hires people who are already labor UNION[1] members. Although it increases labor membership, it does not give the worker the choice to choose membership. It was outlawed by the Labor-Management Relations Act of 1947. *Compare* UNION SHOP, YELLOW-DOG CONTRACT.

closing price (economy) On the STOCK MARKET, the last price of a stock or bond for the day. It is used for figuring the Dow JONES INDUSTRIAL AVERAGE and other market averages.

cloture (government) In the SENATE, a method of ending a FILIBUSTER in which a petition asking to limit the debate is written by 16 SENATORS and signed by 60 senators. [From French *clôture*, meaning "closing" or "end".]

CNN (media) A cable television and radio network founded in 1980 by TED TURNER, which provides 24 hours a day programs concerning news, business, weather and sports. It is noted for its reputation for covering news stories live. Also, it owns "Headline News" a 30-minute news program shown 24 hours a day. It has 71 million SUBSCRIBERS and is based in ATLANTA. [Abbreviation of 'C'able 'N'ews 'N'etwork.]

co-operative/co-op (1, 2 education; 3 food and drink) **1** A combined UNDERGRADUATE program of study and work in which the student studies full-time for one TERM[2] and then works full-time in the following TERM[2]. This gives the student practical experience in a particular field while studying that MAJOR. A BACHELOR'S DEGREE in a co-op program usually takes a student five years to complete successfully. *Compare* WORK-STUDY, PELL GRANT. **2** A store, operated by students, that sells books, sportswear, and SCHOOL[5] supplies to other students at a reduced cost. **3** A grocery store, owned and operated by a group, that sells groceries, packaged food, fresh fruits and vegetables at lower prices than those in CHAIN supermarkets. Usually, it carries HEALTH FOOD items. Also known as "food co-op".

co-operative federalism (government) A type of FEDERALISM in which the federal government is more involved (i.e., financially) in activities and programs of the STATE and local governments, especially by establishing and operating GRANT-IN-AID programs. It developed during the NEW DEAL and GREAT SOCIETY.

co-payment (health) The money a person pays to cover part of the costs of medical care. Specifically, the amount of money an insured person is obliged to pay a doctor or medical center for a health service if the price for that health service

does not exceed the amount agreed to in the insurance policy (and the insurance company pays the balance of the payment). However, if the price does exceed that amount, the health insurance company makes the full payment for the health service.

Coast Guard, the (military) A branch of the ARMED FORCES responsible for enforcing federal maritime laws as well as controlling federal immigration laws. During peacetime, it is overseen by the DEPARTMENT OF TRANSPORTATION but during wartime it becomes a part of the NAVY under the command of the DEPARTMENT OF DEFENSE. It was first established in 1790 as the "Revenue Marine".

coat and tie (clothing) A collective name for a man's suit jacket and a straight necktie. It is written on invitations to indicate the formality level of clothing for some social event. Men commonly wear them to a COCKTAIL PARTY.

cobbler (food and drink) A type of sweet, deep-dish PIE made with fruits (e.g., peach, cherry, apple) and covered in a top layer of baked pastry crust.

cocktail party (customs and traditions) A SEMI-FORMAL[1] or INFORMAL[1] gathering at which HORS D'OEUVRES or FINGER FOODS (i.e., not a whole meal) and 'cocktail' drinks (i.e., alcoholic drinks mixed with SODA POP or fruit juices), are served. It is often held before or after DINNER-time.

Cody, "Buffalo Bill" (people) (1846–1917, born William F. Cody) Western scout, businessman and entertainer. He owned, operated and starred in the "Wild West Show", a popular, circus-like live performance with a western theme, which included acts of COWBOYS[1], INDIANS, gun shooting and RODEO[2] skills. It successfully toured the EAST and Europe (from 1883 to 1913) and made the idea of the WEST popular.

coed (education) Before 1970, a term used to refer to a female UNDERGRADUATE student at a formerly all-male COLLEGE[1]. *Compare* COEDUCATIONAL.

coeducational (education) Describing a SCHOOL[5], CLASS, group or team that has both male and female members or players who are granted equal status (e.g., a coed

DORM, a coed softball team). It is popularly clipped to "coed".

coffee cake (food and drink) A sweet cake flavored with cinnamon, nutmeg, nuts and/or raisins then glazed with brown sugar and often served with 'coffee' for breakfast or as a snack.

Cold War, the (foreign policy) The period from the end of WORLD WAR II until 1989 which was characterized by tension between the US (and its allies) and the former Soviet Union (and its allies) because of the: build up of military weapons (especially nuclear weapons); differences of political and economic ideology (US styled democracy and CAPITALISM versus USSR Communism); and diplomatic conflict between the two countries. [After the fact that it was not a direct, militarily 'hot war'.] *See* CUBAN MISSILE CRISIS, CONTAINMENT, DOMINO THEORY, DÉTENTE.

Cole, Nat "King" (people) (1917–1965) Pianist and singer of JAZZ MUSIC. He is known for his very smooth, rich singing voice which was especially popular during the 1950s; hit songs included "Mona Lisa" and "I Love You (For Sentimental Reasons)".

collective bargaining (work) The active negotiating and discussions between UNION[1] members (who represent the workers of a particular company or organization) and the managers or owners of that company. It is most often used for developing a new workers' contract; especially concerning salaries, working conditions and health and medical benefits for the workers.

college (1, 2, 3 education) **1** A HIGHER EDUCATION academic institution that offers UNDERGRADUATE programs in the HUMANITIES or sciences and awards BACHELOR DEGREES after four or five years of successful study (e.g., DARTMOUTH COLLEGE). Further, it offers its students athletic programs within which they can perform and compete. *See* NCAA, Appendix 4 Educational Levels. **2** A specialized academic division within a UNIVERSITY that offers programs at the UNDERGRADUATE and GRADUATE[2] levels (e.g., the College of Computer Science); another name for a SCHOOL[2]. **3** A general term for "post-

SECONDARY SCHOOL study"; including that at a COMMUNITY COLLEGE or in an UNDER-GRADUATE program.

College Board, the (education) An independent, NONPROFIT national testing organization, founded in 1900, that helps stabilize SECONDARY SCHOOL curricula and COLLEGE[1] admissions nationwide. Three of its programs are: the SAT, the ACCELER-ATED COLLEGE ENROLLMENT PROGRAM and the ADVANCED PLACEMENT PROGRAM. It is formally known as the "College Entrance Examination Board".

college try (language) The best effort. It is usually used in the expression, "give it the old college try".

Collier, John (people) (1884–1968) A white administrator, member of the US government CIVIL SERVICE and the influential Commissioner of the BUREAU OF INDIAN AFFAIRS (1933–1945). He is remembered for his strong support of Indian TRIBES and tribal heritage and for helping to create the INDIAN NEW DEAL. As a young man he had visited the TAOS ART COLONY. *See* NEW DEAL.

Colonial Period (history) The period from 1607 to 1783 when the THIRTEEN COLONIES of AMERICA[1] were controlled by the British government; that is, before the UNITED STATES was an independently-governed, separate country. *See* MAY-FLOWER COMPACT, INDENTURED SERVANT, AMERICAN REVOLUTION; *compare* DECLARA-TION OF INDEPENDENCE.

Colonial Revival (housing and architecture) A conservative architectural style popular for homes and private residences from 1880 to 1955 and again since 1980, which is based on the wooden and stone houses built during the COLONIAL PERIOD in NEW ENGLAND and the MID-ATLANTIC region. Houses in this style are characterized by being made of cement blocks or brick but covered over in wooden siding; having a regular, symmetrical placement of windows and doors in the house façade; having simple columns supporting small roofed porches; and having brick or stone fireplaces. *Compare* MISSION STYLE.

color line, the (minorities) An invisible, psychological boundary that separates whites and blacks from each other. It was particularly strong during the period from the EMANCIPATION PROCLAMATION to the CIVIL RIGHTS MOVEMENT. It produced SEGREGATION and DISCRIMINATION in education, employment, and labor UNIONS[1]. [From a concept stated by W.E.B. DU BOIS in *THE SOULS OF BLACK FOLK*; and later developed in Ray Stannard's book *Following the Color Line* (1908).] *Compare* MA-SON-DIXON LINE.

Coltrane, John (people) (1926–1967) A JAZZ MUSIC musician, tenor saxophone player and leader of a musical quartet. He is known for promoting FREE JAZZ and for his musical experimentations in harmony, namely in *A Love Supreme*.

Columbia (1 customs and traditions; 2 science and technology) **1** The tall, graceful female figure wearing flowing robes gathered at the waist with a belt like those of Ancient Greece and Rome. She represents American patriotism and steadfastness. She is a symbol for the UNITED STATES OF AMERICA. compare STATUE OF LIBERTY, UNCLE SAM. **2** USS **Columbia** The first and longest-serving SPACE SHUT-TLE having had over 20 successful flights since 1981. [After CHRISTOPHER COLUMBUS (1451–1506), whose name in Italian is *Christofo 'Colombo'*.]

Columbia University (education) A well-respected, independent COEDUCA-TIONAL UNIVERSITY and member of the IVY LEAGUE. It was founded by Anglicans in 1754 as King's College, in honor of England's King George II, but was renamed Columbia College in 1784 during the AMERICAN REVOLUTION. In spring 1968, it was seized by male students and it became the site of their protests for the ANTI-WAR MOVEMENT, against the UNIVER-SITY's funding of war-related research as well as against the WASP ESTABLISHMENT. These student protests temporarily closed the university April 21–29, 1968. Today, it is famous for its LIBERAL ARTS COLLEGES: Columbia College (for 4,000 men and women) and BARNARD COLLEGE (women only) as well as its GRADUATE SCHOOLS of business, law and medicine. It is an NCAA member and its teams compete at the INTERCOLLEGIATE level. Its mascot is the Lion. The CAMPUS is located in Morningside Heights on the Upper West Side of MANHATTAN[1] in NEW YORK CITY. It is the

site of the annual ceremony for the distribution of the PULITZER PRIZES. [From Latin, *columbia*, representing the UNITED STATES.] *See* COLUMBIA[1], PRIVATE SCHOOL.

Columbus Day (customs and traditions) A LEGAL HOLIDAY observed on the second Monday of October to remember the Italian sailor CHRISTOPHER COLUMBUS (1451–1506) and the arrival of European influence in the Western Hemisphere on October 12, 1492. It was first observed as a FEDERAL HOLIDAY in 1892 on the 400-year anniversary of the event. On this day, many Italian Americans and their FRATERNAL ORDERS, especially the KNIGHTS OF COLUMBUS, celebrate their heritage usually with parades; the biggest one being in NEW YORK CITY. Some Native American groups protest on this day for they consider it the beginning of the end of independent Indian cultures. *Compare* DISCOVERERS' DAY, PIONEERS' DAY.

Columbus, Christopher (people) (1451–1506, in Italian "Christoforo Colombo") An Italian sailor and navigator who sailed Spanish-owned ships to the Caribbean while trying to get to Asia. He landed at the present-day Bahamas in the Caribbean on October 12, 1492. A children's poem follows: "In fourteen hundred and ninety-two, Columbus sailed the ocean blue". He has long been a symbol of European settlement in the Americas. However, for INDIANS and other MINORITIES, he is a symbol of IMPERIALISM and persecution. *See* COLUMBUS DAY, COLUMBIA[1].

comfort food (food and drink) Any food that people eat to make them feel better or happier; or to remind them of the happiness and security of childhood. Usually, it is eaten for sentimental or emotional reasons, not for nutritional value, fashions or trends (e.g., GRITS, apple sauce). *See* SOUL FOOD, SOUTHERN COOKING.

Commander in Chief of the Armed Forces (government) The PRESIDENT'S title and position as the highest-ranking leader of the ARMED FORCES in the UNITED STATES and of the units of the NATIONAL GUARD of each STATE when they are used for federal service (e.g., LITTLE ROCK

CRISIS). *See* WAR POWERS RESOLUTION ACT (of 1973).

commencement (customs and traditions) The official ceremony sponsored by a SCHOOL[5] in which the students who have successfully completed COURSES receive their diplomas. The event includes speeches by the VALEDICTORIAN, an invited guest speaker and other SCHOOL[5] officials. The MARCHING BAND usually performs the marching song "Pomp and Circumstance" as well as the SCHOOL[5] ALMA MATER[2]. All the students, many SCHOOL[5] officials and instructors wear CAPS AND GOWNS. This event is considered an important RITE OF PASSAGE[1] and often parents and family members attend the ceremony to watch their child GRADUATE[1]. Also known as "graduation".

commerce clause (government) The clause of the CONSTITUTION (i.e., Article I, Section 8, 'Clause' 3) that gives CONGRESS the power to regulate business across STATE boundaries and waterways and all business which affects the people of more than one state.

commercial (media) A message of a company advertising a company's product or services, which is 15, 30 or 60 seconds long. The company pays TV and radio networks to broadcast them. These commercials supplement the costs of a **commercial** radio and/or TV network. Every year, the most expensive commercial times are those commercials played during the SUPER BOWL game because that program is watched by a larger number of American households than any other program. *Compare* PUBLIC BROADCASTING SERVICE.

Commission on Wartime Relocation and Internment of Civilians (minorities) The federal commission which investigated the reasons for and effects of the internment of Japanese Americans from 1942 to 1945 during the period of WORLD WAR II. In 1982, it released its results in a report entitled *Personal Justice Denied* stating that the internment was a serious wrong committed against Japanese Americans. In 1988, CONGRESS followed its suggestion and made a public apology to each of the 60,000 survivors of INTERNMENT CAMPS and made a financial

payment of $20,000 to each person. *See* EX PARTE ENDO.

Commissioner (sports and leisure) The official title of the head administrator of a professional sports organization, especially of the MAJOR LEAGUES, NFL, NBA and NHL.

commodities (economy) An agricultural product (e.g., corn, grain), mineral (e.g., gold, silver), or other physical ASSET (i.e., not money, not shares in stocks) that is bought with cash and transferred immediately or promised to be bought and delivered at a "future" date. Commodities are traded on a **commodity exchange** and are regulated by the Commodity Futures Trading Commission. *See* CHICAGO BOARD OF TRADE; *compare* NEW YORK STOCK EXCHANGE, AMERICAN STOCK EXCHANGE.

Common Cause (politics) A LOBBY group of citizens that wants to improve the performance of STATE and federal governments by making them report expenditures to the public and be more responsible with the money of taxpayers. It supports issues such as public funding of election campaigns for CONGRESS, TAX REFORM and decreasing PAC influence on CAPITOL HILL. It was founded in 1970 and has a total of 250,000 members who are organized into 48 local groups; the main headquarters are in WASHINGTON D.C.

common law (legal system) The total system of laws in the UNITED STATES which includes old, unwritten laws based on custom and tradition (i.e., originally from England), as well as written decisions from court cases and laws written by American legislatures (that is, it is a combination of CASE LAW and STATUTORY LAW). It is based on PRECEDENT and is the legal system in the US by being the system of law in all the STATES except Louisiana. *Compare* CIVIL LAW[2].

common law marriage (legal system) The legal status of marriage between a woman and a man that is assumed by a STATE if the two have lived exclusively with each other for a number of uninterrupted years. Because STATE laws differ, the minimum time frame is between five and seven years of cohabitation. Currently, 12 states and the DISTRICT OF COLUMBIA recognize this type of marriage. *Compare* MARRIAGE LICENSE.

"common school movement", "the" (education) In the nineteenth century, an educational reform movement that promoted a free, compulsory ELEMENTARY SCHOOL education to mostly urban, white students from GRADES[1] one through eight. These **common schools** became the compulsory PUBLIC SCHOOLS of the twentieth century. The movement also wanted "normal schools" to train teachers to work in the common schools. *See* HORACE MANN.

Common Sense (history) A political pamphlet written by Thomas Paine (1737–1809), which was published in January 1776. Because it was written and argued well in direct language, it persuaded many colonists in AMERICA[1] to support separating from Great Britain and fighting for independence in the AMERICAN REVOLUTION. Later, it was followed by Paine's second pamphlet called *Crisis*.

commune (religion) A group of people sharing religious beliefs or similar idealistic goals which organizes its own independent, self-sufficient community where all the members live together, usually in a rural area. Group members share responsibilities (e.g., raising and educating children members) and work together to produce the food and materials (e.g., farming and handicrafts) the group needs to survive for everyday life. *See* SHAKERS, MORAVIAN CHURCH, HIPPIES, COUNTERCULTURE.

community college (education) An academic institution, usually public, that offers two-year, post-SECONDARY SCHOOL programs and awards ASSOCIATE'S DEGREES. It is usually locally controlled and publicly financed so the tuition is cheaper than that at PRIVATE SCHOOLS and STATE UNIVERSITIES. It accepts all students who apply for part-time or full-time study. It originally provided courses in technical training to all people who had a HIGH SCHOOL diploma or a GED. Now, it also offers the first two years of a HUMANITIES education which the student can then finish at a LIBERAL ARTS COLLEGE. It does not have INTERCOLLEGIATE sports teams or

programs. Usually, CAMPUSES are located DOWNTOWN and do not have DORMS for students. Also known as "junior college"; *see* Appendix 4 Educational Levels.

compulsory school attendance laws (education) Any law, written by a STATE legislature, requiring children and teenagers to attend school until a certain age; usually, it is 16 years of age. These laws were first passed during the PROGRESSIVE ERA.

concurrent powers (government) The powers that the federal government and the STATE governments both may exercise (e.g., taxing the people, spending money on government-supported projects).

concurring opinion (legal system) A separate, written statement prepared by one or more judges which agrees with the DECISION of the MAJORITY OPINION of the court but gives different reasons for reaching that same decision. Sometimes also known as "concurrence"; *compare* DISSENTING OPINION.

Coney Island (geography) An amusement park and beachside resort for working-class people in NEW YORK CITY which is located at the southern tip of BROOKLYN. It was popular before the 1950s and many of its attractions and rides have not been updated since its heyday.

Confederate States of America (history) (CSA) The independent country (1861–1865) which believed in STATES' RIGHTS[2] and preserving the system of SLAVERY. It was formed after the election of ABRAHAM LINCOLN as PRESIDENT when eleven American STATES from the SOUTH broke away from the UNITED STATES OF AMERICA. Its capital city was Richmond, Virginia (1862–1865) and its president Jefferson Davis (1808–1889). Its army, which wore gray-colored uniforms, fought in the CIVIL WAR against the UNION[3]. A major part of its army surrendered at APPOMATTOX COURT HOUSE; it finally capitulated May 26, 1865, and then dissolved when these areas returned to the UNITED STATES OF AMERICA. In addition, parts of the "border states" of Missouri and Kentucky were associated with the military of the CSA. Also known as "the Confederacy", "The South" and/or "DIXIE"; *see* SOUTH, *UNCLE TOM'S CABIN*,

MISSOURI COMPROMISE, KANSAS–NEBRASKA ACT, MANASSAS, BULL RUN, BLUE AND THE GRAY, RECONSTRUCTION.

conference (sports and leisure) An organization of member SCHOOLS[5] that controls the sporting events, games and tournaments for the member SCHOOLS[5]. Members of the same conference usually have competitive athletic rivalries, especially in the big, popular SPECTATOR SPORTS of FOOTBALL and BASKETBALL. At the COLLEGE[1] and UNIVERSITY level the members have approximately the same student population, size, academic standards and quality of athletic programs. Also known as "athletic conference"; *see* NCAA, BIG TEN, NIT (NATIONAL INVITATIONAL TOURNAMENT), ATHLETIC DIRECTOR.

conference committee (government) A CONGRESSIONAL COMMITTEE of SENATORS and REPRESENTATIVES that tries to combine two BILLS[2] (i.e., a bill passed in the HOUSE OF REPRESENTATIVES and a bill passed in the SENATE) into one bill which the entire CONGRESS will then vote on.

congregationalism (1, 2 religion) **1** A system of religious organization where each group of people worshipping together as a 'congregation' (i.e., CHURCH[1]) is independent of other congregations; each congregation must agree to its own type of church rules as well as elect its own leaders. Starting in the early eighteenth century, many PURITANS in NEW ENGLAND used this type of political and religious organization. **2** A general name for the **Congregationalist Church**, a type of PROTESTANT DENOMINATION which follows both CONGREGATIONALISM[1] and CALVINISM. In 1957, it experienced a union by ECUMENISM with Reform Churches in order to form the United Church of Christ which today counts 1.5 million members.

Congress (government) The BICAMERAL LEGISLATURE of the UNITED STATES government consisting of the HOUSE OF REPRESENTATIVES and the SENATE. The majority of its work is done in CONGRESSIONAL COMMITTEES. There are 535 total members of Congress (435 REPRESENTATIVES[1] and 100 SENATORS). The 535 members meet in the CAPITOL BUILDING in WASHINGTON D.C. The CONSTITUTION gives it many powers including; the POWER

OF THE PURSE, OVERSIGHT POWER, IMPEACH-MENT POWER and the power to declare war and/or commit American forces to military action. By association, it refers to the American government. *See* CAPITOL HILL[1], ADJOURNMENT[1], RECESS[2], CHECKS AND BALANCES, WAR POWERS RESOLUTION, CONGRESSIONAL BUDGET OFFICE, CONGRESSIONAL RESEARCH SERVICE, CAPITOL HILL, SENATOR, BELTWAY[2]; *compare* STATEHOUSE.

Congressional Black Caucus, the (government) (CBC) An influential, BIPARTISAN black group which tries to improve the economic, educational and political condition of AFRICAN AMERICANS by promoting (or preventing) new federal laws and encouraging blacks to vote. It was founded in 1971 and all its members are blacks who are currently serving in the UNITED STATES CONGRESS as SENATORS and/or REPRESENTATIVES[1]. Sometimes known as the "Black Caucus"; *compare* CONGRESSIONAL committee, CONGRESSIONAL HISPANIC CAUCUS.

Congressional Budget Office (government) (CBO) A support agency for CONGRESS that researches basic information about the federal budget and analyzes the effects of congressional laws and legislation on the budget. It was created in 1975 and is non-partisan (i.e., it is neither DEMOCRAT nor REPUBLICAN). *Compare* OFFICE OF MANAGEMENT AND BUDGET.

Congressional caucus (government) A CAUCUS of elected members of CONGRESS who share common interests or CONSTITUENCIES and meet to write and promote BILLS[2] in order to help those INTEREST GROUPS or voters. The CONGRESSIONAL BLACK CAUCUS and the CONGRESSIONAL HISPANIC CAUCUS are two types of Congressional caucuses.

Congressional committee (government) A general term for any one of the several, organized groups of SENATORS and/or REPRESENTATIVES[1] which meets to do business, research, debate and/or write legislative BILLS[2]. "Select (i.e., special) committees" do investigative work for a short period, then dissolve; other committees are permanent and do important work in CONGRESS, namely, STANDING COMMITTEE, CONFERENCE COMMITTEE and JOINT COMMITTEE. *See* SUBCOMMITTEE, RULES COMMITTEE.

Congressional district (government) A voting district consisting of some 560,000 people who elect one CONGRESSMAN/WOMAN to represent them in the HOUSE OF REPRESENTATIVES. Its boundary lines are drawn by the STATE legislatures. *See* CONSTITUENCY, REAPPORTIONMENT, REDISTRICTING, GERRYMANDERING.

Congressional Hispanic Caucus, the (government) A BIPARTISAN group that tries to represent the issues and improve the condition of HISPANICS and new immigrants in the UNITED STATES through new federal laws. This group was founded in 1977 and all its members are Hispanic Americans who are currently serving in the US CONGRESS as SENATORS or HOUSE OF REPRESENTATIVES members. Also known as "Hispanic Caucus"; *compare* CONGRESSIONAL BLACK CAUCUS.

Congressional Record (government) The written publication of CONGRESS (printed every day that it is in SESSION[1]) containing the oral and written debates, speeches and remarks made by members of the HOUSE OF REPRESENTATIVES and the SENATE. CONGRESSMEMBERS may alter the content of their spoken speeches before they are published in the "*Record*".

Congressional Research Service (government) (CRS) A part of the LIBRARY OF CONGRESS that researches information for individual members of CONGRESS and the CONGRESSIONAL COMMITTEES to use.

congressman/woman (government) A general term used to refer to any of the 535 people elected to serve in the CONGRESS (i.e., any of the 435 persons elected to the HOUSE OF REPRESENTATIVES or any of the 100 persons elected to the Senate); *compare* CONGRESSMEMBER. **Congressman/woman** Specifically the title used for any of the 435 elected members of the HOUSE OF REPRESENTATIVES (e.g., CONGRESSWOMAN Jane Doe). Each member serves a two-year TERM[1]; he or she must be at least 25 years old, a US citizen and a resident of the CONGRESSIONAL DISTRICT which he or she represents. Also known as a REPRESENTATIVE[1]; *compare* SENATOR, CONGRESSMEMBER.

Congressmember (government) A general term for a person elected to the UNITED STATES CONGRESS, that is, the SENATE (i.e., 100 people) or the HOUSE OF REPRESENTATIVES (435 people). There are 535 total CONGRESSMEMBERS. Also sometimes spelled CONGRESSMEMBER. *Compare* SENATOR, CONGRESSMAN/WOMAN.

conservation movement (environment) A general name for those efforts and projects which respect natural areas and resources. It consists of two submovements: the first is a preservation group which wants to create NATIONAL PARKS and other preserves of nature. It was particularly active in the late nineteenth century and eventually led to the ENVIRONMENTAL MOVEMENT. The second submovement is a group that wants to use natural resources in a responsible way that can benefit people and business. For example, damming rivers in order to gain electrical power, growing special forests to be routinely harvested, cutting some (but not all) trees in a timber forest. This second movement was particularly active from 1900 to 1950, and especially during the GREAT DEPRESSION. *See* CIVILIAN CONSERVATION CORPS, TVA, HOOVER DAM, HETCH HETCHY VALLEY/DAM.

conservative (politics) A supporter of CONSERVATIVISM. *Compare* LIBERAL, MODERATE.

Conservative Judaism (religion) The largest branch of the JEWISH religion in the UNITED STATES (currently 2 million total members). It developed in the US during the nineteenth century because new immigrants found REFORM JUDAISM too modern and ORTHODOX JUDAISM too traditional. Its members respect the traditional Jewish Law, known as *"Halachah"* (e.g., baby boys must be circumcised) but they can adapt some of the other laws to suit modern life; (e.g., although they eat KOSHER diets, they do permit some exceptions in this law's details). It is characterized by: allowing men and women to sit together during synagogue services; having ordained male rabbis and female rabbis; and supporting the modern state of Israel. *See* YARMULKE.

conservativism (politics) A political philosophy that prefers slow or no change

to the current situation. Specifically, it favors limited government involvement in businesses and the economy, a strong military presence and established (e.g., traditional, often Christian) social values. CONSERVATIVES are considered RIGHT and are associated with some members of the REPUBLICAN PARTY. *See* JUDICIAL RESTRAINT; *compare* LIBERALISM, MODERATE.

constituency (government) A political and geographical district that a person is elected to represent (e.g., CONGRESSIONAL DISTRICT). **Constituents**, residents, live in a constituency.

Constitution, the (government) The most important document in the UNITED STATES which consists of seven parts (known as "articles"), the BILL OF RIGHTS and the AMENDMENTS. It is the written basic, fundamental law and the plan that created the framework of American government (e.g., federal and STATE government), created and lists the powers and responsibilities of its three branches (i.e., CONGRESS, PRESIDENT, the SUPREME COURT) and describes the connections between the people and the government (e.g., BILL OF RIGHTS). It was created by the FOUNDERS[1] at the CONSTITUTIONAL CONVENTION OF 1787 to replace the ARTICLES OF CONFEDERATION. Although it contains specific information, it was also written in a general way to last for a very long time and allow for future advances and technologies. Due to these generalities and before it can be applied to today's situations, it needs to be "interpreted" by the government, especially legal courts. Since it is still used today to guide the government in making laws and DECISIONS, it is called a "living document". It is a very important symbol of unity in the USA because its principles and ideas are more powerful than the laws of individual STATES. *See MARBURY v. MADISON*, JUDICIAL ACTIVISM, JUDICIAL RESTRAINT, FEDERALISM, SEPARATION OF POWERS, *FEDERALIST PAPERS*, ELEVENTH AMENDMENT through TWENTY-SIXTH AMENDMENT, *McCULLOCH v. MARYLAND*, JOHN MARSHALL, PREAMBLE, CIVIC RELIGION, CONSTITUTIONAL CONVENTION; *compare* DECLARATION OF INDEPENDENCE.

Constitution, USS (military) A wooden ship of the US Navy which began active duty in 1797 and was also used in the War of 1812. It is remembered for never having lost a battle. Its nickname is "Old Ironsides" and currently it is on display in Boston harbor.

Constitutional Convention, the (government) The meeting in Philadelphia in 1787 at which 55 delegates from the 13 new states wrote and approved the Constitution. A debate over the strength of the federal government resulted in two factions; the Federalists[1] and the Anti-Federalists. This debate was solved by the Great Compromise. *See Federalist Papers*, Bill of Rights; *compare* Thirteen Colonies.

Consumer Price Index (economy) (CPI) The major method of measuring inflation in the United States. The CPI selects and fixes a number (i.e., a "basket") of goods and services that the average family (i.e., consumer) spends money on every month (e.g., housing, food, transportation, medical care, entertainment). Any increase in the costs of the "basket" of goods and services indicates a rise in the inflation rate. It is published monthly by the Bureau of Labor Statistics. Also known as "cost-of-living index"; *see* cost-of-living adjustment.

Consumers' Digest (media) A monthly magazine and buying guide that reviews and ranks new products and services. It also has articles on the latest medical and technological developments. It was founded in 1962 and has a circulation of 1.3 million.

contact sport (sports and leisure) A general name for those sports in which the game rules demand that players hit or tackle each other. Professional football is a contact sport but flag football is a **non-contact sport**.

contempt of court (legal system) Any intentional action a person makes which does not obey the rules of a court of law or is done to stop a court of law from doing its work (e.g., refusing to appear in court, lying on an affidavit). The charge of **contempt of Congress** is when the intentional action disobeys any law established by Congress; this charge is usually reserved for Congressmembers, the President, Secretaries of departments[2] and other officials. *See* subpoena.

Continental Congress, the (government) A body of delegates from the Thirteen Colonies that worked as the central government during the American Revolution, meeting first from 1774 to 1775 and again from 1775 to 1781. It approved and signed the Declaration of Independence in 1776 and the Articles of Confederation in 1777. After 1772, it was known as the "Congress of Confederation". It had dissolved by the time the new Constitution took effect.

continental divide (geography) An imaginary line running roughly along the crest of the Rocky Mountains, which divides the North American continent into two halves and is important for water flow and the environment. All the rivers to the east of it flow into the Mississippi River and the Atlantic Ocean, all the rivers to the west of it flow into the Pacific Ocean. Also known as "The Great Divide".

contingency fees (legal system) The payment an attorney receives for working on a client's court case or settlement only if the client wins the case or is successful. It is usually a percentage of the total amount of money that the client wins. *See* damages.

continuing education (education) A system of non-credit courses offered part-time at the post-secondary school level for high school graduates[1]. *Compare* adult education.

convenience store (daily life) Any small store that sells processed, pre-packaged foods, cigarettes, drinks, soda pop, beer, magazines, snacks, candy and maybe gasoline for automobiles. Often, it is found at a cross roads or along busy streets and is meant for people to stop, shop and leave quickly. Usually, it is open 24 hours a day.

convention (1, 2 politics; 3 work) **1** A shortened name for the national convention of a political party. **2** A meeting of delegates at the state level at which other delegates are chosen to attend the national convention. **3** A meeting of different business people organized to discuss business amongst themselves or

to demonstrate or sell certain products to a public.

conversion (sports and leisure) In FOOT-BALL, a method of scoring one additional point after a TOUCHDOWN. It is achieved if the offensive team kicks the ball through the upright goal posts and above the crossbar of the defending team. It is worth one point. Also known as "EXTRA POINT"; *compare* FIELD GOAL.

cookie (food and drink) A sweet, baked patty made of sugar, butter and eggs as well as other ingredients (e.g., chocolate, oatmeal, raisin, peanut butter) which is served as a dessert or a snack. Often, it is served with milk. *See* CHOCOLATE CHIP COOKIE, CHRISTMAS COOKIES.

Cool Jazz (the arts) During the 1950s, a type of BEBOP which contrasted with "Hard Bop" (*see* BEBOP). Cool jazz is intense music especially composed to be listened to (i.e., not danced to). It is characterized by being smooth, somewhat pessimistic, muted and expressing fewer emotions but more intellectualism, rationality and the musical skill of the composer. It has complex, unpredictable rhythms. It was promoted and played in CHICAGO and NEW YORK CITY mostly by black musicians. In the WEST, it was known as "WEST COAST JAZZ". *See* JAZZ MUSIC.

coonskin cap (clothing) A close-fitting hat made of the fur of a raccoon; usually hanging at the back is the tail of the animal. During the COLONIAL PERIOD, it was made and worn by those men living on the FRONTIER of the APPALACHIAN MOUNTAINS. Today, it is a symbol of the frontiersman himself and his independence.

Cooper, James Fenimore (people) (1789–1851) Writer of essays and fiction. He is best remembered for his "Leather-stocking Tales" which encompass five books: *The Deerslayer* (1841), *The Path-finder* (1840), *The Last of the Mohicans* (1826), *The Pioneers* (1823) and *The Prairie* (1827) all of which combine the history, romance, ideas about democracy and life on the FRONTIER in the STATE of New York as well as in the LOUISIANA PURCHASE in the eighteenth and nineteenth centuries. The lead character is NATTY BUMPO, a frontiersman. These

books were popular in the UNITED STATES and in Europe.

Cooperstown (sports and leisure) Since 1939, the site of the National Baseball HALL OF FAME. According to tradition, the rules for BASEBALL were first written down and recorded in this town which is located in the STATE of New York. By association, the birthplace of baseball.

Copland, Aaron (people) (1900–1990) A white music composer. He believed in making music available to all people and created particularly American music by using local history and folk rhythms. Well-known works include *"Appalachian Spring"* (1943–1944) and *"Lincoln Por-trait"* (1942). *See* MARTHA GRAHAM.

copyright (science and technology) The legal power to make copies of or use material (e.g., artistic or musical works, computer software). Since 1978, a copy-right protects material for the lifetime of its creator and fifty years thereafter. All copyrights in the US must be registered with the LIBRARY OF CONGRESS.

Congress of Racial Equality (minorities) (CORE) The biracial, national CIVIL RIGHTS organization which was the first group to use NONVIOLENT ACTIONS and DIRECT ACTION to achieve black integration and equality in white American society. It was founded in 1942 at the UNIVERSITY OF CHICAGO by JAMES FARMER; and during the CIVIL RIGHTS MOVEMENT, it gained wide-spread attention under Farmer's director-ship (1961–1966) through its use of SIT-INS, FREEDOM RIDES, drives for VOTER REGIS-TRATION and its participation in the MARCH ON WASHINGTON OF 1963. By 1966, it had become more militant; and under Floyd McKissick's (1922–1991) di-rectorship (1967–1968) it forced all white members to leave and it then encouraged BLACK POWER. During the 1970s, it be-came less militant; today, it is still active in protesting against racism and DISCRIMINA-TION but in a nonviolent way. *Compare* NAACP, SNCC, BLACK PANTHERS.

CORE (minorities) The popular nick-name for the CONGRESS OF RACIAL EQUAL-ITY. [Acronym from the 'C'ongress 'o'f 'R'acial 'E'quality.]

core curriculum (education) The basic academic courses thought to provide

students with the general knowledge to function well in society; usually, English, math and the sciences. *Compare* THREE R's.

corn bread (food and drink) A soft-textured, yellow-colored bread made of cornmeal which is served with the ENTREE for LUNCH or DINNER in the SOUTH and some MID-ATLANTIC STATES. Traditionally, it is also served for THANKSGIVING DINNER. "Spoon bread" (so soft that it is served and eaten with a 'spoon') and "corn pone" (bread made without milk or eggs) are types of corn bread.

corn on the cob (food and drink) An "ear" of corn (i.e., unit of corn) where the kernels of corn are still attached to the long, thin core. It is a common way of baking, serving and eating corn especially at BARBECUES, picnics, TAILGATING and CLAMBAKES.

corned beef (food and drink) Beef that is soaked in a mixture of garlic, peppercorns and cloves then preserved with salt. It is served cut in thin slices on sandwiches or chopped in CORNED BEEF HASH AND EGGS; both are popular dishes served in DELICATESSENS.

corned beef hash and eggs (food and drink) A breakfast and DELICATESSEN dish of chopped CORNED BEEF, diced boiled potatoes, parsley, onions, flour and milk fried in a skillet and served with eggs.

Cornell University (education) An independent, COEDUCATIONAL UNIVERSITY and IVY LEAGUE member famous for its well respected BACHELOR'S DEGREES programs and GRADUATE SCHOOLS of engineering, law and medicine. It was founded in Ithaca in UPSTATE New York by an endowment in 1865 but also received funds from the MORRILL ACT (1862). From April 19 to 20, 1969, it was occupied by the CAMPUS's black group which wanted more respect for black students. Today, it has about 13,000 UNDERGRADUATES and 5,000 GRADUATES. It is an NCAA member and its teams compete at the INTERCOLLEGIATE level. Its athletic teams are known as "Rig Red". [After Ezra 'Cornell' (1807–1874), a patron.] *See* PRIVATE SCHOOL.

cornflakes (food and drink) A breakfast cereal of small, thin toasted chips made from corn and eaten with cold or warm milk. [Developed in 1906 by Dr. John Harvey Kellogg and promoted by his brother, the businessman, William K. Kellogg.]

corporate culture (economy) A general term referring to the different types of business (i.e., products sold, services provided) which are controlled and operated by a company.

corporate raider (economy) A person or company that gains control of some other company, usually by buying a majority share of stocks in that company.

corporate welfare (economy) Any tax break, tax DEDUCTIBLE[1] or other subsidy that the government (federal, STATE or local) gives to a large company to attract a company to its area or region. *See* SUNBELT.

corporation (economy) An association (e.g., business) that is owned by the various people who own shares or parts of it. It must ask for and receive formal permission from a STATE to operate and conduct business. When the state agrees for it to operate within its legal boundaries, the corporation then is considered **incorporated**. Legally, it is considered a single "artificial person" and can buy property, sue and be sued. Therefore, the SHAREHOLDERS do not have a large LIABILITY in it. It is abbreviated "Corp." *Compare* ENTREPRENEUR.

Corporation for Public Broadcasting (media) (CPB) The nonprofit, non-governmental agency that helps encourage non-commercial radio and TV stations develop programs; it receives funding from the federal government and private foundations, which it then gives to groups to make these programs. It was founded in 1967 by the Public Broadcasting Act.

corrido (the arts) A type of music characterized by a happy or optimistic beat paired with lyrics which treat politics, protest and other serious issues. Frequently, it is performed by bands and groups in the SOUTHWEST. *Compare* TEX-MEX[2].

corvette (transportation) A popular American-made sportscar with two seats and a distinctive long hood covering a large V-8 engine; often, it is made with an automatic transmission or (less often) a

manual transmission (i.e., stick shift). It was first produced by the Chevrolet company in 1953 and has since become a symbol of youth, power, freedom and fun.

Cosmopolitan (media) An illustrated, monthly magazine for women (aged 20 to 40) with careers, carrying articles on health, fashion, sexuality and personal relationships. It was established in 1886 and has a circulation of 2.5 million. It is recognized by its magazine covers which often show sexy photos of fashion models. It is popularly known as "*Cosmo*".

cost-of-living adjustment (economy) (COLA) Any change to the amount of money workers and employees earn which tries to account for the normal, yearly effects of inflation. It is based on the CONSUMER PRICE INDEX.

cost-of-living index (economy) Another, more colloquial name for the CONSUMER PRICE INDEX.

cotillion (1, 2 sports and leisure) **1** A FORMAL[1] dance or ball for a DÉBUTANTE. **2** A FORMAL[1] dance or dance lesson for many couples in which they follow the movements of a single leading couple or professional couple. This is an EXTRACURRICULAR ACTIVITY in some HIGH SCHOOLS.

cottage cheese (food and drink) A type of soft, chunky, unripe and thus mild-tasting, white-colored cheese made from skim-milk curds. It must be eaten with a spoon or fork and is often served with vegetable salads. Sometimes in the MID-ATLANTIC region it is known as "Dutch cheese".

cotton candy (food and drink) A fluffy, sticky sweet in which sugar is blown by hot air into thin threads and wound around a stick. Often pink, yellow or blue food coloring is added. It is commonly served at amusement parks and spectator sporting events.

Cotton Club, the (the arts) A large, popular theater offering good, live entertainment and cabaret acts located on Lenox Avenue in HARLEM. It was known for hosting acts by black performers and musicians to audiences which were both black and white. It was decorated in a jungle motif and had a dance floor. It opened in 1918 and closed in 1940. *See*

HARLEM RENAISSANCE, ROARING TWENTIES, JAZZ AGE, DUKE ELLINGTON.

cotton gin (science and technology) The machine, invented in 1793 by Eli Whitney (1765–1825), that encouraged SLAVERY because it made cotton a cash (i.e., profitable) crop. Up until this point, harvested cotton was "cleaned" (e.g., separating the cotton seed from the valuable cotton ball) by slaves by hand, which made the quality of cotton poorer and the process for cleaning cotton too long and expensive. The cotton gin improved production because it cleaned cotton 50 times faster than cleaning it by hand and thus allowed a planter to plant more cotton and put all of the slaves to work in the fields planting, caring for and harvesting the cotton. This invention encouraged STATES in the SOUTH to become very dependent upon slave labor and the system of slavery. [From 'cotton' en'gin'e.]

Cotton Kingdom (geography) A popular name for the Deep South during the nineteenth century, referring to the richness of the soil and the large amount of cotton produced in this area. *See* SOUTH.

couch potato (media) A negative term for a person who spends too many hours sitting and watching television.

Counterculture, the (society) The movement promoting different attitudes and alternative lifestyles popular among young, COLLEGE[1]-aged people during the 1960s. It grew out of the BEAT GENERATION and reached its height in the late 1960s. The followers of this movement believed that individuals should have personal and sexual freedom. Its followers often wore their hair long and brightly-colored or natural clothes; they promoted ROCK AND ROLL music, using drugs to experience different feelings and rebelling against authority. Many supported the NEW LEFT and the ANTI-WAR MOVEMENT. *See* WOODSTOCK, HAIGHT-ASHBURY; *compare* HIPPIE, YIPPIES.

country (music) (the arts) A type of music traditionally characterized by songs with straightforward lyrics, performed with clear vocals accompanied by string instruments, especially the guitar, BANJO and FIDDLE[1]. It grew out of the songs (e.g., old English ballads, COWBOY[1] songs and

religious songs) and instruments commonly played by the poor white people living in APPALACHIA, Texas, and the WEST during the early twentieth century and before. It became popular before WORLD WAR II. Typically, country songs treat subjects relating to rural, farm or country life (e.g., work, loss of love, economic problems). Its industry center for playing and recording is NASHVILLE, Tennessee. Recording LABELS have always exerted a strong influence over the sound of country music. Before 1949, it was known as "mountain music" or "HILLBILLY MUSIC"; since 1949, it has also been referred to by the industry as COUNTRY AND WESTERN music. "Honky tonk (country music)", a term which was used during the 1960s and 1970s, referred to country music played by white people with electric guitars which produced songs with a resonating sound. Today, "new country", and its synonym "country rock", refer to country music which has a strong drum beat, harder sound and lyrics treating contemporary topics (e.g., divorce, alcoholism). "Redneck rock", and its synonym "progressive country", refer to a style of country music with a harder, percussion-type sound than other forms of country music. BLUEGRASS and WESTERN SWING are unique styles of country music. *See* COUNTRY MUSIC ASSOCIATION, ACADEMY OF COUNTRY MUSIC, BRANSON, GRAND OLD OPRY, HANK WILLIAMS, SR., DOLLY PARTON, WILLIE NELSON, GARTH BROOKS.

Country and Western music (the arts) A standard and formal name for COUNTRY MUSIC; it is commonly used by the music industry to refer to business aspects of this type of music. It was first adopted in 1949 by the trade magazine, *BILLBOARD*, as a name for this type of music. Also known as "C AND W"; *compare* HILLBILLY MUSIC.

country club (sports and leisure) A social club which contains dining restaurant(s), sporting facilities (e.g., tennis courts, swimming pools) and sponsors athletic events (e.g., tournaments) and social events and dances for its members. Usually, it charges a large annual fee and is located on its own golf course in spacious surroundings in the SUBURBS. Sometimes, its membership is selective.

Country Music Association (the arts) (CMA) The largest, most-respected organization promoting COUNTRY MUSIC, namely by presenting the "Country Music Awards" to outstanding country music performers, songwriters and musicians in an annual ceremony held in NASHVILLE every October as well as by operating the Country Music HALL OF FAME (established in 1961). It was originally founded in 1954 as the "Country Music Disc Jockeys' Association"; it has been known by its present name since 1958. Its headquarters are in Nashville and it currently has 7,000 members. *Compare* ACADEMY OF COUNTRY MUSIC.

county (geography) The largest subdivision of a STATE usually, it has its own local government (e.g., executive and judiciary) and police force; in addition, it provides some health and social services to residents of that area. It may be known as a "PARISH" or "BOROUGH"2. *See* COUNTY SEAT.

county fair (customs and traditions) An annual market and agricultural and farming competition similar to a STATE FAIR, but usually much smaller for it draws participants and crowds only from the COUNTY. *See* 4-H.

county seat (geography) The capital city of a COUNTY and where the administration of county government and services take place.

course number (education) An identification number in the title of a COLLEGE[3] course which indicates its level of difficulty. Numbers 100 through 300 usually identify UNDERGRADUATE courses (e.g., Biology 101 is an introductory COLLEGE, FRESHMAN-level course) and numbers 400 through 800 usually identify GRADUATE[2]-level courses (e.g., Biology 796 is a PhD-level course). *See* 101.

court-martial (military) The legal court of the military which hears cases and tries military personnel accused of violating laws and/or rules of any of the branches of the ARMED FORCES. It is especially appointed by a commanding officer to hear cases. DECISIONS are usually made by high-ranking military officers, not judges; military law is not the same as CIVIL LAW[1]. Personnel who have been

court-martialed (i.e., found guilty) are not entitled to their military rank, pensions nor any other FRINGE BENEFITS.

cover (the arts) A song written and initially performed/recorded by some individual or group but which afterwards is played by another person or band. A band that **covers** performs the songs of other recorded artists. Also known as "cover version".

coverage (health) Another way to refer to having an INSURANCE POLICY. Being **covered** means being insured.

cowboy (1, 2 society) **1** A farm cattle ranch worker working on a farm or cattle ranch in the WEST from the 1860s to the present. This person is responsible for various tasks concerning the upkeep and marketability of cattle. **2** A type of folklore hero working temporarily as a ranch hand during the historical period of 1866 to 1886 who is admired for being independent and close to nature and is frequently portrayed in WESTERNS. *Compare* SINGING COWBOYS.

cracker (1 food and drink; 2 society) **1** A flat, salted wafer made of dough and baked. It is frequently topped with cheese slices or dunked into a special dipping sauce and eaten as a snack or at a COCKTAIL PARTY. **2 Cracker** In general, a negative term used to refer to a poor white, often uneducated, person, usually from the SOUTH and/or APPALACHIA. Specifically, a negative term for a person born and raised in Florida or Georgia. *Compare* HILLBILLY.

Cracker Jack (food and drink) A trademark name for a snack of POPCORN and peanuts covered in a sweet caramel sauce and served in a cardboard box. Each box comes with a small plastic toy or prize. It is often sold at sporting events and COUNTY FAIRS. *See* "TAKE ME OUT TO THE BALLPARK".

cranberry relish (food and drink) A sweetened fruit salad or side dish consisting of cooked cranberries as well as fresh apples, celery, oranges, lemons and sugar. It is a colorful red dish traditionally served with turkey during the THANKSGIVING DINNER.

Crash of 1929, the (economy) Another name for BLACK TUESDAY. It marks the beginning of the GREAT DEPRESSION. [It refers to the total collapse, or 'crash', of the NEW YORK STOCK EXCHANGE on October 29, 1929.] Also known as "the Great Crash"; By association, with the relevant year, it can refer to other dips in the strength or performance of the STOCK MARKET, the NEW YORK STOCK EXCHANGE and other exchanges (e.g., the "Crash of 1987"; *see* BLACK MONDAY).

Crazy Horse (people) (1842–1877 also known by Indian name "Tashunka Witko") A SIOUX (Teton) INDIAN and strong military leader. He is known for helping SITTING BULL defend the BLACK HILLS from white settlement; resisting the move of his TRIBE to RESERVATIONS; and for winning the battle of LITTLE BIG HORN. He has long been a symbol of resistance; he only surrendered (in 1877) when he had absolutely no chance for victory.

cream cheese (food and drink) A soft, white-colored, unripened cheese made from full milk. It is smooth and is often spread on breads, BAGELS and sandwiches. *See* CHEESE CAKE.

creche (customs and traditions) Another name for NATIVITY SCENE. [French, meaning "crib", referring to the baby crib of the infant Jesus Christ.] *Compare* MENORAH.

credit (education) A system of assigning values to COLLEGE[3] courses in the decentralized American system of HIGHER EDUCATION. A credit is a value unit assigned to a course that is based on the number of "credit hours" (1 "credit hour" = between 50-60 real minutes) that a course meets every week during the TERM[2] (e.g., if Math 101 meets three days a week for 60 minute sessions during a SEMESTER, it is assigned a value of three credits). Generally, semester courses meet for three "hours" a week and quarter classes meet for five "hours" a week. A student who passes a course earns the number of credits assigned to that course and a student who fails it neither earns nor loses credits. After earning the number of credits required by the MAJOR and COLLEGE[2], a student can graduate. The number of credits required for graduation is set by the individual DEPARTMENT[1], COLLEGE[2] or UNIVERSITY and is approved by the ACCREDITATION organiza-

tion. Students may take courses "not-for-credit" which means they attend lectures but do not write papers nor take exams; therefore, they do not earn credit for that course. Also known as "credit hour" and "hour".

credit card (economy) A method of making immediate payments for various purchases in various different stores and companies (e.g., restaurants, DEPARTMENT STORES, CATALOG SHOPPING). It consists of a small, rectangular card listing the card carrier's name, account number and the date when the card expires. It is either issued by a bank or by a special credit card company (e.g., American Express). The card carrier receives a BILL[3] once a month at which time he or she can pay all or only part of the bill, usually by PERSONAL CHECK or a computer transfer. Also, it is used as a type of ID CARD.

credit union (economy) A kind of banking institution formed by its members, which offers low INTEREST RATES and special banking privileges to those members. Members usually share the same profession (e.g., teachers, labor UNION[1] members).

Creole cuisine (food and drink) A style of cooking using green peppers, onions and garlic to make spicy dishes of seafood and crayfish; a popular dish is JAMBALAYA. It developed in NEW ORLEANS from the mixture of influences of French colonists, Spanish colonists, black slaves and people from the Caribbean islands. It is usually prepared and presented in a more elegant way than dishes of CAJUN COOKING. [From Spanish *criolla*, meaning "native to the place".]

Crèvecoeur, J. Hector St. John, de (people) (1735–1815, born in France as Michel-Guillaume-Jean de Crèvecoeur) Farmer, writer and immigrant to the UNITED STATES from France. He wrote a collection of essays, *Letters from an American Farmer* (1782), in which he praised the democratic freedom and open lifestyle of people living in AMERICA[1].

crewneck (clothing) Describing a SWEATER or SWEATSHIRT where the round collar fits close around the neck. By association, any garment with this sort of neckline.

criminal law (legal system) The set of laws designed to try and then punish persons who have been proven to have committed crimes against another person or society (e.g., murder, theft, rape, FELONY, MISDEMEANOR). Punishment can include a jail term, monetary fines or CAPITAL PUNISHMENT. *See* JURY, BAIL, DEFENDANT, CRIMINAL TRIAL; compare CIVIL LAW[1].

criminal trial (legal system) A court case where a PROSECUTING ATTORNEY charges a person or group for committing a crime (e.g., murder, robbery) and a JURY decides if the person or group is innocent or guilty, and if necessary, the length and type of punishment (e.g., prison sentence, CAPITAL PUNISHMENT). *See* CRIMINAL LAW; compare CIVIL TRIAL .

Crisis (media) The monthly journal of the NAACP. It publishes articles about and by AFRICAN AMERICANS on the danger of racism and prejudice and lists NAACP activities. Usually, it also includes articles on education, the arts, fiction stories and reviews. It was founded by W.E.B. DU BOIS in 1910 who then served as its editor until 1934; during this period, it was an important source of information on various issues for black readers.

Crockett, Davy (David) (people) (1786–1836) Frontiersman, CONGRESSMAN from the STATE of Tennessee and militia man in Texas. On the FRONTIER, he was admired as a folk hero and respected for his bravery, physical strength and contact with INDIANS. He died trying to defend the Texan fort at the battle of the ALAMO.

Crow, Jim (minorities) *See* JIM CROW LAWS.

cruel and unusual punishment (legal system) Any kind of torture, mean treatment, very long prison term or CAPITAL PUNISHMENT sentence given to a prisoner which is more severe than the original crime. It is prohibited by the EIGHTH AMENDMENT. *See* FORMAN V. GEORGIA (1972), *GREG* V. *GEORGIA* (1976).

cub scout (sports and leisure) A minor member (aged seven years to 10) of the BOY SCOUT group. *Compare* BROWNIE[2].

Cuban Missile Crisis (foreign policy) The tense, 1962 COLD WAR conflict between the UNITED STATES and Soviet

Union, concerning nuclear missiles, which the Soviets had placed in Cuba. With this threat of a nuclear war, PRESIDENT JOHN KENNEDY ordered the Soviets to remove the missiles and the US NAVY to stop all boat traffic to Cuba. The force of the American decision encouraged the Soviet leader Nikita Khrushchev (1894–1971) to remove the weapons if the UNITED STATES agreed not to invade Cuba. *Compare* BAY OF PIGS.

cultural literacy (education) A term defined by E. B. Hirsch, Jr. as, "the network of information that all competent readers possess," in his bestselling book called *Cultural Literacy: What Every American Needs to Know* (1987). Hirsch hypothesizes that there is a common set of knowledge about a culture that all members of that culture should learn in or out of SCHOOL[1] in order to be able to function in society. This concept was further supported by *The Dictionary of Cultural Literacy* (1993) by Hirsch et al. *See* BESTSELLER; *compare* MULTICULTURALISM.

cultural/ethnic/area studies (education) A general name for a field of study and coursework in a COLLEGE[1] which includes various courses on the history, society, economics, politics and culture of a particular group of people. It attempts to examine the history of this group from various angles and to develop a body of scholars to create new perspectives on these peoples in American society. Further, it awards a degree in this field (e.g., BA, MA). It specializes in the following areas; "American Studies", "AFRICAN-AMERICAN STUDIES", "Women's Studies", "Native American Studies", "Asian-American Studies", "Jewish Studies", "Hispanic-American Studies", "Latino Studies" or "Chicano Studies" and "Gay Studies". *See* MULTICULTURALISM.

cum laude (education) Describing a student who has earned a high GPA in his or her CLASS. This phrase is written on the student's diploma. [Latin, meaning "with praise".]

cummings, e. e. (people) (1894–1962) Poet. He used humor, everyday speech and subjects in his poetry. His work is frequently characterized by not having punctuation, nor spaces between words, nor capital letters, all of which give visual messages to the reader; for example, in the poem "if there are any heavens my mother will(all by herself)have" (1931).

Cuomo, Mario (people) (born in 1932) LAWYER and former governor of New York (1983–1994). As CHIEF EXECUTIVE of the STATE he became a popular politician in the DEMOCRATIC PARTY because he promoted building public housing for poor people and a woman's right to abortion; he did not support the DEATH PENALTY. He is a member of the ROMAN CATHOLIC CHURCH, an Italian American and currently practices law.

cupcake (food and drink) A small, round cake designed for one individual portion and topped with ICING.

Curb Exchange, the (economy) The original name for the AMERICAN STOCK EXCHANGE. [Because stocks and bonds were traded in the street and on the 'curb' in NEW YORK CITY.]

Currier and Ives (the arts) The successful, American business team of printer Nathaniel 'Currier' (1813–1888) and artist, J[ames.] Merritt 'Ives' (1824–1895) who painted idyllic scenes of daily life both indoors and outside in AMERICA[1] during the nineteenth century and mass produced them as popular lithograph prints. They are particularly noted for their family-oriented CHRISTMAS DAY and HOLIDAY SEASON lithographs. By association, describing a contented, blissful, traditional scene or holiday festivity. *Compare* NORMAN ROCKWELL.

Custer Died for Your Sins: An Indian Manifesto (minorities) The book (published in 1969) which presented Indian concerns for an Indian and white American audience and encouraged INDIANS (not whites) to solve Indian problems. Further, it blamed the US economic system for marginalizing the TRIBES and promoted retaining the unique cultures, languages and histories of Indians as well as encouraging Indians to establish their own systems and SCHOOLS[5] of education. It was written by Vine Deloria, Jr., a SIOUX Indian. *See* LITTLE BIG HORN.

Cy Young Award (sports and leisure) In professional BASEBALL, the annual award first awarded in 1956 to honor the best

pitcher. Since 1967 two awards are distributed every year; one for a pitcher in the NATIONAL LEAGUE and one for a player in the AMERICAN LEAGUE. [After "Cy" Denton Young (1867–1955) a talented pitcher.]

D

Dade County (geography) The largest COUNTY in Florida with a population of 2 million people, many of whom are retired and others who are bilingual (i.e., Spanish-English) Cubans and HISPANICS. The COUNTY SEAT is MIAMI. Its land area includes part of the EVERGLADES, fruit and vegetable farms and tourist resorts on the Atlantic Ocean coast.

Dagwood sandwich (food and drink) A stacked sandwich consisting of several layers of sliced meats, cheese slices, bread and lettuce. [After 'Dagwood' Bumstead, a character from the comic strip "Blondie" known for his big appetite and large, homemade 'sandwiches'.]

daily (media) A newspaper which is printed, published and sold every day. That is, either Monday through Friday; or Monday through SUNDAY.

daily double (sports and leisure) In horse racing and dog racing, a kind of bet that a person makes predicting the winner of two different races. This bet only pays money if both win; but it does pay more than a single race bet.

daiquiri (food and drink) A cool cocktail consisting of rum, lime juice, sugar and chopped ice frequently flavored with fruit (e.g., strawberry, banana) and mixed in an electric blender. [After 'Daiquirí', a town on the east coast of Cuba.]

Dallas (geography) The eighth largest US city (population 1 million) and part of the sprawling metropolitan area of Dallas-Forth Worth (total population 3.9 million). It is an aircraft production center as well as the center of this Southwestern oil producing region. It was the location of the assassination of JOHN F. KENNEDY on November 22, 1963. *See* Appendix 3 Professional Teams.

damages (legal system) In the SETTLEMENT of a CIVIL LAW[1] court case, the money one person (i.e., "A") must give another (i.e., "B") to pay for any physical damage that "A" caused to "B's" person or property (e.g., health, car accident) or any mental or psychological damage that "A" caused to "B's" person or reputation. *See* LIBEL.

DAR (society) A volunteer, cultural and somewhat elite social group founded in 1890 for women whose ancestors had participated in the AMERICAN REVOLUTION. It sponsors cultural, historical and patriotic activities for its members as well as for SCHOOLS[1] and young people. Currently, there are 188,000 members organized into over 3,150 different local groups. [Abbreviation of 'D'aughters of the 'A'merican 'R'evolution.]

dark horse (politics) A candidate who is not well known and therefore not expected to win the nomination of a political party or an election, but who does. [From the sport of horse racing, in which an unknown (i.e., 'dark') competitor (i.e., 'horse') wins.]

Dartmouth College (education) A small, well-respected, independent UNIVERSITY and one of the Ivy LEAGUE members famous for its UNDERGRADUATE programs and the GRADUATE SCHOOL of business. It was founded in 1769 by the Congregational Church to provide European-style education to INDIANS. Although it remains a PRIVATE SCHOOL, it no longer has the religious affiliation and has always graduated many more whites than Indians. It has a COED population of 4,000 UNDERGRADUATES and 1,000 GRADUATES[2]. It is an NCAA member; its teams compete at the INTERCOLLEGIATE level and are known as "Big Green". The CAMPUS is located in Hanover, New Hampshire. *See* DARTMOUTH V. WOODWARD, CONGREGATIONALISM[1,2].

Dartmouth College v. Woodward (education) The SUPREME COURT decision (of 1819) that distinguished private UNIVERSITIES from public ones and protected private HIGHER EDUCATION institutions from STATE and federal interference. *See*

PRIVATE SCHOOL; *compare* STATE UNIVERSITY.

dashiki (clothing) A loose, collarless, men's shirt made of cotton material in bright colors and patterns. It first became popular among African-American men during the 1970s. Today, it may be worn for KWANZA, other special events or for leisure wear. [From the West-African language, Yoruba, *dansiki*, the name for this shirt.]

date (daily life) A romantic appointment for two people and which these two people have agreed to attend (e.g., going to a movie, going to dinner). A "double date" is a romantic date in which two couples (i.e., total four people) go out together. A "blind date" is a date (hopefully romantic) in which the two people do not know each other; their date was arranged by a third person. *Compare* DATING.

dating (daily life) A type of relationship in which two individuals are romantically interested in each other and consider themselves a couple. When two individuals "are dating each other" they go on DATES only with each other. Also known as "going steady" or "going out with each other".

Daughters of Isabella (religion) A social organization for active, female members of the ROMAN CATHOLIC CHURCH, especially, the spouses, sisters or daughters of those members of the KNIGHTS OF COLUMBUS. It helps organize events to celebrate COLUMBUS DAY. [After Queen 'Isabella' I (1451–1504) of Spain, the patroness of CHRISTOPHER COLUMBUS.]

Davis Cup, the (sports and leisure) An annual, international tennis tournament for professional male players. It consists of a country forming a team of players which then plays the teams of other countries. It is played every year in the country of the defending champion. It was first played between the UNITED STATES and Great Britain in 1900. The American team is sponsored by the UNITED STATES TENNIS ASSOCIATION. [After Dwight F. 'Davis' who donated the 'cup'-like trophy in 1900.]

Davis, Miles (people) (1926–1991) African-American trumpet musician and composer of JAZZ MUSIC. He is the originator of the style of BEBOP jazz music and later developed COOL JAZZ. He is known for his creative playing and composing style, especially in the album *Kind of Blue* (1959).

Dawes (Severalty) Act, the (minorities) The federal law (passed February 1887) which worked to end the communal, tribal life of INDIANS and enforce the Indians to accept ASSIMILATION into white American society as farmers and business people. It tried to achieve this namely by: dissolving tribes; and by transferring all Indian tribal lands and RESERVATIONS (which were then owned communally by the entire TRIBE) to individual, former tribe members (where each individual was to own a separate piece of property). This law divided the reservations up into the following pieces, or "allotments": 160 acres of land was given to the head of a family; 80 acres of land to single adults; 40 acres of land to a child. Each private owner of land was permitted to farm or sell his or her allotment of land; many Indians sold their pieces of land to white settlers for immediate sums of money. This law greatly hurt NATIVE AMERICAN tribal unity and identity and dramatically reduced the amount of land controlled by Indians, but did not help Indians assimilate. It was the first law of a series which promoted ALLOTMENT. Formally known as the "Dawes General Allotment Severalty Act".

Dawes Plan (foreign policy) The successful plan designed to stabilize the Germany economy after 1924 (e.g., putting it on the GOLD STANDARD) and to settle the problem of how financially depleted Germany would pay the WORLD WAR I reparations to the allied European nations. [After American lawyer and banker, Charles Gates 'Dawes' (1865–1950) who chaired the Reparations Commission which developed the plan; eventually receiving the Nobel Peace Prize for it.] *Compare* MARSHALL PLAN.

day after Thanksgiving, the (customs and traditions) The Friday after Thanksgiving which is traditionally, the first and busiest shopping day of the HOLIDAY SEASON and the single most busiest shopping day of the entire year. The amount of

sales for CHRISTMAS DAY and/or HANUK-KAH shopping made on this day are an indication of the total success of businesses and merchants. Although it is not a FEDERAL HOLIDAY, many people are not required to work on this day, making it the second day in a LONG WEEKEND.

day care (education) A licensed, FOR-PROFIT center that supervises and provides pre-learning opportunities, social skills and physical activities to children between the ages of two and five. [named for the 'day'time hours of operation, 7:30 a.m. to 5:30 p.m.] *Compare* NURSERY SCHOOL, KINDERGARTEN.

daylight saving(s) time (daily life) The method (first used by CONGRESS in 1918; revised in 1988) of maximizing the use of sunlight hours during the day throughout most of spring, all of summer, and some of autumn. It begins in "spring" on the first Sunday in April (in which clocks are pushed – they "spring" – forward one hour) and ends in "fall" the last Sunday in October (when the clocks are pushed – they "fall" – back one hour).

Daytona 500, the (sports and leisure) The most prestigious race for STOCK CARS and the one that awards the most prize money. It was first held in 1959 and entails successfully completing 500 miles (800 km) on the Daytona International Speedway. It is sponsored by NASCAR and is held every February at Daytona Beach, Florida. The winner receives money and the Harley Earl award. In addition, since this is one race of the WINSTON CUP SERIES its winner earns points for that competition.

Daytona Beach (geography) A resort town with high-rise hotels, BARS[1] and restaurants located on the Atlantic Ocean coast of Florida. It is a popular vacation area for students during SPRING BREAK and tourists, as well as the home of stock-car racing. *See* NASCAR, STOCK CAR.

de facto (legal system) Describing something, especially a condition or system, that is established by social tendencies, economic conditions and/or residential patterns (i.e., not by laws made by the government). "De facto segregation" is racial segregation which is created by members of the society (i.e., whites and blacks) who prefer to live among people of the same race. After WORLD WAR II in many parts of the NORTH, de facto segregation occurred because whites moved out of the cities and into the SUBURBS. [Latin, meaning "actual; in reality".] *See* WHITE FLIGHT; *compare* DE JURE.

de jure (legal system) Describing something, especially a condition or system, that is created and enforced by legal laws made by the government (e.g., federal or STATE government). "De jure segregation" is racial segregation which is established by laws made by the government (e.g., federal or STATE government). After the CIVIL WAR in the SOUTH, de jure segregation was enforced by state laws and JIM CROW. [Latin, meaning "by right" or "by law".] *Compare* DE FACTO.

De Niro, Robert (people) (born in 1943) A film actor respected for his serious and intense acting style. His chosen roles usually explore men who have failed or are very successful; namely, *The Godfather, Part II* (1974) and *Raging Bull* (1980); he won OSCARS for both of these performances.

dead, white males (society) A disparaging term to refer to that group of artists and writers, largely male, white and no longer living, whose literary and philosophical books and works have long been the standard materials for UNIVERSITY students and the general society to study and admire. Often, it is used by MINORITIES and women who demand that the curriculum and society have more representation from living authors who are African American, HISPANIC, Native American, Asian American, other minority group members and/or female. *See* MULTICUL-TURALISM.

dean (1, 2 education) **1** The highest ranking academic officer of a UNIVERSITY SCHOOL[2] or COLLEGE[2] who oversees its daily operation (e.g., Dean of the College of Arts and Sciences). **2** The highest ranking administrator of a UNIVERSITY office who coordinates all the issues related to that office (e.g., Dean of Student Affairs).

dean's list (education) A list published each TERM[2] by the UNIVERSITY that lists the

names of full-time UNDERGRADUATES who have earned high GRADES[2].

Dean, James (people) (1931–1955) Movie actor who portrayed rebellious, individualistic young male characters. Although he starred in only three films (i.e., *Rebel Without a Cause* and *East of Eden* both in 1955 and *Giant* in 1956), he became a movie idol and is remembered for his good looks and acting skill. While still young, he died in a car accident.

Dear Abby (media) The popular SYNDICATED newspaper column in which readers pose written questions about family, parenting, personal relationships and daily life, and to which 'Abigail' Van Buren (the penname of Pauline Esther Friedman, born in 1918) provides direct, sometimes humorous or poignant answers.

Dear John letter, a (language) A type of letter, usually written by a woman and sent to her current boyfriend to inform him that she is ending their relationship. Often, this is done because she has found a new, different boyfriend. By association, a letter or document received giving news of great personal disappointment. [After the first line of the letter.]

death row (legal system) The people who are held in prison and are waiting their court-ordered death by CAPITAL PUNISHMENT. Each person has been accused of committing a crime(s) and a court of law has found each guilty of that crime. Once a prisoner is on death row it is very difficult to stop the planned execution. *See* CRIMINAL TRIAL, PENITENTIARY, PARDON.

Death Valley (environment) A very low area in the MOJAVE DESERT, and since 1994 a NATIONAL PARK. It is the lowest point in the western hemisphere measuring: 282 feet (86 m) below sea level. The average temperature in the summer is 120°F (48.8°C). [After its extreme heat in the summer.] *See* SOUTHWEST; *compare* MOUNT MCKINLEY/DENALI.

débutante (customs and traditions) A young woman (aged 18 or 19) who is going to be formally introduced to "high society" by means of a FORMAL[1] dance held in her honor. During the nineteenth century, wealthy families in the SOUTH and NORTH held a "débutante ball" in honor of their daughter, hoping that she would meet some man who would later marry her. Currently, only some young women are débutantes; further, this idea of arranging a marriage is no longer the focus. At her ball, she wears a FORMAL[3]. The invited guests are also formally dressed and often include her HIGH SCHOOL friends as well as the friends and colleagues of her parents. She is popularly known as a "deb".

decision (legal system) The formal judgment given at the end of trial proceedings concerning a legal case. In order for a decision to be reached, it must have the majority of the vote (i.e., of a JURY or of a panel of judges). Because the American judicial system is based on COMMON LAW, decisions often have the effect of laws. The decisions of the SUPREME COURT are based on the CONSTITUTION and considered "interpretations" of that document and thus serve as very important rules in the society. *See* JUDICIAL ACTIVISM, *PLESSY* V. *FERGUSON, BROWN* V. *BOARD OF EDUCATION, MARBURY* V. *MADISON, MIRANDA* V. *ARIZONA*, WARREN COURT, BURGER COURT.

deck shoes (clothing) A type of low, heel-less, slip-on shoe with a flat, smooth sole surface and a shoe casing made of canvas or leather. They were originally designed to be worn on a boat or yacht, because they provide the wearer with steadiness and do not leave foot prints on the boat's 'deck'; today, they are popularly worn for leisure wear.

Declaration of Independence, the (government) The written document claiming that the THIRTEEN COLONIES were no longer a part of Great Britain but 13 free and independent STATES. THOMAS JEFFERSON wrote most of this document which was then approved by the CONTINENTAL CONGRESS on July 4, 1776, during the AMERICAN REVOLUTION. It is recognized as an eloquent, well-written document. It is now recognized as the symbol of the birth of the UNITED STATES OF AMERICA as a separate country and of American patriotism. It is celebrated and sometimes read on INDEPENDENCE DAY. *See* INALIENABLE RIGHTS, ALL MEN ARE CREATED EQUAL, CIVIC RELIGION; *compare* PREAMBLE, CONSTITUTION.

Declaration of Sentiments and Resolutions, the (minorities) The document presented at the SENECA FALLS CONVENTION which complained of the legal rights and powers that men had and which they did not give to women. Further, it made 12 suggestions to improve women's political, social and economic conditions, specifically demanding: having equal rights as men in voting, marriage, religion, education and work. Most of the document was prepared by Elizabeth Cady Stanton (1815–1902) and Lucretia Mott (1793–1890). The writers intentionally based this document's format on that of the DECLARATION OF INDEPENDENCE to compare the repressed condition of women under men to that of the American THIRTEEN COLONIES during British rule and before the AMERICAN REVOLUTION. FREDERICK DOUGLASS was crucial in encouraging men at this meeting to approve this document.

Decoration Day (customs and traditions) The traditional name for "MEMORIAL DAY" in several STATES in the SOUTH. [From the practice starting after the CIVIL WAR in which women 'decorated' the graves of their family members who had fought and died for the CONFEDERATE STATES OF AMERICA.]

deductible (1 economy; 2 health) Describing any amount of money that an individual donated to charities or spent on other TAX SHELTERS in a given year. The total figure of the **deductible** can be subtracted from an individual's total amount of money to be paid to the INTERNAL REVENUE SERVICE. **2** A basic minimum amount of money that a person with an INSURANCE POLICY must pay in the case of an accident (e.g., car accident) or health problem (e.g., hospital admittance) before receiving benefits from the insurance company. After the deductible, the insurance company pays for the remaining costs. *Compare* CO-PAYMENT.

deer season (sports and leisure) The period of the calendar year when it is legal to hunt adult deer with guns (usually November and December) or bows and arrows (usually November through February). This time period, its length and the number of deer each hunter can kill is usually established and enforced by the STATE. *See* HUNTING SEASON.

defendant (legal system) In a CRIMINAL TRIAL, that person or group that is accused of doing some criminal action.

defense contract (military) An agreement between the DEPARTMENT OF DEFENSE and a private business in which the DEPARTMENT2 pays the businesses to make military equipment and weapons (e.g., planes, guns, tools) for the ARMED FORCES to use. Many businesses want these contracts because usually, the contracts last for a number of years and provide jobs and income in a local region. *See* EXECUTIVE ORDER 8802.

Defunis* v. *Odegaard (education) The case of REVERSE DISCRIMINATION (in 1974) at the University of Washington Law School which refused to admit a white man, Marco 'Defunis', with above average GRADES2 and LSAT scores while accepting MINORITY students with lower academic credentials. The STATE supreme court of Washington state decided that the law SCHOOL4 had violated Marco Defunis's right to the FOURTEENTH AMENDMENT and he was to be admitted as a student there, however the SCHOOL4 won an appeal. While pending a decision, Defunis was allowed to continue his studies and had completed all but one QUARTER2 when this case came before the SUPREME COURT where a majority of the justices decided that the case was MOOT. *See* AFFIRMATIVE ACTION; *compare REGENTS OF THE UNIVERSITY OF CALIFORNIA* v. *ALLEN BAKKE.*

degree mill (1, 2 education) **1** A negative term to describe a SCHOOL5 without ACCREDITATION or another HIGHER EDUCATION institution that awards false diplomas. **2** A slang term describing a HIGHER EDUCATION institution that has ACCREDITATION but has low or unchallenging educational standards and requirements.

delegate (politics) A member of a political party who is locally selected to vote for candidates for PRESIDENT at a NATIONAL CONVENTION. Delegates are chosen in a PRESIDENTIAL PRIMARY and PRESIDENTIAL CAUCUS. A "pledged delegate" has promised voters to vote for the specific candidate of a political party that the

voters have chosen but an "unpledged delegate" can vote for any candidate.

delicatessen/deli (food and drink) A food shop specializing in serving lunchtime sandwiches, BAGELS, cooked meats, CORNED BEEF dishes and prepared salads. It offers customers both restaurant service and TAKEOUT.

demerger (economy) The end of the joining of two businesses; the opposite of a MERGER.

Democracy in America (history) A book (published in 1832) describing life in the UNITED STATES during the first half of the nineteenth century, particularly: the religion, government and openness of white society. It presents an outsider's view of the US because it was written by Alexis de Tocqueville (1805–1859), a Frenchman who had traveled throughout the country for nine months and greatly admired the lack of class distinctions in white society (i.e., no born aristocracy).

Democrat (politics) A member of the DEMOCRATIC PARTY.

Democratic National Committee (politics) (DNC) The official organization of the DEMOCRATIC PARTY. It is responsible for representing the political party, selecting and supporting candidates to run in official elections, organizing FUND-RAISERS and raising money for its candidates. Its largest, most important task is organizing and overseeing the NATIONAL CONVENTION of the DEMOCRATIC PARTY during a presidential CAMPAIGN election year. It is the group which receives money from the FEDERAL ELECTION CAMPAIGN AMENDMENT as well as some public donations for candidates. It was founded in 1848 and is headquartered in WASHINGTON D.C. ; it has 432 officially elected members. *See* WATERGATE, CHICAGO RIOT; *compare* REPUBLICAN NATIONAL COMMITTEE.

Democratic Party (politics) One of the two major political parties in the UNITED STATES. Traditionally, it is LIBERAL and concerned with social change and reform. It originated in the early 1800s with the DEMOCRATIC-REPUBLICAN PARTY and JACKSONIAN DEMOCRACY. DEMOCRATS believe that the government should give money and GRANTS-IN-AID to programs which help solve social, educational, welfare and economic problems. Because of its support for the NEW DEAL, CIVIL RIGHTS MOVEMENT and WAR ON POVERTY it has been popular among labor UNIONS[1], MINORITIES, women and people who earn low incomes. Its mascot is the DONKEY. Non-supporters think that the Democratic Party represents BIG GOVERNMENT. *See* DEMOCRATIC NATIONAL COMMITTEE, JEFFERSONIAN DEMOCRACY, Appendix 2 Presidents; *compare* REPUBLICAN PARTY.

Democratic-Republican Party (politics) The political party founded by THOMAS JEFFERSON and active from 1791 until the 1830s. It supported STATES' RIGHTS[2], a small role for the federal government and equal treatment for all voting citizens. Today's DEMOCRATIC PARTY grew out of this party and JACKSONIAN DEMOCRACY. *See* Appendix 2 Presidents; *compare* FEDERALIST PARTY[2].

den mother/father (sports and leisure) An adult (female/male) leader of a CUB SCOUT group.

Denali (environment) The original name for the cold, majestic, snowcapped mountain in Alaska and the highest point in the UNITED STATES measuring 20,320 feet tall (6,193.5 m). It is the premiere effort in the US for mountain climbers. It is known as "Denali" by many environmentalists and all Alaskans; others, especially those from the LOWER 48, know it as "MOUNT McKINLEY". Further, it is the central focus of Denali National Park, a large wildlife reserve of lakes and tundra for bear, moose, caribou, other wildlife and birds. [The Athabascan Indian language word, meaning "The Great One".]

denomination (religion) A legal and religious grouping which represents all of those congregations or worshippers which share the same religious beliefs.

department (1 education; 2 government) **1** Any formal subdivision of a SCHOOL[5] that provides teaching, advisory or other administrative services to students or faculty (e.g., the English Department). At the post-SECONDARY SCHOOL level, it is responsible for designing curricula, assigning CREDITS to courses, helping students decide which courses to take as well as performing administrative duties. The academic departments in SECONDARY

SCHOOLS are usually staffed by teachers and administrators while the "guidance departments" are staffed by ADVISERS. *See* ADMISSIONS DEPARTMENT. **2** A major administrative division of the executive branch of the federal government which is headed by a SECRETARY. *See* CABINET, APPOINTMENT POWER.

Department of Agriculture (food and drink) (USDA) The federal DEPARTMENT[2] that oversees UNITED STATES policies concerning food, food export and import as well as stabilizing and setting fair prices for agricultural products, supervising conservation-oriented farming methods and inspecting the quality of foods for sale. It was first set up in 1862, but its duties grew with the NEW DEAL programs. *See* AGRICULTURAL ADJUSTMENT ADMINISTRATION, CABINET, SECRETARY.

Department of Commerce (economy) (DOC) The federal DEPARTMENT[2] that encourages the US economy and technology and provides social and economic statistics to businesses and government planners for work purposes. It contains the Patent and Trademark Office, the Bureau of the Census, the OFFICE OF THRIFT SUPERVISION and the MINORITY BUSINESS DEVELOPMENT AGENCY. It is headed by the "SECRETARY of Commerce" who is also a member of the CABINET. *See* CENSUS.

Department of Defense (military) (DOD) The federal DEPARTMENT[2] which is responsible for all aspects of the military and national security. It includes the JOINT CHIEFS OF STAFF, the Marines, Departments of the AIR FORCE, the ARMY and the NAVY and is in charge of all ARMED FORCES and procedures in the US and overseas. It helps develop new military technologies and also operates the service academies (e.g., WEST POINT). It also provides help in non-military aspects (e.g., disaster relief, flood control). All of these offices and functions are housed in the PENTAGON in Northern Virginia. It is headed by the "SECRETARY of Defense" who is also a member of the CABINET. *See* NATIONAL SECURITY COUNCIL, DEFENSE CONTRACTS, HOOVER COMMISSIONS, NATIONAL SECURITY ACT.

Department of Education (education) The federal office that administers, coordinates and reports on most of the federal assistance to and regulations for education, especially in PUBLIC SCHOOLS. Further, it partially supports GALLUDET COLLEGE, HOWARD UNIVERSITY and other SCHOOLS[5]. It was created in 1979 by the Department of Education Act when it split from HEALTH EDUCATION AND WELFARE. This new DEPARTMENT[2] was almost dissolved during PRESIDENT RONALD REAGAN'S first TERM[1] (1981–1984). Its most famous report was *A NATION AT RISK*. The SECRETARY of the Department of Education is currently a member of the CABINET. *Compare* DEPARTMENT OF HEALTH AND HUMAN SERVICES, BOARD OF EDUCATION.

Department of Energy (science and technology) (DOE) The federal DEPARTMENT[2] that organizes and develops federal programs concerning energy development and usage, including: energy research, nuclear energy plans, energy conservation and waste management and nuclear weapons. It was established in 1977 and is headed by a SECRETARY who is a member of the CABINET.

Department of Health and Human Services (health) (HHS) The federal DEPARTMENT[2] that organizes and runs programs for health and welfare; namely, the SOCIAL SECURITY, MEDICARE, MEDICAID. It also conducts medical research at the NATIONAL INSTITUTES OF HEALTH as well as in alcohol, drug abuse and mental health. Until 1996, it ran the AID TO FAMILIES WITH DEPENDENT CHILDREN as a federal program. It is headed by a SECRETARY. Before 1979, it was part of the DEPARTMENT OF HEALTH, EDUCATION AND WELFARE. *See* CABINET, WELFARE.

Department of Health, Education and Welfare (health) (HEW) That former federal DEPARTMENT[2] which was responsible for overseeing federal programs concerning health education and public welfare. It dissolved in 1979 when it was divided into new departments, namely, the DEPARTMENT OF EDUCATION and the DEPARTMENT OF HEALTH AND HUMAN SERVICES.

Department of Housing and Urban Development (housing and architec-

ture) (HUD) The federal DEPARTMENT[2], founded in 1965, that builds and provides affordable public housing, directs mortgage insurance programs for home buyers and helps local groups rehabilitate their neighborhoods. It is headed by a SECRETARY. *See* CABINET, GINNIE MAE.

Department of Justice (legal system) The federal DEPARTMENT[2] which oversees and enforces all those laws designed to protect the people, namely, law enforcement, immigration, naturalization, prison maintenance and fair business and economical rights. It includes various separate divisions, especially: the FEDERAL BUREAU OF INVESTIGATION, IMMIGRATION AND NATURALIZATION SERVICE, FEDERAL MARSHALS, the DRUG ENFORCEMENT ADMINISTRATION and the Antitrust Division. It is headed by the ATTORNEY GENERAL, an important member of the President's CABINET. also known as "Justice"; *see* APPOINTMENT POWER, ANTITRUST LAWS.

Department of State (foreign policy) The federal DEPARTMENT[2] which gives the PRESIDENT advice on issues concerning the US and foreign countries, helps formulate treaties and assists in developing foreign policy. It maintains embassies and consulates in many countries and employs members of the FOREIGN SERVICE to staff them. It also includes the office of the US Ambassador to the United Nations. It is headed by the SECRETARY of State who often is a powerful member of the President's CABINET. Also known as "the State Department" or "State"; *see* FOGGY BOTTOM.

Department of the Interior (geography) (DOI) The federal DEPARTMENT[2] created in 1849 and responsible for overseeing government policies on Indian RESERVATIONS, operating conservation projects for wildlife, managing the PUBLIC LANDS and administering the TERRITORIES. Its divisions include the BUREAU OF INDIAN AFFAIRS, US FISH AND WILDLIFE SERVICE and the Bureau of Reclamation (which handles water management issues, especially in the WEST and SOUTHWEST). Further, it controls the National Park Service which oversees all the NATIONAL PARKS as well as NATIONAL MONUMENTS, NATIONAL RECREATION AREAS, NATIONAL

WILDERNESS AREAS and NATIONAL PRESERVES. It is headed by the "SECRETARY of the Interior" who is also a member of the CABINET. Also known as "Interior"; *see* CENSUS.

Department of the Treasury (economy) The federal DEPARTMENT[2] which controls and regulates financial and tax policies, manufactures coins and currency, regulates the sale of alcohol, tobacco and firearms and attempts to stop the counterfeiting of US DOLLARS. It contains the INTERNAL REVENUE SERVICE, the SECRET SERVICE, OFFICE OF THRIFT SUPERVISION and the Customs Service. It is headed by the "Secretary of the Treasury" which is a CABINET position. *See* SECRETARY, TREASURY BOND, T-BILL.

Department of Transportation (transportation) (DOT) The federal DEPARTMENT[2] which oversees and organizes all projects and plans affecting highway and interstate highway construction as well as monitors air, water and land traffic. It contains the FEDERAL AVIATION ADMINISTRATION, the COAST GUARD, federal raildoads and the St. Lawrence Seaway Development Corporation which monitors the ST. LAWRENCE SEAWAY. It was established in 1966 and is headed by a SECRETARY who is a member of the CABINET.

Department of Veterans' Affairs (military) (VA) The federal DEPARTMENT[2] (since 1988) providing services to US veterans of military service, their spouses and DEPENDENTS, especially by distributing pension and disability benefits, offering medical, dental, hospital and NURSING HOME services and maintaining the veteran cemeteries through the National Cemetery System (e.g., ARLINGTON NATIONAL CEMETERY). It is headed by the SECRETARY of Veterans' Affairs who is a member of the CABINET.

department store (daily life) A large store that sells a variety of products (e.g., clothing, cosmetics, shoes, books) to customers. *See* SHOPPING MALL.

dependent (health) A person who relies on another for financial support, especially an unmarried child under the age of 18.

deportation drive (immigration) An organized effort to physically remove from the UNITED STATES persons who are citizens of another country but who are currently living and/or working (i.e., legally or illegally) in the US. Deportation drives were common during the RED SCARE[2]. A well-known drive were the "Palmer Raids" of 1919 which tried to remove anarchists and Communists throughout the US. Today, they may be used to enforce official immigration laws. *See* TEXAS RANGERS, BORDER PATROL.

deposition (legal system) Before a trial is held, an official declaration or statement which a person makes then swears that it is true. It is made with the assistance of and in the presence of an ATTORNEY. It may be made orally (i.e., "oral deposition") or in a written form (i.e., "written deposition"); all depositions must be filed with a court of law. The information that it contains is potentially related to that trial and, during a trial, is often used as evidence. Commonly referred to as a "dep"; *compare* AFFIDAVIT.

depreciation (economy) In economics, a decrease in the value of an ASSET or money (e.g., the DOLLAR) over time. *See* WEAK DOLLAR; *compare* STRONG DOLLAR.

deregulation (economy) A method of encouraging the free market, promoting competition and lowering prices by decreasing or completely stopping the government's control and/or ownership of businesses. Since the 1970s, the US government has **deregulated** airlines and railroads. *See* CAPITALISM, PRIVATE SECTOR.

Dershowitz, Alan (people) (born in 1938) Law PROFESSOR and criminal defense ATTORNEY. He served as Director of the AMERICAN CIVIL LIBERTIES UNION (1968–1971; 1972–1975) and since has written several books concerning practicing law and criminal defense. He is well known for successfully representing high profile people and celebrities in defense LAWSUITS. He teaches at HARVARD UNIVERSITY.

Desert Shield, Operation (foreign policy) The protective, military occupation in which American forces and the forces of its allies (several countries including Great Britain, France) established units in Saudi Arabia to protect it and the region from a possible invasion by the neighboring country in the Middle East, Iraq. It was started as a response to the Iraqi invasion of its neighboring country, Kuwait (on August 2, 1990), a small country with large supplies of crude oil. It lasted from August 7, 1990, to January 16, 1991, when it escalated into the GULF WAR.

designated hitter (sports and leisure) (DH) The tenth player on a BASEBALL team who takes the offensive role of the PITCHER and bats for him. The DH allows the pitcher to rest and is only used in the AMERICAN LEAGUE.

détente (foreign policy) During the COLD WAR, a term used to describe the mutual US–Soviet Union policy in which these two superpowers agreed to cooperate on economic agreements and limit strategic weapons but did not try to change their ideological perspectives. This period began during the Nixon ADMINISTRATION[2] and ended in 1979 when the Soviets invaded Afghanistan. [French for "relaxation of tension".] *See* SALT I, SALT II, RICHARD NIXON.

Detroit (geography) Located in the GREAT LAKES area, this city became an important industrial center for the US, especially known for its car-making industry, mass production techniques and other heavy industries. However, in the 1970s and 1980s, it experienced an economic decline and was one of the main cities in the RUSTBELT. It is also known for its development of the MOTOWN MUSIC sound. [From French *Ville d'Etroit*, meaning "City of the Strait".] Popularly known as "MOTOWN" or "the Motor City"; *see* SUNBELT, HENRY FORD.

Dewey decimal system (education) The system for organizing books in a general library in which books and other materials are classified by a digit between "000" and "999"; and all the sub-classifications are marked by various decimal points (e.g., 9.879.654). It is generally used in smaller libraries containing general collections, as in SCHOOL[1] libraries and local public libraries. The LIBRARY OF CONGRESS does not use this system; it uses its own system. [After Melvil 'Dewey' (1851–1931), the librarian and developer of this system.]

Dewey, John (people) (1859–1952) A philosopher, UNIVERSITY PROFESSOR, educational reformer and leading member of the education reform aspects during the PROGRESSIVE ERA. He believed that learning and courses should focus on the student as an individual and that the curriculum should combine academic and life experiences. He encouraged early childhood education and promoted the idea of KINDERGARTEN. One of his best known books is *School and Society* (1899) which promoted these aims.

Día de la Constitución (de Puerto Rico), el (customs and traditions) July 25, the day-long, annual festivity among Puerto Ricans in which they celebrate the signing of their Puerto Rican constitution in 1952 which made the island a self-governing possession of the UNITED STATES. This special day is celebrated among Puerto Ricans wherever they are living (e.g., in Puerto Rico or in the US) by attending parties, drinking and eating, especially traditional dishes of red beans and rice and *cerdo al horno* (i.e., roast pork). In NEW YORK CITY, there are particularly large celebrations which last long into the night. [Spanish, meaning "the day of the constitution".] *See* SPANISH HARLEM.

diamond (sports and leisure) In BASEBALL, the nickname for the INFIELD[1]. By association, the collective nickname for the entire playing area of the baseball field (i.e., INFIELD and OUTFIELD). [After the 'diamond' shape of the field.]

diary (daily life) A bound book of lined, blank pages in which a person can regularly (e.g., daily) write ideas, thoughts, poetry or other writings. Also known as "journal"; *compare* APPOINTMENT BOOK.

Dickinson, Emily Elizabeth (people) (1830–1886) Poet. She lived quietly in a small town of Massachusetts, usually never leaving her family home, and wrote 1,775 poems (only seven of which were published in her lifetime). Her poems are characterized by their shortness and originality; they usually concern nature and relationships.

DiMaggio, Joe (people) (born in 1914) A professional BASEBALL player for the New York Yankees team who was very popular because of his skills as both an OUTFIELDER and as a batter; while batting, he hit the ball in a record number of 56 consecutive games. He was voted the MVP of the AMERICAN LEAGUE three different times. His nickname was the "Yankee Clipper" for his smooth, graceful style of playing. He was married to MARILYN MONROE briefly (1954).

dime (economy) A silver-colored coin worth ten cents, or one-tenth of a DOLLAR. Since 1965, it has been made of cupro-nickel-clad alloy. It is embossed with the motto "IN GOD WE TRUST" on one side and the motto *E PLURIBUS UNUM* on the other side.

dime novel (the arts) An inexpensive, trivial novel usually relating sensational stories and romance; it was especially popular during the period 1850 to 1920. [The cost at that time was 10 cents, a 'DIME', per book.]

Diné, the (people) The name that the NAVAJO people use to refer to themselves. [Navajo, meaning "the people".]

diner (daily life) An inexpensive restaurant offering inexpensive meals for breakfast, LUNCH and DINNER. Frequently, it has a counter which people can sit along and eat at as well as tables and booths. It usually serves SHORT ORDER dishes, eggs, CORNED BEEF dishes, PIES and BOTTOMLESS CUPS OF COFFEE.

dinner (daily life) The daily meal eaten in the evening after finishing work and/or school. Usually, it is eaten between 5:30 p.m. and 7:30 p.m.; it is often finished with a dessert. It may be eaten at home with family members or at a restaurant. The only exception to this time frame is THANKSGIVING DINNER which is eaten in the early afternoon. *Compare* LUNCH.

dinner jacket (clothing) An elegant, men's fitted jacket in which the lapels are covered in satin or grosgrain material. It is usually made in a dark blue or black color (for use throughout the year) or in white (for summertime) and worn as evening wear or to SEMIFORMAL[1] dinners. It is another name for the jacket of a TUXEDO. *See* TUXEDO.

direct action (legal system) A type of active, public protest which people participate in as a method of encouraging

political and business leaders to change laws and policies. It is specifically designed to involve several or more people and to attract media coverage in order to appeal to a wider audience. Its tactics include disrupting planned, scheduled events (e.g., government hearings, business meetings) with chants, signs, and other materials which relate to the issue(s) of protest. Although it is a form of CIVIL DISOBE- DIENCE, it is more aggressive than NON- VIOLENT ACTION.

disabled (minorities) Describing a per- son who has a mental condition (i.e., mentally disabled) or physical condition (i.e., physically disabled) which limits one or more of that person's major life activ- ities (e.g., hearing, walking). Sometimes it is also (and especially, formerly) known as "HANDICAPPED". Many people with **dis- abilities** prefer this term to that of "handicapped". *See* AFFIRMATIVE ACTION, SPECIAL EDUCATION, AMERICANS WITH DIS- ABILITIES ACT, VOCATIONAL REHABILITA- TION ACT OF 1973.

disbar (legal system) To remove a LAW- YER from a BAR ASSOCIATION of a STATE because of some illegal action or MAL- PRACTICE on behalf of the lawyer or the lawyer's client. *See* MALPRACTICE INSUR- ANCE.

discount rate (economy) The amount of money the FEDERAL RESERVE SYSTEM charges commercial banks to borrow money from Federal Reserve banks. It is a type of INTEREST RATE. Also known as "federal discount rate"; *compare* PRIME RATE.

Discoverers' Day (customs and tradi- tions) A LEGAL HOLIDAY in some states which celebrates all the people throughout history who contributed to exploring and establishing SETTLEMENTS in the present- day UNITED STATES. It is OBSERVED on the second Monday of October, that is the same day as COLUMBUS DAY.

Discovery Channel, the (media) A cable television network that broadcasts educational, non-fiction TV programs on nature, science, travel and adventure. Its program *Assignment Discovery* is designed to be used in SCHOOL[1] classrooms. It was founded in 1985 and has 70 million SUBSCRIBERS. Further, it owns the Learning

Channel, also broadcasting educational programs, which has 55 million subscri- bers.

discrimination (minorities) A policy or practice of denying someone something because of their race, religion, color or national origin (i.e., racial discrimination), sex or gender (i.e., sexual discrimination), or religion (i.e., religious discrimination). Discrimination is barred from the work- place and other places by the CIVIL RIGHTS ACT of 1964. *Compare* REVERSE DISCRIMI- NATION, SEGREGATION.

disenfranchised (politics) Not having rights, especially, the right to vote because a person never had the right to vote, or because it was taken away from a citizen. **Disenfranchisement** can occur by STATE law (e.g., POLL TAX, GRANDFATHER CLAUSE) or if a person does not re-register to vote. *See* VOTER REGISTRATION; *compare* EN- FRANCHISED.

Disney, Walt (people) (1901–1966, born Walter Elias Disney) An animator and producer of animated cartoons. He is known for creating the characters of Mickey Mouse (in the short film *Steam- boat Willie* 1928), Donald Duck, Pluto, Goofy and others and for making the first full-length feature animated film (*Snow White and the Seven Dwarfs* in 1937). Also, he developed the concept of the theme parks of DISNEYWORLD and DisneyLand.

DisneyWorld (sports and leisure) A popular amusement and theme park founded in 1971, presenting a world of unreality and fantasy originally designed for children but now also popular with adults. Popular attractions include: Fanta- syland, Tomorrowland, Frontierland, Ad- ventureland, EPCOT ("Experimental Prototype Community of Tomorrow") Center (opened in 1982) and Disney- MGM Studios. A similar theme park is located in Anaheim, California and known as "DisneyLand" (opened in 1955). These parks are commonly asso- ciated with families and are symbols of wholesomeness. [After 'WALT DISNEY', the founder.]

disorderly conduct (legal system) A general name for any action in which an individual disrupts or interferes with the

general flow of the public, namely, being drunk or being naked in public.

displaced person (immigration) (DP) A person who is forced to leave his or her home or native region or country because of political crises or military conflicts. This term was first used after WORLD WAR II but since then has been replaced by the term REFUGEE. *See* DISPLACED PERSONS ACT.

Displaced Persons Act (immigration) The first federal REFUGEE policy (passed in 1948) that helped some 450,000 European DISPLACED PERSONS from 1948 to 1952, leave war-devastated Europe after WORLD WAR II and immigrate to the US. It was the first US refugee-oriented legislation.

dissenting opinion (legal system) Along with the reading of the DECISION of a legal case, the separate statement written by one or more judges which disagrees with the MAJORITY OPINION and explains the reasons for disagreeing. Sometimes known as "dissent".

dissertation (education) An original piece of research or a creative written work that is required of a GRADUATE2 before being awarded the PHD degree. The student must formally present it to the DEPARTMENT1 and successfully defend (i.e., pass) the ideas in it before a panel of PROFESSORS. *See* ABD; *compare* THESIS, MASTER'S DEGREE.

District Attorney (legal system) (DA) The government ATTORNEY who brings LAWSUITS against people who are accused of committing crimes. He or she represents the COUNTY or district in CRIMINAL TRIALS, and usually is elected by the voters to a TERM1 of two or four years. He or she is a type of PROSECUTING ATTORNEY. Also known as "public prosecutor"; *compare* ATTORNEY GENERAL.

District of Columbia (geography) The land, not part of any of the 50 STATES, which was especially established in 1790 for the development of the federal capital city of the UNITED STATES. As a result of the enormous growth of WASHINGTON D.C., the surrounding District and the city of Washington D.C. are now synonymous. It is only 68 square miles (179 square km) and although it has ELECTORS for presidential elections, it does not have a voting

REPRESENTATIVE in the US CONGRESS. It is known for its economy based on the federal government and tourism. It has very humid summers and mild winters. Also known as "The District" and "DC"; *see* SHADOW SENATOR; *compare* TERRITORY.

dividend (economy) The amount of money, stocks or bonds, coming from a company's total profits which is divided up and given to that company's SHAREHOLDERS.

Dixie (1 geography; 2 customs and traditions) **1** A popular nickname for the SOUTH and the STATES of the South; especially, the "Old South" before the CIVIL WAR. [Allegedly, from being south of the Mason-'Dix'on line + 'ie'.] Also known as "Dixieland"; *see* MASON-DIXON LINE, Appendix 1 States, "DIXIE". **2** "**Dixie**" A traditional, lively song popular in some areas of the SOUTH whose lyrics celebrate southern life and loyalty to the South. The repeated refrain follows: "Then I wish I was in Dixie, Hooray! Hooray!/In Dixie Land I'll take my stand to live and die in Dixie/Away, away, away down south in Dixie." The words and music were written by Daniel Dacatur Emmet (died in 1904) in 1859 for a MINSTREL show. This song, played with a piccolo, was used as a battle song and very popular among the CONFEDERATE STATES OF AMERICA during the CIVIL WAR. Today, it is played by some Southerners. [After 'DIXIE', the nickname of the South.]

Dixiecrats (politics) A popular name for the members of the States' Rights Party, a THIRD PARTY1 which grew out of the DEMOCRATIC PARTY in the SOUTH. It believed in not giving blacks their CIVIL RIGHTS but did support STATES' RIGHTS2. It was only active in the presidential election of 1948 in which it nominated Strom Thurmond (born in 1902) of South Carolina. It was popular only in DIXIE1. [From the members from 'Dixie' + Demo'crats'.]

Dixieland Jazz (the arts) An early style of JAZZ MUSIC (between the years 1910 and 1929) developed by blacks in the SOUTH which has a fast rhythm (4-4) and lively beat. It is usually performed by a small group of musicians playing the following instruments: trombone, trumpet, clarinet

and sometimes, the piano and drums. This type of music became popular again in the 1940s. [After the name of the white band, "Original 'Dixieland Jazz' Band" which played and was the first to record this kind of music about 1917.] *Compare* NEW ORLEANS JAZZ.

DJ (media) The person at a club, party, or radio station who selects the records or Compact Disks (CDs) to play. [Abbreviation from 'D'isk 'J'ockey, the person who rides the record 'disks'.] Also spelled "deejay" By association, a person who hosts a television music video program is a **VJ** ('V'ideo 'J'ockey). Further, a person who works at a karaoke club is a **KJ** ('K'araoke 'J'ockey).

Doe, Jane (1 society; 2 legal system) *See* JANE DOE[1,2].

Doe, John (1 society; 2 legal system). *See* JOHN DOE[1,2].

dog tag (military) The small metal plate on which the name and identification of a member of the ARMED FORCES (e.g., rank, identification number) is embossed. Usually, it is worn on a metal chain and worn around the neck. By association, any identification or ID. [From the metal plate that a 'dog' wears which is embossed with its name and owner's address and/or phone number.]

doggie bag (food and drink) In a restaurant, the small cardboard or plastic container or 'bag' used to wrap up that food a customer ordered but could not eat (especially meat), and meant to be eaten the next day by that person or by his or her pet 'dog'.

dollar (economy) The basic unit of American currency: one hundred cents (i.e., PENNIES) = one dollar. All of its denominations ($1, 2, 5, 10, 20, 50, 100) are green and of the same size; only the central decoration on each side changes. On one side is a portrait of a famous figure: $1 GEORGE WASHINGTON; $5 ABRAHAM LINCOLN; $10 Alexander Hamilton (1755–1804), former Secretary of the DEPARTMENT OF THE TREASURY; $20 ANDREW JACKSON; $50 ULYSSES S. GRANT; and $100 BENJAMIN FRANKLIN. The $2 dollar BILL[1], with the portrait of THOMAS JEFFERSON, is less common. *See* WEAK DOLLAR, STRONG DOLLAR, GREENBACK[1].

domino theory (foreign policy) The foreign policy concept that if one country adopts a communist system of government, then its neighbor countries will also turn, or fall, to communism (like a line of 'dominos'). Preventing the domino theory by giving military support to certain countries with communist neighbor countries was a frequent US policy during the COLD WAR, especially in Vietnam and Indochina. *See* VIETNAM WAR.

"don't ask, don't tell, don't pursue" (military) Since 1993, the official, anti-DISCRIMINATION policy of the US ARMED FORCES. It entails forbidding all members of the branches of the armed forces from asking fellow members if they are homosexual; forbidding them from telling other members that they are homosexual; and forbidding anyone to continue asking these types of questions or pursue the issue with other service members. It was not favorably accepted by gays and lesbians either in or out of the armed forces. *See* GAY RIGHTS MOVEMENT.

donkey (politics) The symbol and mascot of the DEMOCRATIC PARTY. It was first drawn in a political cartoon in 1874 by Thomas Nast (1840–1902). [From a negative comment about DEMOCRATS made by the REPUBLICAN politician Ignatius Donnelley (1831–1901), "The Democratic Party is like a 'mule' (i.e., donkey) – without pride of ancestry nor hope of posterity" (a mule is the offspring of a male donkey and a female horse and cannot have offspring of its own), meaning that the Democratic Party grew out of different parties and probably would soon dissolve. Democrats embraced this mascot because a donkey is recognized for being determined.]

Doonesbury (media) A four-panel comic for adults which relates the political and personal stories of its characters, who are former 1960s COMMUNE members and HIPPIES. It also satirizes contemporary political life, especially in WASHINGTON D.C., as well as social issues all over the country. It is created by Garry Trudeau (born in 1948), who has won a PULITZER PRIZE for it. Often because of its adult humor and/or content, it is found on the

editorial page and not with the FUNNY PAGES. *See* EDITORIAL.

door-to-door (daily life) Describing the action where an individual visits different residences by ringing the doorbell and speaks to the resident at the front door (i.e., does not enter the house or apartment). This technique is used to sell products, to do CANVASSING for politicians and political issues, to promote religious ideas and to participate in TRICK-OR-TREATING. *See* JEHOVAH'S WITNESSES, AVON.

dorm(itory) (education) The on-CAMPUS living facilities of a SCHOOL[1] or COLLEGE[3] for students currently enrolled in that institution. It is divided into student rooms each of which has a sleeping area, studying area and shower and toilet facilities. Frequently, it has a general cafeteria which provides all resident-students with prepared meals three times a day. Students usually pay for ROOM AND BOARD services once a TERM[2]. Formally known as "dormitory".

double (sports and leisure) In BASEBALL, a successful hit of the ball with a bat which allows a batter to run past FIRST BASE and safely to SECOND BASE. *Compare* SINGLE, TRIPLE.

double consciousness (minorities) A concept first used by W.E.B. DU BOIS which states that blacks possess two souls or ways of thinking: one which is American and the other African.

double feature (the arts) Two different movies which are shown one after the other; the ticket cost for admission is that of one movie.

double jeopardy (legal system) Accusing and trying an individual twice for the same crime or offense. Citizens are protected from this by the FIFTH AMENDMENT. *See* ACQUITTAL.

doubleheader (sports and leisure) When two sporting games, usually in BASEBALL, are played in succession on the same day; either between the same two teams or different teams. By association, a double event.

doughboy (military) During World War I, the popular nickname for American ARMY soldiers in Europe. [Origin unknown.]

doughnut/donut (food and drink) A small breakfast cake, often in the shape of a thick ring (with a hole in the middle), made of sweetened or unsweetened dough fried in deep fat and eaten for breakfast, brunch or as a snack with coffee. By association, any type of sweetened breakfast cake, regardless of shape. *Compare* BAGEL, CUPCAKE.

Douglass, Frederick (people) (1818–1895, born Frederick Augustus Washington Bailey) Abolitionist, writer, speaker, editor and supporter of the WOMEN'S RIGHTS MOVEMENT. He escaped from SLAVERY in Maryland at the age of 20 and went to BOSTON where he then worked for the Massachusetts Anti-Slavery Society to end slavery through federal legislation. He supported the CIVIL WAR as a method of abolishing slavery and helped recruit black troops to fight for the NORTH; further, he provided advice to PRESIDENT ABRAHAM LINCOLN. He is remembered and respected for his eloquence in written articles, speeches and autobiographical books, namely, *Narrative of the Life of Frederick Douglass, An American Slave* (1845), *My Bondage and My Freedom* (1855) and *The Life and Times of Frederick Douglass* (1881) all of which treated the moral wrong of slavery, LYNCHING and JIM CROW laws and argued for their termination. *See* SENECA FALLS, ABOLITION.

dove (foreign policy) A person who does not support war and/or military action; especially during the VIETNAM WAR. [This small bird, usually carrying an olive branch, is the traditional symbol of peace.]

Dow Jones (Industrial Average) (economy) (DJIA) The numerical average which is used to indicate the general strength and movements (i.e., gains or losses) of the US business market. The DJIA is figured by averaging the CLOSING PRICE values of the stocks of 30 different industrial BLUE CHIP companies, which are actively traded on the NEW YORK STOCK EXCHANGE. It has been published daily by *THE WALL STREET JOURNAL* since 1889 and is the most widely-used market figure to indicate the condition of the US economy. In general, the higher the number, the healthier the economy: in the first QUARTER[4] of 1995 the DJIA surpassed

4,000 points; in the last QUARTER[4] of 1996, the DJIA surpassed 6,000 points; in the first QUARTER[4] of 1998, the DJIA surpassed 9,000 points. [After Charles 'Dow' (1851–1902) and Edward 'Jones' (1865–1920) the co-founders of this system.] Popularly known as the "Dow Jones" and/or the "blue chip index".

Dow Jones Averages (economy) Any one of the different averages, including the DOW JONES INDUSTRIAL AVERAGE, which are used as market indicators. [After Charles 'Dow' (1851–1902) and Edward 'Jones' (1865–1920) the co-founders of this system.]

down (1, 2 sports and leisure) **1** In FOOTBALL, one of a set of four chances or plays that an offensive team has to move the ball forward into the territory of the defending team and try to score. A team must advance the ball 10 yards (9.1 m) within these four chances or else it loses possession of the ball. Meanwhile, if it does advance the ball the required yardage, the team receives a FIRST DOWN[2]. **2** By association, a collective name for the complete set of four chances when they are a part of a larger plan of play.

down-easter/Down-Easter (society) A resident of the northeastern STATE of Maine. This person is characterized as not speaking much and being wary of strangers. **"Down East"** is a nickname for Maine. [Boats which sailed from BOSTON harbor to Maine had to sail 'east' 'down' to get to Maine because of the prevailing winds.] See YANKEE[2].

downsizing (1, 2 economy) **1** Reducing (e.g., through firing, offering early retirement) the number of employees or staff in a business or governmental agency. **2** Designing smaller products or programs.

downtown (geography) In a city, the central business and commercial area. In NEW YORK CITY, it encompasses the southern part of MANHATTAN[1], including GREENWICH VILLAGE and WALL STREET. By association, something that is casual or worker-related. [From the location of most early cities on the low (i.e., 'down') land near rivers and waterways which were used to transport commercial products for business.] Compare UPTOWN.

draft, the (1 military; 2 sports and leisure) **1** A system that selects men from a specially compiled list requiring those selected to serve in the ARMED FORCES during a wartime situation. This list is compiled and updated by the Selective Service System, an independent agency of the federal government, and is only activated during a national security crisis. All men between the ages 18 and 26 years must register with the draft. "Draft resistance" was common during the VIETNAM WAR, especially from 1967 to 1973. **2** An annual process in which a professional sports team (e.g., NFL, NBA, and the MAJOR LEAGUES) chooses new players from a list of eligible, currently amateur players (usually from COLLEGE[1]-level sports teams). The team with the worst record in the previous season gets to choose the first player in the draft. The players picked in the first round of this draft are usually the best, new players in that sport. Once a player is chosen by a team, the team controls the contract of that player and can trade that player to another team. Also known as "player draft"; compare FREE AGENT, FARM TEAM.

drag racing (sports and leisure) A short, speed car race between two or more cars. The car which goes from a stationary position to the finish line fastest, wins.

dream team (sports and leisure) A nickname for any sports team composed of the best and most talented athletes. Often it is composed for a short time period or only for a few games. By association, any team (e.g., legal defense team of LAWYERS) composed of talented members. See ALL-STAR GAME.

Dred Scott v. Sanford (legal system) The infamous DECISION of the US SUPREME COURT (1857) stating that blacks were not citizens of the UNITED STATES and could not become citizens. The decision also declared that the MISSOURI COMPROMISE, an act of CONGRESS, was UNCONSTITUTIONAL. The controversy over this case helped lead to the CIVIL WAR. The case concerned 'Dred Scott' (1795–1858), a black man who was born a slave in the SOUTH but was taken to a non-slave STATE in the NORTH where he claimed he was then free of SLAVERY because he was a

citizen of the US. This *Dred Scott* decision ruled that he was not free, because blacks were not US citizens but property. *See* FOURTEENTH AMENDMENT; *compare* NATURALIZATION ACT OF 1870.

drill team/squad (sports and leisure) A group of women (numbering at least 40) who perform synchronized dance steps and high kicks while standing in lines and geometric figures. All the members of this group wear identical uniforms, usually consisting of shiny and short, body-fitting suits, knee-high boots and sometimes hats. They frequently perform to music (e.g., MARCHING BAND) as half-time entertainment at FOOTBALL and BASKETBALL games. This is an EXTRACURRICULAR ACTIVITY at many HIGH SCHOOLS and COLLEGES[1]. Often, the name of the squad is unique to the SCHOOL[5] or organization; it is derived from adding the suffix "-ette" to the name of the SCHOOL's[5] mascot. *Compare* CHEERLEADER, FLAG CORPS, ROCKETTES.

drinking age (legal system) The age of 21 (in all 50 STATES and the DISTRICT OF COLUMBIA) when a person can legally enter a BAR[1], and can buy alcoholic drinks and beverages (e.g., beer, wine, liquor). *See* RITE OF PASSAGE[1], ID CARD.

drive through (daily life) A general term describing any organization offering a short and quick service to people (e.g., banking, shopping, FAST FOOD restaurant), designed for them to access from their cars and afterwards expecting them to leave immediately.

drive-in (daily life) A general term describing any place offering a service which people can use while still in their cars (e.g., drive-in movie). *Compare* DRIVE THROUGH.

driver's license (transportation) A permit to legally drive an automobile that a STATE issues to a person who is usually at least 16 years of age, and who has passed both a written driving exam (treating the rules of driving) and a practical driving exam. In most states, it is a rectangular plastic card which shows a picture of the permit holder and lists that person's name, legal address, and whether he or she is an ORGAN DONOR. It is a popular type of ID CARD.

dropout (education) A student who quits SCHOOL[5] with no intention of returning. By association, any person who leaves a position or task without finishing it.

Drug Czar (government) The popular title for that person who heads the Office of the National Drug Control Policy. This person is a member of the CABINET and oversees that office which works with federal, STATE and local programs to control and limit illegal drug use and abuse. This office is a part of the EXECUTIVE OFFICE OF THE PRESIDENT. The position was created in 1988 by the National Narcotics Leadership Act.

Drug Enforcement Administration (government) (DEA) The federal agency and part of the DEPARTMENT OF JUSTICE created in 1973, responsible for enforcing laws of transport and regulation concerning illegal drugs (i.e., narcotics) and other controlled substances (e.g., prescription drugs) in, from and to the US.

drugstore (daily life) A store selling a variety of products, namely for beauty and body care (e.g., shampoo, razors, lotions), miscellaneous items (e.g., magazines, camera film), seasonal items (e.g., holiday decorations, summer beach balls) and non-prescription drugs (e.g., aspirin). Sometimes, it may also house a separate PHARMACY within it.

dry (food and drink) Describing a city, COUNTY or STATE where the sale of alcohol and alcoholic drinks is limited by law (e.g., not sold on Sundays) or totally forbidden. *See* BLUE LAWS.

Du Bois, W[illiam] E[dward] B[urghardt] (people) (1868–1963) Author, editor, PROFESSOR, African-American intellectual, women's rights advocate and CIVIL RIGHTS activist. He was the first AFRICAN AMERICAN to receive a PhD from HARVARD UNIVERSITY. He founded the NIAGARA MOVEMENT, was a member, then critic of the NAACP and edited its journal, *CRISIS*. His best-known work is *THE SOULS OF BLACK FOLK* (1903). His published writings address the wrongs of racial segregation and discrimination against blacks. His solutions to American racism and political views ranged from white and black integration to BLACK NATIONALISM. He did not approve of BOOKER T. WASHINGTON's

ideas. He is recognized for his influential writings and continual calls for equal rights for blacks. *See* DOUBLE CONSCIOUSNESS.

dual federalism (government) A type of FEDERALISM in which the governments at the federal, STATE and local levels each have unique duties and responsibilities and the freedom to enforce them; yet together, they serve all the needs of the citizens. It can be enforced through BLOCK GRANTS. During the NIXON ADMINISTRATION, it was known as "New Federalism". *Compare* CO-OPERATIVE FEDERALISM.

duck boots (clothing) A type of sturdy, mid-calf, lace-up boot with a leather ankle support and water-proof ridged, rubber soles and rubber foot-casings. It is popularly worn by fisher people, outdoorspeople and hunters.

dude ranch (sports and leisure) A type of ranch which is run as a vacation location for paying guests. It provides guests with ROOM AND BOARD, sometimes camping, and offers them experiences with different but typical COWBOY[1] activities, namely, horseback riding, cattle roping and other RODEO[1] activities.

due process (of law) (legal system) The collective phrase, meaning the rights given to those people accused of committing a crime, namely: a quick, public trial with a neutral JURY; and further, the promise of the government not to take the life, freedom or belongings from a person until all of these conditions have been fulfilled. It is promised to the people by the FIFTH AMENDMENT and FOURTEENTH AMENDMENT. *See* GIDEON V. WAINWRIGHT, CRIMINAL LAW.

dugout (sports and leisure) In BASEBALL, a roofed-over area outfitted with benches where managers and extra players sit, watch the game and wait to play. Usually, it is located several feet lower than the level of the field.

DUI (transportation) An abbreviation for 'Driving (a vehicle) Under the Influence' of alcohol or drugs. It is an offense nationwide for which the offender receives a fine. Formerly known as "DWI" ('D'riving 'W'hile 'I'ntoxicated).

Dunbar, Paul Lawrence (people) (1872–1906) An African-American poet and writer who wrote the English language in a way which simulated oral speech (i.e., BLACK ENGLISH). His works related what it meant to be a black person and were especially popular with white readers in the NORTHEAST and England.

Dust Bowl, the (geography) A nickname for the STATES of Oklahoma and Arkansas during the GREAT DEPRESSION and the droughts of the 1930s, which left the once rich farmland too dry, too dusty and poor for farming, and therefore forced many citizens ("Okies" and "Arkies") from these areas to migrate to the WEST. By association, any dry, poor, empty space. *See* JOHN STEINBECK.

Dutch oven (food and drink) A large, heavy pot with a lid which is usually made of cast iron and frequently used for making soups, stews and POT ROASTS.

Dutch treat (food and drink) A meal eaten by two people or more in which each person pays for his or her own portion of the CHECK[2]. Also known as "to go Dutch".

Dylan, Bob (people) (born Robert Zimmerman in 1941) Singer, songwriter, and composer. He began his career as a FOLK MUSIC singer in the 1960s by writing poetic songs that criticized social problems, racism and the COLD WAR, especially "A Hard Rain's Gonna Fall". He is recognized as a diverse artist and for experimenting with songs in different music styles, namely, folk-rock, heavy rock, Christian GOSPEL MUSIC, COUNTRY MUSIC and love songs. He converted from Judaism to Christianity after having a serious motorcycle accident in 1966. *See* WOODSTOCK, COUNTERCULTURE, WOODY GUTHRIE.

E

E Pluribus Unum (customs and traditions) Since 1776, the motto of the UNITED STATES OF AMERICA. It is used to decorate official US documents, the GREAT SEAL and US monetary coins. It is also the official motto of the SENATE of the UNITED

STATES. [Latin, meaning "out of many, one".]

"*Eagle* has landed", "The" (science and technology) A confirmation comment that NEIL ARMSTRONG made to the mission control room at NASA, that he had landed successfully on the moon in the APOLLO 11 lunar module named *Eagle*. *See* APOLLO PROJECT.

earned run (sports and leisure) In BASEBALL, the successful running from HOME PLATE to FIRST BASE that a batter achieves by hitting a ball that is thrown to him/her. *See* ERA1.

Earth Day (customs and traditions) April 22, when people celebrate the environment and promote conservation efforts through local GRASSROOTS activities, especially speeches, recycling programs, nature hikes, volunteering to pick up garbage in parks and wild areas as well as other outdoor activities. It was first OBSERVED[2] in 1970; its biggest celebrations were in 1970 and 1990. It is not a LEGAL HOLIDAY.

Earth First! (environment) (EF) A radical local movement which supports causes and interests of the ENVIRONMENTAL MOVEMENT. It was founded in 1980 and is based in Arizona; however it does not have any members. Rather, interested people participate in its activities at the GRASSROOTS level. Its critics find it controversial because of its aggressive DIRECT ACTION techniques to save or promote environmental issues. *See* TREE HUGGER, EDWARD ABBEY.

East, the (geography) All the STATES east of the MISSISSIPPI RIVER, including those areas in the NORTH and the SOUTH.

Easter (customs and traditions) A Sunday in late March or April celebrating the religious belief of Christians that Jesus Christ came back from the dead. On this day Christians celebrate the resurrection of Christ; this event is the major Christian holiday of the year (*compare* CHRISTMAS DAY) and is celebrated by religious Christians as well as by the secular community. Christians recognize this event by attending religious services in the morning and sharing with their families a large meal which usually includes ham or mutton. It is also a secular event in which the children of Christian and non-Christian families participate in EASTER EGG HUNTS and receive baskets of candy from the EASTER BUNNY. Often, non-Christians also spend the day with their family by sharing a meal. Many shops and restaurants are closed on this day; this holiday is popular with most young children. Its secular symbols are bunnies, young chicks, colored Easter eggs, JELLY BEANS and pastel colors. It represents the arrival of spring. [After 'Eastre', the ancient, germanic pagan goddess of spring.] *See* EASTER MONDAY, EASTER EGG ROLL, SECULARISM.

Easter Bunny (customs and traditions) The folkloric bunny, rabbit or hare that hides the brightly-colored eggs used in an EASTER EGG HUNT and leaves baskets of JELLY BEANS and chocolate candy for children on EASTER Sunday. Sometimes during the months of March and April, he may be found in a booth in a SHOPPING MALL which children can visit to tell him which particular gifts they want to receive on Easter. (Actually, the children's parents perform these tasks.) Sometimes he is also known as "Peter Cottontail" from a popular children's song "Here comes Peter Cottontail, Hopping Down the Bunny Trail" (1949).

Easter egg hunt (customs and traditions) An organized game in which the EASTER BUNNY hides brightly-colored decorated eggs (i.e., edible hard-boiled eggs, plastic eggs filled with JELLY BEANS or chocolate eggs wrapped in brightly-colored foil) in a house or YARD and that children must look for and collect in a specially decorated Easter basket. It is a traditional but non-religious event held on EASTER Sunday. *See* SECULARISM; compare EASTER EGG ROLL.

Easter egg roll (customs and traditions) An organized children's game in which each child participant uses a long-handled spoon to roll decorated eggs across the YARD or down a slope without breaking the eggs' shells. The most famous one is held the Monday after EASTER on the lawn of the WHITE HOUSE and has been sponsored by the PRESIDENT since 1878. *Compare* EASTER EGG HUNT.

Easter Seals (health) The popular name for the National Easter Seal Society, a

NONPROFIT ORGANIZATION founded in 1919 to help children and adults who are DISABLED, especially through raising money, conducting health programs (e.g., physical therapy, speech therapy) and promoting federal legislation which helps disabled people.

Eastern (Standard Time) (daily life) (EST) The clock time of those geographical areas located between the Atlantic Ocean and the GREAT LAKES and APPALACHIAN MOUNTAINS. Because this is the time zone of some large, major cities (e.g., NEW YORK CITY, WASHINGTON D.C., BOSTON, ATLANTA) it is often listed first for special events and television programs and as the standard time of the US. It corresponds to the Eastern time zone.

easy listening (media) (EZ) A radio station format that plays popular music, especially love songs, instrumental music as well as music from movies and MUSICALS.

Ebbets Field (sports and leisure) The home stadium to the professional BASEBALL team the BROOKLYN DODGERS (from 1915 to 1957) located in BROOKLYN, NEW YORK. After the team moved to California and became the "Los Angeles Dodgers", it was torn down in 1960 in order to make room for an apartment complex much to the regret of the loyal, local baseball fans. *See* HOME TEAM, Appendix 3 Professional Teams.

Ebonics (language) A controversial language-educational policy that promotes the use of BLACK ENGLISH in SCHOOLS[1], to teach CORE CURRICULUM courses or, in some cases, teaching and treating it as a second, separate or foreign language. Supporters claim that it is a separate language and therefore promotes black pride and reveals African-American culture. Critics and opponents argue that it is discriminatory because it teaches African-American students a form of the English language which they cannot use in the future for business, work or politics. These opponents want young black people to learn to speak and write GENERAL AMERICAN ENGLISH. In 1996, it was proposed by the Oakland, California SCHOOL BOARD to be taught as a separate language; but because of this controversy, it was not taught. [From 'Ebo'ny Pho'nics'.]

Ebony Man (media) (EM) A monthly magazine for black men with regular articles on health, sports and fashion; its circulation is 200,000.

Ebony (media) A monthly magazine for black, middle-class readers, carrying articles and editorials from the African-American point of view on politics, business, contemporary black issues, sports and arts. It was established in 1945 and has a current circulation of 1.8 million.

ecosystem (environment) A complex, intricate system of different patterns of life of various animal and plant life forms in a given area. It includes the birth, food supply, mating, reproduction, nesting habits and needs of the smallest animals and plants (e.g., insects, frogs, birds, algae, water plants) up to and including larger animals and plants (e.g., deer, bear, trees). Any natural program promoting an ecosystem is committed to saving all the life forms it supports, not individual species with it. *Compare* ENDANGERED SPECIES ACT, SPOTTED OWL.

ecumenism (religion) A policy of co-operation between different denominations of a religion or between different groups of religions by concentrating on the common goals or beliefs (e.g., fighting world hunger; fighting DISCRIMINATION; for Christians, believing in Jesus Christ). **Ecumenical** policies ignore the differences between CHURCHES[2] (e.g., the rules of independent churches, church hierarchy).

Edelman, Marian Wright (people) (born in 1939) A LAWYER known for helping MINORITIES and children through the legal court system. She is the president and founder of the CHILDREN'S DEFENSE FUND (since 1973). She has also worked for the NAACP LEGAL DEFENSE AND EDUCATIONAL FUND.

Edison, Thomas Alvin (people) (1847–1931) Inventor. He held over 1,000 patents for different inventions including the phonograph and incandescent (i.e., "bright") electric lamp. His laboratory was located in Menlo Park, New Jersey, and he was nicknamed the "Wizard of Menlo Park".

editorial (media) An opinion piece (either an oral statement or a written

article) where a person comments on current affairs. It is prepared by a single "editor" or several individuals of an "editorial board". *Compare* OP-ED PAGE.

Edwards Air Force Base (military) A military base of the AIR FORCE established in 1933 and located in the MOJAVE DESERT. This base was an important military area during WORLD WAR II. Today, the SPACE SHUTTLES often land here.

EFL (education) English language courses provided to a person whose native language is not English, and who is not living in an English-speaking country. [Abbreviation of 'E'nglish as a 'F'oreign 'L'anguage.] *Compare* ESL, ESP.

egg nog (food and drink) A thick, creamy CHRISTMASTIME drink made of eggs, milk and sugar mixed with alcohol, usually rum or BOURBON. It is served warm or at room temperature.

eggs Benedict (food and drink) A breakfast dish of a sliced, toasted ENGLISH MUFFIN covered with a slice of cooked ham and poached eggs topped with hollandaise sauce (i.e., a rich yellow sauce of butter, egg yolks and lemon juice). [Supposedly after Mr. and Mrs. 'Benedict', regular customers at Delmonico's, a hotel in Mid-town MANHATTAN[1], who frequently requested this dish.]

Eighteenth Amendment (government) The AMENDMENT to the CONSTITUTION (1919) that made PROHIBITION legal in the UNITED STATES. It was reversed in 1933 by the TWENTY-FIRST AMENDMENT.

Eighth Amendment (legal system) The AMENDMENT to the CONSTITUTION (1791) that protects persons accused of committing a crime by forbidding law organizations and police officers from charging a very high price for BAIL or for other fines as well as causing CRUEL AND UNUSUAL PUNISHMENT.

Eisenhower, Dwight D. ("Ike") (people) (1890–1969) General in the US ARMY and REPUBLICAN US PRESIDENT (1953–1961). During WORLD WAR II, he served as the Supreme Commander of the Allied Forces in Europe and led the Normandy invasion on June 6, 1944. His CAMPAIGN slogan was "I like Ike". During his presidency, he promoted COLD WAR policies and encouraged an armistice to settle the

KOREAN WAR. In addition, he favored the free-market system and limited the government's involvement in business. *See* LITTLE ROCK NINE, Appendix 2 Presidents.

El, the (transportation) The public transportation system in DOWNTOWN CHICAGO which rides on an elevated track and platform above automobile traffic as well as underground as a subway. Its tracks form the circle of the LOOP. [Clipping of 'el'evated train.]

El Niño (environment) In the Pacific Ocean along the coasts of South America, the movement of warm water near the ocean's surface level which causes geographic changes in North America and South America, namely: an unusually large amount of rainfall in typically dry areas; warm weather during typically cold months; heavy winter snowfalls; as well as a decrease in the population of sea fish living in the ocean waters along the coastlines. Often, this situation occurs annually and affects the weather (i.e., more rainfall and violent tropical storms) in the UNITED STATES from California to Florida, as well as in South America and Central America. Because it can cause so many different types of weather and environmental occurrences, it is jokingly blamed for other unusual or unexplainable occurrences in American culture, politics and economics. [Spanish for "the child", meaning the "christ child" because these changes first begin to appear near CHRISTMAS DAY.]

elastic clause (government) An alternative name for the NECESSARY AND PROPER CLAUSE.

elder statesman/woman (government) An older, more educated and/or experienced individual who has served the public (e.g., in political office) in the past and thus can provide current advice and/or assistance to other, often younger individuals presently active in that field (e.g., new politicians, CONGRESSMEMBERS, PRESIDENT). Usually, he or she is respected by the public for this knowledge, experience and interest in the public good. By association, any older, more experienced individual in any field.

Election Day (customs and traditions) The first Tuesday after the first Monday in November when citizens aged 18 and

older vote for elected officials for federal, STATE and local positions (e.g., PRESIDENT, SENATORS, mayors) and REFERENDUMS. It is not a LEGAL HOLIDAY. *See* VOTER REGISTRATION.

elective (education) A course that students choose to take which is not a CORE CURRICULUM course. Electives are offered at most SECONDARY SCHOOLS and COLLEGES[3] to promote a well-rounded education.

elector (politics) A person chosen by the voters in a STATE to vote (i.e., 'elect') the PRESIDENT and VICE PRESIDENT in the ELECTORAL COLLEGE. Each elector has one ELECTORAL VOTE; there are 538 total electors. This number of electors is compiled in the following manner: the number of electors for each state is the same as the number of SENATORS (i.e., 100) plus the number of REPRESENTATIVES (i.e., 435) that each state currently has in CONGRESS (i.e., 535), as well as three additional electors from the DISTRICT OF COLUMBIA, which makes a grand total of 538 electors. An elector is never a CONGRESSMEMBER. *See* TWENTY-THIRD AMENDMENT; *compare* DELEGATE.

electoral college (politics) An indirect method of electing the PRESIDENT and VICE PRESIDENT that was created by the CONSTITUTION and uses a WINNER-TAKE-ALL system. On a day in December, after ELECTION DAY, ELECTORS meet in the STATE capitals to vote for the candidate with the largest number of POPULAR VOTES in their respective STATES. The ELECTORAL VOTES are counted and the presidential candidate who receives 270 electoral votes formally wins the election. The names of the winning candidate and his or her RUNNING-MATE are announced in January during a JOINT SESSION of CONGRESS. *See* TWELFTH AMENDMENT.

electoral votes (politics) The votes of the ELECTORAL COLLEGE. There are 538 total votes, therefore, each ELECTOR has only one vote. A candidate for PRESIDENT must receive 270 electoral votes to win the election. *See* TWENTY-THIRD AMENDMENT; *compare* POPULAR VOTE.

electronic church (religion) Using television or radio programs or computer networks to broadcast church services, preach religious lessons or other messages. It is frequently used by FUNDAMENTALISTS, EVANGELICALS and other PROTESTANT groups. It includes TELEVANGELISM. *See* RELIGIOUS RIGHT, PAT ROBERTSON, MORAL MAJORITY, PTL.

Elementary and Secondary Education Act (education) (ESEA) A federal law (passed in 1965) that provided assistance to SCHOOL DISTRICTS with large numbers of students from poor or low socio-economic households. It established UPWARD BOUND, Operation HEAD START and other programs and was an important part of PRESIDENT LYNDON JOHNSON'S WAR ON POVERTY strategy. It set a strong precedent for federal government involvement in PUBLIC SCHOOL education.

elementary school (education) A compulsory SCHOOL[1] for students from GRADES[1] one through eight. It can also refer to a SCHOOL[1] from GRADES[1] one through four when it is connected to a MIDDLE SCHOOL and JUNIOR HIGH SCHOOL. Some elementary schools include a KINDERGARTEN. *See* Appendix 4 Education Levels.

elephant (politics) The mascot and symbol of the REPUBLICAN PARTY. It was first created in 1874 by the cartoonist, Thomas Nast (1840–1902). [From the political cartoon drawing showing a "political jungle" in which the image of a big elephant represented the large number of votes that the REPUBLICAN PARTY had in that election.]

Eleventh Amendment (legal system) The AMENDMENT to the CONSTITUTION (1798) which does not allow a person from one STATE (or a foreign country) to bring a LAWSUIT against a different state.

Ellington, Duke (people) (1899–1874, born Edward Kennedy Ellington) Pianist and composer-arranger of JAZZ MUSIC and band leader of a SWING MUSIC band. He and his band became famous performing at the COTTON CLUB (from 1927 to 1931) and for the sensual, tonal style of the music. His band's theme song was "Take the 'A' Train". [Nicknamed 'Duke' as a young man because of his elegant clothing.]

Ellis Island (immigration) The main immigration station and detention center

of the UNITED STATES which received immigrants and briefly housed them while certain procedures and tests were administered (e.g., registering individuals' names and birthdates; administering medical examinations) before officially allowing them to enter the country and NEW YORK CITY. During the years that it was active, from 1892 to 1954, it accepted some 12 million immigrants (mostly coming from Europe). After massive renovations, it was reopened in 1990 as a museum of immigration; it is now a part of the "Statue of Liberty National Monument". By association, it refers to immigration and/or immigrants. [After the name of the island, 'Ellis Island', which it sits on in the harbor of New York City.] *See* STATUE OF LIBERTY, NATIONAL MONUMENT; *compare* ANGEL ISLAND, IMMIGRATION AND NATURALIZATION SERVICE.

Emancipation Day (customs and traditions) May 8 or June 19 (it depended on the community), after the CIVIL WAR, a day on which blacks in the SOUTH celebrated the EMANCIPATION PROCLAMATION. Although it was not a LEGAL HOLIDAY and none of the businesses closed, AFRICAN AMERICANS did not go to work that day. It was celebrated between the CIVIL WAR and the CIVIL RIGHTS MOVEMENT, but is not celebrated today. *Compare* MARTIN LUTHER KING, JR. DAY.

Emancipation Proclamation (history) A law made by PRESIDENT ABRAHAM LINCOLN which gave freedom to all the slaves who were living in "areas still in rebellion" (i.e., the SOUTH). It went into effect January 1, 1863. This law helped the morale of the UNION[3] forces and seriously hurt the morale of the forces of the Confederacy. *See* CONFEDERATE STATES OF AMERICA, EMANCIPATION DAY.

emcee (the arts) During a live or televised event, the individual who introduces the acts and performers and makes jokes in between acts. [Acronym from 'M'aster of 'C'eremonies.] It is an alternative spelling to MC[1].

Emerson, Ralph Waldo (people) (1803–1882) Writer and former PROTESTANT religious minister. He supported and wrote about the ideas of individualism and self-reliance in his books of essays *Nature*

(1836) and *Essays* (1841 and 1844). His works helped develop TRANSCENDENTALISM and influenced many other writers and artists, namely, HENRY DAVID THOREAU, WALT WHITMAN and EMILY DICKINSON. *See* AMERICAN RENAISSANCE.

EMILY's List (politics) An active political network, founded in 1985, that raises funds and donates this money to the political CAMPAIGNS of female candidates of the DEMOCRATIC PARTY who support PRO-CHOICE. [Initials of the group's motto 'E'arning 'M'oney 'I's 'L'ike 'Y'east; in order to grow the baking ingredient of yeast, one must have yeast.]

Emmett Till case (minorities) The case concerning Emmett Till (1941–1955), a young black boy from the NORTH who had been murdered while visiting the SOUTH in La Flore County, Mississippi. According to reports, Till was last seen alive on August 24, 1955, in a local Mississippi shop where he had spoken with a white woman, reportedly asking her for a DATE. Later (August 27), Till's dead body was recovered from the local Tallahatchie River in very poor condition; there was a bullet in the head and the body was seriously decomposed. Two white men were accused of killing the boy, however they claimed that they did not kill him. The CRIMINAL TRIAL of these two white men ended when the JURY's all white members gave them an ACQUITTAL for the murder because identifying Till's body was too difficult due to the advanced state of decomposition. The trial received national attention by both the white and black media and is a symbol of the racism and the unfair justice system for blacks in the South during this period. It was memorialized in JAMES BALDWIN's 1964 play "Blues for Mister Charlie".

Emmy Awards, the (the arts) The annual television awards given to honor the year's best TV programs and broadcasting. Awards are presented in the following categories: the best drama series, comedy series, mini-series, lead actress, lead actor, director, PRIME TIME program, daytime program. They have been presented by the Academy of Television Arts and Sciences since 1949. The award, an "Emmy", is a small statue of a woman

with wings holding a sphere. [From 'Immy', a shortened form of "image-orthicon", a special tube used in a television set; a typographical error made it 'Emmy'.]

Empire State Building, the (housing and architecture) The tall building consisting of 102 stories and measuring 1,250 feet tall (381 m); counting its television tower, it is 1,414 feet tall (430 m). It is totally decorated in Art Deco motifs and designs and contains business offices. It was opened in 1931 and for many years was the tallest building in NEW YORK CITY. Its 86th floor is a popular, public lookout point offering a panoramic view of the entire city. It was designed by the company Shreve, Lamb and Harmon. It was the building that the large ape, King Kong, climbed in the film *King Kong*. Today, it is the symbol of MANHATTAN[1]. [After the nickname of the STATE of New York, "the 'Empire State' ".] *Compare* WORLD TRADE CENTER, CHRYSLER BUILDING.

end zone (sports and leisure) In FOOTBALL, the rectangular area measuring 10 yards long and 160 yards wide (9.1 m long and 49 m long) located beyond the playing field. An offensive player must bring the ball into this area to score. Each field has two end zones; the goal post of each team stands on the outer edge of this area. Often, the name and mascot of the HOME TEAM is written in white powder or paint in these areas.

Endangered Species Act (environment) (ESA) The federal law (first passed in 1973) and its AMENDMENTS (1982, 1988) which protects those animals which are in danger of becoming extinct, especially by stopping federal projects in those areas which would destroy the habitat of those animals. *See* SPOTTED OWL.

endorsement (1 politics; 2 sports and leisure) **1** The official public support that an organization, PAC, magazine, newspaper or public figure or leader gives to a political candidate. Groups **endorse** that candidate who best represents their ideas and interests. **2** The contract between a company and a professional athlete for promoting a company's particular product (e.g., shoes, clothing, equipment). By association, the money paid to

this professional athlete for promoting these products.

endowment (the arts) A gift of money that a private business, foundation or individual gives to some organization, usually to artistic groups, SCHOOLS[5] and/or religious organizations.

enfranchised (legal system) Describing someone who has the rights of citizens, especially the legal right to vote. The voting right was given to black men by the FIFTEENTH AMENDMENT (1870), to all women by the NINETEENTH AMENDMENT (1929) and to citizens aged 18 years or older by the TWENTY-SIXTH AMENDMENT (1971). *Compare* DISENFRANCHISED.

Engel v. Vitale (religion) The DECISION of the SUPREME COURT (in 1962) which stated that PUBLIC SCHOOL students could not be forced to say religious prayers while at SCHOOL[6]. It stated that SCHOOL PRAYER was not legal because of the ESTABLISHMENT CLAUSE. The case concerned a ruling of the New York STATE BOARD OF REGENTS that encouraged all public school students in the SCHOOL DISTRICT to say a non-denominational prayer every day. The AMERICAN CIVIL LIBERTIES UNION and 10 students sued the SCHOOL[1] and won; the students did not have to say the prayer.

English as a Second Language (education). *See* ESL.

English muffin (food and drink) A round, flat yeast bread which is sliced into halves, toasted and served for breakfast with butter, jelly or jam toppings. *See* EGGS BENEDICT; *compare* MUFFIN.

ensemble (the arts) A group of musicians, especially of JAZZ MUSIC, who play music together. By association, describing music that is played by a group (i.e., the opposite of "solo", individual playing).

entitlements (government) The benefits (usually money) from government programs (e.g., SOCIAL SECURITY, CIVIL SERVICE retirement benefits) that are given to individuals or organizations that qualify (i.e., who fit the economic descriptions of that program which is designed to help them).

entree (food and drink) The main course of a DINNER or evening meal; it comes after the APPETIZER and/or soup

and before dessert. [French *entrée*, meaning "entrance".]

entrepreneur (economy) An individual who organizes and owns a business and takes responsibility for the success and failure of that business. *Compare* CORPORATION, SHAREHOLDER.

enumerated powers (government) The powers given to the UNITED STATES federal government that are clearly and specifically listed in the CONSTITUTION.

environmental movement (environment) A collective name for the various groups and organizations which work to preserve the environment. This movement believes in reserving natural areas as wild spaces, preserving endangered species and ECOSYSTEMS, and not changing natural spaces (e.g., it does not support dams or mining for resources). Although it grew out of part of the CONSERVATION MOVEMENT, it is considered to have begun after the publication of *SILENT SPRING* (1962) and to have reached high levels of support in the celebrations of EARTH DAY in 1970 and 1990. It is particularly strong in the WEST; some of the major groups include SIERRA CLUB, NATIONAL AUDUBON SOCIETY and EARTH FIRST!. *See* RACHEL CARSON, EDWARD ABBEY, ALDO LEOPOLD.

Environmental Protection Agency (environment) (EPA) An independent agency of the federal government, founded in 1970, which tries to control and decrease the pollution of air and water by setting and enforcing standards by which businesses and STATES are to abide. It also manages the "SUPERFUND" program. *Compare* DEPARTMENT OF THE INTERIOR.

Episcopal Church (religion) The popular name for the Protestant Episcopalian Church in the UNITED STATES (founded in 1789 after the AMERICAN REVOLUTION). It is a PROTESTANT DENOMINATION and the American branch of the Anglican Church, the established religion of Great Britain. In the US, its members read and follow the Bible and a modern version of the *Book of Prayer* (1979). It is led by an American Bishop who works under the authority of the British Archbishop of Canterbury in England. Women and men may serve as ministers and bishops. It has a current membership of 2.5 million.

Episcopalian (religion) A member of the EPISCOPAL CHURCH.

Epperson v. Arkansas (education) The SUPREME COURT decision (1968) that decided that STATES could not pass laws to forbid schools from teaching Darwin's theory of evolution. *See* SCOPES MONKEY TRIAL, CONSTITUTION.

Equal Employment Opportunity Commission (work) (EEOC) The independent federal agency that investigates all complaints of DISCRIMINATION against MINORITIES and immigrants in job employment, especially in hiring, wages, work training and firing. Further, it sponsors programs to help end job discrimination. It was created in 1964 by the CIVIL RIGHTS ACT. Its five members are appointed by the PRESIDENT with ADVICE AND CONSENT of the SENATE. *See* APPOINTMENT POWER.

equal protection (of the laws) (legal system) The legal protection given to all people by the FOURTEENTH AMENDMENT.

Equal Rights Amendment (minorities) A proposed AMENDMENT to the US CONSTITUTION giving women and men legal equal rights. It states: "Equality of rights under law shall not be denied or abridged by the UNITED STATES or any STATE on account of sex." It was first proposed in 1923; in 1972 CONGRESS approved it. However, only 35 of the necessary 38 states approved (i.e., "ratified") it. Its defeat in 1978 is largely credited with a very long public campaign in which NATIONAL ORGANIZATION FOR WOMEN and other groups fought for it but other, more traditional groups, namely STOP ERA, fought against it. It is popularly known as "ERA". *See* ERA[2].

equal-opportunity employer policy (work) A policy established and enforced by a company or government office that recognizes that DISCRIMINATION in hiring, employment and the workplace can exist but is committed not to discriminate against future and current employees because of their sex, race, religion, disability or other condition. If employees have complaints about this policy, they may notify the EQUAL EMPLOYMENT OPPORTUNITY COMMISSION.

equality of opportunity (legal system) A defining element in American society

which believes that all people are entitled to the right to have the same opportunities to participate in public systems and organizations. However, it does not entail sameness, as in socialism. It is based on the US CONSTITUTION.

ERA (1 sports and leisure; 2 minorities) **1** In BASEBALL, a numerical figure which indicates the skill of a PITCHER in a particular game. It is figured by the number of RUNS batters earned off a pitcher divided by the number of INNINGS. [Abbreviation of 'E'arned 'R'un 'A'verage.] **2** The abbreviation and popular name for the EQUAL RIGHTS AMENDMENT.

Era of Good Feeling (history) A term for the period 1817 through 1825 when James Monroe (1758–1831) was PRESIDENT and the country was marked by peace (the WAR OF 1812 was over), a strong American economy, and American patriotism. Many people had the idea that the future was to be bright for the UNITED STATES. It was a period of peace and prosperity. *See* SECOND GREAT AWAKENING, MONROE DOCTRINE, Appendix 2 Presidents.

Erie Canal (transportation) A long, man-made canal (363 miles; 584 km) important for trading and shipping which connected, by waterways, NEW YORK CITY with Buffalo, New York and then with all the cities of the GREAT LAKES. It was operated fully after 1825 and increased the commercial importance of New York City in the nineteenth century; however its use decreased after railroads were built. Today, it is part of the New York State Barge Canal.

ESL (education) English language courses provided to a person whose native language is not English, but who is living in the US, an English-speaking country. [Abbreviation of 'E'nglish as a 'S'econd 'L'anguage.] *Compare* EFL, ESP.

ESP (education) English language courses for students who want to learn to use the English language for a limited function or specific job (e.g., for business, or in the courtroom). [Abbreviation of 'E'nglish for 'S'pecific 'P'urposes.]

ESPN (media) A cable TV network and channel, established in 1979, that broadcasts sports events, sports news and the results of professional and COLLEGE[1] sports games. It has 71 million SUBSCRIBERS. [Abbreviation of 'E'ntertainment and 'S'ports 'P'rogramming 'N'etwork'.]

Essence (media) A monthly magazine designed for black working women which carries articles on relationships, personal and political issues, money, health and celebrity information. It was founded in 1970 and has a current circulation of 1 million.

establishment, the (society) A general term referring to the groups, manners, traditions, political and economic systems that operate the power of society and establish guides for social behavior. Traditionally, it has been composed of WASPs. *See* FOUR HUNDRED; *compare* COUNTERCULTURE, BABY BOOMER.

establishment clause (religion) The first part of the FIRST AMENDMENT which forbids CONGRESS and the STATES from setting up (i.e., 'establishing') or supporting (e.g., with money or laws) a national or state religion. This clause is the basis for the principle of SEPARATION OF CHURCH AND STATE. *See* SCHOOL PRAYER, *ENGEL* v. *VITALE, SCHOOL DISTRICT OF ABINGTON* v. *SCHEMPP* (and) *MURRAY* v. *CURLETT,* SCOPES MONKEY TRIAL, INCORPORATION.

ethnic minority (minorities) A type of MINORITY group in which all the members share the same race, religion, language and/or nationality and are seen as distinct, different and separate from other people in the same society. Such groups include: AFRICAN AMERICANS, HISPANICS/LATINOS, NATIVE AMERICANS, Asian Americans and JEWISH peoples. *Compare* MODEL MINORITY.

ETS (education) A private, FOR-PROFIT national testing organization which writes, administers and grades MULTIPLE-CHOICE entrance exams for both American and international students under the belief that scientifically designed tests can be used to assess student academic abilities across a wide range of different geographical areas. It is responsible for administering the TOEFL, GRE, GMAT and LSAT. Its offices are based in Princeton, New Jersey. [Abbreviation of 'E'ducational 'T'esting 'S'ervice.]

evangelical (religion) Describing a religious movement spanning several different PROTESTANT DENOMINATIONS believing in the high authority of the Bible (especially the New Testament), the importance of preaching about the Bible and the need for each individual member (including those persons raised as Christians) to experience a personal conversion to Christianity, usually through a REVIVAL. It has no CHURCH[3] hierarchy (e.g., bishops, archbishops) because it believes that each person must have a personal relationship with his or her God. In the nineteenth and twentieth centuries, it became popular and developed opinions on political and social issues, namely, it supported ABOLITION and the WOMEN'S SUFFRAGE MOVEMENT. Its views are more MODERATE than those of Christian FUNDAMENTALISTS. *See* BILLY GRAHAM, TELEVANGELISM.

Everglades, the (environment) A wild, natural area of swamps, salt-water marshes, WETLANDS and unique wildlife (e.g., alligators, egrets, ibises) located in southern Florida. Although some of it is protected by being part of a NATIONAL PARK, other areas of it are under pressure to be drained and farmed or developed. *See* DADE COUNTY, MIAMI.

Evers, Medgar (Wiley) (people) (1925–1963) Lawyer, an African-American leader of the CIVIL RIGHTS MOVEMENT and field director of the NAACP in the STATE of Mississippi. He practiced NONVIOLENT ACTION and was very active in helping blacks receive their CIVIL RIGHTS, namely by holding VOTER REGISTRATION drive projects (from 1961 until 1963). While returning to his home in Jackson, Mississippi on June 11, he was murdered by a promoter of WHITE SUPREMACY. The murderer was charged with the crime in 1964 (charges were dropped) and in 1994 when he was given a jail sentence. Evers is a symbol of the difficulties of blacks' struggle in the Civil Rights Movement during the early 1960s and the legal injustices in those cases where blacks were the victims, especially in the SOUTH. He is buried in ARLINGTON NATIONAL CEMETERY.

Everson v. Board of Education of Ewing Township (religion) The SUPREME COURT DECISION (of 1947) repeating that STATE governments cannot set up or support an official religion, but that the state should pay the costs of transporting students to PAROCHIAL SCHOOLS. *See* ESTABLISHMENT CLAUSE, FIRST AMENDMENT.

Ex parte Endo (minorities) The unanimous SUPREME COURT DECISION of December 18, 1944, stating that an American citizen claiming to be loyal to the UNITED STATES could not be detained against her or his will. This decision succeeded in terminating the WAR RELOCATION AUTHORITY and ending the internment of Japanese Americans in INTERNMENT CAMPS. The LAWSUIT was filed by the AMERICAN CIVIL LIBERTIES UNION on behalf of Miss 'Endo' Mitsuye, who was then held at the Tule Lake internment camp. *See* COMMISSION ON WARTIME RELOCATION AND INTERNMENT OF CIVILIANS.

exclusionary rule (legal system) The judicial doctrine, based on the FOURTEENTH AMENDMENT, stating that any evidence collected illegally cannot be used in a trial (i.e., it must be 'excluded' from a trial). *See* SEARCH AND SEIZURE.

executive agreement (government) An agreement between the PRESIDENT, on behalf of the UNITED STATES, and another country that functions as a TREATY but does not require the ADVICE AND CONSENT of the SENATE.

Executive Office of the President (government) A collection of top groups of staff which helps the PRESIDENT make decisions and carry out executive policy responsibilities. It includes the WHITE HOUSE OFFICE, NATIONAL SECURITY COUNCIL, OFFICE OF MANAGEMENT AND BUDGET, Council of Economic Advisers, DRUG CZAR and the Office of the VICE PRESIDENT. It was created during the ADMINISTRATION[1] of FRANKLIN ROOSEVELT.

executive order (government) A type of domestic and national rule that the CHIEF EXECUTIVE can make which becomes law without having to be approved by the legislature (e.g., CONGRESS).

Executive Order 8802 (government) The first law that prohibited DISCRIMINATION in hiring for federal jobs and contracts for government defense projects. It was signed on June 25, 1941, by PRESIDENT FRANKLIN ROOSEVELT to prevent a march

on "Washington for Jobs and Freedom" to be led by A. PHILIP RANDOLPH. *See* DEFENSE CONTRACTS, MARCH ON WASHINGTON MOVEMENT; *compare* AFFIRMATIVE ACTION, MARCH ON WASHINGTON OF 1963.

Executive Order 9981 (foreign policy) The order that desegregated the ARMED FORCES. It prohibited the SEGREGATION of men according to race, color, religion or national origin. It was signed by PRESIDENT HARRY TRUMAN on July 26, 1948.

executive privilege (government) The claim and traditional custom of a PRESIDENT that the executive branch of the government does not have to give information or evidence to CONGRESS, CONGRESSIONAL COMMITTEES and/or judicial courts concerning military, diplomatic or sensitive national security secrets. The power of this claim was limited by *US* v. *NIXON*.

Exeter Academy (education) A popular name for PHILLIPS EXETER ACADEMY.

exit poll (politics) On ELECTION DAY as citizens leave the voting booth, a type of POLLING that asks those voters how and for whom they voted. **Exit polling** is an unofficial way to predict the results of an election; however, it does not record ABSENTEE BALLOTS. *Compare* STRAW POLL.

extra point (sports and leisure) In FOOTBALL, a scoring point that is earned by a CONVERSION. It is worth one point. By association, another name for a "conversion".

extracurricular activity (education) Any SCHOOL[5]-sponsored non-academic activity that is open to all enrolled students (e.g., sports, MARCHING BAND, choir, CHEERLEADING, FLAG CORPS). These activities hold practices during the week after SCHOOL[5] hours and usually perform on the WEEKENDS. Usually, students can only participate in these if they are passing their academic courses. *See* LETTER, LETTER JACKET.

Exxon Valdez (environment) The large oil tanker which ran aground and leaked 35,000 tons (31,745 metric tonnes) of oil into the pure, pristine Prince William Sound off the coast of Alaska in 1989. This oil leakage polluted the environment and killed many animals and plant life. The long, expensive clean-up effort (until 1991) and its costs of over $100 billion were paid for by the Exxon company and the federal government. It is a symbol of the massive destruction of fragile, natural ECOSYSTEMS due to the carelessness of ship navigation in natural areas; further, it represents the confusion and disorder of clean-up operations. [From the official name of 'Exxon's' oil tanker.]

F

Fair Deal (history) The collective name for the various government programs designed to help Americans that the DEMOCRAT PRESIDENT HARRY TRUMAN planned to make into laws during his elected ADMINISTRATION (1948–1952). Because the CONGRESS was REPUBLICAN during this time, fewer BILLS[2] were passed than Truman wanted. Those which did become laws were: the Housing Act of 1949, farm subsidies, encouraging hydroelectric power, and the creation of the National Science Foundation. It did extend some programs started with the NEW DEAL. By association, the Truman ADMINISTRATION[2]. ['Fair' + NEW 'DEAL'.]

Fair Housing Act (housing and architecture) The federal act (passed in 1968) which prohibited people from discriminating against MINORITIES in the buying or renting of housing and property. *See* DEPARTMENT OF HOUSING AND URBAN DEVELOPMENT, DISCRIMINATION.

Fair Labor Standards Act (work) (FLSA) The federal act (passed in 1938) that first set standards for MINIMUM WAGE, overtime pay and equal pay for equal work. In 1985, the legal case *Garcia* v. *San Antonio Metropolitan Transit Authority* extended this to STATE and local government employees.

Fairness Doctrine (media) A former rule of the FEDERAL COMMUNICATIONS COMMISSION stating that radio and television stations must give equal amounts of broadcasting time to all the candidates during an election (but, not including

news programs). This rule was stopped in 1987.

Fallen Timbers, Battle of (history) The military battle in which a confederacy of several Indian TRIBES (namely, Shawnee, Delaware, Iroquois) and some Canadians fought and lost a battle to American forces on August 20, 1794. The battle was fought to stop Americans from settling on the land then controlled by the NATIVE AMERICANS (present-day STATES of Indiana and Ohio). Most tribal representatives signed the peace TREATY (known as the "first Treaty of Greenville") in which most of the Indians forfeited their rights to land in the present-day MIDWEST and opened it up for white settlement. *Compare* KING PHILIP'S WAR.

FallingWater (housing and architecture) A unique, modern private residence built in geometric shapes of stone, concrete and metal and which perches over a stony creek and waterfall in hilly, forested western Pennsylvania. It was designed and the interior was decorated by FRANK LLOYD WRIGHT from 1935 to 1939 and is internationally admired for its beauty, location, unique placement and comfortable living spaces. Today, it is open to the public as a museum.

family doctor (health) A doctor who provides general medical care to all individuals, both sexes and of all ages, frequently caring for all members of one family. Also known as "family practitioner"; *compare* INTERNIST.

family leave (health) The period of time that a worker may not work in order to take care of his or her medical condition or the health of a child, spouse or parent, or have a baby, or adopt a child. Whether the worker is paid or unpaid during this time, depends on the workplace. *See* FAMILY MEDICAL LEAVE ACT.

Family Medical Leave Act (health) The federal act passed in 1993 that requires businesses (with 50 or more employees) to give a worker up to twelve weeks a year unpaid leave from work, while assuring the worker that he or she may resume work in that same position afterwards. It tries to promote FAMILY VALUES and protect a worker's job security.

family room (daily life) The room in a private house which usually contains a television, couch(es), comfortable chairs and maybe a computer and where its residents spend the most time. Usually, it is located near the kitchen. *Compare* LIVING ROOM.

family values (religion) A collective term to refer to those aspects and morals associated with what is thought to be the "traditional" American family, namely, having a Christian religious faith, honesty, a hard-working attitude, and children raised by mothers and fathers who are married to each other and live together in the same house. It is used and promoted by CONSERVATIVE REPUBLICANS and the RELIGIOUS RIGHT, FUNDAMENTALISTS and other conservative Christian groups. These values do not support legal abortion, divorce, adultery nor homosexual relationships. Sometimes also known as "traditional family values".

fan club (the arts) A GRASSROOTS organization founded to honor and increase the popularity of some entertainer or actor. It publishes and distributes favorable, flattering information (e.g., newsletters, Internet websites) about the celebrity's youth and personal and professional life for the group members. By association, any follower or group that supports some well-known person, unquestioningly.

fancy dance (customs and traditions) An energetic Native American dance characterized by frequent turning and high-stepping. The performers wear brightly-colored costumes of feathers, patterned beads and bells. It is practiced by many different TRIBES and performed at POW-WOWS. *See* INTER-TRIBAL INDIAN CEREMONIAL.

Fannie Mae (1 housing and architecture; 2 economy) **1** The private company which supplies low-interest loans to individuals so that they can buy houses with low-rate mortgages. It was created with support from the federal government. By association, describing any of the loans offered by this private organization. **2** On the STOCK MARKET, a certificate or bond sold by this company which helps supply the money available for the pool of loan/

mortgage money offered to individuals. *Compare* FREDDIE MAC, GINNIE MAE.

fanny pack (clothing) A type of small, zippered bag attached to a strong belt which is worn by women and men around the waist either in front or in back. Originally it was designed for hiking, but today is used by women and men every day. [From a person's back, or 'fanny', side where this bag was originally designed to be worn.] Also known as "belt pack".

farm team (sports and leisure) A type of BASEBALL team (i.e., Triple-A) in the MINOR LEAGUES which serves as a potential team and talent resevoir from which a particular MAJOR LEAGUE team may pick players. Each farm team is an AFFILIATE[1] of the professional team that sponsors it. Its players may be chosen to "move up" and play for THE BIG LEAGUES (i.e., players are not drafted). *Compare* DRAFT[2], FRANCHISE, BUSH LEAGUE.

Farmer, James (people) (born in 1920) AFRICAN-AMERICAN leader of the CIVIL RIGHTS MOVEMENT and educator. He founded the CONGRESS OF RACIAL EQUALITY and served as its national director from 1961 to 1966. He is remembered as being the first individual during the struggle for the CIVIL RIGHTS of blacks to use techniques of passive resistance and NON-VIOLENT ACTION. He did not support the BLACK POWER movement.

Farrakhan, Louis (people) (born in 1933 as Louis Eugene Walcott) African-American religious leader. He was recruited to the NATION OF ISLAM by MALCOLM X in 1955 and, since 1978, he has been the leader of this group. He promotes separation of the races, black self-sufficiency and economic development. In 1995, he called the successful MILLION MAN MARCH. He is a controversial public figure because of his vocal opinions against white people, JEWISH people, homosexuals and abortion. His headquarters are in CHICAGO at Temple #1.

fast food (food and drink) Any food designed to be prepared quickly and efficiently (e.g., HAMBURGERS, FRIED CHICKEN), usually by a team of people. It is a specialty of CHAINS. *See* FRANCHISE; *compare* JUNK FOOD.

fast-track legislation (government) Any federal legislation (e.g., proposed acts, BILLS[2]) that is created and proposed by the PRESIDENT (e.g., EXECUTIVE AGREEMENT) and which the CONGRESS can reject or approve but not amend (i.e., make additions to).

Father's Day (customs and traditions) The third Sunday in June when children thank and honor their fathers. Frequently, they give their fathers GREETING CARDS, small gifts (e.g., necktie) or take them out to LUNCH or DINNER. *Compare* MOTHER'S DAY.

Faulkner, William (people) (1897–1962) Southern writer of novels. He wrote a number of books detailing the stories of the same group of tragic white and black characters. Although all the books concern the people of the same small fictional county of YOKNAPATAWPHA COUNTY found in the SOUTH, they explore universal, human themes. His works include: *The Sound and the Fury* (1929), *Absalom, Absalom!* (1936) and others. He received the Nobel Prize (1949) and two PULITZER PRIZES (1955 and 1963) for his work.

favorite son/favorite daughter (politics) At a NATIONAL CONVENTION, a STATE leader (e.g., governor, CONGRESS MEMBER) who receives the nomination for PRESIDENT only from those DELEGATES of his or her own state. Although not a serious candidate for this nomination, he or she may be chosen as a RUNNING-MATE. [From the favoritism shown by a state for its own outstanding citizens.]

Fed, The (economy) In general, the popular nickname for the FEDERAL RESERVE SYSTEM. Specifically, the popular name for the BOARD OF GOVERNORS of the Federal Reserve System.

Federal Arts Project (the arts) (FAP) A government-sponsored program and one of the divisions of the WORKS PROGRESS ADMINISTRATION which succeeded in employing some 5,000 artists during the GREAT DEPRESSION in exchange for public works of art. It paid painters and sculptors a weekly sum of money to create paintings, large murals and other artworks to be displayed in public buildings, especially libraries, government buildings, SCHOOLS[1] and public housing projects. It

was an important source of income for artists and was active from 1935 until 1943. It was preceded by the PUBLIC WORKS OF ART PROJECT. *See* NEW DEAL.

Federal Aviation Administration (transportation) (FAA) An agency within the DEPARTMENT OF TRANSPORTATION which operates the facilities that control all air traffic and investigates aircraft accidents and the safety of airplane flight in the US.

Federal Bureau of Investigation (government) (FBI) An important office of the DEPARTMENT OF JUSTICE which investigates and collects information concerning the federal government and national interests. It works within the US on cases, often with local police departments. While J. EDGAR HOOVER served as Director (1924–1972), the FBI and its agents were respected and supported for their commitment to the law. The headquarters are in the J. Edgar Hoover Building in WASHINGTON D.C. It is popularly known as the "FBI". *See* G-MEN; *compare* CENTRAL INTELLIGENCE AGENCY.

Federal Communications Commission (media) (FCC) The independent, federal government agency established in 1934 by the Federal Communications Act, that sets and enforces standards for any communication by radio, television, telephone and wire. It also gives licenses to individual radio and television stations (i.e., but not networks).

Federal Deposit Insurance Corporation (economy) (FDIC) The independent federal agency providing insurance of up to $100,000 to individuals or CORPORATIONS who deposit money in commercial banks or mutual savings banks. It was established in 1933 during the GREAT DEPRESSION to give people confidence in banks.

Federal Election Campaign Act of 1972 (politics) (FECA) The act and the FECA AMENDMENTS of 1974, 1976, and 1979 which help control the methods of raising and spending money for election CAMPAIGNS for PRESIDENT and CONGRESS. Also, it gives federal funds to the NATIONAL CONVENTIONS of the DEMOCRATIC PARTY and REPUBLICAN PARTY. Although the amendments became law after WATER-GATE in order to prevent abuses during campaigns, FECA has encouraged the PAC system. *See* FUND-RAISER.

Federal Election Commission (politics) (FEC) An independent federal agency responsible for enforcing the FEDERAL ELECTION CAMPAIGN ACT OF 1972, its AMENDMENTS and other campaign rules.

federal holiday (customs and traditions) Any LEGAL HOLIDAY established by the CONGRESS or the PRESIDENT and on which all UNITED STATES government offices, post offices and courts of law nationwide are officially closed as well as the local government offices and many businesses in the DISTRICT OF COLUMBIA. Federal holidays include NEW YEAR'S DAY, MARTIN LUTHER KING, JR. DAY, PRESIDENTS' DAY, MEMORIAL DAY, INDEPENDENCE DAY, LABOR DAY, COLUMBUS DAY, VETERANS' DAY, THANKSGIVING DAY and CHRISTMAS DAY.

Federal Marshals (legal system) The group of uniformed officers (some 3,500) in the DEPARTMENT OF JUSTICE who establish order for the federal government. They work in the federal courts: providing support and protection to the judges, ATTORNEYS, witnesses and JURY members; and transporting prisoners between courtrooms and prisons. Further, they help the PRESIDENT and the federal government control civil crises, protest demonstrations and terrorist actions. *Compare* BAILIFF, NATIONAL GUARD, JAMES MEREDITH.

Federal Reserve (System) (economy) The independent government agency that functions as the central bank of the UNITED STATES. It controls American monetary policy and the amount of money (e.g., loans, credit) in the US economy. Its duties include buying and selling US government securities, setting the DISCOUNT RATE and deciding how much money other banks may give out in loans. Further, it holds the country's current supply of gold, organizes international economic policies and helps set exchange rates with foreign currencies. The system, which is headed by the BOARD OF GOVERNORS, includes and is responsible for 12 Federal Reserve District Banks, some 5,700 national banks and many STATE banks. Its headquarters are in WA-

SHINGTON D.C. It was founded in 1913 and plays a very important part in the American economy. It is popularly known as "the FED". *See* T-BILL, TREASURY BOND; *compare* FORT KNOX, DEPARTMENT OF THE TREASURY.

Federal Style (architecture) (housing and architecture) A popular style of architecture during the period after the AMERICAN REVOLUTION (1780–1840) found in the NORTHEAST and the SOUTH. Its dominant features include: a grand size; clean, bold, geometric lines; Greek columns (e.g., Ionic, Corinthian); wide staircases; decorative designs in the shapes of squares, half circles and ellipses; and a symmetrical placement of windows and doors in the building. It grew out of American interest in the independent governments of the ancient Greeks and the Roman Republic. It is a common architecture for banks, STATEHOUSES, insurance agencies, SCHOOLS[6] and some private residences. *Compare* GREEK REVIVAL.

Federal Trade Commission (economy) (FTC) The independent federal government agency, founded in 1914, that protects the American free market, free trade and competition by establishing rules which prohibit boycotts, unfair competition among businesses and TRUSTS from developing. It can take legal action against businesses that do not obey its rulings. *See* ANTITRUST LAWS, MONOPOLY.

federalism (government) The system of American government in which powers are shared between a central (i.e., 'federal') government for issues of national interest (e.g., national defense, printing of money) and the STATE and local governments for powers of local concern (e.g., education, liquor). It includes CO-OPERATIVE FEDERALISM and DUAL FEDERALISM. *See* TENTH AMENDMENT, BILL OF RIGHTS, *McCULLOCH V. MARYLAND*.

Federalist Papers (government) A collection of 85 letters that explain the ideas and theories of the CONSTITUTION which were written by "Publius" (Latin, meaning "the public"), the collective pseudonym of JAMES MADISON, Alexander Hamilton (1755–1804) and John Jay (1745–1829). The **Papers** were first published in news-

papers 1787–1788 as a way to encourage and convince the STATE of New York to ratify the Constitution; today, as a collection, they are considered an important book of political philosophy and government.

Federalists (1, 2 politics) **1** During the CONSTITUTIONAL CONVENTION, those people who supported the strong federal government established in the CONSTITUTION and encouraged the STATES to adopt it. Their thoughts are found in the *FEDERALIST PAPERS. Compare* ANTI-FEDERALISTS. **2** A major political party, active from the 1790s until the 1830s, which protected the interests of wealthy citizens, and promoted business, a strong executive and judicial government branches and a centralized national government. It was popular in the NORTHEAST and was the party of GEORGE WASHINGTON, John Adams and JOHN MARSHALL. *See* Appendix 2 Presidents; *compare* DEMOCRATIC-REPUBLICAN PARTY.

fedora (clothing) A man's brimmed hat made of soft or firm felt in which the oblong crown is indented lengthwise. It was popularly worn in urban areas during the 1920s, 1930s and 1940s. [After the play '*Fédora*', by Frenchman Victorian Sardou (1831–1908).]

fellow (the arts) A member of the ACADEMY OF ARTS AND SCIENCES or another established literary, artistic or scientific society.

felony (legal system) A serious crime (e.g., murder, rape, kidnapping, purposefully burning property, using a gun to rob someone) which must be decided in a CRIMINAL TRIAL. It may require a GRAND JURY and JURY. *See* CAPITAL PUNISHMENT; *compare* MISDEMEANOR.

Feminine Mystique, The (minorities) The best-selling book (published 1963) written by Betty Friedan (born in 1921) which criticized the current situation in American society in which women with HIGHER EDUCATION degrees and jobs were forced by society to give up these pursuits and take up the traditional roles of "mother" and "housekeeper", both of which seemed less satisfying in comparison to working. The enormous success of this book helped many women understand

their own personal feelings of dissatisfaction working in the home, and generally it is considered as starting the modern WOMEN'S MOVEMENT (1963–1975).

feminist (minorities) A person, especially a woman but also a man, who supports equal rights for women and an end to sexism and DISCRIMINATION based on gender in the society, workplace and politics. Often, feminists tend to be working women and thus support all programs which increase a woman's right to fair treatment, fair pay, PRO-CHOICE and no SEXUAL HARASSMENT in the workplace. Many feminists supported the FEMINIST MOVEMENT, which is also known as the "WOMEN'S MOVEMENT". A "radical feminist" is a woman (i.e., not a man) who has a zealous belief in improving the condition of women in society, which often entails living and working away from men. *Compare* SUFFRAGIST.

Feminist Movement, the (minorities) A collective term for the spontaneous and organized activities and organizations which were designed to promote equal rights for women from 1963 to 1975. During this time it promoted a woman's right to work at the same jobs and receive the same pay as men; a woman's right to attend the same academic institution as men; and for having equal chances for positions in business and politics. In addition, it supported ERA2 and *ROE* v. *WADE* (1973). It is generally considered to have begun with the publication of *THE FEMININE MYSTIQUE* (published in 1963) and to have received encouragement from the CIVIL RIGHTS MOVEMENT and the CIVIL RIGHTS ACT (of 1964). Its chief organization was the NATIONAL ORGANIZATION FOR WOMEN. *See* PRO-CHOICE, PRESIDENT'S COMMISSION ON THE STATUS OF WOMEN.

Ferraro, Geraldine (Anne) (people) (born in 1935) LAWYER, CONGRESSWOMAN from the STATE of New York and FEMINIST. She was the first female vice-presidential candidate for a major party (although, unsuccessful), as RUNNING MATE to Walter Mondale (born in 1928) for the DEMOCRATIC PARTY in 1984. She was appointed ambassador to the United Nations Human Rights Committee in 1994.

fiddle (1, 2 the arts) A small, wooden, string musical instrument with an hourglass shape and two holes which help to make a resonating sound. It is played with a bow and its four or five strings may be plucked with the fingers. Often it is used in COUNTRY MUSIC and BLUEGRASS MUSIC. **2** A popular nickname for a violin.

Field & Stream (media) A monthly magazine, founded in 1895, that carries articles on fishing, hunting, camping, boating, sporting equipment and travel associated with these sports; as well as issues concerning the environment. Its current circulation is 1.8 million.

field goal (sports and leisure) In FOOTBALL, a method of scoring in which the kicker of an offensive team kicks the ball from anywhere on the field making it pass between the upraised arms of the goal posts and over the crossbar. It equals three points. *Compare* TOUCHDOWN, SAFETY, CONVERSION.

field trip (education) A SCHOOL1-sponsored trip designed to give the students first-hand, practical experience in some aspect related to regular coursework. Teachers, and maybe some volunteer parents, oversee the activities.

Fifteenth Amendment (politics) The AMENDMENT to the CONSTITUTION (1870) that gave all adult male citizens the right to vote regardless of their race, color or previous condition of SLAVERY. It was originally adopted to give the vote to black men and it was the basis for the VOTING RIGHTS ACT OF 1965. *See* FOURTEENTH AMENDMENT.

Fifth Amendment (legal system) The AMENDMENT to the CONSTITUTION (1791) that outlines those rights concerning legal cases and trials given to people who are accused of committing a crime. The rights it includes are: if accused of a crime, a person may be tried for that crime only once; in very serious criminal cases, a GRAND JURY is used; before life, freedom, possessions or property are taken away from a person, he or she has the right to a trial; and a person does not have to speak to authorities if it will incriminate him or her. "Taking the fifth" means to claim the right not to speak and incriminate oneself. *See* MIRANDA v. ARIZONA, DUE PROCESS.

Fifth Avenue (geography) In NEW YORK CITY, a major, wide street running north to south, some of it along CENTRAL PARK; it serves to divide MANHATTAN[1] into east (i.e., the East Side) and west (i.e., the West Side) sections. It is known for its elegant hotels, fashionable stores and designer boutiques. Many parades and demonstrations in the city march down this street. *See* ST. PATRICK'S DAY PARADE.

fight song (education) A song whose lyrics glorify a particular SCHOOL[5] and praise its students and athletes. It is especially written for a SCHOOL[5] and sung by students and CHEERLEADERS before and during athletic events and competitions as well as at a PEP RALLY. By association, any song or chant with somewhat aggressive lyrics which encourages a team or group to win a contest. *Compare* "ALMA MATER"[2].

filibuster (government) A method to kill a BILL[2]. It is a very long talk or speech that a SENATOR gives while discussing a bill until the supporters of that bill withdraw it from discussion (which kills it). **Filibustering** occurs only in the SENATE because that chamber does not have time limits on speeches. It may only be stopped by unanimous consent or CLOTURE. *See* SENATE RULE 22; *compare* RULES COMMITTEE.

Final Four, the (sports and leisure) The last 'four' teams which play each other in Rounds Five and Six in the NCAA BASKETBALL (DIVISION I CHAMPIONSHIP) TOURNAMENT in both the Men's Tournament as well as in the Women's Basketball Tournament. They play each other in late March or early April. The winning team of the Final Four is the national champion of men's COLLEGE[1] basketball; and the champion of women's COLLEGE[1] basketball. The days before and during these games of the Final Four constitute a very suspenseful time for college basketball, its teams and fans. *See* MARCH MADNESS.

final(s) (education) The last, usually cumulative, test of a SCHOOL[5] course which is given at the end of a TERM[2]. It is almost always a written exam. Also known more formally as "final exam(s)"; *see* BLUE BOOK; *compare* MIDTERM.

financial aid (education) Any form of assistance (e.g., GRANT, loan, scholarship, WORK-STUDY) given to a student to help pay for SCHOOL[5] tuition and costs, usually at the HIGHER EDUCATION level. It usually is administered by an office on COLLEGE[3] CAMPUSES.

finger food (food and drink) Any type of snack or HORS D'OEUVRE designed to be served and eaten with the hands (i.e., not with fork, knife or spoon), often it includes cut, raw vegetables and dip, CHIPS AND SALSA, cheese and CRACKERS[1]. It is frequently served at COCKTAIL PARTIES. *Compare* APPETIZER.

Finn, Huckleberry (customs and traditions) The lead character and boy hero of the *Adventures of Huckleberry Finn* (1884) created by MARK TWAIN. This young white boy has a series of interesting experiences in the MISSISSIPPI RIVER region with his friend, a black man named Jim. "Huck" is remembered for his innocence and questioning attitude of the racism and violence in adult white society.

fireside chats (government) The popular, informal radio talks that PRESIDENT FRANKLIN ROOSEVELT presented to the public (starting in 1933), in which he gave reports about the US economy and explained his ADMINISTRATION'S actions and NEW DEAL programs.

First Amendment (government) The AMENDMENT to the CONSTITUTION (1791) stating that the government promises to respect the people's freedoms to practice their own religion; to say, print and publish what they want; to organize into groups and hold meetings; and to complain to the government for a change in laws. Further, it states that CONGRESS cannot make any religion the official religion of the UNITED STATES OF AMERICA or its citizens. In addition, Congress shall not interfere with the right of all citizens to practice their own religion. That is to say, the government is neutral to religion. This is the basis for the BILL OF RIGHTS, and because of the doctrine of INCORPORATION, these rights are guaranteed by federal and STATE governments. The first clause of the First Amendment is said to enforce the SEPARATION OF CHURCH AND STATE. *See* ESTABLISHMENT CLAUSE, FREE EXERCISE CLAUSE, FREE SPEECH CLAUSE, FOURTEENTH AMENDMENT.

first base (sports and leisure) In BASE-BALL, that base located directly to the right of HOME PLATE. It is the first base to which an offensive player runs. By association, the first step in a plan which consists of several, often four, steps. Further, it is also the name of the defensive, INFIELD position of that defensive player who guards this base. *Compare* SECOND BASE, THIRD BASE.

first down (1, 2 sports and leisure) **1** In FOOTBALL, the first DOWN[1] in a series of four DOWNS[1]. **2** A collective name for an additional set of four DOWNS[1] which an offensive team earns by successfully advancing the ball 10 yards (9.1 m). By association, having achieved a first step in any plan with two or more steps or parts.

first family (government) The family of the current PRESIDENT. Also, the family of a current STATE governor. By association, a family that is talented or well-known in some particular field or profession (e.g., politics, acting). *Compare* FIRST LADY.

first floor (housing and architecture) In any building or house, the story that is built on the ground floor. Beneath it (i.e., underground) is the basement and above it is the second floor.

First Lady (government) The wife of the PRESIDENT. Also, the wife of a STATE governor. By association, describing a woman very talented in her field or profession (e.g., singing, acting). *See* FIRST FAMILY, ELLA FITZGERALD.

First Night (customs and traditions) A type of family-oriented outdoor, wintertime fair held on NEW YEAR'S EVE. It usually offers special afternoon activities for families including ice skating, games and a displayed competition of life-sized sculptures made out of blocks of ice. In the evening, booths sell small gifts, handicrafts, food and drinks and live bands perform for teenage and adult audiences. All of the activities are located in one general area permitting people to walk safely from from event to event (i.e., thus decreasing the chance of car accidents caused by drunk driving). It started in 1973 in BOSTON as a type of alternative to the usual alcohol and party festivities only for adults held on New Year's Eve. Cur-

rently, over 120 cities sponsor similar events.

first pitch (sports and leisure) On OPENING DAY of the professional BASEBALL season, the ceremonial toss of the baseball from a person sitting in the audience down to the players on the INFIELD[1]. It is done before the game, usually by the PRESIDENT, other CHIEF EXECUTIVE or other special guest.

first-string (sports and leisure) A regular team player (i.e., not a substitute) who begins the game playing (i.e., not sitting on the sidelines waiting to play). By association, a regular participant.

fiscal year (economy) The bookkeeping and budget year (i.e., not calendar year) for a business or a government. For the federal government, it begins on October 1 and ends on September 30 of the following year; thus, the fiscal year 2000 begins on October 1, 1999, and ends September 30, 2000. *See* BALANCED BUDGET.

fish fry (customs and traditions) A picnic or social gathering and meal where fish is eaten. It is particularly popular among members of the ROMAN CATHOLIC CHURCH since they were traditionally prohibited, by their own religious laws, from eating meat (they could only eat 'fish') on Fridays.

fish-in (minorities) A DIRECT ACTION tactic used by INDIANS (first in 1964) who wanted to receive those fishing benefits and rights granted to them by the federal government in TREATIES. It consisted of Indian volunteers purposefully fishing (with the use of traditional nets) in those rivers of the PACIFIC NORTHWEST and MIDWEST and practicing these fishing rights. This tactic worked for in 1974, the "Boldt decision" granted Indians the traditional rights to fish in rivers in the STATE of Washington. [From 'fish' + SIT-'IN'.]

Fitzgerald, Ella (people) (1918–1996) A JAZZ MUSIC singer who had a talent for being able to improvise. During her long, successful career she made many recordings and earned the nickname "First Lady of Song". *See* FIRST LADY.

Fitzgerald, F[rancis] Scott (people) (1896–1940) Writer of fiction and unsuccessful movie scriptwriter. His popular books treated American characters during

the JAZZ AGE who were financially very wealthy. His works explored the themes of social respectability and American attitudes toward making, saving, earning and spending money, namely, *The Great Gatsby* (1925) and *Tales of the Jazz Age* (1922).

five and ten/dime (daily life) A type of store selling a variety of inexpensive items, most of which are beauty aids and cosmetics (i.e., shampoo, fingernail polish) and household items (e.g., kitchen cleaners). It may also contain a type of DINER and a lunch counter which serves meals to customers. [When it was first founded in the late nineteenth century (*c.* 1879), all its items cost a NICKEL, a DIME or less.] *See* SIT-IN.

Five Civilized Tribes (minorities) A collective name for a group of five Native American TRIBES traditionally from the SOUTHEAST, namely, the Cherokees, Choctaws, Chickasaws, Creeks and Seminoles. Generally they were respected by whites because their well-developed farms and villages resembled white farms and villages. Further, these tribes had adopted many white customs; becoming literate in their own languages, wearing white-styled clothing and owning slaves (in fact, the Cherokees, Choctaws and Chickasaws supported the CONFEDERATE STATES OF AMERICA during the CIVIL WAR). In the twentieth century, these groups opposed the INDIAN NEW DEAL and the INDIAN READJUSTMENT ACT because they wanted to integrate and assimilate with white society. Also known as the "Five Southern Tribes"; *see* ASSIMILATION.

555-1212 (daily life) The telephone number used to ask a local information operator the phone numbers of people, businesses and organizations. Before 1994, it was 411.

five-star (military) Describing the highest-ranking US ARMY commissioned officer who has the title "General of the Army". By association, something that is of the highest quality or rank. [From the metal pin insignia consisting of 'five stars' which this officer wears on the military uniform.] *See* Appendix 7 Military Ranks; *compare* FOUR-STAR.

flag corps (sports and leisure) A group of uniformed women who make line formations, do routine steps and twirl colorful flags to music. This group usually performs with the MARCHING BAND during the halftimes of sporting events, especially football. It is an EXTRACURRICULAR ACTIVITY at most HIGH SCHOOLS and some COLLEGES[1]. A group may also perform at professional sporting events. *See* LETTER; *compare* DRILL TEAM.

Flag Day (customs and traditions) June 14, when the STARS AND STRIPES[1] is celebrated as a national symbol. Since 1949 it has commemorated the date (June 14, 1777) when the CONTINENTAL CONGRESS first adopted the flag for the American people. Although it is not a LEGAL HOLIDAY, many people fly or hang the flag at their homes and in public places. *See* BETSY ROSS.

flag football (sports and leisure) A type of FOOTBALL game in which each player wears a belt from which a strip of material (called a 'flag') hangs. If a defensive player removes the flag from an offensive player, it equals a "tackle". It is played at the amateur level and for leisure because it is less rough than the professional sport.

flak jacket/vest (military) A type of protective VEST[2] worn by members of the ARMED FORCES, especially the AIR FORCE, in combat situations. [After the German aircraft gun *'Fl'ieger 'a'bwehr 'k'anone.*]

flextime (work) A work policy which permits an employee to choose the hours he or she prefers to work (e.g., rather than from 8:00 to 5:00, from 7:00 to 4:00). It has proven to help family life (i.e., facilitates picking up and dropping off children at DAY CARE or SCHOOL[1]) and decrease traffic congestion problems caused by city–SUBURBS commuting.

float (customs and traditions) A movable exhibit on display in parades and festivals which presents a theme and is decorated with costumed people, flowers and balloons. Usually it is built on the flat bed of a trailer and pulled by a car or a team of horses. [After the effect of the decorations which hide the vehicle's wheels and make it appear to 'float' above the pavement.] *See* ROSE BOWL, MACY'S THANKSGIVING DAY PARADE.

flophouse (housing and architecture) A run-down house which rents out rooms to customers or serves as a cheap hotel.

Florida Keys, the (geography) A string of different, low-lying islands extending 100 miles (160 km) into the Caribbean Sea from the southern tip of Florida toward Cuba which are popular among tourists and water enthusiasts of snorkeling, deep-sea diving and fishing. [From Spanish *cayo*, the name for this type of island.] *See* KEY WEST.

flower child(ren) (society) During the ANTI-WAR MOVEMENT, especially in SAN FRANCISCO, a name for those COLLEGE[1] students, young people and other individuals who supported peace and illustrated this by bravely and fearlessly approaching armed US ARMED FORCES (which carried guns) with flowers. "Flower power" is the tactic of encouraging peace by giving one's enemies flowers and other symbols of nonviolence. A "flower girl" is the young female child who carries flowers in a wedding procession.

fly ball (sports and leisure) In BASEBALL, a ball which a batter hits high into the air but which does not go far. It may be playable or a FOUL BALL.

FM (media) Describing a radio station that receives and sends signals through a system which varies the frequency of a radio signal to get a higher quality of sound with less static, making it good for broadcasting music programs. There are some 7,700 COMMERCIAL radio stations in the UNITED STATES which can be found from 88 through 108 megahertz on the radio dial. [Abbreviation of 'F'requency 'M'odulation.] *Compare* AM.

Foggy Bottom (foreign policy) A region of WASHINGTON D.C. near the Potomac River and the location of the office building of the DEPARTMENT OF STATE. By association, a nickname for the State Department.

folk art (the arts) A simple, usually unrefined type of art made by and for people who use it; that is, it is not meant to be sold. It includes paintings, statues and cloth quilts, all of which are made from accessible materials, namely wood and scrap pieces of fabric. It depicts scenes from daily life, as well as decorative patterns of flowers and birds. Because of its simplicity, it often looks modern. *See* "GRANDMA" MOSES.

folk music (the arts) Specifically, a type of music which uses clear vocals, often *a cappella* singing, but also accompanied by the guitar. Its songs treat social conditions and often include the themes of: workers, travel, work, religion, protest and politics. This music became popular in the 1930s during the GREAT DEPRESSION and again in the 1950s and 1960s when people sang it to protest against the federal government, as well as in support for the ANTI-WAR MOVEMENT and for the CIVIL RIGHTS MOVEMENT. It was promoted by the Newport Folk Festivals of the 1960s. "Folk rock" is a type of folk music played with electric guitars common in ROCK MUSIC; "country folk" refers to a music combining the vocals of folk music with the instrumentation of COUNTRY MUSIC (eg, FIDDLE[1], BANJO). In general, folk music refers to any song (often not written down) that people learn from their families or community which is used for religious or ceremonial purposes (e.g., black spirituals, Native American music, ethnic music). *See* NEWPORT FESTIVALS, WOODY GUTHRIE, JOAN BAEZ, BOB DYLAN.

Fonda, Jane (people) (born in 1937) A versatile actress and public figure. She is known for her acting (*Barbarella* in 1968; *The China Syndrome* in 1979); promotion of health, physical fitness and aerobic activity for women (*Jane Fonda's Workout* in 1981); and for having communist sympathies (during the 1960s when she was nicknamed by the US press "Hanoi Jane") and protesting the VIETNAM WAR. She married TED TURNER in 1991.

Food and Drug Administration (health) (FDA) The federal agency of the DEPARTMENT OF HEALTH AND HUMAN SERVICES that tests the safety and effectiveness of foods, cosmetics, drugs and medical products before they are distributed to the general public. It also promotes healthy nutrition among Americans and overseeing the accuracy of FOOD LABEL claims.

food bank (food and drink) Any NON-PROFIT ORGANIZATION that collects and receives canned and prepackaged foods

from various groups and then redirects these food products to those poor and/or needy people to use. Often, it is operated by a CHURCH[1,3] organization or religious or social group.

food court (daily life) In a SHOPPING MALL, any area with a central open sitting/dining which is surrounded by different FAST FOOD eateries and DELICATESSENS.

food label (food and drink) A list of the nutritional content (e.g., sugar, calories, fat, cholesterol, sodium, fiber) contained in a packaged food product. The accuracy of this information is controlled by the Food Labeling and Fair Packaging Act (of 1966) and Nutrition Labeling Education Act (of 1990) and regulated by the FOOD AND DRUG ADMINISTRATION. Also known as the "right-to-know label"; *see* LIGHT, LOW-FAT.

Food Stamp Program (food and drink) A program designed to help poor people buy nutritious foods by giving them a book of FOOD STAMPS. This program is overseen by the DEPARTMENT OF AGRICULTURE and receives funds from the federal government, STATE and local governments. It began during the NEW DEAL and remains important for poor people today.

food stamps (food and drink) A type of valued coupon (i.e., 'stamps') which can be used to "buy" food at certain grocery stores. *See* FOOD STAMP PROGRAM.

football (sports and leisure) A popular CONTACT SPORT and SPECTATOR SPORT in which a team with the most points wins. Points are scored by an offensive team throwing, passing (with the hands) and sometimes kicking the ball down the playing field and over the goal line of the defending team. The defending team tries to stop this action by tackling the ball carrier and/or intercepting the ball and gaining possession of it in order to score for itself. Both teams (each consist of 11 players on the field, which is marked in yards) organize strategies well before the game and play them out during the game. The season begins in August and ends in November; although post-season tournaments, BOWL GAMES and the SUPER BOWL are held in the following January. NFL teams play 16 regular season games each year, usually once a week. Each game consists of four quarters[3] of action; however, between plays the clock is stopped. Often, during the halftime, live entertainment or music is performed on the field. Before all games, the NATIONAL ANTHEM is played and sung by team members and spectators. On Thursday evenings, many JUNIOR VARSITY teams of SECONDARY SCHOOLS play games; on Friday evenings, many VARSITY teams of HIGH SCHOOLS play; on Saturday afternoons, many COLLEGE[1] teams play games; on Sunday afternoons and Monday evenings, most professional teams compete against each other. Outside of the UNITED STATES, it is known as "American football". *See* QUARTERBACK, LINEBACKER, TIGHT END, END ZONE, GRIDIRON, CHEERLEADERS, MARCHING BAND, FUMBLE THE BALL, ROSE BOWL, *NFL MONDAY NIGHT FOOTBALL*, FIRST DOWN[1,2], PIGSKIN.

for-profit (economy) Describing an organization founded to perform or research some artistic, educational, political or government cause and designed to earn money while doing this; a business organization. *Compare* NONPROFIT ORGANIZATION.

Forbes (media) A business magazine established in 1917, carrying information on business, finance, industries and labor. Its circulation is 800,000; it is published twice a month. Once a year, it publishes the FORBES 500. [After founder and publisher Bertie Charles 'Forbes' (1880–1954).] *Compare* FORTUNE.

Forbes 500 (economy) The list of the 500 largest US companies according to company sales, assets, profits and other features. It is published once a year by *FORBES* magazine. [After founder and publisher Bertie Charles 'Forbes' (1880–1954).] *Compare* FORTUNE 500.

Ford Foundation, the (the arts) The private organization, established in 1936, to promote scientific and health research, to end poverty as well as to encourage performance in education and the arts in the UNITED STATES by giving money to many groups working in these fields. [After founders HENRY 'FORD' (1863–1947) and his son Edsel Ford (1893–1943).]

Ford's Theater (history) In WASHING-TON D.C., the live stage theater which PRESIDENT ABRAHAM LINCOLN and his wife were attending on April 14, 1865, when he was shot by an assassin, JOHN WILKES BOOTH. Lincoln was carried to a house, across the street from the theater, where he died the following day. Today, it is a museum and active theater.

Ford, Henry (people) (1863–1947) Car maker, businessman and manufacturer. He founded the Ford Motor Company in 1903 which grew successful by the production and sale of the MODEL T car. He developed the moving assembly-line method of making cars which increased the speed of car manufacturing while lowering the price. He founded the FORD FOUNDATION and disliked BIG LABOR.

Foreign Affairs (media) A journal published six times a year, containing serious, long articles on international relations, economics and trade, written by recognized experts and world leaders. It is printed on a quality paper in a smaller, paperback book sized format. It was founded in 1922 and has a current circulation of 100,400.

Foreign Service, the (foreign policy) The general name for the professional group of people who work for the DEPARTMENT OF STATE both overseas (e.g., in consulates and embassies) and in the UNITED STATES. Individuals must successfully pass special, rigorous exams before becoming **Foreign Service Officers**.

formal (1, 2, 3, 4 clothing) **1** Describing an elaborate, luxurious social event (e.g., dance, gala, ball, the ACADEMY AWARDS CEREMONY); **Formal wear** is that type of clothing worn to such an event (e.g., TAILCOAT). **2** By association, describing the type of clothing appropriate for such an event. **3** A type of special, elaborate dance held at a HIGH SCHOOL, COLLEGE[1] or UNIVERSITY (e.g., PROM, COTILLION). **4** A style of elegant women's dress worn to FORMALS[3]; it may be a long or floor-length, full or straight garment made of taffeta, silk, satin or velvet. *Compare* SEMIFORMAL[1,2].

Fort Knox (economy) Since 1936, the major storage location of American gold reserves for the US DEPARTMENT OF THE TREASURY. It is located in a US ARMY military area and is characterized by being very heavily guarded. By association, any place that has very tight security and is very safe. [After its location near 'Fort Knox' in Kentucky.] *See* GOLD STANDARD.

Fort Sumter (history) A UNITED STATES military fort and arsenal located on an island in the harbor off the coast of Charleston, South Carolina. It was fired upon by forces of the CONFEDERATE STATES OF AMERICA who succeeded in capturing it from UNION[3] forces during April 12 to 14, 1861. It was the first militarily aggressive action of the Confederacy and is considered the start of the CIVIL WAR.

Fortune (media) A prestigious business magazine containing articles on business reports, government control of business and industry, social aspects of business and interviews. It uses quality color photographs and charts which give it an attractive appearance. It was founded in 1930 and has a circulation of 760,000. Once a year, it publishes a special issue listing the *FORTUNE* 500.

Fortune **500** (economy) The list of the 500 largest CORPORATIONS and companies in the UNITED STATES according to sales. This list is an important method used to determine the strength of the national economy as well as the STATE and/or local economy because they produce a product or services which are well sold and they employ many people. By association, a *Fortune* **500** company is a powerful company named on this list.

Forty-Ninth Parallel (geography) Since 1846, the northern and western land border of the UNITED STATES and the international boundary between the US and Canada. *See* BORDER; *compare* RIO GRANDE, GREAT LAKES.

"40 acres and a mule" (minorities) During RECONSTRUCTION, the slogan and promise made to blacks by REPUBLICAN politicians from northern STATES. It was thought that with land and horsepower, AFRICAN AMERICANS could become landholders and economically independent. However, the promise remained unfulfilled because of disagreements over the land (i.e., northerners thought it could come

from former plantations; southerners refused to give blacks land from their plantations).

4868, Form (economy) The official tax form printed by the IRS which individuals use if they cannot or do not file individual INCOME TAXES by APRIL 15. With this form, a taxpayer receives four more months (until the second week of August of the same year) to file taxes; the individual pays interest on the amount owed.

Foster, Stephen Collins (people) (1826–1864) A composer remembered for his popular songs which many people can sing, including "MY OLD KENTUCKY HOME", "OH, SUSANNA" and "Jeannie with the Light Brown Hair".

foul (1, 2 sports and leisure) **1** In BASEBALL, describing a play in which the hit ball or thrown ball is not good and cannot be played (e.g., a ball that is out of the playing boundary). Also known as "FOUL BALL". **2** In BASKETBALL, when a player does something illegal (e.g., pushing an opponent); it results in the opposing team getting possession of the ball and taking free shots, or throws, at the basket.

foul ball (sports and leisure) In BASEBALL, a ball that a batter hits outside the lines of play; a ball that is not playable. Also known as a "FOUL[1]". By association, some statement or action which is not appropriate for a given situation.

Founder (1, 2 government) **1** One of the 55 members of the CONSTITUTIONAL CONVENTION of 1787 who developed and debated the CONSTITUTION. Also known as "Framer"; formerly known as "Founding Father". **2** A general term for any person (male or female) who had a significant role in helping AMERICA[1] earn its independence either by fighting in the AMERICAN REVOLUTION or by shaping the CONSTITUTION.

Founding Fathers (government) An older name for FOUNDER.

Four Corners (geography) In the SOUTHWEST, the name of the district where four STATES meet. From clockwise they are: Colorado, New Mexico, Arizona and Utah.

Four Freedoms, the (foreign policy) According to PRESIDENT FRANKLIN ROOSEVELT, the essential freedoms that all people throughout the world should have, namely, freedom of speech, freedom of religious worship, freedom from want and freedom from fear. Roosevelt presented these in a STATE OF THE UNION MESSAGE of January 6, 1941. *See* WORLD WAR II; compare FOURTEEN POINTS.

Four Hundred, the (society) That wealthy group of 'four hundred' upper-class people whose families' histories in AMERICA[1] stretch back three generations. Frequently, these families spent the summer months in their NEWPORT HOUSES. [This concept was stated by Mrs. Astor, a high society woman of the early twentieth century, who chose this number because it was the maximum number of guests that could comfortably fit in the ballroom of her private residence.]

4.0 (education) A type of GRADING SYSTEM used to record a student's overall academic performance. The highest and best GRADE[2] in this system is '4.0' while the worst is '0.1'. *See* Appendix 5 Grading Systems; *compare* A+.

401-K plan (economy) A kind of savings plan in which an employee can deposit up to 10% of his or her gross salary in a company fund. That fund is then invested in stocks, bonds and/or money markets.

four-star (military) Describing a high-ranking, commissioned general in the US ARMY. By association, something that is of good quality or a high position. [From the metal pin insignia consisting of 'four stars' which this officer wears on the military uniform.] *See* Appendix 7 Military Ranks.

four-year college (education) A COLLEGE[1] that offers BACHELOR'S DEGREES. Also known as "LIBERAL ARTS COLLEGE"; *see* Appendix 4 Educational Levels; *compare* COMMUNITY COLLEGE.

4-H Club (sports and leisure) A club for young people and teenagers that encourages them to learn about and participate in different contemporary farming methods, animal handling and animal care. It provides members with opportunities to participate in events such as horseback riding shows, livestock raising and plant growing. Often, its members compete at COUNTY FAIRS and STATE FAIRS. The many local groups are sponsored by the DEPARTMENT OF AGRICULTURE. [After

the motto of the participants; to advance the 'H'ead, 'H'eart, 'H'ands and 'H'ealth of participants.]

Fourteen Points (foreign policy) The list of 14 actions and goals to create world peace after WORLD WAR I that PRESIDENT WOODROW WILSON presented on January 8, 1918 to a JOINT SESSION of CONGRESS. Basically, they concerned: free, international trade; redrawing the boundaries between some European countries; and creating a League of Nations (e.g., today's United Nations). *Compare* FOUR FREEDOMS.

Fourteenth Amendment (government) The important addition to the CONSTITUTION (ratified in 1868) saying that the people born or living in a STATE are citizens of that state and that they are obliged to follow its rules, and that the state is obliged to protect them with equal protection from the law (i.e., it guarantees people DUE PROCESS). Further, it claims that every person deserves "equal protection of the laws"; this phrase from the AMENDMENT has been used as the basis for many SUPREME COURT DECISIONS supporting CIVIL RIGHTS. Also, it discusses REAPPORTIONMENT. It was first adopted to make former slaves citizens of both the state where they lived and the UNITED STATES and thereby protect recently freed slaves from discriminatory rules in states of the SOUTH, but now is used to protect the rights of all individuals. *See* BILL OF RIGHTS, INCORPORATION, *DRED SCOTT* v. *SANFORD*, EQUAL PROTECTION OF THE LAWS.

Fourth Amendment (legal system) The AMENDMENT to the CONSTITUTION (1791) that protects people, their personal privacy and their property from being searched for unusual reasons or being examined without their permission (i.e., SEARCHES AND SEIZURES). *See* SEARCH AND SEIZURE, EXCLUSIONARY RULE, BILL OF RIGHTS, *MAPP* v. *OHIO*.

fourth estate (media) A general term for the media; the profession of newspapers, magazines, radio and television reporting. In addition, it implies the power of the media to influence politics and current affairs. [From a comment by English statesman, Edmund Burke (1729–1797), where the 'first estate' is the nobility, the 'second estate' is the common people, and the 'third estate' is the clergy.]

Fourth of July, the (customs and traditions) A popular name for INDEPENDENCE DAY which is held every year on July 4.

FOX (media) The fourth major COMMERCIAL television network, established in 1984. It creates and broadcasts action shows and SITCOMS. It is known for producing programs that are unique, innovative and designed for a younger, more up-to-date, current audience. [Shortened from 'Fox' Broadcasting Company.]

Framer (government) *See* FOUNDER[1].

franchise (economy) A type of business enterprise where a company (i.e., the **franchiser**) supplies goods or services to a person (i.e., the **franchisee**) who has paid for the rights to operate (under the franchisee's own management) that business under the franchiser's company's name. It is commonly used with FAST FOOD restaurants and professional sports teams. *See* RAY KROC, NATIONAL BASKETBALL ASSOCIATION, NATIONAL FOOTBALL LEAGUE, NATIONAL HOCKEY LEAGUE; *compare* CHAIN.

Franklin, Aretha (people) (born in 1942) African-American singer. Her career began singing GOSPEL MUSIC but she became popular singing SOUL MUSIC songs (especially from 1961 to 1972); namely with, "Respect" and "(You Make Me Feel Like a) Natural Woman" (1967). She is admired for the strength and wide range of her voice and lyrics which are meant to uplift and empower women. Her nickname is "Queen of Soul"; some friends and loyal fans call her "ReRe", from A're'tha.

Franklin, Benjamin (people) (1706–1790) Writer, inventor, FOUNDER[1] and diplomat. He wrote for the newspaper *NEW ENGLAND COURANT* as well as for POOR RICHARD'S ALMANACK (from 1733 to 1758). He is well known for his experiment which tested for the existence of electricity by flying a kite in a lightning storm. He supported American independence from Great Britain and assisted in writing the DECLARATION OF INDEPENDENCE. He served as the American ambassador to France from 1776 to 1784, during which time he was immensely popular in Europe

and was easily recognized by his sober, simple clothing, typical of QUAKERS, which was so unlike the opulent, elegant clothing of the European nobility. In 1787, he served as one of the leaders of the CONSTITUTIONAL CONVENTION.

fraternal order (sports and leisure) A voluntary organization and men's social club which has secret practices for welcoming new members (e.g., secret handshakes, passwords). Usually, it is concerned with solving community problems and providing its members with social contacts. Also, it sometimes provides its male members with some type of insurance policy. *See* FREEMASONS, MASONS; *compare* OLD BOYS' NETWORK.

fraternity (sports and leisure) A private, GREEK LETTER ORGANIZATION and social club for UNDERGRADUATE men. Most are national organizations with individual chapters established on COLLEGE[1] or UNIVERSITY CAMPUSES. Although all fraternities donate time and some money to philanthropic causes, the main focus is on providing young men with friendship, a place to live, an opportunity to participate in INTRAMURAL sports and to have parties and dances with SORORITIES. Fraternities choose their members once a year during RUSH. The "fraternity house" is the residence building owned, operated and lived in by the active members of the fraternity. "Fraternity brothers" are men who belong to the same fraternity. "Frat boy" is a derogatory name used to refer to a member of a fraternity. Popularly known as a "frat"; *see* RUSH, LETTERS.

Freddie Mac (1 housing and architecture; 2 economy) **1** The popular nickname for the Federal Home Loan Mortgage Corporation, a private company which was created in 1970 at the encouragement of the US CONGRESS. This company provides a source of low-interest home loans to a variety of people (e.g., owners of single family homes or multi-family buildings) by buying that home mortgage from the loan-granting bank. By association, describing any of the loans offered by this private organization. **2** On the STOCK MARKET, a certificate or bond sold by this company which helps supply the money available for the reservoir of loan/mortgage money. [From personalizing 'F'ederal Home Loan 'M'ortgage 'C'orporation.] *Compare* GINNIE MAE.

free agent (sports and leisure) An athlete of a professional sport who does not have a contract to play that sport and thus can (i.e., is 'free' to) independently sign a contract for the most money and benefits with any team at any time. **Free agency** has become the most common method of employing athletes since the end of the RESERVE CLAUSE in 1976. Further, it has led to a huge increase in players' salaries and player power when bargaining with team owners (e.g., the 1994 WORLD SERIES was canceled due to a player STRIKE[1] over their salaries). *See* DRAFT[2].

free jazz (the arts) A style of JAZZ MUSIC which was developed after BEBOP and during the 1960s. It is characterized by being very improvisational and by experimenting with rhythms and harmony. It was played and promoted by JOHN COLTRANE. Also known as "improvised (jazz) music".

free press clause (media) That part of the FIRST AMENDMENT that prevents the government from stopping or controlling the ideas or information a person or group wishes to publish. *Compare* PRIOR RESTRAINT.

free-exercise clause (religion) That part of the FIRST AMENDMENT stating that CONGRESS cannot interfere with or prohibit people from freely practicing (i.e., 'exercising') their religion. However, religious acts cannot be illegal according to American law as stated in the US CONSTITUTION (e.g., religious groups cannot practice DISCRIMINATION, religions cannot promote one man having two or more wives). The INCORPORATION CLAUSE extends this rule to the STATES. *See* CHURCH OF JESUS CHRIST OF LATTER-DAY SAINTS.

Freedmen's Bureau, the (minorities) After the CIVIL WAR, the federal agency designed to help blacks establish themselves in a free society. It gave AFRICAN AMERICANS food, clothing and medical attention, helped them find missing family members and established SCHOOLS[5] and BLACK COLLEGES. Further, it had a legal court to help blacks get and keep work

and solve legal problems. It was created by CONGRESS in March 1865 which then funded it until 1868 when it dissolved. It was an important help to many blacks who had been left homeless after the EMANCIPATION PROCLAMATION; however, it was overwhelmed by the large number of blacks to help and was ceased too soon. Its commissioner was Oliver Otis Howard (1830–1909). Formally known as the "Bureau of Refugees, Freedmen and Abandoned Lands"; *see* HOWARD UNIVERSITY.

"freedom flights" (immigration) After the communist take-over in Cuba in 1959, an agreement between Cuba and the US which allowed over 300,000 mostly middle-class and educated Cuban citizens to immigrate to AMERICA[1] by airplane from December 1965 to April 1973. The airplane flights, offered twice every day, were stopped by an order from the Communist Cuban leader, Fidel Castro (born in 1927), because so many wealthy people had emigrated from Cuba. *See* BRAIN DRAIN, MIAMI, LITTLE HAVANA; *compare* MARIEL BOATLIFT.

Freedom Rides (minorities) During the CIVIL RIGHTS MOVEMENT, a NONVIOLENT ACTION campaign during the summer of 1961 when some 1,000 young black and white members of CORE (which organized the event) and SNCC rode public interstate buses throughout the SOUTH. This campaign was designed to test the strength of the desegregation law of interstate bus travel, bus stations and services which had been established by the INTERSTATE COMMERCE COMMISSION in 1955. The first **freedom ride** traveled from WASHINGTON D.C. to NEW ORLEANS stopping at various southern cities along the way. The volunteer **freedom riders** were often attacked and beaten up with pipes and fists by those local angry white southerners who did not support desegregation. Often, local police forces did nothing to stop the violence. The violence was only stopped after ATTORNEY GENERAL ROBERT KENNEDY sent FEDERAL MARSHALS and the NATIONAL GUARD to those cities. This campaign illustrated to the public and politicians that there was a difference between DE JURE segregation and DE FACTO segregation. Further, it is a symbol of the strength of purpose, belief and courage of the freedom riders. Finally, it symbolizes the success of DIRECT ACTION and NON-VIOLENT ACTION. *Compare* MONTGOMERY BUS BOYCOTT.

Freedom Vote (minorities) During the CIVIL RIGHTS MOVEMENT, an organized, mock vote for AFRICAN AMERICANS in Mississippi (many of whom were prevented from voting because of JIM CROW or not being registered to vote) which coincided with the official elections held in November 1963. This event was organized by the SNCC who succeeded in registering 90,000 blacks to vote. This event successfully increased the whites' awareness of the voting power of blacks.

Freemasons, the (religion) (Masons) A general name for a type of FRATERNAL ORDER as well as organization emphasizing morals and social contacts. It was first established in England in 1717 and was brought to AMERICA[1] during the COLONIAL PERIOD and is still active. It uses some religious ideas which are common to all major world religions. Masons accept that their God created the universe but that people must make their own life choices. They participate in works of charity, brotherhood and help. Members often meet in a space called a "lodge" and have secret rules and customs. [From the group's notion of trying to create better men and society like the many builders, or 'masons', of King Solomon's temple, which was a place of knowledge and understanding in ancient Israel.]

French and Indian War, the (history) A war between England and France, which took place in Europe and North America (1754–1763). France lost and ceded to England all of its property east of the MISSISSIPPI RIVER, except NEW ORLEANS as well as parts of Canada. France ceded to Spain all French territory west of the MISSISSIPPI RIVER. In Europe, this war is known as the "Seven Years' War". *See* AMERICAN REVOLUTION, LOUISIANA PURCHASE. [From the 'French' army and its allies, many different 'Indian' tribes.] *See* CAJUNS.

French Quarter (geography) That old district of NEW ORLEANS built during the late 1700s in the unique architectural

pattern of Spanish colonial buildings with wooden shutters and iron grillwork. During the twentieth century, it had many music clubs and is popularly considered the birthplace of JAZZ MUSIC. Further, it is the center of the annual MARDI GRAS festivities. [From French *Vieux Carré,* meaning "Old 'Quarter' ".] *See* PRESERVATION HALL, BOURBON STREET, STORYVILLE.

French toast (food and drink) A breakfast dish of thin slices of WHITE BREAD dipped in a batter of egg and milk then fried in a skillet until both sides are brown. It is topped with MAPLE SYRUP or sugar and cinnamon.

freshman (1 society; 2 education) **1** A novice; a person lacking in experience or seniority (e.g., a "freshman SENATOR" is a senator who is serving his or her first TERM[1]). **2** A first-year student at a SECONDARY SCHOOL, COLLEGE[1] or UNIVERSITY. Also known as "first-year student"; *see* CLASS.

fried chicken (food and drink) Chicken basted in a batter of milk, flour, butter and spices then cooked in a pan of oil or fat over direct heat. Often, it is served with mashed potatoes and gravy. Originally, it was very popular in the SOUTH but now is eaten nationwide. *See* SOUTHERN COOKING, FAST FOOD; *compare* CHICKEN WINGS.

Friedan, Betty (people) (born in 1921) Mother, author and a leader of the WOMEN'S MOVEMENT. She promoted other roles for women besides motherhood in her successful book *The Feminine Mystique* (1963). She was a co-founder and the first president of NOW (1966–1970). Her later books have presented a more balanced approach to feminism, *The Second Stage* (1981), and to growing older, *Fountain of Age* (1993). *See* FEMINIST MOVEMENT.

Friends, the (religion) The popular name used by the members of the RELIGIOUS SOCIETY OF FRIENDS to refer to themselves. *Compare* QUAKERS.

Friends of the Earth (environment) A conservation INTEREST GROUP which lobbies the government to pass legislation to help protect the environment, especially cleaning up toxic and solid waste sites and protecting the ozone and air quality. It was founded in 1969, is based in WA-SHINGTON D.C. and has a current membership of 35,000. *See* ENVIRONMENTAL MOVEMENT.

fringe benefits (work) In addition to regular pay and/or salary, any other benefit given to a worker or employee, namely: free health care insurance, pension, use of a company-owned car, or DAY CARE services.

Fritchie, Barbara (customs and traditions) A fictional, 90-year-old female character from the NORTH memorialized in a poem by John Greenleaf Whittier (1807–1892). During the CIVIL WAR and while Confederate troops under the leadership of STONEWALL JACKSON were marching by her house in MARYLAND, this woman dared to wave the STARS AND STRIPES[1] in their view. Because of her blatant, bold defiance, the Confederates did not attack her nor the flag. She is a symbol of solid American patriotism.

fritter (food and drink) A side dish consisting of a piece of fruit (e.g., apple), seafood (e.g., clam) or ball of corn meal that is dipped in a batter of egg, onion and flour and fried in oil in a pan.

front runner (politics) The strongest candidate; the one most likely to win the political party nomination or election. [In the sport of horse racing, the horse that 'runs' in 'front' of the others is the better horse and will probably win the race.]

frontier, the (geography) That area untouched by the rules, customs and structures of civilization. During the nineteenth century, it referred to those lands unsettled by whites which lay west of the APPALACHIAN MOUNTAINS. With each white settlement wave and addition of each new STATE to the UNITED STATES, it continually shrank. In 1893, the frontier was reported to be "closed" by the Bureau of the Census, meaning that there was no more PUBLIC LAND available for sale. By association, "on the frontier" means to be on the edge of civility or to be on the verge of discovery. *See* WEST, NEW FRONTIER, TERRITORY, CENSUS, LAND CLAIM[1], FREDERICK JACKSON TURNER, GOLD RUSH, ALLOTMENT.

Frost, Robert (people) (1874–1963) Poet and farmer. His poems combine traditional poetic aspects of meter and rhyme with subject matter that is typically Amer-

ican (e.g., plants, weather). Further, in his poems he used vocabulary and oral speech patterns unique to NEW ENGLAND and YANKEES[1]. Popular poems include "The Road Not Taken" (1914) and "Mending Wall" (1913).

Fruit of Islam (religion) (FOI) The militaristic, special group of African-American guards who protect and serve the NATION OF ISLAM, its ministers and activities. The guards wear distinctive blue-colored military uniforms.

fruitcake (food and drink) A dense, heavy, round cake containing various nuts, dried and preserved candied fruits often baked during CHRISTMASTIME and given to others as a gift. By association, it refers to an unusual, "nutty", eccentric or foolish person.

fudge (food and drink) A soft, rich candy made of chocolate, sugar, butter, milk and sometimes chopped nuts.

Fulbright Scholarship (education) A prestigious merit SCHOLARSHIP exchange program for American and international scholars, researchers, PROFESSORS and GRADUATE[2] students in the fields of education, culture and science. It is funded binationally, that is by the US and foreign governments, as well as PRIVATE SECTOR donations. Since 1947, over 70,000 Americans have gone overseas and over 130,000 internationals have come to the UNITED STATES to research, study or teach. [After SENATOR J. William 'Fulbright' (1905–1995), DEMOCRAT from Arkansas, writer of the BILL[2] that established this program.]

full faith and credit clause (legal system) A section of the US CONSTITUTION that requires all STATES to accept the laws and court decisions of other states. For example, each state respects the MARRIAGE LICENSE of a couple issued by another state.

full-blood (Indian) (minorities) A person whose ancestors include only Indian peoples. Also known as "full-blooded Indian".

fumble the ball (sports and leisure) In offensive plays of FOOTBALL or BASEBALL, a negative expression describing the action of touching or catching a ball but then dropping it before scoring or helping to score. By association, any clumsy or

sloppy action which ends in some unsuccessful result.

fund-raiser (politics) Any organized event (e.g., usually where the candidate attends a dinner or gives a speech) designed to earn money to finance the election CAMPAIGN of a candidate. **Fund-raising** money is earned by asking the guests to pay a fee for attending or to make a donation of money. Similar fund-raising techniques are done by various other groups to support the arts, performing art companies, SCHOOLS[5] and other institutions. *See* FEDERAL ELECTIONS COMMISSION, PAC, BOX SOCIAL.

fundamentalism (religion) A movement of "right-wing" groups in several PROTESTANT DENOMINATIONS whose members believe in living life according to literal interpretations of the Bible (both Old and New Testaments). It developed during the nineteenth century by splitting from the EVANGELICAL movement and today, generally has more CONSERVATIVE opinions about social and political issues that evangelicals. Its supporters favor SCHOOL PRAYER, FAMILY VALUES, patriotism and the ARMED FORCES; usually they do not support the WOMEN'S MOVEMENT nor GAY RIGHTS. *See* RIGHT, BIBLE BELT, MORAL MAJORITY, SCOPES MONKEY TRIAL, ELECTRONIC CHURCH.

fundamentalist (religion) A Christian follower of FUNDAMENTALISM. By association, any person who has very basic, extreme and/or literal beliefs in some religion (e.g., Christianity, Islam).

funeral home/parlor (customs and traditions) A house or building especially outfitted to hold funeral services, especially VIEWINGS and prayer services, as well as to receive guests who come to show their respect for a deceased friend or family member.

funny pages (media) In the SUNDAY EDITION, the usually colored pages containing comics. Also known as "funnies".

Furman v. Georgia (legal system) The DECISION of the SUPREME COURT (1972) stating that CAPITAL PUNISHMENT as practiced at that time in the US was CRUEL AND UNUSUAL PUNISHMENT and could not be used as punishment for CRIMINAL CASES.

This law was adapted by a later decision, GREGG v. GEORGIA.

Future Farmers of America (sports and leisure) (FFA) A national organization of HIGH SCHOOL students who want to pursue careers in farming, breeding and other agriculture-related jobs. It was established in 1928 and now holds annual local fairs to encourage members to compete against each other in events like cattle breeding or fruit and vegetable growing. *See* BLUE RIBBON, COUNTY FAIR; *compare* 4-H.

G

G (the arts) In the movies, the lowest type of ranking of the RATINGS SYSTEM[2] indicating that the movie contains scenes (i.e., non-sexual, non-violent) and language which are acceptable to all people, young and old. Most movies with this ranking are animated movies for children. [From appropriate to be viewed by 'G'eneral Audiences.]

G-men (government) Agents working for the FEDERAL BUREAU OF INVESTIGATION. [Probably from 'g'overnment + 'men'.]

Gadsden Purchase, the (geography) An agreement between the UNITED STATES and Mexico (in 1853) in which the United States acquired more lands in the SOUTHWEST and which fixed the current international border with Mexico. *Compare* TREATY OF GUADALUPE HIDALGO.

gag order (legal system) A formal command that a judicial court makes ordering that JURY members and other people do not discuss a particular case in public or with the media.

gag rule (government) A formal rule in a legislature that limits the amount of time its members can debate and discuss a BILL[2]. *See* RULES COMMITTEE; *compare* SENATE RULE 22.

Galbraith, John Kenneth (people) (born in 1908) Economist, writer, socialist. His first book, *The Affluent Society*

(1958), discussed an American society which had enough natural resources to give some individuals great private wealth and at the same time produce great public poverty. His economic beliefs are influenced by socialism.

Galludet College (education) The only LIBERAL ARTS COLLEGE[1] in the world that is designed for deaf and hearing DISABLED students. It was founded in 1864 and is located in WASHINGTON D.C. It offers its 2,200 students degrees at the ASSOCIATE'S DEGREE, BACHELOR'S DEGREE, MASTER'S DEGREE and PHD levels. Although it is a PRIVATE SCHOOL, it does receive some funding from the federal government. [After the American teacher of the deaf, Thomas Hopkins 'Galludet' (1787–1851).] *See* DEPARTMENT OF EDUCATION.

Gallup Ceremonial (customs and traditions) The popular name for the INTER-TRIBAL INDIAN CEREMONIAL. [After its annual location in 'Gallup' in the STATE of New Mexico.]

Gallup Poll (media) A well-known poll that measures the public's opinions on issues in politics, religion, education, society and immigration. It is compiled by the American Institute of Public Opinion and the results are published monthly in the *Gallup Monthly*. It is particularly known for its accuracy in political pre-election results in CAMPAIGN years. [For founding pollster George Horace 'Gallup' (1901–1984), who took the first polls in the 1930s.] *See* STRAW POLL.

gaming (minorities) A collective name for any of various games of cards, games of chance or gambling. Over 200 tribes participate in some form of gaming. This has been an important source of business revenue for Indian TRIBES since 1988 and the establishment of the INDIAN GAMING REGULATORY ACT. According to federal laws, there are three types of gaming: Class I consists of traditional Indian games of chance; Class II includes bingo and lottery games; Class III includes casinos and all other forms of gambling.

gangsta rap (the arts) A style of RAP music which has lyrics concerning urban gangs, illegal drugs, violence and animosity for, or a demeaning attitude toward, women. [A form of 'gangster rap'.]

Gannet Company (media) A large multimedia company, including the largest newspaper CHAIN of DAILIES. It began and owns *USA TODAY.* [After Frank E. 'Gannet' (1876–1957), the founder.]

GAR (history) During the CIVIL WAR, the nickname for the UNITED STATES ARMY. [Acronym from the 'G'rand 'A'rmy of the 'R'epublic.]

garage sale/yard sale (daily life) The sale of used or unwanted household items, clothing, YARD tools, furniture and other gadgets. It is organized and held by individuals or a group of individuals. These items are marked with a price tag and usually displayed in the 'garage', driveway or 'yard' of a house. Also known as "red tag sale" in NEW ENGLAND.

Garvey, Marcus (people) (1887–1940, born in Jamaica) A leader of BLACK NATIONALISM and black pride. He is remembered for promoting the idea of independence for all blacks (e.g., in Africa and the Americas) outside white society, preferably in Africa. He founded the UNIVERSAL NEGRO IMPROVEMENT ASSOCIATION (UNIA) in 1911 and established the Black Star Shipping line (1919) to transport blacks back to Africa, and to increase economic trade between blacks in Africa and the Americas. The Black Star line went bankrupt, and in 1925 he was indicted for fraud by the FEDERAL BUREAU OF INVESTIGATION, served two years in prison and in 1927 was deported to Jamaica. He was at the height of his power in 1920 with an international convention and a parade of 50,000 people through HARLEM.

-gate (language) A suffix, meaning "scandal" or "damaging scandal"; it is attached to the end of a noun, usually that one associated with the scandal. [After the second word in the compound name WATER'GATE'.] *See* IRAN-GATE.

Gates, Bill (people) (born in 1955) The CEO of Microsoft Corporation (1976), the computer software company, and businessman. He is known for popularizing personal computers by making them affordable for many people and for now owning the rights to many works of art, literature and information. He is one of the wealthiest men in the world. His head-

quarters are in Redmond in the STATE of Washington.

Gates, Henry Louis, Jr. (people) (born in 1950) African-American researcher, writer, editor and educator. He is known for writing, editing and publishing anthologies of black writings and studying the writings of blacks during SLAVERY. His scholarly works have helped establish AFRICAN-AMERICAN STUDIES as a legitimate and solid UNIVERSITY-level academic course. He is a vocal voice about current black and white relations.

Gathering of Nations, the (customs and traditions) A large, annual pan-Indian POWWOW for all members of Indian TRIBES which consists of singing and dancing performances and competitions as well as other social and cultural events for the NATIVE AMERICAN participants and guests. It was first held in 1982 and is held in Albuquerque, New Mexico in April. *Compare* GALLUP CEREMONIAL.

GATT (economy) An international trade agreement that tries to treat all member nations fairly while reducing international trade tariffs and settling trade disputes through discussion. It was signed in 1947 to stimulate the world-wide economy after WORLD WAR II and has been modified many times since by meetings (known as "rounds"). In 1994, the 111 member nations at the Uruguay Round agreed to replace GATT with the World Trade Organization (WTO). [Abbreviation of 'G'eneral 'A'greement on 'T'ariffs and 'T'rade'.] *See* JOHN F. KENNEDY.

Gay Power (minorities) The popular slogan to demand equal rights for homosexuals, namely, same sex marriages, increased funding for AIDS (Acquired Immune Deficiency Syndrome) research and NO DISCRIMINATION in housing and work. *See* GAY RIGHTS MOVEMENT.

Gay Pride Day (minorities) A Sunday in June. An annual event in which supporters of gay-related issues plan and participate in marches and other special events to celebrate gay and lesbian life. It was first held in 1970 as a method of remembering the anniversary of the STONEWALL INN, and is now celebrated in many areas nationwide with games, marches and/or public demonstrations. *See* GAY POWER.

gay rights (minorities) A collective name for the rights and freedoms for which members of the gay and lesbian community want to have. Namely, it consists of CIVIL RIGHTS, creating a more positive image of homosexuals in the general society and repealing all STATE laws which claim that homosexual activities and sexual acts are illegal.

Gay Rights Movement (minorities) The collective name for the independent planned and spontaneous events and actions which promoted GAY RIGHTS. It began with STONEWALL and it received confidence from the CIVIL RIGHTS MOVEMENT. It included the March on Washington D.C. in which 600,000 people, mostly lesbians, gays and bisexuals, marched in support of GAY RIGHTS. Until that time, this event was the largest political demonstration in WASHINGTON D.C. since the VIETNAM WAR. It was a positive event during the Gay Rights Movement. Also know as "GAY POWER" or "Gay Liberation".

GDP (economy) The figure of the total value of all the products and services that are made in the UNITED STATES in a year. This figure is reported once every three months. In 1991, this figure became the official method of measuring the size and activities of the US economy; thereby, it replaced the GNP. Today, the GDP is used because it is that figure which other countries of the world use to measure their own economies. [Abbreviation of 'G'ross 'D'omestic 'P'roduct.]

GED (education) A diploma that a person can earn through ADULT EDUCATION or REMEDIAL EDUCATION courses that is considered to be equal to a HIGH SCHOOL diploma. [Abbreviation of 'G'eneral 'E'quivalency 'D'iploma.]

General American English (language) That form of American English spoken which does not have many regional aspects in its vocabulary, pronunciation or grammar. In general, it is spoken by people living in many areas of the MIDWEST and the WEST. Most often, it is not spoken by those native American English Speakers living in NEW ENGLAND, the SOUTH or NEW YORK CITY. Also known as "North American English"; *compare* BROOKLYNESE.

General Assistance (health) (GA) A collective name for programs which help poor people under the age of 65 and poor children, namely, WELFARE, FOOD STAMPS, MEDICAID, TEMPORARY ASSISTANCE TO NEEDY FAMILIES, and meal programs for children (e.g., the National School Lunch Program, School Breakfast Program).

General Practitioner (health) (GP) An older term used to refer to a doctor who has a medical PRACTICE treating 'general', non-surgical health problems (e.g., colds, stitches). It has largely been replaced by the term "FAMILY DOCTOR". Also known as "generalist".

Generation X (society) A collective name for many of those people born between 1961 and 1971. These people are characterized by being: slightly pessimistic, well-educated, concerned with the environment (e.g., recycling, nature preservation) and working in un-prestigious jobs because they are not interested in making large salaries nor planning for the future. These people are disappointed with the greed, egotism and/or suburban lifestyles of their parents (many of whom are BABY-BOOMERS). [After the novel '*Generation X*' (1991) by Douglas Coupland (born in 1961) which first described these people.] Sometimes, also known as "twentysomethings"; *see* SUBURBS.

Gentleman's Agreement (immigration) An anti-Japanese immigration policy (originally created in 1907) active from 1908 to 1924, in which the Japanese government agreed to stop Japanese citizens from immigrating to the UNITED STATES; in exchange, PRESIDENT THEODORE ROOSEVELT promised not to discriminate against the Japanese immigrants currently living in the US. It is a symbol of American racism and DISCRIMINATION. *See* IMMIGRATION ACT 1924, YELLOW PERIL.

Georgetown (geography) A residential area in WASHINGTON D.C. located west of the CAPITOL and the MALL. It is known for having chic restaurants and student BARS[1] on its main thoroughfare, "M Street" and for being the location of GEORGETOWN UNIVERSITY.

Georgetown University (education) A religiously-affiliated UNIVERSITY with ACCREDITATION which is famous for its UNDERGRADUATE programs, law SCHOOL[4] and NCAA INTERCOLLEGIATE sports. It was founded in 1789 by Roman Catholic priests of the Jesuit Order in WASHINGTON D.C. Its COEDUCATIONAL student body includes 6,000 UNDERGRADUATES and 6,000 GRADUATES[2]. Its mascot is the Hoya, a bulldog. *See* PRIVATE SCHOOL, ROMAN CATHOLIC CHURCH.

Geronimo (people) (1829–1909, also known by his Indian name "Goyathlay") Chiricahua Apache INDIAN and warrior. After his wife, mother and children were killed by Mexican soldiers, he began a career of raiding Mexican villages and cleverly escaping from Mexican authorities and the US ARMY. When he was finally captured by the US in 1886, he joined his people on a RESERVATION in Fort Sill, Oklahoma where he was held as a POW with special permission to travel as a member of traveling exhibitions. He is a symbol of independence, cleverness and fierce fighting. By association, while children are playing and before one does something dangerous or daring (e.g., jumping from a tree), that child often shouts "Geronimo!".

gerrymandering (politics) Drawing the boundary lines for legislative and election districts to give one political party an unfair voting advantage over the other. **Gerrymandered** districts are considered the results of an abuse of power. [After Elbridge 'Gerry' (1744–1814), the Governor of Massachusetts, who approved new lines which produced odd-shaped districts in the form of a sala'mander' to benefit his party, the DEMOCRATIC-REPUBLICAN PARTY; 'gerry' + 'mander'.] *See* REAPPORTIONMENT, REDISTRICTING.

Gershwin, George (people) (1898–1937) A JEWISH-American songwriter, composer and pianist. He started his career working with his brother Ira Gershwin (1896–1983) in writing songs in TIN PAN ALLEY and for BROADWAY (e.g., "Embraceable You" and "Funny Face"). Later, he created uniquely American music by combining JAZZ MUSIC with symphonic music, his works include *Rhapsody in Blue* (1924), *AN AMERICAN IN PARIS*[1] (1928) and *PORGY AND BESS* (1935), the last of which told the stories of some AFRICAN AMERICANS.

Gettysburg (history) During the CIVIL WAR, the site of the bloodiest battle and largest encounter between the UNION[3] forces and the army of the Confederacy July 1–3, 1863. This battle, which marked the Confederacy's only attempt (which was ultimately unsuccessful) to invade the NORTH, left the Confederates with depleted military and moral strength; afterward, they retreated to the SOUTH. The loss of over 51,000 total soldiers prompted the dedication of a UNION[3] national cemetery at this site at which ABRAHAM LINCOLN presented the GETTYSBURG ADDRESS. Today, it serves as a NATIONAL MILITARY PARK and is remembered as the single battle in which the most Americans died. Sometimes referred to as "America's bloodiest battle"; *see* PICKET'S CHARGE.

Gettysburg Address (history) A famous, brief (only 10 sentences long), well-written speech of ABRAHAM LINCOLN, in which he praises the efforts of the dead UNION[3] soldiers and urges the civilian audience to continue supporting the NORTH in the CIVIL WAR effort, making the UNITED STATES one united country again without SLAVERY. It was presented on November 19, 1863, at the dedication ceremonies of the new military cemetery, located at the site of the battle of GETTYSBURG where so many men (i.e., over 51,000) had died in July of that year. *See* EMANCIPATION PROCLAMATION, "GOVERNMENT OF THE PEOPLE. . .".

Ghost Dance (Religion), the (religion) A religious movement popular among several Native American TRIBES of the GREAT BASIN and GREAT PLAINS which combined Indian round dances with Christian EVANGELICAL enthusiasm and gave INDIANS spiritual hope of better times to come. It first began in the 1870s under the leadership of Wodziwob and was revived in 1890 by Wokova (1856–1932) a religious leader of the Paiute Indian tribe. The followers believed that if people performed these dances for several days, life for Indians would return to that time

before white Europeans came to North America; that is, all the buffalo that had been killed and all the Indian people who had died would return to earth and join with the living Indians and live again. The Ghost Dance rituals and beliefs were adapted somewhat differently by each tribe (e.g., in the Oglala SIOUX tribe, which had adopted the dance after their own SUN DANCE had been outlawed by the BIA, performers wore special 'ghost' shirts which they believed would protect them from gun bullets). It was distrusted by the US government and severely attacked at WOUNDED KNEE MASSACRE in 1890 which destroyed this religion. Today, some tribes are practicing a newer, revised form of it.

GI Bill, the (education) The popular name for the SERVICEMEN'S READJUST-MENT ACT of 1944.

Gideon v. Wainwright (legal system) The DECISION of the SUPREME COURT (1963) stating that if a person is charged with committing a serious crime but cannot pay for a LAWYER, the STATES must both provide that person with a lawyer and pay for the lawyer's fees. This expanded the power of the DUE PROCESS clause of the FOURTEENTH AMENDMENT. *See* PUBLIC DEFENDER, WARREN COURT.

gift registry/list (customs and traditions) A select list of items and quantity of item units that are available at a store from which a shopper may select and buy for some other person in honor of some special event, namely, the marriage of a couple or a baby's birth. An engaged couple or individuals may be **listed** at a boutique or, more often, a DEPARTMENT STORE.

gig (the arts) A planned, live musical event at which musicians and/or singers perform to a small group in a club or restaurant. Also, and by association, the uninterrupted period of time that a group performs at the same location under the same payment conditions. In general, a short-term, paid job.

Gilded Age, the (history) A historical term referring to the period of 1870 to 1900, that is from RECONSTRUCTION until the PROGRESSIVE ERA. It is characterized by the excessive business wealth, greed and corruption in business and other parts of American society. [From the book entitled *The Gilded Age* (1873) written by MARK TWAIN and Charles Dudley Warner (1829–1900) which treated these aspects.] *See* ROBBER BARONS, TAMMANY HALL.

ginger ale (food and drink) A non-alcoholic, carbonated drink flavored with an extract from 'ginger'. "Ginger beer" is a type of ginger ale but it has more ginger flavoring.

gingerbread (food and drink) A type of dark brown-colored, sweetened dough made with ginger and molasses which is used to make breads and hard cookies during the HOLIDAY SEASON. "Gingerbread cookies" are made with a cookie cutter often in the shapes of people and houses and decorated with small, hard candies. By association, describing something that is overly decorated with too much ornamentation or craftwork. *Compare* CHRISTMAS COOKIES.

Gingrich, Newt(on) (people) (born in 1943) An Assistant PROFESSOR of History (1970–1978) and elected REPUBLICAN CONGRESSMAN of the HOUSE OF REPRESENTATIVES (1979–1998). He served on the CONGRESSIONAL COMMITTEES for space and the military as well as on the JOINT COMMITTEE on printing and HOUSE administration. He holds CONSERVATIVE opinions on political and social issues; he does not support GAY RIGHTS. He served as the SPEAKER OF THE HOUSE (1995–1998) and is known for trying to push through CONGRESS a series of conservative plans under the label "Contract with America" (in 1995) and for frequently attacking the DEMOCRATIC PARTY, including PRESIDENT BILL CLINTON. His CONSTITUENCY was the Sixth District in Georgia.

Ginnie Mae (1 housing and architecture; 2 economy) **1** A nickname for the Government National Mortgage Association (GNMA), the federal government agency which organizes and supplies funds to pay for those loans which are ensured by the federal government (e.g., loans for veterans which are sponsored and offered by the DEPARTMENT OF VETERANS' AFFAIRS). This agency is part of and overseen by the DEPARTMENT OF HOUSING AND URBAN DEVELOPMENT. By association, describing any of the loans offered by this public

agency. **2** On the stock market, a type of certificate or bond sold by the Government National Mortgage Association (GNMA) which helps fund this agency's supply of loan money. [From personalizing the initials 'GNMA'.] *Compare* FREDDIE MAC, FANNIE MAE.

Ginsberg, Allen (people) (1926–1997) A poet whose career began in the BEAT GENERATION known for his long, non-rhyming poems concerning personal relationships, the current state of AMERICA[1], homosexuality, taking drugs, and the ANTI-WAR MOVEMENT, including: "Howl" (1956) (which was banned for being considered obscene) and "America". He won a NATIONAL BOOK AWARD for poetry for his volume entitled *The Fall of America: Poems of these States* (1973). He was a Buddhist and active supporter of GAY RIGHTS.

girl scout (sports and leisure) A member of the Girl Scouts of the USA, a voluntary organization which provides girls, aged nine through 17, activities to promote individual self-awareness, values, helpfulness as well as instruct them in community service and nature. It was founded in the UNITED STATES in 1912 and currently has 3.5 million members who are organized into local groups known as "troops". Members wear distinctive green-colored hats and uniforms which they may decorate with any of various badges which they can earn through successfully completing various activities. Every year, all members participate in selling and delivering "Girl Scout Cookies" DOOR-TO-DOOR; this is a popular activity and the major fund-raising event of this organization. *See* BROWNIE[2], FUND RAISER; *compare* BOY SCOUT.

"Give me liberty, or give me death!" (history) The final, rousing sentence of a speech given by Patrick Henry (1736–1799), a LAWYER and public speaker, to the Virginia Convention on March 23, 1776, which showed his support and patriotism for the American colonists' cause. In this fragment he states that he would rather die than live under the oppressive power of the British government. *See* THIRTEEN COLONIES, AMERICAN REVOLUTION.

"Give me your tired, your poor" (immigration) A well-known line of poetry which symbolizes the UNITED STATES as welcoming immigrants. It is taken from the poem "THE NEW COLOSSUS".

"Give my Regards to Broadway" (the arts) The traditional, popular song (1904) about the theatrical world in NEW YORK CITY by George Cohan (1878–1948). The four lines are: "Give my regards to Broadway, remember me to Herald Square/Tell all the gang at 42nd Street that I will soon be there/Tell them of how I'm yearning to mingle with the old-time throng/Give my regards to Broadway and say that I'll be there [bef]ore long." It relates the wishes of an actor to be back performing on BROADWAY.

giveaway (customs and traditions) Another name for a POTLATCH ceremony.

GLB (minorities) An abbreviation referring to or pertaining to 'g'ay people, 'l'esbians and 'b'isexuals.

glee club (the arts) A group chorus organized to sing short pieces of music, often *a cappella* (i.e., without musical instruments). This group performs at various local and community events, especially during the HOLIDAY SEASON. Often, it is an EXTRACURRICULAR ACTIVITY in many HIGH SCHOOLS.

Glenn, John (people) (born in 1921) Astronaut and US SENATOR from the STATE of Ohio. In 1962, he was the first American to go into orbit (for five hours and 55 minutes) when he rode in the capsule *Friendship 7* (part of *Mercury 6* space project) and circled the earth three times. In 1998 aboard the SPACE SHUTTLE *Discovery,* he became the oldest person ever to go into space.

GMAT (education) An ETS MULTIPLE-CHOICE admissions exam that is taken by every person who has a BACHELOR'S DEGREE and wants to apply to a GRADAUTE[2]-level business SCHOOL[4]. [Abbreviation of 'G'raduate 'M'anagement 'A'dmissions 'T'est.] *Compare* GRE, LSAT, SAT.

GNP (economy) The figure of the total value of all goods and services produced by American businesses located both in the US and in foreign countries. However, it does not include income earned by foreign companies located in the US. It

is reported once every three months and is an accurate measure of the wealth and strength of the US economy. In 1991, however, it was replaced by the GDP as the official indicator of the national economy. [Abbreviation of 'G'ross 'N'ational 'P'roduct.] *Compare* GDP.

gold record (the arts) In the recording music business, a record (i.e., album, Compact Disc or audio cassette) which has earned over $1 million and sold 500,000 authorized copies. The success of musical artists, especially POP MUSIC artists, is measured in the number of their gold records. Before 1989, 1 million copies had to be sold in order for a record or music artist to "go gold". The necessary sales information is supplied by the Recording Industry Association in WASHINGTON D.C. *Compare* PLATINUM RECORD.

gold rush (history) The quick, sudden migration and/or immigration of people to an area where gold is said to be found, in order to dig and find gold. After gold was discovered in California in 1848, the first and largest gold rush occurred in California in 1849. The other gold rushes include: Colorado (1859); Nevada (1860); Idaho (1861); Montana (1863); South Dakota (1876); Arizona (1877); Colorado (1892); and Alaska (1899). *See* AMERICAN DREAM, STRIKE[3], BLACK HILLS, SEWARD'S FOLLY.

gold standard (economy) An economic tool which stabilizes a currency. A currency "on the gold standard" can be converted into gold on demand because the total value of the currency equals the total value of the gold held by the government. The US permanently went "off the gold standard" in 1971. However, since 1994, the US DEPARTMENT OF THE TREASURY maintains $7.05 billion of gold bullion as reserve ASSETS for the currency which is stored at FORT KNOX.

"Golden Door", "The" (immigration) Specifically, a nickname for ELLIS ISLAND; and in general, a metaphor for immigration. [From the poem "THE NEW COLOSSUS" which is written on the base of the STATUE OF LIBERTY.]

Golden Gate Bridge (transportation) The second largest suspension bridge in the UNITED STATES (4,200 feet; 1,280 m) found in SAN FRANCISCO. It was built in 1937, is painted in a distinctive orange color and is the symbol of the city of San Francisco. *Compare* VERRAZANO-NARROWS BRIDGE.

Golden Globe Awards, the (the arts) The annual entertainment awards given to honor high achievement in movies and television programming. The awards are given by the Hollywood Foreign Press Association in the following film categories: best dramatic movie, best actress, best actor, best MUSICAL as well as others. Further, awards are also given to television broadcasting in the following categories: best dramatic TV series, best actress, best actor and others. The awards presentation ceremony is held every February and serves as a type of prediction for the winners of the ACADEMY AWARDS.

Golden Gloves (sports and leisure) An amateur boxing competition established in 1928 which sponsors bouts in twelve different weight classes. Its winners often proceed to compete for the US Olympic team as amateur boxers and/or to begin professional careers.

good neighbor policy (foreign policy) The foreign policy used by PRESIDENT FRANKLIN ROOSEVELT stating that no country has the right to interfere with the external or internal affairs of another country. [After a statement of Franklin Roosevelt in March 1933: "the policy of the 'good neighbor' – respect(ing) the rights of others."] *Compare* ROOSEVELT COROLLARY.

Goodman, Benny (people) (1909–1986) Clarinetist of JAZZ MUSIC and white band leader during the BIG BAND ERA. He was a very successful entertainer and performer of SWING MUSIC, especially for young white audiences. He received the nickname "King of Swing". His band's theme song was "Let's Dance".

GOP, the (politics) Since before the CIVIL WAR, a nickname for the REPUBLICAN PARTY. [Abbreviation of 'G'rand 'O'ld 'P'arty.]

gospel (music) (religion) A style of music characterized by the harmonized vocals of group or choir singing, hand clapping, humming accompanied by the use of the organ and/or piano. Further, the songs all contain Christian religious

themes (namely, the after-life in heaven, praising the Christian God, asking God or Jesus Christ for help, etc.) and are sung with feeling, inspiration and religious belief. It grew out of the EVANGELICAL songs that whites sung at PROTESTANT REVIVAL meetings in the nineteenth century and, more importantly, the spiritual, vocal songs created and sung by blacks during SLAVERY. Since the 1930s it has grown in popularity; it was often sung and performed during the CIVIL RIGHTS MOVEMENT. This type of music is strongly associated with the BAPTIST CHURCH and the PENTECOSTAL CHURCH.

Gotham (geography) A nickname for NEW YORK CITY; **Gothamites** are New Yorkers.

Gottlieb Trophy (sports and leisure) The name of the NBA award for ROOKIE OF THE YEAR which was established in 1952. [After Eddie 'Gottlieb'.]

"government of the people, by the people [and] for the people, shall not perish from the earth" (history) The last phrases of the GETTYSBURG ADDRESS and the part of that speech which is most frequently quoted because it states that the people (that is, not politicians) control the government and therefore the future of the country.

GPA (education) A numerical system used by many COLLEGES[1] to record the overall GRADE[2] performance of students. The most common is the 4.0 scale. [Abbreviation of 'G'rade 'P'oint 'A'verage.] *See* CLASS RANK, Appendix 5 Grading Systems; *compare* GRADING SYSTEM.

GQ (media) A monthly magazine for men carrying articles and photos on men's fashion, trends and style. It was founded in 1957 and its circulation is 712,000. By association, a man who is described as being **GQ** is considered good-looking and fashionable. [Abbreviation of the full title 'G'entlemen's 'Q'uarterly.]

Graceland (geography) The home and burial place of ELVIS PRESLEY, located in Memphis in the STATE of Tennessee, which is now a major popular museum and touristic mecca honoring the singer of ROCK AND ROLL.

grade (1, 2 education) **1** A particular level of academic study in ELEMENTARY SCHOOL and SECONDARY SCHOOL. *See* Appendix 4 Education Levels. **2** A score or mark that a teacher gives to a student's completed work. *See* Appendix 5 Grading Systems.

grading system (education) A method used by SCHOOLS[1], COLLEGES[1] and UNIVERSITIES to indicate the quality of a student's academic work (e.g., A+, 90%). These GRADES[2] are on REPORT CARDS or transcripts. The three most common types are the LETTER GRADE, 100% scale and 4.0 scale. *See* Appendix 5 Grading Systems.

graduate (1, 2 education) **1** A person who has successfully completed a program at a SCHOOL[5] and holds a degree or certificate from that institution. **2** A person who is pursuing formal academic studies beyond the BACHELOR'S DEGREE level (i.e., a MASTER'S degree or PhD). Also known as "graduate student", "POSTGRADUATE student"; *see* ASSISTANTSHIP; *compare* UNDERGRADUATE.

graduate school (education) A HIGHER EDUCATION institution beyond the BACHELOR'S DEGREE level that offers academic programs in the HUMANITIES (i.e., MASTER'S DEGREE and PhD level). *See* GRADUATE[2]; *compare* PROFESSIONAL SCHOOL.

graham cracker (food and drink) A hard, rectangular-shaped, brown-colored cracker that is slightly sweetened. It is frequently given to children as a snack; also, it may used at the crust of CHEESECAKE. [After the nineteenth century diet promoter, REVEREND Sylvester 'Graham', who created this cracker.]

Graham (Reverend) Billy (people) (born in 1918) Religious leader, Southern BAPTIST minister and PROTESTANT evangelist. Since 1949, he has led many popular REVIVALS, known as "crusades", across the UNITED STATES and the world to convert people to evangelism (see EVANGELICAL). He has promoted disarmament and DESEGREGATION. He is recognized for his personal modesty and honesty and has been the friend and/or adviser to several PRESIDENTS, including: LYNDON JOHNSON, RICHARD NIXON, and RONALD REAGAN.

Graham, Martha (people) (1893–1991) A dancer and choreographer who helped develop the new style of modern dance

especially through free and loose body movements. She choreographed dances to unique American music (e.g., "Frontier" in 1935 and "Appalachian Spring" in 1944) and ancient Greek themes (e.g., "Clytemnestra" in 1958). *See* AARON COPLAND.

Grammys, the (the arts) The important, annual, recorded music awards given to recording musicians for high achievement in some 70 different categories of music. Some of the categories include: "record of the year" (i.e., song), "best album of the year" (i.e., Compact Disc), "best pop music vocal performance" for male and for female performers, JAZZ MUSIC, classical music, COUNTRY MUSIC, etc. The National Academy of Recording Arts and Sciences (NARAC) selects the winners by vote and presents the awards in official ceremonies, first held in 1958. These awards are officially known as the "National Academy of Recording Arts and Sciences awards"; the award itself depicts a small gramophone. [Shortened from the 'gram'ophone, an early version of the record player.]

Grand Canyon, the (environment) A large area of massive and beautifully colored stone covering 1.22 million acres (.49 million hectares) which, over millions of years, has been cut into and shaped by the Colorado River. This enormous natural wonder is part of a NATIONAL PARK and is very popular with tourists and outdoor enthusiasts because of the opportunities for hiking, camping and rock climbing and seeing the wildlife.

Grand Central Station (transportation) On Park Avenue in the middle of NEW YORK CITY, a very large, elegant, cavernous train and subway station as well as bus terminal. It is used daily by numbers of commuters and other travelers. It was opened in 1913, and before the 1960s it was especially busy. By association, a very busy, crowded place. Today, it is also known as "Grand Central Terminal".

grand jury (legal system) A type of JURY consisting of a group of citizens (at least 12, no more than 23) that swear to listen to the facts concerning a person accused of committing a crime and then decide if there are enough facts to bring this case to a CRIMINAL TRIAL. [For the larger number of jury members compared to a PETTY JURY.]

Grand Old Opry, the (the arts) The premiere, live-performance show of COUNTRY MUSIC stars which is held live (since 1974) at the Opryland theme park in NASHVILLE, usually every WEEKEND. It first began as a radio program in 1925 and was known as the *National Barn Dance*. It is still broadcast on the radio on WWSM. It was and remains an important venue to showcase COUNTRY MUSIC and its stars. By association, country music. Also spelled the "Grand Ol' Opry"; also known as "The Opry"; *see* CALL LETTERS; *compare* LOUISIANA BARN DANCE.

Grand Slam, the (1, 2, 3 sports and leisure) **1** In tennis, the four major championships in professional tennis for men and women; the Australian Open, French Open, Wimbledon (formally known as the "All-England Club's Lawn Tennis Championship") and the US OPEN. [From the card game Bridge.] **2** In golf, four men's tournaments, including in order; the MASTERS, the US OPEN, the British Open and the PGA CHAMPIONSHIP. **3 grand slam** In baseball, a HOME RUN that is made when an offensive player is on each base; which equals four points. By association, a total success.

Grand Wizard, the (minorities) During the nineteenth century, the title of the original leader of the KU KLUX KLAN from 1866 to 1872. It has been replaced by the title "IMPERIAL WIZARD".

grandfather clause (1, 2 legal system) **1** A JIM CROW law in many southern STATES that prevented black men from voting. It stated that blacks could vote only if their grandfathers or fathers had voted during RECONSTRUCTION before 1867. In 1915, in the US SUPREME COURT case *Guinn* v. *United States*, the NAACP proved that this clause was UNCONSTITUTIONAL. **2** In the legal system, any clause that allows a person to be exempt from a law because of a condition that existed before the law (e.g., a 19-year-old person receives the right to legally drink alcoholic drinks at 19; if the STATE then changes this drinking age to 21, that 19-year-old person retains

the right to drink alcohol because he or she is protected by the grandfather clause).

grant (education) Money, services or land that is given without any expectation of repayment or services to a GRADUATE[2], a group or SCHOOL[5] which then pays for its own expenses. *See* BLOCK GRANT, PELL GRANT; *compare* ASSISTANTSHIP.

Grant, Ulysses S[impson] (people) (1822–1885) US ARMY General and US PRESIDENT (1869–1877) of the REPUBLICAN PARTY. During the CIVIL WAR, he served as a UNION[3] leader and won the important battles of Shiloh (1862) and Vicksburg (1863). As Supreme Commander of the Union Armies (1864–1865), he accepted ROBERT E. LEE's surrender at APPOMATTOX COURT HOUSE April 9, 1865. He was a skilled military general but because of his alcoholism he proved a weak President. His facial portrait is on the $50 BILL[1]. *See* Appendix 2 Presidents.

grant-in-aid (government) A type of GRANT which STATES and local governments receive from the federal government in order to pay for specific programs on the condition that they must follow the specific rules for these programs that the federal government makes. This type of funding increases the federal government's power in state and local issues. This is a key aspect in CO-OPERATIVE FEDERALISM. *Compare* BLOCK GRANT.

graphic novel (the arts) A story, usually fictional, which is told through the use of comic book methods (i.e., panels, dialogue balloons, drawn figures). It is printed in color on firm, high quality or glossy paper and bound like a book (i.e., either "paperback" or "hardback").

grassroots (society) A collective name for ordinary people who usually do not live in urban areas nor hold political positions; society at the local level.

gravy train (language) A term referring to any positive position or desirable benefits (e.g., money, promotion, political position) which some person or group has achieved or gained without too much trouble or effort.

GRE (education) An ETS MULTIPLE-CHOICE test taken by all people who want to continue studying at the GRADUATE[2] level in the LIBERAL ARTS or hard sciences

at an American UNIVERSITY with ACCREDITATION. It consists of two tests: the "General Test", which tests general knowledge and analytical skills and the "Subject Test" which is offered in several different specialized fields (e.g., English, history, chemistry). Both tests are offered on the same day several times throughout the year. The scores from this exam help a GRADUATE SCHOOL decide which students to accept into its academic program. [Abbreviation of 'G'raduate 'R'ecord 'E'xamination.] *Compare* GMAT, LSAT, SAT.

Great Awakening, the (religion) The period of Christian REVIVAL (1730–1760) in which enthusiastic religious leaders used a more excited and less formal style of religious worship to increase both people's interest in Jesus Christ and their active participation in religion. This movement affected most areas of the THIRTEEN COLONIES and greatly added to the number of members in the PRESBYTERIAN CHURCHES and BAPTIST CHURCHES. The increasing political problems before the AMERICAN REVOLUTION caused it to end. *Compare* SECOND (GREAT) AWAKENING, EVANGELICAL, BILLY GRAHAM.

Great Basin (geography) An area of the WEST consisting of dry, flat, open plains and some mountain ranges. It encompasses parts of the STATES of California, Idaho, Montana, Nevada, Oregon and Utah. It covers some 210,000 square miles (544,000 square km) and includes the Great Basin National Park which became a NATIONAL PARK in 1986. [Because its rivers do not have an outlet to an ocean.]

Great Compromise, the (politics) During the CONTINENTAL CONGRESS, the proposal that solved the debate between large and small STATES over elected representation in CONGRESS. It suggested that the POPULAR VOTE be used in the HOUSE OF REPRESENTATIVES[1] where the number of REPRESENTATIVES is based on the state's population and that the SENATE receive two members from each state, elected by their own state legislators. Also known as "Connecticut Compromise"; *see* SEVENTEENTH AMENDMENT.

Great Depression, the (history) The period (1929–1941) of serious national

economic and banking problems as well as high unemployment (i.e., 25% of adult, employable Americans were out of work). It began on BLACK TUESDAY and continued until the US entered WORLD WAR II. PRESIDENT FRANKLIN ROOSEVELT created the NEW DEAL to help stimulate the economy and provide jobs for the millions of unemployed. It marked the end of the wealth and economic boom of the ROARING TWENTIES. Also known as "the Depression".

Great Divide, the (geography) A nickname for the CONTINENTAL DIVIDE.

Great Lakes, the (geography) The group of the five largest freshwater lakes in the world: Lake Superior, Lake Huron, Lake Erie, Lake Ontario (which form the eastern part of the international US boundary with Canada) and Lake Michigan. They are important for shipping and industry throughout the MIDWEST, and have helped industrial centers develop in that region. *See* CHICAGO, RUSTBELT.

Great Migration, the (1, 2 immigration) **1** The immigration (1630–1642) of some 21,000 white PURITANS from England to the area of NEW ENGLAND in North America. The people left Europe because they wanted to practice their religion in freedom; many of them helped make the MASSACHUSETTS BAY COLONY very successful. *See* CONGREGATIONALISM[1]. **2** The migration (1890–1920) of some 2 million blacks from rural farms in the southern STATES to large urban cities in the NORTHEAST and MIDWEST. They left the SOUTH because of the blight of the "bull weevil" insect (beginning in 1892) which damaged the agricultural market and limited opportunities for agricultural work in those southern areas. By contrast, the NORTH offered more opportunities for work, usually in factory and industrial jobs. *See* SHARECROPPING.

Great Plains, the (geography) The rich, primarily flat prairie land that today is used for large-scale farming. It includes all or part of the STATES of Colorado, Kansas, Nebraska, New Mexico, North Dakota, Oklahoma, South Dakota, Texas and Wyoming and marks the beginning point of the WEST. Originally, it was home to the PLAINS INDIANS; in the beginning in the 1860s, its fertile, practically free land attracted white settlers. The drought in the 1930s transformed it into the "DUST BOWL". It is also known as "the Plains". *See* HOMESTEAD ACT OF 1862, LAND CLAIM[1], SIOUX, BLACK HILLS, BADLANDS.

Great Seal, the (customs and traditions) The official crest and insignia of the UNITED STATES OF AMERICA. It depicts a BALD EAGLE protected by a shield decorated in stripes, it holds an olive branch in one talon (representing peace) and a bundle of arrows in the other talon (representing military strength). In the bird's beak is a ribbon which has the words *E PLURIBUS UNUM*. This seal is put on all official government paper and documents. It was adopted by the CONGRESS in 1782 and has served as the basis for the seals of the PRESIDENT, the VICE PRESIDENT, the DEPARTMENT OF STATE and the SUPREME COURT.

Great Society, the (history) The name that PRESIDENT LYNDON JOHNSON gave the various government programs of the 1960s that were designed to help Americans by carrying on and updating the NEW DEAL policies. It tried to end legal racial discrimination, poverty, discrimination against the elderly and environmental pollution. Its most important aspects were the CIVIL RIGHTS ACT of 1964, VOTING RIGHTS ACT OF 1965, MEDICARE, MEDICAID, WAR ON POVERTY, Older Americans Act of 1965 and the National Wilderness Preservation System of 1964. By association, the Johnson ADMINISTRATION[2]. *See* SOCIAL SECURITY.

Greek Revival (housing and architecture) A style of private residence architecture popular in the NORTHEAST, MID-ATLANTIC region and the MIDWEST from 1820 to 1860 which was based on Roman and Greek models of architecture. It is characterized by having: a low-pitched roof; tall, large, round columns supporting a high porch roof; and symmetrical placement of doors and windows in the walls. Also known the "National Style"; *compare* FEDERAL STYLE.

Greek-letter organization (education) A general term for an UNDERGRADUATE student club where the limited membership is by invitation; either according to

above average or better GRADES[1] or some social criteria. Each club has its own motto which is usually written in the language of Classical Greek. This motto is then abbreviated to the first Greek letter of each word (e.g., "*Delta Zeta*" becomes "DZ"; known as "Dee Zee"). There are two kinds: an HONOR SOCIETY and a FRATERNITY or SORORITY.

Green Berets, the (military) The popular nickname for the elite SPECIAL FORCES group of the US ARMY. It was founded in 1952 and was particularly active during the VIETNAM WAR. [After the uniform 'green'-colored hats its members wear.]

green card (immigration) A permanent resident visa issued by the IMMIGRATION AND NATURALIZATION SERVICE, which gives a non-American (e.g., immigrants, temporary workers) legal permission to live, work, earn money and pay US taxes in the US. [From the 'card's' former 'green' color.]

greenback (1, 2 economy) **1** Today, a colloquial, popular name for the DOLLAR and paper money. **2** In 1862, paper money that was not supported by the GOLD STANDARD but issued to help finance the CIVIL WAR; it had very little value. [After the 'green'-colored ink used for printing it.]

greens (food and drink) A general name for a warm dish made from the edible 'green' leaves of various vegetables or other plants (e.g., beet, collard, spinach, mustard, turnip, dandelion) simmered in bouillon and served with meat ENTREES. It is a typical dish in SOUTHERN COOKING and SOUL FOOD.

Greenspan, Alan (people) (born in 1926) An economist and, currently, the Director of the BOARD OF GOVERNORS (since 1987). Although he has worked in the ADMINISTRATIONS[1] of REPUBLICAN PRESIDENTS (RICHARD NIXON, RONALD REAGAN, GEORGE BUSH), his good management of the economy has led to his long position as the head of the FEDERAL RESERVE BOARD.

greeting card (customs and traditions) A paper card sold in stores which has a decorated outer cover and message printed inside. It is bought and given to celebrate special events, especially birthdays, anniversaries, MOTHER'S DAY and FATHER'S DAY. *See* CHRISTMAS CARDS.

Gregg **v.** *Georgia* (legal system) The DECISION of the SUPREME COURT (1976) stating that CAPITAL PUNISHMENT as a punishment for committing murder was not always CRUEL AND UNUSUAL PUNISHMENT because STATE laws help the judge and JURY consider the ACCUSED as an individual and decide between the death penalty or a prison sentence. This OVERRULED *FURMAN* v. *GEORGIA*. *See* BURGER COURT.

Greyhound (transportation) The name of a large, long-distance commercial bus service. It operates nationwide providing long- and short-distance services. Seats cannot be reserved, they are available on a first come, first served basis.

gridiron (sports and leisure) A nickname for a FOOTBALL field because the green rectangular field (made of grass or artificial turf) crisscrossed with white chalk lines which indicate yard (i.e., distance) measurements. [After the 'iron' 'grid' on which meat is roasted over an open fire in a BARBECUE.]

Grinch (society) A mean, cold-hearted figure from a DR. SEUSS children's storybook entitled *How the Grinch Stole Christmas*. In the story, the central character tries to stop others from being happy during the HOLIDAY SEASON by stealing all the CHRISTMAS DAY decorations and presents from the nearby village of "WHOVILLE". However, when the villagers continue to celebrate the holiday even without the gifts, the Grinch repents and becomes kind and caring. By association, any gruff or unfriendly person.

Griswold **v.** *Connecticut* (legal system) The DECISION of the SUPREME COURT (1952) stating that the STATES cannot control the sale or non-sale of birth control methods (e.g., birth control pills) because that regulation invades a person's right to privacy. This decision helped establish a person's right to privacy as a right protected by the BILL OF RIGHTS. *See* NINTH AMENDMENT, FOURTEENTH AMENDMENT, *ROE* v. *WADE*.

grits (food and drink) Finely ground dried corn kernels that are boiled or fried and topped with butter or gravy. It is

served as a side dish to fried sausage, ham or eggs for breakfast, LUNCH or DINNER, especially in the SOUTH. *See* SOUTHERN COOKING, SOUL FOOD, COMFORT FOOD.

Groundhog Day (customs and traditions) February 2, when forecasts are made for the beginning of warmer, springtime weather by using the traditional, folkloric method of watching a groundhog leave its winter hibernating hole and noting if the animal sees its shadow. If the day is sunny so that the animal can see its own shadow, it will return to its hole to sleep for six more weeks because, according to folklore, it knows that the weather will remain cold and wintry during that period. If the day is cloudy so that it cannot see its shadow, it will not return to its hole because warmer weather will arrive soon. This day is now a media event with many journalists going to Pennsylvania to report the findings of a groundhog named "PUNXUTAWNEY PHIL". [After a similar tradition in Germany used by German farmers who used it to determine when to plant crops.]

group practice (work) A professional business PRACTICE in which several professionals usually share offices, equipment and staff to help decrease costs and, in the case of a medical or dental PRACTICE, to take care of the patients of the other in case of an emergency.

groupie (the arts) A person who is particularly fond of a certain entertainer (e.g., singer, music band, group member) and tries to attend live performances of these individuals regularly; frequently following them from GIG to gig and location to location.

grunge (the arts) A style of music which developed on the WEST COAST in the late 1980s and is characterized by containing elements from different forms of music, namely, ROCK, heavy metal music and punk rock music. It was especially promoted by the singer Kurt Cobain (1967–1994) and his band, Nirvana. By association, the unwashed simple clothing and unkempt, dirty hair worn by "grunge band" members, their GROUPIES and fans.

Guam (geography) An island TERRITORY of the UNITED STATES (since 1898) located in the Pacific Ocean. It is the site of

Andersen Air Force Base and is of military importance to the US, especially during WORLD WAR II and the VIETNAM WAR. It counts 133,000 residents in its current population and has one non-voting REPRESENTATIVE[1] in the US CONGRESS. *See* SPANISH-AMERICAN WAR.

Guggenheim Museum, the (the arts) In NEW YORK CITY, an easily recognized, white-colored building built in the unique shape of a funnel. Inside, it contains a long ramp which winds around and down the building; it was especially designed by FRANK LLOYD WRIGHT in 1952 to display a collection of modern paintings and sculptures (e.g., Cubist, Post-Impressionism). Originally, it was controversial because of its unusual design;. Today, it is recognized for its ingenuity of form and function and is a city landmark. Formally known as the "Solomon R. Guggenheim Museum". [After Solomon Robert 'Guggenheim' (1861–1949), industrialist and benefactor.]

Gulf of Tonkin Resolution, the (foreign policy) The decision written by PRESIDENT LYNDON JOHNSON which increased American military activity in Vietnam from military advising to direct military fighting. It was written after North Vietnamese boats had attacked two American ships which were reportedly sailing in international waters in the 'Gulf of Tonkin', a body of water near North Vietnam and China. CONGRESS widely approved it on August 7, 1964, but after a strong ANTI-WAR MOVEMENT and continued failures in that war, repealed it in December 1970. It marked the beginning of the active military role of the US in the VIETNAM WAR. *See* "IMPERIAL PRESIDENCY".

Gulf War, the (foreign policy) The war in which the UNITED STATES led United Nations forces (supplied by some 30 countries) in an attack against Iraq which had invaded its small neighbor country, Kuwait (which is a big producer and supplier of oil to other nations), because Iraq and its leader, Saddam Hussein (born in 1938), wanted to control the important production and distribution of oil in the Middle East. It began on January 17, 1991, when the US started a military attack against Iraq with airplanes. Then

the US and its allies, led by American General Norman Schwartzkopf (born in 1934), defeated the Iraqi army in a brief and militarily powerful ground battle February 24 to 27, 1991. PRESIDENT GEORGE BUSH called a cease-fire on February 27th and the Iraqi leader, Saddam Hussein, agreed to remove his forces from Kuwait. Although Saddam Hussein remained in power afterwards, the brevity of the war (only 100 hours long), the small number of US deaths (144 battle deaths out of a total 460,000 military personnel), and the US–UN success in achieving set goals made the American public, in general, proud of this war. Because this war developed out of Operation DESERT SHIELD it is sometimes known by its code name "Operation Desert Storm". Also known as "Persian Gulf War"; *see* YELLOW RIBBON, VIETNAM WAR SYNDROME; *compare* VIETNAM WAR.

gumbo (food and drink) A spicy soup thickened with okra and consisting of various different ingredients, usually: chopped onions, tomatoes and other vegetables, chicken, pork, ham, smoked sausage, oysters or other seafood, cayenne pepper and basil. It is served in a bowl with rice. It is typical of the SOUTH. By association, "a mixture" of different ingredients. [From Bantu *ngombo*, meaning "okra", an important vegetable and thickening ingredient for this dish.] *See* CAJUN COOKING, SOUTHERN COOKING, SOUL FOOD.

Guthrie, Woody (people) (1912–1967) A FOLK MUSIC singer and songwriter known for writing hundreds of different songs, many of which are concerned with LIBERAL issues and equality, namely "THIS LAND IS YOUR LAND". He hoped to make a change in society through people singing these songs. He was an influence for many other artists. *See* BOB DYLAN.

gym(nasium) (education) The building which contains the space and equipment for holding PHYS-ED classes, practicing or competing in indoor sports, SCHOOL[1] dances (e.g., PROM, HOMECOMING), and PTA meetings. The gyms of PUBLIC SCHOOLS may be used for local, STATE and federal voting and VOTER REGISTRATION.

H

habeas corpus, the writ of (legal system) An order given by a court of law asking that a person (who has been detained by police officers) be brought before the court to decide if there are good reasons (e.g., his or her connection to a crime) for holding that person in jail. If the reasons are not good then the prisoner is released. This is one of the oldest protections of personal liberty and is the basis of DUE PROCESS. [Latin for "you have the body".] *See* BAIL.

Habitat for Humanity (International) (housing and architecture) An ecumenical *see* ECUMENISM) Christian organization founded in 1976 which works to provide people throughout the world with affordable housing. Its volunteer laborers physically build the structures and then sell them to people at no-interest loans. All of the funding, labor and construction materials are supplied by volunteers and private donations.

Haight-Ashbury (geography) A residential area in SAN FRANCISCO fashionable from 1876 to 1906 when many of its Victorian-styled houses were built and again since the 1970s after these same houses were refurbished. However, during the 1960s it was a run-down area and thus became the popular hang-out of HIPPIES and members of the COUNTERCULTURE, especially during the SUMMER OF LOVE. Today, it remains a symbol of the hippie culture of the 1960s. Also known as "the Haight".

"Hail to the Chief" (customs and traditions) The official song of the US PRESIDENT. It is an upbeat marching song and is played to welcome him at official ceremonies, receptions and at any military institution or establishment.

"Hail, Columbia" (customs and traditions) An upbeat, marching song which is played to honor the VICE PRESIDENT; especially when he or she arrives at a US ARMED FORCES institution or service academy. Although the music is usually played and the words not sung, the first lines are:

"Hail, Columbia happy land/Hail the heroes' heaven-born band/We fought and bled in Freedom's cause."

Haley, Alex(ander) (people) (1921–1992) African-American journalist and writer. He received a PULITZER PRIZE for his book *Roots* (1977) which traced his family's history from Africa to America detailing the plight, problems and spirit of AFRICAN AMERICANS throughout this personal history. This book, which helped millions of Americans understand the black experience, was later made into a successful television mini-series. He first gained fame by assisting MALCOLM X in writing *The Autobiography of Malcolm X* (1965).

half-and-half (food and drink) A mixture composed of milk (50%) and light cream (50%). It is used for cooking. Further, it is often served as a condiment to hot tea and/or coffee. By association, anything mixed of two ingredients in equal parts.

Hall of Fame (sports and leisure) A sports museum honoring the history and the most important players, coaches and referees of the sport. Usually, it includes authentic sports memorabilia, equipment and a library. Former players and others are elected "members" of it by the vote of members of the sports media and current HALL OF FAMERS. There is a Hall of Fame for: professional BASEBALL in COOPERS-TOWN, New York; BASKETBALL in SPRING-FIELD, Massachusetts since 1949; the NFL in CANTON, Ohio since 1963; and the NHL in Toronto, Ontario in Canada since 1961. By association, any museum honoring a pastime or artistic pursuit. *See* HALL OF FAMER.

Hall of Famer (sports and leisure) A person (i.e., player, coach, referee, performing artist) who has been voted into or accepted into the HALL OF FAME for his or her particular field or expertise. Once a person is inducted (i.e., "voted") into the Hall of Fame, he or she can then vote in future elections to permit new entrants into the group.

Halloween (customs and traditions) October 31, when people (children, teenagers and adults) have fun by dressing up in costumes and masks, playing practical jokes, attending parties and telling ghost stories. Traditional, popular costumes include those of witches, vampires and ghosts. It is a favorite holiday among children who carve JACK-O'-LANTERNS and wear funny or scary costumes when going TRICK-OR-TREATING. Traditional snacks and drinks include caramel-covered apples, roasted pumpkin seeds, chocolate candy, apple CIDER and beer. It is not a LEGAL HOLIDAY. Also traditionally spelled "Hallowe'en". [From All Hallows Day, that is November 1, a Christian holiday when people honor the dead. However, the evening before is 'Hallows eve', which, according to Celtic traditions, was the evening when the ghosts of the dead returned to the world of the living for one night of mischief and to frighten the living.] *See* HAUNTED HOUSE, BOBBING FOR APPLES; *compare* BEGGARS' NIGHT.

Hambletonian (sports and leisure) The most prestigious harness-racing horse race for three-year-old trotting horses. It was first held in 1926. [After 'Hambletonian' (1852–1876), a famous American trotting horse.]

hamburger (food and drink) A type of sandwich consisting of a cooked patty of ground beef which is served on a white bread BUN with various toppings (e.g., mustard, ketchup, chopped onions, lettuce). It is one of the most popular dishes in the US. [After immigrants from 'Hamburg', Germany who popularized it.] During WORLD WAR I, it was briefly known as a "liberty sandwich". *See* FAST FOOD.

Hamptons, the (geography) A general name for the summertime sandy beach and ocean resort areas (e.g., South Hampton, West Hampton) on LONG ISLAND. It is especially popular with many artists and wealthy people from NEW YORK CITY who own luxury vacation homes and second homes at the Hamptons. *Compare* CAPE COD.

Hancock, John (people) (1737–1793) Revolutionary, businessman and Governor of Massachusetts. He strongly supported the American colonists before and during the AMERICAN REVOLUTION with money and political influence. He was one of the original signers of the DECLARA-TION OF INDEPENDENCE and encouraged

Massachusetts to adopt the new US CON-STITUTION. *See* JOHN HANCOCK.

handicapped (minorities) Describing a person who has a mental (i.e., mentally handicapped) or physical (physically handicapped) condition which limits one or more of that person's major life activities (e.g., learning, walking). A "qualified handicapped" individual is a person who, although handicapped, is still capable of working in a job according to the VOCATIONAL REHABILITATION ACT OF 1973. Currently when referring to physical limitations, the term "DISABLED" is preferred. *See* AFFIRMATIVE ACTION, SPECIAL EDUCATION, AMERICANS WITH DISABILITIES ACT.

handicapped accessible (minorities) Describing any building or facility that is especially designed for physically HANDICAPPED or DISABLED people to use (e.g., wider hallways, bigger bathrooms, elevators, ramps instead of stairs). All buildings made with federal funds must be handicapped accessible according to the Architectural Barriers Act of 1968 and its AMENDMENTS as well as the AMERICANS WITH DISABILITIES ACT.

Hanukkah (customs and traditions) A festive eight-day religious holiday of the JEWISH faith that celebrates light, the family and dedication. It commemorates a special event in ancient Jewish history; during a period of war, the holy oil lamp in the Jewish Temple in Jerusalem burned for eight days without being refilled. Now, Jews celebrate this event every day for eight days, using the MENORAH, lighting a new candle each day. Each day, families perform plays for each other, share a special meal (often including *latkes*, that is "potato pancakes") and other special foods and give each other gifts. It takes place on the 25th day of *Kislev*, which is the third month of the Jewish lunar calendar; therefore, its exact date changes every solar year; but often it falls in December. This holiday is celebrated in a more festive way by American Jews than it is by Jews elsewhere because of its closeness to CHRISTMASTIME which is a festive holiday period in the US. Also spelled, "Chanukah"; *compare* HIGH HOLIDAYS.

hardball (sports and leisure) A popular nickname for the sport and/or a game of

BASEBALL because the ball is smaller and is made of firmer material than that ball used in the sport of "softball". By association, describing something that is difficult or aggressive. "Playing hardball" is an expression, meaning behaving or working (e.g., in business or politics) in an aggressive way. [The small, fist-sized ball weighs five ounces (140 grams).]

Harlem (geography) In NEW YORK CITY, the section of northern Upper MANHATTAN which throughout the first half of the twentieth century was the home of the most active and prominent black community which itself was concerned with political, social and cultural issues concerning blacks; especially during the HARLEM RENAISSANCE and before the BLACK POWER movement. Its center is 125th Street. The ABYSSINIAN BAPTIST CHURCH is found here, as is the BLACK MUSLIMS' (Harlem) Temple #8. [From Dutch *Nieuwe 'Haarlem'*, a city in The Netherlands.] *See* APOLLO THEATER, COTTON CLUB, JAZZ MUSIC, STRIVER'S ROW; *compare* BROOKLYN, SPANISH HARLEM, SOUTH SIDE.

Harlem Globetrotters, the (sports and leisure) A group of talented BASKETBALL players who entertain audiences with fancy dribbling, shooting and blocking as well as silly antics. It developed its current performance-show in 1940; it is not a member of the NBA.

Harlem Renaissance, the (the arts) The cultural and literary movement that treated black themes, African-American history and folklore. It began in 1917 and was active until 1935; its center was HARLEM, an area of NEW YORK CITY with a large black population. All of its artists were AFRICAN AMERICANS who believed in black pride and wrote works concerning black themes and racial pride in the oral idiom of black spoken speech, BLACK ENGLISH. Its main artists included: novelist ZORA NEALE HURSTON; poets LANGSTON HUGHES, Countee Cullen (1903–1946), Claude McKay (1890–1948); and political, anti-LYNCHING writer Walter White (1893–1955). Sometimes, formerly known as the "Black Renaissance" or "Negro Renaissance".

Harley-Davidson (transportation) A popular, American, UNION[1]-made motorcycle known for its large, heavy body frame and loud engine. It started large-scale production in 1903 in Milwaukee, Wisconsin and since the 1960s has become a symbol of independence, machismo and American patriotism. [After the original makers William 'Harley' and the brothers William, Walter and Arthur 'Davidson'.]

Harper's Monthly (media) A monthly magazine with a current circulation of 216,000, which publishes articles and EDITORIALS of general interest on public affairs, current events and the arts. It has a tradition of literary writing. [Originally, it was started in 1850 by Fletcher 'Harper' and was popular with the educated upper class of the nineteenth century.]

Harvard University (education) The oldest and one of the two most prestigious UNIVERSITIES in the US and an IVY LEAGUE member. It was founded in 1636 in Cambridge, Massachusetts by the Congregational Church as a SCHOOL[3] to train male ministers. Today, it is a COEDUCATIONAL, non-religious PRIVATE SCHOOL famous for its strong BACHELOR'S DEGREE programs and GRADUATE SCHOOLS of business, law and medicine. It consists of two COLLEGES[1] for its 6,500 UNDERGRADUATES: Harvard College (for men and women) and RADCLIFFE COLLEGE (for women and some men) as well as several GRADUATE[2] COLLEGES[2] for the 9,500 GRADUATES[2]. It is an NCAA member and its teams compete at the INTERCOLLEGIATE level. All the teams share the nickname of "Crimson", one of the university's color three colors (the others are black and white). The CAMPUS buildings are built primarily in red brick but differ in architectural style ranging from colonial (*c.* 1721) to the twentieth century. [After clergyman and patron, John 'Harvard' (1607–1638).] *See* CONGREGATIONALISM[1,2], HARVARD–YALE FOOTBALL GAME, HARVARD–YALE REGATTA.

Harvard–Yale football game (sports and leisure) The COLLEGE[1] FOOTBALL game held every year on THANKSGIVING DAY, first in 1890, between the rival teams of HARVARD UNIVERSITY ("Crimson") and YALE UNIVERSITY ("Bulldogs" or "Elis").

Harvard–Yale Regatta (sports and leisure) An annual rowing-race competition between the COLLEGE[1] teams of HARVARD UNIVERSITY and YALE UNIVERSITY. It was first held in 1852 and is the oldest INTERCOLLEGIATE event.

hash brown potatoes (food and drink) A side dish of boiled, chopped potatoes mixed with chopped onions and fried in hot oil or fat until brown-colored and served for breakfast, LUNCH or DINNER. Also known as "hash browns" or "hashed brown potatoes".

Hasidic Jews (religion) An extremely traditional group in ORTHODOX JUDAISM which believes that all modern inventions are distractions from its God and religion so they do not use them. Followers of these groups isolate themselves in distinct communities and rely on the Torah (i.e., the first five books of the Bible), traditional JEWISH law (known as "*Halachah*"), dietary laws (known as "*kashrut*", *see* KOSHER) and the advice from their temple leaders to make all religious, political and social decisions for their community. Usually, group followers speak Yiddish or Hebrew to each other and wear characteristic sober, black coats and hats; often, men wear long curls in their hair and have long beards and women cover their hair with hats or scarves. Most members live in NEW YORK CITY and New York STATE.

Haskell Indian Nations University (education) A BIA-controlled and administered COEDUCATIONAL, HIGHER EDUCATION institution for NATIVE AMERICANS. It was founded in 1884 as a federal, off-RESERVATION BOARDING SCHOOL[2] for ELEMENTARY SCHOOL-aged students to promote the ASSIMILATION of INDIANS. In 1970, it received ACCREDITATION and now offers ASSOCIATE'S DEGREE and BACHELOR'S DEGREE programs to its 900 students. The CAMPUS is located in Lawrence, Kansas. [After CONGRESSMAN Dudley 'Haskell' (1842–1883), SCHOOL[5] promoter.] Formerly known as "Haskell Indian Junior College"; *compare* NAVAJO COMMUNITY COLLEGE.

hat trick (sports and leisure) In ice hockey or soccer, three separate points or goals scored by the same player. By

association, any talented or clever action or play.

haunted house (customs and traditions) A house or building which contains various scary exhibits decorated with ghosts, witches, vampires and other features designed to frighten the visitors who pay to walk though it. It is a traditional element of HALLOWEEN.

"Have a nice day" (language) A friendly expression, meaning "Good-bye".

hawk (foreign policy) A person who supports going to war and/or the use of military forces. *Compare* DOVE.

Hawthorne, Nathaniel (people) (1804–1864) Writer of novels and short stories. His works explored the history of AMERICA[1] during the COLONIAL PERIOD and the thoughts and the ideas of people from NEW ENGLAND, especially during the PURITAN era. Popular works include: *The Scarlet Letter* (1850) and *The House of Seven Gables* (1851). *See* AMERICAN RENAISSANCE.

Haymarket Riots (work) A series of events in 1886 which quickly followed one another and resulted in the public's distrust of labor UNIONS[1] and immigrants. It began on May 1, 1886, as a rally among workers on STRIKE[1] from the McCormick Harvesting Machine Company. On May 3, other workers who supported the eight-hour long work day joined the striking workers. In order to quell this rally, police officers shot into the crowd and killed four people. On May 4, during a rally especially held to honor those killed, a bomb (planted by a separate anarchist group) exploded killing one policeman, to which the police force responded by firing on the crowd again, killing some nine people and wounding 67. Although eight male anarchists (seven German immigrants and one American citizen) were found, the trial was heavily biased and four received the death penalty and were executed on November 11. [From the 'Haymarket' Square in CHICAGO, the site of the killings.] *See* LABOR DAY; *compare* SACCO AND VANZETTI CASE.

Hays Code, the (the arts) The popular name for the HOLLYWOOD PRODUCTION CODE. [After Will H. 'Hays' (1879–1954), the head of the office responsible for writing and enforcing these rules.]

Head Start (education) A federal assistance program created in 1965 by the ELEMENTARY AND SECONDARY EDUCATION ACT and the OFFICE OF ECONOMIC OPPORTUNITY to improve educational opportunities for young children from poor families. Now, it offers pre-academic, social and psychological programs, tutoring and meals to PRESCHOOL and HANDICAPPED students. It is a popular BIPARTISAN program. It was first established as "OPERATION HEAD START". *See* WAR ON POVERTY.

health food (food and drink) A general term referring to food products meant to promote health, especially organically grown fruits and vegetables, vitamins and herbal products.

Health Maintenance Organization (health) (HMO) A health care situation for employed workers who pay a fixed price in advance to a group of doctors which in return agrees to provide medical care when a worker needs it. An HMO focuses on preventing illnesses more than in treating them.

hearing (1 legal system; 2 government) **1** An official, usually brief, presentation of the facts concerning a case or LAWSUIT (e.g., in a case concerning CRIMINAL LAW; what is the crime committed, who is the defendant, etc.). This information is presented to a judge or JUSTICE OF THE PEACE; usually, both lawyers and clients are present. It precedes and is separate from a trial. Also known as a "preliminary hearing". **2** In the legislature, a meeting during which members of a particular CONGRESSIONAL COMMITTEE ask questions of and listen to TESTIMONY of individuals (e.g., lobby members, political appointees) before making some decision about an issue. Before giving ADVICE AND CONSENT, the SENATE conducts HEARINGS[2] for each political appointee that the president makes with the APPOINTMENT POWER.

Hearst Castle (the arts) In southern California, the opulent private residence of WILLIAM RANDOLPH HEARST who had it built in the Arabic/Spanish style and had it decorated, beginning in 1919, with fine antiques and artworks from Europe, the

Middle East, the Americas and ancient Greece. Today, it is a museum open to the public and is one of the richest and finest privately owned and operated museums in the world. Also known as "Hearst-San Simeon" or "San Simeon", the original name of the estate.

Hearst, William Randolph (people) (1863–1951) Newspaper publisher and art collector. He bought and controlled over 40 newspapers, the most powerful ones being the *San Francisco Examiner* and *The New York Journal*. His papers favored LIBERAL causes, especially labor UNIONS[1], immigrant issues and the concerns of the working class. He was one of the leaders of YELLOW JOURNALISM and pushed for reforms in the PROGRESSIVE ERA movement as well as increasing the fear among whites of the YELLOW PERIL. He is remembered for: his shrewd newspaper skills at the turn of the century; successfully getting the "*Yellow Kid*" to be published in his papers; collecting a fortune in art works; building an estate called "San Simeon"; and experiencing financial difficulties later in his life. The movie *Citizen Kane* (1941) is based on his life. *See* HEARST CASTLE; *compare* JOSEPH PULITZER.

Heartland, the (geography) The central area of the UNITED STATES; referring to the central part of the MIDWEST.

Heisman (Memorial Trophy), the (sports and leisure) The most prestigious award in COLLEGE[1] FOOTBALL given every year since 1935 to the best INTERCOLLEGIATE football player. The player is chosen by vote of members of the sports press as well as past winners of the award. The trophy depicts a bronze figure of a football player and is awarded in a ceremony held every December at the Downtown Athletic Club in NEW YORK CITY. Most Heisman winners pursue a career playing professional football. [After football player and coach John W. 'Heisman' (1869–1936).]

Hell's Angels (minorities) A motorcycle gang, founded in 1959 in California, which is known for its usual demands made on members, namely, possessing a gun without a local license. It gained public attention in the 1960s when it became involved

in selling drugs and the HIPPIE culture and professed to be a sort of severe "people's police force". Today, it has many branches in the WEST and in California as well as internationally and membership in this group is a symbol of societal rebelliousness.

Helms, Jesse (people) (born in 1921) A REPUBLICAN US SENATOR from the southern STATE of North Carolina (since 1973) who is known for supporting the tobacco industry and farming and for having traditional and CONSERVATIVE ideas concerning contemporary art. He is a strong opponent to legalized and government-funded abortions.

Hemingway, Ernest (people) (1899–1961) Writer of fiction and journalist. He developed and used a direct writing style using plain, straightforward language and a lot of dialogue between characters. His most popular works include the "Nick Adams stories" which are short stories set in Michigan and treat the themes of hunting, fishing and camping in natural, outdoor locations. He received the PULITZER PRIZE (1953) for the novella *The Old Man and the Sea* (1952) and the Nobel Prize (1954). He was a member of the LOST GENERATION. *See* GERTRUDE STEIN.

Hendrix, Jimi (people) (1942–1970, born James Marshall Hendrix) A talented guitarist, songwriter/collaborator and performer of African-American, Cherokee INDIAN and Irish heritage. He experienced a brief but successful career (1965–1970), first in England, then in the US performing GIGS and concerts; he performed at WOODSTOCK. He is known for his skill at playing the electric guitar (with his left hand) writing lyrics and songs (with his right hand) and for wearing colorful, elaborate costumes during performances.

hero (food and drink) Another name for a SUBMARINE SANDWICH.

Hetch Hetchy Valley/Dam (environment) A large, wild, natural valley in California which was made into a dam in 1913 to provide water for SAN FRANCISCO. Some people (namely JOHN MUIR) unsuccessfully protested against the plans of damming it claiming that the valley's natural beauty was of the same quality as YOSEMITE NATIONAL PARK and thus

should be preserved. It is a symbol of the government and industry's irresponsible use of natural areas; as well as a major loss in the fight of environmentalists to protect natural areas. *See* CONSERVATION MOVEMENT; *compare* ENVIRONMENTAL MOVEMENT.

High Holidays (customs and traditions) A collective, respectful name for the two most important JEWISH holidays, both of which occur in September or October; Rosh Hashanah (the Jewish New Year's Day and the first day of the Jewish month *Tishri*) and Yom Kippur (the most important holiday in the Jewish calendar, held on the tenth day of *Tishri*). Also known as "High Holy Days"; *compare* HANUKKAH.

high school (education) Compulsory education for students from GRADES[1] nine through 12 in either a PUBLIC SCHOOL or PRIVATE SCHOOL (also known as "SECONDARY SCHOOL"). A "senior high school" includes GRADES[1] 10 through 12. *See* Appendix 4 Educational Levels; *compare* JUNIOR HIGH SCHOOL, ELEMENTARY SCHOOL.

high tops (clothing) A type of athletic shoe with a thick rubber sole and a tall shoe-body (made of leather or canvas) which covers and supports the ankles of the wearer. Originally, they were designed for BASKETBALL players.

higher education (education) Any formal education program offered at an academic institution after the HIGH SCHOOL level (i.e., VOCATIONAL SCHOOL, COMMUNITY COLLEGE, COLLEGE[3], GRADUATE SCHOOL and PROFESSIONAL SCHOOL).

Higher Education Act (education) The act (passed in 1964) that gives federal money to HIGHER EDUCATION institutions for library, laboratory, and teaching materials and to help students pay for tuition at COMMUNITY COLLEGES and FOUR-YEAR COLLEGES. It is one part of the Equal Opportunity Act which tried to decrease the differences between students from PUBLIC SCHOOLS in wealthy suburban areas from those in poorer, urban areas. *See* SUBURBS.

hillbilly (society) A white person from APPALACHIA or other areas of the SOUTH who usually does not have a lot of money

and does not have a HIGHER EDUCATION. This term may be used in a disparaging manner by those people who are not from this group (e.g., by people from the NORTH, or groups of other people from the South).

hillbilly music (the arts) From 1925 to 1949, the name commonly used to refer to COUNTRY MUSIC. Because some found it offensive and derogatory, after 1949 it was replaced by "COUNTRY AND WESTERN MUSIC". [After the 'Hill-Billies', a band active about 1925, which played this type of music.]

Hillel (Foundation) (religion) The oldest and largest CAMPUS organization for JEWISH students which organizes special activities and events (e.g., Passover meals, religious services, Hebrew language courses, HIGH HOLIDAYS celebrations) for UNIVERSITY level students who have Jewish heritage and want to practice Judaism or learn more about it. It was founded in 1933 at the University of Illinois and is overseen by B'NAI B'RITH. Formally known as "B'nai B'rith Hillel Foundation".

hip-hop (the arts) An alternative name for RAP MUSIC. [Perhaps from the rap phrase "To the 'hip, hop', hippedy hop" by Lovesbug Starsky.]

hippie (society) During the 1960s, a COLLEGE[3]-aged person, often apolitical, who wore simple, baggy, natural clothing (e.g., TIE-DYE shirts, leather sandals), long hair and especially liked taking illegal drugs and listening to psychedelic ROCK music. By association, a name for any person who currently dresses this way or enjoys these habits. ['hip' (meaning "up-to-date with the latest ideas") + 'ie'.] *Compare* COUNTERCULTURE.

Hippocratic oath (health) A promise made by those medical SCHOOL[4] students during graduation ceremonies to respect the patient, the medical profession and oneself as a doctor. [After the Greek doctor 'Hippocrates' (*c.* 460 to *c.* 377 B.C.), who is recognized as the "father of medicine".]

Hispanic/hispanic (minorities) An American whose ancestors include NATIVE AMERICANS and Spaniards; this person's first language is usually Spanish, but he or

she has some knowledge of the English language or is bilingual. It may also refer to people from PUERTO RICO. It is used by the federal government on the official US CENSUS to refer to this group. It replaces various other terms for people with this heritage, namely: "tejano" (a name for a person with this hispanic heritage living in Texas, especially before the TREATY OF GUADALUPE HIDALGO); it also replaces "californio" (a term for people with this hispanic heritage living in California before 1848); because it is a more general heritage-oriented term, it can thus include the narrower political and social term "CHICANO". Finally, it may be used interchangeably with LATINO/LATINA.

Hoffa, Jimmy (people) (1913–c. 1975, born James Riddle Hoffa) A leader of organized labor and president of the TEAMSTERS (1957–1971). He served a jail sentence (1967–1971) for having mishandled money belonging to the Teamsters and for mail fraud. After his release from jail, he disappeared. Today, he is generally assumed to be dead.

Hoffman, Abbie (people) (1936–1989) A founder of the YIPPIES and leader of the COUNTERCULTURE. He is remembered for staging public protests (frequently funny ones) to challenge authorities and commonly held beliefs during the late 1960s. He was an early member of SNCC and the CHICAGO EIGHT.

hogan (housing and architecture) A traditional type of unattached, architectural structure with eight sides used as a private residence by the NAVAJO people. It has a round, dome shape; the frame is made of wooden sticks and is filled with mud or earth. [Navajo *hooghan*, meaning "home".] *See* NAVAJO COMMUNITY COLLEGE.

holiday season (customs and traditions) A general term for the period of religious and non-religious holidays marked by family reunions, shopping, OFFICE PARTIES and special meals which begins the day after THANKSGIVING DAY and ends the first week of January. It includes CHRISTMAS DAY for Christians and followers of Eastern Orthodox religions; HANUKKAH for JEWISH people; KWANZA for some AFRICAN AMERICANS;

as well as the secular events of NEW YEAR'S EVE and NEW YEAR'S DAY. *See* NUTCRACKER, SECULARISM; *compare* CHRISTMASTIME.

Holiday, Billie (people) (1915–1959, born Eleanora Fagan) An African-American singer of JAZZ MUSIC with a touch of the BLUES[1] who performed with big bands and in small groups. She is remembered for her skill at phrasing song words for extra emotional or dramatic effect, for example in "Lady Sings the Blues" and "Strange Fruit". She sometimes worked with COUNT BASIE and her good friend LESTER YOUNG, who gave her the nickname "Lady Day". She died July 17, a few months after Young.

Hollywood (1 geography; 2 the arts) **1** A centrally-located part of greater LOS ANGELES where many agencies for advertising and talent promotion (i.e., modeling, acting) are based. Originally, because of its warm climate and almost constant sunlight, it was the site of film and TV studios in the 1920s (although many have since moved to other areas of California). *See* WALK OF FAME. **2** By association, a synonym for the large, commercial film industry. *See* HOLLYWOOD BLACKLIST, HOLLYWOOD TEN; *compare* INDIE.

Hollywood blacklist (the arts) The specific BLACKLIST which named those screenwriters, artists and others in the entertainment industries of the HOLLYWOOD[2] film-making, television and radio industries and BROADWAY who had LEFT political beliefs or sympathized with communists. Individuals named on this list were not employed in these fields from 1948 until 1959. This list, and the rejection of screenwriters and artists listed on it, symbolizes a very low point in artistic expression, personal freedom and CIVIL LIBERTIES.

Hollywood Bowl (sports and leisure) A large open-air stadium in LOS ANGELES. It is a popular venue for live music (POP MUSIC, classical music) performances and concerts usually from June through September.

Hollywood Production Code, the (the arts) A set of restrictive, ethical rules that regulated the content of movie scenes in HOLLYWOOD[2] films from 1934 until 1966.

For example, it prohibited movies from showing "illegal drug traffic", as well as actors and actresses involved in "lustful embracing", "pointed profanity", open-mouthed kissing as well as other actions. It was created and enforced by the Motion Picture Producers and Distributors of America, Inc, as a form of self-censorship in order to improve the then poor image of HOLLYWOOD[2] films. Popularly known as the "production code" and the "HAYS CODE". *Compare* RATINGS SYSTEM[2], MOTION PICTURE ASSOCIATION OF AMERICA.

Hollywood Ten, the (the arts) A group of 10 screenwriters from HOLLYWOOD[2] who were accused by the HOUSE UN-AMERICAN ACTIVITIES COMMITTEE (HUAC) in 1947 for having leftist and LEFT political beliefs and for being members of the Communist Party. The artists were SUBPOENAED and appeared in a trial of the CONGRESSIONAL COMMITTEE held in LOS ANGELES; however, all 10 of them refused to reveal their political beliefs claiming their right under the FIRST AMENDMENT. As punishment, HUAC forced them to serve brief prison sentences (less than a year) and/or pay a large monetary fine; further, these writers were then named on the HOLLYWOOD BLACKLIST and not given any work by the large studios of Hollywood for some 10 years. This episode symbolizes a low period in American creativity and the infringement of the creative arts for political purposes. *See* RED SCARE[1], BLACKLIST; *compare* McCARTHYISM.

home (plate) (sports and leisure) In BASEBALL, the five-sided white board indicating where playing action begins (i.e., where a player hits a ball) and ends (i.e., the place to which a player returns to score a RUN).

home fries (food and drink) A side dish of boiled potatoes sliced in thick wedges and fried in butter or oil.

"Home on the Range" (customs and traditions) A traditional song sung slowly and with feeling. It is often called the "cowboy song" because its lyrics speak of the pleasant outdoor life out WEST and the pleasures and happiness of life as a COWBOY[1]. The refrain is: "Home, home on the range, where the deer and the antelope play/Where seldom is heard a discouraging word/And skies are not cloudy all day." Also, it is the official song of the STATE of Kansas.

home run (sports and leisure) In BASEBALL, a hit of the ball with a bat which allows an offensive player to run around all the bases (i.e., first, second, third) and return to HOME PLATE. Usually, it occurs because the ball is hit out of the BALLPARK. It is worth one point. When a player **homers**, he has scored a home run; this term is usually used when describing a game. *Compare* HOMER.

home team (sports and leisure) The favorite team of a particular audience. Usually, it has its practice and playing field or court in a particular local area from which most of the audience comes. In any given game played at its own field or court this team has an advantage over its opponent because it knows the turf/field and is supported by the crowd. *See* HOMECOMING, BOOSTERS, HOMER; *compare* AWAY TEAM.

"Home, Sweet Home" (customs and traditions) A popular song during the nineteenth century and a contemporary saying about the pleasures of being home with the family. Some of the lines are: "Be it ever so humble, there's no place like home." Often, this phrase is displayed in a frame in a family's home.

Homecoming (customs and traditions) An annual reunion for the current students and ALUMS of SECONDARY SCHOOLS and COLLEGES[3] held during a WEEKEND in the fall SEMESTER or QUARTER[2]. The SCHOOLS[5] and current STUDENT COUNCILS host special events for the alumni; such as, picnics, TAILGATING, FOOTBALL games and dances. This "Homecoming Weekend" and these various activities encourage alumni to remain close to and invest in their ALMA MATERS[1]. By association, describing any special event that occurs during this weekend; Homecoming Dance, Homecoming Parade, Homecoming football game. [From 'coming home' to the ALMA MATER[1].] *See* HOMECOMING QUEEN; *compare* PROM.

Homecoming Queen (customs and traditions) A SENIOR or UNDERGRADUATE female student who has been awarded the

honor of overseeing the HOMECOMING events (i.e., FOOTBALL game and Homecoming Dance). This title of honor is awarded to a popular or well-known female student by the current student body of a SCHOOL[5] or, more usually, her fellow CLASS students. Her identity is usually kept secret and only announced during or just before Homecoming Weekend. She is officially "crowned" queen in a ceremony in which a small tiara is placed on her head. Often, she oversees a parade and some activities during the halftime of the Homecoming FOOTBALL game. Now, many SCHOOLS[5] also have a "Homecoming King" (i.e., a male student) and "Homecoming Court" (i.e., three women and three men). *Compare* PROM QUEEN.

homer (sports and leisure) To favor the HOME TEAM excessively. Fans **homer** a team by cheering for that team to excess. The team that **was homered** is the AWAY TEAM that has lost because the referees or UMPIRES have called many FOULS[2] against it in an effort to favor the HOME TEAM and assure a home team victory. *Compare* HOME RUN.

homeroom (period) (education) A period of time (usually 10 to 25 minutes) set aside at the beginning of each SCHOOL[1] day when a teacher meets with a regular group of students to assure their attendance, make announcements and do other administrative tasks. It is a common feature in the daily schedule of ELEMENTARY SCHOOLS and SECONDARY SCHOOLS.

homeschooling (education) A method of educating one's own children in SCHOOL[1] subjects (e.g., math, science, LANGUAGE ARTS at home; that is, the children do not attend formal SCHOOLS[1]. Although supporters of **homeschool** education believe that they give their children a better education with this method, critics claim that the young people do not receive normal social interaction provided at a PUBLIC SCHOOL or a PRIVATE SCHOOL.

Homestead Act (immigration) A Congressional act (passed in 1862) that offered any adult citizen or new immigrant (who planned on becoming a citizen) 160 acres of PUBLIC LAND, free. **Homesteaders** had to pay a small registration fee and use the land for farming. Before it ended, it had encouraged immigration and pulled white settlers into the WEST and MIDWEST (especially the GREAT PLAINS) and eventually led to the end of the FRONTIER.

Homestead strike (work) A major STRIKE[1] in which some 3,800 steelworkers at the Carnegie Steel Company mills refused to work from July 2 to November 20, 1892. Eventually the strikers amassed a group of 10,000 active supporters so that the steel company was forced to call in some 8,000 militiamen to keep order. Conflicts between the strong UNION[1], the Amalgamated Association of Iron and Steelworkers, and the strong company eventually led to the deaths of 11 striking workers and spectators and seven militiamen. After the strike, the company succeeded in lowering the workers' wages and lengthening their working hours. Although it started out well for the UNION[1], this event eventually hurt workers' benefits and led to the public's distrust of UNIONS[1]. [After the location of the event at 'Homestead' in the STATE of Pennsylvania.] *See* ROBBER BARONS, MONOPOLY.

honeymoon period (government) The brief period when a new PRESIDENT has good relations with and is liked by CONGRESS, the media and the public. It begins after the INAUGURATION and ends once the CHIEF EXECUTIVE starts to make PARTISAN decisions about legislation and/or public policy. By association, any brief but happy period. *Compare* HUNDRED DAYS.

honor society (education) A scholarly club or GREEK-LETTER ORGANIZATION for HIGH SCHOOL or UNDERGRADUATE students who have earned high GRADES[1]. Membership is by invitation of the club and lasts a lifetime. The oldest, most famous and most prestigious is PHI BETA KAPPA.

hoops (sports and leisure) A nickname for the sport of BASKETBALL. [From the metal rim, or 'hoop', from which hangs a cotton or synthetic net.]

Hoover Commissions, the (history) The popular name for the two independent commissions created by CONGRESS which studied (1947–1949 and 1959) the organization and efficiency of the executive branch of the federal government. Both made several recommendations to improve the quality of government ser-

vices, namely: the formation of the DE-PARTMENT OF HEALTH, EDUCATION AND WELFARE; developing a system of career CIVIL SERVICE and work advancement; the unification of the ARMED SERVICES; and encouraging the policy of TERMINATION for Indian TRIBES. The formal name was the "Commissions on Organization of the Executive Branch of the Government". [After the former US PRESIDENT and chairman, Herbert 'Hoover' (1874–1964).] *See* NATIONAL SECURITY ACT, DEPARTMENT OF DEFENSE, Appendix 2 Presidents.

Hoover Dam (science and technology) One of the highest dams in the UNITED STATES (760 feet high; 231.6 m) completed during the NEW DEAL in 1936 and located on the border of the STATES of Nevada and Arizona. This dam is a very important source of water and electricity for human and commercial purposes in the WEST. Further, it supplies much-needed water to farms for irrigation purposes. It produced the large reservoir known as Lake Mead which is a popular destination for water sports enthusiasts. [After Herbert 'Hoover' (1874–1964), US PRESIDENT (1929–1933).] *Compare* TVA, LAKE POWELL.

Hoover, J. Edgar (people) (1895–1972) Director of the Federal Bureau (1924–1972). He is remembered for expanding the power and range of the FEDERAL BUREAU OF INVESTIGATION and for involving the Bureau in activities that were legal (e.g., successful work) and illegal (e.g., break-ins).

Hopper, Edward (people) (1882–1967) Painter and commercial illustrator. He is known for painting in a realistic, sparse and precise style. Common themes in his work include the city, man-made environments and the loneliness of urban life.

hopscotch (sports and leisure) A child's game in which a player throws a marker (e.g., stick or pebble) onto a rectangular diagram of squares; then he or she 'hops' through the squares (only one foot in each square) while stopping and bending over to pick up the stick or pebble.

hors d'oeuvre (food and drink) A small portion of food presented in an attractive way usually served on a buffet table at a COCKTAIL PARTY. [French for "outside of work".]

horseshoes (sports and leisure) An outdoor game in which players throw (i.e., "pitch") horseshoes at a metal stake trying to hit that stake. It is a popular leisure activity played at summertime picnics, reunions, CLAMBAKES and BARBECUES. For official play, it is overseen by the National Horseshoe Pitchers' Association of America founded in 1925. Also known as "horseshoe pitching".

hospice (health) A type of health care facility providing personalized medical care and permanent accommodation to patients living in that facility and who are in final stages of a terminal disease (e.g., cancer) or are near death.

hot dog (1 food and drink; 2 sports and leisure) **1** A frankfurter (usually made of pork or beef) served on a long, split white BUN and topped with mustard, ketchup, onions or other relishes. A hot dog covered in CHILI CON CARNE and shredded cheese is a "chili dog". A hot dog dipped in cornmeal batter, fried and served on a stick is a "corn dog". All are popular foods sold at sporting events and picnics. **2** A nickname for a person who shows off a certain athletic skill or trick. By association, also an interjection of excitement or agreement.

hot rod (sports and leisure) A car especially designed or adapted to reach maximum speed quickly and so to perform as a race car.

House, the (government) The popular name for the HOUSE OF REPRESENTATIVES.

House of Representatives, the (government) The largest, most populous chamber of CONGRESS with 435 total REPRESENTATIVES[1]. Membership is based on population in the CONGRESSIONAL DISTRICT. It meets in the CAPITOL BUILDING and is headed by the SPEAKER OF THE HOUSE. Its unique duties include initiating a BILL[2] concerning taxes and revenue; as well as the IMPEACHMENT power. Popularly known as "the HOUSE"; *see* CENSUS, REDISTRICTING, REAPPORTIONMENT, POWER OF THE PURSE, MAJORITY PARTY, MINORITY PARTY, HOUSE UN-AMERICAN ACTIVITIES COMMITTEE (HUAC); *compare* SENATE.

House Un-American Activities Committee (government) (HUAC) A powerful CONGRESSIONAL COMMITTEE of the HOUSE OF REPRESENTATIVES active from 1938 to 1975 which investigated all activities by individuals and groups as well as propaganda by fascists, and especially Communists, that it claimed could hurt the US government and the security of the UNITED STATES. It used questionable methods, namely committee HEARINGS[2], to extract real or implied information from witnesses and pressuring witnesses to name associates who were communists or Leftists (i.e., anti-American); many of the people and groups named were blacklisted, especially the HOLLYWOOD TEN. It is a symbol of infringing the CIVIL LIBERTIES of citizens and other people. *See* MCCARTHYISM, BLACKLIST, LEFT, RED SCARE[1,3], HOLLYWOOD BLACKLIST, WITCH TRIALS.

housemother/father (education) The older woman/man who watches over the people and who lives in a house belonging to younger SORORITY or FRATERNITY members and students; usually serving to provide guidance and support to the members.

"Houston, we have a problem" (science and technology) A comment made by the crew on the *Apollo 13* mission (April 11–17, 1970) to the control mission headquarters of NASA. Unlike the other APOLLO PROJECT space flights, this one was aborted because an oxygen tank had accidentally exploded; the astronauts returned safely to earth in the lunar module.

HOV (transportation) During rush hour, describing a vehicle which is carrying two or more persons in it to or from the workplace. Some cities promote the use of these vehicles as a method of encouraging car pooling and thus decreasing community traffic. [Abbreviation of 'H'igh 'O'ccupancy 'V'ehicle.] *See* HOV LANES.

HOV lanes (transportation) Those lanes of the INTERSTATE HIGHWAY which only HOV vehicles may use. Because they are less congested than the other lanes, cars move along at a steady pace (i.e., no traffic jams) and in this way they encourage car pooling.

Howard University (education) An accredited, COED UNIVERSITY and the first BLACK COLLEGE which is located in WASHINGTON D.C. It was founded in 1867 with help from the MORRILL ACT (1862) and the FREEDMEN'S BUREAU. Its students and faculty were active during the CIVIL RIGHTS MOVEMENT. Today, it offers BACHELOR'S DEGREES, MASTER'S DEGREES, PhD and PROFESSIONAL SCHOOL degrees to its 7,000 UNDERGRADUATES and 4,000 GRADUATES[2]. Its athletic teams compete at the INTERCOLLEGIATE level. The university's mascot is the bison. [After Oliver Otis 'Howard' (1830–1909), a founder, Major-General for the NORTH during the CIVIL WAR and head of the FREEDMEN'S BUREAU.] *See* ACCREDITATION.

Hubble Space Telescope (science and technology) The large (12.5 ton), high technology, sophisticated telescope and observatory which, from its location in space, can give astronomers on earth a view and thus deeper understanding of other more distant galaxies and space bodies. It is located beyond the Earth's atmosphere (because this atmosphere prohibits long-range viewing as it blurs the telescope's lenses). It was built, and is operated and maintained, by NASA. It was set up in orbit in 1990 and will remain there for 15 years, working to report back information. [In honor of Edwin Powell 'Hubble' (1889–1953), the astronomer who helped discover other spatial galaxies outside of our own.]

huddle (sports and leisure) In FOOTBALL, a gathering of a team's players (total 11) on the playing field when the QUARTERBACK gives them assignments and strategy for the game. By association, any small, often important meeting or gathering.

Hudson River School, the (the arts) A movement of painting popular from 1820 to 1880 in which enormous, realistic, precise scenes of natural, wild, large American landscapes were painted with oil paints on large canvasses. All the landscapes were spectacular and uniquely American; sometimes they included small human figures to show the grandeur and size of the locations. Favorite locations included the Hudson River Valley (the origin of the name), NIAGARA FALLS, the

Catskill Mountains, the ADIRONDACK MOUNTAINS and out WEST. After the CIVIL WAR these paintings increased the public's interest in those areas in the West and encouraged the settlement, preservation and the establishment of NATIONAL PARKS. Some of the artists included Thomas Cole (1801–1848), Frederick Church (1826–1900), Alfred Bierstadt (1830–1902), THOMAS MORAN (1837–1926) and others.

Humane Society (the Associated)
(environment) A local NONPROFIT ORGANIZATION, founded in 1906, which is concerned with the treatment and condition of house pets and some wild animals. It runs animal shelters for injured, lost or unwanted animals in local communities. It lobbies to pass laws to protect the treatment of animals. *See* LOBBY.

humanities (education) The subjects offered at COLLEGES[3] and UNIVERSITIES that treat the systems, organizations and issues of people (i.e., history, art, language, literature, philosophy and CULTURAL STUDIES). Also known as "liberal arts"; *see* LIBERAL ARTS COLLEGE.

hundred days (government) The first 100 days of a new PRESIDENT'S term during which, traditionally, he hopes Congress will pass several of his legislative BILLS[2] and programs. [From the busy period lasting exactly '100 days' (March 9 to June 16, 1933) during the presidency of FRANKLIN ROOSEVELT when CONGRESS passed numerous NEW DEAL acts (especially TVA, CIVILIAN CONSERVATION CORPS and the abandonment of the GOLD STANDARD) in order to help the people, economy and country recover from the GREAT DEPRESSION.] *Compare* HONEYMOON PERIOD, THOUSAND DAYS.

"100 Bottles of Beer on the Wall"
(customs and traditions) The first line and title of a long, repetitious song which is frequently sung to pass the time (e.g., long car trips). The first verse follows: "One hundred bottles of beer on the wall, 100 bottles of beer/Take one down, pass it around, 99 bottles of beer on the wall." The song can continue counting down to "no bottles of beer on the wall", but most singers stop long before reaching the end.

hunting season (sports and leisure) The period of time during the calendar year in which it is legal to hunt and kill animals (e.g., deer, turkey, boar). Usually, it is controlled by the STATE. Only individuals who have bought a "hunting license" may legally kill an animal. When hunting is permitted, it is "open season"; when it is not permitted, it is "closed season". *See* DEER SEASON.

Hurston, Zora Neale (people) (1903–1960) Writer and African-American folklore specialist. She was one of the leaders of the HARLEM RENAISSANCE. Her best known work is *Their Eyes Were Watching God* (1937) about a black woman's life and search for herself. *Mules and Men* (1935) presented stories and the lives of a community of blacks living in the STATES of Florida and Louisiana. *See* ALICE WALKER.

hush puppies (food and drink) Small, round balls of cornmeal dough deep-fried in fat and spices and served as a side dish for fish or chicken ENTREES, especially in SOUTHERN COOKING. [Allegedly because, during a meal, it was fed to dogs and 'puppies' sitting under the DINNER table to keep them quiet and 'hush' them up.] *See* SOUL FOOD.

hyphenated American (minorities) A disparaging term used to refer to any American citizen who identifies himself or herself with two cultures, namely, the mainstream American culture and some other immigrant culture (Irish-American officer; Italian-American person) or non-white culture (e.g., African-American teacher, Asian-American student). [From the 'hyphen' used to link the two adjectives denoting the different cultures.] *Compare* MULTICULTURALISM.

I

"I am Joaquin/Yo Soy Joaquín"
(minorities) A short, bilingual epic poem that celebrates the common culture, language and history of Mexican Americans. It was the earliest and most important literary work of the CHICANO MOVEMENT

because it uses myths and memories to create a CHICANO identity. It was written in both English and Spanish in 1964 by Rodolfo "Corky" Gonzáles (born in 1929). It was performed as a play in the TEATRO CAMPESINO; in 1967, it was made into a film.

"I Have a Dream" (minorities) The title and refrain of the eloquent, moving speech written and presented by MARTIN LUTHER KING, JR. to the audience during the MARCH ON WASHINGTON OF 1963. The speech calls for racial equality and a reinterpretation of the AMERICAN DREAM. Two important thoughts follow: "I have a dream that one day this nation will rise up and live out the true meaning of its creed – 'We hold these truths to be self-evident, that all men [people] are created equal' " and the hope that one day his children "will one day live in a nation where they will not be judged by the color of their skin but by the content of their character". *See* SEGREGATION, DISCRIMINATION, EQUAL OPPORTUNITY.

"I'm a Little Teapot" (customs and traditions) A popular song to which children sing and act out the lyrics (i.e., act like a teapot). The four lines follow: "I'm a little teapot, short and stout/Here is my handle, here is my spout/When I get all steamed up, hear me shout/Just tip me over, and pour me out!".

"I've Been Working on the Railroad" (the arts) The first line of a popular FOLK MUSIC song about a railroad building worker. The song follows: "I've been working on the railroad all the livelong day/I've been working on the railroad just to pass the time away/Can't you hear the whistle blowing? Rise up so early in the morn[ing.]/Can't you hear the captain shouting 'Dinah, Blow your horn'/ Dinah won't you blow (three times) your horn (repeat)/Someone's in the kitchen with Dinah/Someone's in the kitchen, I know/ Someone's in the kitchen with Dinah/ Strumming on the old banjo/A-playing fi, fay, fiddle-i-o." Frequently, it is sung by children at SUMMER CAMP or in SCHOOL[1]. *See* BANJO.

Iacocca, Lee (people) (born in 1924) The popular former-CEO of Chrysler Corporation (1979–1993) who increased general public confidence in the American car-making industry by helping that company make profits, especially by promoting the minivan automobile and making convertible cars again. His autobiography (published in 1984) increased his popularity. Formerly, he worked for Ford Motor Company (1946–1978).

icing (food and drink) A smooth, sweet, creamy mixture made of sugar, butter, flavoring (e.g., chocolate, vanilla) and food-coloring dye which is used to cover the tops and decorate cakes and CUPCAKES. By association, the "icing on the cake" is an expression referring to the (positive or negative) final or last action or step.

ID (card) (daily life) A rectangular-shaped card which lists information identifying a person, namely: name, legal address, birth date and, sometimes, hair color, eye color, weight, height and SOCIAL SECURITY NUMBER. It is usually issued to members of a COLLEGE[1] or to people licensed to drive automobiles. [Shortened from 'id'entification 'card'.] *See* DRIVER'S LICENSE, PICTURE ID (CARD).

Iditarod, the (sports and leisure) In Alaska, an annual race for snow sled dog racing beginning in the city of Anchorage and ending in the city of Nome (total distance of 160 miles; 1,868 km). It is held in March and takes about 10 days to complete. The race was first held in 1973 and is based on a real trip made in 1925. [After the town of 'Iditarod', Alaska, a former mining town.]

illegal alien (immigration) A person who has come to the UNITED STATES but who has not registered with the IMMIGRATION AND NATURALIZATION SERVICE or does not have legal permission to stay and work in the US. Legally, if this person is found by authorities, he or she may be deported to his or her native country. *See* DEPORTATION DRIVE, GREEN CARD.

Immigration Act of 1965 (immigration) The federal act that repealed the national origins QUOTAS policies of the NATIONAL ORIGINS ACT OF 1921, the NATIONAL ORIGINS ACT (passed in 1924) and the McCARRAN-WALTER ACT OF 1952. It set only two international quotas: first, it allowed 170,000 immigrants from all countries in the eastern hemisphere and, second,

120,000 immigrants from all countries in the western hemisphere each year (with a maximum of 20,000 immigrants from the same country). It also gave preference to immigrants who were close relatives of US citizens or people living legally in the US and encouraged artists and skilled and unskilled workers to come to the US. This BILL[2] increased the number of immigrants from Asian and Latin-American countries.

Immigration Act of 1990 (immigration) A federal law that encourages immigration by increasing the annual number of visas issued to immigrants all over the world from 500,000 to 700,000. It encourages the immigration of ENTREPRENEURS, skilled workers and immigrants from countries that have not traditionally come to the US. Also, this law allows homosexuals, socialists, communists and more REFUGEES to immigrate. *See* BRAIN DRAIN; *compare* McCARRAN ACT OF 1950.

Immigration and Nationality Act of 1924 (immigration) The formal name for the NATIONAL ORIGINS QUOTA ACT OF 1924.

Immigration and Nationality Act of 1952 (immigration) the standard name for the McCARRAN-WALTER ACT OF 1952.

Immigration and Naturalization Service (immigration) (INS) The federal agency and division of the DEPARTMENT OF JUSTICE that enforces immigration laws, processes visas and GREEN CARDS, provides special relocation services to immigrants and REFUGEES and helps immigrants become US citizens. In addition, it is responsible for reprimanding illegal aliens. It employs the BORDER PATROL and authorizes DEPORTATION DRIVES. It was founded in 1891; today, its headquarters are in WASHINGTON D.C. and it has several smaller offices located across the country. *See* VISA, F-1, VISA, J-1, VISA, M-1.

Immigration Reform and Control Act (immigration) (IRCA) A Congressional act (passed in 1986) trying to control the immigration and employment of ILLEGAL ALIENS. It allowed illegal aliens to apply for legal US residency if they had lived continuously in the UNITED STATES since January 1, 1982, and before. In addition, if employers hired illegal aliens, it made the employer pay a fine of US $10,000 for each worker; however, it forbade employers from not hiring workers because they "looked foreign" or had a "foreign name". Although many immigrants received official residency, this law did not effectively limit illegal immigration because the government did not enforce the employment aspects of this law.

impeachment (government) A formal charge that a government official has committed a crime or done something illegal while in office. This formal charge is usually followed by a trial in the SENATE which decides if the impeached person must be removed from office. The CONSTITUTION gives the HOUSE OF REPRESENTATIVES the power to **impeach** the PRESIDENT, VICE PRESIDENT, federal judges and all other civil officials. The SENATE is responsible for acting as a legal court and trying impeachment cases and, if necessary, removing that **impeached** official from office.

"imperial presidency" (government) A claim that the powers (both foreign and domestic) of the PRESIDENT and the executive branch of the US government have grown too great. [From the title of the book *The Imperial Presidency* (1973) by ARTHUR SCHLESINGER, JR. (born in 1907), which first made this claim. Coincidentally, this book was published during the WATERGATE scandal.] *See* CHECKS AND BALANCES, WAR POWERS ACT.

Imperial Wizard (minorities) Since 1915, the title of the highest political and military leader of the KU KLUX KLAN; he is considered the presiding officer of the region of the Klan's influence, the "Invisible Empire of the South". *Compare* GRAND WIZARD.

imperialism (foreign policy) The principle and practice of a country's government directly (or indirectly) controlling another country, especially its politics, economy, business and/or culture. *Compare* ANTI-IMPERIALISM.

implied powers (government) The powers of the federal government not specifically listed in the CONSTITUTION but suggested (i.e., 'implied') by the wording. It gets the powers from the NECESSARY AND PROPER CLAUSE; although, *McCUL-*

LOCH v. *MARYLAND* first formally mentions these powers in 1819. *Compare* INHERENT POWERS.

"In God We Trust" (customs and traditions) The national motto of the UNITED STATES OF AMERICA. Since it was adopted by CONGRESS in 1956, it has appeared on all American forms of money; on all BILLS[1] and coins. [It comes from the fourth verse of the "STAR-SPANGLED BANNER"[2]; however, it may also stem from a MASON idea.] *See* DOLLAR, PENNY, NICKEL, DIME, QUARTER.

inalienable rights (legal system) Those basic rights of people that are stated in the phrase "LIFE, LIBERTY AND THE PURSUIT OF HAPPINESS" which cannot be taken away nor refused.

Inaugural Address (government) The speech, often positive and hopeful, that the new PRESIDENT presents during the INAUGURATION ceremony outlining his or her legislative and governing plans for the coming four years. *Compare* STATE OF THE UNION MESSAGE/ADDRESS.

Inauguration, the (government) The outdoor ceremony held outside the CAPITOL BUILDING on January 20, when the PRESIDENT-ELECT takes the presidential oath of office. It is the official beginning of a Presidential TERM[1]. By association, the five- or seven-day period (ending on January 20) of festivities, parties and balls which is held in an odd-numbered year once every four years in WASHINGTON D.C. to celebrate the new presidency. *See* INAUGURAL ADDRESS.

income tax (economy) A tax charged by the federal and most STATE governments on the amount of money that a person or company earned in a given year. "Income tax returns" are prepared by an individual or a CERTIFIED PUBLIC ACCOUNTANT and are due every year by APRIL 15. These governments use the money raised to pay for their daily operations and other programs. Income TAX EVASION is illegal. Most STATES charge "state income taxes"; since 1913, the federal government has charged "federal income taxes". *See* INTERNAL REVENUE SERVICE, TAX SEASON, TAX RETURN, 1040, FORM, SIXTEENTH AMENDMENT; *compare* PROPERTY TAX.

incorporation (legal system) The doctrine that the rights of individuals which the federal government protects in the US CONSTITUTION and AMENDMENTS must also be protected by the STATES because of the DUE PROCESS clause of the FOURTEENTH AMENDMENT. This doctrine made the laws of the states more in keeping with those of the federal government. [From the fact that the states must 'incorporate' the laws of the US Constitution into their state constitutions.] Also known as "absorption".

incumbency effect (politics) In an election in which the current CHIEF EXECUTIVE is running for re-election, the positive effect (i.e., encouraging voters to vote for candidates from the same political party) or negative effect (i.e., encouraging voters to vote for candidates from different political parties) that the INCUMBENT has on the election results of other candidates who are running for different positions at that time.

incumbent (politics) The person who currently holds a public office position. In a re-election, incumbents have the advantage over opponents because of their current position and experience. *See* INCUMBENCY EFFECT.

indentured servant (history) During the COLONIAL PERIOD, a system of labor in which a person (white or black) agreed to work as a servant for a fixed period of time (usually from four to seven years) for a master; the master agreed to pay the price of the servant's boat ticket from Europe to AMERICA[1] and give him or her freedom dues (e.g., freedom, work tools, money, gun) at the end of that period. [From the type of contract, 'indenture', between the 'servant' and the master.] *Compare* SLAVERY.

Independence Day (customs and traditions) July 4, the birthday of the UNITED STATES OF AMERICA as an independent nation and a celebration of contemporary American patriotism. It commemorates July 4, 1776, when the CONTINENTAL CONGRESS approved the DECLARATION OF INDEPENDENCE. Today, Americans celebrate with outdoor family picnics, parades, public speeches, live music performances during the day and firework

displays at night. Often, the STARS AND STRIPES[1] is displayed, the colors of RED, WHITE AND BLUE are used for decorations and the song "GOD BLESS AMERICA" is sung. The SALUTE TO THE UNION is given throughout the country and some people even read the Declaration of Independence or the PREAMBLE to the CONSTITUTION. WASHINGTON D.C. has particularly large firework displays on the MALL and other public events (e.g., live concerts). Also known as the "FOURTH OF JULY"; *see* UNCLE SAM, BICENTENNIAL.

Independence Hall (geography) The red brick building in Philadelphia (built in 1732) which served as the site of the signing of the DECLARATION OF INDEPENDENCE, the meeting of the CONSTITUTIONAL CONVENTION and adoption of the US CONSTITUTION. It is a symbol of the birth and early heritage of the UNITED STATES as an independent country. Originally, the LIBERTY BELL was hung here and was used to announce important events.

independent (1 the arts; 2 politics) **1** A person or company who makes a movie using money, staff and usually actors that do not come from HOLLYWOOD[2]. This individual or company makes INDIES. **2**

independent (candidate) A political candidate who is not a member of the DEMOCRATIC PARTY nor the REPUBLICAN PARTY. An independent usually represents a THIRD PARTY[1].

Independent Counsel (government) The title of the person, usually an ATTORNEY who is not associated with a political party, who examines and prosecutes any person and/or figure currently working in public service in the executive branch of the federal government (including the PRESIDENT and the FIRST FAMILY) for any illegal action performed by them before or while working in this public service post. The Independent Counsel is chosen by a panel consisting of three judges to fill this position of a type of short-term PROSECUTING ATTORNEY. All of these provisions were created by the Independent Counsel Act (passed in 1978). This position cannot be filled by the ATTORNEY GENERAL because he or she is appointed by the President and would be unwilling to prosecute his or her boss. Also known as "Independent Prosecutor".

independent study (education) An academic course at the UNDERGRADUATE or GRADUATE[2] level that is not in a classroom but individually arranged between the instructor and the student; it includes readings, exams and papers which may be taken for CREDIT or not-for-credit.

independent voter (politics) A voter who is not a member of and/or does not support the REPUBLICAN PARTY nor DEMOCRATIC PARTY nor any other political party. Since independent voters vote for the "person, not the political party", during a CAMPAIGN candidates try to win their support. *See* VOTER REGISTRATION.

Indian (minorities) A person belonging to the native-born, indigenous population of North America. Many people belonging to this group prefer to identify themselves by this name or the name of their individual TRIBE (e.g., NAVAJO, SIOUX). Each tribe makes its own rules and guidelines for membership. There are currently some 2 million total Indians living in the UNITED STATES. [After the mistake made by CHRISTOPHER COLUMBUS in 1492; on arriving in the Caribbean region, he believed that he had arrived in the subcontinent of 'India' in Asia.] Sometimes formerly known as "Amerindian"; *see* MIXED-BLOOD, FULL-BLOOD; *compare* NATIVE AMERICAN, ALASKA NATIVE.

Indian Appropriations Act (minorities) (IAA) The federal act (passed in March 3, 1871) which ended the federal government's policy of making TREATIES (between the PRESIDENT and/or SENATE) with TRIBES. Rather it declared that, from that moment on, all agreements between the federal government and Indian TRIBES were to be made by Congressional laws and EXECUTIVE ORDERS (e.g., land boundaries, war, peace, political relations, business/trade). However, it declared that all the treaties made between 1778 and 1871 (more than 400) were still to be honored and respected. *See* TRAIL OF BROKEN TREATIES.

Indian Arts and Crafts Board, the (the arts) The federal agency which encourages INDIANS to create traditional art works and crafts as a method of preserving and

respecting traditional Indian cultures. It supplies money to artists and finances artistic exhibitions of the artwork of NATIVE AMERICANS and ALASKA NATIVES. It was created in 1935 as a part of the INDIAN NEW DEAL and is regulated by the DEPARTMENT OF THE INTERIOR. It is an important force in shaping public opinion to consider Indian-made works not as pieces of anthropology and/or ethnography but as artwork. According to the federal law, "Indian Arts and Crafts Act" (of 1990), only members of those tribes recognized by the federal government or STATE may sell Indian Arts and Crafts.

Indian Citizenship Act (legal system) The Congressional law (passed in 1924) which gave all NATIVE AMERICANS born in the UNITED STATES American citizenship; however, it did not change nor harm TREATY agreements or other TRIBE benefits. It was awarded to INDIANS out of thanks for their loyal service in the US war effort during WORLD WAR I. Also known as the "Snyder Act".

Indian Civil Rights Act (minorities) The federal law (passed in 1964) which increased the self-determination of TRIBES and prevented STATES from establishing or enforcing state laws or law enforcement on Indian controlled territory (unless the tribe asked for that). This was the most important law respecting Indian independence since the INDIAN RORGANIZATION ACT; and together the two laws encourage the tribal governments to become more like American government (i.e., democratic groups represented by elected leaders).

Indian Claims Commission (minorities) (ICC) The temporary federal legal court responsible for hearing all cases and disputes concerning claims, especially LAND CLAIMS[2], made by INDIANS against the federal government. It investigated whether the land the Indians claimed had actually and traditionally belonged to those Indian TRIBES claiming it and whether the land had indeed been taken from the tribes in an unfair or unjust way. The commission operated from 1946 until 1978 and awarded $818 million in DAMAGES to various Indian tribes. It is a

symbol of the US government acknowledging government injustices against Indians. *See* BLACK HILLS; *compare* US COURT OF CLAIMS.

Indian Country (geography) In general, a name for those areas and RESERVATIONS where Indian law and customs prevail, mostly in the WEST. Specifically, a name for those areas where tribal governments are self-governing, which is usually in those STATES with the largest Indian populations (e.g., Arizona and Oklahoma). *See* NAVAJO, CHEROKEE NATION, SIOUX, PUEBLO INDIANS, TRIBAL COUNCIL.

Indian Education Act (education) A federal law (passed in 1972) that provides funds for educational programs for NATIVE AMERICAN children and adults.

Indian Gaming Regulatory Act (minorities) (IGRA) The federal law (passed in 1988) which established a system of rules concerning tribal GAMING and gambling on Indian RESERVATIONS. It identifies different classes of gaming, demands that revenues from the gaming business support specific tribal needs and activities (e.g., health care, construction projects, employment, education, housing) and finally, it stipulates that the casinos and gaming businesses be owned by the tribe. The Indian Nation Gaming Commission controls and oversees gaming and gambling on Indian reservations and the profits are to be divided up among TRIBE members.

Indian Health Service (health) (IHS) A division of the US PUBLIC HEALTH SERVICE working with Indian TRIBES and ALASKA NATIVES to help them develop and subsidize health care programs and provide health management for NATIVE AMERICANS. Before 1955, it was part of the BUREAU OF INDIAN AFFAIRS; today, it is a part of the DEPARTMENT OF HEALTH AND HUMAN SERVICES and is located in Rockville, Maryland.

Indian New Deal (minorities) The collective name for the various federal laws which were passed in hopes of making INDIANS self-sufficient and independent of the federal government and its large sums of money. It consisted of the INDIAN REORGANIZATION ACT, the Indian Division of the CIVILIAN CONSERVATION CORPS

(popularly known as CCC-ID) and the INDIAN ARTS AND CRAFTS BOARD. It effectively ended the ALLOTMENT policy. It grew out of the NEW DEAL and the MERIAM REPORT and was promoted by JOHN COLLIER. Because it respected the traditional authority and social structure of the tribe, it was criticized by the FIVE CIVILIZED TRIBES who opposed it. Further, critics (white and Indian) claimed that it still gave a white person, namely, the SECRETARY of the DEPARTMENT OF THE INTERIOR, the power to veto any decision made by the TRIBAL COUNCIL. It ended in 1941 when WORLD WAR II started. [From 'Indian' + FRANKLIN ROOSEVELT's 'New Deal'.]

Indian Removal Act (minorities) The Congressional act (passed 1830) that forced the INDIANS living in the lands of the present-day STATES of the SOUTHEAST to vacate those lands and their ownership of them and to move west of the MISSISSIPPI RIVER where they were given lands in INDIAN TERRITORY. The land which the Indians left behind in the EAST then became part of the holdings of the US government and local STATES. This law affected the FIVE CIVILIZED TRIBES as well as the Miami, Delaware and other tribes. This law was promoted by PRESIDENT ANDREW JACKSON and it started the TRAIL OF TEARS. *Compare* CHEROKEE NATION v. GEORGIA.

Indian Reorganization Act (minorities) (IRA) A federal law (passed in 1934) that encouraged Indian-style tribal life in the politics, government and culture on Indian RESERVATIONS with federal assistance. It supported self-determination of Indian TRIBES namely, by giving each tribe official federal status and the right to have a constitution, encouraging the local governing system of a TRIBAL COUNCIL (i.e., replacing appointed chiefs) and by promoting Indian arts, traditions, languages and education. This law was a major part of the INDIAN NEW DEAL and was crucial to helping INDIANS become more independent and retain and save their tribal heritage. Out of the 500 existing tribes at that time, only 92 decided to accept and abide by the rules set forth in this law. In addition, it restored some land to tribal authorities and it officially abolished AL-

LOTMENT as the official US federal policy. However, some of its white critics claimed that the laws and provisions were too communistic and socialistic. Other critics (Indian and white) claimed that the law still did not give Indians enough independence because it forced Indian tribes to get approval from the BUREAU OF INDIAN AFFAIRS before proceeding with tribal plans and the BIA still had final control and veto powers over the tribal governments and their constitutions. Sometimes also known as the "Wheeler-Howard Act".

Indian summer (customs and traditions) The pleasant period of warm sunny, weather (from 70 to 80°F; from 21 to 26.6°C) which technically occurs after a hard frost sometime during autumn.

Indian Territory (geography) From 1880 until 1907, the legal name for the vast lands west of the MISSISSIPPI RIVER and east of the ROCKY MOUNTAINS which the federal government planned as an area for INDIANS, especially those removed from the EAST, to live on. This territory shrank then disappeared when the present-day STATES of Kansas (1861), Nebraska (1867) and Oklahoma (1907) were created. *See* TRAIL OF TEARS, INDIAN REMOVAL ACT.

Indiana ballot (politics) Another name for the "PARTY-COLUMN BALLOT". [It was first used in the STATE of 'Indiana'.] *Compare* MASSACHUSETTS BALLOT, AUSTRALIAN BALLOT.

Indiana University (education) (IU) A large STATE UNIVERSITY and one of the BIG TEN members famous for its music and medical SCHOOLS[4] and NCAA INTERCOLLEGIATE sports. It was founded in 1820 by order of the Northwest Ordinance and funded by the MORRILL ACT (1862) as an agricultural SCHOOL[3] and grew into a large state university with CAMPUSES found across the state: Bloomington, Richmond, Kokomo and Gary. The COEDUCATIONAL student population has 26,000 UNDERGRADUATES and 9,500 GRADUATES[2]. It has ACCREDITATION. Its teams use the nickname "Hoosier", a name with an unknown origin and referent, and the color crimson.

Indianapolis 500, the (sports and leisure) (Indy 500) The prestigious, annual

500 mile (800 km) race for 33 high-speed motor cars. It takes place on the Sunday of MEMORIAL DAY WEEKEND on the paved 2.5 mile (4 km) track at the Indianapolis Speedway in Indianapolis, Indiana. It was first held in 1911 and since 1956, has been overseen by the United States Auto Club (USAC). Now, the race day is preceded by various festivities including private balls, parties and a street parade which consists of FLOATS and a "Speedway Queen", a young woman chosen to oversee the pre-race festivities. Also known as "The 500".

indicator species (environment) An animal or particular species of animal whose success rate (e.g., increasing numbers of offspring each year) or failure (e.g., abnormal or steady decline in population numbers) shows, or 'indicates', that the overall health of the environment or certain elements of that animal's ECOSYSTEM are poor or polluted. It is determined by different research groups and biologists of the ENVIRONMENTAL MOVEMENT, and may include higher animals (e.g., bear, wolves), wild birds or plants.

indie (the arts) A film made by an INDEPENDENT[1] which is usually more experimental and/or artistic in its choice and presentation of subject material, acting, filming and directing techniques than HOLLYWOOD[2] movies. [Shortened from 'inde'pendent film.] *See* SUNDANCE FILM FESTIVAL.

individual retirement account (economy) (IRA) A type of savings account into which a worker deposits money during the years that he or she is employed and which may not be taxed. Upon retiring (usually, after age 59), this account then converts to a checking account (*see* CHECK) during which time it is taxed. People may use this bank account if their jobs do not offer retirement plans. *See* PERSONAL CHECK.

Industrial Workers of the World (work) (IWW) A radical nationwide labor organization founded in CHICAGO in 1905 by Eugene Debs (1855–1926) and others for male and female workers from all races and all types of jobs (i.e., skilled and unskilled). Although an industrial UNION[1], it was especially successful at organizing lumberjacks, miners, coalminers and tex-

tile workers; at its peak, before 1914, it had some 150,000 members, also known as "WOBBLIES". However, after 1920, it lost popularity and membership because of its stated goals and activities: the overthrow of the system of CAPITALISM and the creation of a new, worker-led system; frequent STRIKES[1] and sabotage; and active opposition to American military efforts during WORLD WAR I.

infield (1, 2, 3 sports and leisure) **1** In BASEBALL, the area inside the boundary lines where the plays of the game are held. **2 The infield** A collective name for the defensive baseball players who play in this part of the field. *See* INFIELDER. **3** At a racetrack (for horses or cars), the grassy area without seats where part of the audience can stand and watch a race; tickets to this area are not expensive because it does not provide a good, overall view of the race.

infielder (sports and leisure) In BASEBALL, a general name for a defensive player stationed in the square area of the field where the bases are located. It includes the first baseman, second baseman, third baseman, PITCHER and shortstop. By association, one of the INFIELD[2]. *See* DIAMOND.

inflation (economy) An overall rise in the prices for products and services. It can be caused by many forces (especially a WEAK DOLLAR) and it affects INTEREST RATES.

information superhighway, the (science and technology) A collective, abstract term referring to the large system of the Internet, World Wide Web, computers, telephones, televisions, fax machines and other electronic appliances and systems which are increasingly used to transport, store and share information among millions of users of these machines and appliances. The term was popularized by VICE PRESIDENT Al Gore (born in 1948) in the early 1990s when he introduced the need for the US government to help build and support the possibilities of this new technology.

inherent powers (foreign policy) The powers that the federal government may exercise in international and foreign affairs. These powers are not specifically

given to the government by the CONSTITU-
TION but rather because it is the national
government of the UNITED STATES.

initiative (politics) A GRASSROOTS
method that citizens (i.e., not legislatures)
can use to propose and pass new STATE
and local laws. Citizens can write a
legislative BILL[2] and if 5% to 15% of the
population signs a petition in favor of it,
the bill is then voted on by the whole
population at the POLLS in an election. If it
receives a majority of votes, it then
becomes law. *See* REFERENDUM.

injunction (legal system) An order is-
sued by a court forcing a person or group
to stop some action, especially STRIKES[1],
marches, demonstrations, picketing and
publishing. *See* NORRIS–LA GUARDIA ACT.

inning (sports and leisure) In BASEBALL,
a two-part period of play when each team
has an opportunity to score and to defend.
The TOP OF THE INNING is when team "A" is
batting and team "B" is defending. When
team "A" collects three OUTS, the teams
switch sides and the BOTTOM OF THE
INNING occurs where team "B" is batting
and team "A" is defending. There are nine
innings in each game. "Extra innings" are
played only if the score is tied.

"innocent until proven guilty" (legal
system) In the legal system, the official
belief that a person accused of committing
a crime is considered 'innocent' of com-
mitting that crime until a court of law
makes a DECISION about him or her: "not
guilty" or "guilty".

insider trading (economy) An illegal
action on the STOCK MARKET in which a
person (i.e., 'insider') gets and uses private,
privileged information to guide him or her
to 'trade' stocks and bonds. The SECURI-
TIES EXCHANGE COMMISSION tries to con-
trol and stop this activity. During the
1980s and 1990s, several scandals at the
AMERICAN STOCK EXCHANGE and the NEW
YORK STOCK EXCHANGE revealed that a
large amount of insider trading had oc-
curred during that period. Those indivi-
duals were banned for life from trading on
the respective stock exchanges and forced
to pay large monetary fines. Also known
as "insider dealing".

Institute for Policy Studies (govern-
ment) A THINK TANK founded in 1963

which researches issues in domestic poli-
cies, human rights, international econom-
ics and foreign policy. It is based in
WASHINGTON D.C.

insurance policy (health) The contract
made between an insurance company and
an individual in which the company agrees
to pay a fixed amount of money to pay for
costs arising in the case of an accident,
sickness or death only if the individual
pays the company an agreed amount of
money each year. *See* INSURANCE PREMIUM.

insurance premium (health) The mem-
bership money that a person regularly
pays an insurance company (e.g., every
year, every three months, every month) to
keep an INSURANCE POLICY active; that is
so that the insurance company will pay for
future costs in case of accidents or pro-
blems (e.g., medical, car, life costs). *Com-
pare* CO-PAYMENT.

Inter-tribal Indian Ceremonial (cus-
toms and traditions) A large four-day
festival of traditional Indian dances,
FANCY DANCES, games, art exhibits and a
parade held every August in Red Rock
State Park in Gallup, New Mexico. It is
presented by various Native American
TRIBES to promote their inter-tribal friend-
ships and to entertain not only INDIANS
but also people who are not Indians.
Popularly known as the "GALLUP CERE-
MONIAL"; *see* POWWOW; compare GATHER-
ING OF NATIONS.

intercollegiate (sports and leisure) De-
scribing a sport for UNDERGRADUATE
players that is organized by a CONFERENCE
of COLLEGES[1] and UNIVERSITIES. In some
large conferences, the sports are broadcast
on radio and television (e.g., BASKETBALL,
BASEBALL and FOOTBALL). *See* NCAA, BIG
TEN, SCHOLARSHIP, NO PASS, NO PLAY, IVY
LEAGUE; *compare* INTRAMURAL.

interest group (government) A neutral
term for any group that shares common
views and goals and actively tries to
influence public laws which directly or
indirectly affect its members. It researches
information concerning its interest and
presents this to public officials. Also
known as "interest". Often, it is used as
another name for "LOBBY". *Compare* PRES-
SURE GROUP, PAC.

interest rate (economy) The amount of money charged to someone or some company for borrowing money. It is set by the FEDERAL RESERVE SYSTEM and is used by banks, CREDIT CARD companies and other institutions.

intern (1 health; 2 work) **1** In the training of a medical doctor, a name for a RESIDENT during the first year of RESIDENCY. Usually, this **internship** lasts for one year. Compare RESIDENCY, INTERNIST. **2** A young person, usually a COLLEGE[3] student or a recent GRADUATE[1] from UNIVERSITY, who works in a political office or business company without receiving a salary in order to gain practical experience. Many college students "do an internship" for a short period of time (e.g., three months to nine months) in WASHINGTON D.C. or in their STATE'S capital city to learn about politics. Others may work in a company to gain business experience. Compare CO-OPERATIVE EDUCATION, WORK STUDY.

Internal Revenue Service (economy) (IRS) The federal agency that enforces US tax laws and collects all the federal INCOME TAXES from individuals and businesses. Also, it is responsible for randomly auditing those people who file taxes, and prosecuting those individuals who are avoiding paying their income taxes (known as "income TAX EVASION"). It was established in 1862 and is part of the DEPARTMENT OF THE TREASURY. During the late 1990s, it was criticized for poor performance and for auditing middle-class people and forcing them to pay fines but not auditing wealthy, upper-class people. See TAX SEASON, APRIL 15, 1040, 1099, 4868.

International Brotherhood of Teamsters, Chauffeurs, Warehousemen, and Helpers of America (work) (TEAMSTERS) A large national trade UNION[1] for transport workers; namely truck drivers and chauffeurs. It was founded in 1903 and its headquarters are located in WASHINGTON D.C. Currently, it has 1.4 million members and some 600 LOCALS; it is an affiliate of the AFL-CIO. It was led by JIMMY HOFFA (from 1957 to 1971), whose mishandling of Teamster money caused some controversy within the UNION[1] in the 1970s.

internist (health) A medical doctor trained to treat the internal organs or processes without surgery (i.e., with prescription medicines). He or she usually receives extra training in this specialty. See RESIDENCY; compare GENERAL PRACTITIONER.

internment camp (minorities) During WORLD WAR II, one of 10 basic camps established by the federal government (from 1942 to 1945) to isolate and guard over 120,000 Japanese-American citizens and immigrant and resident aliens with Japanese ancestry. Also, these camps were meant to prevent the internees from helping the Japanese government which was then at war with the UNITED STATES. The camps were located in semi-desert areas in the WEST and had very poor food and health conditions due to the lack of food and overcrowding. Many of the internees were female, young and old. Today, it is a symbol of offending the CIVIL RIGHTS of these citizens and others and is seen as a shameful act of the federal government. Also called "relocation centers" or "concentration camps"; see COMMISSION ON WARTIME RELOCATION AND INTERNMENT OF CIVILIANS, EX PARTE ENDO, NATIVISM, YELLOW PERIL, PEARL HARBOR.

interpretive reporting (media) A style of writing in newspapers and magazines that gathers the background information and analyzes the implications of current news events, but does not establish an opinion about it. That is, it contains no official editorial comment. See TIME, NEWSWEEK, EDITORIAL; compare MUCKRAKING, INVESTIGATIVE JOURNALISM, NEW JOURNALISM[4].

interstate (highway), the (transportation) The national highway linking major cities in all the STATES (those with a population of 50,000 or more). By association, the collective name for the network of these highways which since the 1950s has been developed, repaired and paid for by the federal government.

Interstate Commerce Commission (transportation) (ICC) The former federal agency and part of the executive branch created by CONGRESS to regulate the rules

and policies for traffic between the STATES (e.g., trucks, trains, buses, river boats). It was active from 1887 to 1995; now its major duties are handled by the DEPARTMENT OF TRANSPORTATION. *See* FREEDOM RIDES.

Intolerable Acts (history) The collective name used by Americans to refer to the four acts passed by the British Parliament in 1774 to punish the colony of Massachusetts by limiting its local legal rights because of its participation in the BOSTON TEA PARTY. Three of the laws affected only Massachusetts (e.g., closing Boston Harbor to trade); the fourth, the Quartering Act, forced all the colonists in all THIRTEEN COLONIES to feed and house British soldiers in their homes, barns and other buildings. These repressive acts led to the AMERICAN REVOLUTION. Also known as "Coercive Acts"; *see* THIRD AMENDMENT.

intramural (sports and leisure) Describing a sport for players that is organized by players. It can be found on the CAMPUSES of COLLEGES[3] and among friends and company employees. It may be single-sex (e.g., women only) or COED. By association, any sport organized by players. Popular intramurals are softball, BASEBALL and soccer. *Compare* INTERCOLLEGIATE.

investigative reporting (media) In the news media, a non-fictional style of writing in which a writer has an idea or notion for a story, then begins discovering and researching the facts supporting that story (e.g., through personal interviews, documents) and finally reports them (e.g., in newspapers, newsmagazines, TV news shows). *See* MUCKRAKING; *compare* INTERPRETIVE JOURNALISM, NEW JOURNALISM[4].

Invisible Man (minorities) A novel (published in 1952) about a southern black man (who has no name) and who feels 'invisible' to the larger, dominant white American society because it does not see nor understand his humanity nor the humanity of blacks in general. It was well received and won the NATIONAL BOOK AWARD in 1953. It was one of the two books written by Ralph Ellison, an African-American writer (1914–1994). This book, with its nameless hero, is an important work in AFRICAN-AMERICAN STUDIES courses.

Iowa Caucus (politics) The PRESIDENTIAL CAUCUS held in the STATE of Iowa in February of a presidential election year. Since it is one of the first to be held, it is an important, early indication of a candidate's popularity in any state. *Compare* NEW HAMPSHIRE PRIMARY.

Iowa Tests of Basic Skills (education) General MULTIPLE-CHOICE tests for GRADES[1] three through eight which help measure the academic levels of ELEMENTARY SCHOOL students in the English language, reading, spelling, math, science and SOCIAL STUDIES.

Iran-Contra Affair, the (foreign policy) The three-part scandal involving illegal actions committed by the REAGAN ADMINISTRATION[2]. In order to encourage Iran (a country then considered a terrorist nation by the US) to help free several American citizens who were being held hostage in Beirut, Lebanon, PRESIDENT RONALD REAGAN and his aides secretly sold military weapons to the government of Iran (which the US was not allowed to do) at higher-than-normal prices. Then without the approval of CONGRESS, the president's aides used the extra money raised from the arms sales to support the anti-Communist guerrilla soldiers of Nicaragua (known as the 'Contras') who were then fighting against communism in that country. The sales began in 1984 and the scandal was discovered in November 1986. Although Reagan was not found responsible for the sales, this scandal shocked the public. Also known as "IRAN-GATE".

Iran-gate/Irangate (foreign policy) An alternative name for the IRAN-CONTRA AFFAIR. *See* -GATE.

Iroquois Confederacy, the (history) During the period from the sixteenth century to the eighteenth century, the loose union of several different INDIAN groups, namely: the Mohawk, Cayuga, Oneida, Onondaga, Seneca and later the Tuscarora TRIBES. Although the tribes remained separate, they had a united, common and central governing system and body which was responsible for negotiating political (e.g., war, peace) or eco-

nomic (e.g., business, trading corn or furs) issues with other NATIVE AMERICAN groups and white groups and governments, colonists and/or Europeans. The purpose of the union was to provide an increased bargaining power with other groups. It was active in the present-day STATE of New York during the COLONIAL PERIOD; during the AMERICAN REVOLUTION, several tribes joined the British and fought against the American colonials. Also known as "Iroquois League" and "Six Nations".

Isabella Stewart Gardner Museum (the arts) In BOSTON, a unique, elegant privately run collection of art works (e.g., paintings, sculptures, tapestries, furniture, porcelain) from Europe, China, Mexico and the UNITED STATES, all of which is housed in an Italian Renaissance-era inspired villa with an interior courtyard, gardens and fountain. It was opened to the public as a museum in 1913. On March 18, 1990, it suffered a major loss when several priceless paintings (i.e., works by Rembrandt, Vermeer) were stolen and have yet to be recovered. The theft has been called the "Heist of the Century". [After 'Isabella Stewart Gardner' (1860–1924) the art collector, museum designer and patroness.]

isolationism (foreign policy) The foreign policy or practice in which a country retreats from international affairs and problems in order to focus on its own national or regional concerns. This was the official policy of the US during much of the nineteenth century and before WORLD WAR I and PEARL HARBOR.

Issei (minorities) A collective name for people born in Japan but who immigrated to the UNITED STATES. They are usually characterized as following the traditions of Japan. [Japanese, literally, meaning "first generation".] *Compare* NISSEI, SANSEI.

"Itsy-Bitsy Spider" (customs and traditions) A moralistic children's song to which they portray the actions of the song with their fingers. The song follows: "Itsy-Bitsy spider crawled up the water spout/ down came the rain and washed the spider out/up came the sun and dried up all the rain/and the itsy-bitsy spider crawled up the spout again". The moral is, keep

working (slowly and steadily) despite adversity and bad luck.

Ivy League (education) A group of eight prestigious, long-established private UNIVERSITIES on the EAST COAST which share similar high academic standards, ACCREDITATION, student populations and enrollment qualifications. Although most were originally established for men by a religious group, today they are all COEDUCATIONAL and no longer have the religious affiliation; that is, they are considered private, independent institutions. The COLLEGES[1] are listed below with their year of founding: Brown University (1764), COLUMBIA UNIVERSITY (1754), CORNELL UNIVERSITY (1865), DARTMOUTH COLLEGE (1769), HARVARD UNIVERSITY (1636), PRINCETON UNIVERSITY (1746), the University of Pennsylvania (1740) and YALE UNIVERSITY (1701). [From the plants of 'ivy' that grow on the old buildings of these COLLEGES[1].] *See* PRIVATE SCHOOL, *DARTMOUTH COLLEGE* v. *WOODWARD; compare* SEVEN SISTERS.

J

Jack Frost (customs and traditions) In winter weather, the personified name given to 'frost' or freezing cold weather.

jack-o'-lantern (customs and traditions) A pumpkin which is cleaned out and carved to look like a human face and into which a candle is placed and lit. It is a traditional HALLOWEEN decoration; usually it is placed on the front porch or before a glass window.

Jackson Day (customs and traditions) January 8, the day celebrating the victory of ANDREW JACKSON and his American forces over the British during the Battle of New Orleans during the WAR OF 1812. It is a LEGAL HOLIDAY in the STATE of Louisiana.

Jackson, "Stonewall" (people) (1824–1863, born Thomas J. Jackson) General of the Confederate Army during the CIVIL WAR. His personal drive and severe but

strong leadership skills helped him lead the cavalry at the battles of: BULL RUN/ MANASSAS (1861 and 1862), Antietam (1862) and Chancellorsville (1863). He was accidentally shot and killed by his own men. [His strength and unmovability when facing UNION[3] troops earned him the nickname "Stonewall".]

Jackson, Andrew (people) (1767–1854) Military leader, INDIAN fighter and US PRESIDENT from the DEMOCRATIC–REPUBLICAN PARTY (1829–1833) and US President from the DEMOCRATIC PARTY (1833–1837). He gained fame for earning victories over the British during the WAR OF 1812 at the Battle of New Orleans as well as the Seminole Indians in present-day Florida (in 1818). During his presidency, he introduced the NATIONAL CONVENTION for political parties and promoted democracy for the "common man" in JACKSONIAN DEMOCRACY. He did not support ABOLITION but did support the removal of Indians from the EAST to the WEST with the INDIAN REMOVAL ACT. Also, he believed in the SPOILS SYSTEM, showing favoritism to his friends and accepting special advice from them. He is considered the developer of the modern Democratic Party. His nickname was "Old Hickory" and his facial portrait is on the $20 BILL[1]. *See* TRAIL OF TEARS, KITCHEN CABINET, JACKSON DAY, INDIAN TERRITORY, Appendix 2 Presidents.

Jackson (Reverend) Jesse (people) (born in 1941) African-American BAPTIST minister, CIVIL RIGHTS leader, public speaker and spokesperson for blacks. After the death of his mentor, MARTIN LUTHER KING, JR., he worked to improve the economic situation of blacks through OPERATION BREADBASKET. Later, he established a separate but similar group, OPERATION PUSH. In 1984, he founded the RAINBOW COALITION Party and ran for (but did not receive) the presidential nomination of the DEMOCRATIC PARTY both in 1984 and 1988. He has also served in CONGRESS as SHADOW SENATOR of WASHINGTON D.C. He is known for his speeches which are marked by eloquence, rhyme and emotion. He is a dominant figure in African-American issues. *See* THIRD PARTY[1].

Jackson, Michael (people) (born in 1958) POP MUSIC singer. As a solo performer, his album *Thriller* (1982) has sold over 40 million copies, making it the best-selling album of all time. He is known for his voice which has a wide range, his youthful behavior and his live performances with intricate footwork and dancing. He wears distinctive snug, spacesuit-like clothes and sometimes one glove. He is sometimes known as the "Prince of Pop". During the 1960s and 1970s, he was the lead, high-voiced singer of the musical group with his brothers (i.e., Jacky, Jermaine, Marlin, Tito and Randy) in "The Jacksons" also known as "The Jackson 5". He became a father to a male child in 1997.

Jacksonian Democracy (politics) The attitude that all men, especially the "common man", should be respected which was promoted by PRESIDENT ANDREW JACKSON during his ADMINISTRATION (1828–1835). This attitude encouraged STATES' RIGHTS[2], voting rights for all adult white male citizens, a split from the DEMOCRATIC– REPUBLICAN PARTY, and the founding of the DEMOCRATIC PARTY. Also known as "Jacksonianism"; *see* Appendix 2 Presidents; *compare* JEFFERSONIAN DEMOCRACY.

jambalaya (food and drink) A spicy ENTREE dish of cooked rice with chicken, ham, sausage, shrimp, oysters, tomatoes and seasoned with herbs. By association, a "potpourri". [From French *jambon*, meaning "ham".] *See* CREOLE CUISINE, CAJUN COOKING.

James, Henry (people) (1843–1916) Writer of fiction, criticism and short stories. His works frequently deal with the conflicts that arise when Americans (characterized as PURITAN-like) and Europeans (characterized as aristocratic or class-oriented) interact. He was known for using long, wordy sentences and complex syntactic patterns in his sentences. Although he did live in BOSTON, he spent much of his life in Europe and England; before his death he became a British citizen.

James, Jesse (people) (1847–1882) A robber of trains and banks and an outlaw who was active during the era of the "Wild West". He is remembered for his indepen-

dence and (according to tradition) for giving away some of this stolen money to others. *See* WEST.

Jamestown (geography) The first permanent and successful settlement of the British in North America which was established in 1607. It was founded off the CHESAPEAKE BAY in the colony of Virginia and became a tobacco-growing region. Englishman Captain John Smith (1580–1631) strengthened the colony during his TERM[1] as governor (1608–1609). In 1609, the first boat-load of black Africans arrived here which started the system of SLAVERY in America, especially in the SOUTH. [After 'James' I (1566–1625), King of Great Britain, who sponsored the group.] *See* POCAHONTAS, TIDEWATER REGION.

Jane Doe (1 society; 2 legal system) **1** The average or anonymous woman. **2** The name given to a female in a legal case to protect her identity from unwanted publicity. *Compare* JOHN DOE[2], BABY DOE.

JAP/Jap (society) A JEWISH woman who is accustomed to getting what she wants, especially receiving attention and presents. [From the abbreviation 'J'ewish 'A'merican 'P'rincess.]

Japanese American Citizens' League (minorities) (JACL) The organization dedicated to defend the educational and CIVIL RIGHTS of Japanese Americans and other MINORITIES and peoples as well as to promote and preserve the culture and history of Japanese Americans. It was founded in 1929, its national headquarters are in SAN FRANCISCO and it currently has over 22,000 members.

jay walking (transportation) Walking across a street carelessly or not in a designated cross walk; in some busy American cities, **jay walkers** pay a fine.

Jaycees, the (sports and leisure) (JCC) An organization and local group for young people designed to get them interested in private business and economic forces. Many **Jaycee** members are students in HIGH SCHOOL. [Acronym of 'J'unior 'C'hamber of 'C'ommerce.]

jayvee (sports and leisure) A member of the JUNIOR VARSITY. [From the initials 'JV' of 'j'unior 'v'arsity.]

jazz (music) (the arts) In general, a unique and important type of improvisation type of music characterized by having complex rhythms (i.e., triple time – three notes per one beat), using BLUE NOTES[1] and polyphony (i.e., two or more melodies played against each other). It usually encompasses various instruments: the clarinet, trumpet, drums, trombone, piano, bass and sometimes the saxophone and BANJO. Although it is often performed in a group, the music allows each musician to individually play or improvise a solo in a song. It developed from various other music forms, namely, RAGTIME, the BLUES[1], spiritual songs, MARCHING BAND music as well as African and European traditions of rhythm, harmony and melody. It is commonly accepted as having originated in NEW ORLEANS'S STORYVILLE by black musicians about 1900. Many styles of jazz have been developed, especially DIXIELAND JAZZ, SWING music and BEBOP. In general, jazz music has had an important effect on other forms of music and individuals, namely, ROCK AND ROLL, POP MUSIC and GEORGE GERSHWIN. Specifically, the "original" jazz played in the SOUTH before WORLD WAR I is known as "classic jazz" or "NEW ORLEANS JAZZ"; further, any jazz played in this manner is also known as "classic jazz" or "New Orleans style". *See* also BIG BAND, "CHICAGO-STYLE" JAZZ, COOL JAZZ, BILLIE HOLIDAY, ELLA FITZGERALD.

Jazz Age, the (history) One of several names for the historical period after WORLD WAR I and before the GREAT CRASH of 1929; that is basically, the 1920s. This period was marked by people's interests in themselves and their new wealth. This period is characterized by a strong STOCK MARKET, newly-made millionaires, many parties, new innovations in music (i.e., JAZZ MUSIC), more independence for and identity for certain blacks in the NORTH (i.e., HARLEM RENAISSANCE) and greater freedom for white women and the relaxation of morals (some women chose to wear shorter dresses, short hairstyles and smoke cigarettes in public). This period was also marked by a certain paranoia caused by PROHIBITION, the RED SCARE[2], NATIVISM and racial problems. [After the title of F.

SCOTT FITZGERALD's book, *Tales of the 'Jazz Age'* (1922).] This same period is also known as the "ROARING TWENTIES". *See* GREAT MIGRATION[2], SACCO AND VANZETTI CASE.

Jazz Singer, The (the arts) The first commercial film (released in 1927) which used sound and showed "talking" characters (i.e., their mouths moved in synchronicity to the speech sounds). It starred Al Jolson (1886–1950), a white man who wore "black-face" (i.e., black-colored face make-up) and portrayed a black singer of RAGTIME MUSIC.

JD (legal system) The degree awarded to a person who has attended three or four years of law SCHOOL[3] courses and successfully completed exams. It is equivalent to a MASTER'S DEGREE program. A person must receive this degree before he or she can be admitted to the BAR[2]. [Abbreviation of *Juris Doctor*, Latin, meaning "doctor of law".] *See* LSAT, PROFESSIONAL SCHOOL.

jeans (clothing) A type of trousers made from a heavy cotton, twilled fabric and strengthened with metal tacks or rivets. They were popularized during the GOLD RUSH of 1849 in California as work pants; in the 1970s they became chic and fashionable when famous designers made them and put their brand label on the back pocket (i.e., "designer jeans"). [Short for "Jean fustians", from "Gene(s) fustian", from "Genoa fustian".] Also known as "blue jeans".

Jefferson, Thomas (people) (1743–1826) Thinker, lawyer, and US PRESIDENT (1801–1809) of the DEMOCRATIC–REPUBLICAN PARTY. He was the major writer of the DECLARATION OF INDEPENDENCE, served as US ambassador to France and served as the US SECRETARY of the DEPARTMENT OF STATE. During his presidency, he supported STATES' RIGHTS[2], majority rule, CIVIL LIBERTIES and a limited central government. In addition, he sponsored the LEWIS AND CLARK EXPEDITION and made the LOUISIANA PURCHASE. He is admired for his skill in a variety of different roles: public figure, writer, farmer and architect; he designed his home of MONTICELLO. He is controversial for having owned slaves but in theory, being against SLAVERY. His facial portrait appears on the $2 BILL[1] and on the NICKEL. *See* JEFFERSONIAN DEMOCRACY, Appendix 2 Presidents.

Jeffersonian Democracy (politics) A general name for the collection of beliefs and practices of THOMAS JEFFERSON during his presidency (1801–1809) which promoted the ideas of a responsible 'republic' of the public majority (i.e., not a monarchy) and kept to a close reading of the CONSTITUTION. It promoted farming and the middle class but also protected the rights of business (however, it did not abolish SLAVERY). Further, it believed in listening to the public's majority and minority groups and it succeeded in decreasing the national debt (caused by the AMERICAN REVOLUTION). It protected CIVIL LIBERTIES and was against the ALIEN AND SEDITION ACTS. Finally, while PRESIDENT, Jefferson walked to his own ceremonies on INAUGURATION DAY and he purposefully wore regular, civilian (i.e., non-military) clothing. These ideas helped shape the DEMOCRATIC–REPUBLICAN PARTY, and are considered the beginning of the DEMOCRATIC PARTY. It developed in protest to the FEDERALIST[2] party. *See* Appendix 2 Presidents; *compare* JACKSONIAN DEMOCRACY.

jello (food and drink) A type of colorful, fruit-flavored (e.g., strawberry, cherry, lime) dessert or snack made with gelatin and sugar and served in a cup. A "jello salad" is a popular picnic or summertime SIDE DISH in which fresh fruit slices have been prepared with the jello; it is then served either alone or on a bed of lettuce. [After the company's trademark, 'Jell-o'.] Also spelled "jell-o".

jelly beans (food and drink) Small candies, the size and shape of oblong 'beans', with a hard coating and soft, chewy, 'jelly'-like center. They come in a variety of bright colors and flavors and are usually eaten during the period of EASTER. *See* EASTER EGG HUNT.

jerky (food and drink) Meat (e.g., beef, turkey) that has been cut into thin strips and dried. It is often eaten as a snack outdoors or while camping. [From Spanish *charqui*.]

Jerry Lewis Telethon (health) The annual televised fund-raising TELETHON

held all day, every LABOR DAY (since 1948), to help raise money to finance projects to research muscular dystrophy. It is hosted by 'Jerry' (Lee) 'Lewis' (born in 1935), a popular entertainer and performer. Formally known as the "Muscular Dystrophy Telethon"; *see* FUND-RAISER.

Jerry's Kids (health) The nickname given to those young children with muscular dystrophy who are helped by the JERRY LEWIS TELETHON.

jet set, the (society) A collective name for the group of very wealthy people who frequently travel to wintertime and tropical resorts by airplane. It includes people of all nationalities.

Jet (media) A weekly magazine of news and cultural items for and affecting AFRICAN AMERICANS. It was founded in 1951 and has a current circulation of 925,000.

Jewish (religion) A term describing a member of, or relating to, one of the three main different groups of **Judaism** in the UNITED STATES: REFORM JUDAISM, CONSERVATIVE JUDAISM and ORTHODOX JUDAISM. Currently, there are a total of 4.3 million **Jews** in the UNITED STATES. *See* SABBATH SCHOOL[1], HASIDIC JUDAISM, YARMULKE, HIGH HOLIDAYS, BAR MITZVAH, BAT MITZVAH.

Jewish penicillin/remedy (health) Hot chicken soup. According to the belief of many JEWISH mothers, this dish cures all.

Jim Crow (laws) (minorities) In the SOUTH, a system of laws passed by STATE and city legislatures that separated blacks from whites in all aspects of daily life in order to keep blacks in an inferior position to whites. They affected many public facilities (e.g., SCHOOLS[5], train cars, buses, restaurants, bathrooms, lunch counters, and drinking fountains). The laws also denied blacks the important citizen's right of voting (e.g., by requiring the POLL TAX, enforcing the GRANDFATHER CLAUSE[1]). These laws were first passed in the 1880s and strengthened by the DECISION of the SUPREME COURT in *PLESSY v. FERGUSON*. This system of DE JURE segregation only began to end with the CIVIL RIGHTS MOVEMENT of the 1950s and 1960s. [A 'crow' is a large black bird of North America that flies in a lazy, weak-looking manner. 'Jim Crow' was the name of a black character

from a popular MINSTREL song and act from the 1830s who was played by a white actor wearing black make-up on his face, who sang, "wheel about" and "jump Jim Crow" in a spineless, stupid way; 'Jim Crow' became a derogatory name for blacks in the nineteenth century.] *See* LYNCH LAW, NAACP; *compare* BLACK CODES. By association, a derogatory name for a black person who promotes ACCOMMODATION and separation of the races.

job-training program (work) A program that offers to teach skills or business courses to workers and/or employees. It may be sponsored by the federal government and/or private companies. *See* EQUAL EMPLOYMENT OPPORTUNITY COMMISSION.

Jobs for Negroes Movement (minorities) During the GREAT DEPRESSION, an organized movement among AFRICAN AMERICANS that attempted to increase the number of urban jobs for blacks. Black protesters carried picket signs and boycotted those businesses that did not have black employees and refused to hire blacks. It began in 1929 in CHICAGO but soon spread to many other American cities (e.g., HARLEM, where the movement was led by Adam Clayton Powell, Jr. 1908–1972). It ended in 1941 when WORLD WAR II began because that event caused an increase in jobs for blacks. Also known as "Don't Buy Where You Can't Work Movement".

Joffrey Ballet (the arts) A well-respected ballet company which works to reinterpret and re-choreograph older ballet pieces in a more athletic and modern style. It was founded in 1956 by Robert Joffrey (1930–1988) and Gerald Arpino (born in 1928) and is based in CHICAGO.

John Birch Society (politics) A right-wing and anti-communist organization and public interest LOBBY. It was founded in 1958 by Robert Welch and its headquarters are in Wisconsin. During the 1960s it was particularly strong and even influenced the REPUBLICAN PARTY. During this time, it tried to encourage the US to leave the United Nations and it believed that the CIVIL RIGHTS MOVEMENT was inspired by communists. Currently, it has some 100,000 members. *See* RIGHT.

"John Brown's Body" (customs and traditions) A popular, robust abolitionist FOLK MUSIC song dating from the CIVIL WAR era and celebrating the brave efforts of John Brown at the RAID ON HARPER'S FERRY. The first two verses are: "John Brown's body lies a-moldering in the grave (three times)/But his soul goes marching on/Glory, Glory Hallelujah (three times)/ His soul goes marching on/John Brown died to put an end to slavery/ But his soul goes marching on (etc.)." It was frequently sung by supporters of ABOLITION. *See* "BATTLE HYMN OF THE REPUBLIC".

John Doe (1 society; 2 legal system) **1** The average, or anonymous man or person. **2** The name given to a male in a legal case to protect his identity from unwanted publicity. *Compare* JANE DOE[2], BABY DOE.

John F. Kennedy Center (for the Performing Arts) (the arts) The premiere, large performance space complex for the live, performing arts (e.g., orchestra, opera, singing, theater) located in WASHINGTON D.C. It also has a theater and screen for showing movies. It was opened in 1971 and distributes the JOHN F. KENNEDY CENTER FOR THE PERFORMING ARTS AWARDS. [In honor of the late JOHN F. KENNEDY.] Also, popularly known as the "Kennedy Center".

John F. Kennedy Center for the Performing Arts Awards (the arts) A number of different, well-respected awards given to those individual artists and individuals who have added to the wealth and quality of the cultural arts in the UNITED STATES. They are distributed annually by, and presented at, the JOHN F. KENNEDY CENTER FOR THE PERFORMING ARTS.

John Hancock (language) An autograph or signature, usually written large and with confidence. [After the signature of 'JOHN HANCOCK' on the DECLARATION OF INDEPENDENCE who was so strongly in support of American independence that he purposefully made his signature large enough for the King of England to see it easily.]

Johnny Appleseed (customs and traditions) The popular nickname of John Chapman (1774–1847), a man who raised apple trees in NEW ENGLAND. He is credited with bringing apple trees to the MIDWEST by traveling through that area on foot for some 40 years in the early nineteenth century and giving people apple tree seeds in order to grow their own trees.

Johns Hopkins Hospital (health) A top-ranking hospital and medical research center located in Baltimore, Maryland specializing in the research and treatment of AIDS (Acquired Immune Deficiency Syndrome) and cancer.

Johns Hopkins University (education) A prestigious, independent UNIVERSITY famous for its strong BACHELOR'S DEGREE programs and respected medical SCHOOL[4] and research center. It was founded in 1876 in Baltimore, Maryland. The COEDUCATIONAL student population includes 3,000 UNDERGRADUATES and 4,500 GRADUATES[2]. It has ACCREDITATION and is an NCAA member; its teams compete at the INTERCOLLEGIATE level. [After 'Johns Hopkins' (1795–1873), a benefactor.] *See* PRIVATE SCHOOL.

Johnson, Lyndon Baines (people) (LBJ) (1908–1973) US CONGRESSMEMBER (1938–1960), Vice President (1961–1963) and US PRESIDENT (1963–1969) with LIBERAL beliefs in the DEMOCRATIC PARTY. He first became president after JOHN F. KENNEDY was assassinated. During his presidency, he promoted programs to help the domestic situation in America, namely, the GREAT SOCIETY, WAR ON POVERTY, MEDICARE, MEDICAID, the CIVIL RIGHTS ACT (1964) the VOTING RIGHTS ACT OF 1965, and the NATIONAL ENDOWMENT FOR THE ARTS AND HUMANITIES. However, his military actions and failures in the VIETNAM WAR hurt the effectiveness of his elected TERM[1]. *See* Appendix 2 Presidents.

Johnson, Magic (people) (born Earvin Jackson in 1959) A former NBA BASKETBALL player for the Los Angeles Lakers recognized for his athletic skill (he was NBA MVP in 1987, 1989 and 1990). He stopped playing after discovering that he had contracted HIV (Human Immunodeficiency Virus). *See* Appendix 3 Professional Teams.

Joint Chiefs of Staff, the (government) The group of advisers that helps the PRESIDENT and SECRETARY OF DEFENSE

make military decisions about the ARMED FORCES and national defense. These advisers are military leaders of the US ARMY, NAVY, AIR FORCE and Marines and are all appointed by the President to these positions (on the ADVICE AND CONSENT of the SENATE) to four-year TERMS[1]. It is headed by the "Chairman of the Joint Chiefs of Staff" who serves a two-year term and who is the President's most important military adviser. It was created in 1947. *See* CABINET, MARINE CORPS.

joint committee (government) A permanent CONGRESSIONAL COMMITTEE that has members from both the SENATE and the HOUSE OF REPRESENTATIVES and which works on business affecting both chambers of CONGRESS. There are four committees in total: Economic; Library of Congress; Printing; Taxation.

joint session (government) In CONGRESS, a SESSION[1] when both chambers meet in the chamber of the HOUSE OF REPRESENTATIVES for a serious or ceremonial purpose or some other special event (e.g., STATE OF THE UNION MESSAGE).

joint venture (economy) A business or research group that forms an association of two or more companies sharing resources and employees in order to work on a special task or project. The two companies share the business risks involved. Commonly, it forms with one group from the PRIVATE SECTOR and one from the PUBLIC SECTOR.

Jones Act (immigration) A federal law (passed in 1917) which gave automatic citizenship to Puerto Ricans unless they refused to take it. *See* PUERTO RICO, DÍA DE LA CONSTITUCIÓN.

Jones, Casey (customs and traditions) (1847–1900; born John Luther Jones) Train engineer. While making a train trip, the train he was steering (i.e., the Illinois Central "Cannonball" express train) hit a freight train head on. However, he died trying to stop his train, with his hand on the locomotive brake. He is a symbol of sacrificing oneself for the good of the group.

Jones, LeRoi (people) The birth name of IMAMU BARAKA and used before 1966.

Joplin, Janis (people) (1943–1970) A white ROCK MUSIC singer who sang in the tradition of the BLUES[1]. She became popular in the 1960s performing with the band Big Brother and the Holding Company and at WOODSTOCK. She died young from a heroin drug overdose. Her most famous song (released after her death) was "Me and Bobby McGee".

Joplin, Scott (people) (1868–1917) African-American music composer. He is known as one of the founders and developers of RAGTIME MUSIC with his RAG[2] entitled "Original Rags" (1899). His success continued with other popular songs including "Maple Leaf Rag" (1899) and "The Entertainer" (1902).

Jordan, Michael (people) (born in 1963) Professional BASKETBALL player for the Chicago Bulls. He is known for his many skills as a basketball player, his good sportsmanship, his grace and beautiful smile. He has won several awards from the NBA including MVP of the year (1988, 1991, 1992, 1996) and NBA PLAYOFFS MVP (1991, 1992, 1993, 1996). His jersey uniform number is 23. Many consider him to be the finest basketball player ever. Briefly, he retired from basketball and unsuccessfully tried to play MINOR LEAGUE BASEBALL (1994–1995). *See* Appendix 3 Professional Teams.

Joseph, Chief (people) (*c.* 1840–1905) Chief of the Nez Percé INDIANS of Oregon and Indian leader. He is remembered for evading the US ARMY (which wanted to restrict his people to a RESERVATION on American land) for several months and over 1,500 miles (2,414 km) while trying to lead his tribe to freedom in Canada. He and his band of followers were eventually captured and sent to different reservations in the present-day STATES of Washington, Oklahoma and Idaho. In the 1970s, he became a symbol for members of the RED POWER movement and other INDIANS.

Joshua Tree National Monument (environment) The NATIONAL MONUMENT located within the NATIONAL PARK found in the MOJAVE DESERT which includes and protects some 800 square miles (2,072 sq. km) of dry, arid land, various forms of desert animal life there and the unique Joshua tree (*Yucca breviflora*), a type of tall, evergreen tree with many twisted branches. [After this tree's smooth

branches which, to the Mormons on the Mormon Trail in 1847, looked like the arms of 'Joshua', the Old Testament biblical figure who led the ancient Israeli people out of the desert to a new homeland.]

Journal of the American Medical Association (media) (*JAMA*) The weekly journal of the American Medical Association containing news reports, letters, editorials and scientific papers by physicians in over 25 different specialties of medicine. It does not support socialized medicine nor national health care programs. It was founded in 1883 and has a current circulation of 350,000. *Compare New England Journal of Medicine.*

judicial activism (legal system) A view and method of judges which uses a liberal or broad interpretation of the Constitution (i.e., not a strict reading of it). It considers judicial review a democratic process to improve and protect the rights (e.g., civil rights) granted to all individuals (i.e., citizens, minorities, immigrants and criminals). Some critics accuse the bench[2] that practices judicial activism of acting like a legislature (i.e., making new laws with its decisions) and not a judiciary (i.e., enforcing established laws). *See* separation of powers, Warren Court; *compare* judicial restraint.

judicial restraint (legal system) A belief that the judiciary should follow a "strict" (i.e., literal) conservative interpretation of the US Constitution when it makes its decisions. It holds that making laws is the duty of the legislature, not the judiciary, and is critical of judicial activism.

judicial review (legal system) The power of the courts to judge if the actions and laws of the federal, state and local governments are unconstitutional (i.e., illegal). It gives judges the right to officially interpret the Constitution. This important power was established as the duty of the Supreme Court by the decision written by Chief Justice John Marshall in *Marbury v. Madison. See* balance of power.

Judiciary Act (of 1789) (legal system) The act of Congress (passed in 1789) which established the federal judicial system, namely, the position of the Attorney General, some additional duties of the Supreme Court and established the US District Courts and Circuit Courts (today's US Court of Appeals). Section 13 of this 1789 act, which gave the Supreme Court the writ of mandamus over Presidential appointment power, was declared illegal in *Marbury v. Madison. See* judicial review.

jug band (customs and traditions) A small band which plays bluegrass music or old folk music tunes on simple instruments (e.g., harmonica) as well as on everyday objects (e.g., washboard, empty cider 'jugs').

Juilliard School (for Music), the (education) The small, well-respected post-secondary school specializing in the study of musical performance, composition and singing located in New York City, New York. It was founded in 1905 as a private school for future musicians. Today, it remains independent, offering bachelor's degrees (e.g., BA, BFA), master's degrees (e.g., MA, MFA) and PhD degrees to its 825 students. The urban campus is located near Lincoln Center and has music classrooms and four auditoriums for student use.

jump ball (sports and leisure) In basketball, when the referee tosses the ball into the air and players from the two teams try to acquire it. It is used when it is not sure which team caused a foul[2].

jumper (clothing) A sleeveless dress usually worn by women over a blouse and under a sweater. It is a common type of girl's uniform in private schools and parochial schools.

jungle gym (sports and leisure) A large solid structure made of interconnecting horizontal and vertical metal bars that is built for children to climb on and is often found on playgrounds. Sometimes referred to as "monkey bars".

junior (education) A student in the third year of high school, college[1] or university. *See* class.

junior college (education) Another name for community college. *See* Appendix 4 Educational Levels.

junior high school (education) A public school or private school for students in grades[1] seven through nine which

precedes a "senior" HIGH SCHOOL. It may be a separate SCHOOL[1] but, is often part of an ELEMENTARY SCHOOL and high school. It is commonly referred to as "junior high". *See* Appendix 4 Education Levels.

Junior Olympics, the (sports and leisure) The official, nationwide sporting competition for young people aged 10 to 19. It offers competition in the following sports: BASEBALL, BASKETBALL, field hockey, gymnastics, karate, soccer, swimming, synchronized swimming, taekwondo, and TRACK AND FIELD. It was first held in 1948 and is organized by the AMATEUR ATHLETIC UNION.

junior varsity (sports and leisure) (JV) The younger or less-experienced team of a sport sponsored by a SECONDARY SCHOOL or COLLEGE[1] that is usually made up of FRESHMEN[2] and SOPHOMORE student athletes. It is also known as the "JAYVEES". *See* EXTRACURRICULAR ACTIVITIES, LETTER; *compare* VARSITY.

junk bond (economy) A bond or security issued by a company which has low credit ratings. It is issued because the company wants to raise money for itself quickly before that company is acquired or taken over by a second company. The investor only receives the investment after the successful BUY-OUT by the second company. Thus, because of its high risk for failure, a junk bond usually pays a high yield. "Junk bond trading" was very popular during the 1980s. *See* INSIDER TRADING.

junk food (food and drink) Any prepared or packaged food (e.g., candy, potato chips) containing high levels of sugar, calories and/or fat, but very little protein or nutrition. By association, anything that is enjoyable in the short term, but does not have substantial value. *Compare* FAST FOOD.

jurisdiction (legal system) The power that a legal court has to try a case. *See* COURT OF APPEALS; *compare* ORIGINAL JURISDICTION.

jury (legal system) A group of citizens (from six to 23, but usually 12) that swear to listen to the facts of a court case (e.g., CRIMINAL TRIAL or CIVIL TRIAL) and together make a decision for punishment or SETTLEMENT. Accused persons have this

right from the SIXTH AMENDMENT and SEVENTH AMENDMENT. *See* JURY DUTY; *compare* GRAND JURY, PETTY JURY.

jury duty (legal system) If called upon to do so, the civil duty of a citizen to serve as a member of a JURY in a court case. A citizen is called upon to do jury duty by the local, COUNTY or STATE government only if he or she is registered to vote. *See* VOTER REGISTRATION, *TAYLOR* v. *LOUISIANA*.

justice of the peace (legal system) (JP) A local legal officer whose responsibilities include hearing some CIVIL TRIALS, giving oaths, setting BAIL and performing marriages. Further, a JP may hear non-serious CRIMINAL TRIALS concerning MISDEMEANORS.

juvenile court (legal system) A STATE or local level court that hears those cases concerning MINORS or other young people (e.g., criminal cases, cases of child neglect, CHILD SUPPORT). Sentences for criminal offenses are not as severe as in regular courts for adults. Also known as "family court"; *compare* MAJORITY, THE AGE OF.

K

Kansas–Nebraska Act, the (history) The Congressional act (passed in 1854) designed to organize the TERRITORIES of 'Kansas' and 'Nebraska' in the WEST, and prepare them for statehood. It was controversial because it left the decision of having legalized slavery to these new, individual soon-to-be US STATES; that is, each was to decide for itself if it would accept SLAVERY (i.e., slave state) or prohibit it (i.e., non-slave state). This act resulted in: repealing the MISSOURI COMPROMISE, hurting relations between the SOUTH and the NORTH and directly leading to the CIVIL WAR. *See* REPUBLICAN PARTY.

Kefauver Commission (work) A special committee that conducted special, televised HEARINGS[2] for eight days and heard the TESTIMONY of people involved with organized crime. Its written report

(published 1951) listed its findings, namely that: organized crime (e.g., narcotics, prostitution and gambling) had increased in NEW YORK CITY because elected City officials (e.g., the mayor) had permitted it and, therefore, these organized crime gangsters would not be prosecuted because of their connection to and power over political leaders. It was officially known as the "Senate's Special Committee to Investigate Organized Crime in Interstate Commerce". [After chairman SENATOR Estes 'Kefauver', DEMOCRAT from Tennessee.]

Keillor, Garrison (people) (born in 1942) A comedian, writer, storyteller and singer who presents "A Prairie Home Companion", a popular radio program that relates humorous stories about the CONSERVATIVE people and customs of his "hometown" of LAKE WOBEGON located in the STATE of Minnesota in the MIDWEST. He has also published popular books relating similar material.

Kennedy Space Center (science and technology) The site where NASA projects are worked on and launched; it is also a tourist attraction. It is located in the STATE of Florida. Officially known as "John F. Kennedy Space Center"; *see* CAPE CANAVERAL.

Kennedy, Edward ("Ted") (people) (born in 1932) US SENATOR from the STATE of Massachusetts (since 1962) and DEMOCRAT. He is known for his LIBERAL beliefs and support for affordable health care, fair labor and work practices and education issues. He is a leading member of the CONGRESSIONAL COMMITTEE on Labor and Human Resources (since 1981). His political career has been limited by his involvement and responsibility in the 1969 death of a young female political worker in a car accident; this accident occurred on "Chappaquiddick" Island, Massachusetts. He is the brother of JOHN F. KENNEDY and ROBERT KENNEDY.

Kennedy, John F[itzgerald] (people) (JFK) (1917–1963) US CONGRESSMEMBER (1947–1960) and US PRESIDENT from the DEMOCRATIC PARTY. During his brief presidency, he encouraged the SPACE RACE, the APOLLO PROJECT, PEACE CORPS and open immigration policies to the US. In addition, he was responsible for the CUBAN MISSILE CRISIS, the BAY OF PIGS, and for increasing the number of troops and US personnel in Vietnam. He is remembered for his talented speaking skills, youthful enthusiasm and for being the first member of the ROMAN CATHOLIC CHURCH elected to that position. He was assassinated on November 22, 1963, in DALLAS, Texas by Lee Harvey Oswald (1939–1963). His two younger brothers were ROBERT KENNEDY and EDWARD KENNEDY. *See* CAMELOT[2], WARREN COMMISSION, LYNDON JOHNSON, McCLELLAN COMMITTEE, Appendix 2 Presidents.

Kennedy, Robert ("Bobby") (people) (RFK) (1925–1968) Lawyer, US ATTORNEY GENERAL of the DEPARTMENT OF JUSTICE (1961–1964) and brother of John F. Kennedy. He served as the CAMPAIGN MANAGER for his brother JOHN F. KENNEDY'S CAMPAIGNS (in 1952, in 1960). He is remembered for his public positions against the Mafia and organized crime and for his support of the ANTI-WAR MOVEMENT. He also served as SENATOR from New York STATE. While he was a candidate in the presidential campaign of 1968 and shortly after having won the state PRIMARY ELECTION of California, he was assassinated by extremist Sirhan Sirhan. *See* McCLELLAN COMMITTEE, EDWARD KENNEDY.

Kent State Massacre/Incident (education) The killing of four UNIVERSITY students and the wounding of nine others by the NATIONAL GUARD of the STATE of Ohio on May 4, 1970, by order of the governor during an ANTI-WAR MOVEMENT protest. The conflict began when these 13 students had joined many others participating in a student demonstration (including setting fire to the ROTC building) against the US military's planned invasion of Cambodia, and its need to draft 150,000 more young American men to fight as soldiers in the VIETNAM WAR. These student deaths prompted unrest and student demonstrations on over 400 COLLEGE[1] CAMPUSES nationwide. [From the location of the incident, on the CAMPUS of 'Kent State' University, a STATE UNIVERSITY located in Kent, Ohio.]

Kentucky Derby, the (sports and leisure) The most famous and prestigious single race in horse racing in which three-year-old thoroughbred horses run a race of 1-1/4 miles (2 km) and the winner receives a large sum of money. It is held every year, first in 1875, on the first Saturday in May at Churchill Downs in Kentucky. It is the first race of the TRIPLE CROWN[1]. It is also a social and cultural event in the city of Louisville among the racegoers who celebrate on the race day by drinking MINT JULEPS and singing "MY OLD KENTUCKY HOME". Its nickname is The "RUN FOR THE ROSES". *See* PARI-MUTUEL.

Kerner Commission Report (minorities) The federal report (1,400 pages long) prepared by the federal commission that had researched the riots of the LONG, HOT SUMMER which was published in 1968. The report listed the causes of those riots as: high black unemployment, poor education opportunities for AFRICAN AMERICANS and, most importantly, white racism. It stated: "Our nation is moving toward two societies, one black, one white – separate and unequal." Its recommended solutions were to use federal money to give blacks job training, education aid and better housing. The commission was formally known as "National Advisory Commission on Civil Disorders". [After Otto 'Kerner' (1908–1976), governor of Illinois and chairman of that commission.] *See* "SEPARATE BUT EQUAL", WATTS RIOTS; *compare* LA RIOTS.

Kerouac, Jack (people) (1922–1969) Writer. His best-known work is *ON THE ROAD* (1957) which relates the tales and travels of a charming young man and his sidekick who travel across the country several times searching for fun. Although he wrote other books, this is the most enduring; it is characterized as being a major book of the BEAT GENERATION and for its use of free, oral speech patterns. Kerouac was a leader of this movement.

Kevorkian, Jack (people) (born in 1928) A medical doctor who trained at a medical school and who, since the 1980s, has become controversial because he has assisted several patients to die (known as "assisted death" or "assisted suicide") .

He has developed an injection which he gives to those patients (who are diagnosed with end-stage cancer or other terminal illnesses) who ask to die by their own choice. This controversial procedure has led critics to give him the nickname "Dr. Death".

Key Club International (sports and leisure) An organization for HIGH SCHOOL students, founded in 1925, which encourages teenagers to become active in serving their local community, especially working with the elderly and children.

key lime pie (food and drink) A type of PIE made with a filling of lime juice, sweetened condensed milk and egg yolks in a crumbly crust of GRAHAM CRACKERS. It is topped with sugar and whipped cream. [It was first made in the 1850s on the FLORIDA 'KEYS' where fresh 'limes' and condensed, but not fresh milk, were readily available.]

Key to the City, the (customs and traditions) A ceremonial award in the shape of a key given by a mayor or other city official to a special person in honor of some work or deed that that person has done. Often, it is given by a city to those persons born in that city who have achieved some fame in the STATE or nation. [From the 'keys' used to unlock the gates of fortified medieval European 'cities' which were held or controlled by important civic leaders.]

Key West (geography) One of the FLORIDA KEYS and a former artists' colony (e.g., ERNEST HEMINGWAY, JOHN JAMES AUDUBON lived there). It is known for its close proximity to Cuba and its residents' attitude of non-conformity; it has a well-established homosexual population. [From Spanish *cayo*, the word for this type of island.]

keynote speech (politics) The first speech of a NATIONAL CONVENTION that introduces the themes of the PLATFORM and CONVENTION[1] and is designed to get the DELEGATES excited about the candidates. By association, any major speech presented to an audience. *Compare* INAUGURAL SPEECH.

khakis (1 military; 2 clothing) **1** The greenish-brown colored uniforms worn by the members of the US ARMY every day or

for informal occasions. *Compare* WHITES, BLUES². **2** A type of pants made of a sturdy, twilled, cotton fabric and usually in a brown-green (i.e., 'khaki') color. They are commonly worn as daily or casual wear.

KIA (military) A military abbreviation used to refer to those individuals killed during military action. [From 'K'illed 'I'n 'A'ction.]

kick off (sports and leisure) In FOOT-BALL, the beginning of play in which the offensive team kicks the ball into the territory of the defensive team. It is done at the beginning of the first and third periods and after the other team has scored a TOUCHDOWN or FIELD GOAL. By association, the beginning of action.

kindergarten (education) (K) A pre-academic PRESCHOOL, before the ELEMEN-TARY SCHOOL, for children aged four to five. It introduces students to personal awareness and socialization skills, some basic math and English reading and writ-ing. It usually meets five days a week for half a day, either 8:00 a.m. to 12:00 p.m. Or 1:00 p.m. to 4:00 p.m. [German, mean-ing "garden of children".] *Compare* NUR-SERY SCHOOL.

King Philip's War (history) In the pre-sent-day STATE of Massachusetts, a bloody war (1675–1676) fought between PURITANS and INDIANS over hunting and land rights. Although 12 Puritan towns were de-stroyed, more Indian villages and crops were destroyed and the whites won the conflict which ended Native American power in NEW ENGLAND. [After the Indian leader of the rebellion, 'King Philip' (*c.* 1639–1676), known as "Metacom" of the Wampanoag tribe.]

King, B.B. (people) (born Riley B. King in 1925) African-American singer and guitarist of the BLUES¹. He began his career in 1947 as a DJ in the city of Memphis where he earned the nickname the "Blues Boy from Beale Street" which was then shortened to "B.B." His greatest successes as a performer (with white and black audiences) came after 1966; hits include "the Thrill is Gone" and "Rock me Baby". He nicknamed his guitar "Lucille". *See* BEALE STREET.

King, Larry (people) (born in 1933) A respected talk show host on radio (*The Larry King Show* since 1978) and televi-sion (*Larry King Live* since 1987). He is known for his in-depth interviews with entertainers, celebrities and those people currently in the news. He is recognized by his thick eyeglasses and suspenders.

King, Martin Luther, Jr., Dr./Reverend (people) (1929–1968) A powerful and eloquent speaker, BAPTIST minister and African-American leader of the CIVIL RIGHTS MOVEMENT who believed racial equality could be achieved through CIVIL DISOBEDIENCE and NONVIOLENT ACTION. He first gained national attention by co-organizing the successful 1955 MONTGOM-ERY BUS BOYCOTT; later, he established the SOUTHERN CHRISTIAN LEADERSHIP CON-FERENCE and served as its first president; he led several demonstrations in Birming-ham, Alabama against SEGREGATION for which he was briefly imprisoned. After his release, he co-coordinated the MARCH ON WASHINGTON OF 1963 where he gave his "I HAVE A DREAM" speech. He received the Nobel Prize for Peace in 1964; his work encouraged the US federal government to pass the CIVIL RIGHTS ACT (1964) and VOTING RIGHTS ACT of 1965. He is re-spected for his eloquence in speaking and for popularizing nonviolent protests and civil disobedience. Also, he called the POOR PEOPLE'S CAMPAIGN and led peace marches during the ANTI-WAR MOVEMENT. He was assassinated by the WHITE SUPREMACY promoter, James Earl Ray (1928–1998) April 4, at the Lorraine Motel in Mem-phis, Tennessee. His death led to riots in over 120 cities across the country. The MARTIN LUTHER KING, JR. CENTER FOR SOCIAL CHANGE is located in ATLANTA. In 1986, his birthday, January 15, became a national holiday. *See* MARTIN LUTHER KING, JR. DAY.

King, Rodney (people) (born Rodney Gary King in 1966) African-American motorist, man on parole for robbery and victim. The beatings that he received from four white local police officers from the Los Angeles Police Department (LAPD) in 1991 led to a trial where the officers received an ACQUITTAL which then caused the LA RIOTS in 1992. Eventually, King

charged a CIVIL LAW[1] LAWSUIT for this beating against the city of LOS ANGELES and in 1994 received $3.8 million in DAMAGES.

Kissinger, Henry (people) (born in Germany in 1923) Foreign policy expert and US SECRETARY of the DEPARTMENT OF STATE (1969–1974). He is known for helping the Nixon ADMINISTRATION[2] re-establish ties with the People's Republic of China and for introducing DÉTENTE. He received the Nobel Peace Prize (1973) for ending US military involvement in the VIETNAM WAR. *See* COLD WAR, RICHARD NIXON.

Kitchen Cabinet (government) The group of informal advisers who counsel the PRESIDENT. Since they are often close friends of the CHIEF EXECUTIVE, they can have more influence over the President than the real CABINET. [From President ANDREW JACKSON's (1829–1837) group of counselor-friends who supposedly were such good friends that they used to enter the WHITE HOUSE through the back door, near the 'kitchen'.]

Kitty Hawk (science and technology) The closest town to the actual site (i.e., Kill Devil hill) of the first powered flight by people in an airplane which was held on December 17, 1903, and lasted 12 seconds. The WRIGHT BROTHERS decided to test their self-built airplane at this sand dune area in North Carolina because of the strong ocean winds. By association, the birth or beginning of the airplane and/or flight technology.

kiva (religion) In a PUEBLO[1], the large, enclosed chamber which is built of ADOBE underground and meant to be used by TRIBE members for religious or special tribal ceremonies. *See* PUEBLO INDIANS.

Kiwanis Club (sports and leisure) An international club organization of adult business people and other professionals interested in community service and international understanding. It offers SCHOLARSHIPS to younger people, usually HIGH SCHOOL students, as well as organizes social activities for and assistance to the elderly (e.g., delivering their groceries to them). It was founded in 1915 and is now established in over 75 countries; there are some 325,000 members.

Klan, the (minorities) A shortened name for the KU KLUX KLAN.

Klein, Calvin (people) (born in 1942) A designer of men's and women's fashion known for his provocative advertising campaigns for Calvin Klein jeans and perfumes and fragrances. He is president of Calvin Klein company (established 1969).

Knights of Columbus (sports and leisure) (K of C) A FRATERNAL ORDER and service organization for active male members of the ROMAN CATHOLIC CHURCH which offers its members health insurance plans as well as social activities and friendship. It was founded in 1882 in Connecticut and currently has some 1.5 million members in local groups nationwide. These groups provided needed social assistance in the US during WORLD WAR II; further, they have long been very active in organizing events and parades to celebrate COLUMBUS DAY. [After the idea that they were assistants, 'knights', of CHRISTOPHER COLUMBUS, the Catholic Italian navigator.] *Compare* DAUGHTERS OF ISABELLA.

Knights of Labor (work) The first nationwide, most powerful and populous industrial UNION[1] (at its peak in the 1880s some 750,000 members) in the US, founded in 1869. It organized to include all workers; male and female, skilled workers and unskilled workers. It was particularly popular with new immigrants, especially those from southeastern Europe, and Catholics. Its most successful STRIKE[1] was against the Union Pacific Railroad. Although it did not officially support the strike that became the HAYMARKET RIOTS, several of its members were involved, which led to its decline and dissolution in the 1890s. Its full name was the "Noble and Holy Order of the Knights of Labor"; *see* TRANSCONTINENTAL RAILROAD, ROMAN CATHOLIC CHURCH; *compare* AFL, AFL-CIO.

Knights of the White Camelia (minorities) A WHITE SUPREMACY group with four distinct periods and purposes. The first group was active from 1867 to 1869 and had secret membership rolls and rituals, was based in Louisiana and had similar tactics to that of the KU KLUX KLAN of this era. It was revived (1934–1942) in the

STATE of West Virginia with similar secret passwords and anti-black programs to the earlier organization. The third movement, active in the 1950s, was anti-JEWISH. The fourth movement was in the 1980s in the state of Texas and aimed at MINORITIES. Today, all these groups are no longer active nor in operation.

knish (food and drink) A type of unsweetened dough pastry which is filled with baked, pureed vegetables (e.g., potato, broccoli) or cooked meat and then fried. It is commonly served in DELICATESSENS. [Yiddish, from the Polish name for this prepared food, *Knysz*.]

Know-Nothing Party (politics) The popular name for members of the American Party, a nativist THIRD PARTY[1] that supported policies which were anti-foreigner and against members of the ROMAN CATHOLIC CHURCH. It was only active in the election for PRESIDENT in 1856, for which it nominated Millard Fillmore (1800–1874). It won only eight ELECTORAL VOTES from a few STATES in the SOUTH and the NORTHEAST. [From the phrase 'I know nothing' which its members used to answer questions from outsiders about this group's secret practices.] *See* NATIVISM; *compare* Appendix 2 Presidents.

KO (1, 2, 3 sports and leisure) **1** In professional boxing, a blow which a boxer gives the opponent causing him to fall to the mat and lose. The boxer who gives the **knockout** wins the match. By association, a winning blow or hit. *Compare* TKO. **2** A slang term for a very attractive woman or man. **3** Describing the final or last blow. [Abbreviation from 'K'nock-'O'ut.]

Korean War, the (foreign policy) During the COLD WAR, the military civil war which began when communist North Korea (later supported by the communist People's Republic of China) invaded South Korea (non-communist) on June 24, 1950. The United Nations asked North Korea to retreat to the recognized border between the two Koreas (i.e., 38 latitude, known as the "38th parallel"), which had been established as the border after WORLD WAR II. Although 16 United Nations member nations sent troops to help South Korea to repel the communist influence, the UNITED STATES sent the majority of troops (5.7 million). After two years of fighting without making reasonable advances, both sides agreed to a cease fire without a winner. In the armistice agreement (signed July 27, 1953), a 2.5 mile (4 km) wide demilitarized zone ("DMZ") was established at the 38th parallel. Because over 37,000 American soldiers died in the conflict and no real benefits were gained, many Americans consider this a "useless war". *See* DOMINO THEORY.

Koreatown (geography) A geographical area composed of housing, businesses, schools, religious organizations and community newspapers, owned and used by Korean immigrants and Korean Americans. The best-known Koreatown is located north of central LOS ANGELES, although there are others nationwide.

kosher (religion) Describing the particular foods (e.g., beef, salmon, chicken) and special methods of cleansing and preparing those foods that some JEWISH people follow (formally known as "*kashrut*" in Hebrew) and which is explained in the Torah (i.e., the first five books of the Old Testament of the Bible and other religious documents). For example, shellfish and pork are not kosher. "Keeping kosher" means obeying the kosher laws. By association, describing something that is good or fine. [From Yiddish, meaning "proper".] *See* ORTHODOX JUDAISM, CONSERVATIVE JUDAISM; *compare* KOSHERSTYLE.

kosher-style (food and drink) Describing typical JEWISH food and dishes but which are not prepared in the customary way according to the religious dietary rules of "*kashrut*".

Kroc, Ray (people) (1902–1984) Businessman. He is remembered for buying the McDonald's restaurant, successfully developing the concept of the FAST FOOD restaurant and perfecting the business of the FRANCHISE. He was a very successful ENTREPRENEUR.

Ku Klux Klan, the (minorities) (KKK) A secret organization of American-born Christian PROTESTANTS that terrorizes MINORITIES in its efforts to promote WHITE SUPREMACY. Its history is marked by three distinct movements and purposes. The

first KKK (active from 1866 to 1872) was formed by a militant group of Confederate veterans of the CIVIL WAR who first wore white sheets to disguise themselves as "ghosts" with the goal of hurting blacks physically, politically and economically (e.g., enacting the LYNCH LAW, prohibiting blacks from voting and ending RECONSTRUCTION) and encouraging the DEMOCRATIC PARTY. It was founded in Pulaski, Tennessee and spread to other rural areas in the SOUTH. In 1872, the federal government declared the KKK illegal and it was largely disbanded. A second Klan was active (from 1915 to 1944) in the SOUTH and MIDWEST and acted out of fear of MINORITIES getting more citizenship rights. It attacked blacks, Jews, Catholics, communists, recent immigrants and members of labor UNIONS[1]. This Klan's members paid dues and mostly lived in cities and urban areas; they participated in parades and politics and began the practice of burning crosses. It decreased its activities during WORLD WAR II. The third Klan (since 1946) organized itself to fight against communism and racial equality, especially the CIVIL RIGHTS MOVEMENT. It is found in urban areas of the SOUTH and MIDWEST and has been active in extreme-right politics. Today, the KKK is led by the IMPERIAL WIZARD. It is a symbol of white racism, intolerance and an organization which enacts its own "laws" outside that of civil, democratic society. [From Greek *kuklos*, meaning "circle".] Also known as "the KLAN"; *see* CONFEDERATE STATES OF AMERICA, ROMAN CATHOLIC CHURCH, KLAN, RED SCARE[1,2,3], RIGHT, *BIRTH OF A NATION*; *compare* GRAND WIZARD.

Kwanza (customs and traditions) A seven-day (December 26 through January 1) ethnic holiday celebrated by some AFRICAN AMERICANS which honors the family, its ancestors and the community. Each day during this period a candle is lighted and a special meal is prepared and eaten at which all the diners drink from a ceremonial "unity cup". Its symbol is a basket of fruit and the decorative colors are black, red and green. Frequently, men wear DASHIKIS and women some traditional, African-inspired dress or piece of clothing. It was first celebrated in 1966 as a non-commercial, black-oriented holiday. [Swahili, meaning "first fruits".] *See* HOLIDAY SEASON, CHRISTMAS CARDS; *compare* CHRISTMAS DAY, CHRISTMASTIME.

L

L.L. Bean catalog (clothing) The catalog displaying and describing the various outdoor wares of the L.L. Bean company (established in 1913), which it offers at its store in Freeport, Maine as well as through CATALOG SHOPPING. It includes CONSERVATIVE, practical clothing used for everyday and leisure wear as well as specific clothing, gear and materials for the pastimes of fishing, hunting and camping.

"La Causa" (minorities) The general idea held by Mexican Americans that encourages them to work for greater equality with WASPs and other white people, especially CIVIL RIGHTS, economic opportunities and social acceptance without losing their unique history, culture and language. It was promoted by CÉSAR CHÁVEZ and the CHICANO MOVEMENT. [Spanish, meaning "the cause".]

la Raza (minorities) A term referring to the community, ancestors and cultural group of a HISPANIC, Puerto Rican or CHICANO, and the pride that he or she must feel for them. During the CHICANO MOVEMENT, it was especially important to remember and be proud of one's family and cultural heritage. [Spanish, meaning "the race" or "the people".]

La Raza Unida Party (politics) (RUP) A THIRD PARTY[1] that works to improve the condition of HISPANICS through passing laws and legislation. It was formed in 1970 and works at the local level (e.g., SCHOOL BOARDS, municipal and STATE governments) in the SOUTHWEST. It works to register hispanic voters and nominate Hispanic-American candidates for election.

LA Riots (minorities) The violent riots in April 1992 which left 53 people dead, 2,000 people injured and $1 billion in property damage in LOS ANGELES. The immediate reason for the riots stemmed from incidents related to white police brutality against black citizens and began (on March 3, 1991) when members of the Los Angeles Police Department (LAPD) stopped RODNEY KING, an African-American motorist, on the charge of speeding. The officers proceeded to beat and kick King, all of which a watching bystander recorded with a video recorder. The LAPD officers were tried in a nearby California county's court of law. However, on April 29, 1992, when the JURY of all white members gave an ACQUITTAL to all the officers, the black community in South Central LA responded in anger and this started the riots. Black, hispanic and white youths participated in burning, looting and destroying businesses, shops and property (most of it owned by blacks) in the South Central area of LA. The rest of the country was shocked by the acquittal verdict and more shocked by the riots. Deeper causes for the riots were attributed to poverty and frustration over continued racism, DISCRIMINATION and LAPD police brutality. The federal trial in April 1993 ended with convictions for two of the white officers.

label (the arts) A popular name referring to a recording music company which looks for new, talented artists, signs contracts with those artists, records their songs and promotes the publicity of their music. Throughout the twentieth century, labels exerted a large influence over new artists and contributed to shaping the "sound" of various styles of music, namely, COUNTRY MUSIC, RHYTHM AND BLUES, POP MUSIC and JAZZ MUSIC. [From the company's logo, or 'label', which is displayed on all its products.]

Labor Day (customs and traditions) A LEGAL HOLIDAY on the first Monday of September which honors all people who work. It began in 1890 when 10,000 labor UNION[1] members marched in NEW YORK CITY in favor of a work-day of only eight hours in length. Today, Americans frequently celebrate it by watching community-organized parades, having picnics, playing sports, or relaxing. It is the last day of LABOR DAY WEEKEND.

Labor Day weekend (customs and traditions) The LONG WEEKEND in late August and/or early September which marks the official end of warm summer weather and SUMMER VACATION. Many Americans spend these three days by going to the beach or swimming pool, playing sports and/or having picnics, CLAMBAKES and family reunions. Many ELEMENTARY SCHOOLS and SECONDARY SCHOOLS begin the ACADEMIC YEAR just before or just after this weekend. *See* MISS AMERICA PAGEANT; *compare* MEMORIAL DAY WEEKEND.

lacrosse (sports and leisure) A fast-moving team sport in which each player uses a stick with a small net affixed to one end to throw, catch and pass a rubber ball to each other and try to score by putting it into the opponent's goal. It developed in North America in the nineteenth century from a game originally popular among NATIVE AMERICANS in today's Canada. The game is divided into four QUARTERS[4] of 15 minutes each. Men's teams consist of 10 players each; women's teams of 12 players. Players wear cleated shoes and, for protection, plastic helmets and padded gloves. [French for "the crook" or "the stick" which is used in this sport.]

Ladies' Home Journal (media) (LHJ) A monthly magazine for married women and mothers (aged 30 to 49), with articles on work, children, travel, relationships and fashion. It was first published in 1883 and has a current circulation of 4.5 million.

Ladies' Professional Golfers' Association (sports and leisure) (LPGA) An organization founded in 1948 that organizes and sponsors professional golf tournaments for women golfers, keeps all records and statistics of female golfers and offers its members a retirement program.

Lady Byng Memorial Trophy (sports and leisure) In professional ice hockey, the annual award given by the NHL to a player for being the "most gentlemanly player" of the season.

Lafayette Park (geography) The small green park of green grass and park benches located on the north side of the official grounds of the WHITE HOUSE. It is a popular place for protesters to meet and demonstrate against government and presidential policies. During the 1980s and early 1990s, it frequently was used by homeless people. [For Marquis de 'Lafayette' (1757–1843), French nobleman and general of American troops in the AMERICAN REVOLUTION.]

laissez-faire (economy) In American-style CAPITALISM, the economic theory supporting free trade between businesses, private companies, competition and international trade. This is possible because of the economy's practice of private ownership and government DEREGULATION. [French for "let do" or "let alone", because the government 'lets' the economy run itself.] *See* PRIVATE SECTOR.

Lake Powell (environment) A large, artificial, freshwater lake located in the very dry lands of the STATE of Utah. It was made (completed in 1966) by damming several rivers, namely, the Colorado, Dirty Devil, Green, Escalante and San Juan Rivers. Initially this dam plan was contested by environmentalists because it flooded the beautiful Glen Canyon and covered over unique, old drawings by an ancient Indian TRIBE. Today, however, it is part of the Glen Canyon Reservoir system and is a popular recreational water area for nature enthusiasts, especially for boating and water sports. [After John Wesley 'Powell' (1834–1902), an early white explorer and geologist of this area.] *See* EDWARD ABBEY.

Lake Wobegon (society) The fictional small town in Minnesota, created by GARRISON KEILLOR to mock, praise and relate stories of the MIDWEST and its inhabitants. Many of the residents have Norwegian and/or Swedish heritage and are members of the LUTHERAN CHURCH. *Compare* YOKNAPATAWPHA COUNTY.

Lambda Legal Defense Fund (minorities) (LLDL) The organization, established in 1973, which works for the legal rights of homosexuals and people who suffer from AIDS (Acquired Immune Deficiency Syndrome) by using the legal court system and legal suits. It is headquartered in NEW YORK CITY and currently has 22,000 members.

lame duck (government) A person holding public office who has less political power because of losing a re-election; or not being able to run for election because of a limit of TERMS[1] (e.g., TWENTY-SECOND AMENDMENT). "The lame duck period" is the time between ELECTION DAY and the INAUGURATION or new SESSION[2] of the legislature (i.e., basically, November to January). [Originally from the sport of duck hunting, a bird that is weakened by a gunshot but not yet dead.] *See* TWENTIETH AMENDMENT.

land claim (1 geography; 2 minorities) **1** Before 1893, an area of US PUBLIC LAND that was open for settlement. It was declared to be the possession of a person or group that physically went to it and 'claimed' it. The HOMESTEAD ACT helped thousands of settlers "stake land claims". **2** Land that an Indian TRIBE states belongs to it because of former TREATIES agreed upon between the tribe and the US government; or former, traditional land holdings of the tribe. *See* INDIAN CLAIMS COMMISSION.

Land Grant College Act (education) The formal name for the MORRILL ACT (1862).

landlady (housing and architecture) A woman who owns or leases residences (e.g., houses, apartments) or rooms to others; a female LANDLORD.

landlord (housing and architecture) An organization or an individual man owning property or residences and leasing them to others.

language arts (education) A subject in ELEMENTARY SCHOOL in which students study English language, grammar, reading, spelling, writing and literature.

Las Vegas (geography) The popular and (during the 1990s) fastest-growing city of the UNITED STATES, located in the middle of the desert of southern Nevada. Since gambling was legalized in 1931, it has been known for its gambling, 24-hour casinos, betting on sporting events and games, live entertainment shows and music concerts. The "Las Vegas Strip" is the city's stretch of hotels and casinos. It is known for its

bright neon signs and gaudy advertising. Further, it attracts many couples in love because it has relaxed laws for divorce and issuing MARRIAGE LICENSES. *See* STRIP; *compare* ATLANTIC CITY.

Latino/latino (minorities) A term for a person whose native language is Spanish and who lives in the Western Hemisphere. [Spanish, meaning "person from 'Latin' America".] People with this heritage often prefer to call themselves "Latino/Latina" rather than HISPANIC because "Latino/ Latina" relates to 'Latin' America and not Spain and/or Europe. However, it is used interchangeably with "Hispanic". *Compare* CHICANO.

Lauren, Ralph (people) (born in 1939) A fashion designer of clothing (i.e., women, men, girls, boys, babies), fragrances, leather goods and home products and founder and president of Polo Fashions (established 1968). He is known for his bright-colored and distinctive American-styled clothes, often promoting a theme of the WEST and/or BOARDING SCHOOLS[1].

law clerk (legal system) An individual (usually a student or recent GRADUATE[1] of law SCHOOL[4]), who assists a judge, legal court or law firm. **Clerking** includes the following type of tasks; keeping up records, researching issues and/or assisting in the courtroom. Also known as "CLERK"; *compare* INTERN[2].

lawsuit (legal system) A dispute that one person or group has with another over a legal issue and which may be decided in a court of law or by a SETTLEMENT. *See* CIVIL LAW[1], CRIMINAL LAW.

lawyer (legal system) An ATTORNEY; the two names are used interchangeably. *Compare* ATTORNEY-AT-LAW, BAILIFF, PARALEGAL.

lay (religion) A term describing any person who is not a member of a religious clergy (i.e., a regular member of the congregation). By association, a non-professional.

League Championship Series (sports and leisure) In professional BASEBALL, the post-season set of games held in the NATIONAL LEAGUE and in the AMERICAN LEAGUE. It consists of the two best teams of the same league playing each other trying to win the best-of-seven games.

The winner is awarded the title "champion" of its league and is awarded that league's PENNANT. The games held before these PLAYOFF games are often called "the race/drive for the pennant". The winner of the National League Championship Series plays the winner of the American League Series in the WORLD SERIES.

League of Revolutionary Black Workers (work) An umbrella organization founded to organize demonstrations, challenge the elections of the UNION[1] officials and help develop active union movements. It was started by black members of the UNITED AUTO WORKERS in DETROIT in 1969, but today is no longer active. *See* BLACK POWER.

League of the Six Nations, the (people) Another, collective name for the IROQUOIS CONFEDERACY. It includes the six Iroquois tribes: the Mohawks, the Senecas, the Oneidas, the Onondagas, the Cayugas, as well as the Tuscaroras.

League of United Latin American Citizens (minorities) (LULAC) The oldest, largest and most-respected national LOBBY group for LATINOS that promotes full social, educational and CIVIL RIGHTS for HISPANICS in mainstream American society. It supported the CIVIL RIGHTS MOVEMENT and the desegregation of SCHOOLS[5]. It was originally founded for Mexican Americans in 1929; it is headquartered in WASHINGTON D.C. and currently has over 200,000 members.

League of Women Voters (of the United States) (minorities) (LWV) An organization which works to promote all issues concerning women and families. It was founded in 1920 by Carrie Chapman Catt (1859–1947) and others to encourage women to become politically active (e.g., voting, VOTER REGISTRATION). Today, it lobbies the government to support family and women-related issues as well as encourages people to vote for these issues in local, STATE and national elections. It did not support ERA[2]. Its headquarters are in WASHINGTON D.C. and it currently counts over 110,000 members (female and male). Originally founded as, and until 1946 known as, the "National League of Women Voters".

Leary, Timothy (people) (1920–1996) PROFESSOR, psychologist and one of the unofficial leading forces of the COUNTER-CULTURE. While working as a psychologist at HARVARD UNIVERSITY, he used LSD (lysergic acid diethylamide) in his psychological tests on people, an action for which he was dismissed from this post in 1963. He then began to publicly promote the recreational use of LSD especially during the SUMMER OF LOVE when he promoted the motto of "TURN ON, TUNE IN, AND DROP OUT!". In 1970 he was imprisoned for possessing marijuana. Before his death of prostate cancer, he promoted computers, cyberspace and virtual reality. His enthusiastic support for LSD and other drugs brought him many young supporters and he remains a symbol of rebelliousness. *See* NEW LEFT.

Lee, Robert E. (people) (1807–1870) ARMY leader for the UNITED STATES OF AMERICA at the RAID ON HARPER'S FERRY. Later because he was from the SOUTH, he became General of the Army of the CONFEDERATE STATES OF AMERICA. During the CIVIL WAR, he led the Army of Northern Virginia to victories at the battles of Fredericksburg (1862) and Chancellorsville (1863). He led the confederate forces during their defeat at GETTYSBURG (1863) and surrendered at APPOMATTOX COURT HOUSE in 1865. He was respected by both the armies of the NORTH and the South and is still remembered for his bravery, honor, wisdom and gentlemanly manner. After the war, he and his wife, Mary Custis, donated their private residence and lands to the UNITED STATES for the establishment of a national cemetery, today's ARLINGTON NATIONAL CEMETERY.

Lee, Spike (people) (born Shelton Jackson Lee in 1957) An African-American film director, scriptwriter and actor known for creating films which portray black issues and concerns. His most common themes include: black history, personal relationships between blacks, and black-white relations, namely in the films: *Do the Right Thing* (1986), *Jungle Fever* (1989) and *Malcolm X* (1992). *See* MALCOLM X.

left/Left, the (politics) A general term for a political view which is LIBERAL. (The "left wing" refers to a person or ideology that is more extreme than the left.) **Leftist** groups include communists and socialists. [From the traditional custom in the French legislature, whereby people with these views sat on the 'left' hand side of the presiding officer.] *Compare* RIGHT, MODERATE.

legal counsel (legal system) A general name for a LAWYER or the professional services of a lawyer (e.g., advice, PLEA BARGAINING) that a client can receive. It is paid for by a client if he or she can afford it or by the government if he or she cannot afford it. *See* GIDEON V. WAINWRIGHT, DUE PROCESS, POWER OF ATTORNEY.

Legal Defense (and Education) Fund (legal system) A legal organization which uses the legal courts and lawsuits to try to force the government (e.g., federal, STATE) to change unfair or illegal actions. Usually, it is part of a larger organization or LOBBY which supports and pays for its services. *See* NAACP, SIERRA CLUB, CHILDREN'S DEFENSE FUND.

legal holiday (customs and traditions) A general term for any day, established by a STATE law or UNITED STATES law, to celebrate some person or event. On this day, government offices, judicial courts, banks, the STOCK MARKET, SCHOOLS[5], business and stores are usually closed. Although each state establishes its own holidays, many choose to celebrate the FEDERAL HOLIDAYS as their own legal holidays. Also known as "PUBLIC HOLIDAY".

Legree, Simon (customs and traditions) In the book *UNCLE TOM'S CABIN*, the mean, white character who is the overseer of the slaves and plantation. He is from NEW ENGLAND.

Lend-Lease Act (Program) (foreign policy) During WORLD WAR II, this program permitted PRESIDENT FRANKLIN ROOSEVELT to 'lend', 'lease' and/or transfer military equipment to Britain and the Soviet Union (over $50 billion worth). This important program, created by a Congressional law (active 1941–1945), allowed the US to help the war effort of those friendly, European countries before it itself was pulled into the conflict. *See* "ARSENAL OF DEMOCRACY"; *compare* PEARL HARBOR.

Leopold, Aldo (people) (1887–1948) Environmentalist and teacher. He is best known for his book *A Sand County Almanac* (1949), a book which put forward his ideas about leaving wild places wild, untouched by people. He also promoted managing wildlife (e.g., occasionally killing deer) in order to keep their numbers down and to thus avoid the overuse of natural resources.

Lerner and Lowe (the arts) The creative, two-person team known for creating popular MUSICALS which had operetta-style music and songs with clever lyrics. The team consisted of Alan Jay 'Lerner', a lyricist (1918–1986), and Frederick 'Lowe', a music composer (1904–1988). Successful hits included *Brigadoon* (1947), *My Fair Lady* (1956) and *CAMELOT* (1960).

letter (sports and leisure) An award from a HIGH SCHOOL or COLLEGE[1], usually the first letter of the name of the SCHOOL[5] made of several layers of felt or heavy material, which is given to a current student for achievement in an EXTRACURRICULAR ACTIVITY. It is meant to be sewn onto the student's LETTER JACKET.

letter grade (education) A type of GRADING SYSTEM commonly used in SCHOOLS[1]. The GRADES[2] include: A+= excellent; A=very good; B=good, above average; C=average; D=below average, bad scores often considered to be unacceptable and indicating that the course should be repeated; F=failing; (note that there is no "E"). *See* A+, Appendix 5 Grading Systems; *compare* 4.0, GPA.

letter jacket (clothing) A lightweight, short jacket worn by HIGH SCHOOL and COLLEGE[1] students which is made in the colors of the SCHOOL[5] with leather sleeves and a wool body. The name of the SCHOOL[5] is printed on the back of the jacket, and the student's name is embroidered on the front where there is also space to sew on a LETTER. [From the 'LETTER' that is sewn onto it.] Also known as "varsity jacket".

letters (sports and leisure) The Greek letters of a GREEK-LETTER ORGANIZATION decorating clothing, baseball caps and other articles that only members of that club are allowed to wear or use. *See* FRATERNITY, SORORITY.

Levittowns (housing and architecture) The collective name for three suburban developments of identical, simply-designed middle-class houses built in the STATES of New York (1947), Pennsylvania (1950s) and New Jersey (1960s). All the houses were built quickly with pre-fabricated (i.e., all-ready made) parts in a factory-like, assembly-line method. This began the trend after WORLD WAR II of building SUBURBS. It is the symbol of the birth of the suburbs. By association, any suburb where every house is exactly like the others. [After the private building company 'Levitt' and Sons + 'town'.]

levy (education) A tax imposed on the people by an official vote by the people. Often the money earned helps the local SCHOOL DISTRICT pay for services (e.g., SCHOOL BUS services, special programs).

Lewis and Clark Expedition (history) The expedition ordered by PRESIDENT THOMAS JEFFERSON which explored the geography, plants and animals of the Louisiana Territory and part of the Pacific Northwest (1804–1806). Through its Indian guide/interpreter SACAGAWEA (*c.* 1786–1812) it also met and made note of the NATIVE AMERICANS living in those areas. [After the head explorers Meriwether 'Lewis' (1774–1809) and William 'Clark' (1770–1838).] *See* LOUISIANA PURCHASE.

Lewis, Sinclair (people) (1885–1951) Writer of fiction. He wrote novels to criticize and address problems found in both the society at large and the individual. He won the Nobel Prize for literature in 1930. Some of his works are: *Main Street* (1920) and *Babbit* (1922).

Lexington and Concord, Battles of (history) The first battles and official start of the AMERICAN REVOLUTION on April 19, 1775. The conflicts began when 700 British soldiers, marching toward Concord, Massachusetts, met 70 colonial MINUTEMEN in the town of 'Lexington'. After a gunshot was fired, the two sides then fired at each other; only eight colonists died but the British counted 273 casualties. This American victory was seen as a positive sign for the colonial effort and gave the colonists confidence in their cause for

independence. *See* "SHOT HEARD ROUND THE WORLD", PATRIOTS' DAY.

liability (legal system) According to CIVIL LAW[1], legal responsibility; also, the duty to do or to stop doing some action (i.e., paying a fine). If during a CIVIL TRIAL, the ACCUSED is found **liable** of some action (e.g., causing physical damage to a car, causing physical or emotional pain to a person) then the accused may have to pay DAMAGES.

libel (media) Anything published or broadcast by the press (e.g., written article, photograph) about/of a person which is false and purposefully mean and that can hurt that person's reputation or cause him or her public embarrassment. A "libel suit" is a legal LAWSUIT brought against the press for committing libel. *Compare* SLANDER, PRIOR RESTRAINT.

liberal (politics) A follower of LIBERALISM. *Compare* CONSERVATIVE.

liberal arts college (education) A four-year HIGHER EDUCATION institution that offers an UNDERGRADUATE education in general knowledge and reasoning as opposed to the specific training at a VOCATIONAL SCHOOL. "Liberal arts and sciences" includes the fields of the HUMANITIES, the social sciences (e.g., economics, sociology) and the hard sciences (e.g., math, chemistry). [From Latin, *liberalis ars*, because during the Roman Empire only free, 'liberal', men (that is, not slaves) received this type of education in the 'arts'.] Also known as "four-year college"; *compare* STATE UNIVERSITY, TUSKEGEE UNIVERSITY.

liberalism (politics) A political philosophy believing in continued progress, the basic goodness of people, the value of each individual person and the need to protect CIVIL LIBERTIES. LIBERALS are associated with the DEMOCRATIC PARTY and the NEW DEAL. *See* JUDICIAL ACTIVISM, LEFT, OLD LEFT, NEW LEFT; *compare* CONSERVATIVISM, MODERATE.

Liberty Bell (customs and traditions) The large, heavy metal and copper bell, originally cast in 1752, measuring 3 feet tall (91 cm) and with a maximum circumference of 12 feet (3.6 m). It is decorated with a verse from the Old Testament: "Proclaim Liberty Throughout All The Land Unto All the Inhabitants Thereof." It has long been tolled for special events, namely: announcing the BOSTON TEA PARTY and the first reading of the DECLARATION OF INDEPENDENCE. According to one tradition, when it was rung to announce the death of CHIEF JUSTICE JOHN MARSHALL, it cracked. It is a symbol of the AMERICAN REVOLUTION, American independence and freedom as well as patriotism.

Library of Congress (government) (LOC) The national library of the UNITED STATES and the largest physical library in the world. In 1800, CONGRESS established it as a research center for its members; THOMAS JEFFERSON donated many of his own books to it. Now, it operates the CONGRESSIONAL RESEARCH SERVICE and Copyright Office. Its materials are organized according to its own thorough cataloging system. The main building, the large, round-shaped "Jefferson Building", sits on CAPITOL HILL[1] behind the CONGRESS BUILDING. It is admired for its classical style and large, elegant form. *See* COPYRIGHT.

license plate/license tag (transportation) The metal plate affixed to the back and sometimes also the front bumper of an automobile or truck which displays the registration and identification number for that vehicle. It is issued by the individual STATES on a regular basis (e.g., usually once every one or three years). Most states decorate the plate with their state nickname. *See* Appendix 1 States.

Lichtenstein, Roy (people) (1923–1997) A painter of the POP ART movement and commercial illustrator. He is characterized by painting enormous, oversized comic panels and for using cartoon-drawing techniques (e.g., Benday dots).

"life, liberty, and the pursuit of happiness" (legal system) The basic, essential rights of life, freedom and being able to do what makes a person happy, which all people have. The government must protect these rights. This is an important belief in American democracy and was established by the DECLARATION OF INDEPENDENCE. *Compare* "ALL MEN ARE CREATED EQUAL".

Life (1, 2, 3 media) **1** (1883–1936) A popular, weekly illustrated magazine liked

for its satirical humor, writing style and content. It was concerned with current affairs, manners and morals. At its high point in 1916, its circulation was 150,000. **2** (1936–1972) The popular, oversized, photo-illustrated weekly magazine carrying articles on news, current events and entertainment. It is remembered for pioneering picture journalism, creating the photo essay and publishing the literary work of contemporary writers. At its high point in 1961, its circulation was 7 million. *Compare* LOOK. **3** Since 1978, the monthly magazine with photographs and stories on current issues and trends. It has a slightly over-sized format and has a current circulation of 1.6 million.

light (food and drink) A descriptive term used by food companies in advertising food, SODA POP or other drinks which implies (but does not always mean) that those products contain fewer calories or less fat. It is associated with dieting and keeping healthy and/or slim. *See* FOOD LABEL; *compare* LOW-FAT, LIGHT BEER.

light beer (food and drink) A type of beer containing fewer calories because it has less alcoholic content (and more water) than regular pilsner or lager beers.

Limbaugh, Rush (people) (born in 1951) A popular host of the talk show *The Rush Limbaugh Show* on radio (since 1988) and on television (since 1992). He is known for his CONSERVATIVE REPUBLICAN opinions on current events and issues. His strong supporters are often known as "Rushers". *Compare* RUSH.

Lincoln (Continental) (transportation) The brand name of a large, comfortable automobile with a large engine and spacious trunk space. It is noted for its unstreamlined box shape, long length, smooth ride and for being designed for passenger comfort. [Named after ABRAHAM 'LINCOLN'.]

Lincoln Center (for the Performing Arts) (the arts) The large complex in NEW YORK CITY, which opened in 1962, encompassing buildings, theaters, musical performance halls and the JUILLIARD SCHOOL. Specifically, it includes: the Metropolitan Opera House for the METROPOLITAN OPERA COMPANY; the Avery Fisher Hall (the home performance space of the New York Philharmonic); the Alice Tully Hall (for chamber orchestras and string quartets); and the New York State Theater (the home performance space for the New York City Ballet). By association, the high(-culture) arts.

Lincoln, Abraham (people) (1809–1865) LAWYER and US PRESIDENT (1861–1865) from the REPUBLICAN PARTY. He was one of the founders of the Republican Party and supported ABOLITION. During his presidency, he was committed to saving the UNITED STATES OF AMERICA and supported the CIVIL WAR because he wanted to preserve the union of the NORTH and the SOUTH in one country. He is remembered for freeing the slaves through the EMANCIPATION PROCLAMATION, preserving the United States as a single country and for speaking the grief of the people in the GETTYSBURG ADDRESS. He was assassinated by JOHN WILKES BOOTH, in April while attending a play in FORD'S THEATER in WASHINGTON D.C. He is also remembered for his honesty (his nickname was "Honest Abe"), fairness and eloquence in speeches. Finally, he is a symbol of hard work and democracy because after living in a simple LOG CABIN as a child, he became President. His facial portrait is on the $5 BILL[1]. *See* PRESIDENTS' DAY.

Lindbergh, Charles (people) (1902–1974) Airplane pilot and airplane promoter. He gained fame by being the first person to fly nonstop (in a one-seat airplane named the *SPIRIT OF ST. LOUIS*) from Long Island, New York to Paris, France. He became an instant hero and made flying popular with the public. His nickname was the "LONE EAGLE".

line dancing (sports and leisure) A type of dance in which men and women stand in 'lines' and move about the dance floor in lines, rows and as partners. It is popular in Texas and other parts of the WEST and MIDWEST. It is associated with COUNTRY AND WESTERN MUSIC.

line of scrimmage (sports and leisure) In FOOTBALL, an imaginary line running across the width of the field separating the two teams which are facing each other. It is the location point at which the ball is put into motion and play begins. *See* SNAP, SCRIMMAGE[1].

line-item veto (government) A type of veto power of a CHIEF EXECUTIVE whereby he or she can remove or 'veto' a part or 'item' of the BILL[2] before signing and making the BILL[2] a law. Many STATE governors have this power (in all sorts of legislation). Since January 1, 1997, the US PRESIDENT can use this power only in certain economic, budget-oriented BILLS[2]. It is used to limit extra RIDERS and PORK-BARREL LEGISLATION from BILLS[2].

linebacker (sports and leisure) In FOOTBALL, a defensive player who stands behind the LINEMEN and is responsible for supporting them and stopping offensive players. Linebackers are known for being physically tall, very heavy and very wide and for wearing a lot of protective equipment while playing (e.g., shoulder pads), all of which makes them look even larger.

lineman (sports and leisure) In FOOTBALL, one of any of the players in the defensive line (i.e., center guard, tackle, end). *Compare* LINEBACKER.

Lions Club (International) (sports and leisure) A multinational club for adult professional and business people which promotes international understanding by working within the local community. It is active in offering young people academic and cultural exchange programs and education in drug awareness and prevention. It also works with the blind providing them services and assistance. It was founded in 1917 and today is found in over 180 countries; currently, it has 1.7 million members.

Little Big Horn (history) The biggest major victory of INDIANS over the US ARMY in the WEST in which 2,000 Cheyenne and SIOUX Indian forces, led by SITTING BULL and CRAZY HORSE, ambushed and soundly defeated the Seventh United States Cavalry (i.e., 265 men) led by George A. Custer (1839–1876) on June 25, 1876. This victory is a symbol of the last, but greatest, victory of the Indians in the West as well as the foolishness of the overly confident General Custer and the total defeat of his US military troop by enemy forces. It is also known as "Custer's Last Stand", because it was here that this usually victorious general faced complete defeat and died. [After the name of the river which passes through the battleground site in the present-day STATE of Montana.] *Compare* WOUNDED KNEE MASSACRE.

Little Board (economy) The popular nickname for the AMERICAN STOCK EXCHANGE. [After the stocks and bonds of mostly medium-sized and small businesses which are listed on the electronic display trading 'board'.] Also known as "CURB EXCHANGE"; *compare* BIG BOARD.

Little Havana (geography) In the southern section of MIAMI, that area of the city (especially since the 1960s) where the majority of Cuban Americans, Cuban immigrants and other immigrants from Latin America live, work and shop. It is characterized by having Cuban-styled cafés, open air markets and using the Spanish language for daily communication. The center of this area is "Calle Ocho" (i.e., "Eighth Street"). *See* FREEDOM FLIGHTS, MARIEL BOATLIFT; *compare* BARRIO.

Little League (sports and leisure) An organization first established in 1939 to organize sport teams and tournaments for young boys and girls aged six to 18. It offers competition in BASEBALL, softball and FOOTBALL. Since 1947, it has sponsored a "World Series" in Williamsport, Pennsylvania for baseball teams.

Little Rock Crisis, the (minorities) A show-down in 1957 between STATE power and federal power over the issue of desegregation in PUBLIC SCHOOLS which only ended when PRESIDENT DWIGHT EISENHOWER overruled the Arkansas governor and resolved the conflict by calling in federal troops to escort nine black students (popularly known as "the LITTLE ROCK NINE") into Little Rock Central High School. Although the SCHOOL BOARD of Little Rock, Arkansas agreed to enroll the nine black children, the trouble began in 1957 when the state governor, Orval Faubus, disagreed and ordered the Arkansas NATIONAL GUARD to physically prohibit the black students from entering the SECONDARY SCHOOL. This incident was the first of many that used the *BROWN* v. *STATE BOARD OF EDUCATION OF TOPEKA, KANSAS* decision to enforce CIVIL RIGHTS

for African Americans. *Compare* PLESSY v. FERGUSON.

Little Rock Nine, the (minorities) During the CIVIL RIGHTS MOVEMENT, the collective name for the nine young black students who were initially refused entry to the legally desegregated Central High School, a PUBLIC SCHOOL in Little Rock, Arkansas during the LITTLE ROCK (SCHOOL) CRISIS in 1957. They are remembered for their bravery in challenging racial SEGREGATION.

Little, Malcolm (people) The birth name of MALCOLM X.

living room (daily life) In a private home or residence, a formal room used for special occasions or entertaining guests (e.g., CHRISTMAS DAY, during the HOLIDAY SEASON). However, if a residence does not have a FAMILY ROOM, a living room may serve as the room for entertaining and for watching television and doing other daily, family activities.

loafers (clothing) A hard-soled, low-heeled, leather (black or burgundy colored) shoe with a two thin pieces of leather sewn over the instep. They are slipped on and off the foot (i.e., there are no laces). Commonly, they are worn everyday or by students at SCHOOL[1]. [After trademark.] "Penny loafers" are loafers in which the wearer has inserted PENNIES between the leather piece bands of the instep. *See* PREPPIE[2].

lobby (government) A general term for any group or organization that tries to influence legislation or administrative action. Often, a national lobby researches problems and presents this information to CONGRESS. It is allowed to exist by the FIRST AMENDMENT. Further, it can give money and gifts to politicians. **Lobbies** are controversial because critics believe that their influence over legislative officials is too great. Many lobbies are headquartered in WASHINGTON D.C. Today, it is also known as an "INTEREST GROUP". [From the hallway, or 'lobby', located outside legislative chambers where these **lobbyists** originally waited to speak to government officials.] *See* (NRA) NATIONAL RIFLE ASSOCIATION, CHILDREN'S DEFENSE FUND; *compare* PAC, PRESSURE GROUP.

local (work) A branch or chapter of a labor UNION[1]; especially at the GRASSROOTS level.

log cabin (housing and architecture) A simple, functional architectural structure of one or two stories made of the trunks of large trees, having small, glass square windows and one or two doors for entering. Traditionally, it was made and used by the settlers and homesteaders themselves in the present-day MIDWEST, APPALACHIA and ROCKY MOUNTAIN region. It is a symbol of simplicity and a humble, unpretentious, hard-working attitude.

log-rolling (government) The practice where a legislator supports the proposals and BILLS[2] of fellow legislators in exchange for their support for his or her planned projects and bills. *See* PORK-BARREL LEGISLATION.

Lombardi Trophy (sports and leisure) The award given to the winning team of the SUPER BOWL. Formally known as the "Vince Lombardi Memorial Trophy". [After Vince 'Lombardi' (1913–1970), an NFL coach.]

London, Jack (people) (1876–1916) Fiction writer of novels and short stories. His popular books were often set in natural areas and often treated the themes of the survival of the fittest and an individual being tested by nature and/or violence. Among his most popular works are *Call of the Wild* (1903) and *White Fang* (1906), books about dogs and wolves.

Lone Eagle, the (people) The nickname of CHARLES LINDBERGH, especially after his historic air flight. *See* SPIRIT OF ST. LOUIS.

Lone Ranger, the (customs and traditions) A fictional male figure and TEXAS RANGER from the WEST of the nineteenth century who wore a mask and was committed to enforcing the law in the "Wild West". He received help from his horse "Silver" and his Indian friend "Tonto" (and his horse "Scout"); his gun had silver bullets. This figure was made very popular due to a successful television program (from 1949 to 1957).

lonelyhearts column (media) In a newspaper, a regular feature column in which readers write and ask questions, especially concerning personal relation-

ships, of the columnist who supplies them with answers and advice. [After the book *Miss Lonelyhearts* (1933), written by Nathanael West (1903–1940), which described this type of newspaper feature.]

Long Island (geography) An island (125 miles long; 200 km) east of NEW YORK CITY which juts out into the Atlantic Ocean. It is a popular residential, suburban area for those upper middle-class and upper-class people who commute to the city. It is known for its rich farm land and beaches and chic summertime beach houses, especially at the eastern tip (e.g., South Hampton). *See* HAMPTONS, SUBURBS.

long weekend (customs and traditions) A WEEKEND (i.e., Saturday and SUNDAY) with one or two extra days (total three or four days), frequently when either a Friday or Monday is not a working day because of personal vacation or a LEGAL HOLIDAY. *See* DAY AFTER THANKSGIVING, MEMORIAL DAY WEEKEND, OBSERVED[2].

Long, Hot Summer (minorities) The summer of 1967 when over 160 urban riots and civil disorders caused deaths, property damage and injured people in the African-American sections of over 120 American cities. The worst riots were in DETROIT (43 dead; $40 million in damage) and Newark, New Jersey (25 dead; $10 million in damage). The KERNER COMMISSION REPORT studied the causes of these riots. *Compare* LA RIOTS, WATTS RIOTS, SUMMER OF LOVE, RED SUMMER.

longhouse (housing and architecture) A long, rectangular structure of Native American architecture made of a wooden frame and bark and grass walls. Traditionally, it was used among Iroquois TRIBES of the EAST for religious purposes, official ceremonies and meetings. It was built in an important, central location of the tribal village.

Look (media) A popular magazine of photographs and general interest articles on world affairs, fads, fashion and celebrities. It was published twice a month (from 1937 to 1971) and its peak circulation in the late 1960s was 8 million. *Compare* LIFE[2].

Loop, the (geography) The main business and financial district and oldest part of DOWNTOWN CHICAGO, including the CHICAGO BOARD OF TRADE. By association, somebody "in the Loop" refers to a person who is well informed or powerful. [From the elevated EL rail track that encircles, 'loops', this central area.] *Compare* BELTWAY[2].

Los Angeles (geography) (LA) A major immigration center (e.g., LATINOS, Asians) and the second largest city in the UNITED STATES (population 3.4 million). It is the major financial center of the west coast, a large producer of electronic media and the center of the commercial movie-making industry. It is known for its good weather, large, sprawling size, many cars, smoggy weather and very wealthy and very poor neighborhoods. Its population includes peoples of all languages and nationalities. [From the original Spanish name used at the founding in 1781, *Nuestra Señora la Reina de 'Los Angeles' de Porciúncula*.] *See* HOLLYWOOD[1,2], UNIVERSITY OF CALIFORNIA, STRIP, KOREATOWN, WATTS RIOTS, LA RIOTS, Appendix 3 Professional Teams.

Los Angeles Times, The (media) The daily newspaper for the southern California region with a special, popular SUNDAY EDITION. Since the 1960s, it has built a reputation of responsible reporting and carries editorials with different perspectives and opinions. It was founded in 1881; its current daily circulation is 1.02 million.

lost generation, the (the arts) The group of American young artists and other people who, through their involvement in WORLD WAR I, lost much or all of their own idealism and beliefs in national governments. These people then became concerned only with their own personal experiences and independence; frequently they chose to live outside the UNITED STATES, usually in Europe. [After a comment by GERTRUDE STEIN describing these people who had no goal or purpose.] *Compare* JAZZ AGE, ROARING TWENTIES, ERNEST HEMINGWAY.

Lou Gherig's disease (health) The common name for "amyotrophic lateral sclerosis"; a disease of the nervous system in which the voluntary muscles become small and withered, which causes an individual, usually an adult, to become paralyzed. This condition is caused by the

decline of motor neurons in the spinal cord and brain stem. [After 'Lou Gherig' (1903–1941), a talented BASEBALL player with the New York YANKEES[4], who developed this disease while still actively playing the sport.]

Louisiana Hayride (the arts) A popular, live radio program (CALL LETTERS KWKH), which is devoted to playing COUNTRY MUSIC and showcasing COUNTRY AND WESTERN music stars. It was founded in 1948 and is based in Shreveport, Louisiana. Usually, once singers and musicians gain popularity and success on this program, they "move up" to play at the GRAND OLD OPRY. See K.

Louisiana Purchase (geography) The large tract of land (830,000 square miles; 2.15 million square km) that the UNITED STATES, under the leadership of PRESIDENT THOMAS JEFFERSON, bought from France in 1803 for $15 million, which doubled the geographical size of the United States and gave it control of the important port city, NEW ORLEANS. See LEWIS AND CLARK EXPEDITION, MISSISSIPPI RIVER; compare FRENCH AND INDIAN WAR.

low-fat (food and drink) Describing foods containing 3 grams of fat for each serving, or less. The use of this term is strictly regulated by the FOOD AND DRUG ADMINISTRATION and FOOD LABEL laws. *Compare* LIGHT.

Lowell Experiment, the (work) The factory workers' management system that purposefully treated workers well and was first used in the STATE of Massachusetts in 1823. The factory hired young women from local farms to come to the town of Lowell to work in its cotton mills. In addition, it provided community housing in the town for these women and paid them well. It proved a successful method of hiring, employing and treating workers.

Lower 48, the (geography) The 48 STATES that are physically connected to each other (i.e., not Hawaii, nor Alaska). [From the perspective of Alaskans.]

lower class (society) A collective name describing people from a particular economic group. It may consist of workers who are WHITE COLLAR and BLUE COLLAR but who do not earn a lot of money.

lower court (legal system) A legal court whose DECISION can be reviewed by and appealed to a more powerful (i.e., higher) court. Higher courts have the authority to change a decision of the lower courts. *See* CERTIORARI, SUPREME COURT, APPEAL.

lox (food and drink) Thin slices of salmon that are seasoned in a brine mixture containing salt or sugar. "lox and Bagels" is a sliced, toasted BAGEL spread with CREAM CHEESE and topped with lox; it is a popular DELI sandwich. [From the Yiddish *laks*, meaning "salmon".]

LSAT (education) An ETS, MULTIPLE-CHOICE entrance exam taken by all people who want to attend an American law SCHOOL[4] The scores from this exam help a SCHOOL[4] decide which students to accept into its program. [Abbreviation of 'L'aw 'S'chool 'A'dmissions 'T'est.] *See* JD; *compare* GMAT, GRE, SAT.

Luddite Movement, the (work) A radical workers' movement in the early nineteenth century in which the members organized themselves to smash the new machines that performed weaving and knitting tasks which had left these workers jobless. By association, a **Luddite** refers to a person who reacts to technology in a radically destructive manner.

lumberjack shirt (clothing) A long-sleeved cotton or flannel fabric, collared shirt decorated in a plaid pattern. [Popularly worn by wood cutters and 'lumberjacks'.]

Luminism, American (the arts) During the first half of the nineteenth century, a style of oil painting in which the paint is spread smooth and flat in order to show fine, precise details. The subject matter usually treated sea scenes, harbors, water views, clouds and colorful sunsets. The preferred manner was showing the calm, stillness and quietness of humans, boats and nature. It was popular in NEW ENGLAND and the MID-ATLANTIC regions. Painters included Fitz Hugh Lane (1804–1865), Martin Johnson Heade (1819–1904) and John Frederick Kensett (1816–1872). [From 'luminous', meaning "shining, reflecting light".]

lunch (daily life) The light meal eaten between 12:00 noon and 2:00 p.m. It

usually consists of a sandwich, soup and/ or salad. Children eat their lunches at SCHOOL[1], usually from LUNCH BOXES. A "luncheon" is a formal lunch which has a more complete menu and maybe a light dessert. A "power lunch" is a lunch during which the participants meet to eat and discuss business plans or other strategies. "To do lunch" is to make an appointment with a colleague or friend to eat a social lunch together. *Compare* DINNER.

lunch box (daily life) The brightly-colored plastic or metal container in which ELEMENTARY SCHOOL students carry their lunches to school. It is designed to hold a sandwich, fruit or potato or nacho chips and a thermos of milk or juice. *Compare* BOX LUNCH.

Lutheran Church (religion) A PROTES-TANT DENOMINATION (i.e., the first one), formally established in Germany in 1519 by Martin 'Luther' (1483–1546) by split-ting from the ROMAN CATHOLIC CHURCH of Rome. It was first brought to America during the COLONIAL PERIOD by German and Swedish immigrants. Members believe that faith in their God as well as the Bible's authoritative teachings are more important than good works and those rituals and traditions made by religious leaders or the CHURCH[3]. The worship services are simple (e.g., simple singing, few visual decorations) and focus on Bible reading, reciting "The Augsburg Confes-sion" (written in 1530) and listening to the sermon. Currently, there are 8.3 million total Lutherans in the US; and the largest Lutheran Churches are the Evangelical Lutheran Church in America with 5.2 million members and the Lutheran Church – Missouri Synod with 2.6 million members.

lynch law (minorities) The action of prosecuting and punishing someone with-out the DUE PROCESS of a court of law. The seizure, physical punishment (including castration and or branding) and death (often by hanging) of the victim are frequently carried out by a group or mob. Before the CIVIL RIGHTS MOVEMENT, this was practiced by the KU KLUX KLAN against its victims, especially blacks, but also Catholics and Jews, and also by others in FRONTIER areas. [From Captain

Charles 'Lynch' (1742–1820), a JUSTICE OF THE PEACE who, without a legal court DECISION, prosecuted Tories and other British sympathizers in his Virginia com-munity during the time of the AMERICAN REVOLUTION.]

lynching (minorities) The action of the LYNCH LAW, especially when blacks are the victims.

M

MA (education) A type of MASTER'S DEGREE. [Abbreviation of 'M'aster of 'A'rts.]

Ma Bell (economy) The popular nick-name for the large, powerful, private telecommunications company officially known as "American Telephone and Tele-gragh" (AT&T). It earned this name because, before 1982, it operated the 'Bell' System of telephoning which in turn controlled the majority of US telephone services in local areas as well as in long-distance telephoning. After a lengthy fed-eral LAWSUIT (from 1969 to 1982) concern-ing offending US ANTITRUST LAWS, AT&T was forced by the US government to surrender and divide up its control of the Bell System's local telephoning market. Although AT&T followed these SETTLE-MENT orders, it still remained the largest telephone company (i.e., Mother, or "Ma" Bell) and the many, newly-created smaller, local telephone companies became known as **Baby Bells**. By association, a large MONOPOLY or any large, powerful company that dominates an industry or market. [Originally after Alexander Graham 'Bell' (1847–1922), the inventor of the tele-phone.].

Mackinaw blanket (clothing) A type of thick, woolen blanket decorated with a plaid pattern or, more traditionally, single parallel stripes of yellow, red, green and black on a white background. It is used to sit on or set things on (e.g., at picnics, while TAILGATING) or to cover a person's shoulders or knees while watching out-

door events during cool weather (e.g., FOOTBALL games). [After the Straits of 'Mackinaw', a region of the MIDWEST where these blankets have long been made and traded.]

MacNeil–Lehrer News Hour, The
(media) A well-respected, hour-long news program, broadcast by PBS every night, since 1976. It summarizes several important issues, interprets one issue in depth and holds interviews with major leaders and scholars. [After the co-anchors Robert 'MacNeil' (born in 1931) and Jim 'Lehrer' (born in 1934).]

Macy's Thanksgiving Day Parade
(customs and traditions) A parade – run through the streets of MANHATTAN[1] on THANKSGIVING DAY – which is famous for its use of larger-than-life helium air balloons in the shapes of popular cartoon characters. It was first held in 1924; every year it ends at 'Macy's' Department Store where a figure dressed as SANTA CLAUS formally enters the store and starts the shopping spree. This event is televised nationwide and raises excitement for the shopping of the secular CHRISTMAS DAY and the HOLIDAY SEASON. See SECULARISM.

Madison Square Garden
(sports and leisure) In NEW YORK CITY, the large, indoor sports and live entertainment complex, originally built in 1968. The sports arena for professional BASKETBALL and ice hockey seats 20,000 and the Paramount (formerly "Felt Forum") for boxing seats 6,000. [After its location at 'Madison Square' in MANHATTAN[1].]

Madison, James
(people) (1751–1836) Political thinker, FOUNDER[1], SECRETARY of State (1801–1809) and US PRESIDENT from the DEMOCRATIC–REPUBLICAN PARTY. His nickname is "Father of the Constitution" because he was quite active during the CONSTITUTIONAL CONVENTION (serving as the recorder of the meeting), supported the BILL OF RIGHTS and was a co-author of the *FEDERALIST PAPERS*. He supported THOMAS JEFFERSON in defending STATES' RIGHTS[1]. He was less successful during his presidency; he himself commanded troops in battle in the WAR OF 1812 and lost the city of WASHINGTON D.C. to the British. *See* Appendix 2 Presidents.

Madonna
(people) (born Madonna Ciccone in 1958) POP MUSIC singer and film actress. She is known for her colorful, dance-oriented, live music concerts, music videos and provocative costumes and dance moves. A popular recording was the *True Blue* (1987) album; she starred in the film MUSICAL production of *Evita* in 1996 and became the mother of a daughter (named Lourdes) in 1997.

magna cum laude
(education) Describing that student who has earned the second-highest GPA in his or her CLASS. This phrase is written on the student's diploma. It describes a SALUTATORIAN. [Latin, meaning "with great praise".]

magnet school
(education) A SCHOOL[1] within a PUBLIC SCHOOL system that offers specialized courses and programs designed to attract students from all over the SCHOOL DISTRICT to create a racially mixed and multicultural student population. Usually, it offers an advanced course (e.g., AP Math, AP Chemistry) or a specialized program (e.g., ESL). These SCHOOLS[1] create voluntary desegregation based on a student's academic interests and needs. *See* SEGREGATION; *compare* BUSING.

Magnificent Mile, the
(geography) A nickname for MICHIGAN AVENUE because of its tall SKYSCRAPERS, elegant shops and restaurants.

maiden speech
(government) The first speech given to a legislative group. By association, any first speech given by anyone to an audience.

mail box
(1, 2 daily life) **1** The container located on a private residence or at the end of the driveway used for receiving mail and for sending stamped mail. Residents put the mailbox's flag "up" to indicate to the postal carrier that there is mail to be picked up. **2** The blue-colored US Postal Service container located in public places in which people put stamped letters to be mailed.

Mailer, Norman
(people) (born in 1923) Writer of fiction, critical reviews, journalistic articles. He is a varied writer and frequently combines fiction, historical fact and essays in his books. He is a contributor to and was a co-founder of the *VILLAGE VOICE*. Popular works include

The Armies of the Night (1968), which treats the VIETNAM WAR, and *The Executioner's Song* (1979), treating a man convicted of murdering his wife. He has won the PULITZER PRIZE for fiction (1980).

Main Street, USA (society) A phrase referring to a typical AMERICA[1]; an average American town.

Maine, the (foreign policy) The American battleship which, while docked in Havana, Cuba, was destroyed by an explosion on February 15, 1898, killing 240 people. Although no one claimed responsibility, Americans wanted to blame someone. Accusations about the responsibility for this explosion led to the SPANISH-AMERICAN WAR. The refrain "Remember the *Maine*" was repeated by those people who supported military action against Spain in order to help Cuba achieve independence. *See* YELLOW JOURNALISM.

major (education) The particular field of study that an UNDERGRADUATE chooses to focus on by taking courses and earning CREDITS in it (e.g., her major is Chemistry). Every student must have a major in order to graduate. Most of the courses in the major are taken in the last two years of the BACHELOR'S DEGREE. By association, the undergraduate who studies a certain field (e.g., she is a Chemistry major[1]. *See* (AGE OF) MAJORITY; *compare* MINOR[1].

major leagues, the (sports and leisure) A collective name for the NATIONAL LEAGUE and the AMERICAN LEAGUE. By association, professional BASEBALL. Also known as "the Majors"; *see* BIG LEAGUE, WORLD SERIES; *compare* MINOR LEAGUES.

majorette (education) A young woman or girl wearing a small, colorful costume who performs dance steps while twirling a baton. Often, she performs outdoor in parades, at halftime performances of sporting events (e.g., FOOTBALL) and with the MARCHING BAND. This may be an EXTRACURRICULAR ACTIVITY in some SECONDARY SCHOOLS. Also known as "drum majorette".

majority, the (age of) (legal system) The age at which a person is legally considered an adult citizen by a court of law. An individual then has the legal right to vote, to get married without a parent's agreement and, if accused of a crime, to be tried as an adult in a regular court (i.e., not JUVENILE COURT). Because it is set by individual STATES it ranges from 15 to 18 years of age. *See* TWENTY-SIXTH AMENDMENT, DRIVER'S LICENSE, SWEET SIXTEEN, DRAFT[1], MARRIAGE LICENSE; *compare* MINOR[2], TWENTY-FIRST BIRTHDAY, MAJOR.

majority (party), the (government) The political party, DEMOCRAT or REPUBLICAN, that has the largest number of elected members in that chamber of CONGRESS. General elections decide the majority party. In the HOUSE OF REPRESENTATIVES, it selects a SPEAKER OF THE HOUSE, MAJORITY LEADER and WHIP. In the SENATE, it selects a PRESIDENT *PRO TEMPORE*, majority leader and whip. *Compare* MINORITY PARTY.

majority leader (government) The chief spokesperson of the MAJORITY party who leads and organizes that PARTY in discussions and debates over legislation. He or she is chosen by fellow members of that political party. In the SENATE, this is the most powerful political position. In the HOUSE OF REPRESENTATIVES, only the SPEAKER OF THE HOUSE is more powerful than the majority leader. *Compare* MINORITY LEADER, PRESIDENT *PRO TEMPORE*.

majority opinion (legal system) A written statement (i.e., DECISION) agreed to by a majority of judges hearing a case which gives their decision on that case and explains how the law was applied to (i.e., "interpreted") the case. Also known as "opinion"; *compare* CONCURRING OPINION, DISSENTING OPINION.

"making the world safe for democracy" (foreign policy) An American slogan of the twentieth century used by political leaders; it justifies the US's involvement in local events around the world as well as conveys America's special mission in the world. *See* MARSHALL PLAN, VIETNAM WAR, "CITY ON A HILL".

Malcolm X (people) (1925–1965, born Malcolm Little) A public speaker and African-American religious leader. While serving a jail term (1946–1952) for burglary, he decided to change his life and converted to the NATION OF ISLAM. After being released, he worked as a BLACK MUSLIM minister in HARLEM speaking often about the need for BLACK NATIONALISM, the need

for blacks to be violent to achieve their aims and that blacks must separate themselves from white culture to survive. Although his outspoken opinions caused him to be expelled from the Black Muslims he then founded his own black nationalist group, the ORGANIZATION OF AFRO-AMERICAN UNITY (OAAU). After a pilgrimage to Mecca, he changed his name to AL HAJJ MALIK AL-SHABAZZ and broadened his views to accept non-blacks in the struggle for CIVIL RIGHTS and the possibility of blacks and whites living together in a society. While still young, he was assassinated on February 21 by a Black Muslim follower. After his death, the book *The Autobiography of Malcolm X* (1965) was published and became an important book for young black people. He is remembered as a dynamic public speaker who recruited many new members to the Black Muslims; his speeches also influenced the BLACK PANTHERS and many other MINORITY members. He was and remains a powerful symbol of black pride for AFRICAN AMERICANS and many others. [The 'X' symbolizes a stolen identity.] *See* ALEX HALEY, SPIKE LEE.

Mall, the (geography) In WASHINGTON D.C., the grassy area extending from CAPITOL HILL to the Lincoln Memorial. It is lined by many museums of the SMITHSONIAN INSTITUTION and is a popular place for tourists and residents to have picnics and play INTRAMURAL sports. Further, it is a common meeting and demonstrating place for protesting groups. *See* MARCH ON WASHINGTON OF 1963, MARCH ON WASHINGTON MOVEMENT, "I HAVE A DREAM", ANTI-WAR MOVEMENT, MILLION MAN MARCH.

Mall of America, the (geography) Located some 10 miles (16 km) south of the TWIN CITIES, the enormous, sprawling SHOPPING MALL complex (built 1992) covering some 78 acres (32 hectares); it is recognized as the largest enclosed shopping mall in the world.

malpractice (health) A violation of professional standards, especially through neglect or sloppiness. It is usually used to refer to the neglectful action of a doctor, but can also be applied to an ATTORNEY or other professional. *See* MALPRACTICE INSURANCE.

malpractice insurance (health) A type of insurance that doctors buy to protect themselves from being sued by patients for MALPRACTICE. Usually, the INSURANCE PREMIUMS for this are very expensive. It is formally known as "professional liability insurance".

man-to-man (coverage) (sports and leisure) A method of defense in which a defensive team member is assigned to (i.e., 'covers', shadows) an offensive player and is responsible for stopping that offensive player from succeeding in any offensive action. *Compare* ZONE (COVERAGE).

Manassas, (First and Second) (history) The name used in the SOUTH to refer to the two Battles of BULL RUN. [After the name of the town 'Manassas' in northeastern Virginia.]

mandamus, writ of (legal system) An order to do some action which a high court makes to some LOWER COURT, to a governmental branch or DEPARTMENT[2]. [Latin for "we command".] *See* JUDICIARY ACT (OF 1789).

Manhattan (1 geography; 2 food and drink) **1** A small, rocky island and the smallest BOROUGH[1] (only 13.5 miles; 22 km) in NEW YORK CITY, but the center of the banking, financial, advertising, clothing and entertainment industries that are located in the city. The southern tip, "Lower Manhattan" (also known as "DOWNTOWN"), includes WALL STREET, GREENWICH VILLAGE and the WORLD TRADE CENTER. "Midtown Manhattan" includes the chic shopping district, the UNITED NATIONS, BROADWAY, LINCOLN CENTER FOR THE PERFORMING ARTS, the JUILLIARD SCHOOL FOR MUSIC, the GUGGENHEIM MUSEUM, and many other museums. "Upper Manhattan" (also known as "UPTOWN") contains many BLOCKS[1] of residential apartment buildings, COLUMBIA UNIVERSITY and HARLEM. On this island, FIFTH AVENUE runs north–south and divides Manhattan into the "West Side" and the "East Side". [After the '*Manhattan*' tribe, an extinct group of NATIVE AMERICANS which used to live on the island.] *See* MET[1,2], TIMES SQUARE, SOHO, TRIBECA, CARNEGIE HALL, EMPIRE STATE BUILDING,

CHRYSLER BUILDING, MADISON SQUARE GARDEN, MACY'S THANKSGIVING DAY PARADE. **2 manhattan** A mixed drink cocktail made of rye whiskey or BOURBON mixed with sweet vermouth, served over ice cubes and garnished with a maraschino cherry (i.e., sweet-tasting cherry). A "dry manhattan" is made with dry vermouth. A "perfect manhattan" is made of whiskey, both sweet and dry vermouth and a lemon twist.

Manhattan Project, the (science and technology) The research project (1943 to 1945) that first developed and built three ATOMIC BOMBS. The first was detonated at ALAMOGORDO, in New Mexico, on July 16, 1945. The second and third were dropped on the Japanese cities of Hiroshima (August 6, 1945) and Nagasaki (August 9, 1945), and led to the end of WORLD WAR II. The project was paid for by federal funds and started on advice given by Albert Einstein (1879–1955) who believed Germany was developing atomic weapons. It was led by Enrico Fermi (1901–1954) and Robert Oppenheimer (1904–1967).

Manifest Destiny (history) In the nineteenth century, a term for the belief that the UNITED STATES had a divine, God-given right to expand its land territory and a divine mission to serve as a democratic, political model for other nations. It was used to justify America's annexation of the REPUBLIC OF TEXAS and its involvement in the MEXICAN-AMERICAN WAR. *Compare* "CITY ON A HILL".

Mann's Chinese Theater (the arts) In HOLLYWOOD[1], a movie theater, first opened in 1927, decorated in an ornate, traditional 'Chinese' palace fashion in whose courtyard are laid cement slabs on which famous celebrities and entertainment stars over the years have left their hand prints, foot prints and/or have signed their names. It is a symbol of the glamour of LOS ANGELES and HOLLYWOOD[2].

Mann, Horace (people) (1796–1859) A lawyer, politician and education reformer from Massachusetts. He was one of the "Friends of Education" and a promoter of the "COMMON SCHOOL MOVEMENT". He pushed for universal education for white boys and girls, a practical school curriculum and improved teacher training at "normal schools" in every STATE.

maple syrup (food and drink) A thick, sweet syrup made from the sap of maple trees and sugar. Although it is produced in NEW ENGLAND, it is eaten for breakfast nationwide, especially poured over pancakes, FRENCH TOAST and/or waffles.

Mapp* v. *Ohio (legal system) The DECISION of the SUPREME COURT (1961) stating that any evidence concerning a crime or the person accused of having committed that crime which is taken by an unnecessary or illegal SEARCH AND SEIZURE cannot be used in a court case. *See* FOURTH AMENDMENT.

Marbury* v. *Madison (legal system) The important SUPREME COURT DECISION (1803) which increased the power of the Supreme Court by establishing the doctrine of JUDICIAL REVIEW and for ruling whether Congressional laws are legal or not. This decision, written by JOHN MARSHALL, stated that the CONSTITUTION contains the law and that it is the duty of the Court to "say what the law is". The case concerned Mr. 'Marbury' who had received a presidential appointment from a LAME DUCK PRESIDENT and who demanded the Court to issue a writ of MANDAMUS (according to the JUDICIARY ACT OF 1789 of CONGRESS, this was legal) to order the new SECRETARY of the DEPARTMENT OF STATE, "JAMES MADISON", to allow Marbury to fill that post in the ADMINISTRATION[1] of the new President. The Court found that part of the law concerning the writ of mandamus UNCONSTITUTIONAL and ruled it void. Marbury was not given the post. *See* SEPARATION OF POWERS, CHECKS AND BALANCES.

March Madness (sports and leisure) A nickname for the period in which the postseason BASKETBALL tournaments are held: namely, NCAA BASKETBALL DIVISION I CHAMPIONSHIP TOURNAMENTS (one for men's teams and one for women's teams) and the (NIT) NATIONAL INVITATIONAL TOURNAMENT. All the tournaments consist of various rounds in which some teams are eliminated and others advance to the following round. [After the excited atmosphere caused by many fans trying to predict the wins and losses of the various

teams involved, picking the winning teams and betting on them as well as the large numbers of teams and games in these tournaments which are both held in 'March'.] *See* FINAL FOUR.

March on Washington of 1963 (minorities) A nonviolent CIVIL RIGHTS demonstration in August 1963 which included mostly black and some white participants who convened at the Lincoln Memorial in WASHINGTON D.C. to encourage the passage of the Civil Rights Bill currently in CONGRESS. The march was called for by A. PHILIP RANDOLPH, held on August 28, 1963, and was a cooperative effort between the SOUTHERN CHRISTIAN LEADERSHIP CONFERENCE, NAACP, SNCC, CORE, Negro American Labor Council and the NATIONAL URBAN LEAGUE. The last of the scheduled speakers was MARTIN LUTHER KING, JR., who at this time gave his famous "I HAVE A DREAM" speech. This march was the high point of the CIVIL RIGHTS MOVEMENT and attracted the largest audience of that movement (over 200,000 participants). It proved important in securing the passage of the CIVIL RIGHTS ACT (of 1964). Officially known as "March on Washington for Jobs and Freedom"; *see* MARCH ON WASHINGTON MOVEMENT.

March on Washington Movement (minorities) (MWM) The organized threat and mass event which was used to illustrate to the federal government the severity of a policy or issue concerning AFRICAN AMERICANS and the strong desire of black people for that policy to be changed. This movement was developed by A. PHILIP RANDOLPH and supported by the BROTHERHOOD OF SLEEPING CAR PORTERS. The first "March on Washington" was called for by Randolph in May 1941 (to be held on July 1) in order to protest and demand that all DISCRIMINATION which prevented blacks from getting jobs in the defense industries be abolished. Because PRESIDENT FRANKLIN ROOSEVELT did not want the protest to occur, he agreed to prohibit discrimination in the defense industries (i.e., EXECUTIVE ORDER 8802). Another major march of this movement was the MARCH ON WASHINGTON OF 1963.

March on Washington to End the War in Vietnam (foreign policy) The march held on April 15, 1967, in WASHINGTON D.C. at which over 200,000 COLLEGE[3] students protested the VIETNAM WAR before the WHITE HOUSE. It was the largest peace march in American history. *See* ANTI-WAR MOVEMENT.

March to the Sea, the (history) During the CIVIL WAR, the decisive military campaign in which a branch of the UNION[3] army under the command of General WILLIAM T. SHERMAN occupied, controlled and then destroyed several key cities, industrial centers and railroad tracks in the SOUTH which helped lead to the collapse of the morale of Southerners and the surrender of the CONFEDERATE STATES OF AMERICA. It began in 1864 at the inland city of ATLANTA; after having ordered its civilians to evacuate that city, Sherman burned the city to the ground on November 16, 1864. Thereafter, he led his army toward the city of Savannah, on the Atlantic Ocean coast, burning and destroying all buildings and killing all animals and plants in its path; later, Sherman continued this tactic when he led the army north through North Carolina and South Carolina. This total devastation of Confederate supply centers as well as the morale of the Southern denizens is considered the creation point of the modern concept of "total (complete) war". Also known as "Sherman's March to the Sea".

marching band (sports and leisure) A uniformed, student musical group that performs and marches at SCHOOL[5] concerts, sporting events, parades and COMMENCEMENTS. It may be joined by CHEERLEADERS, a DRILL TEAM and/or a FLAG CORPS. It is an EXTRACURRICULAR ACTIVITY in HIGH SCHOOLS and COLLEGES[1]. *See* LETTER.

Mardi Gras (customs and traditions) A festive, week-long carnival held every February in which people, known as "maskers", wearing extravagant or silly costumes and masks, attend private dance balls, public parades and parties. NEW ORLEANS, Louisiana hosts the most famous and oldest (since 1857) Mardi Gras festivities in the US. The highlights of its celebration are held on Tuesday in the

FRENCH QUARTER District and include a parade in which maskers ride FLOATS and toss carnival "throws" (plastic, colored beads and whistles) to those parade watchers who shout the refrain "give me something, Mister!"; afterward, a ceremony is held to crown a special man "King of the Carnival" and to give him the title "Rex, Lord of Misrule". All the events are sponsored by social clubs called "krewes". Mardi Gras is a LEGAL HOLIDAY in the STATE of Louisiana and several other cities sponsor Mardi Gras events. [French for 'fat Tuesday', that is Shrove Tuesday, a traditional day in regions loyal to the ROMAN CATHOLIC CHURCH on which people enjoy one last day of eating, dancing, making noise and having fun because the following day, Ash Wednesday, marks the beginning of Lent, which traditionally is a 40-day period of prayerfulness and fasting from food.]

Mariel boatlift (immigration) The mass immigration of 125,000 Cuban REFUGEES on boats to Florida, which the communist government in Cuba permitted and PRESIDENT JIMMY CARTER accepted. This immigration by boat lasted four months (from April 21 to September 26, 1980), but stopped suddenly, when it was discovered that one-sixth of the refugees, **Marielistas**, were former criminals or "undesirables" (e.g., mental patients). It is a symbol of an irregular, chaotic federal policy of accepting immigrants as well as the diplomatic troubles between the US and Cuba. [From the port town 'Mariel' in Cuba where they embarked for the US.] Also known as the "freedom flotilla"; see REFUGEE ACT; compare "FREEDOM FLIGHTS", BOAT PEOPLE.

Marine Corps, the (military) (USMC) A branch of the ARMED FORCES which is especially trained to incorporate forces and military methods on the ground, in the air (e.g., helicopter forces) and in the water. It usually works with the NAVY and/or the ARMY. Its members, **Marines**, are characterized by their rigorous training programs and committed service. They were an important force in winning battles in the Pacific Ocean region during WORLD WAR II. See Appendix 7 Military Ranks .

market economy (economy) The economy of the UNITED STATES in which a variety of different products and services can be bought and sold as well as to which businesses selling products and services can join easily. This is an important element to American-style CAPITALISM.

marriage license (legal system) The legal document which officially unites a man and a woman in marriage, giving that couple a legal status. STATES make their own, specific rules concerning issuing it (e.g., waiting period between delivering papers and receiving the license). However, in all states; individuals must be between ages 16 and 18 or older (if they do not have permission from their parents) and complete a healthy physical exam and blood test before they can be issued the license. It is issued by the local town or city hall. Often, the couple go alone to deliver the necessary papers and buy the license document several days before their large, sometimes religious, festive ceremony. Currently, homosexual couples cannot get a marriage license in any STATE. Compare COMMON LAW MARRIAGE.

Marsalis, Branford (people) (born in 1960) Musician and saxophonist of JAZZ MUSIC. His brother is WYNTON MARSALIS.

Marsalis, Wynton (people) (born in 1961) Musician, trumpet player from NEW ORLEANS. A talented musician of classical music and JAZZ MUSIC (he has won GRAMMY awards in 1984, 1985, in both these fields of music) who is best known for promoting the performance and understanding of jazz music, especially NEW ORLEANS JAZZ. His brother is BRANFORD MARSALIS.

Marshall Plan, the (foreign policy) A massive economic program in which the American government gave over $13 billion (from 1948 to 1951) to Western European nations to help them recover and rebuild their economic systems after WORLD WAR II. It proved to be a very successful program. Its formal name is the "European Recovery Program". [After George C. 'Marshall' (1880–1959), SECRETARY of the DEPARTMENT OF STATE.] Compare DAWES PLAN.

Marshall, John (people) (1755–1835) AMERICAN REVOLUTION soldier, LAWYER

and CHIEF JUSTICE of the SUPREME COURT (1801–1835). During his tenure on the Supreme Court, he helped strengthen its power making it an independent branch of the federal government by stating the principle of JUDICIAL REVIEW. He is greatly respected and remembered for his written decisions which are clear, well thought out and eloquent, namely: *MARBURY* v. *MADISON* and *GIBBONS* v. *OGDEN*. He was a busy, active leader of the Court; when he died, one tradition says that the LIBERTY BELL tolled, and cracked.

Marshall, Thurgood (people) (1908–1993) LAWYER, first African-American ASSOCIATE JUSTICE of the SUPREME COURT (1967–1991). He began his career by establishing the NAACP LEGAL DEFENSE AND EDUCATION FUND and arguing and winning 32 cases before the SUPREME COURT (1940–1961), e.g., *BROWN* v. *BOARD OF EDUCATION*. While serving on the Court, he continuously voted to support AFFIRMATIVE ACTION policies and women's rights and voted against CAPITAL PUNISHMENT. He is remembered for his work for MINORITIES and JUDICIAL ACTIVISM.

marshmallow (food and drink) A sweet, round, soft-centered lump of beaten sugar, egg whites, gelatin and corn syrup. It is popularly prepared and eaten toasted; usually by spearing it on a long, thin stick or wire and holding it over an open fire, especially at SUMMER CAMP, by GIRL SCOUTS, by BOY SCOUTS or while camping. It is also an ingredient for other sweet desserts (e.g., marshmallow and JELLO salad). By association, a kind person who is too soft-hearted to be forceful. [Originally, it was made from the root of the 'marshmallow' plant.] *See* MOONPIE.

Martha's Vineyard (geography) A small island (24 miles long; 39 km) located in the Atlantic Ocean some 7 miles (11 km) south of CAPE COD. It is known for its 'vineyards' of grapes, quaint wooden cottages and for being an elite summertime destination for wealthy tourists. [Allegedly after 'Martha' Gosnold, an early local resident.]

Martin Luther King, Jr. Day (customs and traditions) The LEGAL HOLIDAY on the third Monday in January that celebrates the life and achievements of MARTIN LUTHER KING, JR. It was first celebrated in 1986 and is the final day of a LONG WEEKEND.

Martin Luther King, Jr. Center for Nonviolent Social Change (minorities) The educational and research organization founded in 1980 to educate and train other people and organizations about the work and philosophy of NONVIOLENT ACTION of MARTIN LUTHER KING, JR. It is located in ATLANTA and Mrs. Coretta Scott King (born in 1927) is its president.

Mason (religion) A shortened name for a member of the FREEMASONS.

Mason–Dixon Line, the (geography) The horizontal line which provides the geographical boundary separating the STATE of Pennsylvania from the state of Maryland. It was drawn in the 1760s to resolve land disputes and to establish the colonial boundaries. By association, the horizontal dividing line which symbolically and psychologically separates the STATES of the NORTH from the states of the SOUTH. During the CIVIL WAR, it was the boundary between the UNITED STATES OF AMERICA and the CONFEDERATE STATES OF AMERICA. "North of the Mason–Dixon Line" refers to "the North" and its laws, institutions and customs; "South of the Mason–Dixon line" refers to "the South" and its laws, institutions, customs and traditions. [After the two Englishmen who surveyed the land in the 1760s and established the boundary, Charles 'Mason' (1728–1786) and Jeremiah 'Dixon' (died 1777).] *See* DIXIE[1].

Massachusetts 54th Regiment, the (history) The first regiment composed of black soldiers in the United States ARMY. It was formed during the CIVIL WAR and fought bravely.

Massachusetts ballot (politics) Another name for an OFFICE-BLOCK BALLOT. [After 'Massachusetts', the first STATE to use this type of BALLOT[1] in the 1890s.] *Compare* AUSTRALIAN BALLOT.

Massachusetts Bay Colony (history) During the COLONIAL PERIOD, the successful British colony founded in 1630 which was quickly settled and populated by PURITANS from England. It was established as a theocracy (i.e., a single community in which the people agreed to be

governed by civil rules and religious rules) and it enforced strict social and religious morals. It expelled from the colony any member who disagreed with the religion or other community rules. By the eighteenth century, it shifted from a theocracy to a democracy. It was composed of lands which are in the present-day STATES of Massachusetts, Maine, Connecticut, Rhode Island and New Hampshire. Its largest city was BOSTON. *See* GREAT MIGRATION[1], "CITY ON A HILL".

Massachusetts Institute of Technology (education) (MIT) The prestigious and elite, independent scientific-oriented UNIVERSITY noted for its UNDERGRADUATE programs in engineering and computer science, its GRADUATE SCHOOLS of engineering and business and its distinguished faculty. It was founded in 1861 and later financed in part by the MORRILL ACT (1862) with the purpose of teaching scientific theory and application. Its current urban CAMPUS in Cambridge, Massachusetts houses the Lab for Nuclear Science, the Center for Space Research and the Lab for Computer Science. The student body of 5,000 UNDERGRADUATES and 4,000 GRADUATES[2] is COEDUCATIONAL. *See* PRIVATE SCHOOL; *compare* CALIFORNIA TECHNICAL INSTITUTE.

master's degree (education) A HIGHER EDUCATION degree awarded to a student who has completed two years of study beyond the BACHELOR'S DEGREE level and who has successfully written and defended a THESIS. The student may receive an MA for GRADUATE[2] work in a HUMANITIES program; an MS in a hard sciences program (e.g., chemistry, engineering); or an MFA in the performing arts (e.g., opera singing, theater acting). [From Latin, *magister*, related to "great".] Also known as a "master's"; *see* Appendix 4 Educational Levels; *compare* PHD, DISSERTATION.

Masters, the (sports and leisure) A major golf tournament for professional and amateur male golfers held every April since 1934 in Augusta, Georgia. The course was designed by Bobby Jones (1902–1971), a famous golfer, and it is known for its smoothness (i.e., there is no "rough", long grass) and the beauty of the blooming plants landscaping the course,

namely, forsythia and blooming magnolia and wisteria. It is the first tournament of the golf GRAND SLAM[2].

matching funds (government) In general, an amount of money given to a particular group or program on the condition that an equal amount of money be donated (to that same group) from a different source. Specifically, the money that the federal government gives to a GRANT-IN-AID or other program only if the STATE or group contributes the same amount (i.e., 'matches' the amount). Sometimes, a state is asked to raise only 10% of the federal funds, while at other times 45% to 50% is asked. It is commonly practiced by the PUBLIC SECTOR and PRIVATE SECTOR as a method of encouraging various organizations to share the costs of public projects. *See* DUAL FEDERALISM, COOPERATIVE FEDERALISM, FEDERAL ELECTION CAMPAIGN ACT OF 1972; *compare* GRANT.

Mayflower, **the** (immigration) The wooden ship that carried 102, mostly English PILGRIMS to NEW ENGLAND in 1620. By association, it is now a symbol of immigration to, and the beginning of European-American development in, AMERICA[1]. *Compare* ELLIS ISLAND.

Mayflower **Compact** (history) A contract (i.e., constitution) that outlined the social rules and type of organization and government for the PILGRIMS in their new settlement in AMERICA[1] at PLYMOUTH COLONY. The adult Pilgrim men of the group created, wrote and agreed to these rules in the contract on November 21, 1620, while still aboard their ship, the *MAYFLOWER*. This contract is now a symbol of the beginning of the American idea of democratic self-government. *See* CONSTITUTION.

Mayo Clinic, the (health) A top-ranking hospital and medical center located in Rochester, Minnesota in the MIDWEST specializing in cancer research and treatment as well as other health research projects. [After two brother surgeons, Charles 'Mayo' (1865–1939) and William 'Mayo' (1861–1939).]

Mays, Willie (people) (born in 1931) Professional African-American BASEBALL player in the NATIONAL LEAGUE. He was recognized for his athletic skill, enthusiasm while playing, running speed and

hitting 660 HOME RUNS. While playing for the New York Giants (1951–1971), he earned the nickname "the Amazing Mays".

MBA (education) A GRADUATE SCHOOL degree awarded to a person who has completed two years of successful study in business and management courses and has passed FINAL exams. It is a popular degree for business people and managers to earn and is offered at many universities. [Abbreviation of 'M'aster's of 'B'usiness 'A'dministration.] *See* GMAT; *compare* MA.

MC (1, 2 the arts) **1** A person who hosts a program or event and is responsible for introducing the different acts of a live theater or performance event. [From the abbreviation of 'M'aster of 'C'eremonies.] *See* EMCEE. **2** A person who recites or speaks the lyrics of RAP music songs; also known as a "rapper".

McCall's (media) A monthly magazine designed for working women and mothers (aged 25 to 45) containing articles on health, celebrities, parenting and relationships between men and women. It was first published in 1877 and its current circulation is 4.3 million.

McCarran Act (immigration) The anti-communist, federal act (passed in 1950) which did not permit into the UNITED STATES any new immigrants who belonged to or had belonged to communist or socialist political parties or to any other totalitarian organizations. It also required all communist groups currently in the US to register that organization with the DEPARTMENT OF JUSTICE. Further, it forbade American citizens who were members of the communist party from working in those American industries and businesses related to defense, the ARMED FORCES and national security. It is formally known as the "Internal Security Act". [After the sponsor of the BILL[2], SENATOR Patrick 'McCarran', a DEMOCRAT from the STATE of Nebraska.] *See* RED SCARE[1,2,3], ROSENBURG CASE, IMMIGRATION ACT OF 1990; *compare* McCARTHYISM, McCARRAN–WALTER ACT OF 1952.

McCarran–Walter Act of 1952 (immigration) The federal law which started accepting, every year, immigrants from different races but the number of those immigrants allowed into the country was governed by the discriminatory QUOTA system based on the 1920 CENSUS first established in the NATIONAL ORIGINS ACT OF 1921. (For example, only 100 people from each Asian country were allowed to enter the US.) This law also continued to prohibit communists and fascists from immigrating. Although this BILL[2] was vetoed by PRESIDENT HARRY TRUMAN as discriminatory, CONGRESS approved it and it became law. [After the two writers of the bill, SENATOR Patrick 'McCarran', a DEMOCRAT from Nebraska and REPRESENTATIVE Francis 'Walter'.] Formally known as the "IMMIGRATION AND NATIONALITY ACT OF 1952"; *see* DISCRIMINATION; compare McCARRAN ACT.

McCarthyism (history) During the COLD WAR, the period 1950–1955 when REPUBLICAN Joseph McCarthy (1908–1957), a new SENATOR in the US CONGRESS, was actively accusing ranking officials in the federal government and US ARMY of being communists. He is remembered for making irresponsible statements (i.e., often proved later to be untrue) about American citizens serving in the US government and ARMED FORCES. By association, a method of accusing a person by using faulty or untrue evidence. *See* WITCH TRIALS, HOUSE UN-AMERICAN ACTIVITIES COMMITTEE.

McClellan Committee (work) A government research team that investigated and discovered problems in organized labor UNIONS[1], especially in the TEAMSTERS, namely: bribery, unfair elections of UNION[1] leaders, using UNION[1] funds for personal reasons, and proving that labor union officials had plotted with management to keep labor rates low and establish false welfare funds for labor UNION[1] members. It was carried out by the SUBCOMMITTEE of the Senate Government Operations Committee, a CONGRESSIONAL COMMITTEE from 1955 through 1957, and led to new laws to help union members and decrease corruption in BIG LABOR. ROBERT KENNEDY and JOHN F. KENNEDY also worked on this committee. It is also known as the "Labor-Rackets Committee" [After the first chairman, SENATOR John 'McClellan', DEMO-

CRAT from Arkansas.] *See* TAFT–HARTLEY ACT.

McCulloch v. Maryland (legal system) The important SUPREME COURT DECISION (1819) which expanded the powers of CONGRESS by stating that the powers given to the federal government are stronger than those given to the individual STATES. The case concerned STATES' RIGHTS[2]; the state of Maryland believed it had the power to tax that branch of the Bank of the United States located in Baltimore, Maryland. CHIEF JUSTICE JOHN MARSHALL, on behalf of the Highest Court, decided that the powers given to the federal government are more powerful than those of the states; therefore, the US did not have to pay taxes to the state.

McGuffey's *Reader* (education) A series of graded books used in nineteenth-century ELEMENTARY SCHOOLS and SECONDARY SCHOOLS to teach reading, morality and values. The readings were based on the Bible, PURITAN texts and spelling books. They were commonly used in PUBLIC SCHOOLS from 1836 to after WORLD WAR I; by 1920 over 120 million copies had been sold. [For William 'McGuffey' (1800–1873), the individual who originally prepared these reading books.]

Mead, Margaret (people) (1901–1978) Anthropologist, PROFESSOR and writer. Her studies of "primitive" cultures revealed that the roles for men and women were based on society's rules (e.g., environment) and not on an individual's own abilities and inclinations (e.g., nature). Her most famous books are *Coming of Age in Samoa* (1928) and *Male and Female* (1949).

Medal of Honor, the (military) The highest and most prestigious military award given to a member of the ARMED FORCES to remember his or her self-sacrifice and/or bravery during a situation, usually military action. It was established by CONGRESS in 1862 and is awarded by the PRESIDENT. Each branch of the military has its own particular design. Also known as "Congressional Medal of Honor"; *compare* PURPLE HEART, NAVY CROSS.

Medicaid (health) A program that pays the medical expenses of certain people under the age of 65 who have low incomes and do not have private health insurance. This program began in 1965 as part of the GREAT SOCIETY and is overseen by part of the DEPARTMENT OF HEALTH AND HUMAN SERVICES; it receives money from federal and STATE governments and is operated by the STATES. *See* GENERAL ASSISTANCE; *compare* MEDICARE.

Medicare (health) A two-part (i.e., Part A, Part B) federal health insurance program for: all people aged 65 years and older; certain DISABLED people under 65 years of age; and those people with serious kidney problems. Part A is a hospital insurance program which pays for all medical care expenses that a patient receives in the hospital (and for which there is no INSURANCE PREMIUM). Part B is a supplementary medical insurance program offered to other people when they pay a monthly premium. It was created in 1965, amended in 1973 and is an important part of the SOCIAL SECURITY system. It is administered by the SOCIAL SECURITY ADMINISTRATION. *See* GREAT SOCIETY.

medicine man/woman (religion) In most TRIBES of INDIANS in North America, the respected person responsible for healing tribe members and other people of physical illnesses as well as giving advice and solving problems. Traditionally (before WORLD WAR II), this individual did this by learning about different plants and animals, preparing medicines (from these plants and animals), interpreting dreams (of his/her own and others) and knowing the history of the tribe. By association, today it is also used to refer to any person (i.e., non-Indian, Indian) who can fix problems (e.g., in politics, business, government) or who is wise. Also known as "SHAMAN".

medium rare (food and drink) An order to cook beef long enough so that the exterior and some inner layers are brown but the center is still red. *See* STEAK.

Meet The Press (media) A prestigious, popular 30-minute TV news and interview program in which an invited guest answers questions concerning political and current events which are asked by a panel of journalists. It was first aired in 1947 and

is broadcast on SUNDAY mornings on NBC.

Mellencamp, John "Cougar" (people) (born in 1951) A ROCK AND ROLL singer and songwriter known for his popular songs which treat life in small towns of the MIDWEST. Popular albums include *American Fool* (1982) and *Uh-huh* (1983). He stopped his singing career briefly in the 1980s to pursue a career in oil painting.

melting pot (immigration) A social theory stating that different peoples in the UNITED STATES (e.g., new immigrants, blacks, NATIVE AMERICANS) should forget their native languages, history, religious practices and beliefs, customs and cultures and adopt those of mainstream American society (i.e., WASP) in order to become homogeneous Americans living in a monoculture. Although it was popularly used from 1900 to 1985 as a method of referring to the various different peoples in the US and the process of "Americanization", it has, since the 1980s, largely been replaced by the concept and term of "MULTICULTURALISM". By association, a term referring to the process of becoming similar or homogeneous. [After the 1908 play entitled *The Melting Pot* by the JEWISH playwright Israel Zangwell.] *See* ASSIMILATION; *compare* NATIVISM, RAINBOW COALITION.

Melville, Herman (people) (1819–1891) Author. He began his literary career writing action-packed adventure stories about his own experiences as a sailor; namely, *Typee* (1846) and *Omoo* (1847). Later, however, he wrote a book with more complex themes entitled *MOBY DICK* (1851), a work which relates the story of a ship's captain and crew hunting a large, white-colored whale. *See* AMERICAN RENAISSANCE.

Memorial Day (customs and traditions) A LEGAL HOLIDAY on the last Monday in May honoring the dead, especially those people who died in wars or military service in which the UNITED STATES was involved. Many people visit cemeteries to clean the graves of relatives and decorate them with flowers and miniature American flags. Also, local groups of the VETERANS OF FOREIGN WARS and the AMERICAN LEGION and other community

groups, MARCHING BANDS, GIRL SCOUTS and BOY SCOUTS, hold special remembrance services, speeches, parades and sing the song "AMERICA²". It grew out of the holiday practiced in some STATES of the SOUTH known as "DECORATION DAY". If it rains on the Sunday before, the INDIANAPOLIS 500 may be held on this day, the last day of MEMORIAL DAY WEEKEND. *See* ARLINGTON NATIONAL CEMETERY.

Memorial Day weekend (customs and traditions) The LONG WEEKEND in late May, ending with MEMORIAL DAY, which is traditionally considered the beginning of warmer weather and summer. People spend the weekend having BARBECUES, playing sports, relaxing and attending local parades. Many public beaches, swimming pools, outdoor athletic and/or tennis clubs reopen on this weekend for the summer months. Traditionally, this was the first weekend that adults could wear white-colored shoes and hats and other light-colored summertime clothing. *See* INDIANAPOLIS 500; *compare* LABOR DAY WEEKEND.

Mennonites (religion) Members of a PROTESTANT DENOMINATION which practices baptism of adults and encourages missionary work. It was founded in Holland in the sixteenth century and was first brought to America in 1683. Members' beliefs include refusing to take oaths or to serve in the military or to participate in warlike activities. Today, there are a total of 231,000 members, excluding the AMISH, who are considered an extremely CONSERVATIVE branch of this group. [After Dutch founder, 'Menno' Simons (1496–1561.]

Menominee Tribe of Indians v. United States (minorities) The SUPREME COURT DECISION (of 1968) stating that the federal policy of TERMINATION did end the status of the TRIBE and the assistance it received from the US government but did not affect the end of any special rights given to INDIANS in any TREATY signed between the years 1778 through 1871. The case involved the Menominee tribe which had accepted termination but wanted to keep the hunting and fishing rights that the US federal government had given it in a treaty made in 1854.

menorah (customs and traditions) A candelabrum with nine candle holders. It is a traditional JEWISH religious decoration which is lit and used to celebrate HANUKKAH. *Compare* CRECHE.

Meredith March Against Fear (minorities) During the CIVIL RIGHTS MOVEMENT era, a long march (June 5–26, 1966) from Memphis, Tennessee to Jackson, Mississippi (220 miles; 354 km) that signaled a move from NONVIOLENT ACTION to BLACK POWER. It began as a one-man march by JAMES MEREDITH but after he was shot and wounded (June 6) by a southern white man, it grew in size because various groups wanted to finish the march for Meredith while he recovered in the hospital. MARTIN LUTHER KING, JR., the SOUTHERN CHRISTIAN LEADERSHIP CONFERENCE, STUDENT NONVIOLENT COORDINATING COMMITTEE, CONGRESS OF RACIAL EQUALITY and hundreds of other citizens and CIVIL RIGHTS activists continued the march. In a speech given to reporters (June 16), STOKELY CARMICHAEL angered by the shooting and slow pace of nonviolent action, first spoke of the need for "Black Power" and the need for blacks to arm themselves with weapons.

Meredith, James Howard (people) (born in 1933) African-American CIVIL RIGHTS MOVEMENT activist and lecturer. He gained national attention in 1962 as the first black student to attend the still segregated (i.e., all-white) PUBLIC UNIVERSITY OF MISSISSIPPI despite the STATE Governor Ross Barnett's refusal and violent protests by angry white citizens. In 1966, Meredith organized and partially participated in the MEREDITH MARCH AGAINST FEAR. Since then, he has become a member of the REPUBLICAN PARTY and is a strong supporter of individual initiative. *See* BROWN V. BOARD OF EDUCATION OF TOPEKA, KANSAS.

merger (economy) A permanent, mutual joining of two businesses, usually to increase profits and to enter new markets. *Compare* DEMERGER, JOINT VENTURE.

Meriam Report, The (minorities) The official report (published in 1928 and some 872 pages) which was researched and prepared by a special committee to investigate the status of NATIVE AMERIcans, especially their health, education and economy. The report claimed that the conditions of INDIANS were "deplorable" and it blamed the BUREAU OF INDIAN AFFAIRS for the high infant death rate, poverty, malnutrition and poor SCHOOLS[1] among Indians. It recommended a reform of and increase in funding for the BIA as well as increased programs for Indian health and education. The full, formal title is *The Problem of Indian Administration*. It led to the INDIAN REORGANIZATION ACT. [After Dr. Lewis 'Meriam', the head of the committee.]

Met, the (1, 2 the arts) **1** The popular nickname for the METROPOLITAN OPERA COMPANY. **2** The popular nickname for the "Metropolitan Museum of Art", a very large, prestigious museum in Upper MANHATTAN[1] whose collections include paintings, sculptures and furniture from North America, Asia, Europe, the Middle East and South America. It is located in CENTRAL PARK. [Shortened form of 'Met'ropolitan, an adjective used to describe the large city of NEW YORK CITY.]

Methodist Church (religion) A PROTESTANT DENOMINATION which grew out of an attempt by John Wesley (1703–1791) in 1738 to bring a more personal involvement, response and spirituality to the Church of England. The first Methodist Church group established in America was in Baltimore in 1784. In general, members, **Methodists**, believe in the teachings of the Bible, SOCIAL ACTION and ECUMENISM. Because it believes in CONGREGATIONALISM[1], it has traditionally been a popular CHURCH[1,3] for whites and blacks who, in the past, developed their own separate CHURCHES[1]. Currently, there are 13.5 million total members in the US; and the largest groups are the United Methodist Church (8.6 million mostly white members), African Methodist Episcopal (AME) Church (3.5 million black members) and the African Methodist Episcopal Zion (AMEZ) Church (1.2 million black members). *See* EVANGELICAL.

Metropolitan Opera Company, the (the arts) The premiere, professional group, established in 1883, performing live, quality opera productions in NEW YORK CITY. It performs from September

through April at the Metropolitan Opera House, which is one of the buildings in the LINCOLN CENTER. It sponsors the opera music and chamber music orchestra festival at the NEWPORT FESTIVAL. It is popularly known as the "MET[1]".

Mexican-American War, the (foreign policy) A war fought for American MANIFEST DESTINY and to increase the land territory of the UNITED STATES. It was fought between the US and Mexico and grew out of disputes at the international border and because Mexico was not paying US claims. It began May 13, 1846, and ended February 2, 1848, with the TREATY OF GUADALUPE HIDALGO. Some 79,000 American men served in it; there were over 17,000 American deaths. It succeeded in increasing the land territory and population (mostly, Spanish-speaking) of the United States. *Compare* GADSDEN PURCHASE.

MFA (education) A type of MASTER'S DEGREE. [Abbreviation of 'M'aster of 'F'ine 'A'rts.]

MIA (military) A term used in the military to refer to those soldiers and ARMED SERVICES personnel who are reported 'missing' (not among the surviving individuals and not found among the deceased) after some military action. [Abbreviation of 'M'issing 'I'n 'A'ction.] *Compare* POW.

Miami (geography) The largest city in the STATE of Florida serving as its economic and immigration (largely from Cuba and Latin America) center. It is known for its warm weather, pastel-colored buildings and large hispanic population and cultures and the frequent usage of the Spanish language. It is also the COUNTY SEAT of DADE COUNTY. Currently, the population is over 2 million. Its oceanfront district, "Miami Beach", contains colorful Art Deco architecture and became popular among the wealthy in the 1950s and 1960s. *See* LITTLE HAVANA, FREEDOM FLIGHTS, MARIEL BOATLIFT.

Michigan Avenue (geography) In DOWNTOWN CHICAGO, the main street which has many tall, modern SKYSCRAPERS, upscale offices, chic boutiques and expensive shops. It runs parallel to Lake Michigan. Also known as the "MAGNIFICENT MILE"; *see* GREAT LAKES.

microbrewery (food and drink) A small beer brewery which produces a maximum of 20,000 barrels of beer a year. Often, the beers produced are only sold in a local area. When it is affiliated with a restaurant it is known as a "brewpub".

Mid-Atlantic, the (geography) A region of the UNITED STATES along the East Coast, which is south of NEW ENGLAND and north of the SOUTH. It includes five STATES (i.e., Delaware, Maryland, New Jersey, New York and Pennsylvania) and the DISTRICT OF COLUMBIA. *Compare* NORTHEAST.

mid-term (1 politics; 2 education) **1** A point of time reference which occurs halfway through a TERM[1]. **2** An examination given halfway through an academic TERM[2] in a SCHOOL[1], COLLEGE[3] or UNIVERSITY. [Shortened from 'mid'dle of the 'term'.]

mid-term election (politics) Any election for positions in CONGRESS that occurs at the mid-point of the PRESIDENT'S TERM[1], that is, two years after his or her election. Usually, fewer voters vote in this type of election than in the year of a presidential election. *Compare* OFF-YEAR ELECTION.

Middle America (society) A general term for mainstream America, referring to those people whose political and cultural ideas are not too LIBERAL, nor too CONSERVATIVE, but in the middle. It is often associated with the MIDWEST. *See* MODERATE.

middle class (society) A collective name for that group of people who earn about the same amount of money and thus are members of the same economic class. Usually, this group earns salaries which permit its members to live a "comfortable" life (it includes, teachers, business workers). *See* MAIN STREET.

middle manager (work) In business or industry, a manager of an office in the middle-rung position in the company. Usually, a member of the MIDDLE CLASS.

middle school (education) A SCHOOL[1] that provides ELEMENTARY SCHOOL-level education from GRADES[1] five or six to eight. *See* Appendix 4 Education Levels.

Midwest, the (geography) A political and geographical region in the middle west of the country, known for its industrial cities near the GREAT LAKES (e.g.,

DETROIT, CHICAGO, Pittsburgh, St. Louis) as well as its flat, rich land suitable for farming. Sometimes, it is considered as "typically American", economically oriented and realistic. ['mid'dle + 'west'.] *Compare* MIDDLE AMERICA, RUSTBELT, *AMERICAN GOTHIC*.

Miller, Arthur (people) (born in 1915) A playwright and scriptwriter known for his works which treat issues of personal honor and integrity in society, namely, *The Death of a Salesman* (1949), which won the PULITZER PRIZE and *The Crucible* (1953), both of which have been performed on BROADWAY. He was briefly married to MARILYN MONROE (1956–1961).

Miller, Glen (people) (1904–1944) Band leader, trombone player and JAZZ musician. He was a popular band leader of the BIG BAND ERA, especially with white audiences. His orchestra's theme song was "Moonlight Serenade". He is remembered for enlisting in the AIR FORCE in 1942 and entertaining US and allied troops during WORLD WAR II. He died in a plane crash, December 15, traveling over the English Channel toward Paris, France.

Milliken v. Bradley (education) The DECISION of the SUPREME COURT (of 1974) that slowed the practice of legal court-enforced BUSING stating that SEGREGATION was not always illegal. The case concerned DE FACTO segregation in the PUBLIC SCHOOLS of DETROIT, where blacks who lived in the city attended schools in the city, and whites who lived in the SUBURBS attended those in the suburbs. The decision stated that this type of de facto segregation was not illegal because it occurred by WHITE FLIGHT, not by DE JURE laws of the community.

Million Man March (minorities) On October 15, 1995, the rally of some 800,000 African-American men who gathered together to listen to speeches, register to vote, promote pride in black men and gain encouragement to take responsibility for themselves, their families and communities. It was called for by LOUIS FARRAKHAN who encouraged black men to find spiritual and personal strength. Although it was supported by the CONGRESSIONAL BLACK CAUCUS it was not supported by the NAACP. It was held on the MALL in WASHINGTON D.C. and is considered the largest rally and black demonstration in history. *Compare* MARCH ON WASHINGTON OF 1963.

Mills v. Board of Education of District of Columbia (education) An important, early court case (decided in 1972) which decided that HANDICAPPED children have a right to an education and that it is UNCONSTITUTIONAL to deny them that right. It stated that free PUBLIC SCHOOL services must be advertised and that public money must be spent equally and fairly for educational programs. *See* CONSTITUTION.

Minimal Art (the arts) An artistic movement of very large paintings which used bright colors, different shades of gray and basic geometric shapes to create patterns and the interplay of colors. It was popular in the 1960s and began after the POP ART movement.

minimum wage (work) The lowest hourly rate that must be paid to an employee (aged 16 or older and legally employed) so that he or she may have a basic standard of living. It was first established in 1938 by the FAIR LABOR AND STANDARDS ACT. In 1997, it was $5.15.

minor (1 education; 2 legal system) **1** In COLLEGE³, a secondary, optional field of study that an UNDERGRADUATE concentrates in which demands both fewer courses and CREDITS than the MAJOR. It is not required for graduation (e.g., his minor is philosophy). By association, an undergraduate person who is studying a minor (e.g., he is a philosophy minor). *Compare* MAJOR. **2** In legal language, a person who has not reached the (AGE OF) MAJORITY; because the precise age is set by each STATE it ranges from 17 or 16 years of age and younger. If a minor commits a crime, his or her case is tried in a JUVENILE COURT. In contexts of alcohol and gambling, it is used to refer to any person aged 20 and younger, that is, anyone who has not had a TWENTY-FIRST BIRTHDAY. *Compare* DEPENDENT, DRIVER'S LICENSE, SWEET SIXTEEN.

minor leagues, the (sports and leisure) A collective name for semi-professional league of over 170 BASEBALL teams and UMPIRES which perform live in smaller

cities. It was originally founded in 1877 and today has four classes of play: (highest) Triple-A (i.e., AAA also known as a "FARM TEAM"), Double-A (i.e., AA), Single-A (i.e., A) and Rookie (lowest). Also known as "the Minors" and the "BUSH LEAGUE"; *compare* MAJOR LEAGUES.

minority (minorities) In general, a group which traditionally did not have a large population (i.e., members) and thus did not have a powerful position in mainstream American society. Minority groups include: women, AFRICAN AMERICANS, gays and lesbians, NATIVE AMERICANS and DISABLED people. Specifically and sometimes, another name for an "ETHNIC MINORITY". *Compare* MODEL MINORITY.

minority (party), the (government) In the legislature, the political party that has the second highest number of elected members in that chamber. The HOUSE OF REPRESENTATIVES and the SENATE each select a MINORITY LEADER and WHIP. *Compare* MAJORITY PARTY.

Minority Business Development Agency (work) (MBDA) The federal agency and a division of the DEPARTMENT OF COMMERCE which helps businesses owned by all MINORITIES to overcome social and economic disadvantages in the past to start and operate well-run businesses and industries. In the past it has offered minorities money and long-term credit. It was founded by EXECUTIVE ORDER in 1969 by PRESIDENT RICHARD NIXON. Originally founded as, and until 1979 known as, the "Office of Minority Business Enterprise".

minority leader (government) The main spokesperson of the MINORITY PARTY who directs and organizes that political party in debates and discussions over legislation. He or she is chosen by fellow members of the minority party. There is one in the HOUSE OF REPRESENTATIVES and one in the SENATE. He or she is assisted by a WHIP. *Compare* MAJORITY LEADER.

minstrel show (the arts) During the nineteenth century, a common and popular form of live entertainment for white people. The show included acting and singing and usually traveled from city to city to perform. White actors portrayed black men. *See* JAZZ SINGER.

mint julep (food and drink) A cool, refreshing alcoholic drink made of BOURBON whiskey, sugar and finely crushed ice served in a frosted glass and decorated with a spearmint leaf. "Juleps" are a popular drink in the SOUTH and traditionally are drunk by racegoers at the KENTUCKY DERBY.

Minutemen (history) During the COLONIAL PERIOD, a group of volunteer colonials who supported the American cause and its independence from Great Britain by arming themselves and fighting against the British army before and during the AMERICAN REVOLUTION. These groups were found in Connecticut, Maryland, Massachusetts and New Hampshire. They kept guns in their homes and were trained to be prepared to fight within a 'minute'. *See* LEXINGTON AND CONCORD.

Miranda* v. *Arizona (legal system) The DECISION of the SUPREME COURT (1966) that the police must first tell or remind a person of his or her rights (listed in the FOURTH AMENDMENT and FIFTH AMENDMENT) before arresting that person for a crime. The case concerned Ernesto 'Miranda' (1940–1976) who, when being arrested for kidnapping and raping a girl, confessed to these crimes because he had not been advised that he could keep silent; his own confession was used to send him to jail for the crimes. *See* MIRANDA WARNING.

***Miranda* Warning, the** (legal system) The rights listed in the CONSTITUTION that a police officer tells a person while arresting that person because of suspecting him or her of a crime: "You have the right to remain silent; anything you say can be used against you in a court of law. You have the right to talk to a LAWYER before you make a statement and during any questioning. If you cannot afford a lawyer, one will be appointed to represent you before any questioning if you wish. You can decide at any time to exercise these rights and not to answer any questions or make any statements." [From *MIRANDA* v. *ARIZONA*.] *See* FOURTH AMENDMENT, FIFTH AMENDMENT.

misdemeanor (legal system) A minor type of crime. Each STATE decides the crimes it considers of this type, but usually

it includes shoplifting, car speeding tickets and small, petty theft. Often, it requires no trial and is punished by paying a money fine. It is not as serious as a FELONY.

Miss America Pageant (customs and traditions) An annual five-day beauty contest held in ATLANTIC CITY in which 51 young women (one from each STATE and one from the DISTRICT OF COLUMBIA) are judged by a panel in three areas; how they look in an evening gown and swim-suit and how they perform some talent (e.g., singing, dancing). It begins with a parade on the Tuesday after LABOR DAY and ends with the crowning ceremony on the following Saturday. The winner re-ceives a crown, an academic or training scholarship and the title and position of "Miss America" for one year. The theme song is "THERE SHE IS, MISS AMERICA".

Mission style (housing and architec-ture) A style of architecture originating in California and inspired by the colonial 'mission' buildings built there by the Spanish before 1848. It was especially popular as a style of private residence from 1890 to 1920. It is characterized by having walls made of stucco, roofs covered in red tiles and windows in an arched shape. Further, it has a covered porch or arcade. *See* TREATY OF GUADALUPE HI-DALGO; *compare* COLONIAL REVIVAL.

Mississippi River (geography) The longest river in North America stretching 2,340 miles long (3,770 km) and an important means of commercial transport in the MIDWEST. It is considered to be the physical separation between the east and the west of the UNITED STATES. Its nick-name is "Old Man River", after a song from the musical *Showboat* (1927). *See* NEW ORLEANS, CALL LETTERS.

Missouri Compromise, the (history) A Congressional law, passed in 1820, to compromise the different opinions held by people in the NORTH with those of people in the SOUTH, concerning the heavily debated issue of legalized SLAVERY in any of the new STATES of the US. It established a system by which the number of states where slavery was legal was equal to the number of states where slavery was illegal, by prohibiting slavery in any TER-RITORY organized north of the Missouri–

Arkansas border (i.e., 36° 30′). At the time of its passage, it accepted 'Missouri' as a slave-state (i.e., permitted legal slavery) and Maine as a free-state (i.e., forbade slavery) which kept the number of slave-states and free-states equal and therefore avoided a conflict between the states. It succeeded in temporarily keeping the UNI-TED STATES one country, but only post-poned the CIVIL WAR for some 30 years. *Compare* KANSAS–NEBRASKA ACT.

Mister Charlie (society) A term, usually, pejorative, used by some AFRICAN AMER-ICANS to refer to white men (specifically) or white people (in general).

mistletoe (customs and traditions) Cut and dried branches of the plant (*Viscum album*) with cream-colored berries that is hung overhead from the door frame and used to decorate the home in celebration of CHRISTMASTIME. According to tradition, it has a strong romantic power over those who stand under it, encouraging those people to kiss each other. Because the plant traditionally grows in Europe, many Americans often use a branch of shiny green-leafed holly (genus *Ilex*) with red berries instead.

mixed economy (economy) An econ-omy where products and services are produced and provided by private busi-nesses (e.g., MA BELL) as well as by the government (e.g., US Postal Service). The UNITED STATES has a somewhat mixed economy. *See* PRIVATE SECTOR, PUBLIC SECTOR.

mixed media (the arts) Describing an oil or acrylic painting or sculpture which includes everyday objects (e.g., newspa-pers, photographs, etc. attached to it). By association, describing any material mix-ture, designed to be displayed, consisting of different materials.

mixed-blood (Indian) (minorities) A person whose heritage includes both IN-DIAN and European ancestors.

Moby Dick (the arts) A long book (some 900 pages) about the voyage of a whaling ship, its shipmates and its captain; how-ever, due to Captain Ahab's fascination with one particularly powerful, white-colored whale (named 'Moby Dick'), the voyage turns into a quest to find and kill this animal because, on an earlier voyage,

Ahab had lost his leg to the whale. This book, first published in 1851, is considered the masterpiece of HERMAN MELVILLE and an important tragic American novel. The book begins with the seaman-narrator's request: "Call me Ishmael." *See* AMERICAN RENAISSANCE.

model minority (minorities) A term describing a "successful" minority group, meaning its members have FAMILY VALUES, steady jobs, earn good salaries, perform well in academic programs and successfully graduate from HIGHER EDUCATION institutions. Further, these members do not often rely on welfare programs or commit crimes. It has frequently been used to refer to ASIAN AMERICANS.

Model T (transportation) The simple, four-cylinder black-colored car mass-produced by the Ford Motor Company from 1908 through 1927. It was the first car assembled by a fast-working, efficient assembly line which succeeded in lowering its price and making it a very popular automobile among the wealthy and the MIDDLE CLASS. Over 15 million were produced. *See* HENRY FORD.

moderate (politics) A term used to describe a political view or person that is in the middle (i.e., not extreme). **Moderates** hold political ideas that are combinations of DEMOCRAT and REPUBLICAN thought. *Compare* RIGHT, LEFT.

Modern Language Association (of America) (the arts) (MLA) The premier organization, founded in 1883, promoting the study of the English language and literature from the UNITED STATES and other English-speaking countries. It is based in NEW YORK CITY, and sponsors a variety of seminars and meetings across the country for its current 31,000 members.

Modern Maturity (media) A popular magazine published once every two months for members of AARP; it is designed for people aged 50 and older, and contains articles on health, travel, news and any information concerning SOCIAL SECURITY and retirement. It was founded in 1958 and currently has the largest circulation of any American magazine: 20.5 million.

mojado (immigration) A person, usually from Mexico or Latin America, who enters the UNITED STATES without legal immigration papers. "Mojado" is less pejorative than "WETBACK". [Spanish, literally meaning "wet one" because some of these immigrants enter the US by crossing the RIO GRANDE.] *See* OPERATION WETBACK.

Mojave Desert (environment) A large, dry desert located in southern California that has moon-like landscapes. Its territory includes DEATH VALLEY and the JOSHUA TREE NATIONAL MONUMENT and EDWARDS AIR FORCE BASE.

mom-and-pop (work) Describing a small shop, restaurant or other business which is owned and operated by members of the same family. [After the 'mother' and 'father' who own the business.]

MoMA (the arts) An acronym for the Museum of Modern Art in NEW YORK CITY, established in 1926, which owns a very large, prestigious collection of European and American paintings and sculptures from the late nineteenth and twentieth centuries, namely, impressionism, cubism and POP ART.

Momaday, N. Scott (people) (born in 1934) A Kiowa INDIAN member and Native American writer known for his books which treat themes of personal identity, feelings of not belonging, connections to history and nature. His works include, *House Made of Dawn* (1968) which won the PULITZER PRIZE, *The Return to Rainy Mountain* and *The Names* (1976).

money market (economy) A type of short-term financial investment where several individuals deposit money into a fund which is then used to buy stocks and bonds, which will pay its investors back within a period of one year or less.

monopoly (economy) A company or group of companies controlling the selling and supply of particular goods and services in order to make as much money as possible (i.e., it has no business competitors). Because there is no competition, prices are high, quality is not important (and may be poor) and consumers' needs are unimportant. The FEDERAL TRADE COMMISSION tries to limit monopolies.

See ANTITRUST LAWS, ROBBER BARONS, MA BELL.

Monroe Doctrine, the (foreign policy) The foreign policy belief and practice that the UNITED STATES considers Latin America to be within its American region of influence and will not accept interference from European countries or other world powers (e.g., the former Soviet Union) in these areas. It has been a major part of US foreign policy in the western hemisphere since it was first presented in 1823. [After PRESIDENT James 'Monroe' (1758–1831) who declared this concept.] *Compare* ROOSEVELT COROLLARY.

Monroe, Marilyn (people) (1926–1962, originally Norma Jean(e) Mortenson Baker) Actress. Her physical attractiveness and open sexuality made her a popular star in HOLLYWOOD[2] movies, namely in *Gentlemen Prefer Blondes* (1953) and *Some Like it Hot* (1959). She was married to JOE DIMAGGIO in 1954 then to ARTHUR MILLER (1956–1961). While still young, she died of a drug overdose.

Monterey Jack (food and drink) A semi-soft, yellow cheese made of whole milk and often used in baked cheese dishes (e.g., lasagna, omelets, casseroles). [After David 'Jacks' of 'Monterey', California who first created this cheese.]

Montgomery bus boycott (minorities) In Montgomery, Alabama, the successful boycott by blacks of segregated buses which started the popular interest and DIRECT ACTION tactics of the CIVIL RIGHTS MOVEMENT. It began when ROSA PARKS was arrested (December 1, 1955) for violating the JIM CROW LAWS by sitting in that section of the city bus reserved for whites. In response, MARTIN LUTHER KING, JR. formed the MONTGOMERY IMPROVEMENT ASSOCIATION. The boycott began on December 4, 1955, and lasted 382 days. It ended on December 21, 1956, after the SUPREME COURT and the US DISTRICT COURT decided that segregated public transportation is illegal. *See* FOURTEENTH AMENDMENT; *compare BROWN V. BOARD OF EDUCATION OF TOPEKA, KANSAS,* NAACP, "SEPARATE BUT EQUAL".

Montgomery Improvement Association (minorities) (MIA) The CIVIL RIGHTS group created to organize the 1955–1956

MONTGOMERY BUS BOYCOTT in Alabama. It was responsible for promoting the boycott among the local black population, coordinating alternative rides for blacks throughout the city and carpooling. It was established by MARTIN LUTHER KING, JR. and Ralph Abernathy (1926–1990) in December 1955 and at the successful end of the boycott it was dissolved. It served as the forerunner group to the SOUTHERN CHRISTIAN LEADERSHIP CONFERENCE.

Monticello (housing and architecture) The elegant, permanent residence of THOMAS JEFFERSON which is made of red brick and highlighted with white-colored, Greek-styled columns and tympanums. Jefferson designed the structure (in 1769) after a model of Andrea Palladio (1508–1580; a late-Renaissance Italian architect) and continually adapted it for over 40 years. The house, located in Charlottesville, Virginia, is admired for its elegant simplicity, beauty and stateliness. [Italian, meaning "little mountain".]

Monument Valley (environment) In the SOUTHWEST, a unique, flat, landscape punctured by naturally-made, orange-colored sandstone pillars and rock formations (e.g., "the Mittens"). This area, which is commonly seen in WESTERNS, is found in the Arizona–Utah border region and is on NAVAJO-controlled territory.

Moody's Investment Service (economy) An independent agency that analyzes and rates the stocks and bonds of companies and reports this information to investors. The ratings from the safest and highest are Aaa, Aa, A, Baa, Ba, B, Caa, Ca and C is the lowest rating.

Moonies, the (religion) The popular name for the members of the religious sect known as the UNIFICATION CHURCH. [After the religious leader, Mr. Sun Myung 'Moon' (born in 1920).]

moonlighting (work) A colloquial term for a second job. [During the nineteenth century, when work, usually illegal, was done at night by the 'light' of the 'moon'.]

moonpie (food and drink) A sweet snack consisting of a MARSHMALLOW sandwiched between two COOKIES which are coated in a flavored frosting (e.g., chocolate, banana, coconut).

moonshine (food and drink) A type of homemade, colorless whiskey with a high alcoholic content made of corn, water, sugar and yeast which is not aged. By association, it means "nonsense". [During PROHIBITION, when individuals made it in secret at night, by the 'shining' light of the 'moon'.]

moot (legal system) A term describing a legal case or point which is open to controversy or discussion. A "moot point" is considered arguable.

Moral Majority (religion) A group with beliefs supporting FUNDAMENTALISM, organized to promote CONSERVATIVE political issues and do FUND-RAISING for politicians, especially those supporting PRO-LIFE and FAMILY VALUES. It actively lobbied against abortion rights, the WOMEN'S MOVEMENT, feminism and pornography. It was active from 1979 to 1989 and led by Jerry Falwell (born in 1933), a BAPTIST minister from the SOUTH. It was a powerful group of the RELIGIOUS RIGHT and supported PRESIDENT RONALD REAGAN. *See* LOBBY.

Moran, Thomas (people) (1837–1926) Painter of the HUDSON RIVER SCHOOL. His oil paintings were made on large pieces of canvas and depicted the wide and wild expanses of pure, untouched nature in the WEST. Typically, he placed small figures of people in the painting to show the large size and grandeur of the natural landscapes. His paintings of YELLOWSTONE encouraged officials to make it a NATIONAL PARK.

Moravian Church (religion) Members of an independent PROTESTANT DENOMINATION which began in the present-day Czech Republic in 1457 and was brought to AMERICA[1] (largely to Pennsylvania where people often lived in COMMUNES) through immigration in the 1720s. Members, **Moravians**, are characterized by working as missionaries and refusing to fight in wars, take oaths or obey US government orders (e.g., the DRAFT[1]). Currently, there are 51,800 members in the UNITED STATES.

Morehouse College (education) An elite, private, LIBERAL ARTS COLLEGE for 3,000 African-American men in ATLANTA, Georgia. It was founded in 1867 as a BLACK COLLEGE to provide HIGHER EDUCATION to black men. *See* PRIVATE SCHOOL.

Mormon (religion) A popular name for a member of the CHURCH OF JESUS CHRIST OF LATTER-DAY SAINTS. [From the members' respect for and belief in the *Book of Mormon* (1835) which they believe to have been originally written and edited by a figure named 'Mormon'.]

Mormon Tabernacle Choir (religion) The amateur, musical group (of some 300 men and women) sponsored by the CHURCH OF JESUS CHRIST OF LATTER-DAY SAINTS which sings GOSPEL MUSIC, spiritual and FOLK MUSIC songs in a harmonic and melodic manner. It gives weekly radio broadcasts from the MORMONS' Great Tabernacle in SALT LAKE CITY and also travels, performing in live concerts.

Mormon Trail (religion) The cross-country migration route from Nauvo, Illinois, to SALT LAKE CITY in the present-day STATE of Utah, in which over 16,000 members of the CHURCH OF JESUS CHRIST OF LATTER-DAY SAINTS took part from 1846 to 1852 to escape religious persecution.

Morrill Act (1862) (education) The important federal act (passed in 1862) that promoted HIGHER EDUCATION at the STATE level by setting aside 17 million acres (6.8 million hectares) of land in various STATES in the NORTH which was later sold to pay for the establishment of public institutions of education. This act established 69 HIGHER EDUCATION institutions, most of which taught agricultural and mechanical training. Today, these COLLEGES[1] are large, research-oriented STATE UNIVERSITIES. A "second Morrill Act" in (1890) extended this act to southern states to help develop BLACK COLLEGES. [After Justin 'Morrill' (1810–1898), the CONGRESSMAN from Vermont who sponsored this BILL[2].] *See* CORNELL UNIVERSITY, HOWARD UNIVERSITY, MASSACHUSETTS INSTITUTE OF TECHNOLOGY, OHIO STATE UNIVERSITY.

Morrison, Toni (people) (born in 1931, as Chloe An'thony' Wofford) African-American writer and educator. She is respected for her popular works of fiction which present unique, usually uplifting stories, full of African-American characters and history. Some of her works

include: *Song of Solomon* (1977), treating a young man's search for his family history, which won the NATIONAL BOOK CRITICS' CIRCLE AWARD; and *Beloved* (1987), presenting the story of a female slave and her child. She won the Nobel Prize for literature in 1993.

Moses, "Grandma" (people) (1860–1961, original name was Anna Mary Robertson Moses) African-American painter of FOLK ART. Her career as a painter began after her 70th birthday. Her paintings are characterized by showing everyday scenes of rural life in the nineteenth and twentieth centuries (e.g., picnics, farms), having a large number of figures and giving minute, cultural details. Most of her works were painted on wooden board.

most-favored nation (economy) (MFN) In international trade, a foreign country that can import its products to the UNITED STATES without high tariffs; and vice versa. This status is agreed upon by a commercial TREATY between the two countries. The decision of the United States to give MFN status to its trading partners often reflects US approval of that country's form of government (e.g., democratic) or human rights policies (e.g., not using prisoner labor to make products for export). Actually, it is merely "normal trade relations" between the US and another country. *See* GATT.

motor-voter bill (politics) The federal law which allows American citizens to register to vote at the same time and place that they renew their DRIVER'S LICENSE. It was passed in 1993 with the aim of increasing voter participation on all future ELECTION DAYS. It was a popular BILL[2] and has proven a successful law; by 1995, it had 5 million new registered voters. Formally known as the "National Voter Registration Act"; *see* VOTER REGISTRATION.

Mother's Day (customs and traditions) The second Sunday in May when children thank and honor their mothers by giving them flowers, plants, GREETING CARDS or treating them to a special breakfast, LUNCH or DINNER. It was OBSERVED[2] nationwide for the first time in 1911. *Compare* FATHER'S DAY.

Motion Picture Association of America (the arts) (MPAA) The largest organization, founded in 1922, for producers and distributors of movies and entertainment videos. It contains the Ratings Administration which sets and enforces the classifications for the movie RATING SYSTEM[2]. Formerly known as the "Motion Picture Producers and Distributors of America"; *compare* HOLLYWOOD PRODUCTION CODE.

motor home (transportation) A type of recreational vehicle composed of a self-contained cabin with sleeping and eating facilities and utilities (e.g., kitchen, toilet) which many people use for vacationing. Also known as "mobile home"; *see* RV; *compare* TRAILER PARK.

Motown (geography) The popular nickname for DETROIT, which has been the most important center and the largest car-producing city in the US since the early 1900s. Further, it is the headquarters of the UNITED AUTO WORKERS. ['mo'tor (meaning "car") + 'town'.]

Motown music (the arts) A collective name for a type of smooth, danceable, party music characterized by group singing, harmonized voices and hand clapping by black male and/or female groups. It was very popular among black and white listeners from 1959 until the late 1960s. This music was promoted and recorded by the black-owned and black-controlled music recording company, named "Motown" (founded by an African-American car factory worker, Berry Gordy III, born in 1929) which was based in DETROIT (1959–1971) and now is located in LOS ANGELES (since 1972). Also known as the "Motown sound". [After the company's original location in DETROIT, also known as 'MOTOWN'.]

Mound Builders, the (people) A general name for any of the various ancient Native American groups living east of the MISSISSIPPI RIVER between 800 A.D. and 1500 A.D. which constructed large hills or 'mounds', and incorporated them into their villages. Archeological excavations of the twentieth century of these mounds and written reports of Spanish explorations during the sixteenth century of these areas reveal that these peoples had an

advanced, ritualistic, agricultural society which used the grass-covered mounds for religious and/or ceremonial purposes.

Mount McKinley (environment) The popular name for the tallest mountain and highest point in the UNITED STATES; it measures 20,320 feet tall (6,193.5 m) and is found in Alaska. [Named by white explorers after William 'McKinley' (1843–1901), then governor of Ohio, and later US PRESIDENT (1897–1901).] Also known as "DENALI". *Compare* DEATH VALLEY.

Mount Rushmore (environment) An enormous sculpture presenting the busts of PRESIDENTS (from left to right) GEORGE WASHINGTON, THOMAS JEFFERSON, ABRAHAM LINCOLN and THEODORE ROOSEVELT, carved from a granite stone mountain in the southern part of the BLACK HILLS in South Dakota.

Mount St. Helens (environment) A tall (8,363 feet; 2,549 m), active volcano in Washington STATE. Its most violent eruption was in 1980 in which it spewed ash and lava over surrounding areas killing 57 people and countless animals and wild plants. It encouraged environmentalist groups to study the destruction and regeneration of plant and animal life. It had a smaller eruption in 1991. *See* ENVIRONMENTAL MOVEMENT.

Mount Vernon (housing and architecture) The well-tended private residence and large estate of GEORGE WASHINGTON located in the STATE of Northern Virginia. During his lifetime, it was a working plantation with slaves. Today it is a museum open to the public. *See* SLAVERY.

Mountain (Standard Time) (daily life) (MST) The clock time of those geographical areas located in the ROCKY MOUNTAIN region, including Denver. It corresponds to the Mountain time zone. It is two hours later than EASTERN STANDARD TIME.

Mrs. O'Leary's Cow (geography) According to tradition, the Great Fire of CHICAGO, October 8–11, 1871, in which the majority of the city was destroyed, started when the milking cow owned by Mrs. O'Leary kicked over the oil lamp that that woman was using to see to her CHORES. Because many of the city's buildings were then made of wood, the fire

quickly spread and destroyed the majority of buildings. Today, Chicago is known for its modern architecture. By association, a small, local action which produces a great, far-reaching and often terrible result.

MS (education) A type of MASTER'S DEGREE. [Abbreviation of 'M'aster of 'S'cience.]

Ms. (1 language; 2 media) **1** A form of address used before the family name (i.e., last name) of a woman. It is preferred by many women because it does not indicate if she is married (i.e., Mrs.) or single (i.e., Miss). **2 *Ms.*** (media) A magazine published once every two months, presenting a feminist perspective on current political, social and business issues. It was co-founded in 1972 by GLORIA STEINEM and was the first magazine to present material and information for working women who were FEMINISTS. In 1990, it was reorganized without any commercial advertising. Its current circulation is 160,000. *See* COMMERCIAL, FEMINIST MOVEMENT, WOMEN'S MOVEMENT.

MTV (media) A cable television channel established in the US in 1988, which broadcasts daily, 24 hours a day, TV videos of music songs (i.e., "music videos"), interviews with music stars, TV programs on fashion and trends which are interesting for teenagers and other members of youth culture. It is hosted by a VJ *see* DJ).

muckraking (media) A style of writing newspaper and magazine articles, designed to report to the public problems in government or society and to encourage changes and reform, often in an enthusiastic or aggressive manner. **Muckrakers** were most active during the PROGRESSIVE ERA. [From a comment by THEODORE ROOSEVELT who equated these tactics to the character the "Man with the 'Muckrake'" in the novel *Pilgrim's Progress* (1684) by Englishman, John Bunyan (1628–1688).] *See* NEW JOURNALISM[3]; *compare* YELLOW JOURNALISM.

muffin (food and drink) A small, round-topped QUICK BREAD of a single helping made of flour, bran and a variety of different possible flavors (e.g., fruit, nut) baked in a pan and eaten with butter, CREAM CHEESE or SOUR CREAM for breakfast,

LUNCH or a snack. *Compare* CUPCAKE, ENGLISH MUFFIN.

Muhammad, Elijah (people) (1896–1975, born Elijah Poole) African-American religious leader of the NATION OF ISLAM. After meeting the founder of the BLACK MUSLIMS in the early 1930s, he converted to that faith and in 1934 he took over its leadership and became known as the "Messenger of Allah" or "Supreme Minister of the Nation of Islam". He believed in separate self-sufficiency for AFRICAN AMERICANS and the need for BLACK NATIONALISM. He expelled MALCOLM X from the Black Muslims.

Muir, John (people) (1838–1914, born in Scotland) An American naturalist and writer concerned with the preservation of natural and wild places in North America. He helped push CONGRESS to make YOSEMITE a NATIONAL PARK, encouraged THEODORE ROOSEVELT to buy land for forest reserves and he himself founded the SIERRA CLUB.

multiculturalism (immigration) A social theory believing that all groups should retain their uniqueness (e.g., respecting the different racial, ethnic, religious and gender (i.e., "women") groups in American society) and wanting to preserve them, especially by teaching others about the language, history and cultures of these immigrant groups and MINORITIES. It became popular on COLLEGE[1] and UNIVERSITY CAMPUSES during the mid-1980s. Supporters of this view believe it to be a more accepting view of the reality of the US than that of the MELTING POT. Critics of this theory claim that it hurts American society because it favors individuals and smaller groups over the larger society. *See* POLITICALLY CORRECT.

multiple-choice (education) Describing a common type of written, standardized examination where each question is followed by three or more possible answers from which the test-taker must choose one. This type of test is a common format for tests.

Murphy Brown (customs and traditions) The title character and working news ANCHOR of the popular television SITCOM SERIES who, in several show episodes in 1992, decided to get pregnant, have and raise a child alone without asking the father of the baby (her ex-husband) to help raise the child. She is a symbol of working women and independence. *Compare* FAMILY VALUES.

Museum Mile (the arts) A general name for that area of a city where the museums and buildings for the cultural and performing arts are located. In NEW YORK CITY, that part of FIFTH AVENUE running parallel to CENTRAL PARK on the Upper East Side of MANHATTAN[1] is called "Museum Mile". *See* GUGGENHEIM MUSEUM, MET[2].

musical (the arts) A professional, organized form of entertainment which uses acting, music, singing and dance to tell a story (either live or on film). Usually, it uses everyday (i.e., English) language and romantic themes. It developed in the 1930s out of the European operetta and the American VAUDEVILLE traditions; today, it is popularly produced on BROADWAY. Its full name is "musical comedy". *See* ROGERS AND HAMMERSTEIN, LERNER AND LOWE.

mutual fund (economy) A type of investment in which an individual supplies the money and the investment group or company invests that money into a diverse group of securities for that individual. Also known as a "mutual".

mutual savings bank (economy) A type of savings bank common in the NORTHEAST that is owned by and operated for the various people who deposit money into it. *Compare* CREDIT UNION.

MVP (sports and leisure) An award given to the outstanding player of an amateur, INTERCOLLEGIATE or professional team. The professional sports award the following trophies to honor players playing well all season: AMERICAN LEAGUE (since 1922); NATIONAL LEAGUE (since 1924); the NHL offers the Hart Memorial Trophy (since 1923); the NFL offers the Jim Thorpe Trophy (since 1955); and the NBA offers the Maurice Podoloff Trophy (since 1956). Also, an MVP award is distributed to a player for good playing during the championship tournament in the NBA and NHL and for the SUPER BOWL in the NFL. [Abbreviation of 'M'ost 'V'aluable 'P'layer.]

"My Country 'Tis of Thee" (customs and traditions) The first line of the song "AMERICA"[2] and a popular title for this song.

My Lai massacre (foreign policy) During the VIETNAM WAR, the killing of over 400 defenseless Vietnamese civilians by the 23rd Infantry Division of the US ARMY on March 16, 1968; these killings were ordered by Second Lieutenant William Calley. After INVESTIGATIVE REPORTING, the news reportage of this event in November 1969 shocked the American public for its cold-bloodedness. Calley was court-martialed for his leadership in the event and served a prison term from 1971 to 1975. *See* COURT-MARTIAL.

"My Old Kentucky Home" (customs and traditions) A slow song, written by STEPHEN FOSTER, whose lyrics remember the earlier, happy times of life in the STATE of Kentucky. During the festivities of the KENTUCKY DERBY and before the horse race itself, many of the racegoers sing this song. The refrain is: "Weep no more, my lady, oh! Weep no more today! We will sing one song for the old Kentucky home, for the old Kentucky home far away."

N

NAACP (minorities) The oldest, largest and most respected national CIVIL RIGHTS organization. It uses the US legislatures, legal court system and legal DECISIONS to help blacks achieve full equality and integration in American society. It was founded in 1909 by a biracial group of intellectuals, including W.E.B. DU BOIS, with the belief that AFRICAN AMERICANS deserve equal rights in the US and the full, legal protection of those rights, especially concerning voting for black men and women and ending DISCRIMINATION. Over the years it has won many legal cases by proving the illegality of: the GRANDFATHER CLAUSE[1] (1915); the PRIMARY ELECTION only for white voters (1927); and SEGREGATION laws in housing (1935). In 1939 it established the NAACP LEGAL DEFENSE AND EDUCATION FUND (NAACP-LDF) to continue this work. It publishes the *CRISIS* and serves as a spokesman for the MODERATE African-American community. It supported the MARCH ON WASHINGTON OF 1963 but did not support BLACK POWER, the BLACK PANTHERS nor the MILLION MAN MARCH. Currently, it remains a strong organization and counts 400,000 members. [Abbreviation of 'N'ational 'A'ssociation for the 'A'dvancement of 'C'olored 'P'eople.] *Compare* NIAGARA MOVEMENT.

NAACP Legal Defense and Education Fund (minorities) (NAACP-LDF) The LEGAL DEFENSE FUND of the NAACP which is committed to defending the CIVIL RIGHTS of AFRICAN AMERICANS through legal LAWSUITS, especially concerning voting rights, education and criminal justice. Some of its most important cases include: outlawing transportation SEGREGATION laws (1946) and outlawing segregation in PUBLIC SCHOOLS (1955). Its most famous success was the *BROWN V. BOARD OF EDUCATION TOPEKA, KANSAS* decision in 1955 which helped start the modern CIVIL RIGHTS MOVEMENT. It also legally defended ROSA PARKS after her arrest, which succeeded in ending segregation in public city buses (1956). It was founded in 1939, is staffed by ATTORNEYS and is an independent division of the NAACP. *See* THURGOOD MARSHALL, MONTGOMERY BUS BOYCOTT.

Nader, Ralph (people) (born in 1934) A LAWYER and activist who has made a career out of promoting the rights of consumers and the duties of companies to produce quality products. He has been most active in promoting changes in the car industry (e.g., car safety, seat belts, blinking hazard lights) and the meat industry.

NAFTA (economy) An international trade agreement to abolish tariffs and investment restrictions between Canada, Mexico and the UNITED STATES. It was signed in 1994 and thus created the world's largest (i.e., in the number of consumers and in the size of the land mass) free trade zone. Most of its elements will be in place and functioning between 2000 and 2005.

[Acronym of 'N'orth 'A'merican 'F'ree 'T'rade 'A'greement.]

Naismith, James, Dr. (people) (1861–1936) Director of the YMCA in SPRING-FIELD, Massachusetts and creator of BAS-KETBALL. He is known for creating the sport of BASKETBALL (in 1891) and writing the game's rules in order to give young men an indoor activity that would keep them physically active after the FOOTBALL season ended and before the BASEBALL season started. *See* HALL OF FAME.

Napa Valley (geography) One of the premiere and most popular areas of the wine-making region known for its very suitable climate in the STATE of California. It is located north of SAN FRANCISCO and is a popular attraction for wine tasters and other tourists.

NASA (science and technology) The independent federal agency responsible for conducting the research and building the technology for space tests and exploration. It was created in 1958; its successful ventures include: APOLLO PROJECT and the SPACE SHUTTLE. The NASA Space Center is located 25 miles (40 km) south of Houston, Texas. [Acronym from 'N'ational 'A'eronautics and 'S'pace 'A'dministration.] *See* SPACE RACE, CAPE CANAVERAL, *CHALLENGER* DISASTER.

NASCAR (sports and leisure) The organization founded in 1947 to govern the rules and organize tournaments for stock-car racing. It sponsors the DAYTONA 500 and the WINSTON CUP. Its headquarters are in Daytona, Florida. [Abbreviation of 'N'ational 'A'ssociation for 'S'tock-'C'ar 'A'uto 'R'acing.] Also spelled "Nascar".

NASDAQ (economy) A national, computerized network listing the prices of stocks and bonds which dealers use in order to buy and sell them OVER-THE-COUNTER. It lists the stocks and bonds of many technology-oriented businesses. This is the major method of trading OVER-THE-COUNTER. [Abbreviation of 'N'ational 'A'ssociation of 'S'ecurities 'D'ealers 'A'utomated 'Q'uotation.] *Compare* NEW YORK STOCK EXCHANGE, CHICAGO BOARD OF TRADE.

NASDAQ indexes (economy) A composite listing which averages the trading prices of more than 3,000 American OVER-THE-COUNTER companies. It is used as an indicator to measure over-the-counter prices specifically, and the strength of the market in general. It is based on indexes covering banks, industrial companies, insurance companies, transportation companies, utilities and other financial institutions. [Abbreviation of 'N'ational 'A'ssociation of 'S'ecurities 'D'ealers 'A'utomated 'Q'uotation + 'index'.]

Nashville (geography) The capital city of the STATE of Tennessee, originally founded in 1779, with a current population of 505,000 people. It experienced economic growth after the development of the TVA in the 1930s. Since the 1940s, it has been the capital of the music writing and recording industry, the center of the COUN-TRY AND WESTERN MUSIC scene and home to the GRAND OLD OPRY. By association, COUNTRY MUSIC. *Compare* BRANSON.

Nat Turner's rebellion (history) The local slave rebellion in the STATE of Virginia during August 1831 in which black slaves escaped from SLAVERY and murdered 57 whites. US military troops responded by killing 100 blacks and capturing the leader, Nathanial Turner (1800–1831), an escaped black slave, whom they tried in a legal court and hanged for treason. This rebellion encouraged the ABOLITION movement among people in the NORTH and illustrated the frustration and anger of blacks under this system of slavery.

Nation at Risk, A (education) The DEPARTMENT OF EDUCATION's landmark report (published in 1983) that shocked Americans by detailing the poor condition of the PUBLIC SCHOOL education system in the US compared with those in foreign countries and concluded that the US was 'at risk' of losing its economic and trade power status in the world. The report demanded greater excellence in ELEMEN-TARY SCHOOL and SECONDARY SCHOOL curricula and more challenging standards for teachers and students. Its full title was "*A Nation at Risk: the Imperative for Educational Reform*".

Nation of Islam, the (religion) An African-American religious group promoting BLACK NATIONALISM which is based on the writings of ELIJAH MUHAMMAD and

some of the teachings of Islam, although it is not a part of the larger religion of Islam. It was founded in DETROIT in 1930 by Wali Farad (c. 1877 to c. 1934) but increased its membership (to 500,000 in 1963) under the leadership of Elijah Muhammad. Muhammad's lieutenant, MALCOLM X, had a noticeable enthusiasm and excited preaching style which succeeded in recruiting many new members in the 1960s. In general, its members believe that blacks are superior to whites (whom they regard as evil) so the races must remain separate from each other. It encourages its members to be disciplined and to respect religious authority figures; it demands that its members drink no alcohol and take no drugs. Today, there are some 20,000 members, its headquarters are in Chicago at Temple #1 Further, it has various "temples" in other cities; Harlem Temple #7 and Detroit Temple #2 have many members. Popularly known as the "BLACK MUSLIMS"; *see* LOUIS FARRAKHAN, FRUIT OF ISLAM, CIVIL RIGHTS MOVEMENT.

Nation, The (media) A weekly magazine publishing well-written articles on political and cultural issues and the arts. It has a reputation for publishing EDITORIALS and covering subjects which are more LEFT than MODERATE. It was founded in 1865 by former abolitionists and its current circulation is 79,000. *See* ABOLITION.

national anthem, the (customs and traditions) Since 1931, the official name for the song, the "STAR-SPANGLED BANNER"; the official song of the UNITED STATES OF AMERICA. This song is played and sung before all sporting events, professional and amateur, across the country.

National Audubon Society (environment) (NAS) A private conservation group organized in 1905 to preserve and repair natural environments and to protect wild birds and other animals. It publishes a bimonthly magazine *Audubon* and is an active group in the ENVIRONMENTAL MOVEMENT. Its headquarters are in NEW YORK CITY and it counts 520 local groups and 600,000 total members. [For JOHN JAMES 'AUDUBON', the naturalist and painter.]

National Basketball Association (sports and leisure) (NBA) The organization founded in 1946 to establish the rules for the professional sport of BASKETBALL, namely, scheduling, players and tournaments. It is composed of 29 total member teams which are arranged into two conferences: Eastern Conference (consisting of Atlantic Division and Central Division) and Western Conference (consisting of Midwest Division and Pacific Division). It is headed by the Basketball COMMISSIONER and awards the Maurice Podoloff MVP Trophy (since 1956) and ROOKIE OF THE YEAR award (since 1952). By association, professional basketball. *See* NBA WORLD CHAMPIONSHIP SERIES, Appendix 3 Professional Teams.

National Book Awards, the (the arts) Prestigious, annual awards (since 1950) and prize money given to writers who are American citizens to honor them for outstanding work in the field of writing. Awards are given in the categories of fiction, nonfiction, poetry, biography and others. The awards are distributed every November in NEW YORK CITY by the National Book Foundation; currently, the prize money is worth $10,000.

National Book Critics Circle Award, the (the arts) (NBCCA) A prestigious, annual award given to writers to honor them for work in one of several fields of writing, namely: fiction, nonfiction (auto)-biography, poetry and criticism. Finalists may be picked by a 500-member 'circle' of readers; however, the winners are finally selected by a 24-member board of 'critics'. The winning authors are announced every March and it was first awarded in 1975. Before 1998, it was only awarded to American writers.

National Conference of Christians and Jews (religion) (NCCJ) A group consisting of LAY individuals from all religions and DENOMINATIONS (e.g., JEWISH people and non-Jews) who present educational programs together in order to eliminate all DISCRIMINATION based on religious beliefs. It was founded in 1928 originally as a method to stop ANTI-SEMITISM.

National Congress of American Indians (minorities) (NCAI) The oldest, nationwide pan-Indian organization of INDIANS which works to help all Indians, both living in urban areas and tribal

RESERVATIONS. It protects Indian rights and traditional ways by filing cases in the legal system and defending Indians' CIVIL RIGHTS in the courtroom. During the 1960s, it was criticized for focusing too much on the needs and problems of Indians living in urban areas. In the past, it did not support TERMINATION, the ALCATRAZ OCCUPATION, nor WOUNDED KNEE II. It was founded in 1944 in Denver and currently counts members from 200 different tribes. *Compare* NATIONAL TRIBAL CHAIRMAN'S ASSOCIATION, NAACP.

national convention (politics) The four- or five-day-long meeting of a political party held once every four years in July or August which marks the official beginning of the election campaign for PRESIDENT. At this meeting its DELEGATES from the 50 STATES, the DISTRICT OF COLUMBIA and the TERRITORIES choose a nominee for President, agree to and present their political party's PLATFORM and adopt party rules (e.g., concerning voting). It was first held in 1831; traditionally, the candidate for VICE PRESIDENT is announced at this time. Also known as CONVENTION[1]; *see* DEMOCRATIC PARTY, REPUBLICAN PARTY, FEDERAL ELECTION CAMPAIGN ACT OF 1972; *compare* CONVENTION[2].

National Council of Churches (of Christ in the USA) (religion) An organization of over 30 different Christian denominations (i.e., Episcopalian, Orthodox) which coordinates the disaster-relief, missionary and charity work sponsored by these member groups both in the UNITED STATES and in other countries. It includes all the major Christian groups except the ROMAN CATHOLIC CHURCH and Southern BAPTIST CHURCH. It was founded in 1908; until 1950 it was known as the "Federal Council of Churches of Christ".

National Defense Education Act (education) The legislation that was passed by CONGRESS in 1958 after the successful launch of *Sputnik 1* by the Soviet Union in 1957. It was aimed at improving the quality of American PUBLIC SCHOOL education, especially in math and the sciences, in order to improve American chances in the SPACE RACE. *See* COLD WAR.

National Education Association (education) (NEA) The largest teacher organization in the US with local and STATE chapters. It was founded in 1857 as the "National Teachers' Association" with the goal of promoting quality education. Since the 1950s, it has worked for teachers' rights at the local, state and national levels and is now a teacher's trade UNION[1], promoting teacher benefits, salaries and the professional status of teachers.

National Endowment for the Arts (the arts) (NEA) The division of the NATIONAL FOUNDATION ON THE ARTS AND HUMANITIES which accepts and reviews applications for art projects funding made by artists, musicians, sculptors; if the NEA approves the projects, it then gives a GRANT to the artists to begin or complete the work. Its funding is an important way to promote creative, independent artwork. *Compare* PUBLIC WORKS OF ART PROJECT, WORKS PROGRESS ADMINISTRATION.

National Enquirer, The (media) A weekly TABLOID containing sensational stories and photographs of celebrities and film stars. It has a reputation for publishing stories about famous and not-so-famous people using questionable information from "unnamed sources". It was founded in 1926 and its current circulation is 2.5 million.

National Farm Workers Association (work) (NFWA) The original name (before 1962) of the UNITED FARM WORKERS.

National Football Conference (sports and leisure) (NFC) One of the two parts of the NFL. It consists of 15 professional FOOTBALL teams which are organized into three (basically geographical) divisions: Eastern Division, Central Division and Western Division. The winner of this conference plays the winner of the AMERICAN FOOTBALL CONFERENCE in the SUPER BOWL. *See* Appendix 3 Professional Teams.

National Football League (sports and leisure) (NFL) The organization, established in 1920, that regulates all aspects and rules of professional FOOTBALL, especially television coverage of games, game rules and DRAFT[2] policies. It consists of 30 member teams which are divided into two conferences: the AMERICAN FOOTBALL

CONFERENCE and the NATIONAL FOOTBALL CONFERENCE. It sponsors the SUPER BOWL and awards the Jim Thorpe MVP Trophy (since 1955). Until 1946, it enforced SEGREGATION in its teams. It is headed by the Football COMMISSIONER. By association, professional football. *See NFL MONDAY NIGHT FOOTBALL*, Appendix 3 Professional Teams.

National Foundation on the Arts and the Humanities (the arts) The independent, federal agency which promotes the arts by providing GRANTS to artists, musicians, sculptors, social scientists and others. It was created in 1965 by the National Foundation on the Arts and the Humanities, a federal act. It is divided into three branches: the NATIONAL ENDOWMENT FOR THE ARTS (NEA); the National Endowment for the Humanities (NEH), which supports education and research in the social sciences and the HUMANITIES; and the Institute for Museum Services (IMS), which helps museums improve services and attract the public.

National Gay and Lesbian Task Force (minorities) An organization which works to eliminate discrimination against homosexual people by using DIRECT ACTION. It also serves as an INTEREST GROUP and is concerned with all issues and legislation concerning GAY RIGHTS, namely, it encourages support and research concerning AIDS (Acquired Immune Deficiency Syndrome); it works to repeal the policy in the ARMED FORCES toward homosexuals as well as STATE laws prohibiting sexual relations between members of the same sex. It was established in 1973 and currently has 18,000 members. *See BOWERS V. HARDWICK*, "DON'T ASK, DON'T TELL, DON'T PURSUE".

National Geographic (media) A monthly magazine carrying in-depth essays and full color photographs on history, culture, the environment and the world. It was established in 1888 by the National Geographic Society and has a current circulation of 9 million.

National Guard, the (military) The military forces (i.e., ARMY and AIR FORCE) that each STATE has. It was created in 1916 to work in civil situations, national emergencies and to serve as a reserve force of trained military personnel in times of military action or war. Usually, these forces are under the command of each state's governor; however, when working in national situations, they are commanded by the PRESIDENT and DEPARTMENT OF DEFENSE.

National Hockey League (sports and leisure) (NHL) The organization which regulates and promotes professional ice hockey in the US and Canada, namely, the rules of the game and tournaments. Currently, it consists of 26 total member teams which are divided into two conferences: Eastern Conference (consisting of the Northeast Division and the Atlantic Division) and Western Conference (consisting of the Central Division and the Pacific Division). It was founded in 1917, is headed by the Ice Hockey COMMISSIONER and sponsors the STANLEY CUP. It also awards the Hart Memorial MVP Trophy (since 1923) and a ROOKIE OF THE YEAR AWARD. By association, professional ice hockey. *See* Appendix 3 Professional Teams; *compare* AMERICAN HOCKEY LEAGUE.

National Industrial Recovery Act (work) (NIRA) During the GREAT DEPRESSION, the federal act (passed in 1933) and part of the NEW DEAL intending to reform business and the rights of industrial workers by establishing codes which fixed hours, wages and prices; also, it outlawed YELLOW-DOG CONTRACTS (that is, it overrode ANTITRUST LAWS). Because it was too powerful, the SUPREME COURT declared it UNCONSTITUTIONAL in 1935.

National Institutes of Health (health) (NIH) The federal agency responsible for conducting biomedical research on the causes and remedies for diseases, especially cancer, heart disease, kidney disease and aging. It then releases its findings to the public. It is part of the DEPARTMENT OF HEALTH AND HUMAN SERVICES and is located in Bethesda, Maryland, near WASHINGTON D.C.

National Labor Relations Act (work) The federal act (passed in 1935) which encouraged the strength and powers of labor UNIONS[1] and, especially, guaranteed workers certain rights. It outlawed YELLOW-DOG CONTRACTS. It established the

NATIONAL LABOR RELATIONS BOARD to enforce these policies. Also known as the "Wagner Act".

National Labor Relations Board (work) (NLRB) The current federal agency (composed of five appointed members) that administers the federal laws concerning labor and mediates problems between workers, employers and UNIONS[1]. In addition, it tries to protect the employee's rights, specifically to organize or join labor UNIONS[1], by organizing elections where employees choose representatives to do COLLECTIVE BARGAINING for them. Generally, it is supportive of labor groups. It was created by the NATIONAL LABOR RELATIONS ACT of 1935. *Compare* NATIONAL MEDIATION BOARD.

National League, the (sports and leisure) (NL) The oldest organization for professional sports, founded in 1876, and one of the two MAJOR LEAGUES for professional BASEBALL. It makes and enforces the rules for games and sponsors the LEAGUE CHAMPIONSHIP SERIES for the PENNANT of this league. It is composed of 16 member teams which are divided into three Divisions (largely geographical): Western, Central and Eastern. *See* WORLD SERIES, Appendix 3 Professional Teams; *compare* AMERICAN LEAGUE.

National Medal of Arts, the (the arts) An annual award (maximum 12 per year) given to honor American artists, artistic groups or art sponsors for their work in promoting American culture and the arts. Every October, the PRESIDENT distributes the awards (first in 1985) at an official ceremony at the WHITE HOUSE. *See* CHIEF OF STATE.

National Mediation Board (work) (NMB) The independent federal agency responsible for investigating and facilitating those issues related to the rights of workers in national railroad and airline industries, especially: helping workers solve contract problems with employers and mediating COLLECTIVE BARGAINING between the two sides. It was established by the Railway Labor Act of 1934 and was formerly known as the "Railroad Adjustment Board". *Compare* NATIONAL LABOR RELATIONS BOARD; FEDERAL AVIATION ADMINISTRATION.

National Merit Scholarship (education) (NMS) An organization which awards academic scholarships to attend COLLEGE[3] to any SECONDARY SCHOOL student who has high GRADES[2], good scores on the SAT, participates in EXTRACURRICULAR ACTIVITIES and places well on the NMS qualifying test. It was founded in 1955 and is funded by the FORD FOUNDATION and the Carnegie Foundation.

national monument (environment) One of over 73 different natural areas of importance or uniqueness which has been set aside for its preservation and may be visited by people. It is usually smaller in land area than a NATIONAL PARK, but is an important way to establish protected areas. It is overseen by the DEPARTMENT OF THE INTERIOR. *See* JOSHUA TREE NATIONAL MONUMENT.

National Organization for Women (minorities) (NOW) The major organization, established in 1966, promoting the equal rights and CIVIL RIGHTS of women. During the 1960s and 1970s it supported ERA[2], legalized abortion (i.e., it supported the decision of *ROE* v. *WADE*), and women's rights to receive the same salaries and chances for jobs as men. Today, it supports and lobbies in favor of AFFIRMATIVE ACTION, PRO-CHOICE, lesbian and GAY RIGHTS, and laws preventing SEXUAL HARASSMENT and affordable child care. The NOW LEGAL DEFENSE AND EDUCATION FUND provides LEGAL COUNSEL to women and others concerning these issues. It was and remains a major force representing the concerns of many women, especially working women. Its headquarters are located in WASHINGTON D.C.; currently, it has about 270,000 members (female and male) and 800 local groups. It is generally considered the spokesperson for working and independent women. *See* LOBBY, DISCRIMINATION, PRESIDENT'S COMMISSION ON THE STATUS OF WOMEN, FEMINIST MOVEMENT, WOMEN'S MOVEMENT.

National Origins Quota Act of 1924 (immigration) The federal act (passed in 1924) that severely limited immigration from 1924 to 1965 by issuing fewer visas (only 150,000 each year), and adapting the QUOTA system first used in the NATIONAL ORIGINS ACT OF 1921. With this law of

1924, the number of immigration visas given to the people legally emigrating from a country to the UNITED STATES, equaled only 2% of that nationality's total foreign-born population living in the US (as reported in the 1890 CENSUS). This reduction in the percentage (from 3% in 1921 to 2% in 1924) purposefully and systematically limited the number of immigrants to the US and discriminated against people from southern and eastern Europe, as well as Asia, because these groups were very small according to the 1890 US census. *See* NATIVISM, IMMIGRATION ACT OF 1965.

National Origins Quota Act of 1921 (immigration) The first federal immigration law which limited all immigration to the US by creating and using the system of national origins and QUOTAS. That is, the number of immigration visas it gave to foreigners born outside of the UNITED STATES equaled 3% of that nationality's population living in the US as reported in the 1910 US CENSUS. It was formally known as the "Immigration Act of 1921". When this law expired, the NATIONAL ORIGINS QUOTA ACT OF 1924 continued this type of policy. *See* NATIVISM, IMMIGRATION ACT OF 1965.

national park (environment) A large reserve with diverse land and/or water wonders especially set aside to protect it from commercial development, as well as to provide areas for the public to camp, hike and enjoy other outdoor activities. The DEPARTMENT OF THE INTERIOR maintains over 50 national parks. *See* YELLOWSTONE, YOSEMITE, GRAND CANYON, ARCHES NATIONAL PARK, ENVIRONMENTAL MOVEMENT; *compare* NATIONAL MONUMENT.

"national pastime", the (sports and leisure) Since the 1870s, the nickname for BASEBALL because so many people play it, watch it and like it. By association, any currently popular, favorite sport or leisure activity of Americans.

national preserve (environment) A certain land area that is set aside in order to protect it from development. It is overseen by the DEPARTMENT OF THE INTERIOR. A **national reserve** is a similar sort of area, but it is overseen by the individual, respective STATE(s).

National Press Club (media) (NPC) A FOR-PROFIT organization for journalists and newspeople in TV, radio, magazines, newspapers and wire services, which sponsors cultural and travel events for members as well as news sessions at its offices in which current news makers and/or authors present speeches. It was founded in 1908, is located in WASHINGTON D.C., and currently has some 4,400 members.

National Public Radio (media) (NPR) The organization established in 1970 that creates, produces and provides radio programs for non-COMMERCIAL radio stations. It is paid for by member stations and other GRANTS. Popular programs include "Morning Edition", a news program; and "Car Talk", a self-help, car repair CALL-IN program.

national recreation area (environment) Those lands and areas controlled by the DEPARTMENT OF THE INTERIOR which are purposefully set aside to be used by visiting people for boating, fishing and other forms of recreation. Originally, they were those areas near dams; especially, LAKE POWELL and HOOVER DAM.

National Review, The (media) A CONSERVATIVE monthly magazine publishing opinion articles and commentary on national and international politics and stories. It was founded in 1955 by the CONSERVATIVE REPUBLICAN, William F. Buckley, Jr. (born in 1925). Its circulation is some 100,000.

National Road (transportation) The road built by the federal government (1815–1850) to connect the eastern UNITED STATES with the west (i.e., the present-day MIDWEST). It began in Baltimore, Maryland, and ran though to present-day Illinois. In the twentieth century, it was surfaced as a two-lane road with stop lights and is now also known by the name "Route 40".

National Science Foundation (science and technology) (NSF) The independent federal agency which encourages science-oriented programs by supporting other research and education programs. It was founded in 1950 and is headquartered in Arlington, Virginia, near WASHINGTON D.C.

National Security Act (foreign policy) The federal law passed in 1947 that reorganized the US military establishment to make it better able to respond quickly to military actions. It organized the Departments of the ARMY, NAVY, AIR FORCE and Marines under the DEPARTMENT OF DEFENSE; and it created the NATIONAL SECURITY COUNCIL. *See* HOOVER COMMISSIONS, MARINE CORPS.

National Tribal Chairman's Association (minorities) (NTCA) The organization founded in 1971 by and for those tribal leaders on the RESERVATIONS. It works to protect and promote those issues important to INDIANS living on tribal lands and reservations, especially local government, tribal businesses and usage of resources on reservations (e.g., mining, logging, GAMING). *See* TRIBAL COUNCIL; *compare* NATIONAL CONGRESS OF AMERICAN INDIANS.

National Urban League (minorities) (NUL) The organization founded in 1910 to help end DISCRIMINATION against blacks and other MINORITIES especially in industry, the workplace and housing. It also offers minorities job counseling. It was originally founded to help those AFRICAN AMERICANS living in and migrating to cities in the NORTH before WORLD WAR I to get equal jobs and equal pay. Its headquarters are in NEW YORK CITY and currently it counts 50,000 members. Originally known as the "National League on Urban Conditions Among Negroes".

national wilderness area (environment) A natural, wild area set aside for wild animal and plant life, meaning that it is totally protected from human development and usage (e.g., no roads or structures may be built in that land, no people may live there). These areas were first set aside and continue to be protected by the federal law, known as the Wilderness Act of 1964. These lands are overseen by the DEPARTMENT OF THE INTERIOR and are often found within NATIONAL PARKS.

National Woman's Temperance Union (health) (NWTC) The contemporary name of the WOMAN'S CHRISTIAN TEMPERANCE UNION. Today, it works to teach young people about the negative effects of smoking, taking drugs and drinking alcohol. Its headquarters are in CHICAGO and currently it has 15,000 members.

National Women's Political Caucus (politics) (NWPC) The BIPARTISAN organization which works to establish equal representation for women at all levels of politics, including the local, STATE and national levels. Its practical concerns are to encourage the registration of women voters and to financially support the CAMPAIGNS of female and male political candidates who support ending sexism, racism and abuse. It was founded in 1971 with encouragement from NOW. *Compare* EMILY's LIST.

Native American (minorities) A person who is of INDIAN descent; that is a person who is at least 1/16th Indian (i.e., one great-great grandparent or closer relative was a native). This is a demographic term used by the government in helping to identify native peoples living in all STATES (except Alaska – "ALASKA NATIVE"; and Hawaii – "Pacific Islander"). [From 'native' inhabitant of North 'America'.] Sometimes and formerly known as "Amerindian".

Native American Church (of North America) (religion) A religion for all NATIVE AMERICANS formally founded in 1918 which combines traditional practices of religions from different Indian TRIBES with Christian figures and ideas and uses PEYOTE as part of the sacraments. For worship services, its members meet to participate in occasional, all-night Saturday meetings where they say prayers and eat peyote believing that this helps them become closer to their God, sacred entities and themselves. In daily life, it encourages its members to work hard and to drink no alcohol. Because its members may belong to other organized religions (e.g., PROTESTANT groups, ROMAN CATHOLIC CHURCH) the number of members is not known. Its use of peyote makes it controversial. Also, sometimes known as "the peyote religion"; *see* AMERICAN INDIAN RELIGIOUS FREEDOM ACT.

Native American Graves Protection and Repatriation Act (minorities) (NAGPRA) The federal law (passed in 1990) that provides full-scale protection to the remains and burial grounds of NATIVE

AMERICANS. Specifically, it permits certain tribes to receive the bones and other human remains as well as materials buried with those remains which are currently held in some private, UNIVERSITY and public museum collections. Initially, some archeologists, anthropologists and museum directors were not pleased with this BILL[2], however many remains have now been returned to TRIBES. Finally, it serves to recognize a tribe's right to hold and care for the remains of deceased ancestors and it supports the AMERICAN INDIAN RELIGIOUS FREEDOM ACT.

Native American Rights Fund (minorities) (NARF) A NONPROFIT ORGANIZATION which represents INDIANS and Indian affairs in court cases. It is especially concerned with the positive, self-sufficient future existence of TRIBES, the protection of tribal resources and rights (e.g., hunting rights, water rights, fishing rights), the enforcement of treaty rights and the protection of tribal lands, graves and artifacts. It supported the NATIVE AMERICAN GRAVES PROTECTION AND REPATRIATION ACT. It was established in 1970 and is headquartered in Boulder, Colorado. *Compare* NATIONAL CONGRESS OF AMERICAN INDIANS.

nativism (immigration) An attitude or policy that is anti-foreign or anti-immigrant, which native-born citizens have as a way of protecting their own economic and/ or political power. It has led to the formation of the KNOW-NOTHING PARTY, KU KLUX KLAN and several discriminatory Congressional laws. *See* ALIEN AND SEDITION ACTS, CHINESE EXCLUSION ACT, GENTLEMEN'S AGREEMENT, IMMIGRATION AND NATIONALITY ACT OF 1952.

nativity scene (customs and traditions) During the HOLIDAY SEASON, a scaled-down representation of the Christian, religious event of the birth of Jesus Christ; usually it includes three dimensional figures of the "baby Jesus", his mother "Mary", her husband "Joseph" as well as barn animals and shepherds and the three visiting kings. Many Christian families display a form of the nativity scene (e.g., small figures, a picture) in their home. Also known as "CRECHE"; *compare* MENORAH, CHRISTMAS TREE, *NUTCRACKER*

Natty Bumpo (customs and traditions) The fictional character and white frontiersman hero in the "Leatherstocking Tales" by JAMES FENIMORE COOPER. This character was raised by INDIANS and lived independently on the FRONTIER; he appreciated the wilderness and lamented its loss because of continued settlement and development. He was also referred to by Cooper as "Leatherstocking", "Hawkeye" and/or "Deerslayer". This character was based on the person of DANIEL BOONE.

Naturalization Act (immigration) The federal law (passed in 1870) stating that only whites, and blacks of African descent, could receive US citizenship (i.e., people from Asia could not become citizens). *See* CHINESE EXCLUSION ACT OF 1882, DISCRIMINATION; *compare* FOURTEENTH AMENDMENT, INDIAN CITIZENSHIP ACT.

Naturalization Acts of 1795 and 1802 (immigration) The Congressional acts that gave citizenship to any white, adult male immigrant who met the following criteria: had lived in the UNITED STATES for five years; had requested to become a citizen; and took an oath to respect the CONSTITUTION. They were passed by the DEMOCRATIC–REPUBLICANS in 1795 and 1802. *Compare* ALIEN AND SEDITION ACTS, IMMIGRATION ACT OF 1952, INDIAN CITIZENSHIP ACT.

Navajo (Nation), the (people) An Indian TRIBE of the SOUTHWEST known for its rich tradition of designing and making silver and turquoise jewelry and woven woolen blankets, and for working as shepherds. Today, it is the largest tribe, counting 225,298 members, yet remains one of the poorest tribes. Since the fourteenth century, the **Navajo** have lived in this area and since 1868 they have been living on a RESERVATION. Currently, it is the largest reservation of land (over 28,000 square miles; 72,000 sq. km) and is rich in natural resources oil, coal and uranium. There is some dispute over land and property rights between the Navajo and the neighboring, different tribe of the Hopi. Also known as "DINÉ". *See* NAVAJO COMMUNITY COLLEGE; *compare* PUEBLO INDIANS.

Navajo Community College (education) A federally funded, public COMMU-

NITY COLLEGE designed and administered by INDIANS for Indian students which stresses a Native American-centered curriculum. It was founded in 1968 by the NAVAJO TRIBE and receives financial support from the TRIBALLY CONTROLLED COMMUNITY COLLEGE ASSISTANCE ACT of 1978. It has a COEDUCATIONAL population of 3,000 students. The CAMPUS is located on Navajo-controlled land in Tsaile, Arizona and its buildings are designed according to traditional Navajo ideas, namely the HOGAN; the Ned Hatathli Cultural Center has eight sides. *See* DINÉ, SOUTHWEST; *compare* HASKELL JUNIOR COLLEGE.

Navy, the (military) The branch of the military concerned with ship and water-oriented operations and forces during wartime and peacetime situations. It was founded in 1775; from 1789 to 1949 it was controlled solely by the Department of the Navy. Since 1947, it has been overseen by the DEPARTMENT OF DEFENSE. Its highest commissioned ranking official is an "admiral" (in peacetime) and "fleet admiral" (in wartime). By association, it is also the nickname of the UNITED STATES NAVAL ACADEMY. *See* NATIONAL SECURITY ACT, SEALS, Appendix 7 Military Ranks.

Navy Cross (military) The highest award given to any member of the NAVY in honor of his or her outstanding heroism against the enemy during military action. *Compare* PURPLE HEART.

NBA World Championship Series (sports and leisure) The series of post-season professional BASKETBALL games held every year in May and/or June in which the team that wins four games out of a possible seven games is the NBA champion of the year. An MVP award for the best player of the tournament is awarded. Also known as the "NBA Finals".

NBC (media) The COMMERCIAL network, formally established in 1940, supplying radio and television programs to AFFILIATES[2]. Its mascot is the peacock and its motto is "proud as a peacock". It is one of the major NETWORK TELEVISION companies. [Abbreviation of 'N'ational 'B'roadcasting 'C'ompany.] *See* BIG THREE; *compare* ABC[1], CBS, FOX.

NC-17 (the arts) In the movies, the most restrictive type of ranking of the RATINGS SYSTEM[2] which indicates that the movie contains scenes displaying adult sexual situations and violence as well as adult (i.e., "dirty") language which is not appropriate for children or teenagers. Therefore, no child under the age of 17 is permitted to enter the movie theater where such a film is showing. Before 1990, it was known as "X". [From 'N'o 'C'hildren under the age of '17'.]

NCAA (sports and leisure) The organization, founded in 1906, which regulates and administers all aspects of INTERCOLLEGIATE athletic rules, competition and tournaments for its 1,100 members. In order to be an **NCAA** member, COLLEGES[3] must offer six VARSITY sports for men's teams and six varsity sports for women's teams. It oversees over 40 different sports which it organizes into one of three competition levels; the most competitive Division I (e.g., large STATE UNIVERSITIES), Division II (e.g., small institutions) and the less competitive Division III (e.g., small LIBERAL ARTS COLLEGES). All team athletes are UNDERGRADUATE students, some of whom may receive full or partial SCHOLARSHIPS to attend that COLLEGE[1]. [Abbreviation of 'N'ational 'C'ollegiate 'A'thletic 'A'ssociation.] *See* PRIVATE SCHOOLS, OHIO STATE UNIVERSITY, NOTRE DAME UNIVERSITY, ROSE BOWL, BIG TEN, NCAA BASKETBALL (DIVISION I) CHAMPIONSHIP TOURNAMENT, MARCH MADNESS, NO PASS, NO PLAY, PROPOSITION 42, PROPOSITION 16.

NCAA Basketball (Division I) Championship Tournament (sports and leisure) A post-season national championship tournament for NCAA Division I COLLEGE[1] BASKETBALL teams. Every March, 64 different NCAA Division I teams are chosen to participate in the tournament, each playing the other with only the winners advancing to the next round of games. There are a total of six rounds of games all of which take place during that March and April: Round One has 64 teams; Round Two has 32 teams; Round Three has 16 teams; Round Four has 8 teams; Round Five has 4 teams; and Round Six has 2 teams. In advance, many fans try to predict the wins and losses of

the various teams involved, picking the winning team and the various teams it beats to get to that point and betting on it. One tournament is held for men's COL-LEGE[1] teams while, at the same time, another tournament is held for women's COLLEGE[1] teams. The NCAA tournaments (men's and women's) choose the teams that are to participate before the (NIT) NATIONAL INVITATIONAL TOURNAMENT can choose its teams. *See* FINAL FOUR, MARCH MADNESS.

NEASC (education) An official ACCRED-ITATION association for HIGH SCHOOLS, BOARDING SCHOOLS[1], COLLEGES[1] and UNI-VERSITIES in NEW ENGLAND. [Abbreviation of 'N'ew 'E'ngland 'A'ssociation of 'S'chools and 'C'olleges.]

necessary and proper clause (govern-ment) That part of the CONSTITUTION (Article I, Section 8) which gives CON-GRESS the power to create all laws 'neces-sary and proper' for it to carry out its powers and responsibilities. This clause gives Congress additional powers. Also known as the "ELASTIC CLAUSE".

Negro/negro (minorities) A term in popular use before the CIVIL RIGHTS MOVEMENT to refer to a person of African and American ancestry. Since the 1950s, it has been superseded by black and Afro-American. Today, "AFRICAN AMERICAN" is the preferred name for people of this group. [From Latin *niger*, meaning "black".]

Negro American Labor Council (work) A support organization for black members of labor UNIONS[1] designed to help them combat racism in those labor unions. It was founded in 1960 by A. PHILIP RANDOLPH and was an organizing force of the MARCH ON WASHINGTON OF 1963. After 1972, it was known as "Coali-tion of Black Trade Unionists".

Negro Leagues, the (sports and lei-sure) In BASEBALL, the organized leagues in which African-American players played professional-level baseball (from the 1920s through the 1950s) because they were excluded from playing in the MAJOR LEA-GUES because of their race. They went out of business once blacks started playing in the major leagues (after 1947). *See* JACKIE ROBINSON, SEGREGATION.

Nelson, Willie (people) (born in 1933) COUNTRY MUSIC singer, songwriter and performer. He is known for recording popular songs with lyrics that are sad or are about COWBOYS[2], especially "Mammas Don't Let your Babies Grow Up to Be Cowboys" and "On the Road Again". He has also acted in some movie CAMEO roles, recorded with other stars, and has also helped raise money for impoverished farmers through organizing concerts (known as "Farm Aid"). In the early 1990s, he was forced by the INTERNAL REVENUE SERVICE to pay a large amount of money in outstanding, unpaid indivi-dual INCOME TAXES. He is easily recognized by his rough-looking appearance (e.g., unshaved), long hair held back by a bandanna and simple T-shirt and JEANS.

network television (media) The collec-tive name for those national television networks which are independently owned and are funded by the use of COMMER-CIALS; ABC[1], NBC, CBS and FOX. *See* BIG THREE.

New Age (1 religion; 2 the arts) **1** A movement interested in individual healing and, sometimes, changing the mental state through using drugs (e.g., marijuana). It developed out of the COUNTERCULTURE of the 1960s and borrows ideas from various religions: Hinduism, Buddhism and tradi-tional NATIVE AMERICAN religions. Fol-lowers often practice yoga, meditation, massage, astrology and maybe illegal drug use. Further, followers believe that every-thing in the universe is interconnected and they hope that a better society will come on earth, but usually they do not actively participate in groups to change the current social conditions. **2** Describing a type of music containing instrumental and synthesized sounds which was originally designed to be played during the medita-tion and other practices of followers of the NEW AGE[1] movement.

"New Colossus", "The" (immigration) The poem inscribed on the base of the STATUE OF LIBERTY, written by Jewish-American poet Emma Lazarus (1849–1887), which celebrates America's wel-come and acceptance of immigrants. The final stanza is: "Give me your tired, your poor, Your huddled masses yearning to be

free, The wretched refuse of your teeming shore, Send these, the homeless, tempest-tossed to me, I lift my lamp beside the golden door." *See* GOLDEN DOOR.

New Deal, the (history) The collective name for the various LIBERAL political, social and economic programs that FRANKLIN D. ROOSEVELT enacted during his first two TERMS[1] as PRESIDENT as a method of improving the desperate employment and economic conditions during the serious economic crisis caused by the GREAT DEPRESSION. During the first one HUNDRED DAYS of his term in 1933, several bills were passed (also known as the "First New Deal"), namely, the FEDERAL DEPOSIT INSURANCE CORPORATION, TVA, CIVILIAN CONSERVATION CORPS, PUBLIC WORKS ADMINISTRATION and the abandonment of the GOLD STANDARD. In 1935, the second wave of programs was pushed through (known as the "Second New Deal"), the very important SOCIAL SECURITY Act as well as the WAGNER ACT and the important WORKS PROGRESS ADMINISTRATION. It also included the act which created the SECURITIES AND EXCHANGE COMMISSION. These programs were helpful in giving some people jobs and encouraging the economy; however, it was only with the increased demands of production due to WORLD WAR II that the American economy fully recovered. The New Deal is responsible for introducing into the American system the ideas and programs of social and societal welfare and is thus generally admired. The success of the various programs has led supporters to name Roosevelt as one of the best US presidents. It influenced several later presidents, especially HARRY TRUMAN, JOHN KENNEDY and, most importantly, LYNDON JOHNSON. *Compare* FAIR DEAL, NEW FRONTIER, GREAT SOCIETY, WAR ON POVERTY. [From Roosevelt's speech at the DEMOCRATIC PARTY'S NATIONAL CONVENTION promising "a 'new deal' for the American people".]

New England (geography) A geographical region of five STATES in the northeastern part of the UNITED STATES originally settled mostly by people from Great Britain. Because of its characteristic cold winters, short growing season and rocky soil, it has long been and remains an area focused on shipping, fishing, shipbuilding, trading and industry (i.e., not farming). It is also noted for its academic institutions and rich intellectual life. *See* BOSTON, YANKEE[1], PURITANS, PILGRIMS, MASSACHUSETTS BAY COLONY, NORTH, TRANSCENDENTALISM, DOWN-EASTER.

New England Courant (media) An early American newspaper published once a week in BOSTON (from 1721 to 1726) which contained articles about current colonial and European news. It fought against PRIOR RESTRAINT; and its strong EDITORIAL opinions did not favor the British government. It was published by BENJAMIN FRANKLIN and founded by his brother, James Franklin.

New England Journal of Medicine, The (media) The well-respected, weekly journal publishing papers written by doctors on the most recent research and results concerning medical studies and scientific tests. Much of the information concerning health, drug testing and illnesses appear in this journal first. It was founded in 1812 by the Massachusetts Medical Society and has a circulation of 234,000.

New Frontier, the (history) The LIBERAL political programs that JOHN KENNEDY promoted during his campaign and presidency (1960–1963). It tried to help the American economy by lowering federal taxes, calling the Kennedy Round of GATT to help world trade and encouraging space exploration and study. By association, another name for the KENNEDY ADMINISTRATION[2]. *See* FRONTIER, SPACE RACE; *compare* CAMELOT[2].

New Hampshire Primary (politics) The PRESIDENTIAL PRIMARY held in February in the STATE of New Hampshire (located in NEW ENGLAND) during a presidential campaign year. Since it is one of the first to take place, it is an important test of a candidate's popularity with voters in general. *Compare* IOWA CAUCUS.

new journalism (1, 2, 3, 4, 5 media) **1** Any 'new' style of writing journalistic stories. **2** The information published in the PENNY PAPER of the 1830s to the 1860s. **3** During the PROGRESSIVE ERA, a neutral name for YELLOW JOURNALISM. **4** The style

of writing used by MUCKRAKERS. **5** Beginning in the 1960s, a term used to describe writing in magazines and books, which blended news-story facts with creative aspects of fiction. It was characterized by colorful stories, a direct language style, an author's use of personal opinions (i.e., not facts) and the creation of fictional quotes and characters in a non-fictional story.

New Left, the (politics) A political movement popular among young adults and UNIVERSITY students from the DEMOCRATIC PARTY and active from the late 1950s to the early 1970s. Its members practiced CIVIL DISOBEDIENCE in support of the CIVIL RIGHTS MOVEMENT, CIVIL LIBERTIES, reform on COLLEGE[1] CAMPUSES and the ANTI-WAR MOVEMENT. It participated in the demonstrations of THE CHICAGO RIOT. It did not support American IMPERIALISM, CAPITALISM, materialism nor racism. *See* LEFT, PORT HURON STATEMENT, COUNTERCULTURE, HIPPIES, STUDENTS FOR A DEMOCRATIC SOCIETY; *compare* OLD LEFT.

New Orleans (geography) The largest port city in the entire SOUTH with most of its commerce in oil refining, the chemical industries and shipping connected to its key position at the mouth of the MISSISSIPPI RIVER. It was originally founded by the French in 1718 and became UNITED STATES property through the LOUISIANA PURCHASE. It is known for its unique, multicultural population and history (e.g., blacks, whites, Catholics, French, Spanish), for being a city of fun, the birthplace of JAZZ MUSIC and for hosting the famous celebration of MARDI GRAS. Currently, the population is 1.2 million in the metropolitan area. *See* BOURBON STREET, FRENCH QUARTER, PRESERVATION HALL, STORYVILLE, CREOLE CUISINE, CAJUN COOKING, WAR OF 1812, JACKSON DAY, PARISH, CIVIL LAW[2], Appendix 3 Professional Teams.

New Orleans Jazz (the arts) The specific name for the first type of JAZZ MUSIC which originated in NEW ORLEANS about 1900. Initially, this music had a rhythm of 2/4; after 1950, it developed a more fluid 4/4 rhythm. Its supporters consider it the "purest" form of jazz music. It experienced a revival in the 1940s and again in the 1980s and 1990s. Today, it is promoted by WYNTON MARSALIS. Also known as "classic jazz" or, in a specific sense, simply "jazz"; *see* PRESERVATION HALL.

New Republic, The (media) A weekly magazine publishing quality articles of opinion and political commentary on current issues and culture as well as reviews of books, music and the arts. It was founded in 1914 as a MUCKRAKING magazine in support of LIBERAL opinions. Since the 1970s its editorial opinions have become more MODERATE; its current circulation is about 100,000.

New Year's Day (customs and traditions) January 1, a LEGAL HOLIDAY celebrating the beginning of the New Year. Most people spend the day recuperating from the late-night parties of NEW YEAR'S EVE by relaxing at home, making NEW YEAR'S RESOLUTIONS, playing sports and/or watching FOOTBALL games. Several cities sponsor parades with FLOATS and host football BOWL GAMES which are broadcast on television. All stores and businesses are closed. The symbol of the New Year is a baby in diapers. *See* ROSE BOWL.

New Year's Eve (customs and traditions) December 31, the day recognizing both the end of the current year and the promise of the coming New Year. Many people celebrate by going out to dinner or attending fancy parties with food, champagne and dancing. The highlights of the night include counting down the last 10–20 seconds before 12 o'clock midnight and, at midnight itself, blowing horns, making noise, and throwing confetti. Just after midnight, people shout "Happy New Year", kiss each other and then sing "AULD LANG SYNE". Many cities plan public gatherings to "welcome in the New Year"; the largest and most famous being in TIMES SQUARE in NEW YORK CITY where a large plastic sculpture of a lighted ball descends a pole. Other cities sponsor the FIRST NIGHT festivities. Although it is not a LEGAL HOLIDAY, many businesses are closed on this day. The symbol for this day is an old, bearded man wearing long white robes. *Compare* NEW YEAR'S DAY.

New Year's resolution (customs and traditions) A promise a person makes, usually to himself or herself, to do certain

things (e.g., go on a diet, start exercising, stop smoking) in the New Year to help him or her live better or more fully. **Resolutions** begin on NEW YEAR'S DAY.

New York City (geography) (NYC) The largest city in the UNITED STATES (population 7.3 million). It consists of five BOROUGHS[1]: The Bronx, BROOKLYN, Queens, Staten Island and MANHATTAN[1], which functions as its central part. It was first settled by the Dutch as "New Amsterdam" in 1624, but in 1664 it was seized by the British and renamed "New York". Its strategic location for river and ocean trade has long made it an important business, financial and industrial center as well as immigration hub. Because of its wealth and cultural diversity, it has long been considered and remains the major modern artistic and cultural center of the US, especially for the live, performing arts and urban architecture. It is nicknamed "GOTHAM" and popularly known as the "BIG APPLE". [After the Duke of 'York', the brother of the British King.] *See* WALL STREET, HARLEM, ELLIS ISLAND, STATUE OF LIBERTY, EMPIRE STATE BUILDING, FIFTH AVENUE, GUGGENHEIM MUSEUM, BROADWAY, OFF-BROADWAY, MADISON AVENUE, COLUMBIA UNIVERSITY, Appendix 3 Professional Teams; *compare* WASHINGTON D.C.

New York City Marathon (sports and leisure) An annual 26.2 mile (42 km) running race held on the last Saturday in October or the first Sunday in November. The course begins at Staten Island and passes through all five BOROUGHS[1] of NEW YORK CITY before it ends at the Tavern on the Green restaurant in CENTRAL PARK. It was first run in 1970 and, today, is open to all male and female runners aged 16 and older.

New York Stock Exchange (economy) (NYSE) The largest and most prestigious organized exchange for stocks and bonds with over 1,500 stocks and bonds listings. It has a large common hall where STOCKBROKERS meet to trade stocks and bonds. It is located at the corner of Broad Street and Wall Street in NEW YORK CITY. The DOW JONES INDUSTRIAL AVERAGE is based on BLUE CHIPS from this exchange. It was formally organized in March 1817. Today,

it is the major institution of WALL STREET and is one of the most important financial institutions in the world. It is popularly known as the "BIG BOARD". *See* BLACK MONDAY, BLACK TUESDAY, INSIDER TRADING; *compare* AMERICAN STOCK EXCHANGE, CHICAGO BOARD OF TRADE, NASDAQ.

New York Times, The (media) The daily newspaper for the metropolitan area of NEW YORK CITY, founded in 1851. Because of its long tradition of thorough research, full presentation of stories and accurate information, it has won more journalism PULITZER PRIZES than any other newspaper. It is recognized as one of the best American newspapers and the one that sets the agenda for news. Its own motto is: "All the news that's fit to print." It has a current circulation of 1.07 million; the circulation of its popular, thicker SUNDAY EDITION (which contains the *Sunday Magazine* and *The New York Times Book Review*) is 1.7 million. *See* NEW YORK TIMES CO. v. UNITED STATES, NEW YORK TIMES CO. v. SULLIVAN, PENTAGON PAPERS.

New York Times Co. v. Sullivan (media) The DECISION of the SUPREME COURT (in 1964) protecting the freedom of the press. It protects the press from libel suits filed by public officials unless the official can prove that the reports made were false and made with actual malice (i.e., that the errors were intentional). *See* FIRST AMENDMENT, LIBEL.

New York Times Co. v. United States (media) The DECISION of the SUPREME COURT (in 1971) stating that the UNITED STATES government could not block the publication of government-oriented information in a newspaper. The case, which concerned the *PENTAGON PAPERS*, established that PRIOR RESTRAINT cannot be enforced in the great majority of situations. This decision gave newspapers greater freedom in what information they published. *See* FIRST AMENDMENT.

New York World, The (media) A daily newspaper in NEW YORK CITY (1860–1931) that was particularly influential during the PROGRESSIVE ERA because of its combination of news reporting, MUCKRAKING and YELLOW JOURNALISM. Under the influence of JOSEPH PULITZER, it successfully pioneered using the SUNDAY EDITION com-

plete with sports information and issues interesting to women, in order to increase its sales.

New Yorker, The (media) A weekly, literary-oriented magazine containing intelligent EDITORIALS, reviews, articles and essays on urban life, the arts, and current affairs. It is recognized as one of the leading, wide-reaching publications of new artistic works. Each issue contains creative pieces of fiction, non-fiction and poetry. It is also noted for its humor and clever, single-panel black and white hand-drawn cartoons. It was founded in 1925. Its current circulation of 850,000 is primarily on the EAST COAST.

Newberry Medal (the arts) A well-respected, annual award given to the author of an outstanding children's book published in the UNITED STATES. It is awarded by the American Library Association, and was first presented in 1922. [After Englishman, John 'Newberry' (1713–1757), the first English-language publisher of children's books.]

Newport Festival(s) (the arts) One of a couple of organized, live music events featuring many different performing artists and attracting thousands of fans. The "Newport Jazz Festival" is an annual outdoor event, first held in 1953, for JAZZ MUSIC musicians and groups. The "Newport Folk Festival" was an important venue for FOLK MUSIC performers when it operated from 1959 to 1969. Later, this folk festival was revived, and today it is known as "Ben and Jerry's Folk Festival" (after its sponsor, 'Ben and Jerry's' Ice Cream). Both events are held outdoors in August at the Fort Adams State Park near 'Newport' in the STATE of Rhode Island. The "Newport Music Festival" is an annual event, first held in 1969, for opera music singers and classical orchestral and chamber music musicians. All events are held indoors in one or several of the NEWPORT HOUSES. It is sponsored by the METROPOLITAN OPERA COMPANY and is considered an important venue for young talented performers and artists to perform for a large audience. *Compare* TANGLEWOOD.

Newport Houses (housing and architecture) A collective term referring to the large number of enormous, luxury mansions built in lavish styles (e.g., Italian palaces, French *chateaux*) but only used during the summertime as vacation and party "cottages" for the wealthy owners. They were built during the nineteenth century by wealthy southerners and northern industrialists and were used by the rich from the 1850s until the 1930s. They are a symbol of the extravagant wealth of the GILDED AGE. [After their location at the Atlantic Ocean beach resort of 'Newport', Rhode Island.] *See* NEWPORT FESTIVALS, FOUR HUNDRED, ROBBER BARONS.

Newspaper Preservation Act of 1970 (media) The federal law stating that if companies publishing newspapers are bankrupt or losing money, they can be bought by other, larger newspaper companies because ANTITRUST LAWS do not apply to newspaper CHAINS. *See* GANNET COMPANY.

newspaper route (media) The set geographical area that a "newspaper carrier" visits in order to deliver newspapers (usually, local ones) to the homes of subscribers. By association, the job and the money that a person receives for delivering those newspapers. *See* PAPERBOY/GIRL.

Newspaper Row (media) In NEW YORK CITY, the popular name for Park 'Row', the street in lower MANHATTAN[1] where the head offices of many 'newspapers' were located in the early twentieth century.

Newsweek (media) A weekly, illustrated news magazine which focuses on reporting current news stories, covering the background information leading to those stories and interpreting some significance of those events. It also carries some reviews of current books, films and the arts. It was established in 1933 and helped popularize INTERPRETIVE REPORTING. Today, it publishes a national US edition (which has a circulation of 3.2 million), and different international editions. *Compare* TIME.

Newton, Huey (people) (1942–1989) A political leader and promoter of BLACK NATIONALISM who co-founded the BLACK PANTHERS in 1966 and served as its first president. Beginning in 1967, he is known for being tried in a court of law and imprisoned for the charge of killing a

California STATE police officer. Although these charges were eventually reversed, these events brought the Black Panthers national attention and made him a symbol of the group. During the trial, supporters used to chant "Free Huey!".

NFL Monday Night Football (sports and leisure) A very popular, weekly TV broadcast of professional FOOTBALL games on Monday nights during the football season (from autumn through to January). ABC[1] has been broadcasting it since 1970. *Compare* ESPN.

Niagara Falls (environment) A group of tall, large waterfalls (i.e., "American Falls", "Bridalveil Falls", "Horseshoe Falls") in the Niagara River in UPSTATE New York. Because they are on the international border between the UNITED STATES and Canada they may be viewed from the American side or the Canadian side. It was a popular destination for the wealthy and honeymooners during the nineteenth and early twentieth centuries. Today, it is a rather commercial, touristic attraction.

Niagara Movement, the (minorities) The intellectual movement among blacks and whites that promoted CIVIL RIGHTS for all AFRICAN AMERICANS and dismissed the ACCOMMODATION and conciliatory philosophy of BOOKER T. WASHINGTON which he had outlined in his "ATLANTA COMPROMISE". It was particularly concerned with DISCRIMINATION, SEGREGATION, LYNCHING and helping African Americans achieve economic equality. It started in 1905 and dissolved in 1909, because of a lack of funds and organizational weakness. However, several of its founders, namely W.E.B. DU BOIS, then helped found the NAACP in 1909. [After 'NIAGARA' FALLS, the location of the first meeting, which was held on the Canadian side of the waterfalls since the hotels on the American side did not permit blacks to register and rent rooms.]

nickel (economy) The silver-colored five cent coin worth five PENNIES or one-twentieth of a DOLLAR. It is made of 75% copper and 25% nickel. It is embossed with the motto "IN GOD WE TRUST" and the bust of THOMAS JEFFERSON on one side and the motto *E PLURIBUS UNUM* and an image of MONTICELLO on the other side.

Nielsen Ratings (media) The most widely used RATINGS SYSTEM[1] for television programs which is published every week in periodicals. It uses a system in which an electronic box counts the minutes that a particular television program is turned on during a particular period of the day. These electronic boxes are in a specified number of American homes throughout the country. [After Arthur C. 'Nielsen' (1897–1980), the developer of this system.]

900 number (daily life) A telephone service which callers can dial to receive information or service for a fee, usually charged by the minute (e.g., the results of sporting events, weather reports, adult telephone calls). It has 11 digits, the first four of which are '1-900'. *Compare* 911.

911 (daily life) In any city or STATE, the emergency telephone number used to call a service which then contacts and sends out a medical ambulance, the police department or fire department. All telephone calls made to this service are recorded.

Nineteenth Amendment (politics) The AMENDMENT to the CONSTITUTION (1920) that gave women the right to vote. It successfully ended the WOMEN'S SUFFRAGE MOVEMENT. *See* WOMEN'S MOVEMENT, NATIONAL LEAGUE OF WOMEN VOTERS.

Ninth Amendment (legal system) The AMENDMENT (1791) stating that the people can be given other individual rights, not specifically mentioned in the CONSTITUTION, as long as those new rights are consistent with American laws and values. It is part of the BILL OF RIGHTS.

Nisei (minorities) A collective name for those people born in the UNITED STATES because their Japanese parents (i.e., ISSEI) immigrated to AMERICA[1]. They are characterized by generally favoring ACCULTURATION to American society. During WORLD WAR II, many were removed to INTERNMENT CAMPS. [Japanese, literally meaning "second generation".] *Compare* SANSEI.

NIT [abbreviation of 'N'ational 'I'nvitational 'T'ournament] (sports and leisure) A post-season tournament for COLLEGE[1] basketball teams. It was first held 1938 and today is played every March in NEW YORK CITY. It selects teams to compete in

its tournament after the NCAA selects its teams. *See* NCAA Basketball (Division I) Championship Tournament.

Nixon, Richard (people) (1913–1994) US Congressmember (1946–1951), US Vice President (1963–1961) and President (1969–1974) from the Republican Party. During his presidency, he promoted détente with the USSR and was instrumental in re-establishing American ties with Communist China. During the Vietnam War, he sent troops to the war, invaded Cambodia and pulled US troops out of the war. He is remembered for his active, knowing role in the Watergate scandal which forced him to resign from the presidency before being impeached. Late in life he was recognized by some as an elder statesman of foreign policy. *See* Gerald Ford, *US* v. *Nixon*, "imperial presidency", impeachment, Henry Kissinger, Appendix 2 Presidents.

No Pass, No Play (sports and leisure) The popular name for the NCAA rule which established academic guidelines that freshmen student-athletes must meet before playing intercollegiate sports in their first year of college[1]. The student must have received a 2.0 GPA in 11 academic classes of the core curriculum or the student must have received a minimum score on the SAT or ACT tests. It is formally known as "Proposition 48" (passed in 1983). Students who had earned the GPA but had poor test scores were able to receive scholarships but were not permitted to play sports the first year. This measure was passed and enforced as a method of helping the students earn an academic degree while playing sports and encouraging coaches and others to help athletes study. It was amended by Proposition 42 and Proposition 16.

"No taxation without representation" (history) During the Colonial Period, a claim and political slogan that American colonists could not be taxed by the British Parliament if they could not elect their own representatives[2] to serve in that Parliament. By association, unfair taxation. *See* American revolution.

No-Raiding Agreement (work) An agreement between two competing un-

ions[1] not to recruit new members from the locals of the other union[1].

"Nobody Knows" (religion) A well-known, African-American spiritual song which is usually sung by a male baritone in a solemn manner when he has problems or is facing adversity. The refrain is: "Nobody Knows the Trouble I've Seen/Nobody knows but Jesus [my sorrow.]/ Nobody knows the trouble I've Seen/ Glory halleluia!"

nonprofit organization (the arts) A group that is organized to give health, educational, artistic, environmental or social help to the public, the environment or a special group of people (e.g., children, low-income families, homeless people). All of its expenses are paid for by private donations and foundations (i.e., not state or federal funds). It does not pay taxes. Also known as "not-for-profit organization"; *see* tax-exempt, deductible[1].

nonviolent action (legal system) A public method to protest a condition and to work for a change in social habits or rules. The ideas are drawn from Henry David Thoreau and Mohandas K. Ghandi (1869–1948) of India and were promoted by Martin Luther King, Jr. The techniques used are sit-ins, strikes[1], boycotts, marches, singing, fasts, etc. It was used during the March on Washington of 1963 and the Civil Rights Movement. Also known as "nonviolent resistance"; *see* Congress of Racial Equality, March on Washington Movement, A. Philip Randolph, James Farmer.

Norris–La Guardia Act (work) A federal law (passed in 1932) that prohibited: workers from picketing (i.e., striking); legal courts from ending workers' strikes[1] by issuing injunctions; and employers from enforcing yellow-dog contracts. Further, it protected the rights of unions[1], workers and management to participate in collective bargaining. It is formally known as the "Anti-Injunction law". [After Republican Senator George 'Norris' and Democrat Congressman Fiorello 'La Guardia', the co-sponsors of this bill[2].]

North, the (geography) Today, the geographical region including the states of New England, the Mid-Atlantic and

parts of the MIDWEST, that lie north of the MASON–DIXON LINE, north of the Ohio River and east of the MISSISSIPPI RIVER. Starting in the seventeenth century, it was settled by a variety of different immigrant groups; it has always been active in industry, business and shipping. In the first half of the nineteenth century before the CIVIL WAR, it included the states north of the Mason–Dixon Line where SLAVERY was illegal. During the Civil War, it was the political region including those 23 states of the UNION[3] and the other states that joined the UNION[3] struggle. *See* RUSTBELT, GREAT LAKES, NEW YORK CITY, BOSTON, DETROIT.

Northeast, the (geography) A political and geographical region including NEW ENGLAND and the STATES of New York, New Jersey and Pennsylvania. It is known for its industry, businesses, immigration and strong academic institutions. *See* IVY LEAGUE, DOWN-EASTER, YANKEE[1]; *compare* MID-ATLANTIC.

notary public (legal system) A public officer (who may be an ATTORNEY) who has the power from the STATE or federal government to give oaths to other people, stamp official papers and confirm that they are authentic and take AFFIDAVITS. Also known as "public notary".

Notre Dame (education) The popular name for the UNIVERSITY OF NOTRE DAME.

NOW (minorities) The popular nickname for the NATIONAL ORGANIZATION FOR WOMEN. [Acronym from 'N'ational 'O'rganization for 'W'omen.]

"Now I Lay Me Down to Sleep" (religion) A common Christian children's prayer said before going to bed. It follows: "Now I lay me down to sleep/I pray the Lord my soul to keep/And if I die before I wake/I pray the Lord my soul to take."

NRA [abbreviation of 'N'ational 'R'ifle 'A'ssociation of America] (sports and leisure) An organization for people interested in guns, especially hunters, police officers, gun collectors and others. It encourages gun marksmanship (i.e., shooting), gun safety, gun collecting and wildlife conservation. It serves as an INTEREST GROUP and actively lobbies the government to protect the right of citizens to own and use weapons. It supports the SECOND AMENDMENT and is against any legal limitation to guns and gun use. It was founded in 1871 and currently counts 2.5 million members who are organized into 14,000 local groups.

Nuclear Regulatory Commission (science and technology) (NRC) The independent federal agency overseeing nuclear power, while protecting the health of the public and the environment. It sets rules to regulate nuclear power plants and gives licenses to the military and private companies wanting to operate nuclear facilities. It was created by the Energy Reorganization Act of 1974 and replaced the ATOMIC ENERGY COMMISSION, which was established in 1946. *See* THREE MILE ISLAND.

nursery school (education) A pre-academic PRESCHOOL that provides organized playing and socialization skills for children between two and five years of age. It usually precedes KINDERGARTEN. *See* Appendix 4 Education Levels; *compare* DAY CARE.

nursing home (health) A health care and living center for elderly people, especially those with serious illnesses or other physical (e.g., paralysis) or mental disabilities (e.g., speech or memory problems).

Nutcracker, The (the arts) The popular ballet whose music was written by the Russian composer, Pytor Ilyich Tchaikovsky (1840–1893). It relates the story of a young girl, Clara, who receives a Christmas gift of a toy soldier which is also a 'nutcracker' (i.e., the toy's mouth can crack nuts) who then becomes a live man. Further, it shows their fantastical trip to the unusual places they visit together and the international guests they meet. It ends when she awakes to discover that it had all been a dream and the "man" is still a Nutcracker toy. This ballet is a popular, annual production during the HOLIDAY SEASON in most large cities. Big-hatted, uniformed nutcracker soldiers are popular secular public decorations during this period. *See* SECULARISM.

O

O'Keeffe, Georgia (people) (1887–1986) Painter. Her abstract oil paintings frequently show soft, sensual, simplified forms (e.g., in the series of large, oversized flowers) as well as bright colors, sun-bleached bones (e.g., cow skull), stars and stark scenery of the desert landscape of the SOUTHWEST. *See* TAOS ART COLONY.

O'Neill, Eugene (people) (1888–1953) Playwright. Many of his 30 plays are tragedies and deal with the themes of drunkenness, adultery, insanity and/or suffering. Several plays concern the "Tyrone" family (which he based on his own family), namely, *Long Day's Journey into Night* (1939–1940) and *A Moon for the Misbegotten* (1943). He frequently experimented with different writing and stage techniques. He was the first playwright in history to win the Nobel Prize for literature (1936).

Oakley, Annie (people) (1820–1926) Gunshooter and entertainer. Her skills in shooting pistols and rifles led her to a career performing gunshooting stunts with the traveling "Wild West Show" of "BUFFALO" BILL CODY. While performing in Europe, in one stunt she successfully shot away the cigarette which the future German Kaiser Willem II was holding between his lips. During her long career, she earned the nickname "Little Sure Shot". Her life was the inspiration for the Irving Berlin (1888–1989) MUSICAL *Annie Get Your Gun* (1946).

OASDI (health) A federal program that gives a sum of money every month to retired people (aged 65 and older), DISABLED people, their DEPENDENTS, spouses, widows/widowers and children of workers who are dead. In order to receive these benefits a person must have a SOCIAL SECURITY NUMBER and must have worked at least 10 years in a registered job. The money distributed by this program is extracted from the earnings of working people during those years of employment. It was created by the Social Security Act of 1935 and is now the major part of the general system of SOCIAL SECURITY. [Abbreviation of the full, formal title 'Old-Age, Survivors, and Disability Insurance'.]

Obie Awards (the arts) Annual awards sponsored and presented by the *VILLAGE VOICE* to honor outstanding achievement working in live, OFF-BROADWAY plays. Categories include "best play of the season", "best actor", "best actress" and others. [Acronym from 'O'ff-'B'roadway.]

objection (legal system) During a trial, a complaint made by a LAWYER on behalf of a client because the lawyer thinks that a certain aspect of the trial (e.g., evidence, statement by the opposing ATTORNEY) is not correct and asks the judge (on behalf of his or her client) to rule that aspect illegal. The judge may agree (i.e., "SUSTAINED") or disagree (i.e., "OVERRULED") with it.

observed (1, 2 customs and traditions) **1** Describing the weekday (often the following Monday or preceding Friday) designated to officially celebrate a LEGAL HOLIDAY which, in that year, technically occurs during a WEEKEND. *See* LONG WEEKEND, MARTIN LUTHER KING, JR. DAY. **2** Describing a day or holiday that is celebrated in a special way but is not a LEGAL HOLIDAY or FEDERAL HOLIDAY. *See* EARTH DAY.

Occupational Safety and Health Administration (work) (OSHA) The federal agency that protects the general safety and health of workers in their jobs by setting standards about the conditions in business and workplaces and inspecting those business and work locations. It is authorized to assign penalties to those businesses which do not follow OSHA standards. It was established in 1970 and is part of the DEPARTMENT OF LABOR.

Off-Broadway (the arts) Describing a type of new theatrical play or more experimental play written by contemporary playwrights and performed in NEW YORK CITY. If these plays are successful, they may "move up" and be performed "on Broadway" itself. Off-Broadway plays tend to be less commercialized and treat more contemporary, unexplored issues or techniques than those on BROADWAY. By association, a collective name for any of the NEW YORK CITY theaters (on or near

West 42nd Street) which perform these plays. *See* OBIE; *compare* OFF-OFF-BROAD-WAY.

Off-Off-Broadway (the arts) Describing a very experimental play which often treats unusual, non-mainstream but usually contemporary subject material, uses amateur actors and is presented in cafés or empty buildings (i.e., not theaters). By association, a collective name for those plays and that quality of art in those live "theaters". *Compare* BROADWAY, OFF-BROADWAY.

off-year election (politics) Specifically, any election held in the year before or the year after a presidential election. In general, any election held in a year when there is no presidential election. *Compare* MID-TERM ELECTION.

Office of Management and Budget (government) (OMB) The office that helps the PRESIDENT prepare the annual federal budget, develop fiscal policies and approve the legislation BILLS[2] planned by the executive branch. This important office, created in 1970, operates the EXECUTIVE OFFICE OF THE PRESIDENT. Its Director is appointed by the President. *Compare* CONGRESSIONAL BUDGET OFFICE.

Office of Thrift Supervision (economy) (OTS) The federal agency responsible for giving charters to new THRIFT INSTITUTIONS and regulating all those STATE and federal thrifts which are registered with the Savings Association Fund. It was created in 1989 by CONGRESS as a method of trying to control and stabilize the financial crisis caused by THRIFTS during the 1980s. It is a part of the DEPARTMENT OF THE TREASURY.

office party (work) A party for employees and employer(s) held either in the work location or at a restaurant which includes eating, drinking, music and maybe dancing and singing. Usually, it is held once a year in December to celebrate the HOLIDAY SEASON and thank employees for their work during the year; frequently, an employer will personally distribute a BONUS to each employee at this time.

office-block ballot (politics) A BALLOT[1] which, first, names the political office and underneath, in alphabetical order, lists all the names of the candidates and their respective political parties running for that position. Also known as the "MASSACHU-SETTS BALLOT"; *compare* PARTY-COLUMN BALLOT.

"Oh, Susannah!" (customs and traditions) A popular nineteenth-century FOLK MUSIC song written by STEPHEN FOSTER about a man traveling to see his true love. The refrain follows: "Oh, Susanna! Don't you cry for me/For I come from Alabama with a banjo on my knee." It was popularized by the miners during the GOLD RUSH in California in 1849 who sang it. *See* BANJO.

"Oh, What a Beautiful Morning" (the arts) A popular, upbeat song from the well-liked MUSICAL, *Oklahoma* (1943) by ROGERS AND HAMMERSTEIN, which celebrates the beauty of the land and life in that midwestern region for the new white settlers. The first lines are: "Oh, What a Beautiful Morning/Oh, What a beautiful day/I've got a wonderful feeling/Everything's going my way."

Ohio State University, the (education) (OSU) A public, COEDUCATIONAL institution of HIGHER EDUCATION and a BIG TEN member. It was founded in 1870 with the MORRILL ACT (1862). Today, it is one of the largest STATE UNIVERSITIES in the US with some 59,000 UNDERGRADUATES and GRADUATES[2] on several CAMPUSES (e.g., Columbus, Lima, Mansfield, Marion, and Newark). It is famous for its agricultural and veterinary SCHOOLS[4] and strong tradition in NCAA INTERCOLLEGIATE sports, especially FOOTBALL and BASKETBALL. Its mascot is the "buckeye", a type of tough nut which grows on the "buckeye tree" which is the official tree of the state of Ohio. OSU students and athletic teams are popularly known as "the Bucks".

old boy's network/club, the (society) A network of men who have the same education and social background, and share the same friends and interests who help each other (and their children, friends) get jobs in business and positions in politics. *See* COUNTRY CLUB.

old country, the (immigration) The country from which a person (or that person's family ancestors) emigrated; the country of origin, especially various European countries.

Old Deluder Satan Act (education) In the MASSACHUSETTS BAY COLONY, the law

passed by PURITANS (in 1647) which encouraged education of children at the expense of the town. It demanded that every town with 50 people must hire a teacher to teach the boys of that town to read and do some mathematics. It led to today's system of PUBLIC SCHOOL education. [From the law's written introduction: "It being one chief project of the 'old, deluder, Satan', to keep men from the knowledge of the Scriptures. . ."]

Old Faithful (environment) In YELLOWSTONE NATIONAL PARK, the most famous, most popular and one of the largest of the natural geysers, it expels some 11,000 gallons (42,000 liters) of water into the air at a height of over 100 feet (30 m). By association, a nickname for anything which performs regularly or is highly dependable. [From its supposedly regular, 'faithful', eruptions once every 30 to 90 minutes.]

Old Glory (customs and traditions) Since 1824, the nickname for the national flag of the UNITED STATES OF AMERICA. *See* STARS AND STRIPES[1].

old guard (society) The collective name for the very CONSERVATIVE or old-fashioned members of a group, political party (e.g., REPUBLICAN) or of society who are reluctant to change and/or determined to hold on to power. This group often represents the conservative elements in the ESTABLISHMENT. [From French *Vielle Garde*, literally "old guard".] *See* BOURBONS.

Old Left, the (politics) A LIBERAL group within the DEMOCRATIC PARTY that supported NONVIOLENT ACTION and had respect for the wishes of the majority of the population. It was active from the time of the RED SCARE[2] until the 1960s, when it was then succeeded by the NEW LEFT. *See* LEFT.

"Old MacDonald" (customs and traditions) A popular children's song about the farmer, Mr. MacDonald and his collection of barnyard animals. Often an adult sings the main song while permitting the children to sing/shout the "E-AY-E-AY-O" and animal noises of the various animals. The first verse follows: "Old MacDonald had a farm, E-AY-E-AY-O/And on that farm he had some ducks/E-AY-E-AY-O/ With a quack-quack here and a quack-quack there/Here a quack, there a quack, everywhere a quack-quack/Old MacDonald had a farm/ E-AY-E-AY-O." The other animals and their noises are: pig, oink-oink; cow, moo-moo; horse, whinny-whinny.

"Old Time Religion" (religion) The title and part of the refrain to a well-known spiritual song which is usually sung without instrumentation. The first verse follows: "Give me that old time religion (three times)/And that's good enough for me." This song (and title) have since served as a general term referring to an earlier period in which religion, especially that of PROTESTANT groups, was characterized by strong morals and ethics and provided people with a solid, unified community. *See* FAMILY VALUES, REVIVAL, EVANGELICAL.

oldies (1, 2 the arts) **1** A collective classification of music used by radio stations to refer to the popular albums, Compact Disks (CDs) and cassettes of earlier years, especially the early period of ROCK AND ROLL. Also known as "golden oldies". **2** Any old song (20 years old or older), movie joke, artistic project, etc. The singular form is spelled "oldie" or "oldy".

Olmstead, Frederick Law (people) (1857–1880) Writer and landscape architect. He believed in creating natural spaces for the public to use and enjoy and designed several public places throughout the US; CENTRAL PARK in NEW YORK CITY (1857–1880), the CAMPUS of STANFORD UNIVERSITY (1888), and Druid Hills in ATLANTA.

1-800 number (daily life) A telephone number used to make orders, to do shopping or reply to advertisements. The telephone call is paid for by the person or group who placed the advertisement, not the caller. *See* CATALOG SHOPPING, CLASSIFIED ADS; *compare* 900 NUMBER.

101 (education) The lowest level course offered in a DEPARTMENT[1] course in a COLLEGE[3]. Usually it is an introductory course for FRESHMEN[2] or SOPHOMORES (e.g., Psychology 101). *See* COURSE NUMBER.

On the Road (the arts) The important, defining book of the BEAT GENERATION

which details the cross country trips between NEW YORK CITY and SAN FRANCISCO and care-free activities of two young men (i.e., Dean Moriarty and Sal(vatore) Paradise) and their friends. It was based on the real-life trips of Neal Cassady and JACK KEROUAC, respectively. It was written by Kerouac and published in 1957.

"one small step for man, one giant leap for mankind" (science and technology) On July 20, 1969, the comment NEIL ARMSTRONG made while stepping onto the moon, which refers to the importance of this historical, technological event. *See* APOLLO PROJECT, SPACE RACE.

one-armed bandit (sports and leisure) A popular name for a slot machine. It is played by pulling the lever (or 'arm') on the right hand side in order to start the spinning figures and to match three figures in a row (e.g., apples, grapes, etc.). [From the infrequency of winning with this gambling machine.] By association, gambling.

one-room schoolhouse (education) A building containing one room that was built and used (primarily from 1850 to 1950) by the local residents in rural areas to educate their children. All students, regardless of age or academic level, were taught the THREE R's in this one room. It remains a symbol of locally controlled PUBLIC SCHOOL education.

one-stop shopping (economy) Shopping for different items in one big store or SHOPPING MALL, rather than in several smaller, specialized stores. By association, doing a variety of tasks in one location or institution. It is seen as a positive thing because it facilitates shopping, work and/ or financial services and tasks. *See* DEPARTMENT STORE.

Op art (the arts) An artistic movement based on the scientific and optical illusionary principles of color (e.g., complementary colors) and patterns of colors in paintings and human perception of these patterns. It entailed that a viewer look intensely at a colored, patterned painting then look away at a blank wall; this action produced an "after image" of the colors for the viewer. It is characterized by using bold colors, hard lines and geometrical patterns. It developed as a reaction to POP

ART and was popular during the 1960s. [From clipping of 'Op'tical 'art'.]

op-ed page (media) The page in a newspaper, opposite the editorial page, which usually prints special, SYNDICATED essays on current issues or letters written and signed by other contributors or readers. [Clipped form of 'op'posite the 'ed'itorial page.]

Open Door policy, the (foreign policy) The foreign policy agreement in the early twentieth century concerning China in which the UNITED STATES and other countries (i.e., France, Great Britain, Germany, Italy, Japan and Russia) respected the independence of China as a separate country and did not want to enforce IMPERIALISM on it; but still wanted to open up Chinese markets to foreign trading partners. Although it was first established in 1899 and reaffirmed in 1922, it did not prevent the Japanese from invading China in 1932 which helped lead to WORLD WAR II in the Pacific Ocean region. Thus, it was less than successful. *See* ANTI-IMPERIALISM.

open primary (politics) A type of PRIMARY ELECTION where voters can cast one BALLOT[1] in the primary held by any political party; but it does not have to be the political party to which he or she belongs. It may be used in a PRESIDENTIAL PRIMARY but is not as common as a CLOSED PRIMARY. Also known as "cross-over primary"; *see* VOTER REGISTRATION.

Opening Day (sports and leisure) In professional BASEBALL, the first day of the official playing season which is held during the second week of April. It is usually marked with ceremonies in the BALLPARK[1], namely, the FIRST PITCH. *Compare* SPRING TRAINING, WORLD SERIES.

Operation Bootstrap (immigration) The general name for the programs initiated by the island's government (active from the 1940s through the 1960s) which attempted to improve the economy of PUERTO RICO as well as the financial security of Puerto Ricans. First it tried to give Puerto Ricans jobs by encouraging American businesses to move their factories and manufacturing to the island by offering them low-interest loans and the option of not paying corporate taxes for 10 or 17 years. Further, it encouraged the

US tourist trade to the island. Although it was quite successful, many Puerto Ricans chose to move to the mainland US in order to find work; there is a large population of Puerto Ricans living in NEW YORK CITY. *See* BARRIO, SPANISH HARLEM.

Operation Breadbasket (minorities) The employment and economic improvement program of the SOUTHERN CHRISTIAN LEADERSHIP CONFERENCE to increase the self-reliance of AFRICAN AMERICANS in urban areas. It encourages white CHAIN stores in urban, largely black neighborhoods to hire black workers by the selective buying of black buyers. It was founded in 1967 by MARTIN LUTHER KING, JR.; it was directed by JESSE JACKSON from 1967 to 1971. In 1972, the splinter group OPERATION PUSH was founded with similar tactics and objectives.

Operation Head Start (education) The original, formal name for HEAD START.

Operation PUSH (minorities) The nationwide program designed to increase the economic condition and financial resources of African-American individuals, families, businesses and banks. It encouraged national companies to hire more black employees as workers, distributors and wholesalers and to use AFRICAN AMERICANS as models in advertising, especially in black neighborhoods. It was founded in CHICAGO in 1971 by JESSE JACKSON, but by the late 1980s was experiencing financial problems. [Acronym from 'P'eople 'U'nited to 'S'ave 'H'umanity.] *Compare* OPERATION BREADBASKET, RAINBOW COALITION.

Operation Rescue (religion) The radical, anti-abortion group of religious clergy and LAY people which stages SIT-INS to physically stop women from having abortions by blocking the entrances to medical clinics where abortions are performed. Since it was organized in 1987, this PRO-LIFE group's activities have caused over 50,000 arrests of participants and have stopped some 900 abortions. *Compare* NATIONAL ORGANIZATION FOR WOMEN, PLANNED PARENTHOOD.

Operation Wetback (immigration) A federal immigration-control program that removed from the UNITED STATES some 3.8 million undocumented ILLEGAL ALIENS, and returned them to Mexico. It was active from 1954 to 1958 and was enforced by the office of the ATTORNEY GENERAL in the DEPARTMENT OF JUSTICE. Its goal was to stop the flow of illegal immigrants into the SOUTHWEST after the BRACERO PROGRAM; however, it was not successful in this. Critics of this program claimed that the American law enforcement officials treated the deported people very roughly. *See* WETBACK.

opinion of the court, the (legal system) Another name for the MAJORITY OPINION. *Compare* CONCURRING OPINION, DISSENTING OPINION.

Orange County (science and technology) An area south of LOS ANGELES where many high technology research institutions and computer companies are located. *Compare* SILICON VALLEY, RESEARCH TRIANGLE.

Oregon Trail (geography) One of the major routes that settlers took out WEST. It began in Independence, Missouri, and ended some 2,000 miles (3,200 km) further, at the Platte River in Oregon.

organ donor (health) An individual, if in the case of death in a motor vehicle accident (e.g., motorcycle, car), who volunteers to have some or all of his or her vital body organs (e.g., heart, kidney, liver, eyes) medically removed to be transplanted as soon as possible into the body of some other person who needs those organs. This status of "organ donor" is voluntary and is noted on an individual's DRIVER'S LICENSE.

Organization of Afro-American Unity (minorities) (OAAU) A non-religious, BLACK NATIONALISM movement founded in 1964 by MALCOLM X to promote black unity in the western hemisphere and to work for freedom of racism and DISCRIMINATION. Its main project was to elevate CIVIL RIGHTS from a domestic US problem to an international human rights problem, and thereby appeal to the United Nations to solve racial problems in America. Malcolm X died before it could be very effective.

Oriental Exclusion Act (immigration) The discriminatory federal law (passed in 1924) which stopped all immigration from

Asian countries to the UNITED STATES. It was overturned by the IMMIGRATION ACT OF 1965. *See* NATIVISM, YELLOW PERIL; *compare* CHINESE EXCLUSION ACT, GENTLEMAN'S AGREEMENT.

original jurisdiction (legal system) The authority of a court to try a case in the first instance; that is, not hearing it on APPEAL. This is a type of JURISDICTION.

Orthodox Judaism (religion) A traditional branch of the JEWISH religion and the same form of Judaism as the official religion of the modern state of Israel. It was brought from Europe to AMERICA[1] through immigration in 1654 and, more importantly, by Eastern European immigrants between the years 1880 and 1924. Members believe in the holy importance of the Torah and traditional Jewish laws (known as "*Halachah*") and they believe that these cannot ever be changed. Members still practice these laws and follow a KOSHER diet. In the US, it has grown in membership since 1967 and Israel's victory in the Six Day War. Today, the 1 million members live primarily in NEW YORK CITY. *See* HASIDIC JEWS, HIGH HOLIDAYS; *compare* REFORM JUDAISM, CONSERVATIVE JUDAISM.

Oscar (the arts) The popular name for the ACADEMY AWARD which is a small statuette (30.5 inches tall; 77 cm tall) of a male knight holding a sword and standing on a reel of film. "The Oscars" is the popular name for the Academy Awards which are presented at the ACADEMY AWARDS CEREMONY. [After a comment by the Academy-Award winning actress, Margaret Hamilton (1902–1985), who stated that the bald statuette resembled her Uncle 'Oscar'.]

out (1, 2 sports and leisure) **1** In BASEBALL, in general, describing an offensive player who has been stopped from scoring. **2** In baseball, specifically, the negative point awarded to an offensive team when one of its players has been stopped from scoring, either by: receiving three STRIKES[2] AT BAT; or being tagged with the ball and mitt by a defensive player while that offensive player is running between two bases. Once an offensive team receives three outs, it must switch positions to then play defensively. By association, a failure.

See BOTTOM OF THE INNING, "THREE STRIKES, YOU'RE OUT".

out-of-court settlement (legal system) A type of SETTLEMENT to a dispute concerning CIVIL LAW[1]. The parties and their LAWYERS agree to a solution without having to go to court, which decreases the total costs of the LAWSUITS.

outfield (sports and leisure) In BASEBALL, the area of the playing space that is beyond the INFIELD[1] and still within the boundaries of play. By association, a collective name for all the players in the outfield; that is, the OUTFIELDERS.

outfielder (sports and leisure) In BASEBALL, a defensive player (e.g., right fielder, left fielder, center fielder) who is stationed in the OUTFIELD and is responsible for catching or retrieving balls which are hit into that area of the BALLPARK[1]. Usually, outfielders experience less continuous action than their fellow defensive players in the INFIELD[2].

outlet (economy) A large store selling retail items of a particular brand or wholesaler. Usually it is not located in an urban area nor does it have many staff personnel to help customers; however, it is known for offering quality merchandise at low, affordable prices.

Oval Office (government) The official working office of the PRESIDENT of the UNITED STATES OF AMERICA located in the West Wing of the WHITE HOUSE. By association, the presidency or the current President. [For the 'oval' shape of the 'office' which was built in the 1930s.]

over-the-counter (market) (economy) A market where the stocks of smaller companies are traded through a computerized network system, or over the telephone. In the amount of DOLLARS traded, it is the largest stocks and bonds market in the US. It is regulated by the National Association of Securities Dealers. The NASDAQ is an over-the-counter market. *Compare* NEW YORK STOCK EXCHANGE, CHICAGO BOARD OF TRADE.

overalls (clothing) A loose-fitting garment, worn over a shirt, which has a pair of pants with an attached "bib" and which are affixed by two shoulder straps and buckles. It is the typical clothing of men and women from rural, farming commu-

nities; since the 1980s, it has been a chic piece of clothing for urban young people. Sometimes known as "bibs".

overruled (legal system) Specifically, during a trial in a courtroom, an official decision by a judge to cancel out some previous decision or request *see* OBJECTION; *compare* SUSTAINED). In general, a legal DECISION made by a higher court which changes any decision made by a LOWER COURT because a higher court has greater authority, its decisions are above, or "over", those rulings made in lower courts.

oversight power (government) The total authority and methods (usually through CONGRESSIONAL COMMITTEES and hearings) of the CONGRESS to check the powers and abuses of the PRESIDENT, DEPARTMENTS[2] and federal agencies of the executive branch. Also known as "Congressional oversight power".

Owens, Jesse (people) (1913–1980) A talented African-American athlete in the TRACK AND FIELD events of sprints, long jump and hurdles. He is remembered for participating in the Olympic Games of Berlin, Germany, in 1936 and although he won four gold medals, Chancellor Adolf Hitler (1889–1945) refused to shake his hand because Owens was black. He supported other young athletes and became a symbol of overcoming racism.

oysters Rockefeller (food and drink) An expensive, elegant dish consisting of a cooked mixture of spinach, bacon, cheese and spices spooned on to fresh oysters still on the half shell and then baked. It is served in the oyster shell. [First made at Antoine's, a restaurant in NEW ORLEANS, after JOHN D. 'ROCKEFELLER'[1].]

Ozark Mountains, the (environment) A natural area in the MIDWEST containing a range of small mountains and several lakes formed by dammed rivers, which is popular for vacations and outdoor recreation. *See* BRANSON.

Ozzie and Harriot (media) A real life husband and wife and the title characters of the popular television SITCOM aired from 1952 to 1966. The TV SERIES treated the relationships of this couple, Ozzie and Harriot Nelson, and their real life (and TV) children, Ricky and David. They became the symbol of a model, happy family. *See* FAMILY VALUES.

P

PAC (politics) An organization (especially created by a CORPORATION, INTEREST GROUP or labor UNION[1]) designed to raise money and donate that money to the CAMPAIGNS of candidates. Currently, there are several thousand active PACs. Although PACs are an important way for candidates to do FUND-RAISING some opponents believe that they have too strong an influence over government officials once they are elected. [Acronym from 'P'olitical 'A'ction 'C'ommittee.] *See* FEDERAL ELECTION CAMPAIGN ACT OF 1972, AMERICAN MEDICAL ASSOCIATION.

Pachuco (1 language; 2 minorities) **1** A distinctive slang-dialect of the Spanish language used by Mexican-American youths in the SOUTHWEST and LOS ANGELES which uses many English language vocabulary words. It was used by some Mexican Americans before the VIETNAM WAR and later revived during the CHICANO MOVEMENT. **2** A male member of a distinctive Mexican-American male youth gang committed to defending his BARRIO, language and/or culture; this gang was popular in the 1940s and 1950s and popularized the PACHUCO[1] slang. *See* ZOOT SUIT RIOTS.

Pacific (Standard Time) (daily life) (PST) The clock time of the STATES of California, Oregon, Washington, Nevada and parts of Montana; that is, those areas located west of the ROCKY MOUNTAINS (e.g., LOS ANGELES, SAN FRANCISCO, SEATTLE, LAS VEGAS). It corresponds to the Pacific time zone. It is three hours later than EASTERN STANDARD TIME.

Pacific Northwest, the (geography) A collective name for the STATES of Washington, Oregon and parts of northern California; it is characterized by having wet, rainy winters and warm summers and for having a strong interest in the ENVIRON-

MENTAL MOVEMENT. *See* SEATTLE, SPOTTED OWL, OREGON TRAIL.

package (government) A legislative BILL[2] that combines various programs and/or features in order to satisfy both the legislature and the CHIEF EXECUTIVE and thus to avoid a veto. Usually, it combines several BILLS[2] into one.

Paglia, Camille (people) (born in 1947) Art historian, intellectual and PROFESSOR. She has written on art, pornography and feminism, claiming that great art comes from male lust, namely in the book, *Sex, Art and American Culture* (1992). She is known for supporting lesbian issues and for writing an essay which first regarded MADONNA as a FEMINIST.

Palm Beach (geography) A town in southern Florida (population 9,700) on the Atlantic Coast which serves as a popular beach and seaside resort during the winter.

Palm Springs (geography) A city (population 32,200) located in the MOJAVE DESERT 500 miles (800 km) east of LOS ANGELES. It is known for having a sunny, warm, dry climate making it a popular resort area for the wealthy and other celebrities from California.

Pan-American Games (sports and leisure) A formal athletic competition in 26 different sports for amateur athletes from North America and South America. It is held in a different country once every four years, in the year before the International Summer Olympics games. It was first held in 1951 but has been held in the UNITED STATES only twice; CHICAGO in 1959 and Indianapolis, Indiana in 1987.

panama (hat) (clothing) A soft, light, bendable hat made from the young leaves of the tropical jipijapa plant worn in the summertime by both men and women to protect their faces from the sun. [Originally made in the country of 'Panama' but popularized in the UNITED STATES after the construction of the Panama Canal, about 1914.]

Parade (media) A weekly magazine distributed as a supplement in the SUNDAY EDITION with many nationwide newspapers. It contains general interest articles and features about current events, health, celebrities and the achievements of ordin-ary people. It was founded in 1941 and has a current circulation of 37 million.

paralegal (legal system) A person trained in the law (but who is not an ATTORNEY), and who helps attorneys to perform their work. *Compare* LAW CLERK.

pardon (government) The power of the PRESIDENT and some governors to stop all legal cases, legal proceedings or punishment against a person who is accused of, or is thought to have committed, a crime. It may be given before or after a conviction. Also, it can be used to reduce or delay the prison sentence of some person that that official chooses. Also known as "presidential pardon" and "executive pardon".

Parent Teacher Association (education) (PTA) A nationwide organization in ELEMENTARY SCHOOLS and HIGH SCHOOLS for parents and teachers. It was originally founded to create cooperation between parents and SCHOOL[1] staff but now it also works with curriculum decisions and legal issues. It has local branches in many SCHOOLS[1] with offices at the STATE and national levels. [Popularly known as the "PTA" from the abbreviation of 'P'arent 'T'eacher 'A'ssociation.] *Compare* PARENT TEACHER ORGANIZATION.

Parent Teacher Organization (education) (PTO) A national organization that encourages volunteer parental involvement in the public ELEMENTARY SCHOOLS and SECONDARY SCHOOLS. Parents work as volunteers in classroom activities, FIELD TRIPS and tutoring. [Popularly known as the "PTO" from the abbreviation of 'P'arent 'T'eacher 'O'rganization.] *See* PUBLIC SCHOOL; *compare* PARENT TEACHER ASSOCIATION.

parents' weekend (education) A WEEKEND when parents visit their UNDERGRADUATE children at COLLEGE[1] and together participate in COLLEGE[1]-sponsored dinners and dances on-CAMPUS and watch sporting events. It is a time for the parents to get to know the COLLEGE[1] while spending time with their children. Similar activities are held for mothers and their child-student(s) on "Mothers' Weekend"; as well as fathers and their child-student(s) on "Fathers' Weekend".

pari-mutuel (sports and leisure) A type of bet in horse racing which pays all the winning bettors money in proportion to the bet that each placed. Therefore, the bigger the bet, the bigger the amount of money earned. It is figured by dividing the total amount of money bet on a race by the amount of the bet placed by each bettor. The lowest and most common is the "$2.00 mutuel bet". Also known as "mutuel"; *see* KENTUCKY DERBY.

parish (geography) In the STATE of Louisiana, the name for a COUNTY.

Parker, Charlie "Bird" (people) (1920–1955) JAZZ MUSICIAN and alto saxophone soloist, African-American bandleader and composer. He excelled at performing SWING MUSIC and was a key figure in developing BEBOP. He suffered from drinking too much alcohol and a drug addiction to heroin which caused him to die young. Today, he is still admired for his skill at improvising and innovating with both forms of jazz music and is considered one of the greatest artists of jazz in the twentieth century. [His nickname was "Bird", a shortened form of "Yard Bird", which is a slang name for a "chicken".]

parking ticket (transportation) A money fine given to the driver of a car by a local or city police department for parking that car illegally.

Parks, Rosa (people) (born in 1913) African-American seamstress, NAACP member and CIVIL RIGHTS leader. She is known for a bus trip that she took in December 1955 in which she refused to stand and give a white man her seat (which was the rule at that time in that segregated Southern city of Montgomery, Alabama). Her refusal to follow the rule led to the MONTGOMERY BUS BOYCOTT. She is known as the "Mother of the Civil Rights Movement" and has become a strong symbol of CIVIL DISOBEDIENCE and courage. *See* MARTIN LUTHER KING, JR.

parochial school (education) A PRIVATE SCHOOL at the ELEMENTARY SCHOOL or SECONDARY SCHOOL level administered and funded by an archdiocese of the ROMAN CATHOLIC CHURCH. It teaches students a CORE CURRICULUM plus religion class of Catholic values and philosophy. Usually, these schools are very disciplined and structured, require students to wear uniforms and, before 1970, the majority of the teachers were members of a religious order (e.g., nuns and priests). *Compare* PUBLIC SCHOOL.

partisan (government) Describing something that pertains, belongs to or favors one particular group (e.g., political party) over another; biased. *Compare* BIPARTISAN.

Parton, Dolly (people) (born in 1943) COUNTRY MUSIC singer, songwriter and actress. A successful entertainer, she now owns the Dollywood Entertainment Theme Park in NASHVILLE. Her best known song is "Working Nine to Five". She is easily recognized by her large breasts, petite body frame and full blond/white hair.

party-column ballot (politics) A BALLOT[1] divided into columns which lists the candidates in those columns according to their political parties. Also known as "INDIANA BALLOT"; *compare* OFFICE-BLOCK BALLOT.

Patriots' Day (customs and traditions) The third Monday in April honoring the battles of LEXINGTON AND CONCORD and the start of the AMERICAN REVOLUTION in 1775. It is a LEGAL HOLIDAY only in the STATES of Massachusetts and Maine. The BOSTON MARATHON is held on this day.

pay-TV (media) A system of television programming in which a person 'pays' to watch a program at home either by the month (e.g., cable TV) or by the program. *See* SUBSCRIBER.

PBS (media) A public television network, created in 1969, that distributes (but does not make) programs to its television AFFILIATES[2]. Popular programs include *SESAME STREET*, *NOVA* and *American Playhouse*. [Abbreviation of 'P'ublic 'B'roadcasting 'S'ervice.] *See* PUBLIC BROADCASTING.

PC (language) [Abbreviation of 'P'OLITICALLY 'C'ORRECT.]

pea coat (clothing) A short, double-breasted, button-up sturdy, wool coat with wide lapels which is worn over sweaters and other clothing. Traditionally, it was made of navy blue wool and worn by seamen. [From Dutch *pij*, a type of clothing made of sturdy or rough fabric.] Also known as "pea jacket".

Peace Corps, the (foreign policy) The independent government agency which sends American volunteers to the poorest regions of developing countries for a two-year period in order to work there independently in projects concerning education, economic development, health care or agriculture. Most **Peace Corps Volunteers** (PCVs) are characterized by being recent and idealistic COLLEGE[3] GRADUATES[1] and, since the 1980s, by more experienced older people. It was started by PRESIDENT JOHN KENNEDY in 1961 and is a popular program among both major political parties and the American public. *Compare* AGENCY FOR INTERNATIONAL DEVELOPMENT (AID).

Peaceable Kingdom (the arts) A painting (from 1834) depicting two scenes in the same work; on the right are wild animals lying down in a group headed by a young child. On the left is depicted the significant event of the QUAKERS and WILLIAM PENN acquiring land peacefully from the TRIBE of Delaware Indians. The painting is based on a famous quote from the Bible, Isaiah 11:6, which states that when lasting peace occurs, it will entail that the wild animals become tame and follow the leadership of a child. It was painted by Edward Hicks (1780–1849).

Peale, Charles Winston (people) (1741–1827) A portrait painter known for creating realistic-looking paintings. He frequently painted military and political leaders of the early history of the US; he painted over 10 different portraits of GEORGE WASHINGTON.

peanut butter and jelly sandwich (food and drink) (PB&J) A popular LUNCH BOX sandwich consisting of peanut butter spread on one piece of sliced bread and fruit jelly (e.g., strawberry, grape) spread on the other. It is a favorite food of children.

Pearl Harbor (history) The headquarters of the US Naval Pacific Fleet and the site of a surprise bomb attack by Japanese military airplanes on the morning of December 7, 1941. The bombings sunk the *USS Arizona*, killing 1,100 men (many of whom were still sleeping on board), as well as several other ships and airplanes. In total, 2,400 people died. This event shocked and angered the American public; PRESIDENT FRANKLIN ROOSEVELT claimed that this "day will live in infamy". This event led to the UNITED STATES becoming militarily active in WORLD WAR II; the next day, PRESIDENT ROOSEVELT declared war on Japan.

Pearl, Minnie (people) (born Sarah Ophelia Colley in 1912) Entertainer. The stage name of the female character created by Ms. Colley. Minnie Pearl is known for wearing cheap dresses, a hat with the price tag still hanging from it ("$1"), for telling bad jokes, and for talking a lot while relating stories about the happenings in the small town of "Grinder's Switch". She was a popular performing figure in the COUNTRY MUSIC entertainment business from 1940 until 1991.

Pei, I[eoh] M[ing] (people) (born in China in 1917) An American-trained architect. His designs are in the late modernist style and are characterized by straight lines, large, smooth geometric shapes, and the use of glass, marble and concrete. Some of his designs include: the John F. Kennedy Library (1979), the East Wing of the National Gallery of the SMITHSONIAN[1], the Holocaust Museum in WASHINGTON D.C. and, in Paris, France, the pyramids of the Louvre Museum.

Pell Grant (education) A federal FINANCIAL AID program that provides paid work to financially needy, full-time students enrolled in HIGHER EDUCATION which helps them pay VOCATIONAL SCHOOL or COLLEGE[3] tuition as well as ROOM AND BOARD costs. Before 1981, it was known as the program of "Basic Educational Opportunity Grant" (BEOG). [After Rhode Island SENATOR Claiborne 'Pell' (born in 1918), who sponsored this BILL[2].] *Compare* WORK-STUDY, SCHOLARSHIP, CO-OP.

pen(itentiary) (legal system) A prison; it may be operated by the federal government (i.e., "federal pen") or a STATE government (i.e., "state pen").

PEN/Faulkner Award (the arts) A literary prize established by fiction writers which is awarded to a writer of fiction. A panel of three contemporary fiction writer-judges selects the winning author. It is awarded every April (first in 1980); currently, the prize money is $15,000.

Penn, William (people) (1644–1718) An English QUAKER, social activist, pacifist and advocate for religious freedom. He was a leading member of the British SOCIETY OF FRIENDS and established the colony of Pennsylvania (1682) in America as a place where religious groups could practice their religion without being persecuted and NATIVE AMERICANS would be treated fairly. He has long been a symbol of religious freedom.

pennant, the (sports and leisure) In professional BASEBALL, the three-pointed long flag and the title of "league champion" awarded to the two winners of the LEAGUE CHAMPIONSHIP SERIES. It is awarded to the winner of the National League Championship Series held in the NATIONAL LEAGUE and to the winner of the American League Championship Series held in the AMERICAN LEAGUE. Each team flies its flag over its HOME TEAM stadium. By association, a nickname for the LEAGUE CHAMPIONSHIP SERIES.

Pennsylvania Avenue (government) The nickname for the WHITE HOUSE. By association, a nickname for the current PRESIDENT. [For its street address; 1600 'Pennsylvania Avenue' in WASHINGTON D.C. 20090.]

Pennsylvania Dutch (1 society; 2 language) **1** A collective name for those groups of people descended from Germans who immigrated to North America in the seventeenth and eighteenth centuries. Currently, most of these people live in the eastern part of the STATE of 'Pennsylvania' and follow traditional, old-fashioned lifestyles (e.g., farming). They are characterized by speaking PENNSYLVANIA DUTCH[2] among themselves. **2** A dialect of English using the syntax and pronunciation of German. It is the first language spoken by the PENNSYLVANIA DUTCH[1] people, especially the AMISH.

penny (economy) An orange-colored coin, worth one cent or one-hundredth of a DOLLAR. It is embossed with the motto "IN GOD WE TRUST" and the bust of ABRAHAM LINCOLN on one side and the motto *E PLURIBUS UNUM* and an image of the Lincoln Memorial on the other side.

penny paper (media) A type of DAILY in the nineteenth century that used newer print machines to print quickly on inexpensive paper. It reported information for the average person, especially local news, crime stories and humor. It began in 1833 and became popular during JACKSONIAN DEMOCRACY. [They were sold on street corners by PAPERBOYS for one 'PENNY'.] *See* NEW JOURNALISM[2].

Pentagon, the (military) The world's largest office building, located just south of WASHINGTON D.C. in Northern Virginia, which contains the headquarters of the DEPARTMENT OF DEFENSE and its various DEPARTMENTS[2]. By association, a nickname for the Department of Defense, military leadership and/or the military establishment of the US. [From the building's unique geometrical shape of five sides.]

***Pentagon Papers*, the** (media) The popular name for the case in which the *NEW YORK TIMES* and the *WASHINGTON POST* obtained and published information from a classified 40-volume study by the PENTAGON (1964–1965) concerning the VIETNAM WAR, the US government's decisions in that war and the incidents leading to the GULF OF TONKIN RESOLUTION. The government did not want these papers published; the newspapers believed that it was their responsibility to publish them. This conflict was only resolved in the court decision of *NEW YORK TIMES CO. v. UNITED STATES*. This case is an example of the freedom of the press. *See* FIRST AMENDMENT.

Pentecostal Church (religion) A diverse EVANGELICAL movement which is based on PROTESTANT beliefs and developed out of REVIVALS in Kansas and California (from 1901 to 1906). Followers believe in experiencing a "spiritual baptism" by Jesus Christ which causes them to "speak in tongues" (i.e., meaning "speaking in an excited way with different sounds"). Other **Pentecostal** beliefs include the importance of the Bible, baptism, spontaneous behavior in worship services and that Jesus Christ will return to earth soon. Currently in the US, there are 10.6 million total members; the largest organized groups practicing **Pentecostalism** are the Church of God in Christ

with 5.5 million members and Assemblies of Christ with 2.3 million members.

People Weekly (media) A weekly entertainment magazine containing articles and photographs of the public and private lives of celebrities and TV and movie stars. It was reorganized in 1974 and has a current circulation of 3.4 million.

pep rally (education) A SCHOOL[5]-sponsored organized gathering of athletes and students held to increase the support of an athletic team from that SCHOOL[5] and to heighten the excitement and enthusiasm of the crowd and players; it is usually held before an important game or tournament game. Usually, coaches and certain players give speeches to the students, CHEERLEADERS chant and perform and a few musicians of the MARCHING BAND perform the FIGHT SONG and other excited songs. By association, any organized event which promotes the qualities of some person or group and has an unusually elevated amount of enthusiasm and cheering.

performance art (the arts) A unique form of art in which the performer combines movements and aspects from dance, acting, pantomime and painting to convey a message to the public. It began during the 1970s and is frequently performed on the streets or in public parks.

Perot, H. Ross (people) (born in 1930) A businessman, billionaire and founder of the Reform Party who has an interest in politics. He was an INDEPENDENT CANDIDATE for US PRESIDENT in 1992 (receiving 19 million POPULAR VOTES) and in 1996 (8 million popular votes). Both his CAMPAIGNS were hurt because several times he decided to be a candidate, then decided not to be one, then again decided to be one. He is known for having an outspoken manner, giving long (i.e., 20 minute) TV information-COMMERCIALS (known as "infomercials") to explain a political issue to the public and not being able to commit himself fully to a decision. *See* THIRD PARTY[1]; SPOT.

personals, the (media) Any advertisement which an individual can use to print personal requests (e.g., DATING) or messages (e.g., birthday, VALENTINE'S DAY) and printed in a newspaper or magazine.

[From 'personal' advertisements.] *Compare* CLASSIFIED ADVERTISEMENTS.

petty jury/petit jury (legal system) A group of six to 12 persons who have agreed (i.e., sworn) to listen to the facts during a CRIMINAL TRIAL or CIVIL TRAIL and to make a decision (i.e., "guilty" or "not guilty") to solve it. ['petty' is a variation of *petit,* the French word, meaning "small".] *See* JURY DUTY; *compare* GRAND JURY.

peyote (religion) A type of small cactus (*Lophophora williamsii*) growing in Texas and Mexico and producing round, buttonsized tops which, when dried and eaten, give a person feelings of relaxation, timelessness and happiness as well as visions. Although it has been eaten by INDIANS in the SOUTHWEST for hundreds of years it is controversial because of these psychedelic properties. According to the federal Drug Abuse Control Act (1965), members of the NATIVE AMERICAN CHURCH may use it in religious services; however, others may not. *See* AMERICAN INDIAN RELIGIOUS FREEDOM ACT.

PG (the arts) In the movies, the type of ranking of the RATINGS SYSTEM[2] indicating that children and young teenagers can only see this film if they are accompanied by their parent(s) because the movie contains scenes with some violent or frightening actions and/or adult language. However, it is more appropriate for young people to see than films rated PG-13. [Abbreviation of 'P'arental 'G'uidance.]

PG-13 (the arts) In the movies, the type of ranking of the RATINGS SYSTEM[2] indicating that children who are under the age of 13 cannot see this movie alone because the movie contains scenes containing some sexual or violent scenes and adult language. However, they may see it if they are accompanied by an adult. [Abbreviation of 'P'arental 'G'uidance for those children under the age of '13'.] *Compare* PG.

PGA (Championship), the (sports and leisure) One of the top tournaments for professional male golfers first held in 1916. It is held in August and its location changes every year. It is the last tournament in the GRAND SLAM[2].

pharmacy (health) A shop which is licensed to mix and sell prescription drugs

and medicines ordered by doctors. It also sells vitamins, non-prescription medications and other health care equipment. It is operated by a trained, registered **pharmacist**. *Compare* DRUG STORE.

PhD (education) The highest academic degree in the LIBERAL ARTS and sciences in American education. It is awarded to a GRADUATE[2] student who has completed a few years of academic courses, passed PRELIMS, done independent research and written a DISSERTATION. An "honorary doctorate" is a commemorative PhD given by a UNIVERSITY to a well-known person to recognize that person's work in public service or the arts. All PhD degree holders are addressed with the title "doctor" (e.g., Dr. King). Also known as "doctorate". [From Latin, *philosophiae doctor*, meaning "teacher of philosophy".] *See* Appendix 4 Education Levels; *compare* LIBERAL ARTS COLLEGE.

Phi Beta Kappa (education) A GREEK-LETTER ORGANIZATION and national HONOR SOCIETY for COLLEGE[1] students which was first established in 1776. By association, an UNDERGRADUATE who receives high GRADES[1] and is elected a member of this society. [The acronym comes from Greek, *'phi'losophi 'b'iou 'k'ybernetes*, meaning, "philosophy, the guide of life".] *See* LETTERS, PIN.

Phillips Exeter Academy (education) A prestigious BOARDING SCHOOL (although some students live off-CAMPUS, too) with a PREP SCHOOL curriculum. It is located in 'Exeter', New Hampshire, and was founded in 1781. It has a COED population of 1,000 students and has ACCREDITATION from the NEASC. Also known as "Exeter Academy".

Phys-Ed (education) A practical course in ELEMENTARY SCHOOLS and HIGH SCHOOLS which teaches students how to exercise, care for and feed the body. Usually classes are taught in a GYM, weight room, on a field or a court. [Shortened from 'phys'ical + 'ed'ucation.]

Pickett's Charge (history) During the difficult Battle of GETTYSBURG, the failed attempt that part of the Confederate Army made to capture a small hill which the UNION[3] troops were holding. The 15,000 Confederate troops ran across a wide, open field and up that hill, an action which exposed them to heavy gunfire killing two-thirds of them. Only one-third of them succeeded in climbing the hill. By association, a brave, but unsound action which fails. [After the intended Confederate leader of this 'charge', George 'Pickett' (1825–1875).] *See* CONFEDERATE STATES OF AMERICA.

pickup truck (transportation) A type of vehicle with an enclosed front cab for the driver and passengers and an open back bed which can be used to haul or carry things. It is used for work and recreation and is a perennially popular vehicle. *Compare* SUBURBAN.

picture ID (card) (daily life) A type of ID CARD which includes written identifying information as well as a facial photo of the card holder. It is often shown as proof of a person's age (to enter BARS[1]) and proof of identity (when writing PERSONAL CHECKS). Also known as "photo ID".

picture-bride (immigration) A woman who immigrates to the US in order to marry a man in the US. The marriage between the two is usually arranged by a neutral party. [From the 'picture' of the future 'bride', which the future groom usually sees before agreeing to the union and paying for her ticket to the US.]

pie (food and drink) A popular dish of a pastry shell filled with any of various fillings for dessert; fruit (e.g., apple, cherry), vegetable (e.g., rhubarb, pumpkin, sweet potato) and nut (e.g., pecan, walnut). Further, it may be filled with meats (known as "potpie") and served as an ENTREE. *See* KEY LIME PIE, SHOOFLY PIE, A LA MODE, PUMPKIN PIE.

pig in a blanket (food and drink) Pork sausage fried and rolled in a breaded dough mixture and cut into bite-sized pieces. It is dipped in mustard or ketchup sauces and served as a type of FINGER FOOD.

piggy bank (economy) A children's bank (made of metal or plastic) for saving coins. Traditionally, it has been made in the form of a small, round-bodied 'pig'. It is a symbol of saving money and hard work.

pigskin (sports and leisure) A nickname for the elliptical-shaped, leather ball used

in FOOTBALL. [The ball's leather is made from the 'skin' of a 'pig'.]

Pilgrims, the (society) A radical religious group of 102 people who established an English settlement in AMERICA[1] at PLYMOUTH, Massachusetts on November 21, 1620. They left England and Holland for America because they wanted to separate from the Church of England and practice their own independent, Calvinist-type religion without harassment. By association, their descendants in America during the COLONIAL PERIOD. *See MAYFLOWER, MAYFLOWER COMPACT, "CITY ON A HILL", EPISCOPALIAN, THANKSGIVING DAY, CALVINISM; compare* PURITANS, JAMESTOWN.

pin (customs and traditions) In COLLEGE[1] social life, a small decorative membership badge for a social GREEK-LETTER ORGANIZATION. It is decorated with the crest and Greek letters of the SORORITY or FRATERNITY. It is worn over the heart by members with formal clothing and usually to special club meetings. **To pin** someone is when a fraternity member gives his pin to a girlfriend as a sign of their commitment to each other. If the woman is a member of a sorority, she attaches it to her own pin with a small chain. A **pinned** couple is DATING each other seriously. *Compare* CLASS RING.

Pine Ridge Indian Reservation (geography) The second largest Indian RESERVATION which is home to the Oglala SIOUX TRIBE. It is located in the BADLANDS in the STATE of South Dakota and contains the sites of the WOUNDED KNEE MASSACRE and WOUNDED KNEE II. *Compare* NAVAJO.

pinochle (sports and leisure) A card game using 48 cards in which the players (at least two people) try to earn points by collecting sets of cards and then laying them. By association, the best two card combination of queen of spades and jack of diamonds (which carries a special value of 40 points) is also known as "pinochle".

pinstriped suit (clothing) A dark-colored wool suit (i.e., blue, black, gray) through which very thin vertical stripes run. It is often worn by men or women who work in banking and the investment businesses or other WHITE-COLLAR workers.

Pioneers' Day (customs and traditions) A LEGAL HOLIDAY in some STATES of the MIDWEST and WEST which celebrates the people in the past who helped make settlements in areas of the present-day UNITED STATES. It is recognized on the second Monday of October, that is the same day as, and in place of, COLUMBUS DAY and DISCOVERERS' DAY.

pit, the (economy) In the stock exchange, the place where traders physically gather to trade shares and other COMMODITIES. The traders use a unique hand system in the pit for trading. It is characterized as being noisy, loud and crowded.

pitcher (sports and leisure) In BASEBALL, the defensive team player who stands on the "pitcher's mound" in the center of the DIAMOND and throws (i.e., 'pitches') the ball a distance of 60.5 feet (18.4 m) to the batter of the opposing team. This player's arm and shoulder are very important to performing this position well. *See* CY YOUNG AWARD, ERA[1], WALK[1]; *compare* RELIEF PITCHER.

placement test (education) An exam, usually MULTIPLE-CHOICE, that tests students' academic knowledge in a subject so as to 'place' them in the appropriate level of a course or to give academic CREDITS. *See* ADVANCED PLACEMENT PROGRAM.

Plains Indians (people) A collective name for the various Indian TRIBES that traditionally lived on and migrated around the GREAT PLAINS hunting wild game and whose economy was based on buffalo and riding horses, namely, the SIOUX, the Kiowa, the Araphoe and the Pawnee. These traditional cultures had reached a particularly advanced state of societal organization and development during the early nineteenth century.

plaintiff (legal system) In the CIVIL LAW[1] system, the person or group who has a complaint and starts legal action against someone else (i.e., DEFENDANT).

plank (politics) A political statement or opinion about a specific issue (e.g., supporting ERA[2], not supporting the death penalty). Several planks make up a political party's PLATFORM.

Planned Parenthood (health) A national organization which operates over

180 health clinics nationwide for women, providing women with gynecological services, health check-ups, birth control information and supplies and abortions. It was originally founded in 1916 and its headquarters are in NEW YORK CITY. It is an active group of the PRO-CHOICE movement. In 1942, it took over operations of the AMERICAN BIRTH CONTROL LEAGUE.

platform (politics) The official statement of a political party that lists the positions and opinions (e.g., PLANKS) that it will support for the next four years. It is agreed upon by the DELEGATES at a NATIONAL CONVENTION and can influence the programs that a nominee presents in his or her campaign.

platinum record (the arts) In the recording music business, describing a record (i.e., album, Compact Disk or audio cassette) which has sold 1 million authorized copies. Before 1989, 2 million copies had to be sold in order for a record or music artist to "go platinum". The success of musical artists, especially POP MUSIC artists, is measured in the number of their platinum records and GOLD RECORDS. The sales information is supplied by the Recording Industry Association in WASHINGTON D.C.; *compare* GOLD RECORD.

Playboy (media) A monthly men's magazine which features photographs of nude young women; in the middle of every issue is a large, fold-out photograph (i.e., the "centerfold") of a particular woman (known as the "Playmate of the Month"). Because the magazine also includes articles on current events, interviews with famous individuals and short works of fiction and/or nonfiction, many male customers claim that they "buy the magazine for [the quality of] the articles" (actually, this is a popular, standing joke). Also, it has sponsored live clubs in several cities where the female companions, known as "Playboy Bunnies", wore small, revealing costumes and bunny ears. FEMINISTS found these activities degrading to women. It was established by Hugh Hefner (born in 1926) in CHICAGO in 1953. Since 1988, it has been headed by his daughter Christie Hefner (born in 1952) and currently has a current circulation in the US of 3.2 million.

playlist (the arts) In a radio station or on a video TV channel, the set list of recorded songs or videos which are selected by the station (i.e., not the DJ) and to be played at specific times during the programming.

playoff (sports and leisure) Describing any post-season game in which teams of the same conference or division play each other. Playoff games are held in BASEBALL (e.g., Division Series, LEAGUE CHAMPIONSHIP SERIES), BASKETBALL and FOOTBALL.

plea bargaining (legal system) A method of settling criminal cases without having a CRIMINAL TRIAL. A **plea bargain** is an agreement between a PROSECUTING ATTORNEY and the DEFENDANT (or his or her ATTORNEY) when the defendant admits his or her guilt in a crime in exchange for a less severe punishment. *See* OUT-OF-COURT SETTLEMENT.

Pledge of Allegiance to the Flag (customs and traditions) An oath respecting both the STARS AND STRIPES[1] and the UNITED STATES. It was written in 1892 and is recited in unison by SCHOOL[1] children before beginning each academic day. The full text is: "I pledge allegiance to the flag of the United States of America and to the Republic for which it stands, one nation under God, indivisible, with liberty and justice for all." Because some religions in the US prohibit members from reciting oaths (e.g., QUAKERS, SEVENTH-DAY ADVENTISTS), these students are no longer required to recite this oath. *See* MINERSVILLE SCHOOL DISTRICT v. GOBITIS.

Plessy* v. *Ferguson (legal system) The infamous and powerful SUPREME COURT DECISION (1896) that permitted STATES to pass and enforce state-level laws of "SEPARATE BUT EQUAL"; especially in permitting segregated public services for whites and blacks as long as those facilities were equal. The case concerned a black man, Homer 'Plessy', who in the STATE of Louisiana wanted to ride in a public train car reserved for whites. He lost the case because there was a separate car available for blacks to ride in. This decision encouraged states in the SOUTH to pass JIM CROW LAWS and DE JURE segregation based on racial DISCRIMINATION which affected transportation, PUBLIC SCHOOLS, restaurants, swimming pools, water fountains,

etc. This decision was important in shaping black–white interpersonal, political and social relations for over 50 years. It was only OVERRULED in 1954 with *BROWN* v. *BOARD OF EDUCATION, SEGREGATION.*

pluralism (government) The political principle and practice of different groups in the society exercising their separate, various activities and beliefs, while still participating and/or lobbying the government and following its rules. *See E PLURIBUS UNUM,* LOBBY.

Plymouth Colony (history) The lands of the PILGRIM villages in present-day Massachusetts, that began as a grant from James I, King of England (1603–1625). *See* WILLIAM BRADFORD, *MAYFLOWER COMPACT.*

Pocahontas (people) (1595–1617) NATIVE AMERICAN and diplomat. According to tradition, she worked to avoid war between the Indian group known as the "Powhatan Confederacy", which was led by her father Powhatan (*c.* 1550–1618), and the new English colonists living at JAMESTOWN. Tradition says that when the English colonists' leader, Captain John Smith (*c.* 1580–1631), was captured and threatened with death, she saved him by asking Powhatan to free him. Based on this story, she is known for her self-sacrifice and interest in the cohabitation of whites and INDIANS. In 1614, she married the colonial Englishman, John Rolfe (1585–1622), was given the name Lady Rebecca Rolfe and visited England where she became popular; however, she contracted an illness and died there.

pocket veto (government) A special veto power of the CHIEF EXECUTIVE whereby he or she can kill a BILL[2] without formally vetoing it. If the PRESIDENT receives a Congressional bill 10 days before CONGRESS leaves for an ADJOURNMENT[1], and he or she does not sign it, the bill automatically dies, thus not becoming law. *Compare* LINE-ITEM VETO.

Poe, Edgar Allan (people) (1809–1849) Writer of short stories, poetry and criticism, and editor. He is best known for his imaginative stories (often narrated by an unusual or crazed character), many of which contain elements of suspense, fantasy and/or horror, as in "The Tell-Tale

Heart" (1843). One of his best-known poems, "The Raven" (1845), is admired for similar reasons as well as its repetition and melody. He is also recognized as the first person in the English language to create and use the detective story: in "The Murders in the Rue Morgue" (1841). *See* AMERICAN RENAISSANCE.

poet laureate (the arts) The honorary but paid position and award, usually for one year, granted to a current, active American poet to write and create poetry. It is presented by the LIBRARY OF CONGRESS; it was first presented in 1986.

pol (politics) A popular name for a politician. [Clipping from 'pol'itician.]

Political Correctness (language) (PC) A belief and practice of not offending certain MINORITIES and women and other groups by using derogatory language to refer to these groups or their members. It became popular in the late 1980s and 1990s especially on COLLEGE[3] campuses. However, although it supports MULTICULTURALISM (e.g., promoting the use of "AFRICAN AMERICAN" to refer to this group of people), some critics believe that it offends an individual's freedom of speech by prohibiting them from saying what they want to say. *See* FIRST AMENDMENT, FREEDOM OF SPEECH.

poll tax (politics) A special tax used to control voting by demanding that a citizen pays money before voting (i.e., at the POLLS). It was forbidden by the TWENTY-FOURTH AMENDMENT and the SUPREME COURT declared it UNCONSTITUTIONAL in 1966. *See* JIM CROW LAWS, NAACP, VOTER REGISTRATION.

polling (politics) A method of measuring the opinions of people by asking them a number of questions. A **poll** may be taken over the telephone, by computer or in person. *See* GALLUP POLL, EXIT POLL; *compare* CANVASSING.

Pollock, Jackson (people) (1912–1956) An oil painter and a major force in ABSTRACT EXPRESSIONISM. His paintings are characterized by being very large but containing no images; in fact, he applied the paint to all the canvas without the use of brushes (therefore, he poured, sprinkled, or dropped paint on it) and

without a general plan or pattern. He called this method "ACTION PAINTING".

polls, the (politics) The physical location where voters go to vote in a PRIMARY ELECTION or on ELECTION DAY, usually in a post office, PUBLIC SCHOOL or public library.

pom pom (sports and leisure) A fluffy, round-shaped hand-held instrument consisting of long, thin strips of colored plastic or paper bound to a piece of wood or plastic. It is shaken and waved by CHEERLEADERS when leading cheers. Female cheerleaders may be called "pom-pom girls".

Poor People's Campaign (minorities) A peaceful demonstration held in WASHINGTON D.C. that tried to highlight the problems of poor people living in the US and to encourage the CONGRESS to pass legislation to help poor people afford good, low-income housing and other aid. During the campaign, the 2,000 participants, mostly poor blacks, whites and some Indian TRIBE members, built a settlement of tents and sheds on the MALL near the Lincoln Memorial to illustrate to federal officials the quality of life of poor people. This settlement was called RESURRECTION CITY and JESSE JACKSON served as its unofficial mayor. The month-long demonstration (May 11 to June 10, 1968) was originally planned by MARTIN LUTHER KING, JR., but was led by Ralph Abernathy (1926–1990) and the SOUTHERN CHRISTIAN LEADERSHIP CONFERENCE. It was not so successful due to the rainy, bad weather and organizational problems.

Poor Richard's Almanack (the arts) A written collection of pieces of information, humor, essays and proverbs. They were written by BENJAMIN FRANKLIN and published in the eighteenth century.

Pop art (the arts) The artistic movement which used everyday, common objects from popular culture as subject matter; especially the containers of these products – cans of soup, boxes of cleansing materials and powders – as well as the images of celebrities (e.g., ELVIS PRESLEY, MARILYN MONROE) and oversized cartoon panels. Art works from this movement are characterized by having bright colors, hard lines and by being, shiny, glossy and

anonymous (artists signed the works on the back). Often these images were reproduced, repeated and oversized as a method of showing the power and pervasiveness of commercial, mass advertising and marketing. It started in the mid-1950s and used elements from commercial illustration. It was based in NEW YORK CITY and active through the 1960s. It was led by ANDY WARHOL and ROY LICHTENSTEIN; other painters included Robert Indiana (born in 1928) and Jim Dine (born in 1925). [Clipped from 'pop'ular culture 'art'.]

Pop music (the arts) In general, music which is currently popular among the public. Specifically and since the 1970s, any music in which the music and the singer(s) and/or performer(s) are produced and promoted as an appealing package in order to attract listeners/buyers and sell records, Compact Disks (CDs) and audio cassettes. [Shortened from 'Pop'ular 'music'.] *See BILLBOARD*, CHARTS, MADONNA, MICHAEL JACKSON.

popcorn (food and drink) A snack of corn kernels heated in oil or by air until they burst out of the kernel shell and served with salt and/or butter. *See* CRACKER JACK.

popular vote, the (politics) The votes of the people registered to vote. Also known as "popular votes"; *see* VOTER REGISTRATION; *compare* ELECTORAL VOTES.

Populist Party (politics) A popular name for the People's Party, a THIRD PARTY[1] that promoted monetary reform, the end of national banks, a nationalized railroad and a progressive INCOME TAX. It was only active in the presidential election of 1892 (its nominee for PRESIDENT was James Weaver) and received support mostly from farmers in the SOUTH and WEST. *See* PROGRESSIVE ERA.

Porgy and Bess (the arts) The romantic opera set in a poor black fishing community in Charleston, South Carolina. The music, which uses BLUE NOTES[1], African drums and the BANJO, was composed by GEORGE GERSHWIN and the lyrics and libretto were written by Dubose Heyward (1885–1940) and Ira Gershwin (1896–1983). It relates the love story of Porgy (bass), a poor, HANDICAPPED black man who is in love with Bess (soprano), a

pretty African-American woman. Although Porgy takes care of her, Bess eventually is encouraged by a drug dealer, named Sportin' Life (tenor), to move away with him to the big city of NEW YORK CITY. It was first presented in 1935. *See* "SUMMERTIME".

pork-barrel legislation (government) A type of legislative BILL2 that gives APPROPRIATIONS to local projects which are not vital nor critically needed. **Pork barreling** is practiced by a CONGRESSMEMBER to help give his or her voting district opportunities for increased business, new jobs and money. This usually occurs because of LOG-ROLLING. *See* LINE-ITEM VETO.

Port Huron Statement (education) A type of constitution and defining document of purpose written in June 1962 and used by the members of the STUDENTS FOR A DEMOCRATIC SOCIETY (SDS). It believed people should become active in protesting and praising their own government; it supported helping oppressed peoples; and it called for decreasing the US government's military presence in the world. Eventually, other members of the COUNTERCULTURE and supporters of the ANTI-WAR MOVEMENT adopted these claims as well. [After the location of the meeting in 'Port Huron', Michigan, where this document was written and first agreed upon.]

portfolio (economy) A collective name for the investments that an investor (i.e., company or individual) has. It may include: stocks, bonds, securities, COMMODITIES and/or real estate.

post-Cold War era (foreign policy) The political period of time generally considered to have begun on November 9, 1989, when the Berlin Wall started to be physically torn down by the German people, and lasting until the present.

post-graduate (education) Another name for a GRADUATE1 and/or GRADUATE2.

potlatch (customs and traditions) A special ceremony held to celebrate some important life event (e.g., birth, marriage) of a hosting individual. During the ceremony, the host gives each of the guests gifts, often from his or her own personal collection of items (e.g., clothing, special utensils, food). This giving and receiving of the gifts is considered an honor; the more a person gives, the more prestigious or respected he or she is. Because in the past the host often gave away all his or her possessions, many white people considered this practice socialist and distrusted it. This ceremony was a traditional ceremony unique to INDIAN TRIBES of the PACIFIC NORTHWEST; however, it is now practiced by various other Native American groups as well as some non-Indian groups. Likewise, the gifts are also known as "potlatch"; and when a person hosts such an event, he or she "gives potlatch". By association, a party or special celebration. [From the Chinook language *pátlac*.] Also known as a "GIVEAWAY".

potluck (food and drink) A kind of meal (e.g., LUNCH, DINNER) for a group of people which does not have a set menu because each person brings a prepared dish of food to share with the whole group. By association, it describes anything in which special arrangements have not been made.

Potomac fever (politics) The strong wish and/or actions of some individual of wanting to hold government power by being appointed or elected to a federal position. [After the 'Potomac' River, which flows through WASHINGTON D.C.]

pound (daily life) (lb.) A kind of American measurement for determining body weight or dry ingredients for cooking (i.e., not liquids). One pound = .45 kg; one pound consists of 16 ounces.

pound cake (food and drink) A sweet, yellow dessert cake originally made with a 'POUND' each of butter, sugar and flour.

POW (military) A military abbreviation referring to a member of the ARMED SERVICES who was seized and held by the enemy as a prisoner during and sometimes after the war or military conflict. [Abbreviation of 'P'risoner 'o'f 'W'ar.] *Compare* KIA.

Powell, Colin (people) (born in 1937) A commissioned General of the US ARMY and military adviser. He is recognized as being the first black (his family immigrated from Haiti) Chairman of the JOINT CHIEFS OF STAFF (1989–1993) and for being an important adviser during the GULF WAR. He is respected for his professionalism by both DEMOCRATS and REPUB-

LICANS both of which wanted him to serve as a candidate in the US presidential election of 1996. He served two TOURS OF DUTY in the VIETNAM WAR. Since 1997, he has been Chairman of the President's Summit for America's Future, a program that encourages volunteers to work toward helping to solve social problems.

power of attorney (legal system) The collective name for the rights and powers usually held and handled by an ATTORNEY (e.g., signing contracts, receiving payments, serving as a witness to signing contracts) which are given to an attorney or to some other responsible person.

power of the purse, the (government) The power that the CONSTITUTION gives to CONGRESS (specifically the HOUSE OF REPRESENTATIVES) to begin all BILLS2 that raise money (i.e., taxes). By association, that power of any person or group to control the money being earned (e.g., taxes) and spent (e.g., ENTITLEMENTS).

powwow (1, 2 customs and traditions) **1** An event of a TRIBE or group of tribes which consists of various ceremonial and/or competitive events, currently, these especially include singing, dancing, religious events, speeches, large meals or GIVEAWAYS. It may be a private event or public. Often prizes are awarded to the best singers and dancers. Often, men, women and children participate in the events wearing colorful or tribally significant costumes. *See* FANCY DANCE, GATHERING OF NATIONS, GALLUP CEREMONIAL, SUN DANCE. **2** A meeting of a political CAUCUS or some social event. [From Algonquin *pauau*, meaning "gathering of people".]

practice (work) The business of a qualified professional exercising his or her profession (e.g., a medical doctor, a defense ATTORNEY). *Compare* GROUP PRACTICE.

Prairie school, the (housing and architecture) A modern style of American architecture popularized in the MIDWEST during the period 1890 to 1920 and developed by a group of architects in CHICAGO. The buildings, mostly private suburban houses, are characterized by having low-pitched roofs which stretch wide over the walls of the building; as well

as having only one story; thick, square pillars, and rectangular windows. This style was especially promoted by FRANK LLOYD WRIGHT. *See* SUBURBS.

preacher (religion) A Christian, usually of a PROTESTANT DENOMINATION, or an EVANGELICAL who lectures and teaches a group of people about the Bible or other religious texts. He or she is usually addressed as "REVEREND". *See* REVIVAL, BILLY GRAHAM.

Preakness Stakes, the (sports and leisure) A 1-3/16 mile (1.91 km) long race for three-year-old thoroughbred horses. It is run on the third Saturday in May, first in 1873, at the dirt track at Pimlico Racetrack in Maryland. The winner receives money and an expensive trophy known as the Woodlawn Vase, recognized as the richest trophy in American sports. It is the second race of the TRIPLE CROWN1. [After the horse 'Preakness' which won an early race.]

Preamble, the (customs and traditions) The introductory statement to the CONSTITUTION which explains both the reasons for writing the Constitution and those goals that it was designed to achieve. Finally, it states that the power of the American government comes from the people. The statement begins with the phrase, "We the people of the UNITED STATES, in order to form a more perfect union, establish justice and insure domestic tranquillity. . .".

precedent (legal system) In law, a legal DECISION that is used to guide, explain or set a pattern for future decisions (which concern similar situations). *See* COMMON LAW, CASE LAW.

prelims (education) The exams, usually oral, that PHD candidates take after finishing their course work and before starting work on their DISSERTATIONS. After passing prelims, a GRADUATE2 is considered "ABD". [Shortened from 'prelim'inary examination's'.] *Compare* FINALS.

prep school (education) A disciplined, sometimes elite, SECONDARY SCHOOL that provides academic courses and experiences that prepares students for COLLEGE1 life. Most of its GRADUATES1 attend UNDERGRADUATE programs. [Shortened from college 'prep'aratory 'school'.] Also known

as "college prep school"; *see* PREPPIE[1], PHILLIPS EXETER ACADEMY.

preppie (1 education; 2 clothing) **1** A student or ALUM of a PREP SCHOOL. **2** A particular CONSERVATIVE style of dress, behavior and way of life long practiced by alumni of prep schools that was popular during the 1980s especially after the publication of *The Official Preppie Handbook* (1980), edited by Lisa Birnbach, which described this group. It includes LOAFERS and BLAZERS.

Presbyterian Church (religion) A branch of Protestantism which stresses the importance of the Bible (both the Old Testament and New Testament) and the minister's sermon. It was originally founded in Scotland in 1558 by John Knox (1505–1572) who believed in CALVINISM. It was first established in America in 1706 in Philadelphia and then spread to other areas. It supports equality and democracy among members and LAY persons and insists that they participate with ministers in the representative CHURCH[2] government which consists of (at the lowest level) local congregations, presbyteries, synods and the general assembly (at the highest level). Currently in the US, there are 4.2 million total members: the largest congregation is the Presbyterian Church U.S.A. with 3.7 million members. [From Greek *presbyteros*, meaning "older (wiser) man".] *See* PROTESTANT.

preschool (education) A general term for NURSERY SCHOOL and KINDERGARTEN.

Preservation Hall (the arts) In NEW ORLEANS, the small, basic, rather rundown JAZZ MUSIC club located in the FRENCH QUARTER where live "classic jazz" is still performed. It was established in the 1960s by Alan Philip Jaffe (1936–1987) to 'preserve' the sounds of NEW ORLEANS JAZZ.

President (government) The head of the executive branch of the federal government and symbolic leader of the UNITED STATES OF AMERICA. He is elected by POPULAR VOTE and the ELECTORAL COLLEGE to a four-year TERM[1] with a maximum of two elected terms. He must be at least 35 years of age, a native-born citizen and a resident of the US for at least 14 years. The President's workspace is in the OVAL OFFICE which, along with his official, residential home, is found in the WHITE HOUSE. He is addressed as "Mr. President". **Presidential** titles and powers include: CHIEF EXECUTIVE, CHIEF OF STATE of the United States of America and COMMANDER IN CHIEF of the ARMED FORCES. *See* CHECKS AND BALANCES, APPOINTMENT POWER, ADVICE AND CONSENT, INAUGURATION, FIRST LADY, FIRST FAMILY, AIR FORCE ONE, "IMPERIAL PRESIDENCY", IMPEACHMENT, TWENTIETH AMENDMENT, TWENTY-SECOND AMENDMENT, TWELFTH AMENDMENT, EXECUTIVE OFFICE, PENNSYLVANIA AVENUE, Appendix 2 Presidents.

president *pro tempore* (government) The SENATOR elected by the other senators to serve as the chief officer of the Senate (when the VICE PRESIDENT is not present). This ceremonial position has very little power and usually is given to the senator from the MAJORITY PARTY who has served in the Senate the longest period of time or number of TERMS[1] as a sign of respect. [Latin, meaning "for the time being".] *Compare* MAJORITY LEADER, MINORITY LEADER.

President of the Senate (government) The person who oversees the activities of the SENATE. Officially, the VICE PRESIDENT has this duty but he or she only attends Senate SESSIONS[1] and votes when there is a tie in the voting. Normally then, the PRESIDENT *PRO TEMPORE* serves in this position.

President's Commission on the Status of Women, the (minorities) The federal commission, appointed by JOHN F. KENNEDY in 1961 and led by ELEANOR ROOSEVELT, which studied the various issues concerning women, namely economics, politics, education and other aspects of society. This federal commission succeeded in encouraging all 50 STATES to operate similar commissions, which in turn led to the founding in 1966 of the NATIONAL ORGANIZATION FOR WOMEN.

President-elect (politics) The title used to address the newly-elected PRESIDENT during that period after having earned the most votes on ELECTION DAY and until the swearing-in ceremony on INAUGURATION DAY. Men are addressed as "Mr. President-elect".

presidential caucus (politics) An indirect system of nominating a candidate for PRESIDENT which consists of the series of various meetings held in a STATE to select DELEGATES. First, local political party activists meet to choose delegates to attend COUNTY CAUCUSES. These delegates choose new delegates to attend STATE meetings who then select others to represent the political party of the state at the NATIONAL CONVENTION. *See* IOWA CAUCUS; *compare* PRESIDENTIAL PRIMARY.

Presidential Medal of Freedom (customs and traditions) The highest and most prestigious, non-military award given by the UNITED STATES government to a person who has made a major contribution to American culture and/interests, world peace or some other significant achievement. It was established in 1963 and is awarded by the PRESIDENT. Also known as "Medal of Freedom"; *compare* MEDAL OF HONOR.

presidential primary (politics) A statewide PRIMARY ELECTION where voters vote for DELEGATES to represent them and vote for their desired candidates at the NATIONAL CONVENTIONS of the political parties. It is used by most STATES as an indirect way of selecting presidential nominees. Potential candidates for PRESIDENT participate in this event to win delegates. It may be either a "CLOSED PRIMARY" or an "OPEN PRIMARY". *See* NEW HAMPSHIRE PRIMARY, SUPER TUESDAY, BEAUTY CONTEST; *compare* PRESIDENTIAL CAUCUS.

Presidential salute (customs and traditions) The official, ceremonial 21-GUN SALUTE used to honor the current PRESIDENT or a former President. It is especially given when the COMMANDER IN CHIEF is visiting an American military group or ARMED FORCES institution. *See* "HAIL TO THE CHIEF".

Presidents' Day (customs and traditions) A FEDERAL HOLIDAY held on the third Monday in February that celebrates the lives and works of all past and former PRESIDENTS of the UNITED STATES. Before the mid-1970s, it celebrated only the birthdays and lives of GEORGE WASHINGTON (born February 22, 1732) and ABRAHAM LINCOLN (born February 12, 1809), both of whom remain symbols of the holiday.

This holiday's decorations are representations of these two men, usually depicted in black-colored suits and with sober facial expressions. During the LONG WEEKEND of "Presidents' Day", many stores offer sales on products and some communities have parades. Originally known as "Washington's Birthday".

Presley, Elvis (people) (1935–1977) A ROCK AND ROLL singer and movie actor. He combined musical elements from black and RHYTHM AND BLUES music with white and ROCKABILLY music to create a unique style of music. His early hits included "Heartbreak Hotel" (1956) and "Don't Be Cruel" (1956). He has influenced many other musicians. He is remembered for his rebellious image, active, energetic live performances and versatile, wide range of his voice. He also sang COUNTRY MUSIC and GOSPEL MUSIC. His nickname is the "King of Rock and Roll"; because his voice, style and music have inspired many other music artists and countless fans. *See* GRACELAND.

pressure group (government) A negative term for an INTEREST GROUP that uses strong lobbying and advertising to influence lawmakers to pass or kill BILLS[2] which affect this group. *See* LOBBY.

primary election (politics) A preliminary election in which voters vote to choose nominees for a public office. It is always held at least one month before ELECTION DAY. *See* PRESIDENTIAL PRIMARY, NEW HAMPSHIRE PRIMARY.

prime rate (economy) In banking, the lowest, most desirable INTEREST RATE on short-term loans which commercial banks charge their best and most reliable customers. *Compare* DISCOUNT RATE.

prime time (media) Those evening hours, 7:30/8:00 p.m. to 11:00 p.m., which usually attract the largest available TV and radio audiences; thus TV companies which want to show their COMMERCIALS at this time must pay larger rates.

Princeton University (education) A prestigious, COEDUCATIONAL UNIVERSITY and IVY LEAGUE member famous for its solid UNDERGRADUATE programs and the GRADUATE SCHOOL, the Woodrow Wilson School of Diplomacy. It was founded in 1746 as the College of New Jersey by the

PRESBYTERIAN CHURCH but in 1896 it was reorganized without the religious affiliation and renamed. It is an accredited UNIVERSITY and an NCAA member; its teams compete intercollegiately. The university mascot is a Tiger. The CAMPUS is located in 'Princeton', New Jersey, and contains the Institute of Advanced Studies. *See* PRIVATE SCHOOL, ACCREDITATION, INTERCOLLEGIATE.

prior restraint (media) An official order stopping the media from publishing information that might be damaging to a person or group (e.g., the government). It is considered to offend the FIRST AMENDMENT and, thus, is not often enforced. *See NEW YORK TIMES CO.* v. *UNITED STATES.*

private school (education) A general term for a SCHOOL[1], COLLEGE[1] or UNIVERSITY that is founded, run and supported by a non-governmental group (that is, either a religious group or an independent group). It is not funded by the government but by endowments, voluntary alumni gifts, GRANTS and student tuition; because of this, its student tuition is more expensive than that of PUBLIC SCHOOLS and STATE UNIVERSITIES. Many private schools are PAROCHIAL SCHOOLS. *See DARTMOUTH COLLEGE* v. *WOODWARD*, BRIGHAM YOUNG UNIVERSITY, NOTRE DAME UNIVERSITY, HARVARD UNIVERSITY, IVY LEAGUE; *compare* PUBLIC SCHOOL.

private sector (economy) A collective term for all economic organizations and their activities that are independent of the government. It includes all the households, private businesses, foundations and NONPROFIT ORGANIZATIONS. It makes up over 85% of the GDP of the US. *See* MIXED ECONOMY; *compare* PUBLIC SECTOR.

pro ball (sports and leisure) A popular name for any professional team sport, especially FOOTBALL, BASEBALL and BASKETBALL. [From 'pro'fessional + 'ball'.] *See* NFL, MAJOR LEAGUES, NBA, ROOKIE.

Pro Bowl (sports and leisure) The postseason ALL-STAR GAME for professional NFL FOOTBALL in which a team composed of ALL-STAR players from the AMERICAN FOOTBALL LEAGUE plays a team of All-Star players from the NATIONAL FOOTBALL LEAGUE. It is held every year in January (first in 1947), one week after the SUPER BOWL.

pro rata (work) A method of payment which is calculated according to the amount of work done (e.g., construction of a house) or services given (e.g., ATTORNEY). [Latin, meaning "in proportion".] Also written in the more English language form "pro rate".

pro-bono (work) Describing work or services (e.g., the legal services of a LAWYER) which are done without a financial charge. [Latin, meaning "for the good".] *Compare* PRO RATA.

Pro-Choice (minorities) Describing someone or something that supports abortion and a woman's right to have an abortion. The "Pro-Choice movement" consists of various independent groups that support this right of a woman to chose whether to have an abortion or not to have an abortion. It supports and agrees with *ROE* v. *WADE*, considering abortion a private matter that a woman decides for herself. Some of its major groups are NATIONAL ORGANIZATION FOR WOMEN, EMILY's LIST and PLANNED PARENTHOOD. *See* FEMINIST MOVEMENT; *compare* PRO-LIFE.

Pro-Life (religion) Describing someone or something that does not support abortion except sometimes in some extreme cases (e.g., the mother's health is endangered by the pregnancy; the woman is pregnant because of rape). The "Pro-Life movement" consists of various independent groups, all of which oppose legal abortion in most situations. It believes that the unborn fetus is alive and has CIVIL RIGHTS, namely, life. It works to limit the scope of *ROE* v. *WADE* by making STATE restrictions on the availability of abortions and ending all government funding of abortions. Its major groups include OPERATION RESCUE and the RELIGIOUS RIGHT. *See* FAMILY VALUES; *compare* PRO-CHOICE.

probable cause (legal system) An assessment that a crime has been committed or that some person is connected to that crime. This must be established before getting a permit for SEARCH AND SEIZURE.

Probate Court (legal system) A type of court in which a judge (i.e., not JURY) settles disputes between people over

properties, wills and estates. In some STATES and COUNTIES it can approve adoptions of MINORS[2].

probation　(legal system) For people accused of crimes or prisoners, an alternative to going to jail. It allows a prisoner to remain in the civilian community but prevents him or her from leaving the UNITED STATES. *See* PROBATION OFFICER.

probation officer　(legal system) The law officer and/or counseling individual responsible for meeting with and supervising the activities of that person "on probation".

Professional Golfers' Association, the　(sports and leisure) (PGA) The organization that regulates playing rules, television coverage and sponsors tournaments for its membership of professional male golf players. It was founded in 1916 and its headquarters are in Palm Beach Gardens, Florida. It organizes the PGA CHAMPIONSHIP and other professional tournaments. By association, professional golf for men.

professional school　(education) A HIGHER EDUCATION institution or part of a UNIVERSITY that offers POST-GRADUATE training programs in business, law, medicine and dentistry. "Professional degrees" include a JD for law; an MD (Doctor of Medicine); and DDS (Doctor of Dental Science).

professor　(education) The highest-ranking faculty member who holds a PHD and teaches at a COLLEGE[1] or UNIVERSITY. Usually, a professor has TENURE and thus ranks above both an "associate professor" and an "assistant professor". This person often is addressed as "Dr." *See* "PUBLISH OR PERISH"; *compare* GRADUATE[2], ASSISTANTSHIP.

Progressive Era　(history) A period (1890–1920) in which people worked to reform individuals and social problems (especially in cities) and improve the general society through the help of government-supported programs. It supported the WOMEN'S SUFFRAGE MOVEMENT, business and ANTITRUST LAWS. Also known as "Progressivism"; *see* MUCKRAKING, PROGRESSIVE PARTY, SETTLEMENT HOUSE, THEODORE ROOSEVELT, YELLOW JOURNALISM, SPANISH-AMERICAN WAR.

Progressive Party　(1, 2, 3 politics) **1** A THIRD PARTY[1] founded by THEODORE ROOSEVELT who split it from the REPUBLICAN PARTY; he was its nominee for PRESIDENT in 1912, the only election in which it was active. Its members, known as BULL MOOSERS, supported lower business tariffs, a PRIMARY ELECTION system, women's right to vote, child labor laws and a MINIMUM WAGE. Although it had 88 ELECTORAL VOTES in the election, it only received support from STATES in the WEST and MIDWEST. **2** A THIRD PARTY[1] in the presidential election of 1924 which nominated Robert LaFollette (1855–1925) for PRESIDENT and supported rights for farmers and laborers. It was popular mostly in the MIDWEST and WEST. **3** A THIRD PARTY[1] active in the 1948 presidential election in which it nominated Henry Wallace (1888–1965) and supported measures to end the COLD WAR. It was supported only in the STATES of New York and California. *Compare* Appendix 2 Presidents.

progressive tax　(government) A kind of tax in which the amount of money paid in taxes increases according to the amount of money the taxpayer earns; that is, the greater the money earned, the larger the tax. *See* PROPERTY TAX.

Prohibition　(history) The period (1917–1932) when buying and selling alcohol (i.e., beer, wine, whiskey) in the US was not legal. It formally began when the US CONGRESS approved the EIGHTEENTH AMENDMENT and ended with the TWENTY-FIRST AMENDMENT. Liquor laws are now decided by the STATES. *See* BLUE LAWS, DRINKING AGE, JAZZ AGE, ROARING TWENTIES, WOMEN'S CHRISTIAN TEMPERANCE UNION.

Prom　(customs and traditions) An annual, FORMAL[3] dance held in the spring (e.g., May or June) for HIGH SCHOOL students which is often organized and paid for by the JUNIOR CLASS as a gift to the SENIOR CLASS. The men usually wear rented TUXEDOS and the women wear very fancy dresses made of silk or taffeta that they buy or rent. It is a very elegant evening of dinner, dancing and partying that has become a RITE OF PASSAGE[1] for many American teenagers. [Shortened from

'prom'enade, a kind of formal dance.] *See* PROM QUEEN; *compare* HOMECOMING.

Prom Queen (customs and traditions) In HIGH SCHOOL, the title of honor that is awarded to a popular or well-known female SENIOR by her current CLASS. During the evening of the PROM, she receives a crown (i.e., a small tiara) and the title "queen". Now, many SCHOOLS[1] also have a "Prom King" (i.e., a male student) and a "Prom Court" (i.e., three women and three men). *See* PROM; *compare* HOMECOMING QUEEN.

property tax (government) Any tax that the government assigns to the land, buildings, housing, etc., which an individual, CORPORATION or other group owns. It is used to fund the BOARD OF EDUCATION and local and STATE governments. *See* SERRANO V. PRIEST.

Proposition 13 (government) An AMENDMENT to the STATE constitution of California (passed in 1978), which decreased PROPERTY TAXES and then created a maximum limit for property taxes. This action began a movement for TAX REFORM and relief in the 1980s and early 1990s.

Proposition 16 (sports and leisure) The NCAA ruling that made it more possible for student athletes to receive funding to attend COLLEGE[1]. It permits COLLEGES[1] to admit those student-athletes who have less than a 2.0 GPA or low test scores on the SAT or ACT and it allows COLLEGES[1] to give them a SCHOLARSHIP based on an inability to pay for tuition (but not an athletic scholarship). However, it prohibits those players from playing INTERCOLLEGIATE sports the first year. This rule (passed in 1990) amended PROPOSITION 42. *See* NO PASS, NO PLAY.

Proposition 42 (sports and leisure) The NCAA ruling (passed in 1989) which states that any student-athlete who does not have a 2.0 GPA and minimum good scores on the SAT or ACT cannot receive an athletic SCHOLARSHIP to attend a COLLEGE[1] and cannot play sports during the FRESHMAN[2] year. These students, however, may receive other academic or need-based scholarships and attend that COLLEGE[1] trying to improve their academic grades. It was designed to make the NO PASS, NO PLAY rule tougher and to emphasize academics. As many black student-athletes lost scholarships because of this rule, it was amended by another rule. *See* PROPOSITION 16.

Proposition 187 of California (immigration) An anti-immigrant REFERENDUM in the STATE of California which gained the support of the majority of the voters (in 1994). In it the voters (i.e., the majority of 59%) agreed to refuse to give medical care and PUBLIC SCHOOL education to any ILLEGAL IMMIGRANTS living in California. However, the day after the election, state and federal courts stopped it claiming that it was unfair. Since "Prop 187", DISCRIMINATION against non-white peoples in California has increased. *See* NATIVISM.

prosecuting attorney (legal system) A general title for an ATTORNEY who works for the government and enforces the law against an individual or group in a CRIMINAL TRAIL or CIVIL TRIAL. He or she may represent the government (i.e., the people, in general) or the PLAINTIFF (specifically). A DISTRICT ATTORNEY is a type of prosecuting attorney. Also known as "prosecutor".

Protestant (religion) A term describing any CHURCH[1,3], member of that CHURCH or policy which was originally founded during the Reformation (the period of the 1500s in Western Europe which began when Catholic people tried to reform the ROMAN CATHOLIC CHURCH but ended when they created new, separate CHURCHES[1] in 'protest' against the Roman Catholic Church). **Protestants** believe that the Bible and an individual's personal faith in God have great importance; Protestant churches do not follow the teachings of the Pope and they use fewer man-made rituals and traditions than Catholic churches. There is a wide variety of different Protestant DENOMINATIONS in the US; namely, CONGREGATIONALISM[1,2], the METHODIST CHURCH, the PRESBYTERIAN CHURCH and the BAPTISTS which, when counted together, make it the largest single religion in the UNITED STATES. *See* WASP; *compare* JEWISH.

Protestant work ethic (customs and traditions) A belief that hard work, self-discipline and thrift lead to financial success. It grew out of the PURITAN WORK

ETHIC and throughout the nineteenth and twentieth centuries was admired as a good way to live and work in WASP communities. *See* AMERICAN DREAM, HORATIO ALGER.

PTL (religion) A negative name for TELEVANGELISM specifically, and the ELECTRONIC CHURCH in general. [After the originally successful televangelist program, *The PTL ('P'raise 'T'he 'L'ord) Club* which was popular during the 1980s until it had a few scandals. First, the host, Jim Bakker, was arrested and sent to jail in 1987 on charges of mail fraud. Second, it was revealed that Bakker, a married man, had had a sexual relationship with his office secretary.]

public broadcasting (media) Broadcasting on TV (i.e., "public television") and radio stations (i.e., "public radio") that is paid for by SUBSCRIBERS and GRANTS from foundations and the government. It contains no COMMERCIALS. *See* PBS, NATIONAL PUBLIC RADIO, TELETHON.

public defender (legal system) An ATTORNEY appointed by a court to represent and defend a client who is unable to pay for attorney services or LEGAL COUNSEL. *See* SIXTH AMENDMENT, *GIDEON* V. *WAINWRIGHT*; *compare* PROSECUTING ATTORNEY.

public holiday (customs and traditions) Another name for a LEGAL HOLIDAY, especially for a holiday that is celebrated in several or all the STATES. *Compare* FEDERAL HOLIDAY.

public land (geography) The land, mostly located in the WEST, that is owned by the UNITED STATES and which the government may rent to certain groups for a fee (e.g., for cattle grazing, mineral mining). It is controlled by the DEPARTMENT OF THE INTERIOR.

public school (education) A SCHOOL[1] that is financially supported by government taxes; student tuition is free or very low. It is controlled by a local and STATE BOARD OF EDUCATION but must have the support of the community where it is located. Often, it is funded by LEVIES and local PROPERTY TAXES. *See* SERRANO V. PRIEST, STATE UNIVERSITY, SCHOOL PRAYER; *compare* PRIVATE SCHOOL, BUSING.

public sector (government) A collective name for any and all the organizations, offices, DEPARTMENTS[2], services and groups that work for the government (i.e., federal, STATE, local). *Compare* PRIVATE SECTOR.

public service announcement (media) (PSA) A message of general interest to the public that is broadcast without a cost on the radio or television by the government or a NONPROFIT ORGANIZATION (e.g., concerning emergencies, hurricanes).

Public Works Administration (history) (PWA) During the GREAT DEPRESSION, the federal agency that created projects to employ people. Most of the work involved building or repairing SCHOOLS[1], city sewer lines, highways, dams, low-cost housing, airports and other public projects. It was created in 1933 and in 1939 was transferred to the Federal Works Agency. It was not as active as the more successful WORKS PROGRESS ADMINISTRATION. *See* HOOVER DAM.

Public Works of Art Project (the arts) (PWAP) The short-term, government-sponsored program created during the GREAT DEPRESSION to employ artists. Although it only lasted for six months in 1933, it employed over 3,700 artists who created over 15,000 art works which were then used to decorate public buildings. The success of this program led to the creation of the longer-running programs of the WORKS PROGRESS ADMINISTRATION. *See* FEDERAL ARTS PROJECT.

Public, John Q. (society) The average or typical citizen of the UNITED STATES. *Compare* JOHN DOE[1], JANE DOE[1], SIX-PACK.

public-access channel (media) Television broadcasting by local community groups about local issues, events and information. This channel is free and especially set aside by law on cable television for these groups to use.

"publish or perish" (education) The phrase referring to the need for tenured PROFESSORS at a UNIVERSITY to continue researching and publishing articles in their fields of specialty. If they do not publish articles, then they run the risk of losing their tenured position in the DEPARTMENT[1].

Publishers' Weekly (media) A weekly magazine containing the lists for the BESTSELLERS for that given week (which are based on sales figures) as well as articles about fiction and non-fiction books, wri-

ters, awards and other information for professionals in publishing and book promotion. *Compare* BILLBOARD.

pueblo (1 housing and architecture; 2 geography) **1** A block-shaped dwelling structure with a flat roof, usually made of stone or ADOBE and divided into several separate units (like an apartment BLOCK³) in order that several families may live there. **2** A type of rural village of an Indian TRIBE in the SOUTHWEST; usually the structures include separate ADOBE houses and the people work in subsistence farming and sheep-raising. *See* PUEBLO INDIANS, NAVAJO.

Pueblo Indians, the (people) A general name for diverse groups of INDIANS living in the SOUTHWEST (including the Zuni and Hopi TRIBES) whose ancestors include the ancient tribe of the Anasazi Indians (from before the 1200s) and Spanish colonials and explorers of the 1600s. Traditionally, they are known for living in ADOBE villages and for working as farmers and sheep herders. They have a rich tradition of making handmade arts, crafts, jewelry and pottery. Today, they practice cultural and religious traditions taken from traditional religions (e.g., the KIVA) as well as from the ROMAN CATHOLIC CHURCH. Currently, there are some 55,330 **Pueblo** people, many of whom live on RESERVATIONS in the STATES of New Mexico and Arizona; especially, the Zuni Pueblo and the Hopi and Trust Lands. *Compare* NAVAJO, CHEROKEE NATION, SIOUX.

Puerto Rico, Commonwealth of (geography) A heavily-populated tropical island in the Caribbean Sea known for its beaches, resorts, businesses and large, official population (3.7 million). It is a possession (*see* TERRITORY) of the UNITED STATES (acquired in 1898 after the SPANISH-AMERICAN WAR), but since 1952 it has governed itself using its own constitution. Although it is not one of the 50 STATES, since 1917 all its Spanish-speaking residents have had US citizenship and many of them live in NEW YORK CITY. It experienced economic growth with OPERATION BOOTSTRAP. Its population is represented by a non-voting delegate in CONGRESS, known as "Resident Commissioner". Its capital city is San Juan. Its full name is

Estado Libre Asociado de Puerto Rico. [Spanish, meaning "rich port".] *See* DÍA DE LA CONSTITUCIÓN, JONES ACT.

Pulitzer Prize (the arts) One of various very prestigious awards given every year in the fields of writing, including: newspaper journalism (since 1917), photo-journalism (since 1942), literature (e.g., fiction, poetry, theater plays, non-fiction, since 1918), and musical composition (since 1943). Originally, the awards were only distributed for journalism, thus there are many journalism categories, especially editorial writing, public service, national reporting, international reporting and editorial cartooning. The winners are chosen by the Pulitzer Prize Board and awarded prizes of $3,000 each by the president of COLUMBIA UNIVERSITY. [After benefactor and NEW YORK CITY publisher JOSEPH 'PULITZER'.]

Pulitzer, Joseph (people) (1847–1911) The journalist and newspaper publisher who popularized his newspaper, NEW YORK *WORLD*, by including articles which attacked government waste and the UPPER CLASS while supporting the working class. He is remembered for practicing an aggressive form of YELLOW JOURNALISM as well as establishing the PULITZER PRIZE to honor excellence in writing. *Compare* WILLIAM RANDOLPH HEARST.

Pullman Strike, the (work) After the Pullman sleeping car company fired one-third of its workers and cut the wages of the others, the remaining railroad workers, led by Eugene Debs (1855–1926), held a STRIKE¹, from May to July 1894, in which they refused to work on any train that had a 'Pullman' sleeping car. The federal government, the PRESIDENT and the legal courts supported Pullman. This STRIKE¹ revealed the bias against workers and organized labor. [After George 'Pullman' (1831–1987), the train car creator.] *See* ROBBER BARONS.

pullover (clothing) Describing a piece of clothing (e.g., SWEATER, SWEATSHIRT) which is put on by 'pulling' it 'over' the head (i.e., it does not have zippers nor buttons). Often, it is used alone to refer to such a piece of clothing.

pulp (media) A general name for books or magazines that are printed on cheap

newspaper-quality paper, usually with sensational stories and information. [From the cheap 'pulp' of wood that is used to make the paper.]

pumpkin pie (food and drink) A PIE made of brown sugar, nutmeg, cinnamon, milk, eggs and the meat of a pumpkin which is traditionally served as a dessert for the THANKSGIVING DINNER.

Punxutawney Phil (customs and traditions) The "name" of the groundhog used to provide the forecast on GROUNDHOG DAY. [After the name of the small town 'Punxutawney', in the STATE of Pennsylvania, which has held this event every year since 1886.]

Puritan (religion) A member of a PROTESTANT religious and social movement that believed in **Puritanism**; that is, a direct relationship between a person and his or her God, self-reliance, hard work and focusing on and having a sincere belief in the Bible's importance. Further, they supported local government and education. It was active in NEW ENGLAND especially during the COLONIAL PERIOD and has also influenced the law and government of Americans by insisting on local control. Puritans, who were originally members of the Church of England, immigrated from England to AMERICA[1] in the seventeenth century to live in religious communities like those which promoted CALVINISM. By the eighteenth century, Puritans had joined CHURCHES[1] in the tradition of CONGREGATIONALISM[2]. [From their wish to remove from, or 'purify', the Church of England of all Roman Catholic rituals and traditions.] *See* PURITAN WORK ETHIC, OLD DELUDER SATAN ACT, MASSACHUSETTS BAY COLONY, GREAT MIGRATION[1]; compare ROMAN CATHOLIC CHURCH, PILGRIMS.

Puritan work ethic (customs and traditions) The belief that it is important for a person to work hard and achieve, as well as be thrifty, honest and respectful for authority and that any financial or political success from this manner of working and living is a sign that God approves of that person. It was developed and believed in by the PURITANS during the COLONIAL PERIOD. *Compare* PROTESTANT WORK ETHIC.

Purple Heart (military) The prestigious award given to any member of the ARMED FORCES who is wounded or killed in action during a military situation or terrorist attack. It was first established by GEORGE WASHINGTON in 1782. The medal pin consists of an image of Washington and his coat of arms mounted on a purple heart; purple and white ribbons are attached to it. *Compare* NAVY CROSS.

Q

Quakers (religion) A popular name for members of the RELIGIOUS SOCIETY OF FRIENDS. [From their distinctive trembling, or 'quaking', manner while praying.] *See* FRIENDS; *compare* SHAKERS.

quarter (1 economy; education; 3 sports and leisure; 4 economy) **1** A silver-colored coin made of cupronickel-clad alloy, worth 25 cents or one-fourth of a DOLLAR. It is embossed with the motto "IN GOD WE TRUST" and the bust of GEORGE WASHINGTON on one side and the motto *E PLURIBUS UNUM* and the GREAT SEAL on the other side. **2** A division of the ACADEMIC YEAR used by SCHOOLS[5] of 11 weeks, including classes and one week of FINALS. The academic year of SCHOOLS[5] which use the quarter system usually begins in September and ends in June. *See* TERM[2], SUMMER SCHOOL[3]; *compare* SEMESTER. **3** One of four timed periods of play in an athletic competition or game, especially FOOTBALL, LACROSSE and professional BASKETBALL. *See* NBA. **4** In the economic and business world, one of the four divisions (each consisting of three months) of the calendar year used to examine and study economic predictors, employment levels and overall economic growth. Usually, it is referred to as the "first quarter" (i.e., January, February, March), "second quarter" (i.e., April through June); "third quarter" (i.e., July through September); and "fourth quarter" (i.e., October through December).

quarterback (sports and leisure) (QB) In FOOTBALL, the key player who directs the offense of the team and throws the ball to other players who then score points. He lines up behind the center player and gives directions to fellow players during the HUDDLE. By association, the most important person or the leader of a group, ADMINISTRATION[1] or DEPARTMENT[2].

quick bread (food and drink) A bread as sweet as cake but baked with baking powder not yeast. It is often flavored with fruit (e.g., banana, raisin), nuts or dates. *See* MUFFIN.

quorum (government) The smallest number of people who must be present for official decisions or voting to take place at a meeting (e.g., in a legislature, in a courtroom).

quota (system) (minorities) A system in which a fixed number of positions (e.g., in education, work, admissions to a SCHOOL[5]) or contracts is reserved for each different group of people (i.e., a certain number of positions for minorities – for blacks, for women, for HISPANICS). These fixed numbers are often figured by the percentage of that minority in the total US population. Since the late 1960s, **quotas** have been used to shape the AFFIRMATIVE ACTION programs of many schools, businesses and industries. However, since the late 1970s they have been attacked in LAWSUITS. *See REGENTS OF THE UNIVERSITY OF CALIFORNIA V. ALLAN BAKKE.*

R

R (the arts) In the movies, a RATINGS SYSTEM[2] ranking indicating that children under 17 years of age cannot watch the movie (i.e., purchase tickets, enter the theater) without being accompanied by a parent or adult guardian. By association, something "rated R" describes something that is sexually explicit or violent. [Abbreviation of 'R'estricted.] *Compare* NC-17, X.

R and R (military) In the ARMED FORCES, a short-term period (usually, two or three days or longer) of vacation from military duty. [Abbreviation of 'R'est 'and' 'R'elaxation.]

Radcliffe College (education) A prestigious, private LIBERAL ARTS COLLEGE for UNDERGRADUATE students and one of the SEVEN SISTERS. It was founded in 1894 as "The Harvard Annex" to provide a post-SECONDARY SCHOOL education to women only. Today it is a COEDUCATIONAL institution offering courses to both female and male students and is also one of the COLLEGES[1] of HARVARD UNIVERSITY. [After Anne 'Radcliffe' (died 1661), a benefactor of Harvard College.] *See* PRIVATE SCHOOL; *compare* BARNARD COLLEGE, IVY LEAGUE.

Radio City Music Hall (the arts) An elegant, enormous theater (with seating capacity for 6,000 people) for live stage performances. It is particularly noted for its interior decoration which is richly and elaborately done in the Art Deco style. The building was opened in 1932 and is the main theater of the ROCKEFELLER CENTER complex of buildings in MANHATTAN[1]. It is the home stage of the ROCKETTES and it is often used for large presentations; the ceremonies for the GRAMMY AWARDS are held here. Commonly referred to as "Radio City".

rag (1 media; 2 the arts) **1** A low-quality, or sensational newspaper or magazine. By association, an informal name for a daily newspaper. **2** A RAGTIME MUSIC song, or a song in this tradition.

rag wool (clothing) A type of wool which has a characteristic, unique brownish grayish-white color. It is often used to make warm winter SWEATERS and/or socks. By association, describing clothing made of this type of wool.

Ragtime (music) (the arts) A type of lively, composed (i.e., not-improvised) piano music which originated among black musicians in the MIDWEST and SOUTH between 1890 and 1900. It was influenced by VAUDEVILLE music, black FOLK MUSIC and dance music and was very popular with black and white audiences from 1906 through 1917. It is characterized by having a "syncopated melody"; that is, the pianist used the right hand to

play the usual soft (i.e., unstressed) notes, hard (i.e., stressed), and played the usual hard notes, softly. Meanwhile, the left hand played a steady tempo in 2-4 time (i.e., duple time). This "syncopation" gave the piano a "tin-like/quality" sound. This music was easy to dance to and was sometimes commonly known as the "two-step" or "cakewalk music"; many of the songs used the word RAG² in the title. It was an important influence on JAZZ MUSIC. [After the rough-sounding, 'rag'ged, time in which it is played.] *See* SCOTT JOPLIN.

Raid on Harpers Ferry (history) The raid of 22 abolitionists from the NORTH on the US federal armory on October 16, 1859. The group was led by a white man named John Brown (1800–1859) whose plan was to gain control of the federal armory, steal weapons from the armory and establish a secure place to which slaves could escape. Brown hoped that all of these actions would encourage a slave rebellion which would help end SLAVERY. This raid was stopped by US Lieutenant-Colonel ROBERT E. LEE and US troops. Although Brown was hanged, this bold raid drew support from northerners and encouraged the start of the CIVIL WAR. [From the armory's location in 'Harpers Ferry' in the present-day STATE of northern West Virginia.] *See* "JOHN BROWN'S BODY".

rain check (language) In the case of some event being canceled (e.g., POP MUSIC concert, LUNCH appointment), the promise to hold that same event under the same conditions at a later date. [Originally from the slip of paper given to those people who had bought tickets to some outdoor, artistic event which had to be canceled due to 'RAIN'. This slip, or 'check', allowed them to enter the rescheduled event.]

Rainbow Coalition, National (minorities) A political coalition of different minority groups that work together to develop one view on economic, educational, business and political issues and want to end DISCRIMINATION in all aspects of life. It was founded by JESSE JACKSON in 1984, who then used it as a base for his CAMPAIGN for the nomination for the US PRESIDENT. Its membership includes AFRI-CAN AMERICANS, HISPANICS, Asian Americans and disadvantaged whites; currently, there are 13,000 total members. [From the collection of the many races or 'colors' of its members.]

ranch house (housing and architecture) A type of suburban house characterized by horizontal lines, a single story, spreading out over a lot and containing a built-in garage, a back porch and a low-pitched roof. By association, an architectural style frequently used from 1935 to 1975 to build primarily suburban homes. *See* SUBURBS; *compare* SPLIT LEVEL.

Randolph, A[sa] Philip (people) (1889–1979) Leader of black organized labor and the CIVIL RIGHTS MOVEMENT. He founded the BROTHERHOOD OF SLEEPING CAR PORTERS (1925) and helped it earn contracts. He persuaded PRESIDENT FRANKLIN ROOSEVELT to pass EXECUTIVE ORDER 8802. Randolph achieved this in 1941 by threatening Roosevelt to recruit 100,000 blacks to march on Washington in a mass, nonviolent protest to end job discrimination. Randolph used this tactic in 1963 for CIVIL RIGHTS when he called the MARCH ON WASHINGTON OF 1963. He served the AFL-CIO on its executive council (1955) and as its vice-president (1957–1960). *See* MARCH ON WASHINGTON MOVEMENT.

Rangers (military) A division of the SPECIAL FORCES of soldiers especially trained to make surprise raids in small groups.

rank-and-file (politics) The ordinary members, especially of a political party. *Compare* GRASSROOTS, LAY.

Rap (music) (the arts) A type of music with a pounding, steady beat and direct, spoken, rhyming lyrics presented by a **rapper** or MC². It was popularized by young blacks and LATINOS in NEW YORK CITY during the late 1970s. "East Coast Rap" refers to that music made by eastern groups containing lyrics and references concerning the life and places of the EAST COAST; "West Coast Rap" refers to that music and lyrics made on the WEST COAST. The "rap culture" includes breakdancing, baggy clothing, thick gold neck chains and painted graffiti on public buildings and structures. [After the 1960s slang word

'rap', meaning "conversation".] Also known as "HIP-HOP"; *see* GANGSTA RAP.

rare (food and drink) An order to cook beef lightly so that the exterior is brown but the entire interior remains red, tender and juicy. *See* STEAK.

ratings system (1 media; 2 the arts) **1** In television, a system that ranks the popularity of programs based on the number of viewers who watch those programs. *See* NIELSEN RATINGS. **2** In the movies, a ranking system based upon the presentation and content of violence, nudity and adult sexual situations in scenes of a movie. The rankings serve to indicate the minimum age that a person must be in order to watch a film either in a movie cinema or on video cassette. It was developed and is enforced by the MOTION PICTURE PRODUCERS AND DISTRIBUTORS OF AMERICA. Every American-made movie receives one of the following rankings: G (indicating a film appropriate for all audiences), PG, PG-13, R, NC-17 (the most restrictive). *Compare* X.

rbi (sports and leisure) In BASEBALL, the points that are earned when an offensive player AT BAT hits the ball in such a way to allow fellow teammates currently on bases, and maybe himself/herself, to run to HOME PLATE and score. The number of rbi's a player makes is an indication of his skill. [Abbreviation of 'r'uns 'b'atted 'i'n.] *See* RUN; *compare* BATTING AVERAGE.

Reader's Digest (media) A popular monthly magazine which reprints articles published in other magazines in a shorter form as well as printing original articles. It focuses on current issues, relationships and fictional and nonfictional stories; one humor section is entitled "Life in these United States". It was started in 1922 and has a current US circulation of 15 million. It is translated into over 20 different languages worldwide.

Reagan, Ronald (people) (born in 1911) HOLLYWOOD[2] movie actor, Governor of California (1967–1971) and US PRESIDENT (1981–1989) from the REPUBLICAN PARTY and holding CONSERVATIVE ideas. During his presidency, he attacked BIG GOVERNMENT and cut many programs paid for by the federal government, especially those of the GREAT SOCIETY (but not SOCIAL SECURITY). His confidence in AMERICA[1] and strong support for the defense industry during the end of the COLD WAR helped make him a popular president during his two TERMS[1]. When his ADMINISTRATION[1] was involved in the IRAN-CONTRA AFFAIR, he earned the nickname the "TEFLON PRESIDENT". He survived an assassination attempt (March 30, 1981); in 1994, it was reported that he was suffering from Alzheimer's disease. *See* BRADY BILL, Appendix 2 Presidents, RELIGIOUS RIGHT.

Reaganomics (economy) The economic program of the Reagan ADMINISTRATION[2], which included trickle-down economy, DEREGULATION and a strict financial policy to control INFLATION. It was introduced in 1981 in the Economic Recovery Act. *See* RONALD REAGAN.

Realist painting (the arts) A movement in painting committed to recording and showing the modern world in all its dirtiness, happiness and ugliness. **Realism** was particularly popular in the late nineteenth century and was centered in Philadelphia. *See* ASHCAN SCHOOL.

reapportionment (politics) Reassigning the number of elected legislative officials in voting districts in relation to the number of people (according to the CENSUS) living there. It is done once every 10 years and is particularly important for determining the number of CONGRESSMEN/WOMEN (that is, the number of CONGRESSIONAL DISTRICTS and ELECTORAL VOTES) in a STATE. *Compare* REDISTRICTING, GERRYMANDERING.

rebound (sports and leisure) In BASKETBALL, the successful seizing of the ball which occurs after the offensive team has unsuccessfully thrown the ball trying to score a basket, and failed. Both teams try to capture the ball in order to score. By association, a person "on the rebound" is someone who is continuing to play or participate after a disappointment.

rec(reation) room (daily life) A room in a private residence or public building used for children and teenagers for them to play games, watch TV and hold parties, sleepovers and dances. Often, it may have a ping pong table or pool table. *See* SUBURBS.

recess (1 education; 2 government; 3 legal system) **1** The noon-time period after lunch when students have a break from studying and are able to play sports and relax before returning for afternoon classes. **2** In a legislature SESSION[2], a short break called by the legislature usually connected to a vacation time. CONGRESS takes a recess of thirty days in August and a two-week recess at EASTER. *Compare* ADJOURNMENT[1]. **3** In the legal system, the time between court SESSIONS[1] when no work is done. The SUPREME COURT is "in recess" during the summer months (i.e., July through September).

Reconstruction (history) The period after the CIVIL WAR (1867–1877) when the REPUBLICAN CONGRESS passed a number of laws to rebuild and modernize the SOUTH, specifically the businesses, jobs and railroads as well as politics and social order. In addition, it tried to help blacks adjust their lives from SLAVERY to freedom, especially through the FREEDMEN'S BUREAU. Although help was given by the US ARMY and others, this period was also marked by corruption and embezzlement. Since it was overseen by the Congress, it is also known as "Radical Reconstruction" or "Congressional Reconstruction"; *see* BLACK CODES, "Solid SOUTH", "New SOUTH", CARPETBAGGER, SCALAWAG, KU KLUX KLAN[1].

Red Power (Movement) (minorities) A collective term referring to the pan-Indian organized and spontaneous groups and events which promoted social, political and land rights for all INDIANS, namely: Indian self-government, self-determination, the enforcement of Indian rights, Indian-oriented education, and a positive belief and pride in Indian cultures, languages and heritages. Many of its supporters were young, COLLEGE[1]-aged students. The movement was based in SEATTLE, Washington, and was active from 1961 until 1973. The events it included are: FISH-INS, protests, marches, the ALCATRAZ OCCUPATION and the TRAIL OF BROKEN TREATIES. It did not support TERMINATION nor RELOCATION. As a slogan, it refers to independent, proud and strong Indian groups. [From 'red', an old, former, sometimes pejorative, designation for "Indian",

+ BLACK 'POWER'.] Sometimes also known as the "Indian Power Movement"; *see* TRIBAL COUNCIL; *compare* BLACK POWER.

red ribbon (minorities) A red-colored strip of cloth or ribbon which is folded once into the shape of an upside-down (i.e., inverted) "V" which is pinned to clothing as a symbol of AIDS (Acquired Immune Deficiency Syndrome) awareness and support for AIDS-related medical research. [After the YELLOW RIBBONS worn in 1991 by supporters of American ARMED FORCES in the GULF WAR.]

red scare (1, 2, 3 history) **1** A general fear of communists, radicals and anarchists. [From the 'red' color of communist flags.] **2** The period from 1917 to 1920 when many Americans were afraid of the radical communist ideas of the organized labor UNIONS[1]. The government arrested and questioned people (citizens and non-citizens) on charges of being a communist, even deporting those non-citizens. *See* DEPORTATION DRIVE; *compare* HOUSE UN-AMERICAN ACTIVITIES COMMITTEE. **3** After WORLD WAR II, the period of McCARTHYISM.

red shirt (sports and leisure) Describing a SECONDARY SCHOOL or COLLEGE[1] student-athlete who is enrolled in the SCHOOL[5] but is purposefully not playing a VARSITY sport the first year so that that player may grow stronger and develop as an athlete. A **red-shirted** player is eligible for playing four full years of a varsity sport. [From the 'red' colored 'shirts' worn by these players at practice.] By association, a group member who is being prohibited from performing or playing.

Red Summer (minorities) A collective term referring to the violent period, primarily from May to September in 1919, when over 20 different race riots (whites attacking blacks) occurred in various areas of the NORTH and SOUTH (especially in the cities of CHICAGO and WASHINGTON D.C.). After WORLD WAR I, many black veterans of that war demanded the exercise of their legal rights (e.g., voting rights and no job DISCRIMINATION) in the US. In the riots, gangs of whites (which included white veterans of World War I), attacked, terrorized and killed black victims; 70 blacks died by LYNCHING. *Com-*

pare WATTS RIOTS, LA RIOTS, LONG, HOT SUMMER.

red, white and blue (customs and traditions) The three colors of the American flag; the official colors of the UNITED STATES OF AMERICA. By association, describing something or someone that is American and/or patriotic. *See* STARS AND STRIPES[1].

redistricting (politics) The process of redrawing the boundary lines of legislative and election districts (in order that they reflect the current population). Although this is the responsibility of the STATE legislature, it affects CONGRESSIONAL DISTRICTS. *See* REAPPORTIONMENT, GERRYMANDERING.

referendum (politics) A special power of voters via an election to approve or veto those BILLS[2] or STATE constitutional AMENDMENTS that the state legislature proposes. *Compare* INITIATIVE.

Reform Judaism (religion) A distinctive branch of the JEWISH religion whose members accept and adapt to modern life and reject "*Halachah*" (i.e., traditional Jewish Law) when it does not keep with modern ideas. It grew out of the Enlightenment (during the 1700s) in Europe and was first established in the US in Baltimore in 1846 by German-Jewish immigrants. It is characterized by: allowing women and men to sit together during worship services; considering children "Jewish" if at least one parent is Jewish (e.g., having a Jewish father and a non-Jewish mother); not ordering members to follow a KOSHER food diet; ordaining both male and female rabbis; and accepting homosexual members. Currently in the US, it has 1.3 million total members. *See* HIGH HOLIDAYS; *compare* ORTHODOX JUDAISM, CONSERVATIVE JUDAISM.

refugee (immigration) As defined by the United Nations in 1968: "Anyone outside of his or her country, who is unable or unwilling to return to it because of fear of persecution, because of his or her race, religion, nationality, political group or membership of a particular social group." The US adopted this definition in the REFUGEE ACT OF 1980. Refugees only appear after WORLD WAR II. The term "refugee" replaced the earlier term "DIS-

PLACED PERSON". *Compare* DISPLACED PERSONS ACT.

Refugee Act (immigration) The federal law increasing the number of REFUGEES allowed to enter the US (from 17,400 to 50,000 per year) and which gives money to help them resettle in the UNITED STATES. It was passed March 17, 1980, as a method of accepting refugees in an organized manner. *Compare* MARIEL BOATLIFT.

Regents of the University of California v. Allan Bakke (education) The SUPREME COURT decision (in 1978) declaring that AFFIRMATIVE ACTION was constitutional, but that the fixed admission quotas for racial MINORITIES at the medical SCHOOL[4] of the UNIVERSITY OF CALIFORNIA at Davis were not. The case was brought to court by a white student, Allan 'Bakke', who claimed that his academic credentials were better than those minority students who were accepted by the UC Davis Medical School but that he was denied admission to the SCHOOL[4] because it was required by its own affirmative action QUOTA SYSTEM rules to meet a quota of racial minorities. This decision permitted Bakke to attend the SCHOOL[4]. It also succeeded in complicating the effectiveness of creating and enforcing affirmative action programs. *See* CONSTITUTION; *compare* DEFUNIS V. ODEGAARD.

Registered Nurse (health) (RN) A person who has successfully completed an academic and practical accredited nursing program, has passed the STATE exam and has been registered and licensed to practice nursing by a STATE. *See* ACCREDITATION.

registration drive (politics) An organized effort by a political party, INTEREST GROUP or other organization to encourage VOTER REGISTRATION among UNITED STATES citizens. *See* FREEDOM SUMMER.

Rehabilitation Act (minorities) A federal law (passed in 1973) that prevents DISCRIMINATION against HANDICAPPED people who apply for jobs with, or are currently working for, the federal government or a federal program.

relief pitcher (sports and leisure) In BASEBALL, the extra, fresh player-PITCHER who replaces the pitcher, especially at

serious points in the game. By association, a much-needed replacement.

Religious Right (religion) A general name for the various people and organizations that have religious beliefs which support Christian FUNDAMENTALISM as well as have CONSERVATIVE political views. It appeals to the GRASSROOTS through the ELECTRONIC CHURCH. In the past, it has supported the OLD GUARD and the conservative members of the REPUBLICAN PARTY. It was organized in the 1920s to fight against communism and for Bible teaching during the SCOPES MONKEY TRIAL (referred to as the "Old Religious Right"). It was revived in the 1970s (sometimes known as the "New Religious Right") to support SCHOOL PRAYER and traditional FAMILY VALUES. It does not support legal BUSING, *ROE* v. *WADE*, or GAY RIGHTS. *See* PAT ROBERTSON, MORAL MAJORITY.

Religious Society of Friends, the (religion) A Christian religious group founded in England in 1652 by George Fox (1624–1691) which was successfully established in the colony of Pennsylvania in 1681 by WILLIAM PENN. Its members, the FRIENDS, believe that the spirit of Jesus Christ (i.e., what they call the "inner light") exists in all people and things. In the past, the Friends have supported religious tolerance, ABOLITION, peace movements and women's right to vote. Today, the some 15,000 members still refuse to fight in wars or to take oaths. Also known as "QUAKERS"; *compare* SHAKERS.

relocation programs (minorities) A general name for any of various programs which helped to move INDIANS from the RESERVATIONS and re-establish them with housing and jobs in large cities, especially in LOS ANGELES, CHICAGO, Denver and Minneapolis. They were set up and operated by the BUREAU OF INDIAN AFFAIRS during the 1950s. One program was the Direct Employment Assistance (begun in 1951) which provided Indians with employment help, counseling and education programs. These programs were one feature of TERMINATION.

remedial education (education) A course or educational program designed to help students improve skills in a weak subject area in preparation for taking regular course work.

Remington, Frederick (people) (1861–1909) A painter, illustrator and sculptor. His works portray the action and drama of INDIAN life and conflicts between the US Cavalry and Indian warriors in the WEST during the 1880s through to the early twentieth century. Popular themes in his works include the "last stand" of individuals and groups as well as the end of the FRONTIER.

rent control (housing and architecture) Any type of government law setting the maximum and minimum limits that LANDLORDS can charge for rent. They are based on location, age of the building and other criteria.

replacement workers (work) A neutral term for a worker who is hired to work in the place of others during a STRIKE[1]. *Compare* SCAB.

report card (education) A summary of an ELEMENTARY SCHOOL or SECONDARY SCHOOL student's performance during a TERM[2] which includes GRADES[2] (usually, LETTER GRADE, 100% SCALE) and comments from teachers about behavior. *See* Appendix 5 Grading Systems.

Representative (1, 2 government) **1** Specifically, another title and/or name for a CONGRESSMAN/WOMAN serving in the HOUSE OF REPRESENTATIVES. Each Representative serves a two-year TERM[1]; he or she must be at least 25 years old, a US citizen and a resident of the CONGRESSIONAL DISTRICT which he or she represents. **2 representative** A general term for any person elected to a legislature or other governing body. *See* CONGRESSMAN/WOMAN, ASSEMBLY.

Republic of Texas, the (history) From May 14, 1836, to March 1, 1845, the independent country of Texas. It won its freedom from Mexico and had autonomy for nine years; its national flag was decorated with one star. It became an American STATE when the US annexed it in 1845, an action which then led to the MEXICAN WAR. Today, it is the modern state of present-day Texas. *See* ALAMO, DALLAS, "YELLOW ROSE OF TEXAS".

Republican (politics) A member of the REPUBLICAN PARTY.

Republican National Committee (politics) (RNC) The official organization of the REPUBLICAN PARTY. It is responsible for representing the political party, choosing and supporting candidates to run in official elections and raising money for these candidates. Its largest, most important task is organizing and overseeing the NATIONAL CONVENTION of the REPUBLICAN PARTY held once every four years, during a presidential CAMPAIGN election year. It is the group which receives money from the FEDERAL ELECTION CAMPAIGN ACT OF 1972 as well as some public donations for candidates. It was founded in 1856 and its headquarters are in WASHINGTON D.C. compare DEMOCRATIC NATIONAL COMMITTEE.

Republican Party (politics) One of the two major political parties in the UNITED STATES. Traditionally, it is CONSERVATIVE and concerned with business, BIG BUSINESS, FREE ENTERPRISE, STATES' RIGHTS[2] and individual improvement. It wants to limit government and the use of federal funds that pay for social programs in education and welfare. However, it supports government funding of national defense, businesses and the ARMED FORCES. It is popular among business people and other people. It was founded in 1854 with a NO-SLAVERY PLATFORM and promoted by ABRAHAM LINCOLN. Its mascot is the ELEPHANT. From the time of the EMANCIPATION PROCLAMATION and RECONSTRUCTION until the 1920s, it was the favorite party of blacks. *See* REPUBLICAN NATIONAL COMMITTEE, Appendix 2 Presidents; *compare* DEMOCRATIC PARTY.

rerun (media) A TV program or SERIES that is broadcast again, usually some time after it was originally broadcast. Reruns are often SYNDICATED programs.

Research Triangle, the (science and technology) In North Carolina, the collective name for the various respected research groups, THINK TANKS and technology companies established in various SCIENCE PARKS as well as medical hospitals and educational universities (e.g., University of North Carolina at Chapel Hill, Duke University) in the region of the three cities: Raleigh (the capital city of the STATE), Durham and Charlotte. It is a symbol of high technology and research-oriented medial care and education. *Compare* SILICON VALLEY, ORANGE COUNTY.

reservation (minorities) A piece or various pieces of land set aside by the federal government which an Indian TRIBE owns or controls in common. It is governed by the resident Indian tribal government and is commonly regarded as an area where the native culture, traditional ways and local governing systems can be practiced freely (i.e., without STATE interference). All lands and natural resources from those lands are TAX-EXEMPT from state-imposed PROPERTY TAXES. On many reservations, the TRIBAL COUNCILS permit GAMING, mining (for silver, copper, oil) and resort and leisure activities to the public (e.g., ski resorts). All revenue raised by tribal projects on the reservations is shared equally among tribe members. Today, there are some 300 reservations, the largest one belonging to the NAVAJO people. Historically, the first reservation was established by the US government in 1778; since 1919 only CONGRESS can grant reservations. During the eighteenth, nineteenth and first half of the twentieth centuries, the reservation was a very poor area (e.g., bad land for farming, no work) used as a method to force the ASSIMILATION of Indians as well as to organize and limit the land use of groups of Indians and thus provide more land for non-Indian settlement. Popularly known as "REZ" or "res"; *see* INDIAN COUNTRY, INDIAN REORGANIZATION ACT; *compare* ALLOTMENT, TERMINATION, INDIAN TERRITORY.

reserve clause (sports and leisure) A clause in a professional athlete's contract in which his employer (i.e., team) had the right to keep (i.e., 'reserve') him and his services for the following year and every year thereafter. This clause was enforced unless the player was sold or traded or his contract was dissolved. This clause was active in MAJOR LEAGUE BASEBALL from 1879 until 1976 and helped team owners control players and keep the salaries of players low and fixed. *Compare* FREE AGENT.

reserved powers (government) Those powers which are held and 'reserved' for

the people, according to the TENTH AMENDMENT.

residency (health) After graduation from medical SCHOOL[5], a period of advanced training giving a person practical experience in a special field of medicine. Generally, it lasts from three to five years; during which a RESIDENT receives a typically low salary as this is a part of the educational training. *See* INTERN[1].

resident (health) A person who has graduated from medical SCHOOL[5] and who is working in a hospital or medical center gaining the required practical, medical experience before beginning a medical PRACTICE or post. *See* INTERN[1], RESIDENCY; compare INTERNIST.

restraining order (legal system) An official court order demanding that the current situation continue temporarily (e.g., if a husband has left his wife, a judge can issue this order to prevent the husband from returning to the wife for a short, fixed period of time). It may be a preliminary step to an INJUNCTION.

Resurrection City (minorities) During the POOR PEOPLE'S CAMPAIGN in WASHINGTON D.C., the name given to the temporary "town" erected on the MALL which consisted of tents and was lived in by members of the protest campaign. It was designed as a visual statement for the government, illustrating the condition of the poor and the need of the federal government to do something to improve the domestic situation of the poor people in America. JESSE JACKSON was its honorary "mayor".

"return to normalcy" (history) The political slogan used successfully by REPUBLICAN Warren Harding (1865–1923) in the 1920 CAMPAIGN for US PRESIDENT. With this slogan in that period after WORLD WAR I, President Harding meant to re-focus the country on domestic economic issues; he lowered taxes, restricted immigration and raised import tariffs.

Reuben sandwich (food and drink) A LUNCH-time and DELICATESSEN grilled sandwich of CORNED BEEF, Swiss cheese and sauerkraut served on rye bread. [After US restaurant owner, Arnold 'Reuben' (1883–1970) who first created it.]

Revere, Paul (people) (1735–1818) A silversmith who was an active supporter of independence for the American colonies, especially Massachusetts, before and during the AMERICAN REVOLUTION. He is best remembered for riding a horse from BOSTON to LEXINGTON AND CONCORD in order to warn fellow colonials that armed British troops were coming soon to those towns (he called out: "The British are coming!"). This event was retold in a popular poem of the nineteenth century: "Listen my children and you will hear/of the midnight ride of Paul Revere."

Reverend (religion) The respectful title used for a PROTESTANT minister or PREACHER (e.g., the Reverend MARTIN LUTHER KING, JR.); often abbreviated "Rev.".

reverse discrimination (minorities) To give a woman or MINORITY person or group a more favorable position or other benefit to the detriment of a white man or white men's group. It may be claimed to exist in education or work opportunities, in the AFFIRMATIVE ACTION programs or in the QUOTA SYSTEM. A type of reverse discrimination was declared in *REGENTS OF THE UNIVERSITY OF CALIFORNIA* v. *ALLAN BAKKE* and the SUPREME COURT agreed with the white DEFENDANT. However, although reverse discrimination was claimed in the case *UNITED STEEL WORKERS* v. *WEBER ET AL.* , the SUPREME COURT did not find it to be so. *Compare* DISCRIMINATION.

Revised Standard Version (religion) (RSV) A more modern American English-language version of the Bible using more contemporary language and grammar. It was prepared by American Bible scholars and published in 1952; it is used in PROTESTANT CHURCHES[1,3]. It is based on the King James Version of the Bible (of 1601) and the American Revised Version (also known as the "American Standard Version") which was published in 1901.

revival (religion) A special religious event that consists of preaching, music, group prayer and WORKSHOPS about God. It is used by Christian PROTESTANTS, especially EVANGELICALS, to begin or 're-vive' the people's interest in religion by encouraging each individual present to

have a personal religious experience. *See* BILLY GRAHAM, GREAT AWAKENING.

rez, the (minorities) A popular nickname used by INDIANS to refer to the "reservation". [Clipping of 'res'ervation.]

Rhodes Scholarship (education) A very prestigious academic SCHOLARSHIP, first established in 1905, which is awarded to UNDERGRADUATES to study for one to two years at Oxford University, in England. It is open to all students from the UNITED STATES as well as the Commonwealth countries. [After British administrator, Cecil 'Rhodes' (1853–1902), who established the scholarship.]

Rhythm and Blues (the arts) (R&B) A type of black popular music originating in the 1940s; it is characterized by danceable, party music with clever lyrics containing some non-word syllables (e.g., "sheeboom"). It was performed by many MOTOWN MUSIC groups. It was a major source of inspiration and development for ROCK AND ROLL during the 1950s and 1960s. Currently, it is sometimes known as "urban blues" and "R and B". *Compare* SOUL MUSIC.

Ride, Sally K. (people) (born in 1951) An astronaut known as the first American woman to travel in space, first aboard the SPACE SHUTTLE *Columbia* in June 1983. She has promoted women working in the field of space.

rider (government) Often an extra clause or unrelated AMENDMENT to a legislative BILL². It 'rides' the bill because it would not pass as a BILL² on its own. It becomes law if the BILL² it rides is passed. Usually, new **riders** are attached to APPROPRIATIONS legislation either to make PORK-BARREL LEGISLATION or to encourage a veto. *See* LINE-ITEM VETO.

Right-to-Life (religion) An alternative name for PRO-LIFE.

right to work laws (work) Any law which forbids any agreement making it necessary for workers to join a UNION¹ after they are hired. *See* UNION SHOP.

right/Right, the (politics) A general term to describe a political view which is CONSERVATIVE. (The "right wing" refers to a person or ideology that is more extreme than the right.) **Rightist** groups include fascists and neo-nazis. [From the custom

in the French legislature, whereby people with these views sat on the 'right' hand side of the presiding officer.] *Compare* LEFT, MODERATE.

Rio Grande (environment) In the SOUTHWEST, the river forming most of the international boundary between the UNITED STATES and Mexico. Because of farming in the SOUTHWEST, much of its waters are removed and used to irrigate agricultural areas, so that for most of its length it is a small stream. [Spanish, meaning "large river".] *See* TEXAS RANGERS.

"Rip Van Winkle" (customs and traditions) The main character in a story by Washington Irving (1783–1859), who bowls, drinks with some elves and then falls asleep for 20 years. When he awakes, he is an old man with a long, gray beard and realizes that many changes have occurred, namely, his wife has died and the AMERICAN REVOLUTION has taken place. By association, a person who sleeps a long time; a person who is not up-to-date with the current situation.

rite of passage (1, 2 customs and traditions) **1** An activity or organized event marking a major life change for a person (e.g., graduation from SCHOOL⁵, BAR MITZVAH, marriage). **2** Any action or experience (positive or negative) that causes a person to grow up, develop, mature or change (e.g., having something stolen).

road game (sports and leisure) Any athletic sport or game in which the AWAY TEAM plays. It is challenging to win this type of game because of the advantage of the HOME TEAM. *See* HOMER.

Roaring Twenties, the (history) The name for the historical period of the 1920s, a time which is characterized by PROHIBITION, parties, dancing, illegal drinking, a busy STOCK MARKET, quick investments made on credit as well as relaxed social rules and an increased freedom for women (e.g., wearing short dresses and short hair, driving cars, smoking in public). It also was marked by PROHIBITION, NATIVISM and racial conflicts. It began after WORLD WAR I and ended on BLACK TUESDAY. [From 'roar', referring to the "active, busy" time of the '1920s'.]

This same period is also known as the "JAZZ AGE". *See* HARLEM RENAISSANCE, RED SUMMER.

robber barons (economy) A negative, collective term for the very wealthy businessmen of the late nineteenth century and their manner of showing off their enormous financial wealth with large, expensive homes, European art collections and properties. Men like ANDREW CARNEGIE and JOHN D. ROCKEFELLER[1] became millionaires from their strong, powerful companies, which were all MONOPOLIES and controlled the industries of steel and oil, respectively. [From *The Robber Barons* (1934), a book describing this period.]

robe (legal system) In the law system, the long (at least below the knee) loose, plain black garment which judges wear while working in the courtroom and on ceremonial occasions. It is a symbol of a judge's position and is worn over regular clothing. Also known as "robes"; *see* BENCH[1,2,3]; *compare* CAP AND GOWN.

Robert E. Lee's Birthday (customs and traditions) The third Monday in January, established by some STATES in the SOUTH as a LEGAL HOLIDAY to celebrate the accomplishments of General ROBERT E. LEE, born January 21, 1807. Since 1986, this holiday has largely been replaced by the FEDERAL HOLIDAY of MARTIN LUTHER KING, JR. DAY. *See* CIVIL WAR.

Robertson, Pat (people) (born in 1930) EVANGELICAL preacher and minister of the Southern Baptist Convention, the largest group of BAPTISTS in the US. He is the founder and host of the most popular TELEVANGELISM television program, "The 700 Club", and the founder of the Christian Broadcasting Network (CBN) established in 1960, which broadcasts programs with "FAMILY VALUES". Later, he became politically active establishing the CHRISTIAN COALITION (1989) and then running unsuccessfully for the nomination for US PRESIDENT of the REPUBLICAN PARTY in 1988. He is known for his CONSERVATIVE opinions.

Robinson, Jackie (people) (1919–1972) The first African-American player in professional BASEBALL (1946) and the person who "broke the color barrier" (in 1947) which had, until then, unofficially barred all black athletes from playing in the MAJOR LEAGUES. He is remembered for his athletic skill (receiving the MVP award in 1949 while playing for the BROOKLYN DODGERS), for calmly accepting the insults from white fans and other players who did not want baseball to be desegregated, and for encouraging blacks to play in all professional sports. He is a symbol of strength, skill and possibility. *See* EBBETS FIELD, NEGRO LEAGUES.

Rock and Roll (the arts) Specifically, a type of music recognized about 1955 when white musicians (namely, ELVIS PRESLEY, Buddy Holly 1936–1959) performed RHYTHM AND BLUES songs in a cleaner manner with cleaner lyrics (i.e., no overt references to sex) than the original black songwriters and performers. Later, the music was influenced by the BLUES[1] and JAZZ MUSIC. This music is characterized by having 12-bars and non-word sung syllables (e.g., "shee-bop"). Its song themes treated love, lack of love, HIGH SCHOOL, girlfriends/boyfriends and the daily life of teenagers. It was very popular among white audiences from 1955 until 1966 and is associated with the performers dancing while performing. It was replaced by "ROCK MUSIC" in 1967. In general, the collective term including Rock and Roll and ROCK MUSIC. [Originally, from black slang of the early twentieth century, meaning "having sexual intercourse".] Also known as "rock 'n' roll" and by the abbreviation R 'n' R; *see* ELVIS PRESLEY, "BRITISH INVASION", BRUCE SPRINGSTEEN, JOHN "COUGAR" MELLENCAMP.

Rock music (the arts) A type of music characterized by harder lyrics and longer, heavier music instrumentation than that played in ROCK AND ROLL from which it developed about 1967. The subject matter of its lyrics now included a variety of themes and stories written by the bands themselves (e.g., personal stories, love, experimentation with drugs). Performers wore brightly-colored clothes and costumes and began to use stage props and displays (e.g., light shows). "Progressive rock" also refers to that music and lyrics that are written by the singers and performers themselves (i.e., not COVERS); "acid rock" and "psychedelic rock" refer to that

music popularized in the late 1960s and early 1970s by HIPPIES which contained long periods of instrumental playing. Also spelled "rock music"; *see* JIMI HENDRIX, JANIS JOPLIN.

rockabilly (the arts) A type of fast-paced music developed in the 1950s which combines the singing of COUNTRY MUSIC and the rhythms of RHYTHM AND BLUES. Traditionally, it has been played on guitars (but not electric guitars).

Rockefeller Center (housing and architecture) In NEW YORK CITY, the stylish, urban 13-building complex of shops, offices, entertainment theaters and restaurants found in Midtown MANHATTAN[1]. It is made of stone and most of it was constructed from 1929 to 1939; other parts were completed in 1973. It includes a public, outdoor wintertime ice rink, RADIO CITY MUSIC HALL and the RCA building, a SKYSCRAPER measuring 850 feet (259 m) with 70 stories. It is admired for its wise, multipurpose use of buildings in a city and its elegant decoration in the Art Deco style. [After JOHN D. ROCKEFELLER, JR. (1874–1960), the patron.]

Rockefeller Foundation, the (the arts) The private organization, founded in 1937, that gives money to scientific research to help solve problems in health, agriculture, farming poverty, the environment both in the UNITED STATES and in other countries. It also supports equal opportunity and artistic and cultural programs in the US. [After JOHN D. ROCKEFELLER[1] (1839–1937), the founder.]

Rockefeller, John D. (1, 2 people) **1** (1839–1937) An industrialist and businessman known for his immense wealth. He co-founded and operated the Standard Oil Company (1870–1911), established the UNIVERSITY OF CHICAGO (1891) and started the ROCKEFELLER FOUNDATION (1913). He is remembered for totally controlling his MONOPOLY business over the oil industry. *See* ROBBER BARON. **2** (1874–1960) The philanthropist who planned and built the ROCKEFELLER CENTER in NEW YORK CITY and funded the restoration of WILLIAMSBURG[1]. Also known as "John D. Rockefeller, Jr.".

Rockettes, The (the arts) A professional DRILL TEAM troupe of 64 female dancers which performs routines and synchronized dancing shows; especially the popular Christmas Show (in December and January) and the Easter Show (in spring). Each **Rockette** is between 5'4" and 5'7" (162.5 cm and 170.1 cm) tall; annual tryouts are held each April. Their home stage is the RADIO CITY MUSIC HALL. They are a symbol of the glamour of NEW YORK CITY. Formerly known as "Roxyettes" [After Samuel Lionel 'Roxy' Rothafel, a patron, entertainer and developer of Radio City.]

Rockwell, Norman (people) (1894–1978) The painter and illustrator who created many of the popular magazines covers of the *SATURDAY EVENING POST*. His realistic-looking works usually show happy, almost idyllic, scenes of everyday, small-town American life. *Compare* CURRIER AND IVES.

Rocky Mountain spotted fever (health) A serious disease in which a person can suffer from a high fever, skin rash and pain in the muscles and joints. It is transmitted to humans by the wood tick, a parasite insect found in natural, wild and mountainous areas.

Rocky Mountains (environment) The tallest, longest and very beautiful range of mountains in North America which runs north–south (i.e., from Alaska to the STATE of New Mexico) and marks the western end of the GREAT PLAINS. During the nineteenth century, it proved an impediment to massive migration to California. Today, it is known for the wealth of copper and mineral mines and its natural areas of outdoor recreation, ski resorts, recreation areas, wildlife (e.g., bear, moose, wolves) and NATIONAL PARKS. *See* CONTINENTAL DIVIDE, ASPEN; *compare* APPALACHIAN MOUNTAINS.

rodeo (1 work; 2 sports and leisure) **1** Originally before the twentieth century, an activity in which COWBOYS[1] rounded up cattle and horses in order to care for the sick animals and determine the ownership of calves and colts and brand them with the owner's symbol. [From Spanish *rodear*, meaning "to go around".] **2** A sporting (professional and amateur levels) and social event held throughout the year and mostly in the WEST in which partici-

pants perform COWBOY[1], farm and cattle-ranching skills. Events usually include: Calf or Steer Roping, Bareback (horse) Riding, Bull Riding, Saddle Bronc and Barrel Racing.

Rodeo Drive (geography) In BEVERLY HILLS, the expensive shopping district of chic boutiques and high fashion shops. By association, it represents shopping and wealth.

Rodgers and Hammerstein (the arts) The successful music team of music composer Richard 'Rodgers' (1902–1979), who was known as the "King of Broadway", and songwriter and librettist, Oscar 'Hammerstein' II (1895–1960) who together created several popular MUSICALS with upbeat, memorable tunes and words. Among their most successful were: *Oklahoma* (1943), *South Pacific* (1949), *The King and I* (1951) and *The Sound of Music* (1959). *Compare* LERNER AND LOWE.

Rodman, Dennis (people) (born in 1961) Professional BASKETBALL player. He is known for his talents as an aggressive forward and rebounder for the Chicago Bulls team (uniform number 91) from 1991 to 1997. Further, he is easily recognized by his rather eccentric physical appearance and behavior, namely, several tattoos on his body and short hair dyed in bright colors (e.g., orange, green). *See* Appendix 3 Professional Teams, REBOUND, NBA.

Roe v. Wade (legal system) The DECISION of the SUPREME COURT (1973) that protects a woman's right to choose to end a pregnancy through abortion (especially in the first six months). Initially, this decision was controversial because it established abortion as an issue of privacy for each woman to decide (i.e., not murder); it OVERRULED those STATE laws which considered abortion murder and prevented it. It also holds that the fetus is not a person with Constitutional rights in the first three months of pregnancy. This case concerned a Texas law that considered abortion murder unless it was done to preserve a woman's own life. Today, the question of abortion is still very debatable. Popularly known as "*R* v. *Wade*"; *see* PRO-CHOICE, PRO-LIFE, FOURTEENTH AMEND-MENT, NINTH AMENDMENT, OPERATION RESCUE, FEMINIST MOVEMENT.

roll-call vote (government) A vote which records how (i.e., "for" or "against") an elected member of a legislature votes. This may be done by calling the name or STATE of the member, but now usually is done by using electronic machines (several of which are located in the legislative buildings). *Compare* VOICE VOTE.

Rolling Stone (media) The popular cultural magazine published once every two weeks and covering music, current issues in politics, arts and sports. It is noted for having journalists with strong writing styles and for publishing interviews with artists and newsmakers. Originally it was founded in SAN FRANCISCO in 1967 for HIPPIES and is now read by BABY BOOMERS and others. Its current circulation is 1.2 million.

Roman Catholic Church (religion) The second largest Christian religion and the single largest DENOMINATION in the US with a current membership of 60.2 million total members. During the COLONIAL PERIOD, it was brought from Western Europe to America by the Spanish (i.e., Florida, California, the SOUTHWEST) and the French (i.e., Louisiana) and was the official religion of the English colony of Maryland (founded in 1634). Other immigrants in the nineteenth and twentieth centuries (i.e., Irish, German, Italian and HISPANICS) also added to its numbers. CARDINALS[1] and other clergy members administer the daily functioning of the CHURCH[3] in North America and PUERTO RICO, although all Church-related dogma and beliefs are decided by the Pope in the Vatican City.

rookie (sports and leisure) Any player currently playing with the first year of a professional sport. By association, any person who is just beginning or is still new to some work, a particular job or task. Also, a novice; a beginner. *See* ROOKIE OF THE YEAR, DRAFT[2], PRO BALL.

Rookie of the Year (sports and leisure) An annual award given to a ROOKIE for outstanding performance during his or her first season. The winning players are usually determined by a vote of sports media people and/or professional sports

organizations. The two MAJOR LEAGUES have awarded one each since 1949; the NBA since 1952; and the NHL has awarded the Rookie of the Year Calder Memorial Trophy since 1933; professional FOOTBALL players have received an award since 1970.

room and board (housing and architecture) (R&B) A room for sleeping and meal that are offered for one set price in a DORM, hotel or bed and breakfast.

Rooney, Andy (people) (born in 1919) Writer and humorist. He has long provided commentary, often in a humorous or silly way, on current issues and everyday life; namely through his SYNDICATED newspaper column, books and for some years in a brief five-minute section of *60 Minutes*.

Roosevelt Corollary, the (foreign policy) The foreign policy idea practiced by PRESIDENT THEODORE ROOSEVELT which gave the UNITED STATES the authority of an "international police force" and to become involved in the political and international economic affairs of the countries located in the Western Hemisphere. It expanded the concepts of the MONROE DOCTRINE. *See* "BIG STICK".

Roosevelt, Eleanor (people) (1884–1962) FIRST LADY (1933–1945), author and humanitarian. She is remembered for promoting LIBERAL causes and social issues through writing books and articles and through her position as First Lady, especially CIVIL RIGHTS, organized labor relations and women's issues, although she never did support the concept of the EQUAL RIGHTS AMENDMENT. She also served as delegate to the United Nations (1945; 1949–1952; and 1961). She married FRANKLIN ROOSEVELT, her second cousin, in 1905; she was the niece of THEODORE ROOSEVELT. *See* PRESIDENT'S COMMISSION ON THE STATUS OF WOMEN.

Roosevelt, Franklin D[elano] (people) (FDR) (1882–1945) Governor of the STATE of New York (1929–1933) and US PRESIDENT (1933–1945) from the DEMOCRATIC PARTY. He was the only president elected to serve four TERMS[1] and thus had a strong effect on the presidency and the country. He developed the NEW DEAL to treat the serious economic crisis caused by the GREAT DEPRESSION and created a system which made the federal government more responsible for helping the elderly, the poor and for regulating business. He repealed PROHIBITION. Despite American ISOLATIONISM, he gave federal help to Great Britain with the LEND-LEASE ACT; led the US into WORLD WAR II; and promoted American support for the United Nations. His legs were permanently paralyzed after 1921 when he contracted polio (i.e., "poliomyelitis"). He died in office from a brain hemorrhage. He is remembered for his understandable manner of explaining concepts and his FIRESIDE CHATS. Further, he is regarded as a forceful, busy president who increased the power of the CHIEF EXECUTIVE, re-shaped the executive branch of the federal government and helped establish the US as a world leader. In addition, his many successful programs and the NEW DEAL have led many to consider him the best president of the twentieth century. *See* SOCIAL SECURITY, YALTA CONFERENCE, FOUR FREEDOMS, TVA, GOOD NEIGHBOR POLICY, HOOVER DAM, HUNDRED DAYS, EXECUTIVE OFFICE OF THE PRESIDENT, WAR RELOCATION AUTHORITY, INTERNMENT CAMPS, EXECUTIVE ORDER 8802, HARRY TRUMAN, Appendix 2 Presidents.

Roosevelt, Theodore ("Teddy") (people) (1858–1919) Leader of the volunteer regiment (known as the "Rough Riders") during the SPANISH-AMERICAN WAR, US VICE PRESIDENT (1901) and US PRESIDENT (1901–1909) from the REPUBLICAN PARTY. He became the youngest president after President William McKinley was assassinated (September 6, 1901). Roosevelt is regarded as having been an active president: he supported the PROGRESSIVE ERA and its reforms, tried to limit BIG BUSINESS, and established new NATIONAL PARKS. On the international level, he expanded the role of the US in the Western Hemisphere (i.e., "BIG STICK"), especially with the Panama Canal, and was the first American to win the Nobel Peace Prize (1906). He founded the PROGRESSIVE PARTY[1] and ran for president unsuccessfully as a BULL MOOSER. He is remembered for being a popular leader and for having a dynamic personality, getting enjoyment from nat-

ure and hunting and having a great interest in conservation. His niece was ELEANOR ROOSEVELT. *See* ROOSEVELT COROLLARY; Appendix 2 Presidents; *compare* FRANKLIN ROOSEVELT.

root beer (food and drink) A type of SODA POP flavored with sugar, yeast and a syrup mixture made from the juices of 'roots' and barks of plants (especially, sarsaparilla) and other herbs.

Roots: The Saga of an American Family (minorities) The best-selling book (published in 1976) which detailed the history of six generations of an African-American family; it included elements of their lives in Gambia in West Africa, where they lived freely, as well as in the UNITED STATES, where they survived SLAVERY and experienced the HARLEM RENAISSANCE. It was written by ALEX HALEY and was made into a very successful television mini-series (in 1977) because, for the first time, it detailed the unique, rich ancestry of a black American family and thus revealed family histories that millions of other blacks had never known about themselves or their families.

Rose Bowl, the (sports and leisure) The oldest COLLEGE[1] FOOTBALL tournament (first played in 1902) and the most prestigious BOWL GAME in INTERCOLLEGIATE sports. It is held on NEW YEAR'S DAY in Pasadena, California. It is known for its elaborate parade with FLOATS decorated with live 'roses' and other fresh flowers, marching bands and music. *See* Appendix 6 Bowl Games.

Rosenberg case, the (history) During the COLD WAR, the controversial political-legal case involving the first two UNITED STATES citizens to be executed for spying. The married American couple Julius Rosenberg (1918–1953) and his wife Ethel Greenglass Rosenberg (1915–1953) were arrested (July 17, 1950) on the charge of receiving secret information about the US-made ATOMIC BOMB and giving it to the communist government of the Soviet Union. The Rosenbergs did support leftist causes but claimed that they were innocent of these charges. After a trial by JURY, an APPEAL and a review of their case by the SUPREME COURT, the Rosenbergs were considered guilty and executed by the electric chair on June 19, 1953. Many people questioned the methods of the trial and the political climate of the country at this time and believe that the Rosenbergs should not have been executed. The couple were, and remain, a symbol of victims of an unfair legal-justice system and an American society hostile to communist groups. *See* LOS ALAMOS, MCCARTHYISM, RED SCARE[3], CAPITAL PUNISHMENT; *compare* SACCO AND VANZETTI CASE.

Ross, Betsy (customs and traditions) (1752–1836, born Elizabeth Griscom) According to tradition, the seamstress from Philadelphia who designed and made the first authentic version of the STARS AND STRIPES[1] of the UNITED STATES OF AMERICA. The flag pattern was agreed upon by the FOUNDERS[1] (June 14, 1777) at the CONTINENTAL CONGRESS. *See* FLAG DAY.

Rotary International (sports and leisure) An international organization of adults which promotes international understanding and GRASSROOTS-level contact by sponsoring exchange programs to study, teach travel and/or work for students, teachers and professional and business people. It also sponsors polio immunizations. It was established in 1905; today, it is found in 150 countries and counts 1.2 million members.

ROTC (military) An UNDERGRADUATE academic program combined with military training and studies. It is offered at most STATE UNIVERSITIES and public COLLEGES[1] for both men and women in the AIR FORCE (AFROTC), ARMY (AROTC) and NAVY (NROTC). During COLLEGE[3], the military pays for part or all of the student's tuition. After graduation, the student is commissioned to serve in the ARMED FORCES from four to six years. [Abbreviation of 'R'eserve 'O'fficer's 'T'raining 'C'orps.] *See* PUBLIC SCHOOL; *compare* WEST POINT, NATIONAL GUARD, DRAFT[1].

round robin (sports and leisure) Describing a tournament in which all of the participants play each other at least once before being eliminated. *Compare* NCAA (DIVISION I) BASKETBALL TOURNAMENT.

Round Table, the (the arts) The collective name for that group of writers and friends who regularly met for lunch in the Rose Room of the ALGONQUIN HOTEL

during the 1920s to discuss issues, art, society, ideas and gossip. Regular members included the writer and organizing force, Dorothy Parker (1893–1967) as well as the journalist Franklin P. Adams (known as "FPA", 1889–1961), the writer Edna Ferber (1887–1968), the dramatist George Kaufman (1889–1961), and others.

Route 66 (transportation) The two-lane highway which runs 2,260 miles long (3,636 km) from CHICAGO, passing through eight STATES (i.e., Illinois, Missouri, Oklahoma, Kansas, Texas, New Mexico, Arizona and California), different urban and rural landscapes and several deserts finally ending at the Pacific Ocean in Santa Monica, California. It was popularized in a song as the "Main Street of America".

Rules Committee (government) In the HOUSE OF REPRESENTATIVES, an important STANDING COMMITTEE which controls the date and specific length of time BILLS2 will be debated, considered and voted on in the chamber. *Compare* FILIBUSTER.

run (sports and leisure) In BASEBALL, a score equal to one point. It is earned by an offensive player who has batted a ball and 'run' around the field touching the three bases (i.e., first, second and third) and HOME PLATE. A HOME RUN is a type of run. *See* ERA1, EARNED RUN.

Run for the Roses, the (sports and leisure) The nickname for the KENTUCKY DERBY. [From the wreath of fresh 'roses' that is placed around the neck of the winning horse of that race in the winners' circle.]

running back (sports and leisure) In FOOTBALL, an offensive player who helps move the ball toward the opponent's goal by carrying the ball following preplanned plays from practice. *See* HUDDLE; *compare* QUARTERBACK, LINEBACKER.

running-mate (politics) The candidate for VICE PRESIDENT of a political party who is chosen by that party's candidate for PRESIDENT and whose identity is traditionally announced during the NATIONAL CONVENTION. Often he or she is chosen as a way of BALANCING THE TICKET. [From the sport of horse racing, where horse "A" runs hard and fast next to horse "B" to help and encourage "B" to run to the finish line and win.]

rush (sports and leisure) The formal, sometimes regulated, process where an UNDERGRADUATE, or "rushee", visits many different SORORITY or FRATERNITY houses and meets the current members in hopes of receiving a BID2 to join the club. Rush usually takes place once a year and is particularly stressful for women and sororities. *Compare* RUSH LIMBAUGH.

rushing (sports and leisure) In FOOTBALL, any try or action of the offensive team to move the football across the LINE OF SCRIMMAGE and forward toward the goal post of the defending team. The distance of rushing is measured in yards (one yard = 0.9 meter).

Rustbelt, the (geography) A general, collective name for those once powerful, busy industrial areas of the NORTH and MIDWEST which had experienced an economic decline and population loss from the 1970s through to the early 1990s because of their continued use of outdated industries and/or industrial factories. *See* DETROIT; *compare* SUNBELT.

Ruth, Babe (people) (1895–1948, born George Herman Ruth) A MAJOR LEAGUE professional BASEBALL player famous for his skills as a PITCHER and batter; in his career, he batted 714 HOME RUNS. He is characterized by his athletic talents and large, heavy body. He played for the Boston Red Sox (1914–1919) and the New York YANKEES4 (1920–1934) and helped make baseball popular. [He was given the nickname "Babe" because of his boyish, 'bab'yish enthusiasm for baseball.] *See* Appendix 3 Professional Teams.

RV (transportation) A van especially designed to be driven about and traveled in. It is outfitted with a kitchenette, toilet, eating area and sleeping bunk and is used for traveling and taking vacations, but not for permanent living. [Abbreviation of 'r'ecreational 'v'ehicle.] Also known as a "motor home"; *compare* TRAILER PARK.

Ryder Cup, the (sports and leisure) A professional men's golf competition between an American team (composed of 12 players chosen by the PROFESSIONAL GOLFERS' ASSOCIATION) and a European team (composed of 12 European players).

It was first held in 1926 in England between the UNITED STATES and Great Britain. It is held every other year (i.e., odd-numbered years) in a different location. [After Englishman Samuel A. 'Ryder', the patron who donated the trophy.]

S

Sabbath school (1, 2 religion) **1** Lessons in the JEWISH religion, Jewish history and the Hebrew language which are offered on Saturdays to Jewish children and teenagers. *Compare* HILLEL. **2** Lessons in the religion of SEVENTH-DAY ADVENTISTS which are offered to the children of CHURCH[1,3] members on Saturdays. [Saturday is the 'Sabbath', or holy day, for Jews and Seventh-Day Adventists.]

Sacagawea (people) (1786–1812) A Shoshone INDIAN, interpreter and guide. She assisted the LEWIS AND CLARK expedition by guiding the explorers through new geographical areas and serving as linguistic interpreter between that group and several different NATIVE AMERICAN groups.

Sacco and Vanzetti case (history) During the RED SCARE[2], the debated, controversial legal case concerning two Italian immigrants living in BOSTON who described themselves as anarchists, Nicola 'Sacco' (1891–1927) and Bartolomeo 'Vanzetti' (1888–1927). In May 1920, the two were arrested on the charge of robbing and murdering the paymaster and guard of a shoe factory in Braintree, a suburb in Massachusetts. Both men denied this charge, and many people believed them to be innocent and supported them. After a lengthy JURY trial based on questionable TESTIMONY by witnesses and repeated refusals by government officials for a retrial, the court decided that they were guilty and issued them the death penalty; both died by electric chair in 1927. Many of their supporters believed that they were executed because they were foreigners and held unusual, radical political ideas. This case was and still is seen as the result of an unfair justice system; and the two men became symbols for people with opinions of the LEFT. *See* NATIVISM, RED SCARE[1], OLD LEFT, SUBURBS; *compare* ROSENBERG CASE.

safety (sports and leisure) In FOOTBALL, a method of scoring when the offensive team is in its own END ZONE and the defensive team tackles an offensive player holding the football. It is worth two points. *Compare* TOUCHDOWN, FIELD GOAL, CONVERSION.

Safire, William (people) (born in 1929) A SYNDICATED journalist and writer respected for his political commentary as well as his books and weekly articles on GENERAL AMERICAN ENGLISH, especially its usages, varieties and unique history.

sales tax (economy) The tax a buyer pays on the total sales price of goods or services. Because this tax is set by STATES and local governments (e.g., anywhere between zero and 8% of the cost of the product), it is not figured into the price displayed on the product, but only at the CHECKOUT COUNTER. Also known as "general sales tax".

Salisbury steak (food and drink) A flat meat patty made of ground beef mixed with bread crumbs and onions. It may be broiled or fried. [After John 'Salisbury' (1823–1905), the creator of this meat dish and a dietitian.]

SALT I (foreign policy) A short-term treaty agreement signed by the US and the USSR in which both agreed to a five-year ban on testing and deploying nuclear weapons; especially intercontinental ballistic missiles (ICBMs) and submarine-launched ballistic missiles (SLBMs). It was signed in Moscow on May 26, 1972; and because it proved successful, the two countries agreed in September 1977 to continue abiding by it. [Acronym of 'S'trategic 'A'rms 'L'imitation 'T'reaty.] *See* DÉTENTE; *compare* SALT II.

SALT II (foreign policy) A treaty between the US and the USSR which tried to limit the number and deployment of nuclear weapons. It was signed in June 18, 1979, in Vienna, Austria; however, after the Soviet Union invaded Afghanistan, the US refused to follow it. [Acronym from 'S'tra-

tegic 'A'rms 'L'imitation 'T'reaty.] *See* DÉTENTE; *compare* SALT I.

Salt Lake City (geography) The capital city in the STATE of Utah founded by the MORMONS in 1847 as a religious refuge and which today serves as the world head-quarters of the CHURCH OF JESUS CHRIST OF LATTER-DAY SAINTS. It also has active coal- and gold-mining industries and is close to several NATIONAL PARKS. *See* BRIGHAM YOUNG UNIVERSITY.

Saltbox house (housing and architecture) A house which has a narrow, rectangular two-story section as well as a one-story section built behind or next to it. Traditionally, it was built of wood and found in NEW ENGLAND.

salutatorian (education) In a SECOND-ARY SCHOOL or COLLEGE[3], the student with the second highest GPA in the graduating CLASS. This title is a prestigious honor. This student may present a special speech at the COMMENCEMENT ceremony; it is called the "salutatory speech". *Compare* VALEDICTORIAN, VALEDICTORY SPEECH.

salute to the Union, the (customs and traditions) The firing of guns, a total of 50 separate shots, one in honor of each STATE of the UNION[4]. It is fired every INDEPEN-DENCE DAY at 12:00 noon at all military posts and bases on American land. After the firing, it is immediately followed by the playing of the NATIONAL ANTHEM. *Compare* 21-GUN SALUTE.

Salvation Army, the (religion) A PRO-TESTANT religious group committed to social work, especially to helping the poor and homeless. It was founded in England in 1878 by a British Methodist, William Booth (1829–1912) and in 1888 his daughter Evangeline Booth (1865–1950) brought it to the US. Members have an EVANGELICAL belief in the importance of the Bible and are committed to missionary work. Traditionally, its members wear distinctive military-like uniforms and are often seen in SHOPPING MALLS and shop-ping areas during CHRISTMASTIME and the HOLIDAY SEASON playing music in small bands or ringing bells to raise money for their charity social work. Currently in the US, it has a total of 443,000 members. *See* METHODIST CHURCH.

San Andreas Fault (environment) A major fault line, running from the north-east to the southwest of the STATE of California (i.e., between the North American Plate land mass and the Pacific Plate land mass), which is responsible for caus-ing most of the earthquakes in that region (e.g., SAN FRANCISCO in 1906, 1989).

San Francisco (geography) The city built on several different hills in northern California. Although it was originally founded by the Spanish in 1776, the US acquired it in 1846 and it developed quickly after the GOLD RUSH in 1849. The TRANSCONTINENTAL RAILROAD brought it wealth and many immigrants from China. It was seriously destroyed during the earthquakes of 1906 (503 killed) and 1989 (62 killed). In the 1950s, it was one of the destinations of the BEAT GENERA-TION (i.e., North Beach) and it hosted several planned and unplanned events during the SUMMER OF LOVE in 1967. It is recognized for its hilly terrain, cable cars used for public transportation, mild cli-mate (i.e., no snow) and misty weather. Its symbol is the GOLDEN GATE BRIDGE. It has long been known for its residents' LIBERAL, educated attitude; currently, its population is 734,000. *See* ANGEL ISLAND, BAY AREA, UNIVERSITY OF CALIFORNIA, BERKELEY, HAIGHT–ASHBURY, TREATY OF GUADALUPE HIDALGO, NAPA VALLEY, STANFORD UNI-VERSITY, SILICON VALLEY, SAN ANDREAS FAULT.

Sandman, the (customs and traditions) A figure of folklore who sprinkles sand in children's eyes to make them sleepy and encourage them to sleep. He is the perso-nification of sleepiness or sleep. [After the crusty 'sand' material found in one's eyes in the morning after having slept.]

Sanger, Margaret (people) (1883–1966) Promoter of birth control for women and founder of the AMERICAN BIRTH CONTROL LEAGUE. She led the campaign to educate the public about birth control for women. She believed that a woman's opportunity to choose whether to be a mother and/or when to be a mother were important aspects in helping women be free indivi-duals. *See* PLANNED PARENTHOOD.

Sansei (minorities) Asian-American people of Japanese descent who were born

in the UNITED STATES and who are usually very assimilated to mainstream American society. Their parents are NISEI. *Compare* ISSEI.

Santa Claus (customs and traditions) The kind, plump, older man recognized by his white hair and long white beard and red snow suit with white trim who is well liked by children. On CHRISTMAS EVE he travels in a sleigh pulled by reindeer to the homes of well-behaved children leaving presents for them under the CHRISTMAS TREE and in CHRISTMAS STOCKINGS. During most of the year he lives at the "North Pole" where he and his assistants, known as "elves", work making toys and gifts for children. However, during the HOLIDAY SEASON he may be found in a booth in a SHOPPING MALL which children can visit to tell him which particular gifts they want to receive on CHRISTMAS DAY. Children may also write him letters asking for special gifts. He is the major secular symbol of CHRISTMASTIME. (Actually, parents and other adults perform these tasks.) [From Dutch *'Sint' Ni'kolaas',* a fourth-century bishop of the ROMAN CATHOLIC CHURCH, who is the patron saint of children.] *See* MACY'S THANKSGIVING DAY PARADE, SECULARISM.

SAT (education) A standardized, MULTIPLE-CHOICE admission test taken by HIGH SCHOOL students who want to attend COLLEGE[1] which tries to judge a student's ability to do UNDERGRADUATE-level work and is used by more than 2,000 different COLLEGES[1] and UNIVERSITIES nationwide. It is written, administered and graded by the COLLEGE BOARD which in the early 1990s rewrote the exam questions and changed the test format to reflect a more multicultural population in the US. The new format has two parts which are given at specific dates and locations worldwide during the year. "SAT I" tests verbal English and math abilities and "SAT II" tests the following five fields: English, foreign languages, mathematics, history and social sciences, and the hard sciences. The score on the SAT is one factor in a student's application to COLLEGE[3]. [Abbreviation of 'S'cholastic 'A'ssessment 'T'est.] Prior to 1994, SAT stood for "Scholastic Aptitude Test". *See* MULTICULTURALISM, ADMISSIONS DEPARTMENT; *compare* ACT.

Saturday Evening Post (media) A popular, weekly general interest magazine for middle-class readers (from 1821 to 1969). It published SERIALS of detective stories, WESTERNS and romantic fiction; it was known as "America's favorite magazine". It favored REPUBLICAN policies and CONSERVATIVE opinions. Its popular, illustrated covers, many by NORMAN ROCKWELL, depicted sentimental views of American life. In 1960, its peak circulation was 7 million. *Compare* CURRIER AND IVES.

Saturday Night Live (media) *(SNL)* On Saturdays, a popular, late-night live TV program on NBC, where young comedians perform skits, making fun of current issues and political events. Its permanent cast, music band and invited special guests perform in the weekly show, which began in 1975.

Savings and Loan Association (economy) (S&L) A financial institution established to loan money to help people and companies buy and/or construct homes and buildings. S&Ls also make other real estate and business loans. Its deposits are ensured by the FEDERAL DEPOSIT INSURANCE CORPORATION. The "Savings & Loans bail-out" refers to the federal government assistance (law passed 1989) which paid $300 billion to stabilize the bankrupt S&L industry.

scab (work) The pejorative name for a person (usually not a member of a UNION[1]) who is hired temporarily to work the job of a full-time worker during a STRIKE[1]. *Compare* REPLACEMENT WORKERS.

scalawag (history) During RECONSTRUCTION, a derogatory name for a white person born in the SOUTH (usually from small non-slave-holding farms) who supported the REPUBLICAN PARTY and engaged in new business deals with whites from the north and blacks from the South. *Compare* CARPETBAGGER.

Schlesinger, Arthur, Jr. (people) (born in 1917) A historian and writer known for his well-researched books on American political leaders and issues, namely: *The Age of Jackson* (1945) about ANDREW JACKSON and *Imperial Presidency* (1973). In *The Disuniting of America* (1991) he

discusses the negative side of MULTICUL-TURALISM. *See* "IMPERIAL PRESIDENCY".

scholarship (education) A gift of money given to students at the HIGH SCHOOL, COLLEGE[1] or GRADUATE SCHOOL level which pays for their education expenses. A scholarship may be "full" (pays for all tuition and ROOM AND BOARD) or "partial" (pays for some part of tuition). There are three types: academic merit, athletic, or financial need ("need-based"). The federal, STATE, or local government or individual SCHOOLS[5] can give a student a scholarship. *See* NO PASS, NO PLAY, RHODES SCHOLARSHIP, FULBRIGHT SCHOLARSHIP, FINANCIAL AID; *compare* ASSISTANTSHIP, PELL GRANT, WORK-STUDY.

school (1, 2, 3, 4, 5, 6 education) **1** A general term for compulsory, formal education for children in ELEMENTARY SCHOOL and HIGH SCHOOL (i.e., GRADES[1] one through 12). **2** The specialized academic division within a COLLEGE[1] or UNIVERSITY (e.g., the School of Computer Science). **3** An institution of specialized instruction (e.g., driving school). **4** A PROFESSIONAL SCHOOL or GRADUATE SCHOOL (e.g., business school). **5** A general term for any institution that provides instruction at any learning level (e.g., MIDDLE SCHOOL or medical school). **6** The building(s) where academic or instructive classes are held.

school board (education) Another, more popular name for BOARD OF EDUCATION.

school bus (education) The yellow-painted bus used to transport children between home and SCHOOL[1]. It is paid for, maintained and operated with money from local, STATE and/or federal taxes. It was a key element in the BUSING debate.

school district (education) A local administering body for PUBLIC SCHOOLS in a city or across several towns in a STATE. It receives its powers from the state and they include: levying and collecting taxes, distributing money to all SCHOOLS[1] in its area, erecting SCHOOL[1] buildings, and making decisions about what courses to teach, how to teach them and what materials to use. *See* LEVY.

School District of Abington v. Schempp; (and) Murray v. Curlett (religion) The two UNITED STATES SU-PREME COURT DECISIONS (both made in 1963) stating that SCHOOL PRAYER or other religious activities are not permitted in PUBLIC SCHOOLS because of the ESTABLISHMENT CLAUSE. *See* FIRST AMENDMENT.

school prayer (religion) Any religious statement or prayer said together by students, teachers or staff as a required activity of a SCHOOL[1]. It is limited and/or not permitted in PUBLIC SCHOOLS because of the SEPARATION OF CHURCH AND STATE clause. *See* ENGEL V. VITALE, SCHOOL DISTRICT OF ABINGTON V. SCHEMPP, (and) MURRAY V. CURLETT.

school year (education) Another name for ACADEMIC YEAR.

science park (science and technology) A general name for a scientific research center compound, usually located in a residential, suburban area or along the INTERSTATE HIGHWAY. *See* SUBURBS.

Scientific American (media) Since 1921, a monthly magazine, publishing reliable and understandable articles on the physical, social and life sciences as well as how to use them in industry and public policy. Its current circulation is 640,000. Formerly (from 1845 to 1921), it was a weekly magazine reporting on new inventions.

Scientology (religion) A kind of religious group/cult founded in 1953 by L. Ron Hubbard (1911–1986) and based on his book *Dianetics: the Modern Science of Mental Health* (1950). It is controversial because it encourages its members, **Scientologists**, to search for happiness by clearing their brains of memories of experiences in the past and any previous lives they have lived. It is popular among some HOLLYWOOD[2] actors, however the total number of members is not known. In 1993, the federal government recognized it as a TAX-EXEMPT organization.

Scopes Monkey Trial, the (education) A famous 1925 trial that challenged the STATE law of Tennessee which prohibited teachers from teaching the theory of evolution in PUBLIC SCHOOLS because it conflicted with the Bible. The case concerned the young instructor, John 'Scopes' (1900–1970), who had been teaching the Darwinian theory of evolution in his science class. The case was made famous:

first, because of the "old RELIGIOUS RIGHT" which disapproved of Darwin's theories; second, because it was the first legal case to be broadcast over the radio and thus was heard by a very large audience; and, third, because of the well-respected LAWYERS arguing the case – the PROSECUTING ATTORNEY William Jennings Bryant (1860–1925) and the defense ATTORNEY Clarence Darrow (1857–1938). Scopes, the DEFENDANT, lost the case. It is sometimes known as the "Monkey Trial". *See EPPERSON v. ARKANSAS.*

scout (sports and leisure) An individual who represents an athletic team (e.g., COLLEGE[1] level or professional) and who visits other teams to recruit younger players to play for his or her team. Also known as a "talent scout".

Screen Actors' Guild (the arts) (SAG) A labor UNION[1], founded in 1933, for movie performers which collects statistics on actors and actresses and encourages AFFIRMATIVE ACTION in hiring. It is an AFL-CIO member and has 75,000 members. It distributes awards to members for excellence in acting.

screwball comedy (the arts) An entertaining, humorous, romantic type of movie in which characters (willingly or unwillingly) get into silly situations; it is also characterized by having a love triangle (e.g., two men and one woman) and spacey or dizzy characters. It was a popular type of HOLLYWOOD[2] film during the 1930s and 1940s.

scrimmage (1, 2 sports and leisure) **1** In FOOTBALL, any play that is performed during a game; it begins when the ball is put into motion (i.e., the SNAP) and ends when the active play is over. *Compare LINE OF SCRIMMAGE.* **2** An athletic game which is conducted to give the two teams practice but does not count in the team's victory record.

SEALS, the (military) The elite branch of the SPECIAL FORCES originating in the Navy which is responsible for water-oriented maneuvers (underwater reconnaissance and demolition) and the deliveries of military vehicles. [Acronym from 'Se'a 'A'ir and 'L'and 'S'oldiers'.]

search and seizure (legal system) The practice of police whereby a person or

place is looked at (i.e., 'searched') in order to take (i.e., 'seize') evidence (e.g., guns, knives, personal belongings) that may be useful to a court of law in a case. This practice is limited by the FOURTH AMENDMENT and FOURTEENTH AMENDMENT. Also, law enforcement officers must have a search warrant to conduct this procedure.

Sears Tower (housing and architecture) The tall, glass-covered office building in CHICAGO measuring 1,450 feet (442 m) or 1/4 mile tall (.42 km). It was completed in 1974 and has 101 stories and over 100 elevators. It is the tallest SKYSCRAPER in the UNITED STATES and North America. It is located DOWNTOWN, but just outside the LOOP. [After 'Sears' Roebuck & Company.] *Compare WORLD TRADE CENTER.*

season, the (media) A period of 13 weeks, beginning in September; when television networks show their new TV programs.

season tickets (sports and leisure) A set or block of tickets which allow a person to attend artistic events (e.g., theatrical plays, operas) or sporting events (FOOTBALL, BASKETBALL games). A person buys season tickets before the theater, opera or athletic season begins.

Seattle (geography) A major city in the northwest corner of the US whose economy is largely based on the technological industries of aerospace and computer software as well as the traditional work of logging. It is located in a region known for the natural beauty of its waterways, mountains and forests. Since the 1980s, it has also been known for fostering new trends in music and for promoting the ENVIRONMENTAL MOVEMENT. *See PACIFIC NORTHWEST, SPOTTED OWL, MOUNT ST. HELENS, APPENDIX 3 PROFESSIONAL TEAMS.*

Second (Great) Awakening, the (religion) The period of enthusiastic religious REVIVALS (1790s–1830s) throughout the UNITED STATES that promoted the belief of reforming and perfecting the individual person and American society. It increased the number of members in various PROTESTANT DENOMINATIONS (e.g., BAPTISTS, PRESBYTERIAN CHURCHES, METHODIST CHURCHES), created new religious groups (e.g., MORMONS, SEVENTH-DAY ADVEN-

TISTS) and encouraged people to establish reform movements to improve society (e.g., ABOLITION, WOMEN'S MOVEMENT). *Compare* GREAT AWAKENING, BILLY GRAHAM, EVANGELICAL.

Second Amendment (legal system) The addition to the CONSTITUTION (in 1791) which gives people the right to protect themselves from community problems and foreign enemies by keeping (i.e., "bearing") arms and guns. This AMENDMENT was passed and became part of the BILL OF RIGHTS shortly after the AMERICAN REVOLUTION when self-defense was an important local concern. *See* NRA (NATIONAL RIFLE ASSOCIATION), INTOLERABLE ACTS, BRADY BILL.

second base (sports and leisure) In BASEBALL, that base located directly across the DIAMOND from HOME PLATE. It is the second base to which an offensive player runs. By association, the second step in a plan which consists of several, often four, steps. Further, it is also the name of the defensive, INFIELD position of that defensive player who guards this base.

secondary school (education) A general term for HIGH SCHOOL. A collective name for both a JUNIOR HIGH SCHOOL and a "senior HIGH SCHOOL". *See* Appendix 4 Education Levels.

Secret Service, the (government) An agency of the DEPARTMENT OF THE TREASURY that physically protects the PRESIDENT, VICE PRESIDENT, their families, guests and any visitors from other countries. Secret Service Agents also protect former Presidents. Further, this agency prevents the counterfeiting of US money.

Secretary (government) The head of a CABINET DEPARTMENT[2] of the UNITED STATES government (e.g., Secretary of the DEPARTMENT OF COMMERCE) who is appointed by the PRESIDENT and approved by the SENATE. Usually, this is a PARTISAN position. *See* APPOINTMENT POWER, ADVICE AND CONSENT, HEARING[2]; *compare* ATTORNEY GENERAL.

secularism (religion) The attitude or action of not practicing or belonging to a religion but having interests in other, non-religious fields. **Secular** interests include work, entertainment, academic studies.

Securities and Exchange Commission (economy) (SEC) An independent federal agency controlling and enforcing the financial reporting and disclosure of businesses held, owned and operated by the government. It was created in 1934 and tries to protect the interests of the public and investors in stocks and bonds (i.e., 'securities') issued by the UNITED STATES. *See* BLACK MONDAY, DOW JONES INDUSTRIAL AVERAGE, STOCK MARKET.

segregation (minorities) In general, a social policy of separating or keeping an ETHNIC MINORITY or religious group apart from the dominant group. Specifically, a social practice that was legally enforced in the UNITED STATES after the DECISION in *PLESSY* v. *FERGUSON* and until the late 1950s requiring that different racial groups (e.g., blacks, whites, Asian Americans, etc.) use different public facilities and services. During that period, **segregated** facilities included PUBLIC SCHOOLS, swimming pools, restaurants, drinking fountains and toilets. Also it encouraged the development of BLACK COLLEGES. *See* "SEPARATE BUT EQUAL", JIM CROW, CIVIL RIGHTS MOVEMENT, DE FACTO, DE JURE, *BROWN* v. *BOARD OF EDUCATION*.

Select Commission on Immigration and Refugee Policy (immigration) The federal commission which studied and reported on the condition of immigration to the UNITED STATES. In 1981, it published its report which made several suggestions, namely: that the LIBERAL immigration policies established in 1965 with the federal IMMIGRATION ACT OF 1965 should be maintained; that surveillance at the BORDERS should be tightened to prevent illegal immigration; and that an amnesty program for illegal immigrants should be established.

Selma to Montgomery March, the (minorities) A five-day CIVIL RIGHTS march (from March 21 to 25, 1965) in which 25,000 people (both black and white) marched to encourage fair VOTER REGISTRATION and voting rights for blacks living in the southern STATE of Alabama. The march leaders had secured permission by a judicial court to hold the march and the US ARMY served to provide marchers with protection from angry local residents and

police forces. The event, which was organized by SNCC and led by MARTIN LUTHER KING, JR., began in the city of Selma, Alabama, and ended at the STATE capital of Montgomery, Alabama. Although the march was postponed twice – first on March 7, 1965, after the marchers experienced severe harassment (e.g., beatings, tear gas) by the local, white police force; and second on March 9, 1965, after a court's RESTRAINING ORDER prohibited the CIVIL RIGHTS demonstration – it proved to be one of the biggest and most successful events of the CIVIL RIGHTS MOVEMENT. These problems brought much media attention to the event and since much of the march was televised on news programs many white and black television viewers nationwide sympathized with the marchers.

semester (education) A 15- or 16-week period of academic instruction and courses including one week for FINALS. Two semesters = one ACADEMIC YEAR, usually; FALL semester (e.g., from September to December) and spring semester (e.g., from January to May). *Compare* QUARTER[2] .

semiformal (1, 2 clothing) **1** Describing a type of social event which is less formal than a FORMAL[1] yet more elegant than a daily event (e.g., COCKTAIL PARTY). **2** By association, describing the suggested type of clothing appropriate for guests to wear to such an event: usually, meaning for men, a TUXEDO or a DINNER JACKET; for women, a pants suit or a dress with a hem length to the ankle, the knee or above the knee. Also spelled "semi-formal"; *compare* FORMAL[3,4].

Senate, the (government) The smaller and more CONSERVATIVE chamber of the US CONGRESS. It has 100 total members (i.e., two SENATORS from each STATE). It gives ADVICE AND CONSENT to the PRESIDENT; introduces legislative BILLS[2] and works with the HOUSE OF REPRESENTATIVES in JOINT COMMITTEES to revise and approve BILLS[2]. Its everyday activities are organized by the MAJORITY LEADER, MINORITY LEADER and WHIPS. *See* IMPEACHMENT, HEARING[2].

Senate Rule 22 (government) In the US SENATE, the rule that gives any SENATOR the right to talk without a time limit about pending legislation. This can cause a FILIBUSTER. *Compare* RULES COMMITTEE.

Senator (government) A member of the SENATE who is elected to a six-year TERM[1]. Each one must be at least 30 years old, a citizen of the UNITED STATES and a resident of his or her CONSTITUENCY. There are two for each STATE, making a total of 100 voting members. *See* SEVENTEENTH AMENDMENT; PRESIDENT *PRO TEMPORE*; *compare* REPRESENTATIVE[1]; SHADOW SENATOR.

Seneca Falls Convention, the (minorities) The meeting in which some 300 women and men declared that women had few rights in American society and agreed to promote the rights of women, especially the right to: an education, work and the vote. These rights were written in the DECLARATION OF SENTIMENTS AND RESOLUTIONS. This two-day meeting is considered the beginning of the WOMEN'S RIGHTS movement in the UNITED STATES. [For the meeting's location in the town of 'Seneca Falls' in UPSTATE New York.]

senior (education) A fourth- or fifth-year student at a HIGH SCHOOL, COLLEGE[1] or UNIVERSITY. Sometimes known as "fourth year". By association, describing a person who is experienced (e.g., senior SENATOR). *See* CLASS, CONGRESS; *compare* FRESHMAN[1,2].

senior (citizen) (society) An elderly person; especially one who is retired. A person who is 60 to 65 years and older. **Seniors** often get discounts on tickets for museums, movies and travel. *See* AARP.

"separate but equal" (legal system) The official doctrine in the UNITED STATES that ruled all social relations between whites and blacks from 1896 until 1954. It was used by the STATES to create state laws designed to enforce SEGREGATION in all public and private areas and facilities. Most noticeably: railroad cars, buses, restaurants, DINERS, housing, neighborhoods, phone booths, drinking fountains, swimming pools and beaches. It was established by the SUPREME COURT DECISION in *PLESSY* v. *FERGUSON* (in 1896). It was only overturned in 1954 by *BROWN* v. *BOARD OF EDUCATION OF TOPEKA, KANSAS.* By association, another name for "segre-

gation". It is an example of a poor interpretation of the US CONSTITUTION by the Supreme Court. [From the phrase used by the Supreme Court in its MAJORITY OPINION in the *Plessy* decision.] *See* CIVIL RIGHTS MOVEMENT.

separation of church and state, the (religion) The important principle that the ideas, actions and organizations of religions must not influence nor mix with the ideas, actions and organizations of government and vice versa. It supports the practices of all organized, individual religions except when they intrude into parts of American culture and life that are paid for by, or represent, the government (e.g., in PUBLIC SCHOOLS, SCHOOL PRAYER). [From the phrase written by THOMAS JEFFERSON claiming that the FIRST AMENDMENT builds a "wall of 'separation between church and state' (meaning, the government)".]

separation of powers (government) The governing principle that divides the federal government into three branches (i.e., executive, legislative, judicial) and gives each branch different 'powers', tasks and jobs. This is a key element of American government and was established by the CONSTITUTION. *See* PRESIDENT, CONGRESS and the SUPREME COURT; *compare* CHECKS AND BALANCES.

series (media) A TV or radio program broadcast, or written article published at regular intervals (e.g., once a day, once a week, once a month). A "mini-series" is a special type of series, broadcast for one to several weeks only. Also known as a "serial".

Serrano v. Priest (education) The DECISION of the SUPREME COURT of the STATE of California (in 1971) claiming that the state's method of financing PUBLIC SCHOOLS was discriminatory and had to be changed. At this time, a SCHOOL[5] in a community was funded by collecting PROPERTY TAXES from the members of that community; meaning, the lower the value of the property, the lower the taxes paid and the smaller amount of money collected and given to the SCHOOL[1]. The case concerned John 'Serrano', a hispanic man, who filed a suit against the state Treasurer, Mr. 'Priest'. Serrano claimed that his son was receiving an inferior education in the

hispanic BARRIO of East Los Angeles because that area had low property values and, therefore, there was a low funding of PUBLIC SCHOOLS in that area. Thus, Serrano believed that his child was denied equal protection by the law because he was denied a good education at a school with more funds because he happened to live in a poor area. This decision changed the system of California SCHOOL[5] funding.

service industry (work) A collective name for all those jobs in which the workers provide some service in exchange for a MINIMUM WAGE. "Service jobs" include waitressing, retail sales clerk, hotel staff, BUS BOY/GIRL, bartenders and health care attendants. *See* TIP.

Serviceman's Readjustment Act, the (education) The federal act (passed in 1944) that provided funds to post-SECONDARY SCHOOLS with ACCREDITATION specifically for VETERANS to pursue HIGHER EDUCATION. It reintroduced WORLD WAR II veterans to civilian life and returned the student enrollment at COLLEGES[1] and UNIVERSITIES to pre-war levels. It lasted from 1944 until 1971 and helped 2.3 million veterans earn an education. Since most BLACK COLLEGES did not have accreditation, they were ineligible for this BILL[2]. It is popularly known as the "GI BILL".

Sesame Street (media) A popular, 30-minute educational PUBLIC BROADCASTING television program, designed to teach children language (English and basic Spanish), math (e.g., numbers, counting) and social skills. Favorite characters include the puppets/muppets, Cookie Monster, Grover, Big Bird and Bert and Ernie. It is admired for its consistent high quality and educational format for children. It is created by the Children's Television Workshop and its programming began in 1969.

session (1 legal system; 1, 2, 3 government) **1** The daily meeting of a judicial court or a legislature. *See* JOINT SESSION. **2** The official two-year period of CONGRESS, which corresponds to the length of a TERM[1] of a CONGRESSMAN/WOMAN. **3** A year-long meeting of Congress (i.e., half of Congress's official SESSION[2]) which begins in January and ends with ADJOURNMENT[1]. The "First Session" begins in January of an odd-numbered year; the

"Second Session" begins in January of the following, even-numbered year.

settlement (legal system) The solution to a legal matter, especially a CIVIL TRAIL; often it is a compromise between the PLAINTIFF and DEFENDANT and involves a sum of money. *See* DAMAGES, LIABILITY; *compare* OUT-OF-COURT SETTLEMENT.

settlement house (immigration) A NONPROFIT ORGANIZATION institution whose members provided various social and artistic programs to help the community; especially by offering special services to new immigrants (i.e., English language courses, helping find work). It was especially popular in many cities during the PROGRESSIVE ERA.

Seuss, Dr. (people) The pen name of Theodor 'Seuss' Geisel (1904–1991) a writer and illustrator of very popular children's books characterized by a simple, rhyming language pattern and very bright, colorful drawings, and human-like, colorful characters and animals. His most famous works are *The Cat in the Hat*, *The Grinch Who Stole Christmas* and *Oh! The Places You'll Go!*. *See* GRINCH.

Seven Sisters, the (education) A group of prestigious, long-established, private LIBERAL ARTS COLLEGES on the EAST COAST originally founded for women. They include: BARNARD COLLEGE (1889), RADCLIFFE COLLEGE (1879), Mount Holyoke College (1893), Smith College (1875), Sarah Lawrence College (1926), Vassar College (1861) and Wellesley College (1870). Changes in the system of HIGHER EDUCATION in the 1960s encouraged some of these to merge with male COLLEGES[1] or to directly admit male students. BARNARD, Mount Holyoke and Smith still remain only for women. [From the 'Seven Sisters', the popular name for the "Pleiades", a group of particularly bright stars in the night sky.] *See* PRIVATE SCHOOLS; *compare* IVY LEAGUE.

Seventeen (media) A monthly magazine designed for teenage girls and young women (aged 12 to 21 years). Each issue carries articles and photographs concerning current trends, fashion and personal relationships as well as a fictional story. It was founded in 1944 and has a current circulation of 2.4 million.

Seventeenth Amendment (government) The AMENDMENT to the CONSTITUTION (1913) ordering that members of the US SENATE be elected by POPULAR VOTE. Until this time, SENATORS were elected by the legislatures of STATES.

Seventh Amendment (legal system) The addition to the CONSTITUTION (in 1791) that guarantees a trial by JURY to every person accused of an offense or crime (in most instances) and assures that the facts from one legal case cannot be raised again in another, different legal case. It is part of the BILL OF RIGHTS.

Seventh-Day Adventists (religion) A PROTESTANT DENOMINATION established in the 1850s by Ellen Gould White (1827–1915) and based on the teachings of William Miller (1782–1849) which claimed that Jesus Christ was to come again to earth soon. Today, the 776,000 believers prepare for Christ's "second coming" or 'advent' by practicing health reform and living a pure life. Members: are vegetarians; promote education; smoke no tobacco; and drink no coffee nor caffeinated tea. They attend religious services on the 'seventh day' of the week, Saturday. *See* SABBATH SCHOOL[2].

severance pay (work) A sum of money a company gives a worker who does not qualify for a pension, but is leaving a job. *See* DOWNSIZING.

Seward's Folly (geography) The popular nickname for the US purchase of the current STATE of Alaska from Russia. The US government paid $7.2 million in gold for the largely unseen, unexplored, snowy lands. Although the TREATY between the two countries was signed in 1867, CONGRESS was hesitant to approve it and did not do so until 1868. In 1896, Alaska was the site of a GOLD RUSH and since the 1970s it has supplied large quantities of oil to the LOWER 48. By association, something that at first appears to be foolish, but later proves to be very wise. At that time, it was also known as "Seward's Icebox". [After William 'Seward' (1801–1872) the US SECRETARY of the DEPARTMENT OF STATE who arranged and promoted this purchase.]

sexual harassment (minorities) Any unwanted sexual advance (e.g., comment,

action) made in the workplace. Frequently it entails some action or comment by a superior (e.g., employer) to an inferior (e.g., employee) with the notion that the employee's job may end if she or he does not participate in the sexual action. See CLARENCE THOMAS/ANITA HILL HEARINGS.

Shabazz, Al Hajj Malik Al- (people) The name which MALCOLM X adopted in 1963 after he had made a pilgrimage to the city of Mecca in Saudi Arabia. His widow and children use this family name. Sometimes also written as "El Hajj Malik El-Shabazz".

shadow senator of Washington D.C. (government) A person chosen by the city council of WASHINGTON D.C. to lobby CONGRESS to make the DISTRICT OF COLUMBIA the 51st STATE and to represent the District, as a non-voting member, in the US SENATE on current issues. See LOBBY.

Shaker furniture (the arts) A functional and simplistic style of furniture (e.g., chairs, dressers, oval storage boxes) entirely made of wood, cane and metal tacks which is recognized for its fine, handmade craftsmanship. It originated with the SHAKERS of the nineteenth century, whose motto encouraged such well-made pieces, give one's "hands to work, hearts to God". "Classic Shaker" refers to those pieces in this style which were very functional and brightly painted and made between 1810 and 1860.

Shakers (religion) The popular name for members of the UNITED SOCIETY OF BELIEVERS IN CHRIST'S SECOND APPEARING. [From the 'Shaking Quakers', the name that others gave them because of their enthusiastic style of dancing, singing and praying during worship services.] Compare QUAKERS.

shaman (religion) Another name for a MEDICINE MAN/WOMAN.

sharecropping (history) A method of farming in which a laborer rents the right to live on a piece of land owned by someone else and agrees to work that land. After the crop is harvested and sold, the land owner divides the net sum of money with the worker. This was a common method of agriculture in the SOUTH after the CIVIL WAR and before the GREAT MIGRATION[2]. Usually, blacks

worked as **sharecroppers** and whites were the land owners. Compare SLAVERY.

Shay's Rebellion (history) The collective name given to a series of protests and military action (including trying to capture a federal arsenal in 1786 and 1787) made by impoverished local farmers against the government as a way of protesting the high government taxes during that period of poor farm harvests. The fact that these 'rebellions' occurred illustrated the weakness of the national economic response to local issues provided by the ARTICLES OF CONFEDERATION and urged for a single national currency. [After Daniel 'Shay', the leader of the group of farmers in Massachusetts that was particularly active.]

"Shenandoah" (the arts) A well-known FOLK MUSIC song about traveling west from Virginia on a river. The first verse is: "O, Shenandoah, I long to see you/Away, you rolling river/O, Shenandoah, I long to see you/Away, we're bound away/Across the wide Missouri [river.]". There was also a MUSICAL entitled Shenandoah.

Sherman Antitrust Act (economy) The first federal act (passed 1890) designed to prevent TRUSTS and MONOPOLIES from developing in business and industry nationwide. Although it did affect labor UNIONS[1], it did not affect manufacturing. See CLAYTON ANTITRUST ACT.

Sherman, William T[ecumseh] (people) (1820–1891) UNION[3] army general during the CIVIL WAR. He planned and successfully carried out the MARCH TO THE SEA and is thus credited with creating the concept of "total (complete) war", meaning that he took the war to the civilians and the supply centers of the enemy army. Because, as he proved, an army cannot continue fighting without supplies, transportation of supplies or the physical and psychological support of its civilians. Later, he worked in the present-day MIDWEST fighting the PLAINS INDIANS by using similar tactics. He is reported to have said, "War is Hell".

shirts and skins (sports and leisure) A method of dividing a group of players (usually male) into two teams to participate in a sport for leisure. One group forms a team by keeping its 'shirts' on,

and the other group forms a team by the members playing without shirts (i.e., in bare 'skin').

shoofly pie (food and drink) A traditional dessert of the PENNSYLVANIA DUTCH[1] which is a type of baked dessert PIE with a crumbly, sticky filling of molasses, brown sugar, nutmeg and butter. [After removing the baked pie from the oven, it was set on an open windowsill to cool; flies had to be scared away from the sweet, sticky filling by saying 'shoo' (i.e., "go away") 'fly'.]

shopping mall (daily life) A large shopping complex usually with a variety of shops, chain stores, DEPARTMENT STORES, restaurants and businesses housed in one single building or in several connected buildings. Also known as a "mall"; *see* STRIP MALL.

short order (food and drink) In a DINER or DELI, a helping of food that is quick to prepare (e.g., sandwiches, French fries). By association, "in short order" means to do something quickly.

shortstop (sports and leisure) In BASEBALL, the defensive player who stands between SECOND BASE and THIRD BASE and tries to tag offensive players with the ball. It is an INFIELD[1] position.

"shot heard round the world", "the" (history) A phrase referring to the gun 'shot' fired in the town of Lexington on April 19, 1775. Although it is not clear who fired it, this shot represented a challenge to the strength of European powers over colonies in North America. This was the first shot of the AMERICAN REVOLUTION. *See* LEXINGTON AND CONCORD, PATRIOTS' DAY.

shower (customs and traditions) A theme party given for a guest of honor, usually a woman who is going to get married (i.e., "bridal shower") or have a baby (i.e., "baby shower"). Each invited guest brings a gift for the female guest of honor according to the agreed upon theme. For example, a bridal shower may have a theme of "kitchenware" in which case, the invited guests bring gifts of cooking utensils, pots, pans, and other kitchen materials. [For the presents which are generously given to her, 'showered'

upon her, for the short period of the party.]

shut-out (sports and leisure) Any game or sporting event in which the winner prevents the loser from scoring a single point (as in ice hockey or soccer) or from scoring many points (as in BASKETBALL). By association, an event between two sides where there was no contest because one team or side was so superior to the other.

Sierra (media) An environmental magazine published once every two months and founded in 1893 for SIERRA CLUB members and other people interested in the environment and conservation. It carries articles and attractive photographs on outdoor events and sports, travel and all issues related to the ENVIRONMENTAL MOVEMENT. Its current circulation is 520,000.

Sierra Club (environment) A well-respected conservation organization and INTEREST GROUP which works to protect and conserve natural areas and wildlife animals and plants in the UNITED STATES and other areas. It is particularly active in lobbying for legislation to promote clean air, land use and forestry. Further, it organizes educational wilderness outings and trips for the public and members. It was founded by JOHN MUIR in 1892. Today, its headquarters are in SAN FRANCISCO, it publishes *SIERRA* and has over 550,000 total members organized into local and state groups. *See* ENVIRONMENTAL MOVEMENT.

Silent Spring (environment) The important book (published 1962) revealing the adverse effects of the use of chemical pesticides on the natural wildlife and environment. This book, written by RACHEL CARSON, a marine biologist, was a powerful force in encouraging the ENVIRONMENTAL MOVEMENT.

Silicon Valley (science and technology) A popular name for the region in northern California (only 15.5 miles long; 25 km) where a number of large research and production companies in the personal computer and business computer industry are located. Also, it is active in the aerospace industry. It is a symbol of advanced technology and the latest in the computer industry. [After 'silicon', the material of

which computer chips are made.] *See* BAY AREA.

Simpson, O. J. (people) (born Orenthal James Simpson in 1947) African-American former professional FOOTBALL player and guest sports broadcaster. He won the HEISMAN TROPHY (1968) and was awarded the NFL Player of the Decade Award (for the 1970s). On June 17, 1994, he was charged with the stabbing murders of two whites; his ex-wife, Nicole Brown Simpson and her friend, Ronald Goldman. After a lengthy, televised CRIMINAL TRIAL (September 1994 through October 1995) he received an ACQUITTAL of the murders. In a second, different CIVIL TRIAL in 1997, a JURY decided that he should pay the Brown and Goldman families a large sum of money for the loss of their children. The events surrounding the two murders, the history of wife abuse, the issues of race and the trials themselves shocked the public and, with the help of the media, held its attention for several years.

SIN (media) A network, founded in 1961, offering TV programs in the Spanish language. [Abbreviation of 'S'panish 'I'nternational 'N'etwork.]

Sinatra, Frank (people) (1915–1998) A popular singer easily recognized by his deep, smooth baritone voice; he is most associated with the song "My Way" (1967). After an acting career; notably, *From Here to Eternity* (1952) and *Manchurian Candidate* (1962), he returned to singing, frequently performing live in LAS VEGAS. He earned the nickname "Old Blue Eyes" for the striking color of his eyes and the name "The Voice" for the smooth quality of voice. He is also known as the "Chairman of the Board".

Sing Sing (legal system) A prison operated by the STATE of New York known for its high security. [After its location at Ossining, New York.]

singing cowboy (the arts) A type of COWBOY[2] character in numerous WESTERN-like movies in which there was singing and acting. The two most famous singing cowboys were Gene Autry (1907–1998) and Roy Rogers (born in 1911), the latter was known as the "King of the Cowboys"; these singing actors also promoted country-style music. During the 1930s and 1940s this type of movie was popular with young people and adults. The **singing cowboy** movies were B-MOVIES and were usually shown at a Saturday MATINEE. *See* COUNTRY AND WESTERN MUSIC.

single (sports and leisure) In BASEBALL, a successful hit of the ball with a bat which allows a batter to run safely to FIRST BASE. *Compare* DOUBLE, TRIPLE.

Sioux, the (people) The general name for a TRIBE of INDIANS of the GREAT PLAINS which consists of several divisions, specifically the Lakota, Dakota, Nakota and Oglala. Traditionally, they lived in areas in the present-day STATES of Minnesota, North Dakota and South Dakota about which they migrated in search of buffalo (which they hunted for survival), lived in TIPIS and considered the region of the BLACK HILLS to be sacred. In 1868, they agreed to the Fort Laramie Treaty because, although it forced them to live on RESERVATIONS, it promised to protect the Black Hills from settlement by whites. Major reservations include PINE RIDGE, Rosebud and Hunkpapa. Many members participated in the GHOST DANCE RELIGION and died at the WOUNDED KNEE MASSACRE. Historically, they have a reputation for being great warriors and speakers, namely, CRAZY HORSE, SITTING BULL and Red Cloud (1822–1909); they won the Battle at LITTLE BIG HORN and many tribe members fought in the US ARMED FORCES during WORLD WAR II. During the 1960s, members participated in WOUNDED KNEE II and were active in the RED POWER movement. Today, there are over 107,000 total Sioux (making it the third largest Indian tribe in the US), half of whom do not live on the reservation. They still celebrate the SWEAT LODGE and a modified version of the SUN DANCE; they are still trying to regain control of the Black Hills. [French from Ojibwa Indian language word, meaning "snake, adder, enemy"; Today, some Sioux prefer to be called by the name of the division to which they belong – Lakota, Dakota, Nakota or Oglala.] *See* TRAIL OF BROKEN TREATIES.

sit-in (minorities) A popular form of NONVIOLENT ACTION and protest in which

protesters enter a public place or business (which practices illegal activities – namely, racial DISCRIMINATION) and 'sit' down 'in' that area. Protesters remain seated there, refusing to leave, until they are evicted or until their grievances are heard. Despite harassment by staff, customers and others, the protesters do not fight back. The "sit-in movement" of the CIVIL RIGHTS MOVEMENT began in 1960 in the southern town of Greensboro in North Carolina, when four black students sat in a "Whites Only" section of a Woolworth's lunch counter/DINER. This method of protest helped in desegregating public facilities. Its success led to similar actions in various other locations, namely: "knee-ins" at CHURCHES[2]; "wade-ins" at segregated beaches; "swim-ins" at segregated swimming pools. See FISH-IN.

sitcom (media) A funny, television entertainment program lasting 30 or 60 minutes with the same characters on each show which is usually broadcast once a week. [Clipping from 'sit'uation + 'com'edy.]

Sitting Bull (people) (1831–1890, also known by Indian name "Tatanka Yotanka") A SIOUX (Teton) member, MEDICINE MAN, spiritual, military and political Native American leader. He is known for never signing a TREATY, resisting a move to RESERVATIONS for INDIANS, winning the battle of the LITTLE BIG HORN and appearing in "BUFFALO BILL" CODY's "Wild West Show" (1885). He did not discourage the GHOST DANCE religion and was ("accidentally") killed at WOUNDED KNEE. He is a symbol of independence and wanted to live life according to traditional Indian ways.

six-pack (food and drink) Any drink (SODA POP or more often, beer) that is prepackaged and sold in a set of six cans. Frequently, these drinks are drunk straight from the can. By association, "Joe Six-pack" is a nickname for the common man.

Sixteenth Amendment (government) The AMENDMENT to the CONSTITUTION (1913) that gives the federal government the right to collect INCOME TAXES from the people. Until this time, no income tax had been collected. See INTERNAL REVENUE SERVICE.

Sixth Amendment (legal system) The addition to the CONSTITUTION (in 1791) that guarantees certain rights to those persons accused of committing a crime; specifically: to be told the reasons he or she is accused of the crime, to have a public trial by JURY with witnesses (if possible) both for and against him or her; and to have LEGAL COUNSEL. See MIRANDA v. ARIZONA, MIRANDA WARNING, GIDEON v. WAINWRIGHT, BILL OF RIGHTS.

60 Minutes (media) A popular, informative, one-hour-long TV news program with interviews and in-depth reporting of two or three current issues. It began in 1968 and is broadcast by CBS on SUNDAY evenings. See ANDY ROONEY.

Skid Row (geography) In a city, the general name for that district which has cheap BARS[1] and hotels which are frequented and lived in by alcoholics, prostitutes and unemployed people. By association, describing a person or thing that is desperate, depressed and "down". [After the rough, depressed neighborhood in nineteenth-century SEATTLE where cut logs for the lumber industry slid, or 'skid', down into the water to be transported downstream and cut up and processed; many lumberjacks and other depressed people used to live and work in this unsightly working area.]

skyscraper (housing and architecture) A tall building made of a system of metal frames which both gives the structure support and allows for great height. It is considered the symbol of modernity and many have been built in the cities of CHICAGO and NEW YORK CITY. Although at the beginning of the twentieth century, architects dreamed of building a one-mile (1.6 km) high building, SEARS TOWER (one-quarter mile high; 0.42 km) is the tallest one in the UNITED STATES.

slander (media) Any oral comment or statement which is false or is designed to damage a person's reputation. *Compare* LIBEL.

slate (1, 2 politics) **1** The list of candidates from the same political party that are running in an election and for whom the voters can vote. **2** The TICKET of a political party.

slavery (history) An economic and social system (legally from 1650 to 1865) in which black Africans and their children were bought, sold and forced to work without pay on farms, plantations and in houses in the NORTH (until 1804) but especially in the SOUTH (until 1865). It was one of the main reasons for the CIVIL WAR. It was formally outlawed by the THIRTEENTH AMENDMENT. A "non-slave state" referred to a state where slavery was not legal; a slave-state referred to a state where slavery was legal. *See* MISSOURI COMPROMISE, *DRED SCOTT* V. *SANFORD*, EMANCIPATION PROCLAMATION, ABOLITION; *compare* SHARECROPPING, CIVIL RIGHTS MOVEMENT.

Small Claims (legal system) The type of court which hears and settles disputes concerning those claims on debts that are not large. Also known as "Court of Small Claims".

Smithsonian (Institution), the (1 the arts; 2 media) **1** The general, collective name for the 14 museums (e.g., National Air and Space Museum, National Portrait Gallery, National Museum of Natural History, National Museum of the American Indian and others) and one zoo displaying to the public countless artworks as well as cultural and natural history artifacts and AMERICANA. Nine of the buildings, including "the Castle" (its center of administration), are located along the MALL in WASHINGTON D.C. It was established in 1846 and calls itself "the Nation's attic". [After British benefactor, James 'Smithson' (1765–1829).] **2** *Smithsonian* A monthly, general interest magazine of articles on cultural and historical information, especially related to AMERICANA. It was founded in 1970 and has a circulation of 2 million. It is published by the Smithsonian Institution.

snap, the (sports and leisure) In FOOTBALL when at the LINE OF SCRIMMAGE, the throw or pass of the ball to the QUARTERBACK or other offensive player. This action puts the ball into play and begins the event. By association, something or some action which begins an event. *See* SCRIMMAGE[1].

SNCC (minorities) The popular nickname for the STUDENT NONVIOLENT CO-ORDINATING COMMITTEE. [Acronym from the 'S'tudent 'N'onviolent 'C'oordinating 'C'ommittee.].

sneakers (clothing) A low, rubber-soled shoe with a leather or canvas material foot-casing popularly worn for leisure. This word is used interchangeably with "TENNIS SHOES" when referring to leisure wear.

Social Security (health) The popular, collective name for several government programs (federal and STATE) that give money and/or medical benefits to those people who worked or have had to stop working, namely: elderly people, DISABLED people, retired people and their DEPENDENTS. Specifically, it includes OASDI (Old-Age, Survivors, and Disability Insurance), MEDICARE, the BLACK LUNG PROGRAM and SUPPLEMENTAL SECURITY INCOME. It was first established in 1935 as part of the NEW DEAL and was extended with GREAT SOCIETY programs. It is operated by the SOCIAL SECURITY ADMINISTRATION and its costs are a major part of the federal budget every year. Since 1972, if there is an increase in the CONSUMER PRICE INDEX, Social Security benefits automatically increase every December to account for INFLATION. *Compare* WELFARE.

Social Security Administration (health) (SSA) The large, independent federal agency in charge of collecting money and distributing it to the SOCIAL SECURITY programs, namely, OASDI (Old-Age, Survivors, and Disability Insurance), MEDICARE, the BLACK LUNG PROGRAM and SUPPLEMENTAL SECURITY INCOME. It was created in 1935 by the Social Security Act to run these programs and amended in 1972; until 1995, it was a part of the DEPARTMENT OF HEALTH AND HUMAN SERVICES. *See* NEW DEAL; *compare* WELFARE.

Social Security number (health) (SSN) A nine-digit identification number (e.g., 999-99-9999) given to every person who works and used by the SOCIAL SECURITY ADMINISTRATION to calculate his or her contributions to SOCIAL SECURITY. Often, it is used as an identification number on an ID CARD. Also formally known as "Social Security card number".

social studies (education) A subject in ELEMENTARY SCHOOL that includes lessons in American citizenship, history, geography and economics.

soda pop/soda (food and drink) Any nonalcoholic beverage that contains carbonation (i.e., gas), sweetening and flavoring. It is also known as "pop", especially in the MIDWEST and "tonic" in NEW ENGLAND. *See* ROOT BEER.

sodomy laws (minorities) Any law which prohibits people (especially two men) from having sex with each other. Several STATES have and enforce sodomy laws. *See* BOWERS v. HARDWICK; *compare* GAY RIGHTS.

SoHo (geography) In NEW YORK CITY, a fashionable area of the lower west side of MANHATTAN[1] known for its art galleries, chic restaurants and spacious lofts used as private residences. Many of the buildings were built with an iron frame and are decorated in unique iron work because they were originally used for wholesale sales and storage during the late 1800s and early 1900s. [Acronym from 'so'uth of 'Ho'uston Street.] Also spelled "Soho".

Soldier Field (sports and leisure) A sports stadium with a seating capacity of 66,9000 and a grass turf which is located on the SOUTH SIDE of CHICAGO, Illinois. It was built in 1924 and since 1971 has been the HOME TEAM FOOTBALL field of the Chicago Bears, a member of the NFL. *See* Appendix 3 Professional Teams.

Sonoran Desert (environment) The largest (30,000 square miles; 78,000 square km) and overall hottest desert in the SOUTHWEST which is home to a variety of unique animals and cactus plant life.

sophomore (education) A second-year student in a HIGH SCHOOL, COLLEGE[1] or UNIVERSITY. Also known as "second year"; *see* CLASS.

sorority (sports and leisure) A private, social GREEK-LETTER ORGANIZATION and club for UNDERGRADUATE women. Most are national organizations with individual chapters established on individual CAMPUSES of COLLEGES[1] or UNIVERSITIES. Although sororities donate time and money to a special philanthropy group of their choice, the main foci are on helping members develop friendships with fellow members, providing housing to members and on social activities with FRATERNITIES (e.g., dances and parties). Sororities choose their members once a year during RUSH. The "sorority house" is the residence building owned, operated and lived in by the active members of the sorority and which is usually located near CAMPUS. "Sorority sisters" are women who belong to the same sorority. *See* LETTERS.

Sotheby's (the arts) A well-respected auctioneer company which sells various art works (e.g., paintings, sculptures, rugs) antique items (e.g., furniture, books, porcelain) as well as those possessions belonging to famous people or celebrities (e.g., books, jewelry, clothing). It was originally founded in London, England in 1744; its American branch opened in 1964 and is located in NEW YORK CITY. [After Englishman John 'Sotheby' (1740–1807), one of the early London partners.] *Compare* CHRISTIE'S.

soul food (food and drink) A traditional style of cooking among some AFRICAN AMERICANS based on SOUTHERN COOKING ingredients as well as eating habits during SLAVERY. The foods include: CORN BREAD, GREENS, deep-fried okra, black-eyed peas, as well as those leftover parts of animals often not eaten in other dishes but which contain high nutritional value (e.g., CHITTERLINGS, hogjaw, ham hocks, SPARE RIBS). Today, it is eaten as a sign of pride in black culture and history, as well as a sort of COMFORT FOOD for some blacks. *Compare* SOUTHERN COOKING.

Soul music (the arts) A type of popular black music in which the vocals (usually clear and harmonized – known as "malisma") are important and are sung with emotion and excitement; the instruments include the drums, keyboard and guitar. It originated in the SOUTH growing out of the vocals of GOSPEL MUSIC and the instrumentation of RHYTHM AND BLUES. It was written and performed mostly by black performers; but managed by white producers. It was popular from 1957 to 1968 (a period known as the "Soul era") among both black and white audiences. "Blue-eyed soul" refers to white singers and performers of Soul music; "sweet soul" refers to Soul music which does

not use electric instruments. *See* ARETHA FRANKLIN; *compare* MOTOWN MUSIC.

Souls of Black Folk, The (minorities) A collection of 14 essays (published in 1903) which described the various cultural, spiritual and political aspects of the lives of blacks in America. It promoted the idea of black equality with whites and rejected the ideas of BOOKER T. WASHINGTON. It was written by W.E.B. DU BOIS and remains an important book because of the ideas that it introduced, namely, that AFRICAN AMERICANS suffer from "DOUBLE CONSCIOUSNESS"; at that time, Du Bois' prediction was that the problem of the twentieth century was to be the COLOR LINE.

sound bite (media) A short, usually snappy, piece or message (on TV or radio) taken from a speech or interview, that is used to support a story on a news program.

South, the (geography) The geographical and political region which includes part or all of some 11 STATES south of the MASON–DIXON LINE. It was settled largely in the seventeenth and eighteenth centuries by British colonials who developed a farming economy heavily dependent upon the use of slave labor. In the nineteenth century disputes with northern states over the much contested issue of SLAVERY led to the CIVIL WAR. The "Old South" refers to the south of the slave-based labor economy. The "New South" refers to the period immediately after RECONSTRUCTION (1870s) when new railroads and businesses were being built there. It also refers to the 1980s–1990s when the growth of industries in this area attracted new workers and improved the local economies. The "Solid South" refers to the period of the 1870s to the 1960s when, predictably, most white people in the southern states voted for the DEMOCRATIC PARTY. *See* SUNBELT, SOUTHERN COOKING, SOUL FOOD, NEW ORLEANS, JIM CROW, CIVIL RIGHTS MOVEMENT.

South Side, the (geography) In the greater metropolitan city of CHICAGO, a collection of neighborhoods located 'south' of the LOOP. After WORLD WAR I, it had a large Irish and black population. Today, it is largely black and is considered the cultural center for AFRICAN AMERICANS

in the MIDWEST. The Chicago White Sox BASEBALL team is based here. *See* UNIVERSITY OF CHICAGO, Appendix 3 Professional Teams; *compare* HARLEM.

Southern Christian Leadership Conference (minorities) (SCLC) An important organization which promotes the use of NONVIOLENT ACTIONS to help all people practice their current CIVIL RIGHTS, as well as improve the quality of rights for all peoples. It was established in 1957 by MARTIN LUTHER KING, JR. and Ralph Abernathy (1929–1990) in ATLANTA and soon established other chapters in cities of many other STATES. It was most active during the CIVIL RIGHTS MOVEMENT when it worked to coordinate GRASSROOTS-level protests to secure citizenship and voting rights for AFRICAN AMERICANS as well as led the struggle against legal SEGREGATION in the SOUTH. It was involved in the SIT-INS, MARCH ON WASHINGTON OF 1963, MEREDITH MARCH AGAINST FEAR and it operated OPERATION BREADBASKET and the POOR PEOPLE'S CAMPAIGN. Its slogan was "Freedom Now" and its efforts encouraged CONGRESS to pass the CIVIL RIGHTS ACT (1964) and VOTING RIGHTS ACT OF 1965. It remains active today.

Southern cooking (food and drink) A style of cooking developed in the SOUTH during the nineteenth and early twentieth centuries, using local ingredients and characterized by fried meat dishes, corn, peanuts, sweet potato, gravy and okra (a kind of vegetable). Common dishes include: FRIED CHICKEN, GRITS, GREENS, HUSH PUPPIES, CORN BREAD, GUMBO and sweet potato PIE. It is associated with wholesome cooking and eating. *Compare* SOUL FOOD, CREOLE CUISINE, COMFORT FOOD.

Southwest, the (geography) The geographical region of dry, arid lands and deserts (e.g., including the SONORAN DESERT, MOJAVE DESERT) located in some five STATES in the southwestern corner of the country. It became a part of the UNITED STATES through the TREATY OF GUADALUPE HIDALGO in 1848 and the GADSDEN PURCHASE. Today, it is part of the SUNBELT and steadily increasing in population, especially SENIOR CITIZENS. Its major issues of concern are water usage rights, the use

of PUBLIC LANDS and the environment. *See* RESERVATION, FOUR CORNERS.

Space Race, the (science and technology) From 1957 to 1989, a competitive race of scientific space research and space technology between the UNITED STATES and the USSR. The competition began with the Soviets' successful *Sputnik 1* (October 1957, the first artificial satellite), followed by the Americans' *Explorer 1* (January 1958), the Soviets' *Vostok 1* (April 1961, with Juri Gagarin, the first person in orbital space), the Americans' APOLLO PROJECT, etc. During the COLD WAR, this Space Race was an important way for the two countries to show off their technological expertise and the strength of their country, society and idealism. In the United States, it encouraged SCHOOLS[1] to concentrate on teaching scientific courses. *See* NASA, NATIONAL DEFENSE EDUCATION ACT.

space shuttle (science and technology) A combination space ship and airplane especially designed by NASA to take off from earth erect, like a rocket, and land like an airplane on a landing strip, and then be used again. The *Columbia, Atlantis, Discovery* and *Endeavour* are active shuttles. All the shuttles are equipped with areas for several traveling astronauts to eat, sleep, work and conduct experiments while in space. They take off from earth at CAPE CANAVERAL and later land at EDWARDS AIR FORCE BASE. *See CHALLENGER* DISASTER.

spaghetti westerns (the arts) WESTERN movies made and produced by Italians. Generally, they starred an American actor and had an Italian supporting cast; many were filmed during the 1960s.

Spanish Harlem (geography) That eastern section of HARLEM between Park Avenue and the East River where many HISPANICS, usually lower income or poor, live. This is the center of the Puerto Rican community in NEW YORK CITY. *See* PUERTO RICO, DÍA DE LA CONSTITUCIÓN, BARRIO.

Spanish-American War, the (foreign policy) The war between the UNITED STATES and Spain. The hostilities started after the American ship *USS MAINE*, docked in Havana, Cuba, exploded and concerned Spanish control of lands in the Caribbean Sea and the Pacific Ocean (e.g.,

GUAM, the Philippines and Cuba). The US declared war on April 24, 1898, and won several battles quickly. On December 10, 1898, Spain agreed to: cede PUERTO RICO and Guam to the US; sell the Philippines to the US for $20 million; and give Cuba its independence. This war helped the US become an international power and increased its land holdings. *See* MUCKRAKING, YELLOW JOURNALISM.

spare ribs (food and drink) A dish of pork meat still connected to and served with the rib bones which is basted in a spicy sauce and baked, roasted or grilled. Traditionally, it is a specialty of the SOUTH; although today it is served nationwide. Also known as "ribs"; *see* SOUTHERN COOKING, SOUL FOOD.

speakeasy (food and drink) During PROHIBITION, a BAR that sold alcoholic beverages; an illegal bar.

Speaker (of the House of Representatives), the (government) The leader of the HOUSE OF REPRESENTATIVES. The **Speaker** is first selected by the MAJORITY party, then by all the CONGRESSMEN and CONGRESSWOMEN to act as the leader of the HOUSE. The Speaker is the most powerful and influential REPRESENTATIVE[1] because he or she directs the business and enforces the rules of the HOUSE. After the VICE PRESIDENT, the Speaker is the second in line to the presidency. *Compare* MAJORITY LEADER, MINORITY LEADER.

Special (Operations) Forces (military) A general name for various elite groups of the ARMED FORCES or intelligence agencies which work on specific, usually short-term actions. It includes the GREEN BERETS, RANGERS and SEALS.

special education (education) A collective term for any learning course or any other special course designed for students who are DISABLED (mentally disabled or physically disabled). Further, it includes any program or course which is led or organized by specially trained teachers and/or aides. These courses and services, which are generally expensive, are paid for by the Education for All Handicapped Children Act of 1975. Some programs of HEAD START are for HANDICAPPED students. *See MILLS* v. *BOARD OF EDUCATION OF DISTRICT OF COLUMBIA.*

spectator sport (sports and leisure) An organized sport which can be watched by an audience, either live or on television (e.g., FOOTBALL, BASKETBALL, BASEBALL). It usually charges an admission fee.

spelling bee (language) An oral contest of spelling English language words. As soon as contestants misspell a word, they are eliminated from the game. The person who consecutively spells the most words correctly, wins.

Spirit of St. Louis (science and technology) The name of the single-person airplane built and flown by Charles Lindbergh (1902–1975) from LONG ISLAND, New York to Paris, France in 1927. This was the world's first transatlantic airplane flight and it excited many Americans because of the possibilities of technology and air travel which it presented with the airplane.

split ticket (politics) A BALLOT[1] on which a voter votes for candidates from different political parties. *Compare* STRAIGHT TICKET.

split-level (house) (housing and architecture) A popular type of suburban house in which the floor levels are built on three different levels (i.e., basement, FIRST FLOOR and second floor) so that each level is about half a floor above or below the one next to it. It was commonly built from 1955 to 1975 in the NORTHEAST and MIDWEST. *See* SUBURBS.

Spock, Benjamin, Dr. (people) (1903–1998) Physician and author who researched and wrote popular books instructing parents in how to care for their babies and raise children, *Baby and Child Care* (1946; 1973).

spoils system, the (government) The system in which the friends or major contributors to the CAMPAIGNS of an elected official are given positions in government (i.e., unelected positions). Often these individuals are not especially qualified to perform the functions of this position. This system was very popular in the nineteenth century; however today for the most part, it has been replaced by the system of the CIVIL SERVICE. *See* CIVIL SERVICE REFORM, KITCHEN CABINET, APPOINTMENT POWER.

Sports Illustrated (media) A weekly sports magazine with articles and color photographs covering professional sports and some COLLEGE[1] sports. It is owned by Time Inc., was founded in 1954 and has a current circulation of 3.2 million. *See TIME*, Appendix 3 Professional Teams.

spot (media) A short announcement broadcast on the radio or on television giving some message to the public. They are often made by and for political candidates to promote their messages to the public during a political CAMPAIGN.

Spotted owl, the Northern (environment) A medium-sized owl (*Strix occidentalis*) with bars of color across its breast and a brown-colored back with white spots which lives in the wooded forests of Douglas fir trees of the PACIFIC NORTHWEST. Because this bird is officially an endangered species (less than 2,500 pairs exist) and protected by the ENDANGERED SPECIES ACT, many millions of acres were reserved (i.e., the trees were not to be cut down) for it to live in and repopulate. However, during the early 1990s, many loggers and timber businesses complained that the amount of land that was being reserved for this bird was limiting business and threatening the jobs of some 131,000 timber-industry workers. This bird species and the conflict concerning it are symbols of the importance and value of preservation of certain animal and plant species versus the importance of jobs for human workers, especially those in the realm of mineral and natural resources. This conflict helped develop the preservation idea of ECOSYSTEMS rather than an individual species. *See* ENVIRONMENTAL MOVEMENT.

spring break (customs and traditions) A week-long vacation in March or April for students during the spring TERM[2] of most PRIMARY SCHOOLS, SECONDARY SCHOOLS and COLLEGES[1]. Most students aged 16 years and older spend this period in some warm weather and/or beach location having parties, going to BARS[1] and relaxing. Locations in the STATES of Florida, California and Texas are popular. *See* DAYTONA BEACH; *compare* SUMMER VACATION.

spring training (sports and leisure) The two month period, from February to

April, when MAJOR LEAGUE teams temporarily move to Florida, Arizona and other SUN BELT areas to train, work out, practice and SCRIMMAGE[2] outdoors as a team in order to be prepared for the BASEBALL season. During this period, they play 30 total games. It is popularly known as "CAMP" and is a period of great speculation among sports writers and announcers about the upcoming baseball season. *See* OPENING DAY.

Springarn Medal (the arts) The annual prestigious award given by the NAACP to an African-American man or woman for their outstanding work in promoting African-American culture and/or pride in the previous year. Today, it consists of a gold medal and $20,000. It has been awarded every year since 1913 (except for 1938). [After Joel 'Springarn', the man who established the award.]

Springfield (sports and leisure) The town in the STATE of Massachusetts which has served as the site of the Naismith Memorial Basketball HALL OF FAME for the sport of BASKETBALL (including male and female athletes from the COLLEGE[1] leagues and professional leagues, both from the UNITED STATES and overseas) since 1968 when the building was first erected. (The Hall of Fame itself was founded in 1949.) DR. JAMES NAISMITH created the game of basketball in this town. By association, the beginning of basketball.

Springsteen, Bruce (people) (born in 1949) A ROCK AND ROLL singer and songwriter known for his rough, raspy voice and for wearing simple blue JEANS and tight T-shirts. His songs treat American themes, especially the everyday people, feelings and actions of those of the working class. Popular albums include: *Born to Run* (1975), *Born in the USA* (1984) and *Tunnel of Love* (1987). He performs with the E Street band; his nickname is "The Boss".

square dancing (sports and leisure) A type of traditional, entertaining dance in which four couples (total eight people) move about the dance floor in synchronized dance steps in a grid, or 'square' pattern. The dancers usually listen to and follow the dance commands of a CALLER.

This type of dance is associated with COUNTRY MUSIC as well as FOLK MUSIC tunes of the nineteenth century and is often danced at a BARN DANCE. Female dancers may wear full, knee-length dresses made of gingham cloth and male dancers often wear plaid or denim shirts, JEANS and BOLO TIES.

square meal (food and drink) A nourishing, satisfying meal that contains meat, carbohydrates (e.g., potatoes, bread), vegetables and dairy products (e.g., cheese).

squash (food and drink) A type of edible gourd prepared baked or fried and served with the ENTREE, especially at THANKSGIVING DINNER.

SRO (the arts) An indication that there are no more seats available and that customers will have to stand. [Abbreviation of 'S'tanding 'R'oom 'O'nly.]

St. Lawrence Seaway (transportation) The 2,341 mile long (3,768 km) waterway system of natural lakes and rivers as well as man-made locks and canals which links the Atlantic Ocean with the GREAT LAKES. It opened in 1959 and permits large sea ships to transport and deliver products between inland areas of North America and other regions of the world. It has helped the economy of the MIDWEST.

St. Patrick's Day (customs and traditions) March 17, when Americans of Irish descent celebrate their heritage by "wearing the green", that is green-colored clothing (green is the national color of Ireland), and going to BARS[1] to drink beer which is sometimes dyed green with food coloring. Cities with large Irish-American communities hold parades with MARCHING BANDS and FLOATS; NEW YORK CITY's parade marches down FIFTH AVENUE and CHICAGO's parade is DOWNTOWN; in addition, Chicago's city officials dye the Chicago River "green" for the occasion. Many non-Irish Americans become "Irish for the day" and enjoy the festivities, too. The symbol of the day is a "leprechaun", a small, elf-like figure of a man wearing a bowler hat and green-colored clothing. It is not a LEGAL HOLIDAY. [For the ROMAN CATHOLIC CHURCH feast day dedicated to 'Saint Patrick' (A.D. 389-461), the patron saint of Ireland.]

St. Valentine's Day (customs and traditions) It is popularly known as "VALENTINE'S DAY".

St. Valentine's Day Massacre (history) The brutal murders of six gangster members of "Bugs" Moran's gang by the opposing gang which was headed by AL CAPONE. It took place in CHICAGO on February 14, 1929, VALENTINE'S DAY. *See* PROHIBITION.

stagflation (economy) A period with a high rate of INFLATION and a stopping of the economic growth (i.e., 'stagnation') marked by high level of unemployment. [From 'stag'nation + in'flation'.]

Standard and Poor's Stock Price Index (economy) (S&P) A figure used to predict possible movements in the STOCK MARKET which is based on an average of 500 of the most commonly held stocks and bonds on the NEW YORK STOCK EXCHANGE. According to a risk scale, it rates stocks and bonds with the following grades: (from the most secure) AAA, AA, A, BBB, BB, B, CCC, CC, C (to the least secure). *Compare* MOODY'S INVESTMENT SERVICE.

standing committee (government) A permanent CONGRESSIONAL COMMITTEE that studies issues and prepares legislative BILLS[2] to be debated in a chamber of CONGRESS. There are some 19 in the HOUSE OF REPRESENTATIVES and 17 in the SENATE.

Stanford University (education) One of the most prestigious, independent, research UNIVERSITIES in the UNITED STATES. It was founded in 1891 in Palo Alto, near SAN FRANCISCO, California. It is most famous for its GRADUATE SCHOOLS in business, engineering, law and medicine and its well-respected faculty. The COEDUCATIONAL student population counts 6,500 UNDERGRADUATES and 7,500 GRADUATES[2]. It operates the Stanford Linear Accelerator (SLAC) research center for the DEPARTMENT OF ENERGY. It is an accredited university and an NCAA member; its teams compete at the INTERCOLLEGIATE level and the mascot is the "Cardinals". The SCHOOL[6] is built in the Romanesque style with arched arcades and red tile roofs and the CAMPUS grounds were created by FREDERICK LAW OLMSTEAD. [In honor of Leland 'Stanford', Jr. (1869–1884), son of California SENATOR and Governor, Leland Stanford (1824–1893).] *See* PRIVATE SCHOOL.

Stanley Cup, the (sports and leisure) The championship series competition in professional ice hockey which is played every year in late May and June. In the finals the best team of the Eastern Conference plays the best team of the Western Conference; the winner is the team that wins four games out of a possible seven. It was first played in 1893 and has been sponsored by the NHL since 1910. The "Stanley Cup MVP award", known as the "Conn Smythe Trophy", is given to the best player of the tournament. [After Frederick Arthur, Lord 'Stanley' of Preston (and son of the Englishman, Earl of Derby) who first donated the 'cup'-shaped trophy.]

Star Wars (foreign policy) The popular, somewhat derisive, nickname given to the STRATEGIC DEFENSE INITIATIVE by its critics. [After the movie *Star Wars* (1977) which featured fantasy-oriented, high-technology weapon battles in space.]

"Star-Spangled Banner", "The" (customs and traditions) The national song of the UNITED STATES. It was written by Francis Scott Key (1779–1843), a LAWYER and poet, during the British navy's one-day long bombardment of the US Fort McHenry during the WAR OF 1812. Key was watching this battle from a distant ship and the only indication that he saw to learn that the Americans had won the battle was that the US flag was still flying over the fort. The second part of the first verse is: "And the rocket's red glare, the bombs bursting in air/Gave proof through the night that our flag was still there/Oh, say does that 'star-spangled banner' yet wave/O[v]er the land of the free and the home of the brave?" The melody is from a popular song of the nineteenth century, "Anacreon in Heaven". Since 1931, and by an act of CONGRESS, this song has been the NATIONAL ANTHEM of the US. Today, when it is sung, singers and/or the audience frequently put their right hand over their hearts or stand erect with hands and arms at their sides in a respectful manner. It is sung before the beginning of each sporting event. Sometimes, the song is criticized

that the notes are too high for many men and baritone singers to sing it properly. By association, another name for the American flag; the STARS AND STRIPES[1].

Stars and Stripes, the (1 customs and traditions; 2 media) **1** The name of the official national flag of the UNITED STATES. It has 13 red and white 'stripes' (representing the original THIRTEEN COLONIES) and a blue rectangle in the upper corner which is covered in 50 white 'stars' (each star represents one of the total 50 STATES). The Stars and Stripes is celebrated on FLAG DAY. Often, it is flown on all FEDERAL HOLIDAYS. *See WEST VIRGINIA STATE BOARD OF EDUCATION v. BARNETTE.* **2** *Stars and Stripes* The daily newspaper prepared for members of the US ARMED FORCES and US government families who are currently not stationed in the UNITED STATES. It contains American news and sports articles, as well as local news, sports, comics and entertainment information.

START I (foreign policy) The treaty signed by the US and the USSR (today's Russia, Ukraine, Belarus and Kazakhstan). The agreement was the first treaty to reduce the number of nuclear weapons controlled by the superpowers. It was signed in Moscow July 31, 1991. [Acronym from 'St'rategic 'A'rms 'R'eduction 'T'alks.] *Compare* START II.

START II (foreign policy) The treaty in which both the UNITED STATES and Russia agreed to large reductions in the number of long-range nuclear weapons in their possession. It was signed in Moscow, Russia on January 3, 1997. [Acronym from S'trategic 'A'rms 'R'eduction 'T'alks.] *Compare* START I.

state (geography) One of the 50 self-governing member units of the UNITED STATES. After the AMERICAN REVOLUTION, they originally developed out of the THIRTEEN COLONIES. Like the federal government, each also has three branches: legislature (meeting in the STATEHOUSE), executive (i.e., a governor) and judiciary (state supreme court). In addition, it manages its own educational programs through a BOARD OF EDUCATION. Further, it makes and enforces many of its own laws (e.g., MARRIAGE LICENSE), manages its

own police forces and has the right to give professionals and businesses licenses to practice and operate within that state (e.g., BAR ASSOCIATION, CORPORATION, REGISTERED NURSE). All of its government offices and operations are controlled by a state constitution; however all state rules may be OVERRULED by the US CONSTITUTION. Its residents are represented in the federal government by REPRESENTATIVES[1] to CONGRESS; in presidential elections, each has ELECTORAL VOTES in the ELECTORAL COLLEGE. *See* Appendix 1 States, NATIONAL GUARD, LEGAL HOLIDAY, MINOR[2], MAJORITY (AGE OF); *compare* TERRITORY, WASHINGTON D.C.

state fair (customs and traditions) A large festival focused on farming and agricultural techniques attracting participants from across a STATE. Its diverse events include: livestock competitions and auctions; agricultural contests; horse shows and horse racing; RODEO[2] events; POP MUSIC and COUNTRY MUSIC live concerts; amusement park rides; and other forms of entertainment. Awards of prize money or ribbons (e.g., BLUE RIBBON, red and yellow ribbons) are given to competitors. Usually, it is held sometime during the months of August to October and lasts from one to several weeks. *Compare* COUNTY FAIR.

State of the Union Message/Address, the (government) A somewhat ceremonial annual speech (or "message") presented every January by the PRESIDENT to a JOINT SESSION of CONGRESS. In it, he describes past successes of federal programs as well as his plans for legislation in the coming budget year. The CONSTITUTION requires the CHIEF EXECUTIVE to do this. It usually begins by addressing "My fellow Americans . . .". *Compare* INAUGURAL ADDRESS.

state university (education) An academic institution of HIGHER EDUCATION that is supported by federal and STATE taxes, controlled by the individual state and a BOARD OF DIRECTORS. Student tuition is cheaper at a state university than at a PRIVATE SCHOOL. Many of them grew out of the MORRILL ACT (1862). In the post-WORLD WAR II period, these SCHOOLS[5] have become large, POST-GRADUATE research-

oriented institutions. Sometimes, formerly referred to as "land grant college"; *see* UNIVERSITY OF CALIFORNIA, OHIO STATE UNIVERSITY; *compare* PRIVATE SCHOOL.

statehouse (government) The building where both houses (or in some cases, only one house) of the STATE legislature meet, which is located in the capital city of that state. *See* ASSEMBLY; *compare* CAPITOL BUILDING.

states' rights (1, 2 government) **1** A political principle that the powers of the STATES are those powers that the US CONSTITUTION did not give to the federal government but did not deny the states. These rights were questioned in the CIVIL WAR, the CIVIL RIGHTS MOVEMENT and in connection with JIM CROW LAWS. **2** A political view favoring STATE decisions to be made by the individual states (i.e., not the federal government). It is popular among some CONSERVATIVES and THIRD PARTIES[1].

Statue of Liberty, the (immigration) The large statue of a female figure made of copper sheets who, with her pedestal, measures 305 feet (91.5 m). She holds a flaming torch in her right hand (to "enlighten the world") and a book in her left hand (with the date "July 4, 1776" written upon it). She was designed by Frenchman, Fréderic Auguste Bartholdi (1834–1904), and given to the UNITED STATES by the French government as a symbol of Franco-American friendship. She stands on Liberty Island in New York Harbor and has long welcomed immigrants with hope to the US. She is now a national icon representing American ideas of freedom. Her whole name is "Liberty Enlightening the World"; also referred to as "Miss Liberty"; *see* DECLARATION OF INDEPENDENCE.

statute (government) A law made by CONGRESS, or by any other legislature.

statutes of limitations (legal system) Laws that set time limits and claims that a person or group cannot be charged or charge others for offenses or crimes after a certain, set period of time.

statutory law (legal system) The set of written laws, including: laws passed by CONGRESS, STATE legislatures, city governments, the CONSTITUTION, presidential proclamations, EXECUTIVE ORDERS and TREATIES. Since the nineteenth century, it has become an important part of COMMON LAW. *Compare* CASE LAW.

steak (food and drink) The fleshy meat from a dead animal especially, beef. "Ribeye steak" is a beef steak cut from the outer or 'eye' side of the ribs. "Porterhouse steak" is a beef cut from the tenderloin. "T-bone steak" is a cut of beef from the short loin which contains a "T"-shaped bone. Texas and the MIDWEST are big producers of beef steak. It is usually prepared RARE, MEDIUM RARE or WELL-DONE.

Stein, Gertrude (people) (1874–1946) A writer of fiction, philosophy, psychology and biography whose works frequently treated modernity, Americans and the US (*The Making of Americans* 1925). She spent most of her adult life living and working in France (1903–1946) where she had a popular salon which served as an influential venue for young, creative modern artists, writers and other guests. She is recognized for having a long relationship with her partner, Alice B. Toklas (1877–1967). She is most remembered for stating "A rose, is a rose, is a rose". *See* LOST GENERATION.

Steinbeck, John (people) (1902–1968) A writer of fiction known for his works treating the lives and tragedies of ordinary people, especially the poor and disadvantaged. He won the PULITZER PRIZE for his book *The Grapes of Wrath* (1939) which relates the story of the Joads, a poor family who traveled to California during the GREAT DEPRESSION looking for a better life. He won the Nobel Prize for literature in 1962. *See* DUST BOWL.

Steinem, Gloria (people) (born in 1934) Writer, FEMINIST and journalist known for writing about women's rights and promoting feminism. She was a co-founder of *Ms.* magazine and worked as its full-time editor until 1987. She also has supported other social causes, namely, CIVIL RIGHTS, the ANTI-WAR MOVEMENT and the CAMPAIGNS of DEMOCRAT candidates. She is widely admired for her independence of thought and promotion of women's issues.

stetson (hat) (clothing) A type of felt or leather hat with a high crown and a broad

brim which can be rolled up or spread out. It is often worn by COWBOYS[1,2]. [After the company, owned by John B. 'Stetson', which first made these hats in 1865.]

Stewart, Martha (people) (born in 1941) A home decorator, magazine writer and editor. She gives do-it-yourself tips to people on how to decorate their homes and gardens elegantly as well as how to entertain and make crafts. She is known (and popularly envied) for doing home-oriented activities creatively, beautifully and perfectly. She owns and edits *Martha Stewart Living* (established 1990), a monthly magazine publishing articles and attractive photographs on recipes and home decoration tips. She has also written several books and makes regular television appearances giving similar information.

stock car (sports and leisure) A standard-model automobile that has been physically changed and adapted by the owner to improve its speed and racing ability. It is raced in the WINSTON CUP Series. *See* DAYTONA 500; *compare* INDIANAPOLIS 500.

stock market, the (economy) A term for the organized buying and selling of stocks and bonds that takes place in the stock exchanges (e.g., NEW YORK STOCK EXCHANGE, AMERICAN STOCK EXCHANGE, NASDAQ). It is symbolized by WALL STREET.

stockbroker (economy) The person who buys and sells stocks and bonds for other people. This person is paid a commission of the sales made and must be registered with the STOCK MARKET exchange where he or she trades. Also known as "broker".

Stonewall Inn (minorities) In NEW YORK CITY, the name of the gay bar in GREENWICH VILLAGE which was raided by police (June 27, 1969) wanting to arrest gays and lesbians because of their sexual orientation. However the clients in the bar for the most part resisted the arrests by throwing glass bottles and rioting against the police for two days. These events marked the first time that homosexual people had resisted arrests and fought back against a police force. These events succeeded in uniting gay people and marked the beginning of the active GAY RIGHTS MOVEMENT. This event is celebrated every year on GAY PRIDE DAY.

Stop ERA (minorities) The CONSERVATIVE, short-lived group and movement of the early 1970s which successfully stopped the EQUAL RIGHTS AMENDMENT from becoming an AMENDMENT to the US CONSTITUTION. This group feared that if ERA[2] became legal, it would end all financial support for dependent wives and children. Further, it claimed that ERA would destroy FAMILY VALUES and encourage homosexuality and lesbian lifestyles. It was created and led by Phyllis Schlafly (born in 1924). It dissolved after 1982.

Storyville (the arts) Within the FRENCH QUARTER, that district which was especially set aside in 1897 for the practice of prostitution (which had been outlawed from other areas of the city of NEW ORLEANS). This area was characterized by having many brothels and cheap clubs where live JAZZ MUSIC was played. It is considered the very cradle of jazz music. It was closed in 1917 by order of the US NAVY, which caused many local musicians to move north to CHICAGO and NEW YORK CITY. [After Joseph 'Story', the city's alderman who created it + 'ville'.] It was known as "the District" to local residents.

Stowe, Harriet Beecher (people) (1811–1896) Writer and supporter of ABOLITION. She is best known for writing the book *UNCLE TOM'S CABIN* which caused a national stir and encouraged many people in the NORTH to join the abolitionist cause. This book is considered to have helped bring on the CIVIL WAR. When Stowe, a petite woman, met PRESIDENT ABRAHAM LINCOLN, a very tall man, he asked if "this was the little lady who caused this big war".

straight A's (education) Receiving the best score (i.e., the LETTER GRADE 'A'), in all subjects in a SCHOOL[1] term which is noted on the REPORT CARD. By association, an excellent performance in a variety of tasks. *See* GRADING SYSTEM.

straight ticket (politics) A BALLOT[1], especially a PARTY-COLUMN BALLOT, on which all votes have been cast for candidates of the same political party. *Compare* SPLIT TICKET.

Strategic Defense Initiative (foreign policy) (SDI) During the COLD WAR, the military program using advanced technology to create a defense station in space which would attack any enemy missiles launched at the US. It was promoted by the REAGAN ADMINISTRATION[2]. Its critics thought that it was too unrealistic to produce and dismissively called it STAR WARS. Although it was never put into action, it is still being studied.

straw poll (politics) An unofficial poll that a newspaper or private organization takes before an election to forecast the winner. [After the game of chance of drawing 'straws' to determine a winner.] *See* POLLING; *compare* EXIT POLL.

strep throat (health) A common, nonserious type of throat infection caused by the bacteria known as "hemolytic streptococci" which causes a sore throat, nasal congestion and tiredness. [From 'strep'to-cocci + 'throat'.]

strike (1 work; 2 sports and leisure; 3 work) **1** An agreement among workers (e.g., UNION[1] members, BASEBALL players) to stop working, temporarily, in order to win or change their working conditions (e.g., current wages or contracts). It is often done before COLLECTIVE BARGAINING and may prompt the use of STRIKE-BREAKERS. **2** In baseball, when the offensive player does not hit a ball with the bat (e.g., swings the bat but misses). Once the offensive team has three strikes, it switches to the defensive play. By association, a failure. *See* INNING, OUT[1,2], "THREE STRIKES, YOU'RE OUT". **3** When mining or looking for minerals, a successful find of minerals (e.g., gold, silver). To "strike it rich" is to become wealthy, immediately. *See* GOLD RUSH.

strike fund (work) The money taken from the members' dues to the UNION[1] and specifically set aside by the union to pay members during a STRIKE[1].

strikebreaker (work) A general name for any person trying to end a STRIKE[1] (e.g., a worker working; a company hiring REPLACEMENT WORKERS). *Compare* SCAB.

strip, the (geography) The commercial and entertainment district located outside a city or between two cities, characteristically with bright, neon lights and flashy signs. The "Las Vegas Strip" is in LAS VEGAS and the "Sunset Strip" is in HOLLYWOOD[1].

strip mall (daily life) A type of SHOPPING MALL in which the buildings are laid out in bands (or 'strips') stretching parallel to a street and usually having a narrow parking lot between the buildings and the street. Also known as a "mall"; *compare* OUTLET.

Strivers' Row (geography) In HARLEM, the popular name for the two-BLOCK[1] part of 138th Street with attractive attached houses (built in 1891) which was very fashionable among AFRICAN AMERICANS during the HARLEM RENAISSANCE. [After the hard work, or 'striving', that its residents did in order to afford to live in that desirable part of Harlem.]

strong dollar (economy) A rise in the value of the DOLLAR compared to foreign currencies. A strong dollar means that the prices of goods imported to the US are lower and that Americans can buy more goods and services when they are overseas. The "dollar can be strengthened" by higher INTEREST RATES. *Compare* DEPRECIATION, WEAK DOLLAR.

Stuart, Gilbert (people) (1755–1828) A painter known for creating realistic portraits of several FOUNDERS[1] who are usually depicted wearing sober, dark-colored clothing, namely, THOMAS JEFFERSON, JAMES MADISON but, most importantly, over 100 separate (but very similar) paintings of GEORGE WASHINGTON.

student council (education) An organization of students in HIGH SCHOOLS and COLLEGES[3] that plans and organizes CAMPUS events for all students (e.g., FUNDRAISERS, dances, HOMECOMING and student council elections) and in some cases, may also represent the student population before a SCHOOL's[5] administration. It usually consists of four positions – President, Vice President, Secretary and Treasurer – and holds elections for each position every year with the winners of the election holding that position for one-year TERMS[1]. Also known as "student government".

Student Nonviolent Coordinating Committee (minorities) (SNCC) An important biracial CIVIL RIGHTS organiza-

tion for younger people that struggled against racism through the means of NONVIOLENT ACTIONS of SIT-INS, jail-ins, FREEDOM RIDES and VOTER REGISTRATION drives. It was founded in 1960 by southern black COLLEGE[3] students, with support from the SCLC, but soon had local chapters nationwide composed of black and white members. It organized successful drives to register black adults in the SOUTH to vote in the FREEDOM VOTE and participated in the MARCH ON WASHINGTON OF 1963. Under the leadership of STOKELY CARMICHAEL (1966–1967) and H. "Rap" Brown (1967–1969), it accepted the idea of BLACK POWER and militant actions. Thereafter, it lost many members because it expelled all white members and abandoned nonviolence in favor of militancy. In keeping with this new image, in 1969 it renamed itself the "Student National Coordinating Committee", and shortly thereafter ceased operation. It is remembered as an active, popular organization of the CIVIL RIGHTS MOVEMENT. *See* DIRECT ACTION, CIVIL DISOBEDIENCE; *compare* CORE.

Students for a Democratic Society (education) (SDS) An active student group largely for COLLEGE[3]-aged people which reflected the political views of the NEW LEFT; specifically, it supported the CIVIL RIGHTS MOVEMENT, and the ANTI-WAR MOVEMENT and it operated programs to help others get work and job training. It was founded in 1960 and led by the ideas of the PORT HURON STATEMENT. Although it was headquartered in CHICAGO, it included chapters on various CAMPUSES across the UNITED STATES. Its largest event was sponsoring a march in WASHINGTON D.C. on April 17, 1965, which attracted 15,000 protesters. It dissolved in June 1969 after it divided into the Revolutionary Youth Movement II (RYMII) and the WEATHERMEN (originally known as "Revolutionary Youth Movement I"). .

stuffing (food and drink) A moist puree dish of bread, onions, celery, mushrooms, nuts and spices spooned or 'stuffed' into a turkey, cooked inside the bird until soft then removed and eaten as a side dish to the ENTREE. It is a traditional dish for the THANKSGIVING DINNER.

Stuyvesant, Peter (people) (1610–1672, born in Holland) political and religious leader of the Dutch West India Company. He is remembered as the director general (i.e., governor) of the Dutch colony of New Netherland (parts of today's New York STATE) from 1647 until 1664. His control of the colony was efficient but as a member of the Dutch Reformed Church, he did not tolerate any other religions in the colony. He surrendered to the English in 1664.

subcommittee (government) In CONGRESS, a small group which helps do some of the research for a particular CONGRESSIONAL COMMITTEE.

subcontractor (work) A person or company that agrees to provide some service or material to help another company meet the needs of a contract. *See* DEFENSE CONTRACTS.

submarine sandwich (food and drink) A long loaf, WHITE BREAD sandwich consisting of various types of meat (e.g., meatballs, cold cuts of ham, turkey or other meats), seafood, cheese, lettuce, tomato, onions and other toppings. [After the long, low shape of a 'submarine' boat.] Also known as a "sub" or a "HERO"; in Philadelphia as a "hoagie" or "grinder"; in NEW ORLEANS as a "poor boy" (i.e., "po-boy"); or in Italian-American neighborhoods as an "Italian sandwich".

subpoena (legal system) An official order requiring a person to come before a legal official (usually in a court of law) in order to provide evidence in some legal case. It is given to any person who is reluctant or otherwise would not be willing to provide this information. If a person has been **subpoenaed** but refuses to appear in court, then he or she is acting in CONTEMPT OF COURT and may have to pay a fine or be put into jail. Subpoenas are often issued to witnesses in trials involving a GRAND JURY and/or a PETTY JURY.

subscriber (media) A person who buys a monthly or yearly contract with a company (e.g., newspaper, magazine, cable TV network) in order to receive newspapers or magazines or get access to TV or radio programs. *See* PAY TV; *compare* PUBLIC BROADCASTING.

Suburban (transportation) The name of the vehicle model which has a car-like cab with two seats (for one driver and three passengers) and a truck-like covered bed for hauling and carrying things. It is a long vehicle and is often used by people who spend time in the outdoors or have children. It is made by Chevrolet. *Compare* PICKUP TRUCK.

suburbs, the (geography) A middle-class or upper-class residential area located outside the city limits; typically the homes are for single families and have front and back YARDS. Usually, a commercial district and/or SHOPPING MALLS are located nearby. *See* ZONING REGULATIONS, LEVITTOWNS; *compare* BLOCK[3].

sue (legal system) In CIVIL LAW[1], to bring a LAWSUIT against some person or group for an offense or crime. It can lead to a CIVIL TRIAL or CRIMINAL TRIAL. *See* LIABILITY, MALPRACTICE, OUT-OF-COURT SETTLEMENT, CLASS ACTION.

suffragist (minorities) The name for a woman who supported the right for adult WOMEN to vote in public elections. Suffragists were very active in the WOMEN'S SUFFRAGE movement and in encouraging the US CONGRESS and STATES to pass the NINETEENTH AMENDMENT which gave women the right to vote.

summa cum laude (education) Describing that student who has earned the highest GPA in his or her CLASS. This phrase is written on the student's diploma. Describing a VALEDICTORIAN. [Latin, meaning "with highest praise".]

summer camp (customs and traditions) A camp outfitted with cabins or tents for sleeping and eating which is designed to give children opportunities for outdoor and sporting activities. It may last for a period of one week to several months during SUMMER VACATION. Also known as "CAMP". *Compare* BIBLE CAMP.

Summer of Love, the (history) The summer of 1967 in SAN FRANCISCO which attracted thousands of HIPPIES to the HAIGHT-ASHBURY in order to forget about the country's political problems and in order to relax, take drugs together (especially, marijuana and LSD) and partake in sexual relations with other people (i.e., "free sex"). It is considered a high point of the hippie and COUNTERCULTURE movements. *See* TIMOTHY LEARY.

summer school (1, 2, 3 education) **1** A general term for any course that is offered at any instructive institution during the summer, usually July and August. **2** Make-up or remedial courses required of ELEMENTARY SCHOOL or HIGH SCHOOL students who failed courses during the regular ACADEMIC YEAR. **3** Regular level but intensive courses offered at a COLLEGE[1] or UNIVERSITY to UNDERGRADUATES or GRADUATES[2] who wish to attend courses year-round.

summer vacation (customs and traditions) The period, generally June, July and August, when SCHOOLS[5] are not in session. Usually, it begins just after MEMORIAL DAY WEEKEND and ends around the time of LABOR DAY WEEKEND. *See* SUMMER CAMP, SUMMER SCHOOL[1,2,3]; *compare* SPRING BREAK.

"Summertime" (the arts) The opening song and sort of lullaby of *PORGY AND BESS*; the first lines are: "Summertime and the living is easy/Fish are jumping and the cotton is high." It is popular still and refers to the wealth and happiness of the summer season which encourages the listener to relax and enjoy these pleasures.

Sun Dance, the (religion) A special ceremony traditionally practiced by INDIANS of the GREAT PLAINS once a year, over a period of several days. Some members of the TRIBE performed the ceremony which included fasting, praying and dancing while looking at the sun (which produced a kind of trance). Sometimes, if the dancer agreed, a cord was inserted into a cut in his chest muscle causing the muscle to tear. Tribe members and dancers believe that this sacred dance helped cleanse and renew the tribe and the individual dancers. In 1883, because of the chest cutting, the BIA ordered that Indians not perform it. Today, it is practiced by some groups but usually without the chest muscle-cutting. [From the Oglala SIOUX language *Wi wanyang wacipi*, meaning 'Sun'-gazing 'Dance'.] *See* AMERICAN INDIAN RELIGIOUS FREEDOM ACT; *compare* GHOST DANCE.

Sunbelt, the (geography) Those geographical areas located in the SOUTH and

SOUTHWEST which are popular with businesses and working professionals because they are characterized by warm weather and lower business taxes for CORPORATIONS. *See* SPRING TRAINING; *compare* RUSTBELT.

sundae (food and drink) An ice cream dessert served in a cup and topped with a sauce (e.g., chocolate, strawberry), nuts and whipped cream. [Because it contains no soda water (and many alcoholic drinks usually do) it was particularly sold and eaten on 'Sundays' because of BLUE LAWS.]

Sundance Film Festival (the arts) A respected entertainment movie festival which showcases INDIES and INDEPENDENTS[1] and awards them prizes. Awards are given to dramatic films and to documentary films in the following categories; "grand jury", "directing", "cinematography" and others. It is held every year in the STATE of Utah in the middle of January and serves as the single best promoter of independent films. It is organized by the actor and director, Robert Redford (born in 1937). [After the location of the event at the wintertime ski resort 'Sundance'.]

Sunday (customs and traditions) The last day of the WEEKEND. This day is a non-working day and usually it is spent with family and/or friends reading the SUNDAY EDITION newspaper, playing sports and/or watching professional SPECTATOR SPORTS. Further, since the 1970s with the decreased enforcement of BLUE LAWS, many people go shopping or out for brunch or an early LUNCH. Many Christian people begin the day by attending religious services on this day.

Sunday edition (media) A tradition in the UNITED STATES since the 1890s of a daily newspaper publishing and selling a special thicker edition on SUNDAY containing special, extra sections, usually of: news, business, the week in review, fashion, arts, culture, travel and leisure, food, garden and home, comics, real estate and the CLASSIFIEDS. Reading all or most of it is a popular SUNDAY activity. *See NEW YORK TIMES, LOS ANGELES TIMES, FUNNY PAGES.*

Sunday school (1 religion; 2 education) **1** Currently, lessons held on SUNDAYS by some PROTESTANT groups and ROMAN CATHOLIC CHURCHES which offer instruction in Christianity, morality and Bible reading to children. **2** From 1800 to 1830, a SCHOOL[5] on the FRONTIER or in cities that offered courses on Sundays in reading, writing, Bible reading and proper social behavior to adults or children who were too busy working during the week to attend regular SCHOOLS[5].

Super Bowl (sports and leisure) The NFL championship game of professional FOOTBALL in which the best team of the AMERICAN FOOTBALL CONFERENCE plays the best team in the NATIONAL FOOTBALL CONFERENCE. It is played on the third Sunday in January and is televised nationwide; more Americans watch this single program than any other program throughout the year. It was first played in 1967 and has been played every year since; these games are counted in roman numerals (i.e., in the year 2000 is the 34th game, Super Bowl XXXIV). The winning team receives the (Vince) LOMBARDI TROPHY and the players receive cash, prizes and a special Super Bowl finger ring. It is the single most important professional football game in the year. *See* AMERICAN FOOTBALL LEAGUE.

Super Sunday (sports and leisure) A nickname for the day in January, always a Sunday, when several professional play-off games for the AMERICAN FOOTBALL CONFERENCE and NATIONAL FOOTBALL CONFERENCE are played. It usually occurs at least one week before the SUPER BOWL. *Compare* SUPER TUESDAY.

Super Tuesday (politics) In a year of a presidential election, the Tuesday, usually in March, when several STATES hold PRESIDENTIAL PRIMARIES.

"Superfund" (environment) A federal program operated by the ENVIRONMENTAL PROTECTION AGENCY and designed to clean up toxic waste sites. It was created by the Comprehensive Environmental Response, Compensation and Liability Act of 1980 and is paid for by taxes on the chemical industry.

superintendent of schools (education) The chief administrative officer of a SCHOOL DISTRICT who oversees the daily duties of the PUBLIC SCHOOLS under a jurisdiction. This administrator is appointed by the STATE SCHOOL BOARD and

serves TERMS[1]. Often referred to as the "Super".

Supplemental Security Income (health) (SSI) A program operated with STATE and federal money that provides a monthly gift of money to poor or needy people who are aged 65 or older, are DISABLED or are blind. It was established by the Social Security Act of 1972 and is operated by the SOCIAL SECURITY ADMINISTRATION. It is included in the general term of "SOCIAL SECURITY".

supremacy clause (legal system) The clause in the sixth article of the CONSTITUTION (i.e., Article VI) stating that the UNITED STATES' Constitution is the "supreme law of the land", meaning that it is more powerful than any other law (i.e., made by any STATE), any person or group. The Constitution is often called the "law of the land". *See MARBURY v. MADISON*, SUPREME COURT, UNCONSTITUTIONAL, "SUPREME LAW OF THE LAND".

Supreme Court (Building), the (legal system) The building where the SUPREME COURT hears cases and the ASSOCIATE JUSTICES and the CHIEF JUSTICE have their CHAMBERS. It was built of marble in the Greek Corinthian architectural style and first opened in 1935. It is located behind the CAPITOL BUILDING on CAPITOL HILL[1]. Before this time, the highest court met in other chambers.

Supreme Court (of the United States), the (legal system) The highest judicial court in the UNITED STATES. It has nine total members (i.e., one CHIEF JUSTICE and eight ASSOCIATE JUSTICES), but no JURY. It is responsible for deciding all cases involving foreign ambassadors or ministers to the US and for hearing other cases on APPEAL that were decided in LOWER COURTS concerning the rights and freedoms of individuals. The Court studies and uses (i.e., interprets) the laws of the US CONSTITUTION, its AMENDMENTS, US CONGRESS laws, STATE laws and Supreme Court DECISIONS in past cases to decide how far the rights of the individual extend within the limits of the group (i.e., American society). Because the appeals cases concern individuals' rights and freedoms, a Supreme Court decision affects the lower courts and laws of legislatures in similar cases; Supreme Court decisions are important. It was established by the Constitution in 1789 and it hears cases in the SUPREME COURT BUILDING located in WASHINGTON D.C. It works nine months a year (usually, October through June) during which period it studies cases and makes and presents its decisions and opinions. *See CAPITOL HILL[1]*.

"supreme law of the land", the (legal system) The collection of laws made by the federal government, including the CONSTITUTION, and any new laws and TREATIES made which agree with it. They are more powerful than STATE or local laws. [This phrase comes from the Constitution, Article VI, Section 2.] *See SUPREMACY CLAUSE*.

Surgeon General (1 health; 2 military) **1** The head medical doctor of the US PUBLIC HEALTH SERVICE who advises the PRESIDENT and gives the public warnings on health issues. This person is appointed by the President and serves as an Assistant Secretary in the DEPARTMENT OF HEALTH AND HUMAN SERVICES. **2** The title for the chief medical officer of one of the branches of the ARMED FORCES.

sustained (legal system) During a trial, an orally stated decision, meaning that something is correct, proper or just. It is made by a judge and is used to approve of the complaint that a LAWYER has just made (*see* OBJECTION); it agrees with the complaint and thus does not allow the objectionable statement to become a part of the official court record. *Compare* OVERRULED.

Swann v. Charlotte-Mecklenburg Board of Education (education) The first SUPREME COURT decision (in 1971) that established the practice of BUSING as a method of desegregating PUBLIC SCHOOLS where SEGREGATION had existed in the past. It was quite controversial because busing was ordered by the appointed judiciary not the elected legislature. [After James 'Swann' (born in 1958), the PLAINTIFF.] Also known as the "busing decision"; *see BROWN v. BOARD OF EDUCATION OF TOPEKA, KANSAS*, SEGREGATION, JUDICIAL ACTIVISM; *compare* MAGNET SCHOOL.

Sweat Lodge (customs and traditions) A special ceremony of prayer and fasting

traditionally practiced by INDIAN groups of the EAST. [After the wooden or wooden-frame building where this ceremony is held; the building frame is covered over in blankets, canvas and other materials; hot stones are placed in the 'lodge' and water is poured over them to produce steam.]

sweater (clothing) An upper body garment made of knitted cotton, wool, acrylic or any other man-made materials which has sleeves (e.g., long, short, cap) and is worn for warmth and/or style. A "cardigan sweater" has buttons, snaps or a zipper up the front; a "pullover sweater" is a type of PULLOVER. *Compare* SWEATSHIRT, JUMPER.

sweatshirt (clothing) A long-sleeved, cotton PULLOVER top, usually with a CREW-NECK neckline, which is commonly worn as casual leisure wear with JEANS or as athletic wear with sweatpants. *See* SWEATSUIT, LETTERS.

sweatshop (work) A factory or a shop in which its workers are required to work long hours, in unsafe or unhealthy conditions in exchange for earning a small sum of money.

sweatsuit (clothing) An outfit often made of cotton, polyester or other man-made materials, which is worn over athletic sports clothing before or after exercising or alone to relax in. It consists of a long-sleeved jacket which zips up the front and a pair of pants with an elastic waistband (known as "sweatpants"). This ensemble, or just the pants, are also known as "sweats".

Sweet Sixteen (customs and traditions) The 16th birthday of a teenage girl. By association, it may also simply refer to a young woman on her 16th birthday. Traditionally, this birthday was considered special because it generally coincided with a young girl's physical body development, thus marking her as an adult woman. After this date, she was and still is generally considered by her family and friends and the legal systems in some STATES to be an adult woman. *See* DRIVER'S LICENSE.

sweetheart contract (work) A type of contract made between representatives of a labor UNION[1] and the company's management which is designed to help both groups of these REPRESENTATIVES[2] (e.g., giving them money, benefits) and usually hurting the labor UNION[1] members. An illegal contract.

"Swing Low, Sweet Chariot" (religion) A well-known African-American spiritual song. Some lines are: "Swing low, sweet chariot/Coming for to carry me home/I'm sometimes up and sometimes down/But still I know I'm heavenly [Freedom.] bound". It was popularly sung by protesters and workers of the CIVIL RIGHTS MOVEMENT to show solidarity and that one has divine help.

Swing music (the arts) A style of optimistic, romantic JAZZ MUSIC with smooth rhythms which was designed to be played by a large number of different instruments. The musicians (usually at least 10) and their instruments (clarinet, trumpet, cornet, piano, drums, violin, percussion and saxophone – which first became popular at this time) were divided into different sound sections; the band leader usually arranged the music. The music contained four beats to a bar; the first and the third beats were emphasized. It was meant to be danced to and often was performed live on the radio and in ballrooms. Each band had its own signature, theme song. The "Swing Era" lasted from about 1935 through 1950. During this period, "Swing" was used by blacks to refer to this type of music; while the term "BIG BAND MUSIC" was used by whites to refer to this same type of music. *See* COUNT BASIE, DUKE ELLINGTON.

syndicated (media) Describing a newspaper or magazine article or radio or TV program that is provided by a **syndicate** (a syndicate is an agency selling articles, comics and programs to a number of AFFILIATES[2]) and therefore reaching a large audience.

T

T-ball (sports and leisure) A form of BASEBALL/softball for young children in which there is no PITCHER. Instead, the ball is perched on a 'T'-shaped stand at the HOME PLATE and the batter hits the ball from there.

T-bill (economy) A low-risk, short-term investment method, whereby the federal government sells an official note for a designated period of time (e.g., three, six, nine months or one year) to an investor at a discounted price. After the designated period has transpired, the full amount of the note, plus its profit, are paid back to the investor. The government uses these notes to make fast money. It is sold by the DEPARTMENT OF THE TREASURY. [Abbreviation of 'T'reasury 'bill'.]

tab (daily life) In a BAR[1], DINER or restaurant, the total amount that one must pay for the food ordered and service. By association, the piece of paper on which is written the total sum to be paid. *See* TIP, BILL[3].

tabloid (media) A newspaper giving news in a shortened form with simple sentences, often focusing on sensational information. It is printed on pages of a smaller format-size than daily newspapers and uses big headlines and many pictures. Because it is usually sold in grocery stores, it is also known as a "supermarket tabloid". [From French *tabloide*, meaning "little pill".]

Taft–Hartly Act (economy) A Congressional law (passed in 1947) that regulated UNION[1] and administration leaders as well as limited some of the powers of organized labor. It defined the "unfair practices" of labor UNIONS[1] (e.g., union payments to political campaigns), it outlawed CLOSED SHOPS (but not UNION SHOPS), and it ordered UNIONS[1] to register and file financial reports to the DEPARTMENT OF LABOR. It gave the PRESIDENT the power to stop national STRIKES[1] by obtaining an INJUNCTION lasting 80 days, during which time an executive commission is to study the situation and make suggestions to solve

it and thus avoid the STRIKE[1]. Also known as "Labor–Management Relations Act".

tailcoat (clothing) (tails) A FORMAL[2], fitted men's jacket which in front is short (i.e., at or above the waist) and in the back stretches long into two parallel panels of material or 'tails'. Usually, it is made in black-colored material (for evening events) or gray or white-colored material (for morning or afternoon events). It is worn with trousers made of the same material, a white shirt and a bow tie (usually colored white, gray or black).

tailgating (customs and traditions) A type of buffet-style outdoor picnic and/or small party in which the food (e.g., sandwiches, salads, BAKED BEANS) and drinks (e.g., beer, hot chocolate, coffee) are set up and displayed in the open, back part of a car or van and the picnickers stand or sit on chairs outside the vehicle eating their helpings of food off plates. **Tailgate parties** are commonly held in the parking lot or a park before, at, or during a sporting event. [From the back part, or 'tailgate', of a truck that can be opened in order to reach things in the rear of the vehicle.]

"Take Me Out to the Ball Park" (sports and leisure) A popular, short song dating from the late 1800s about the fun aspects of watching a BASEBALL game live in the BALL PARK; it is frequently played and sung by the audience during most MAJOR LEAGUE and MINOR LEAGUE games. The song follows: "Take me out to the ball game, take me out to the crowd/Buy me some peanuts and Cracker Jack, I don't care if we never get back/So its root, root, root for the home team, if they don't win it's a shame/For it's one, two, three strikes you're out at the old ball game!" *See* CRACKER JACK; *compare* NATIONAL ANTHEM.

take-out (food and drink) Food that is ordered and prepared in a restaurant but packaged so that the customer (or a restaurant delivery person) may 'take' it 'out' of the eatery to eat it. Also known as "carry-out"; *compare* JUNK FOOD.

takeover (economy) The try, either in a friendly or a hostile way, of one company buying another company. *Compare* MERGER.

"Talented Tenth", the (minorities) The belief that, in any group, 10% of its members are creative and highly intelligent (e.g., artists, writers) and are given the opportunities to speak for the other 90% of the group. W.E.B. Du Bois believed that if whites could recognize this percentage in the African-American population, then racism and DISCRIMINATION would disappear. This idea was presented in Du Bois's book *THE SOULS OF BLACK FOLK*.

Taliesin (housing and architecture) The personal home and studio of FRANK LLOYD WRIGHT, located in Spring Green, Wisconsin, a town with many building designed by him. Wright's other home and workspace were located in the SOUTH-WEST at "Taliesin West".

talk show (media) A radio or TV program with interviews, telephone conversations with listeners and taking questions from and interacting with a live studio audience. *See* OPRAH WINFREY.

talkies, the (the arts) An old-fashioned name for movies with sound, especially those movies in the 1920s and 1930s. *See JAZZ SINGER.*

tallith (religion) A shawl with a long fringe worn over the head or on the shoulders (and regular clothing) of JEWISH men during religious prayer, while in the synagogue or at some other prayerful or religious event. [Hebrew, meaning "cloak" or "cover".] Also spelled "tallit".

Tammany Hall (politics) A powerful political or business club in NEW YORK CITY (active from 1800 to 1924) which endorsed the DEMOCRATIC-REPUBLICAN PARTY and the DEMOCRATIC PARTY and received favors from politicians from those parties in return (e.g., money, political positions). However, after the 1860s, it had grown rather corrupt and greedy, and was stealing money from public funds. By association, a greedy political or business group. [From the club's full name "The Society of St. 'Tammany' ".] *See* ENDORSEMENT[1].

Tanglewood (the arts) A well-respected annual, outdoor, classical music festival held May through early September near the town of Stockbridge in the BERKSHIRE HILLS in Massachusetts. The Boston Symphony Orchestra performs here throughout the summer; also, other guest orchestras and soloists perform here. [After the name of the estate where it is held.] *Compare* NEWPORT FESTIVAL.

Taos Art colony (the arts) A collective name for the various artistic groups (white and Indian peoples) that lived and worked in northern New Mexico, especially after WORLD WAR I. The art works created by these people (e.g., paintings, literary books) were influenced by and depicted the unusual light of the SOUTHWEST, the desert landscapes, ADOBE structures and NATIVE AMERICANS engaged in traditional tasks and settings. It was popularized by the art patron Dodge Luhan, as well as the artist GEORGIA O'KEEFFE and the British writer D.H. Lawrence (1885–1930). [After the group's base at the city of 'Taos' and Taos Pueblo.]

tax evasion (economy) The action of not paying federal or STATE INCOME TAXES (either purposefully or not knowingly). It is illegal and any individual found to be committing it may be arrested and/or fined by the federal (i.e., INTERNAL REVENUE SERVICE) or state agencies. Also known as "Income tax evasion".

tax reform (government) A government effort by the legislature and/or executive to change the system of taxing (i.e., increase taxes or decrease taxes). *See* INTERNAL REVENUE SERVICE, PROPERTY TAX, TAX EVASION.

tax return (economy) An official form issued by the government on which an individual or company lists the earned income (including donations, deductions, TAX-SHELTERS and other exemptions) as well as the total amount of taxes due. The 1040 and 1099 are examples of tax returns. They are prepared by people during the TAX SEASON (either on paper or on computer) and are filed before APRIL 15 (either by mail or electronically) to the INTERNAL REVENUE SERVICE. Also known as "return"; *see* INCOME TAX, TAX SEASON.

tax season (economy) Generally, the period before APRIL 15 (usually March and April) when individuals, companies and CERTIFIED PUBLIC ACCOUNTANTS work preparing tax forms and then submit them to the INTERNAL REVENUE SERVICE. It is a busy, productive period for accountants

and the IRS. Most private paying individuals do not like it.

tax shelter (economy) A general term for any investment (e.g., private donations to NONPROFIT ORGANIZATIONS, real estate property) that a person can make which reduces the total amount of federal INCOME TAXES to be paid. In some investments (e.g., owning a second home, rental properties), it serves to protect that money and its profits from being heavily taxed. *See* TAX-EXEMPT.

tax-exempt (the arts) Describing an organization (e.g., organized religion, government-owned buildings, NONPROFIT ORGANIZATIONS) which receives legal permission from the federal government not to pay taxes because that organization provides some worthwhile, reputable service to the public. Having tax-exempt status indicates that the government officially recognizes that organization as providing a valuable service or product to the public. Donations to such organizations can serve as TAX SHELTERS for any individual or group.

Taylor v. Louisiana (legal system) The DECISION of the SUPREME COURT (1975) which required women to do JURY DUTY. Before this case, women were automatically exempted from this public duty. In addition, it strengthened the right of a DEFENDANT to be judged by a jury whose members represent the population figures of that community (e.g., in a mostly black community, the JURY should consist mostly of black people). *See* SEVENTH AMENDMENT.

Teach for America (education) (TFA) A national NONPROFIT teacher placement program for recent COLLEGE[1] GRADUATES[1] which places them for two-year stints as teachers in poor urban and/or rural PUBLIC SCHOOLS in several STATES. It gives its participants an eight-week teacher training course, pays them a small salary and allows them to defer federal student loan repayments they may owe until they have completed this teaching service. It was founded in 1990 by Wendy Kopp. *Compare* AMERICORPS, TEACHER CORPS.

Teacher Corps (education) A federal program to provide educational opportunities for children of low-income families

and to increase the number of MINORITIES in teaching jobs. It began with the HIGHER EDUCATION ACT (1965). *Compare* TEACH FOR AMERICA, AMERICORPS, PEACE CORPS.

Teamsters, the (work) The popular name for the INTERNATIONAL BROTHERHOOD OF TEAMSTERS and its member LOCALS. [In the era before cars, the job name of the person hired to steer a 'team' of two or more horses. It is now used to refer to truck drivers.]

Teatro Campesino, El (minorities) The theater group of the CHICANO MOVEMENT which wrote and produced live plays to promote concepts important to this movement. It was especially important for putting on plays concerning the farmer. In addition, it performed the play named "Zoot Suit" (1978) and the play version of "I am Joaquin/Yo Soy Joaquín". It was founded in 1965 by Luis Valdez (born in 1940). [Spanish for "farmer's theater".] *See* ZOOT SUIT RIOTS, "I AM JOAQUIN/YO SOY JOAQUÍN".

Tecumseh (people) (1768–1813) Shawnee INDIAN and Native American political leader. He planned to stop American expansion into Indian lands of the MIDWEST by organizing various tribes into a pan-Indian force. This force collapsed after it embarked on a hasty battle under Tecumseh's brother, Tenskwatawa (known as "the Prophet") against the Americans. Although he fought with the British army against the Americans in the WAR OF 1812, Tecumseh is remembered for his bravery, eloquent speeches and skills of war. *See* BATTLE OF FALLEN TIMBERS.

"Teflon President", "the" (people) A popular nickname for RONALD REAGAN during his presidency (1981–1989), because his reputation and popularity with the public were not damaged or diminished by any of the political scandals which occurred during his ADMINISTRATION[1] (e.g., IRAN-CONTRA AFFAIR); that is, problems did not seem to "stick" to him. [From the special, smooth material 'teflon' used in frying pans to prevent foods from sticking to the pan.]

telethon (media) A long TV program (usually lasting one day or several days in a week) especially designed to raise money from viewers (who call in with promises of

donations, either of PERSONAL CHECK or charged to their CREDIT CARDS) for a charity or to pay for the programs on non-COMMERCIAL networks. [From 'tele'phone + mara'thon'.] *See* PUBLIC BROADCASTING, JERRY LEWIS TELETHON.

televangelism (religion) Using television programs and networks to broadcast religious programs and messages. It is part of the ELECTRONIC CHURCH. [From 'tel'evision + 'evangelism'.] *See* EVANGELICAL.

Temporary Assistance to Needy Families (health) (TANF) The GENERAL ASSISTANCE program which gives money to those poor families with one or more DEPENDENTS. It is operated by the individual STATES and paid for with some funds received from the federal government in BLOCK GRANTS. When it started in 1996, it replaced the AID TO FAMILIES WITH DEPENDENT CHILDREN program and ended direct federal aid to poor families.

1040, Form (economy) A federal tax form distributed by the INTERNAL REVENUE SERVICE that those individuals who earn $50,000 or more must use to help figure their TAX RETURNS for their individual INCOME TAX. **1040EZ** is that federal tax form used by those people who earn less than $50,000 and do not have children. **1040A** is used by those individuals who have a salary of less than $50,000 but do have DEPENDENTS.

1099, Form (economy) A federal tax form distributed by the INTERNAL REVENUE SERVICE to help tax payers list interest, DIVIDEND and fee payments for stocks and bonds, all of which helps them figure the taxes to be paid on those securities.

ten-gallon hat (clothing) A hat with a high, rounded top around which a decorative piece of leather is wound. Also, the hat has a wide brim which may be rolled up. A COWBOY[1,2] hat. [From Spanish *galón*, meaning "braid".] *Compare* STETSON HAT.

Tennessee Valley Authority (environment) (TVA) The independent corporation owned by the federal government which oversees the maintenance of 25 dams, several electrical water plants, water and flood control and outdoor recreation facilities. The dams and plants were developed in the area of the Tennessee River Valley as a way to provide electricity to this area, water routes for transport and to give jobs to the unemployed during the GREAT DEPRESSION. The organization was created in 1933 and is still active. It is a good example of the CONSERVATION MOVEMENT and resource management. *See* NASHVILLE, NEW DEAL.

tennis shoes (clothing) A type of shoe with a soft, rubber sole and a low, leather or canvas foot-casing. It was originally designed for 'tennis' players but now is worn by many people for leisure wear. When it is used for leisure, this word is used interchangeably with the word "SNEAKERS". *Compare* HIGH TOPS.

Tenth Amendment (government) The part of the BILL OF RIGHTS (1791) which concerns FEDERALISM. It states that those powers not given to the federal government by the CONSTITUTION, but which are not forbidden to the STATES, are powers which are 'reserved' (i.e., belong to) the states and/or to the people. Also known as "RESERVED POWERS".

tenure (work) The right to remain in a job, especially a UNIVERSITY PROFESSOR, without having to renew a contract. An individual is "granted tenure" after working for a university for a number of years and is thereafter obligated to publish scholarly academic papers in his or her field of interest, serve on DEPARTMENT[1] committees and teach university courses. *See* "PUBLISH OR PERISH".

term (1 politics; 2 education) **1** A period of time that a public (e.g., elected, appointed) official serves in public office. **2** A period of time in the academic calendar (e.g., a SEMESTER, TRIMESTER, QUARTER[2]).

termination (minorities) The program designed to end the special relationship between Indian TRIBES and the US government and end all special, federal assistance to INDIANS, namely by: ending the RESERVATION system for Indians; ending the communal, collective life of Indian tribes; ending all TREATY obligations of the US government to Indians; and forcing Indians to accept ASSIMILATION. The government program consisted of an exchange: when a current tribe of Indians agreed to no longer consider itself a tribe and its

members promised to live independently as individuals or as a single family, the federal government agreed to pay that tribe a single sum of money to settle all outstanding fees and claims against the US (which the people were to divide among themselves). Further, the lands belonging to the tribe were incorporated into the surrounding STATE; all Indian people were now governed by state (i.e., not tribal) laws; and all medical and education services provided by the BUREAU OF INDIAN AFFAIRS were canceled or transferred to other federal DEPARTMENTS[2] or STATE agencies. This was the official federal policy of the US government toward Indian tribes from 1953 until 1970; it was enforced by the BIA and greatly damaged tribal identities, histories and traditions. It was opposed by FULL-BLOODS, AIM and the NATIONAL CONGRESS OF AMERICAN INDIANS; but it was supported by the AMERICAN ASSOCIATION OF INDIAN AFFAIRS (a mostly non-Indian group) and MIXED-BLOODS. Ten tribes were officially **terminated** during this period. By association, any program or attitude which supports this program. Because it was enacted by "House Concurrent Resolution 108" in 1953, it is also known by this name. *See* RELOCATION PROGRAMS, FIVE CIVILIZED TRIBES.

territory (geography) A district of land that the UNITED STATES administers but which does not have full equality with the 50 STATES (namely, it cannot have elected, voting REPRESENTATIVES[1] in the US CONGRESS). Often, many of its laws are created by a locally-elected legislature and it is run by a locally-elected official (e.g., governor). Further, it uses the American DOLLAR as currency and receives some federal social and WELFARE benefits. In the nineteenth and early twentieth centuries, a territory was meant to be a preliminary step to statehood; specifically, land on the North American continent was temporarily organized into a territory in order to facilitate white settlement before becoming a state. Previously, some 32 states were territories. However, in the second half of the twentieth century, especially those territory islands in the Pacific Ocean, many are content to remain territories

(i.e., not become states). Current US territories include PUERTO RICO, GUAM, the Virgin Islands, American Samoa, the Midway Islands, the Northern Mariana Islands, the Wake Islands and the Baker and Howard Islands. All territories are overseen by the DEPARTMENT OF THE INTERIOR; *compare* STATE, THIRTEEN COLONIES.

testimony (legal system) During a trial in court, the statement that a witness makes giving information relating to the case. Before a person can **testify**, he or she must take an oath swearing to tell the truth; usually with one hand on a copy of the Bible (for Christians), Koran (for Muslims), or Torah for (JEWISH people).

Tet offensive, the (foreign policy) During the VIETNAM WAR, a massive offensive military attack by communist Viet Cong (VC) forces of North Vietnam against cities, towns and military bases in South Vietnam; these enemy forces even temporarily controlled part of the American embassy located in Saigon, South Vietnam. The attack, which occurred during a period of mutual truce between the warring sides (on January 30, 1968), came as a surprise to the American military leaders in Vietnam. This attack showed that the Viet Cong was still strong and determined to continue fighting and that the US should re-examine its own position in the war. ['*Tet*' is Vietnamese for the Chinese lunar new year's day, a holiday honored during most of that war by not fighting.]

Tex-Mex (1 food and drink; 2 the arts) **1** A spicy style of cooking popular in the SOUTHWEST combining the beef and STEAKS of Texas, pork and chicken with vegetable ingredients and flavorings of foods from Mexico, especially CHILI CON CARNE, hot green chili peppers, serrano peppers and cumin. **2** A type of music characterized by the use of the accordion with guitar and percussion instruments and by the song themes which include outlaws, life along the US or Texas and Mexico border and smuggling. It originated in the region of the BORDER about 1928 although it has been played and performed by people who are from the Texas-Mexico border region since the nineteenth century. [From 'Tex'as +

'Mex'ico.] Also known as "border music" and "tejano music"; *see* HISPANIC; *compare* CORRIDO.

Texas Rangers (immigration) A special law enforcement agency of the STATE of Texas which is responsible for protecting that state's borders (from other states as well as from the country of Mexico) and protecting its laws. It was founded in 1823 and is overseen by the state government. Also known as "Rangers"; *compare* BORDER PATROL, RANGERS.

Thanksgiving Day (customs and traditions) The fourth Thursday in November when families gather together and show their 'thankfulness' and happiness for the successes in the past year. They celebrate by eating a THANKSGIVING DINNER at home or in a restaurant, watching FOOTBALL games, usually on television, and attending religious services. It was first celebrated in 1863 during the CIVIL WAR to help increase the morale and spirits of the UNION[3] army troops. Today, it is a FEDERAL HOLIDAY and one of the most important national events and family reunions of the year. It is popularly known as "TURKEY DAY". [It commemorates both the first successful harvest that the PILGRIMS had in AMERICA[1] in 1621 and the help that they received from local INDIAN groups for that harvest.]

Thanksgiving dinner (food and drink) The very large afternoon meal shared by families and the single most important event of THANKSGIVING DAY. Traditionally it begins with a religious prayer and includes those foods the PILGRIMS ate in 1621, namely, roast turkey, STUFFING, gravy, sweet potatoes, SQUASH, mashed white potatoes, corn and CRANBERRY RELISH (or any other dish with cranberries). Dessert usually consists of sweet potato PIE (mostly in the SOUTH), apple pie and/or PUMPKIN PIE. Often, much more food is prepared and served than most guests can eat. This oversupply of food is a symbol of the family's comfort and prosperity. *See* TURKEY DAY.

"There She is, Miss America" (customs and traditions) During the final evening of the televised MISS AMERICA PAGEANT, this song refrain is sung by an appointed singer after the new female winner has been announced and is about to receive the crown of Miss America.

thesis (education) A formal, written paper of creative study or research which a GRADUATE[2] submits to receive a MASTER'S DEGREE. *Compare* DISSERTATION.

Third Amendment (military) The AMENDMENT to the CONSTITUTION which does not permit soldiers to lodge (i.e., to eat, to sleep free of charge) in houses or properties belonging to civilians or other people. Before the AMERICAN REVOLUTION, and by order of the British Parliament, British soldiers were permitted to lodge in the homes and barns of American colonists. *See* INTOLERABLE ACTS.

third base (sports and leisure) In BASEBALL, that base located directly to the left of the HOME PLATE, but the last base on the DIAMOND. It is the third and last base to which an offensive player runs. Further, it is also the name of the defensive, INFIELD[1] position of that defensive player who guards this base. By association, the third or final step in a plan which consists of several, often four, steps.

third party (1 politics; 2 legal system) **1** A political party which forms to promote particular issues or a special PLATFORM. Although it helps to focus national attention on important, current issues and areas needing reform, it usually does not succeed in developing popular support after a presidential election year because of the strength of the TWO-PARTY SYSTEM. *See* H. ROSS PEROT, PROGRESSIVE PARTY[1,2,3], AMERICAN INDEPENDENT PARTY, KNOW-NOTHING PARTY, INDEPENDENT CANDIDATE. **2** In a legal case, a person (e.g., judge, LAWYER, witness, other individual) who is not one of the two persons or groups in the LAWSUIT. *See* ADVERSARY SYSTEM.

Thirteen Colonies, the (history) During the COLONIAL PERIOD, those organized possessions in AMERICA[1] controlled by the British. Each of the thirteen had a local British governor and all were governed indirectly by the British Parliament. The established language was English and British laws and social groups were used. After the DECLARATION OF INDEPENDENCE, they became the first thirteen American STATES. *See* COMMON LAW, FREEMASONS,

MASONS, BOSTON TEA PARTY, AMERICAN REVOLUTION; compare NEW ORLEANS, CIVIL LAW[2].

Thirteenth Amendment (legal system) The AMENDMENT to the CONSTITUTION (1865) that made SLAVERY in all STATES of the UNITED STATES OF AMERICA illegal. *See* ABOLITION, CIVIL WAR, EMANCIPATION PROCLAMATION; *compare* JIM CROW LAWS.

"This Land is Your Land" (customs and traditions) The first line and the title of the popular FOLK MUSIC song written by WOODY GUTHRIE which praises the beauty of the natural places and the size of AMERICA[1] as well as the equality of all the people in the UNITED STATES. The first verse follows: "This land is your land, this land is my land/From California to the New York Island/From the redwood forest to the Gulf Stream waters/This land was made for you and me."

"This Old Man" (customs and traditions) A popular rhyming children's song about a talented man who could play music and musical beats using a variety of different, everyday objects and instruments. The first verse follows: "This old man, he played 'one'/He played knick-knack on my 'thumb'/With a knick-knack, paddy-wack give your dog a bone/This old man came rolling home." Other verses substitute the following beats and objects: two, on my shoe; three, on my knee; four, on the door; etc.

Thomas, Clarence (people) (born in 1948) Director of the EQUAL EMPLOYMENT OPPORTUNITY COMMISSION (eight years), ASSOCIATE JUSTICE of the US SUPREME COURT (since 1991) and CONSERVATIVE REPUBLICAN. His presidential appointment by GEORGE BUSH to the SUPREME COURT (1991) was questioned during the CLARENCE THOMAS/ANITA HILL HEARINGS because of allegations of gender DISCRIMINATION and SEXUAL HARASSMENT. Eventually his nomination was approved by the SENATE, but the ordeal and its issues remain on his record.

Thoreau, Henry David (people) (1817–1862) A writer and thinker of the TRANSCENDENTALISM movement and abolitionist. After choosing to live alone for two years in the rural, natural area of Walden Pond in Massachusetts, he developed ideas concerning nature in a journal which was later published in the book *WALDEN* (1854). This book and other works (e.g., *A Week on the Concord and Merrimack Rivers* 1849) promoted individual independence and a personal contact with nature which challenged the ideas of CAPITALISM and affluence of the times. Only after his death and especially in the twentieth century, he and his ideas about nature became guiding forces for many other writers, artists, environmentalists and other Americans. His essay, "Civil Disobedience" (1849) later became an important document in the development of NONVIOLENT ACTION. *See* MARTIN LUTHER KING, JR., CIVIL DISOBEDIENCE, ABOLITION, ENVIRONMENTAL MOVEMENT, AMERICAN RENAISSANCE.

Thorpe, Jim (people) (1888–1953) A NATIVE AMERICAN of the Sac and Fox tribe and athlete recognized for his skills and versatility to perform well in a variety of sports: FOOTBALL, BASEBALL, BASKETBALL. He won Olympic gold medals in 1912 for the decathlon and pentathlon. He is also remembered for having these gold medals revoked (although, returned in 1982) over a question over his amateur athlete status.

Thousand Days (government) The approximate length of the Kennedy ADMINISTRATION[2] (actually, 1,037 days) which was favorably and fondly remembered in a book by ARTHUR SCHLESINGER, JR. entitled *A Thousand Days*. The book commemorated the programs, the PRESIDENT, friend and father who was JOHN F. KENNEDY and was published shortly after the assassination of Kennedy. [From a phrase used by Kennedy in his INAUGURAL ADDRESS in which he claimed that the work of his ADMINISTRATION[1] would not be finished in the "first one 'thousand days'". *Compare* HUNDRED DAYS.

Thousand Island dressing (food and drink) An orange-colored salad dressing garnish made of mayonnaise with chopped pickles, pimento chili peppers and green peppers. [It was first made and popularized at the hotels in the THOUSAND ISLANDS.]

Thousand Islands, the (geography) The collective name for that region in the St. Lawrence River between the STATE

of New York and the province of Ontario in Canada. It includes some 1,500 different islands. The fresh water and air have long made this a popular summertime resort area for wealthy and middle-class people.

Three Mile Island (science and technology) The site of a nuclear power plant and the worst UNITED STATES nuclear power accident (March 28 through April 9, 1979) which forced many local residents to evacuate the premises out of fear of nuclear contamination to their homes and health. Although no one died, it caused many Americans to question the use of nuclear power as a safe source of energy. It has become a symbol of contamination of the environment and public health. [After the location of the plant site near Harrisburg, Pennsylvania.] *See* NUCLEAR REGULATORY COMMISSION.

three R's, the (education) The traditional, CORE CURRICULUM of reading and writing in English and math offered in ELEMENTARY SCHOOLS and HIGH SCHOOLS from the COLONIAL PERIOD until the post-WORLD WAR II period. Historically, this method of education relied upon rote learning and discipline. The educational reforms of the 1960s encouraged many schools to adopt more experimental teaching techniques and ELECTIVES at the expense of the three R's. Currently, PUBLIC SCHOOLS are criticized for abolishing these basic features of educational programs. [Abbreviation of 'R'eading, w'R'iting and a'R'ithmetic.] *See* McGUFFEY'S *READER*.

"three strikes, you're out" (sports and leisure) In BASEBALL, the phrase called by an UMPIRE after a batter has failed three times to hit a play-able ball. By association, receiving three chances before a punishment. *See* OUT[1,2], STRIKE[2].

thrift (institution) (economy) A general term for a financial institution that often invests its funds in mortgages and real estate purchases. During the 1980s, many thrifts went bankrupt because the real estate market was not strong. During this period, the federal government helped finance the pay-offs of the thrifts. *See* OFFICE OF THRIFT SUPERVISION.

ticker-tape parade (customs and traditions) A celebratory type of parade held to honor special people and in which those same people march and are greeted with cheers and long strips of paper as well as bits of confetti from the watching crowd. In NEW YORK CITY, most ticker-tape parades are held DOWNTOWN in WALL STREET. [From the cut paper ribbons or 'ticker tape', an old kind of paper used for telegraphs, which is thrown in celebration.] By association, high accolades or praise.

ticket (politics) The list of candidates from a political party who are running for a nomination or election; especially a candidate for PRESIDENT and his or her RUNNING-MATE. *See* SPLIT TICKET, STRAIGHT TICKET.

Tidewater Region, the (geography) On the EAST COAST and in Virginia, that area of low lands near the Chesapeake Bay and Atlantic Ocean which is largely agricultural. Because it includes the towns of JAMESTOWN and WILLIAMSBURG[1] it is recognized as that part of the SOUTH (and AMERICA[1]) which has been settled by whites and blacks the longest in America.

tie dye (clothing) Describing a colorful, uniquely patterned piece of clothing (e.g., T-shirt, pants, SWEATSHIRT). It is colored through a process in which the garment is 'tied' into various knots then dipped into a vat of colored 'dye'; after drying, the clothing then has a unique, colored pattern. **Tie dyes** were first self-made and popularized by HIPPIES in the 1960s.

tight end (sports and leisure) In FOOTBALL, an offensive player responsible for receiving passes of the ball and for helping protect fellow teammates by blocking opposing defensive players. *Compare* QUARTERBACK, LINEBACKER.

Time (media) A weekly newsmagazine that gathers and summarizes the news. It covers items in national politics, international news, law, business, education and the arts. Every year it features a "Man of the Year" issue. It was founded in 1923 by Henry Luce (1898–1967) and popularized the technique of INTERPRETIVE REPORTING. Currently, it has a current circulation of 4.1 million.

Times Square (geography) A busy crossroads site in the entertainment and BROADWAY district of MANHATTAN[1] which is characterized by large gaudy, bright, neon lights and large stores selling retail products. Every year it sponsors a NEW YEAR'S EVE celebration. Before being refurbished in the 1990s, it was characterized by its status as a dirty red-light district with prostitution and cheap BARS[1]. [From the original site of the newspaper printing and offices of *THE NEW YORK 'TIMES'*.]

Tin Pan Alley (the arts) Specifically, a collective name for a successful, commercialized type of music and song writing which combined simple piano music, sometimes using elements from JAZZ MUSIC and RAGTIME, with words that were easy to remember because they rhymed or were repeated. It was popular from 1895 to 1930, and was used on the radio and in some movies, but mostly in BROADWAY plays. After WORLD WAR II, its best concepts were used in the MUSICAL. In general, an older name for the commercial music industry. [After the noise, like hitting a 'pan' made of 'tin', produced by the many different pianos being played in the different piano music offices which were located on 28th Street ('alley') in NEW YORK CITY.] *See* GEORGE GERSHWIN.

Tinseltown (the arts) The slang and somewhat dismissive name for HOLLY-WOOD[2] and the commercial film industry, especially during the 1930s when the movie business consisted of several large, powerful companies and the actors and actresses were portrayed as showy and glamorous, but unrealistic, figures. [For 'tinsel' (a shiny, showy material) + 'town'.]

tip (work) An expected, additional amount of money that a customer gives a server for a service (e.g., porters, taxi cab drivers, waiters). In a restaurant or DINER, a customer **tips** the waiter/waitress 15% to 20% of the total amount of the food listed on the check. *See* SERVICE INDUSTRY.

tipi (housing and architecture) A cone-shaped, portable structure (usual diameter, 16 feet; 4.8 m) composed of a wooden pole frame covered by a single sheet of cloth (e.g., canvas) or leather (e.g., buffalo skins sewn together) which served as the traditional house of the PLAINS INDIANS. Also spelled "tepee" and formerly spelled "typee". [From SIOUX *ti* (meaning "to dwell") + *pi* (meaning "used for").]

TKO (sports and leisure) In professional boxing, the ending of a match called by officials when the health or condition of the losing boxer is in danger. [From the abbreviation of 'T'echnical 'K'nock-'O'ut.] *Compare* KO.

TOEFL (education) An ETS MULTIPLE-CHOICE exam used to measure the English language proficiency of students whose native language is not English. The test consists of three parts: listening comprehension, structure and writing, vocabulary and reading comprehension. This test was first given in 1963–1964. TOEFL scores are usually required of an international student when applying to an American institution for HIGHER EDUCATION or an ESL program. The test is offered at set times throughout the year in more than 170 countries. [Abbreviation of 'T'est 'o'f 'E'nglish as a 'F'oreign 'L'anguage.]

Tom Collins (food and drink) A cool, refreshing, mixed drink cocktail consisting of dry gin, orange juice and soda water which is served with ice in a tall glass.

Tomb of the Unknowns (military) A grave containing the remains of several different soldiers who died in each of the US wars from WORLD WAR I to the present but whose identities and names were never discovered. They represent American patriotism and self-sacrifice for the US. Every year on VETERANS' DAY, a ceremony in which a wreath is laid on the tomb is held to honor them. This tomb is guarded 24 hours a day by the ARMY and is located in the ARLINGTON NATIONAL CEMETERY, southeast of WASHINGTON D.C. *See* MEMORIAL DAY.

Tong war (minorities) The collective name for the armed conflicts (1880s through 1900) fought between secretly-organized rival Chinese gang-groups in order to control illegal crime activities (especially gambling, smuggling, drug selling) in CHINATOWN. [*Tong* is the Chinese word for this type of secret, political group/Mafia-type group popular in California in the late nineteenth century.]

Tony Awards, the (the arts) The prestigious awards given to honor excellence in live theater plays and MUSICALS on BROADWAY and in NEW YORK CITY theaters. The many categories include best actor, actress, director, producer, choreographer, set designers and others. They are presented by the American Theatre Wing every year in May or June; the first awards were distributed in 1947. [After Antoinette "Toni" Perry (1888–1946), an actress, producer and director of the American Theatre Wing.]

tooth fairy (customs and traditions) The kind but never-seen female fairy who visits a child who has recently lost a tooth and has placed it under his or her bed's pillow. During the night while the child sleeps, the tooth fairy takes the tooth and replaces it with candy or some small sum of money. (Actually, the child's parents perform this task.)

Top 40 (1 the arts; 2 media) **1** A list of the most popular songs in a given week according to sales figures published weekly in *BILLBOARD* magazine; especially a POP MUSIC song. By association, describing a singer, group or song that is on this list. **2** A common type of format for a radio station that only plays **top-40** songs.

top hat (clothing) A men's tall tubular hat with a firm brim, all of which is covered in black silk or satin. It was popularly worn by civilian men during the era of the CIVIL WAR. Today, it is sometimes worn for FORMAL[1] occasions with a TAILCOAT (i.e., "top hat and tails").

top of the (inning) (sports and leisure) In BASEBALL, the first part of an INNING when team "A" plays defensively (i.e., is in the field) and team "B" plays offensively (i.e., is AT BAT). Often the name of the inning is given; "top of the fifth (inning)". *Compare* BOTTOM OF THE (INNING).

touch football (sports and leisure) A type of FOOTBALL in which defensive players stop offensive players by lightly tapping or 'touching' them (i.e., not tackling). It is usually played for leisure and is less rough than INTERCOLLEGIATE or NFL play. *Compare* FLAG FOOTBALL.

touchdown (sports and leisure) (TD) In FOOTBALL, a successful scoring which is worth six points. It may be augmented by an EXTRA POINT. By association, a meaningful success.

tour (1 sports and leisure; 2 military) **1** An annual series of competitions which award money and are officially sponsored by sports organizations that professional and/or amateur players participate in, especially in tennis and golf. *See* GRAND SLAM[1,2], LADIES' PROFESSIONAL GOLFERS' ASSOCIATION, PROFESSIONAL GOLFERS' ASSOCIATION. **2 tour (of duty)** In the ARMED FORCES, a period of service (usually two years) in a particular work position or geographical location (e.g., city, country). *See* DRAFT[1].

town meeting (1, 2 government) **1** Any public meeting in which people discuss issues affecting their town. **2** In the majority of NEW ENGLAND towns, a system of government where the citizens themselves hold official meetings to discuss legislation, then vote and make laws for their town. Each town resident has an opportunity to speak and listen to the debate concerning an issue before voting on it. It is considered the action and symbol of democracy in the purest form.

township (government) A small, local governing unit of some STATES. They were established in the MIDWEST and NORTHEAST during settlement in the seventeenth and eighteenth centuries. Today for the most part, they have been superseded by cities and/or SCHOOL DISTRICTS.

track and field (sports and leisure) The collective name for various different running, jumping and throwing sports events which originated with the ancient Greeks, namely, 100 meters running race, marathon (26.2 miles; 42 km), long jump, high jump, shot put and javelin throwing. *See* PAN-AMERICAN GAMES.

trade balance (economy) The financial difference between the values of exports and imports. A negative **balance of trade** for the US (i.e., too many imports) is a US trade deficit. A positive balance of trade for the US (i.e., a large number of exports) is a US trade surplus. *See* MOST-FAVORED NATION.

Trade Representative (government) (USTR) The adviser to the PRESIDENT on international trade and treaties and busi-

ness policies. He or she is appointed to this position and is a member of the CABINET.

traditionals (minorities) Indian members of a TRIBE who believe in and respect the old, traditional tribal ways (e.g., tribal life, religion, values, hereditary tribal government) and are opposed to all modern changes to Indian life. *Compare* RED POWER.

Trail of Broken Treaties, the (minorities) An event in 1972 organized to peacefully promote rights for INDIANS and self-determination in which 400 Indians traveled cross country in a caravan of different vehicles from SAN FRANCISCO to WASHINGTON D.C., stopping at various RESERVATIONS along the way to encourage local Indians to join the group. The trip was organized by the AMERICAN INDIAN MOVEMENT and the National Indian Youth Council which had drawn up the "Twenty Points", a list of specific benefits and rights that Indians were to receive (but at that time were not receiving) according to various past TREATIES signed between the US government and tribes. When the BUREAU OF INDIAN AFFAIRS officials in Washington refused to give the Indians all their demanded rights, the group of a couple hundred Indians responded by seizing the BIA building and occupying and controlling it for six days (November 3–9, 1972). Although this event had been planned as a peaceful demonstration, it turned into a violent stand-off between NATIVE AMERICANS and US government officials. Finally, the government agreed to discuss the listed demands and rights as well as give the Indians $66,000 in order to pay for transportation costs back to their homes. The event's final days (which occurred around the ELECTION DAY for the US PRESIDENT) succeeded in producing a media event which dramatized Indian issues and made the American public, in general, more sympathetic to Indian concerns and issues. This event was a high point of the RED POWER Movement. [After the 'TRAIL OF' TEARS and the many 'treaties' between tribes and the US government which the US had 'broken', that is, not respected.]

Trail of Tears (minorities) The US government's forced round-up of some 13,000 Indian people and their removal from lands in the present-day STATES of Georgia, North Carolina, Alabama and Tennessee to INDIAN TERRITORY located west of the MISSISSIPPI RIVER. Most of these peoples were members of the FIVE CIVILIZED TRIBES. The trip was 800 miles (1,287 km) long and took place during the cold winter of 1838–1839; because of the cold and lack of food over 3,300 Indians died en route before reaching the destination. The removal was encouraged by PRESIDENT ANDREW JACKSON and enforced by the US ARMY. It remains a symbol of the US government's poor treatment of Indian peoples. *See* INDIAN REMOVAL ACT, TRAIL OF BROKEN TREATIES, *CHEROKEE NATION* v. *GEORGIA,* WORCHESTER V. *GEORGIA*; *compare* JACKSONIAN DEMOCRACY.

trailer park/court (housing and architecture) A residential area supplied with electrical-line hook-ups and other utilities (e.g., running water, cable television) meant to be used by people who live permanently, year-round in a trailer. *Compare* MOTOR HOME.

Trans-Alaska Pipeline, the (science and technology) Since 1977, the network of pipes, covering some 800 miles (1,280 km), which transports crude oil from Prudhoe Bay to Valdez in Alaska. This massive energy project was approved and subsidized by the Congressional Alaska Pipeline Act (of 1973). The pipeline supplies the LOWER 48 with crude oil extracted from underground oil reserves found in the STATE of Alaska. *See* SEWARD'S FOLLY.

transcendentalism (religion) A general term referring to a literary, philosophical and religious movement believing that individuals must rely on themselves and each other, not a God, to do good actions and improve society. Also, it wanted to discover the truths of life and disliked some Americans' habit of greed and materialism. It began in 1836 when various artists and social reformers met at the house of RALPH WALDO EMERSON to discuss some of these issues. The works of some **transcendentalist** writers (namely, Emerson and HENRY DAVID THOREAU)

have influenced other artists specifically, and American society in general. *See* WALT WHITMAN, EMILY DICKINSON, ENVIRONMENTAL MOVEMENT, CIVIL DISOBEDIENCE, MARTIN LUTHER KING, JR.

transcontinental railroads (transportation) A series of railroads, approved by the US CONGRESS, that linked cities in the MIDWEST and on the EAST COAST with the WEST and encouraged quick development and white settlement there, as well as immigration from China. These railroads were built by private companies which had received loans from the federal government. The Central Pacific Co. and the Union Pacific Railroad built the stretch between Sacramento, California and Omaha, Nebraska (it was finished in 1869 and is often considered "the (first) transcontinental railroad"); Southern Pacific Railroad and Atlantic and Pacific Railroad built the stretch between LOS ANGELES and Albuquerque, New Mexico (finished in 1881); the Northern Pacific Railroad built the stretch between St. Paul, Minnesota and SEATTLE (finished in 1883). The Southern Pacific Railroad built the stretch between NEW ORLEANS and Los Angeles (finished in 1885); The Santa Fe Railroad connected CHICAGO and Kansas City with Los Angeles (finished 1887); The Great Northern Railroad connected Duluth, Minnesota with Seattle (finished in 1889); and finally, The Chicago, Milwaukee, St. Paul and Pacific Railroad linked Chicago with Seattle (finished in 1909). *See* BURLINGAME TREATY, SAN FRANCISCO.

Treasury bond (economy) A low-risk, longer-term bond offered by the US DEPARTMENT OF THE TREASURY and sold by the FEDERAL RESERVE in denominations of $50 to $1 million for a period of 10 years. Although it takes 10 years to mature, it does pay interest twice a year to the investor; this interest is then exempt from STATE and local taxes. The "30 year Treasury bond" is an important type of investment because it indicates the overall strength and confidence in the buying and selling of bonds.

treaty (government) An agreement between the US government and another foreign nation which is used to make peace, transfer land, establish land boundaries, grant special rights or give other benefits. According to the CONSTITUTION, treaties may be established by the PRESIDENT or by the SENATE; however, all treaties must be approved by the Senate. From 1778 to 1871 (*see* INDIAN APPROPRIATIONS ACT), the federal government signed over 400 different treaties with different Indian groups because treaty-making was the method employed by the federal government to settle issues with Indian tribes. Since 1872, Congressional laws, not treaties, have governed Indian-related issues. However, since the 1960s, Indian groups have demanded that the US government fulfill the earlier treaty agreements made with TRIBES. *See* TREATY OF PARIS, TREATY OF GUADALUPE HIDALGO, TRAIL OF BROKEN TREATIES.

Treaty of Guadalupe Hidalgo (foreign policy) The TREATY ending the MEXICAN-AMERICAN WAR which established the almost 2,000 mile (3,210 km) long border between Mexico and the UNITED STATES; from the RIO GRANDE and Gila River to the Pacific Ocean. In this treaty Mexico gave the winners about 1 million square miles (2.59 million km) of land, mostly in the present-day SOUTHWEST. In exchange, the US gave Mexico $15 million for the land and to help the Mexican economy. At the time, all the 80,000 people (mostly Spanish-speaking) living in this territory had the choice of becoming American citizens or remaining Mexicans. *Compare* GADSDEN PURCHASE.

Treaty of Paris (foreign policy) The treaty that established peace after the AMERICAN REVOLUTION and signed (September 3, 1783) by Great Britain and the Americans. It recognized the former THIRTEEN COLONIES now as the independent country of the UNITED STATES OF AMERICA; and established the western border of the US at the MISSISSIPPI RIVER and the northern border at the GREAT LAKES. *Compare* LOUISIANA PURCHASE.

tree hugger (environment) A pejorative name used for any person who radically supports the preservation of natural environments and animals, sometimes even putting his or her own life in danger. [From the tactic of one EARTH FIRST!

group in which members joined hands and encircled a large 'tree' in a large 'hug' in an attempt to stop lumberjacks from cutting trees down.] *See* EDWARD ABBEY.

tree-trimming party (customs and traditions) During CHRISTMASTIME, a small party at which the hosts provide decorations (e.g., tinsel, full cranberries and POPCORN to be threaded on a string) and guests help them 'trim', that is decorate, the CHRISTMAS TREE. FINGER FOOD, warm appetizers, EGG NOG and CHRISTMAS COOKIES and desserts are often served.

tribal council (minorities) A form of governing system for a TRIBE which makes and enforces the rules for the tribe, its RESERVATION, the services of the reservation and for the tribe members. In addition, it may operate its own tribal police force, tribal SCHOOLS5, social services, GAMING businesses and legal courts where cases concerning tribal law are decided. Usually, it consists of a chairman, a vice chairman and from five to 11 elected tribal members. Members are elected by POPULAR VOTE and serve a TERM1 of a pre-designated time period. Members are known as "councilman" or "councilwoman"; one member, usually the chairman or the ceremonial leader of the council, may be addressed as "Chief". The exact duties of a tribal council are voted upon and determined by each individual tribe.

Tribally Controlled Community College Act (education) A federal law that provides funding and GRANTS to tribally-controlled COLLEGES1 which provide Indian-oriented academic programs, services and an environment to its largely INDIAN student population. By law, each TRIBE can have only one tribal COLLEGE3. There are over 15 of them in the US. *See* NAVAJO COMMUNITY COLLEGE.

tribe (minorities) A group of NATIVE AMERICANS who share a common language, culture, history and ancestors; they are bound to each other by family relationships and are ruled by certain political (e.g., TRIBAL COUNCIL) and social organizations (e.g., matriarchy, patriarchy). Traditionally, the members share common beliefs about creation; favor a communal lifestyle and system of ownership (e.g.,

today's RESERVATION); and believe in a spirituality which respects natural environments and creatures. Membership in a tribe is based on ancestry and each tribe determines its own policies for membership. Sometimes, the requirement is that a member claim one-fourth (e.g., one grandparent was a member) or at least one-sixteenth (e.g., a great-great-grandparent was a member) of his or her heritage as belonging to that tribe. Today, a "federally-recognized tribe" is a tribe or ALASKA NATIVE government which the federal government considers to be a unified, communal group of people and with which it enters into and respects previously made TREATIES, EXECUTIVE ORDERS, official contracts and acts of CONGRESS. Currently, there are some 320 different federally-recognized tribes in the LOWER 48 and 210 different federally-recognized governments of Alaska Natives. Many social services pertaining to **tribal** groups are overseen by the BUREAU OF INDIAN AFFAIRS. In the past, the US government has recognized tribes in different manners: in the eighteenth century, the US CONSTITUTION recognized the special status (i.e., "foreign government") of tribes; in the nineteenth century, tribes were recognized as independent nations under the control of the US government; from 1900 to 1930, the Indian Agent of the BIA controlled the tribal government; and during part of the twentieth century, the federal government attempted to dissolve tribes (i.e., TERMINATION). *See* NAVAJO, SIOUX, CHEROKEE NATION, IROQUOIS CONFEDERACY, PUEBLO INDIANS, INDIAN REORGANIZATION ACT, RED POWER, gaming, *CHEROKEE NATION* v. *GEORGIA*, *WORCHESTER* v. *GEORGIA*.

TriBeCa (geography) In NEW YORK CITY, a region of MANHATTAN1 known for its comfortable private, residential apartments and industrial businesses housed in the large, spacious buildings of that region. [Acronym from the 'Tri'angle 'Be'low 'Ca'nal Street.]

trick-or-treating (customs and traditions) The traditional HALLOWEEN practice in which children, dressed in costumes and masks, walk to the houses of neighbors and ring the doorbells. After the adult opens the door, the children shout

"trick or treat!" and the adult responds by giving them a 'treat', usually individually wrapped pieces of candy or coins of money. Frequently, children are accompanied by their parents and they make these rounds in the local neighborhood either in the early evening of Halloween or on some other night appointed by the local government. [From the threat of children, "give me a sweet candy 'treat' or else I will play a 'trick' on you!"] *See* BEGGARS' NIGHT.

trickle-down economy (economy) The economic theory that if the government gives tax breaks and benefits to BIG BUSINESS and the wealthy UPPER CLASS, the economic prosperity experienced by these few businesses and individuals will filter down to the MIDDLE CLASS, LOWER CLASS and the poor by providing these other groups with increased employment and greater opportunity. It was used during the Reagan ADMINISTRATION[2] as a method of fighting INFLATION, however its results were not positive for any of the mentioned groups. *See* RONALD REAGAN.

trimester (education) A 15- or 16-week period of academic courses including one week for FINALS. Although it stretches from September to the following September, students usually attend only two of the three trimesters (i.e., they usually do not attend SUMMER SCHOOL[3]). Three trimesters = one calendar year.

triple (sports and leisure) In BASEBALL, a successful hit of the ball with a bat which allows a batter to run past FIRST BASE and SECOND BASE and safely to THIRD BASE. *Compare* SINGLE, DOUBLE, HOME RUN.

Triple A (transportation) (AAA) The popular nickname for the AMERICAN AUTOMOBILE ASSOCIATION. [Abbreviation of the 'A'merican 'A'utomobile 'A'ssociation.]

Triple Crown, the (1, 2 sports and leisure) **1** In horse racing, the title given to the three-year-old thoroughbred horse which has won the KENTUCKY DERBY, the PREAKNESS STAKES and the BELMONT STAKES (all of which are raced within a five-week period) in the same year. This prestigious title is not easy to earn. **2** In BASEBALL, the title given to the player who in one season earns the most HOME RUNS, RBI's and has the highest BATTING AVER-

AGE. By association, a person or participant who wins three separate events. *Compare* GRAND SLAM[3].

triple witching hour (economy) On the NEW YORK STOCK EXCHANGE, the last hour on a Friday (occurring once every QUARTER[4]) when all stock options and all futures expire. Therefore, before expiring, traders rush to trade stocks and futures which produces a burst of trading activity. This is a very busy, volatile hour. By association, any short, busy period of time when big, expensive and/or, meaningful decisions and/or actions are made. *See* PIT.

Truman Doctrine, the (foreign policy) The foreign policy promising US military and/or economic help (e.g., soldiers, money) to any foreign government that is friendly to the US government but which is threatened by communist influence. [After PRESIDENT Harry 'Truman' (1884–1972) who announced this policy as a rationale for helping Greece and Turkey stem communism in 1947.]

Trump, Donald (people) (born in 1946) A real estate developer and billionaire. He owns many important buildings in NEW YORK CITY (eg. Plaza Hotel, Trump Tower, etc.) and has promoted ATLANTIC CITY as a casino and hotel resort. He is known for the gaudy display of his wealth, especially during the 1980s.

trust (economy) A number of powerful companies working together to control the supply and prices of products in a particular business or industry. This causes higher prices for consumers and gives trusts more money. ANTITRUST LAWS limit trusts from developing. *See* MONOPOLY, ROBBER BARONS.

Truth, Sojourner (people) (1797–1883) African-American lecturer who supported ABOLITION and women's rights by giving personal testimony and moving speeches and singing GOSPEL MUSIC songs to audiences in NEW ENGLAND and the MID-ATLANTIC (she had been a slave herself before 1826). She supported the CIVIL WAR and helped raise money which supported black military regiments. Late in her life, she promoted the establishment of a "Negro State" in the WEST and supported the WOMEN'S SUFFRAGE MOVEMENT. *See* BLACK NATIONALISM.

Tubman, Harriet (people) (1821–1913) African-American activist and supporter of women's rights. As a leader (called "conductor") of the UNDERGROUND RAILROAD she made 19 trips to the SOUTH to help over 300 blacks escape from SLAVERY by leading them to the NORTH. During the CIVIL WAR, she worked as a scout, spy and nurse; she is remembered for her daring, cleverness and self-sacrifice.

Turkey Day (customs and traditions) A nickname for THANKSGIVING DAY because roasted 'turkey' is traditionally eaten during the THANKSGIVING DINNER.

"turn on, tune in, and drop out!" (history) A slogan of the COUNTERCULTURE and HIPPIE movement popularized by TIMOTHY LEARY. It encouraged young people to 'turn on' to (i.e., start taking) drugs, usually illegal (e.g., LSD); 'tune in' to (i.e., learn about) the new concepts of universal peace and understanding that one could feel while taking these drugs; and 'drop out' of (i.e., leave) mainstream, capitalistic, aggressive society. *See* ANTIWAR MOVEMENT, SUMMER OF LOVE.

turnabout (customs and traditions) A type of DATE dance event in which women ask men to attend that event with them. Many HIGH SCHOOLS sponsor this type of SEMIFORMAL[1] dance. Also spelled "turnabout".

Turner, Frederick Jackson (people) (1861–1932) The historian credited with developing and promoting the theory that Americans had a unique character (e.g., independent, adventurous, willing to begin again) and history because of the FRONTIER. The essay he wrote which introduced this idea was entitled "The Significance of the Frontier in American History" (1893). This essay is sometimes known as the "Turner Thesis". *See* WEST, HOMESTEAD ACT.

Turner, Ted (people) (born Robert Edward Turner in 1938) A television executive and billionaire. He is known for founding the Turner Broadcasting System, Inc. (TBS) in 1970 and for owning CNN as well as for his charitable donation in 1997 of $1 billion dollars to the United Nations. He married JANE FONDA in 1991. He is based in ATLANTA.

Tuskegee University (education) An independent, accredited HIGHER EDUCATION institution in Tuskegee, Alabama. It was founded in 1881 by BOOKER T. WASHINGTON on an abandoned plantation to provide an agricultural and VOCATIONAL SCHOOL training to blacks. Now, it offers its 3,000 COEDUCATIONAL students programs at the ASSOCIATE'S DEGREE, BACHELOR'S DEGREE and MASTER'S DEGREE level. It was formerly known as "Tuskegee Institute". *See* PRIVATE SCHOOL; *compare* LIBERAL ARTS COLLEGE.

tuxedo (clothing) A men's suit consisting of a fitted jacket with satin or grosgrain lapels (known as a "DINNER JACKET") and a pair of trousers with a satin ribbon stripe running down the length of each pant leg. Underneath is worn a dress shirt with a wing collar and a bow tie; often a wide, fabric (e.g., silk) belt (i.e., cummerbund). Usually, it is worn for SEMIFORMAL[1] occasions. [After the COUNTRY CLUB at 'Tuxedo' Park, New York where this suit was worn.]

TV Guide (media) A weekly magazine, published in a smaller booklet-sized format, that contains the time schedules of programs and brief descriptions of COMMERCIAL and PAY-TV programs as well as articles about television celebrities and reviews of TV movies. It was founded in 1953 and has a circulation of 13 million.

Twain, Mark (people) (1835–1910, born Samuel Clemens) A writer of fiction and humor who used colloquial speech, the viewpoints of children, and humor to reveal different positive aspects (e.g., beauty of nature, friendship) and negative aspects (e.g., DISCRIMINATION, racism) of American culture. His most popular books include *The Adventures of Tom Sawyer* (1876) and *The Adventures of Huckleberry Finn* (1884), both of which take place on the MISSISSIPPI RIVER. [His pen name, 'Mark Twain', means "two fathoms" deep (i.e., 6 feet; 1.83 m) which is riverboat slang, meaning "safe water".]

Twelfth Amendment (politics) The AMENDMENT to the CONSTITUTION (ratified in 1804) that further established the law of electing the PRESIDENT and VICE PRESIDENT by ELECTORAL VOTES in the ELECTORAL COLLEGE.

Twentieth Amendment (government) The AMENDMENT to the CONSTITUTION (1933) that changed the beginning point of the PRESIDENT'S TERM[1] to 12:00 noon on January 20 and that of Congressional SESSIONS[2] to the first week of January. Since it shortened the "LAME DUCK period" it is also known as the "lame duck amendment". Before this time, the presidential term began in March. *See* INAUGURATION.

Twenty-fifth Amendment (government) The AMENDMENT to the CONSTITUTION (1967) stating that if the position of VICE PRESIDENT is vacant a PRESIDENT can appoint a Vice President. In addition, if the President cannot perform official duties (because of, e.g., physical sickness, medical operation), it allows the Vice President to act temporarily as President until the President has recovered.

Twenty-first Amendment (legal system) The addition to the CONSTITUTION (1933) that made it legal to buy and sell alcohol in the UNITED STATES; it repealed PROHIBITION and OVERRULED the EIGHTEENTH AMENDMENT.

twenty-first birthday (legal system) The birthday on which all people receive additional societal rights from the STATES, namely, buying alcohol, drinking alcohol and legally entering BARS[1]. Also, in many states, individuals are now legally able to gamble. It is considered an important RITE OF PASSAGE[1]. *Compare* (AGE OF) MAJORITY, MINOR[2].

Twenty-fourth Amendment (politics) The AMENDMENT to the CONSTITUTION (established in 1964) that abolished the POLL TAX in all STATE and national elections.

21-gun salute (customs and traditions) The firing of guns, a total of 21 separate shots. It is an official sign of respect and is done by any branch of the ARMED FORCES to honor a high-ranking person or the flag or the US. To honor the PRESIDENT, it is fired and then immediately followed by the playing of the song HAIL TO THE CHIEF (this is sometimes known as the "PRESIDENTIAL SALUTE"). To honor the flag, the STARS AND STRIPES[1] and/or the UNITED STATES OF AMERICA, it is fired and then immediately followed by the NATIONAL ANTHEM. Also known as the "national salute"; *compare* SALUTE TO THE UNION.

Twenty-second Amendment (politics) The AMENDMENT to the CONSTITUTION (ratified in 1951) stating that a person can be elected PRESIDENT only twice (i.e., to two TERMS[1]) or hold that position a maximum of 10 years. It was adopted after FRANKLIN ROOSEVELT had been elected for four TERMS[1].

Twenty-seventh Amendment (government) The AMENDMENT to the CONSTITUTION (1992) stating that when CONGRESSMEMBERS vote to give themselves an increase in salary, that raise occurs only after the next Congressional election.

Twenty-sixth Amendment (legal system) The addition to the CONSTITUTION (1971) that gives American citizens aged 18 years and older the right to vote in elections. *See* MAJORITY (AGE OF), DRAFT[1].

Twenty-third Amendment (politics) The AMENDMENT to the CONSTITUTION (established in 1961) giving the DISTRICT OF COLUMBIA three ELECTORAL VOTES in the ELECTORAL COLLEGE. *See* ELECTORS.

Twin Cities, the (geography) The collective name for St. Paul (the capital city) and Minneapolis (the larger city of the two), the two major cities of the STATE of Minnesota which are separated from each other only by the MISSISSIPPI RIVER. Together, the two are consistently ranked by organizations as pleasant, clean places to live.

two-bit (the arts) Describing something that is second rate, or of a lower quality. [A nineteenth-century term, meaning "25 cents".]

two-party system, the (politics) The long political tradition in the UNITED STATES of having only two major political parties which has resulted in voters viewing issues as a DEMOCRAT or as a REPUBLICAN and the development of election laws which benefit these two parties. This makes the lasting success of any new THIRD PARTY[1] very difficult. *See* FEDERAL ELECTION CAMPAIGN ACT OF 1972.

two-year college (education) Another name for COMMUNITY COLLEGE.

U

Umpire (sports and leisure) In sports, the official officer on the playing court or field who decides if a ball is good (i.e., can be played) or not and if the actions of the players are FOUL[1,2] or not. He or she wears distinctive dark clothing to be distinguished from the players. In BASKETBALL, this official wears black pants and a shirt with black and white vertical stripes. Usually, there are one or two umpires officiating a basketball game. In BASEBALL, this official wears a black baseball cap, black pants and a black jacket worn over a light blue shirt. Most MAJOR LEAGUE games have four umpires, one each at FIRST BASE, SECOND BASE, THIRD BASE and HOME PLATE.

Uncle Remus stories (the arts) A collective name for the various short, moralistic stories for children with animal characters, namely BRIAR RABBIT. They have a distinctive oral, storytelling quality to them. These stories are based on African folk tales and were told by AFRICAN AMERICANS living in the SOUTH to their children. During the nineteenth century, some of them were told to Joel Chandler Harris (1848–1908), a white writer, who then wrote them down and published them.

Uncle Sam (customs and traditions) A tall, thin, older male folk character who has white hair, a white beard on his chin and wears clothing decorated with the patterns of the STARS AND STRIPES[1], namely, a blue tailcoat, red and white striped pants and a top hat with stars. He is a symbol of the UNITED STATES and represents patriotism. [After 'Uncle Sam' (his initials were "US") Wilson, a real person remembered for his patriotism as a soldier in the AMERICAN REVOLUTION and a food inspector for the United States ARMY during the WAR OF 1812.] *See* RED, WHITE AND BLUE; *compare* COLUMBIA[1].

Uncle Tom (minorities) A pejorative name for a black person who is meek and too eager to please and win the approval of whites, often serving and caring for whites or superiors to the detriment of his or her own condition. By association, any person of a low position who is overeager to please superiors even though it hurts his or her own position. [After the devoted black slave and title character in the book *UNCLE TOM'S CABIN* published in 1852.] Also known as a "Tom"; *compare* UNCLE TOMAHAWK.

Uncle Tom's Cabin (history) The anti-SLAVERY book (published 1852), which details the hard life (under white overseers) of black slaves in Kentucky. The novel was written by HARRIET BEECHER STOWE and encouraged many readers in the NORTH to support ABOLITION. *See* SIMON LEGREE, AMERICAN RENAISSANCE.

Uncle Tomahawk (minorities) The pejorative term used to refer to a CONSERVATIVE NATIVE AMERICAN who tries to please white people, the BUREAU OF INDIAN AFFAIRS and/or other people in positions of power, especially by choosing to agree with those more powerful people even when it hurts himself or herself. During the 1960s, this type of person usually lived on a RESERVATION but accepted TERMINATION; he or she did not support RED POWER. [From 'UNCLE' TOM + 'tomahawk', a traditional weapon used by INDIANS.] *Compare* TRADITIONALS.

unconstitutional (legal system) Describing a law, action or statement that does not follow the rules laid out by the CONSTITUTION and the COMMON LAW derived from it; describing something that is illegal.

undergraduate (education) A student enrolled in an academic program at a COLLEGE[1] or UNIVERSITY which leads to a BACHELOR'S DEGREE. By association, relating to academic or social life during this period.

Underground Railroad, the (history) Before the CIVIL WAR, the name for the human network in which people, usually free blacks from the NORTH, traveled to the SOUTH and led black slaves to freedom in the northern STATES and Canada. During the long, usually foot-trip north through several states, the leader (known as a "conductor") and the escaped slaves lodged in the homes, barns and storage

areas owned by sympathetic civilians or they bivouacked. HARRIET TUBMAN was one of its most famous and successful "conductors". *See* ABOLITION, BIVOUAC.

underwriting (economy) The business of bankers who buy stocks and bonds from a CORPORATION, government and/or bank at a certain price and then sell them at a higher price to investors. The **underwriter** guarantees the value and growth of these stocks and bonds to the investors.

Unemployment Compensation (work) A type of insurance plan for workers which gives cash or medical care to employees who were hurt while working on the job, or gives cash payments to the family of a worker who was killed while on the job. This money comes from federal and STATE governments as well as workers' and employers' taxes. Its distribution is overseen by the Unemployment Insurance Service program of the DEPARTMENT OF LABOR and is operated by the federal government and states. It covers workers in industry, the PRIVATE SECTOR and the federal government. It is a type of SOCIAL SECURITY program. Also known as "Unemployment benefits".

Unification Church (religion) A religious group which promotes FAMILY VALUES, marriage and avoiding drugs. It was founded in Korea in 1954 by Mr. Sun Myng Moon (born in 1920) and became popular in the US in the early 1970s after Moon immigrated to the US; it was particularly popular among young Americans who were not members of the COUNTERCULTURE. Members, known as "MOONIES", follow the teachings in Moon's book *The Divine Principle* (1957) and believe that both Jesus Christ and Moon are holy. Occasionally, Moon performs mass marriages of hundreds of young couples, dressed in identical clothing, held in large sports stadiums. It is controversial because new members usually end all contact with their own birth families; also because, in 1982, Moon served a jail sentence for not paying personal INCOME TAXES in the US. Also known as "THE MOONIES".

union (1 work; 2 education; 3 history; 4 government) **1** A worker's organization; a labor union. An "industrial union" is a labor union in which all types of workers may be members (e.g., WOBBLIES, skilled and unskilled workers). A "craft union" or "trade union" is a labor union whose membership is limited to workers who share the same job or skill (e.g., UNITED AUTO WORKERS). **2** A building containing many CAMPUS-oriented activities and student services at a COLLEGE[3]. Usually, it houses the offices of different student groups (i.e., STUDENT COUNCIL, FRATERNITIES, SORORITIES, college newspaper and HONOR SOCIETIES) as well as having restaurants/cafeterias, pool halls, game rooms, bookstores, gift shops and providing banking services. **3 the Union** Historical term referring to the NORTH, its army and military forces and its anti-SLAVERY supporters during the CIVIL WAR. Its soldiers wore blue-colored uniforms. It fought against the army of the CONFEDERATE STATES OF AMERICA. *See* BLUE AND THE GRAY. **4** A term referring to the UNITED STATES (e.g., the STATE OF THE UNION MESSAGE) and the collection of the STATES.

union shop (work) A term describing a business practice which requires all newly hired workers to join, within a specified period of time (e.g., 30 days), the labor UNION[1] that is appropriate for their jobs. If a worker signs the contract, he or she agrees to "union shop". *Compare* YELLOW-DOG CONTRACT.

United Auto Workers (work) (UAW) A national craft labor UNION[1] and one of the strongest and most powerful UNIONS[1] in the UNITED STATES with some 1.3 million members and over 1,100 LOCALS. It was founded in 1935 originally for workers in the car and truck manufacturing industry. It joined the CIO in 1936; but due to a dispute in 1968 it left the AFL-CIO. Today, it is again an AFFILIATE[1] of the AFL-CIO and its headquarters are located in DETROIT, Michigan. Its full name is the "United Automobile, Aerospace, and Agricultural Implement Workers of America". *See* RUSTBELT, MOTOWN.

United Farm Workers of America (work) (UFW) A labor UNION[1] that works to improve the working conditions, salaries and health care programs for migrant workers and farm workers in the fruit industry. It was first established in

1962 by CÉSAR CHÁVEZ which, under his leadership (1962–1993), held worker STRIKES[1] of grapes and lettuce in order to negotiate contracts with the management of these fruit businesses. It became a full member of the AFL-CIO in 1972 and currently has 50,000 members. Because many of the original members were LATINOS, it also served as a social group during the CHICANO MOVEMENT practicing Chávez's idea of "LA CAUSA". Before 1972, it was known as the "NATIONAL FARM WORKERS' ASSOCIATION" (NFWA).

United Mine Workers of America (work) (UMWA) A craft UNION[1] for people who work in the coal and other mining industries. It was founded in 1890 and its headquarters are in WASHINGTON D.C. Currently, it counts 130,000 members in some 600 LOCALS. It is an AFFILIATE[1] of the AFL-CIO.

United Negro College Fund (education) (UNCF) An organization that helps raise money to support some 40 different private BLACK COLLEGES largely located in the SOUTH. After it gives these COLLEGES[1] the money, the SCHOOLS[5] offer that money to needy SECONDARY SCHOOL and COLLEGE[3]-aged black students in the form of academic SCHOLARSHIPS.

United Press International (media) (UPI) The large news wire service which provides prepared news articles to other newspapers for publication in exchange for a fee. Further, its sports writers nominate amateur athletes to the status of ALL-AMERICAN[1]. *Compare* ASSOCIATED PRESS.

United Society of Believers in Christ's Second Coming (religion) A Christian religious group that grew out of the QUAKER movement and was established in the US in 1774 by the Englishwoman, "Mother" Ann Lee (1736–1784). Its members, SHAKERS, form COMMUNES in order to live in a more simple, independent way. Shakers oppose war and believe that men and women are equal but must remain separate from each other (that is, they cannot have sex with each other). In the early nineteenth century, it had 5,000 total members in 19 different communes. Today, however, because of the no-sex rule, there is only one small group left. Also known as "SHAKERS"; *see* SHAKER FURNITURE.

United States Air Force Academy (education) A federally funded COLLEGE[1] that gives men and women an academic education and special training for a future career in the US AIR FORCE. It was founded in 1954 by Congressional law. Upon graduation, the 4,000 UNDERGRADUATES earn a BACHELOR'S DEGREE and a four- to six-year-long commission in the Air Force. Its athletic teams are known either as "Air Force" or by their mascot, the "Falcons". The CAMPUS is located in Colorado Springs, Colorado.

United States Military Academy (education) The formal, full name for WEST POINT.

United States Naval Academy (education) (Navy) A federally-funded COLLEGE[1] where students receive a BACHELOR'S DEGREE and a military training and, after graduation, a (four- to six-year-long) commission in the US NAVY. It was established by the SECRETARY of the Navy in 1845 and is located in Annapolis, Maryland. The COEDUCATIONAL student body consists of 4,000 UNDERGRADUATES. Its athletic teams are known either as "Navy" or by their mascot, the "Midshipmen". On the CAMPUS is the NAVY–MARINE CORPS stadium where the famous ARMY–NAVY FOOTBALL GAMES are held. *See* MARINE CORPS.

United States (of America), the (geography) (USA) The independent country lying on the North American continent which consists of 3,022,378 square miles (7,827,982 sq. km) of land; when the regions of Alaska and Hawaii are included, it consists of a total of 3,615,122 square miles (9,363,166 sq. km) of land. To the north lies the separate country of Canada; to the south lies the independent country of Mexico. The USA consists of 50 total STATES and several TERRITORIES; its political capital city is WASHINGTON D.C. It is popularly and neutrally referred to by its citizens as "The States" and "the US"; *see* AMERICA[1], Appendix 2 Presidents, TREATY OF GUADALUPE HIDALGO.

United States Golf Association (sports and leisure) (USGA) The organized group formed in 1894 that governs the sport of golf in the UNITED STATES,

including making rules for amateur golf and professional golf. It sponsors some 13 different tournaments for professionals, amateurs, seniors (*see* SENIOR CITIZEN) and juniors, including the US OPEN TOURNAMENT, US WOMEN'S OPEN TOURNAMENT and the USGA Championships.

United States Tennis Association (sports and leisure) (USTA) An organized body to promote the sport of tennis at the family, junior (until 14 years of age), amateur and professional level. It keeps records of tennis matches and players' statistics and sponsors many tournaments for players of all levels, notably the DAVIS CUP and the US OPEN CHAMPIONSHIP. It was founded in 1881 as the "US Lawn Tennis Association"; since 1975 it has been known by its current name.

United Steel Workers of America* v. *Weber, et al. (work) The DECISION of the SUPREME COURT (1979) stating that black employees could receive preference (over whites) in those job training programs that businesses offer voluntarily to their workers. The case concerned Mr. 'Weber', a white man who claimed he was suffering from REVERSE DISCRIMINATION by his employer, UNITED STEEL WORKERS; because the training program offered by his employer to help workers improve their skills had chosen blacks with fewer skills and not him. This decision claimed that reverse discrimination was not an issue here, therefore agreeing with a ruling decided by a LOWER COURT. *Compare* REGENTS OF THE UNIVERSITY OF CALIFORNIA v. ALLAN BAKKE, DISCRIMINATION.

United Steelworkers of America (work) (USWA) A craft UNION[1] for people who work in the steel industry. It was founded in 1936 and its headquarters are in Pittsburgh, Pennsylvania. Currently, it counts 550,000 members in some 2,300 LOCALS. It is an AFFILIATE[1] of the AFL-CIO. *Compare* RUSTBELT.

Universal Negro Improvement Association (minorities) (UNIA) An organization promoting BLACK NATIONALISM and separatism that tried to improve the conditions of Africans and all peoples of African descent by encouraging them to unite and for all blacks and AFRICAN AMERICANS to return to Africa and to live

there (*see* BACK-TO-AFRICA movement). It was also interested in creating real economic opportunities for blacks. It was founded in 1916 by MARCUS GARVEY who after 1920 served as its president-general and chief administrator. Its colors were red, black and green and it published its ideas in its own newspaper, *Negro World*. Although it was popular immediately after WORLD WAR I, due to Garvey's king-like behavior and poor handling of finances, the organization lost members, suffered and disintegrated after 1930.

university (education) An academic institution that is composed of COLLEGES[2] and SCHOOLS[2] at the UNDERGRADUATE level in LIBERAL ARTS and sciences, as well as SCHOOLS[4] at the GRADUATE SCHOOL and PROFESSIONAL SCHOOL levels. Often, it is located on a CAMPUS and it offers its students athletic programs and sports teams to compete at the INTERCOLLEGIATE level. It is another name for COLLEGE[1]. *See* STATE UNIVERSITY, PRIVATE UNIVERSITY, SORORITY, FRATERNITY, Appendix 4 Education Levels.

University of California (education) (UC) One of the largest and most well-respected COEDUCATIONAL, non-religious STATE UNIVERSITY systems. It is composed of nine CAMPUSES, all of which were established at different times (UC BERKELEY, 1868; UC Davis, 1905; UC Irvine, 1964; UC Los Angeles (or UCLA), 1919; UC Riverside, 1954; UC Santa Barbara, 1898; UC Santa Cruz, 1965; UC San Diego, 1959; and UC San Francisco, 1864), and has a total population of almost 200,000 students. In addition, the UC system has various scientific laboratories, observatories and agricultural experiment stations in other locations in California. It has ACCREDITATION and offers 565 different UNDERGRADUATE programs, 250 MASTER'S DEGREE-level programs, and 200 PHD programs. It is an NCAA member; its teams compete at the INTERCOLLEGIATE level and its athletic mascot is the "Golden Bear". *See* PUBLIC SCHOOL, INTERCOLLEGIATE.

University of California, Berkeley (education) The oldest CAMPUS and most prestigious UNIVERSITY in the public UNIVERSITY OF CALIFORNIA system. It was

founded in 1868 in Berkeley, CALIFORNIA. It is famous for its very strong BACHELOR'S DEGREE programs, its GRADUATE SCHOOL of engineering and its talented faculty which includes more PULITZER PRIZE winners, NATIONAL ACADEMY OF SCIENCE members and Nobel Laureates than any other university in the US. During the 1960s it was the scene of LIBERAL ANTI-WAR MOVEMENT student protests. Currently, the CO-EDUCATIONAL student population has 21,000 UNDERGRADUATES and 8,000 GRADUATES[2]. [After Irish bishop, George 'Berkeley' (1685–1753).] Also known as "U Cal, Berkeley" as well as "Berkeley"; *see* STATE UNIVERSITY, PUBLIC SCHOOL, SUMMER OF LOVE.

University of Chicago (education) A very well-respected, independent UNIVERSITY which is famous for its strong academic programs at the BACHELOR'S DEGREE level, its law SCHOOL[4] and its prestigious faculty. It is located in CHICAGO, Illinois and was originally founded in 1890 by the BAPTIST CHURCH and financed by an endowment from JOHN D. ROCKEFELLER[1]. Its COED student body counts 3,400 UNDERGRADUATES and 8,000 GRADUATES[2]. It is an accredited UNIVERSITY and an NCAA member; its teams compete at the INTERCOLLEGIATE level. It owns and operates the famous University of Chicago Press which publishes scholarly journals and books. *See* PRIVATE SCHOOL, ACCREDITATION.

University of Michigan (education) (U of M) A large, STATE UNIVERSITY and BIG TEN member which is well respected for the strength of its UNDERGRADUATE programs, GRADUATE SCHOOLS of business, engineering, law and medicine as well as its NCAA INTERCOLLEGIATE athletics, especially FOOTBALL. Its athletic teams are known as the "Wolverines". It was founded in 1817 in Ann Arbor, Michigan and later was funded by the MORRILL ACT (1862). During the 1960s, its students were active in the ANTI-WAR MOVEMENT and protests. Today, the COED population includes 23,000 UNDERGRADUATES and 13,000 GRADUATES[2]. It has ACCREDITATION.

University of Mississippi (education) A STATE-supported, accredited UNIVERSITY. It was founded in 1844 in Oxford, Mississippi. Its campus was the site of CIVIL RIGHTS protests in the 1960s, especially with the enrollment of JAMES MEREDITH. Today, it has a COED population of 8,000 UNDERGRADUATES and 2,000 GRADUATES[2] and is an NCAA member; its teams compete at the INTERCOLLEGIATE level. Its athletic teams are known as the "Rebels", the university's mascot. Often, it is referred to as "Ol' Miss". *See* ACCREDITATION.

University of Notre Dame (education) A private, ROMAN CATHOLIC CHURCH-affiliated UNIVERSITY famous for its UNDERGRADUATE LIBERAL ARTS programs, GRADUATE SCHOOL in business and competitive INTERCOLLEGIATE NCAA FOOTBALL team. It was founded in 1842 in Southbend, Indiana by the Jesuit order. The COEDUCATIONAL student body has 7,600 UNDERGRADUATES and 2,500 GRADUATES[2]. It is an accredited university. Its sport mascot is an Irish leprechaun (i.e., a small figure of an orange-haired man wearing a green-colored suit) representing the "Fighting Irish" spirit. It is popularly known as "Notre Dame". *See* PRIVATE SCHOOL, ACCREDITATION.

University of Virginia (education) (UVA) A large, public UNIVERSITY well respected for its BACHELOR'S DEGREE programs and its law SCHOOL[4]. It was founded in 1819 in Charlottesville, Virginia by THOMAS JEFFERSON who also designed the CAMPUS buildings which are built of red brick. Today, it is a COED institution with 12,000 UNDERGRADUATES and 5,000 GRADUATES[2]. It has ACCREDITATION and is an NCAA member; its teams compete at the INTERCOLLEGIATE level. The athletic teams and the university mascot are the "Cavaliers".

University of Wisconsin, at Madison (education) A large STATE UNIVERSITY which is known for the LIBERAL attitude and spirit of its students and professors. It is located in the small town of 'Madison' in the MIDWEST. It was founded in 1848; during the 1960s, its student population was very active in the ANTI-WAR MOVEMENT. Today, its COED population counts 40,000 UNDERGRADUATE and GRADUATE[2] students. It is a member of the BIG TEN and its athletic teams compete at the NCAA INTERCOLLEGIATE level. Its teams'

mascot is the badger. It is the oldest of the 13 total branches of the larger system of the University of Wisconsin.

Updike, John (people) (born in 1932) An author whose many books of fiction often treat contemporary middle-class concerns and have middle-class characters. His most famous character is Harry "Rabbit" Angstrom, whose middle-class "life" Updike explored through a series of novels beginning with *Rabbit, Run* (1961) and ending with *Rabbit at Rest* (1990) which won the PULITZER PRIZE.

upper class (society) A collective name for that group who earn salaries which allow them to live in a comfortable or luxurious way. "Middle upper-class" and "upper upper-class" usually make large salaries and therefore can afford to live in an expensive way. It includes doctors, LAWYERS; ENTREPENEUERS and some high-ranking business managers. *Compare* MIDDLE CLASS, UPPER CRUST.

upper crust, the (society) Those people who make up the highest, wealthiest social class. [From the COLONIAL PERIOD when a sign of wealth was to make a PIE with a bottom pastry crust as well as 'upper' rows of pastry 'crust' strips on top of the fruit. Only wealthy families could afford to buy the flour and fat necessary for this type of upper crust pie.] *Compare* UPPER CLASS.

upstate (geography) Land and businesses found in the northern part of a STATE. Specifically, it refers to all areas of New York STATE north and west of NEW YORK CITY (i.e., not LONG ISLAND).

uptown (geography) That part of a town or city located on a higher ground surface (e.g., a hill) than DOWNTOWN. In NEW YORK CITY, it usually refers to the elegant residential areas on the northern half of MANHATTAN[1]. By association, describing something that is rich, wealthy, fancy or pertaining to the UPPER CRUST.

Upward Bound (education) A federally-supported program that gives GRANTS to students from lower socio-economic families in order to pay for HIGHER EDUCATION. It offers remedial teaching, private tutoring and WORK-STUDY opportunities. *See* HIGHER EDUCATION ACT, REMEDIAL EDUCATION.

urban contemporary (media) A format for music radio stations, playing current recorded music, popular with adult black audiences. Also known as "urban adult contemporary".

US, the (geography) (USA) An abbreviation for the UNITED STATES (OF AMERICA). Usually, it is used to refer to the country's federal government, national policies and/or nationwide laws. *See* UNCLE SAM; compare AMERICA[1].

US Court of Appeals (legal system) A system of federal courts that hears those cases on APPEAL which were already tried in the US DISTRICT COURTS. It was created in 1891 to alleviate the workload of the Supreme Court, especially by hearing appeal cases from the federal trial courts. The Court of Appeals is the last national court before the SUPREME COURT; and the higher court rarely reverses a decision of the Court of Appeals. The UNITED STATES is divided into 12 judicial regions or circuits, and there is one US Court of Appeals for each circuit. All judges are appointed by the PRESIDENT. Before 1948, these courts were known as "Circuit Courts of Appeals". Many STATES have a similar system of state court of appeals. *See* APPOINTMENT POWER.

US Court of Claims (legal system) A special federal judicial court settling problems that an individual or group brings against the UNITED STATES, especially concerning a right to property (e.g., land claim suits by Indian TRIBES) in the CONSTITUTION, Congressional law or EXECUTIVE ORDER or action. It was created by CONGRESS in 1855. Today, many STATES have their own state courts of claims. *Compare* INDIAN CLAIMS COMMISSION.

US District Court (legal system) The lowest court in the system of federal courts and the only one that uses a JURY and witnesses to decide a legal case. It hears those CIVIL TRIALS and CRIMINAL TRIALS that concern federal laws and is the court where most federal cases begin (i.e., ORIGINAL JURISDICTION). All the judges are appointed by the PRESIDENT with the ADVICE AND CONSENT of the SENATE. The US is divided into (93 total) geographical districts with each having a US District Court. Also known as "Dis-

trict Court" and "federal district court"; *see* APPOINTMENT POWER; *compare* US COURT OF APPEALS.

US Fish and Wildlife Service (environment) The federal agency which protects the various species of fish and forms of wildlife as well as their habitats and ECOSYSTEMS. Also, it studies the problems of chemicals and other products on the environment. It is part of the DEPARTMENT OF THE INTERIOR.

US Open (Championship), the (sports and leisure) An annual international tennis tournament for professional and amateur players. It holds competitions for men and women in singles, doubles and mixed doubles. It was first held in 1881 for men and in 1887 for women. It is sponsored by the USTA and held at Flushing Meadow, New York. It is the last championship tournament of the GRAND SLAM[1].

US Open (Tournament), the (sports and leisure) In golf, a major tournament 'open' to professional and amateur international male golfers. It was first held in 1895 and is sponsored by the USGA. It is held in June but its location changes every year. It is the second championship tournament of the GRAND SLAM[2]. *Compare* US WOMEN'S OPEN TOURNAMENT.

US Public Health Service (health) (USPHS) The division of the federal government which tries to protect the physical and mental health of people through prevention and warnings, namely by providing immunizations, supplying family planning advice, conducting medical research and providing care services, especially for the INDIAN HEALTH SERVICE (since 1955). It was founded in 1798 and is now overseen by the SURGEON GENERAL whose office is part of the DEPARTMENT OF HEALTH AND HUMAN SERVICES.

US Women's Open (Tournament), the (sports and leisure) In golf, a major tournament open to professional and amateur international female golfers. It was first held in 1946 and is sponsored by the USGA. Its location changes every year. *Compare* US OPEN TOURNAMENT.

USA Today (media) The daily newspaper printed nationwide. It contains short, concise news articles, brightly-colored pictures, charts and graphs and an in-depth sports section. It was founded in 1982 by the GANNET COMPANY; its current circulation is 1.6 million.

USS (transportation) An abbreviation of 'United States ship', a prefix to the name of any sea or space ship.

Utne Reader (media) A magazine founded in 1984, that publishes excerpts of articles found in other magazines and books of LIBERAL opinions. The topics include: national politics, environmental issues, women and MINORITY issues and the arts and sciences. Its subtitle is "The Best of Alternative Press". It is printed once every two months; its current circulation is 300,000.

V

valedictorian (education) In a SECONDARY SCHOOL or COLLEGE[3], the student with the highest GPA in the graduating CLASS. This title is a very prestigious honor. This student is given the honor of presenting the VALEDICTORY SPEECH at the COMMENCEMENT exercises. *Compare* SALUTATORIAN.

valedictory speech (education) During COMMENCEMENT ceremonies, the speech presented by the VALEDICTORIAN to fellow students and the audience. Usually, it is a respectful speech which examines the CLASS's past years at that SCHOOL[5] and looks forward to the future of those graduating.

valentine (customs and traditions) A GREETING CARD or self-made card often decorated in red and pink hearts and containing a poem which is given to a special friend, partner or spouse on VALENTINE'S DAY.

Valentine's Day (customs and traditions) February 14, the day lovers celebrate their romantic love by giving each other red roses, chocolate candy, VALENTINES, poems, messages printed for each other in the PERSONALS of newspapers or other public actions and displays. Children may give their friends or classmates small valentines, chocolates or other can-

dies. [After the ROMAN CATHOLIC CHURCH feast day honoring 'Saint Valentine' who was beheaded for his belief in Christianity on this day in the year *c.* 270 A.D.; however, it is associated with lovers because of a natural folkloric belief that on this date wild birds begin choosing their mates.] Formally known as "Saint Valentine's Day".

Vanity Fair (media) A monthly, general interest magazine containing articles and glossy photographs of current social issues, celebrities and the arts. It was founded in 1983 and has a circulation of 1.1 million.

varsity (sports and leisure) The main team of a HIGH SCHOOL or COLLEGE[1] sport that is usually made up of JUNIORS and SENIORS. Often it is governed by the NCAA. *See* EXTRACURRICULAR ACTIVITIES, LETTER; *compare* JUNIOR VARSITY.

vaudeville (the arts) A type of live entertainment popular during the nineteenth century which included singing, dancing, mime and the acting out of comedic scenes. It disappeared about 1920 due to the rise of talking movies. *See* TALKIES.

Venice Beach (geography) The white, sandy beach on the Pacific Coast located west of DOWNTOWN LOS ANGELES. It is known for attracting a daily variety of people practicing unusual athletic or personal displays, namely body builders, weight lifters, roller bladers, jugglers and people wearing unusual clothing. [After its location in the town, Venice, California, which was designed in 1905 and developed with canals and large houses after the famous Italian city, 'Venice'.]

Verrazano-Narrows Bridge (transportation) In NEW YORK CITY, a long two-tiered bridge for auto traffic and the longest suspension bridge in the UNITED STATES (4,260 feet; 1,278 m); it connects BROOKLYN with Staten Island. After it was built, it encouraged economic and housing development on Staten Island. [After Giovanni 'Verrazano' (*c.* 1485–1528) a navigator from Florence, Italy.]

vest (1, 2 clothing) **1** A sleeveless, upper-body piece of clothing which covers the chest, has buttons up the front and is worn over a shirt and under a jacket. With a

pair of pants and jacket it is the third component of a "three-piece suit". **2** Any sleeveless garment worn over the chest (e.g., bullet-proof vest).

Veterans' Day (military) November 11, the legal holiday celebrating the living veterans of all American wars and military actions. Originally, and before 1954, it was known as "Armistice Day" and celebrated the end of World War I (on November 1918) and its veterans. Today, many different veterans' groups, especially the VETERANS OF FOREIGN WARS and the AMERICAN LEGION, sponsor parades, speeches and hold special events and services in local communities to honor all veterans and promote veterans' issues (e.g., affordable health care, housing, education). Often these events and services are held in public places such as at military monuments, military statues and/or military hospitals. *Compare* MEMORIAL DAY.

Veterans of Foreign Wars (of the US) (military) (VFW) The oldest and second largest organization for American veterans. The VFW was founded in 1899 and today has meeting halls (known as "posts") located throughout the country. It counts some 2.1 million members, many of whom participate in parades or special services on VETERANS' DAY and MEMORIAL DAY.

Vice President (government) The person who is elected with the PRESIDENT and acts as the President in his or her absence, or becomes the President if the CHIEF EXECUTIVE dies, resigns or is impeached and removed by CONGRESS from that position. His or her only official duty is as PRESIDENT OF THE SENATE. *See* TWELFTH AMENDMENT, TWENTY-FIFTH AMENDMENT, IMPEACHMENT, AIR FORCE Two, Appendix 2 Presidents.

Vietnam Veterans' Memorial, the (military) A long, black marble wall honoring the soldiers who died in the VIETNAM WAR designed by Ms.[1] Maya Ying Lin. The wall is engraved with the names of the 58,000 Americans who died in that conflict and war. It is located in WASHINGTON D.C. and is a powerful, emotional symbol for veterans of that war. Many visitors leave flowers before that panel of the wall where the loved

one's name is engraved as well as make a rubbing of that person's name on a piece of paper.

Vietnam War, the (foreign policy) During the COLD WAR, the war in which the UNITED STATES tried to preserve the noncommunist country of South Vietnam (known as the Republic of Vietnam) as separate and independent of its communist neighbor, North Vietnam (known as the Democratic Republic of Vietnam). North Vietnam was controlled by Ho Chi Minh (1890–1969), supported by the special, National Liberation Forces (NLF), known as the "Viet Cong" (VC) forces, and received assistance from the Soviet Union and Communist China. The South Vietnamese received support from the US to help prevent a communist takeover: from 1955 to 1961, the US sent them money and American military advisers; after 1962, the US sent military troops. The US became directly involved in the war and combat in 1964, after the GULF OF TONKIN RESOLUTION. During the active war (1964–1973) the US employed, in total, over 8.7 million military personnel; spent over $140 billion; used advanced technology, airplanes, bombs and ground forces to fight the enemy forces in South Vietnam and even invaded the neighboring country of Cambodia (from April 30 to June 30, 1970) to destroy enemy supply stations. However, despite these efforts and western-style warfare, the US did not make substantial gains. After the TET OFFENSIVE, the US and North Vietnam signed the Paris Peace Agreement (on January 27, 1973) in which a cease-fire was established, and the US agreed to remove its ARMED FORCES in exchange for the return of American POWs. Although many young American men were drafted to serve in the war, the American public grew continually less supportive of it after 1967; people often held public demonstrations against it (*see* ANTI-WAR MOVEMENT). This war is generally considered a US failure because, although it was the longest war in which the United States has ever fought (i.e., nine years long) and some 58,000 American soldiers died in it, it was the first war in which the US did not achieve its goals. On April 30, 1975, the North Vietnamese and Viet Cong forces invaded and captured the South Vietnamese capital city of Saigon, which then became communist. Reasons named for this failure include: too much media coverage of the war; the strong determination of the enemy; limitations of the US military; and lack of support from the American public. This war encouraged US PRESIDENTS to use more war powers than they are given by the CONSTITUTION; and it encouraged the public's general distrust of politicians as well as military conflicts. Meanwhile, it hurt the domestic programs of President LYNDON JOHNSON and showed that no one country in the world is allpowerful. *See* CONTAINMENT, DRAFT[1], MARCH ON WASHINGTON TO END THE WAR IN VIETNAM, KENT STATE MASSACRE/INCIDENT, PENTAGON PAPERS, SPECIAL FORCES, MY LAI MASSACRE, "IMPERIAL PRESIDENCY", GREAT SOCIETY, WAR ON POVERTY, VIETNAM WAR SYNDROME, VIETNAM VETERANS' MEMORIAL; *compare* GULF WAR.

Vietnam War Syndrome (foreign policy) The fear or refusal of the American public to support the use of US military and ARMED FORCES in a foreign country, largely because they do not see a need for it or because they do not know the purpose of it. It was slightly diminished by the quick US victory in the GULF WAR. [After the public's general decrease of support for the 'VIETNAM WAR'.]

viewing (customs and traditions) A short type of respectful, supportive service in which the family of a deceased person receives guests who wish to show their respect for that deceased person or support for the family that has lost a member. Usually, it is held at a FUNERAL HOME. Guests may sign a book and make comments about the deceased (which the family keeps and reads later) and/or speak to family members and sometimes hear a bible reading or sing hymns or songs. Usually, the coffin with the body of the deceased is present, and guests show respect or acknowledge it in their own manner (e.g., approaching it, not approaching it). "Open casket" refers to a type of viewing at which part or all of the coffin lid is open allowing guests to see all

or part of the dressed and prepared body of the deceased. "Closed casket" refers to a type of viewing at which the lid of the coffin is shut; guests cannot see the body. Today, viewings may be held with or without coffins or with or without urns. Usually, it is held in the evening and lasts from two to four hours over a period of one to three days. Often, it precedes the funeral by one or more days. Sometimes called a "wake".

Village Voice, The (media) A weekly newspaper with LIBERAL opinions that covers the arts, fashion and investigates the current issues in and affecting GREEN-WICH VILLAGE in NEW YORK CITY. It sponsors and distributes the annual OBIE awards. It was founded in 1955 and has a circulation of 150,000.

visa, F-1 (immigration) A type of visa issued by the IMMIGRATION AND NATURA-LIZATION SERVICE to a non-American student who has been accepted to attend a HIGHER EDUCATION institution for academic or English language courses (i.e., ESL). The **F-2** visa is given to the spouse and/or children of an F-1 visa holder.

visa, J-1 (immigration) A type of visa permit issued by the IMMIGRATION AND NATURALIZATION SERVICE to international visitors on exchange programs (e.g., UNI-VERSITY PROFESSORS, SECONDARY SCHOOL teachers and students) which permits them to live and travel in the US for a deter-mined period of time.

visa, M-1 (immigration) A visa permit issued by the IMMIGRATION AND NATURA-LIZATION SERVICE to non-American stu-dents who have been accepted to study at a VOCATIONAL SCHOOL in the US.

VISTA (history) A nationwide program targeted on improving urban and rural poverty in the UNITED STATES which was based on the successful PEACE CORPS program. VISTA recruited people to live and work for one year in poorer urban and/or rural American areas in various fields, namely, education and health. It was created by the Economic Opportunity Act of 1964, which was a key piece of legislation of the GREAT SOCIETY. In 1971 it was replaced by ACTION. [Abbrevia-tion of 'V'olunteers 'i'n 'S'ervice 't'o 'A'merica.] *See* WAR ON POVERTY.

Vocational Rehabilitation Act (mino-rities) The federal law (passed in 1973) and its various amendments in which federal contractors and SUBCONTRACTORS must try to give jobs to those qualified HANDI-CAPPED individuals who apply. It is an example of an AFFIRMATIVE ACTION federal law.

vocational school (education) A post-SECONDARY SCHOOL that gives a practical training (from six months to two years) in various jobs (e.g., plumbing, cosmetology, heating/air conditioning repair) and awards a certificate of completion. Also known as "technical school" or "technical institute"; *see* Appendix 4 Educational Levels.

Vogue (media) A glossy monthly maga-zine for women aged 20 to 40, with articles and photographs of women's chic, con-temporary fashion, beauty and health. Its current US circulation is 1.2 million. It was founded in 1892. By association, describing something or some woman that is chic and/or glamorous.

voice vote (government) A vote taken in a legislature where members say "aye" (i.e., yes) or "nay" (i.e., no). The group that says "aye" or "nay" louder, according to the presiding officer, wins. By associa-tion, a unanimous vote. *Compare* ROLL-CALL VOTE.

voter registration (politics) Signing up to vote in an official election. Citizens 18 years old or older record their name, birth date and preferred political party on an official list. Citizens must be **registered to vote** before being allowed to vote in an election and some PRIMARY ELECTIONS. Voting is not mandatory. *See* ENFRAN-CHISED, TWENTY-SIXTH AMENDMENT, CLOSED PRIMARY, "MOTOR-VOTER", REGIS-TRATION DRIVE; *compare* DISENFRANCHISED.

Voting Rights Act of 1866 (minorities) The federal law which secured citizen rights (e.g., voting) and worker rights (e.g., contracts) for blacks, especially those living in the SOUTH. It was passed during RECONSTRUCTION and based upon the THIRTEENTH AMENDMENT; its purpose was to overrule the BLACK CODES. *Com-pare* VOTING RIGHTS ACT OF 1965.

Voting Rights Act of 1965 (minorities) The important federal legislation that

abolished JIM CROW voting tests (especially the literacy test and GRANDFATHER CLAUSE[1]) and ensured the right of blacks to vote by positioning federal voting examiners in local voting stations where the VOTING BOOTHS are located. This resulted in an increase in the number of registered voters in, and elected officials among, the African-American population. The passage of this law was a major success of the CIVIL RIGHTS MOVEMENT.

W

Walden (the arts) The influential book written by HENRY DAVID THOREAU (published in 1854) which relates his observations of nature, non-materialism, independence and people's relationship to nature and the need to be near nature. It promotes independence of thought and simple living. This book was written after Thoreau built a one-room cabin on the shore of 'Walden' Pond northwest of BOSTON in Massachusetts and lived there more or less for two years. This book encouraged the ENVIRONMENTAL MOVEMENT and has influenced countless thinkers, poets, nature writers and other citizens. Today it is required reading in most American HIGH SCHOOLS. *See* AMERICAN RENAISSANCE.

Waldorf salad (food and drink) A salad of lettuce combined with sliced apples, chopped celery, walnuts and raisins with a mayonnaise and lemon juice dressing. [After the stylish 'Waldorf'-Astoria Hotel in NEW YORK CITY where it was first made.]

walk (1, 2 sports and leisure) **1** In BASEBALL, to allow a batter to advance uninhibited from HOME PLATE to FIRST BASE; only those batters to whom four balls have been pitched may be **walked**. This can help the offensive team score. **2** In BASKETBALL, any player who moves about the court but does not dribble the ball. This is a FOUL[2].

Walk of Fame, the (the arts) In HOLLYWOOD[1], the sidewalks of Hollywood Boulevard and Vine Street which are inlaid with large, five-pointed bronze stars, each bearing the name of a well-known actor or actress from the movies, television and/or radio. It is a symbol of the entertainment industry, and is the most famous sidewalk in the country. Also known as the "Hollywood Walk of Fame".

Walker, Alice (people) (born in 1944) An African-American writer of poetry, fiction and essays. Many of her works are about the personal relationships of black women and men. She received a PULITZER PRIZE for her book *The Color Purple* (1982) which is structured as letters using oral, BLACK ENGLISH language between two sisters. She was instrumental in rediscovering the works of ZORA NEALE HURSTON during the 1970s.

Wall Street (economy) Specifically, the financial district in NEW YORK CITY, where the NEW YORK STOCK EXCHANGE, the AMERICAN STOCK EXCHANGE and other financial institutions are located. By association, a collective term for the financial community and its organizations of the UNITED STATES. [From 'Wall Street', that street in downtown MANHATTAN[1] where many of these institutions are located.] Popularly known as "the Street".

Wall Street Journal (media) A daily (Monday through Friday) national newspaper providing current financial, business and tax information, in-depth business articles and summary articles on major world news events. It supports a FREE-MARKET economy and has a CONSERVATIVE EDITORIAL board and OP-ED page. It was the first paper to print the DOW JONES INDUSTRIAL AVERAGE, which it still prints. It was founded in 1889 by Charles Dow (1851–1902) and Edward Jones (1865–1920); currently, it has the largest newspaper circulation in the UNITED STATES of 1.8 million.

wampum (customs and traditions) In general, something given in exchange for something else; a unit used for bargaining. Specifically, small cylinder-shaped beads which are cut from plastic or shell. Traditionally, INDIANS sewed these beads onto a piece of leather into some pattern to

record the elements of TREATIES, tribal history and/or official agreements. By association, something that is agreed to or given in exchange.

War between the States, the (history) A nickname for the CIVIL WAR.

war bride (immigration) During a wartime situation, any woman (usually, not an American) who marries a member of the American military. The "War Brides Act" of 1945 was the first federal law that tried to unite families by allowing 120,000 'brides' and children (mostly Asians) of members of the US ARMED FORCES to enter the US as immigrants.

War of 1812, the (foreign policy) The war fought between the UNITED STATES and Great Britain (and some of its Indian allies) in Canada, DETROIT, NEW ORLEANS, and on the GREAT LAKES for business-related reasons from June 18, 1812, until January 8, 1815. The American government declared war on Great Britain in response to the practice of British ships seizing American ships, American export products and American sailors. Although the British army invaded, captured and burned the capital city of WASHINGTON D.C. and won some battles, American forces succeeded in the Battle of the Thames in Canada, the Battle of Lake Erie and the Battle of Plattsburg Bay. The peace TREATY was signed in Ghent (in present-day Belgium) on December 14, 1814, and in it the two sides agreed to their respective, original boundaries in North America and international commerce rights. Unaware of the peace treaty, a final conflict, the Battle of New Orleans (January 8, 1815), was fought and won by US forces under the leadership of ANDREW JACKSON. The treaty and this last battle succeeded in making Americans proud of their independence and patriotism. *See* WHITE HOUSE, JACKSON DAY.

War on Poverty (history) The collective name used by PRESIDENT LYNDON JOHN-SON's ADMINISTRATION[1] to describe several government programs of the GREAT SOCIETY that tried to help poor people and tried to stop the causes of poverty in the UNITED STATES; specifically MEDICAID, Operation HEAD START and the Economic Opportunity Act of 1964. [From a STATE OF THE UNION MESSAGE Johnson made in 1964; "this administration .. declares unconditional 'war on poverty' in America".]

War Powers Act (government) This federal act (passed in 1973) returned to CONGRESS its right (according to the CONSTITUTION) to declare a war and it forces the PRESIDENT to ask the approval of Congress before he orders any of the ARMED FORCES to do any military action. This act was passed during the VIETNAM WAR and tried to limit the President's military powers. *See* "IMPERIAL PRESIDENCY".

War Relocation Authority (minorities) (WRA) During WORLD WAR II, the federal office responsible for building and operating 10 different INTERNMENT CAMPS, removing people of Japanese descent from their homes to these camps and taking control of the property and possessions left behind by these internee-prisoners. It was created by EXECUTIVE ORDER number 9102 of PRESIDENT FRANKLIN ROOSEVELT on March 18, 1942, to protect Americans from Japanese spies. It was finally disbanded June 30, 1946. It was much criticized for its actions and work and is a symbol of the poor treatment that the federal government gave to many Japanese Americans during this time. *See* NATIVISM, YELLOW PERIL, *EX PARTE ENDO.*

"War to end all Wars", "the" (foreign policy) The phrase used to refer to WORLD WAR I describing the severity of the war; the use of inhuman military weapons and techniques, the large numbers of the dead and the great personal suffering. It was first used by PRESIDENT WOODROW WILSON. *Compare* WORLD WAR II.

"War to save Democracy", "the" (foreign policy) A nickname for WORLD WAR I which served as a rationale for the UNITED STATES to join this European war in 1917. It comes from a speech made by PRESIDENT WOODROW WILSON in April 1917 ("the World must be made safe for Democracy") in which he asked CONGRESS to support him and declare war on Germany.

Warhol, Andy (people) (1928–1987) An artist and commercial illustrator known for his leadership in and promotion of POP ART. He used acrylic paints and a clean

line to create a unique style; repeating an image from the current consumer culture (e.g., "Campbell's Soup Cans", MARILYN MONROE), often on a silk screen. He is credited with stating that, in the future, "everyone will be famous for 15 minutes".

Warren Commission Report (history) The report prepared by the investigative commission appointed to study the conditions and reasons for the assassination of PRESIDENT JOHN F. KENNEDY. Its findings, published in September 1964, were that Lee Harvey Oswald (1939–1963) had acted alone in killing President Kennedy. Although this report unanimously denied conspiracy theories, it could not determine Oswald's motive. The public did not believe all that was stated in this report and some groups hold that there was a conspiracy of more people involved in wanting to kill the president. [After Chief Justice Earl 'Warren' (1891–1974), the chairman of this committee.] *See* DALLAS.

Warren Court, the (legal system) The SUPREME COURT during the years (1953–1969), which is known for practicing JUDICIAL ACTIVISM, especially in protecting CIVIL RIGHTS, racial equality, desegregation, freedom of expression and the rights of people accused of crimes. Its most famous cases include: *BROWN* v. *BOARD OF EDUCATION, ENGEL* v. *VITALE, MIRANDA* v. *ARIZONA, MAPP* v. *OHIO* and *GIDEON* v. *WAINWRIGHT*. [After Earl 'Warren' (1891–1974) the CHIEF JUSTICE during this period.] *Compare* BURGER COURT.

Washington D.C. (geography) (D.C.) The capital city of the UNITED STATES OF AMERICA. It was especially established in 1790 as the city within the DISTRICT OF COLUMBIA to serve as the capital city of the federal government. It was formally designed and laid out by the French architect, Pierre L'Enfant (1754–1825), and has spacious parks and broad avenues. Today, it is synonymous with "the District" and counts over 600,000 residents. At its center sits CAPITOL HILL and the MALL; it is home to the WHITE HOUSE and the DEPARTMENTS[2], as well as to cultural and educational institutions such as the SMITHSONIAN INSTITUTION, HOWARD UNIVERSITY, GEORGETOWN UNIVERSITY and the JOHN F. KENNEDY CENTER FOR THE PER-FORMING ARTS. Many LOBBIES and INTEREST GROUPS are headquartered here. Its residents and local politics are governed by a mayor and city council. In CONGRESS, it is represented by a SHADOW SENATOR; it has ELECTORAL VOTES in presidential elections. It is formally and officially known as "Washington, District of Columbia". It is commonly referred to as "Washington" and/or "D.C."; it is popularly known as "The BELTWAY[2]". [In honor of GEORGE 'WASHINGTON', the first president.] *See* SUPREME COURT BUILDING, TOMB OF THE UNKNOWNS, GEORGETOWN, ELECTORAL COLLEGE, Appendix 3 Professional Teams; *compare* STATE, TERRITORY.

Washington Post, The (media) A daily newspaper in the metropolitan WASHINGTON D.C. area. It is known for its thorough reporting and national perspective on news events as well as its strong EDITORIAL opinions. It was founded in 1877; currently, its daily circulation is 800,000 and its SUNDAY EDITION circulation is 1.5 million. *See* PENTAGON PAPERS.

Washington, Booker T[aliaferro] (people) (1856–1915) A black leader, African-American educator and writer. He believed in a society where whites and blacks lived and worked separately and he encouraged blacks to earn money and financial power before CIVIL RIGHTS and political power. As a teacher, he encouraged black students to work in manual labor jobs (e.g., bricklaying, carpentry). He promoted these ideas through his autobiography *Up From Slavery* (1905) and in the speech the "ATLANTA COMPROMISE". Although his ideas were popular at that time with whites, W.E.B. DU BOIS did not agree with him. *See* TUSKEGEE UNIVERSITY.

Washington, George (people) (1732–1799) General of the American Continental Army (1775–1781), a FOUNDER[1], and the first US PRESIDENT (1789–1797). During the AMERICAN REVOLUTION he was a capable, concerned leader for his troops, especially at the camp of Valley Forge. As president, he supported the FEDERALISTS[2], the WHISKEY REBELLION and he insisted on being addressed as "Mr. President" (not "King"). He has long been a symbol of patriotism, bravery, modesty and, espe-

cially, honesty. According to tradition, when still a boy, he chopped down a cherry tree owned by his father; when his father asked George if he had done it, the boy admitted, Yes, "I can not tell a lie". When he retired to his home at MOUNT VERNON, he was commonly regarded as "first in war, first in peace, and first in the hearts of his countrymen". In honor of him, his image is on the $1 BILL[1] and the STATE of Washington, the city of WASHINGTON D.C., and many other cities are named after him. *See* YORKTOWN, PRESIDENTS' DAY.

WASP/Wasp (society) Any white person whose ethnic background includes ancestors who emigrated from Northern Europe, especially England, to AMERICA[1], and who belongs to a PROTESTANT DENOMINATION. Traditionally, because of this background, this type of person has long been a member of the elite, dominant, ruling political, social and economic class. [Acronym 'W'hite 'A'nglo 'S'axon 'P'rotestant.]

Watergate (history) A collective term for various illegal actions of the REPUBLICAN Nixon ADMINISTRATION[2] and its attempts to hide and cover-up these illegal actions. First, during the presidential election CAMPAIGN of 1972, the WHITE HOUSE gave orders to a group of seven men to break into the headquarters of the DEMOCRATIC NATIONAL COMMITTEE. Second, the Administration used the CIA and FBI and other government agencies to spy for it on the DEMOCRATIC PARTY and its members. Third, PRESIDENT RICHARD NIXON denied having ordered any of these illegal activities, however, over 60 different audiotapes of White House telephone conversations revealed that Nixon did order these actions; and therefore he had lied to the American people. Before being impeached by the HOUSE OF REPRESENTATIVES, Nixon resigned as President and his VICE PRESIDENT, GERALD FORD, then became President. This series of events has become a symbol of presidential scandals as well as the abuse of presidential and government power. Further, it encouraged the American public to distrust its elected politicians, the politics of the federal government and the BELTWAY[2]. However,

it is also a symbol that the CHECKS AND BALANCES system of the federal government works. Finally, it is a symbol of a mistake made by a person in power which removes that person from power. [After the name of the hotel/apartment/shopping complex known as 'Watergate' in WASHINGTON D.C., where the Democratic National Committee had its headquarters and where the break-in took place.] *See* TWENTY-FIFTH AMENDMENT, FEDERAL ELECTION CAMPAIGN ACT OF 1972, "IMPERIAL PRESIDENCY", -GATE, WIRETAPPING.

Wattleton, Faye (people) (born in 1943) The president of PLANNED PARENTHOOD (since 1978). She is known for promoting family planning and sexual education classes for young people. *See* PRO-CHOICE.

Watts riots (minorities) The violent burning and destruction of Watts, an overpopulated, run-down, poor and predominantly black district of LOS ANGELES, California during the hot summer period of (August 11–16, 1965). It began on August 11, 1965, when police officers stopped and arrested an African-American motorist on a street in Watts on the charge of drunk driving. The crowd that had gathered to watch the arrest grew hostile toward the police and started throwing things at them, which then erupted into the six-day riot. However, the violence soon spread and many blacks attacked white- and black-owned businesses and shops. The mob violence, much of it directed at other blacks, killed 34 people, injured over 880 others and caused $200 million in property damage. It illustrated the collective frustrations of AFRICAN AMERICANS at the slow pace of the CIVIL RIGHTS MOVEMENT and blacks' lack of jobs and money. It preceded the LONG, HOT SUMMER. [After the name of the district, 'Watts', a 20 square mile (52 sq. km), poor black GHETTO of LA which has some 20,000 inhabitants.] *See* KERNER COMMISSION REPORT; *compare* LA RIOTS, RED SUMMER.

Wayne, John (people) (1907–1979) A popular, big-bodied HOLLYWOOD[2] actor who portrayed strong, male soldier and COWBOY[2] characters in war movies and in 80 different WESTERNS.

"We Shall Overcome" (customs and traditions) A traditional, hopeful, spiritual song that is frequently sung in CHURCHES[2] and during religious services. The first verse and refrain follow: "We shall overcome (repeat twice)/Oh deep in my heart I do believe/We shall overcome some day". During the 1960s, it was played and sung by workers and protesters during the CIVIL RIGHTS MOVEMENT in order to create a feeling of hopeful togetherness. It became the anthem of this movement.

weak dollar (economy) A decrease in the value of the DOLLAR compared to other currencies in the world or gold. A weak dollar makes the prices of imported goods more expensive, which can encourage people to "BUY AMERICAN". If the dollar is too weak, it can cause INFLATION in the US. Also known as a "cheap dollar"; *see* DEPRECIATION; *compare* STRONG DOLLAR.

Weathermen, the (education) A radical white student group which broke off from the STUDENTS FOR A DEMOCRATIC SOCIETY in June 1969. The group was committed to supporting all movements for liberation and freedom both in the UNITED STATES and overseas. Namely, it supported the BLACK PANTHERS as well as the DEFENDANTS in the trial of the CHICAGO EIGHT in October 1969 by chanting and being present outside the courthouse (they called this event "Days of Rage" October 9–11, 1969). They also were attributed with setting off bombs at various locations across the US. It dissolved shortly thereafter. Also, more formally known as the "Revolutionary Youth Movement" (RYMI) [From a line from a BOB DYLAN song; "You Don't Need a 'Weatherman' to Know Which Way the Wind is Blowing".]

Webster, Noah (people) (1758–1843) An author and lexicographer known for developing the first dictionary which contained new spellings of many English words and vocabulary items unique to American English, *American Dictionary of the English Language* (1828). He is a symbol of American English and the spelling differences between the UNITED STATES and Great Britain. By association, **Webster's** is a common reference to a copy of a dictionary of American English.

weekend (customs and traditions) The two-and-a-half day period when people do not have to work. Technically, it begins on Friday afternoon after work (i.e., 6 o'clock) and runs until Monday morning before work (e.g., 8 o'clock). Friday and Saturday nights are considered the "weekend nights" and the time to go out to DINNER, go to a BAR[1] or watch some entertainment. *See* SUNDAY; *compare* LONG WEEKEND, PARENTS' WEEKEND.

welfare (health) In general, an abstract term for any government assistance provided to needy, old or poor people. Specifically, the common name for the AID TO FAMILIES WITH DEPENDENT CHILDREN program. This program was abolished in 1996 after many years of discussion about the high costs of this program and the unwillingness of the people receiving these benefits to work. It was replaced with a new program called the TEMPORARY ASSISTANCE TO NEEDY FAMILIES which requires STATES to create and operate their own welfare programs, which are partially subsidized by the federal government through BLOCK GRANTS. It is a type of GENERAL ASSISTANCE program. *Compare* SOCIAL SECURITY.

well-done (food and drink) An order to cook beef thoroughly so that the exterior and the interior are brown. *See* STEAK.

Welles, Orson (people) (1915–1985) Actor and director of theater, radio and movies. As an actor he is remembered for his roles in Shakespearean productions; his nickname was "Boy Wonder". As a film director, he is known for his creative use of angle, lighting and deep focus photography, especially in the movie, *Citizen Kane* (1941).

West, the (geography) A geographical region of some 11 STATES including the STATES of the ROCKY MOUNTAINS, the PACIFIC NORTHWEST and the SOUTHWEST. It has long represented the FRONTIER in American history and settlers largely settled it during the nineteenth century. Today, some of its major industries include farming, cattle raising, mining and the aerospace industries. It is associated with nature, wild animals and unusual, beautiful natural areas; the ENVIRONMEN-

TAL MOVEMENT and Indian rights are of particular interest for people from the West. The "Far West" includes those lands between the Rocky Mountains and the Pacific Ocean. The "Wild West" refers to those lawless regions of the GREAT PLAINS and SOUTHWEST during the nineteenth century before the establishment of statehood and government laws; it is often popularized in WESTERN films and books.

West Coast jazz (the arts) The COOL JAZZ which was played and popularized in California during the 1950s, mostly by white musicians; namely Chet Baker (1929–1988) on the trumpet and Gil Evans (1912–1988) on the piano and as an arranger.

West Point (education) A fully-funded COLLEGE[1] which provides a LIBERAL ARTS and sciences education and physical and military training. It was founded by the US CONGRESS in 1802 and the government pays for student tuition and ROOM AND BOARD. Its motto is "duty, honor and country" and it enrolls 4,000 COEDUCATIONAL "cadets" or UNDERGRADUATES. It is an accredited UNIVERSITY and an NCAA member; its teams compete intercollegiately. Upon graduation, a cadet is commissioned as a 2nd lieutenant in the ARMY and must serve at least six years of active duty. It is formally known as the "United States Military Academy"; its athletic teams are known as "Army" or as the "Cadets" or by the college's mascot, the "Black Knights". [For the SCHOOL'S[5] location at the 'West Point' of the Hudson River in New York STATE.] See INTERCOLLEGIATE, ARMY–NAVY FOOTBALL GAME, ARMED FORCES.

West Virginia State Board of Education v. Barnette (religion) The US SUPREME COURT DECISION (1943), supporting the freedom of religion, freedom of speech and freedom of silence. This decision states that a PUBLIC SCHOOL cannot force a person to salute the American flag if that person's religion does not allow him or her to make salutes or take oaths. The decision was announced on FLAG DAY and the case concerned students who were members of JEHOVAH'S WITNESSES. It OVERRULED the earlier decision in the case of *Minersville School District* v. *Gobits*

(decided in 1940 just before WORLD WAR II) which had forced public school students to say the PLEDGE OF ALLEGIANCE. *See* FIRST AMENDMENT, STARS AND STRIPES[1].

western (the arts) A very popular genre of American art especially realized in the movies, television series and books. The western depicts life and conflicts on the FRONTIER in the WEST during the nineteenth and early twentieth centuries. In any form, it often treats themes of independence, freedom, justice, lawlessness, settlement, civilization and movement. Characters include settlers, COWBOYS[2], INDIANS, whites, blacks, women and Mexicans. *See* SPAGHETTI WESTERN.

western omelet (food and drink) A breakfast omelet made of eggs, diced ham, chopped green peppers and onions.

Western swing (the arts) A style of COUNTRY MUSIC which has longer songs containing both lyrics and orchestration for a band and which is meant to be danced to. It originated in the WEST, especially in Texas in the 1940s. It was popularized by Bob Wills (1905–1975), who was known as the "King of Western Swing". [After the danceable band music of JAZZ 'swing' bands.] *See* SWING MUSIC.

wetback (immigration) The pejorative name for an illegal immigrant from Mexico or Latin America living illegally in the UNITED STATES. [Because these immigrants' bodies are 'wet' from swimming across the RIO GRANDE in order to enter the US.]

wetlands (environment) A unique type of area which is moist or underwater at least seven days each year, usually it includes swamps, bogs, BAYOUS and marshes. Because these areas are unsightly or "unuseful" for farming or commercial development, many of them were filled in during the second half of the twentieth century. However, it has since been discovered that these lands perform special functions, namely, purifying the land and water and providing vital food sources and nesting areas to various mammals, birds, reptiles, insects and other creatures and plants. *See* EVERGLADES.

Wheatley, Phyllis (people) (1753–1784) A house slave to a BOSTON family and

poet. She wrote metered verse and rhyme in the traditional European style. The themes of her poetry include a forced removal from Africa, liberation from paganism, redemption of the soul and slavery of the body. *Compare* PAUL LAWRENCE DUNBAR.

"When the Saints Come Marching In" (customs and traditions) The popular, upbeat Christian spiritual song in which the singer asks to join the Christian saints when they enter Heaven on judgment day. This song is most memorably performed by DIXIELAND JAZZ music bands in NEW ORLEANS and Louisiana. Often it is performed during MARDI GRAS. The refrain follows: "O when the saints go marching in (twice)/Oh Lord I want to be in that number/When the saints go marching in." By association, a strong wish to receive some desirable thing.

whip (government) A REPRESENTATIVE[1] or SENATOR elected by his or her political party to assist the leader, encourage party members to attend debates and voting sessions and to help keep track of legislation being debated in the chamber. There is a MAJORITY whip and a MINORITY whip in each chamber of CONGRESS. [From the British Parliament which uses whips in the legislature. Originally, the term derives from 'whip'per-in, the person working to control the excited hounds during a fox hunt.]

Whiskey Rebellion, the (history) From 1791 to 1794, the refusal of farmers (living in western Pennsylvania) to pay a federal tax on liquor. It only ended when PRESIDENT GEORGE WASHINGTON personally led over 12,000 troops to that farming region to encourage them to pay. This incident illustrated that federal laws were to be stronger than STATE laws.

whistle blower (work) An employee in a company or government job who publicly reports that his or her employer or co-workers have done some illegal or harmful activities. Because of this action, they are disliked by their co-workers and/or the company. Frequently, they fear losing their jobs or positions for having reported this information or activity. The Civil Service Reform Act of 1978 protects those who work for the federal government from losing their jobs, but workers in the PRIVATE SECTOR are not always protected. [From the expression "to 'blow' the 'whistle' on someone", meaning "to betray, to give away".]

Whistler, James McNeil (people) (1834–1903) An artist who worked in the impressionist tradition and painted images in flat colors with little depth. His best-known painting is *Whistler's Mother* (1871), showing a side view of an older woman wearing a long, sober black dress.

white academy (1, 2 education) **1** A private, racially-segregated HIGH SCHOOL for whites in the southern STATES many of which were created after the SUPREME COURT decision of *BROWN v. BOARD OF EDUCATION OF TOPEKA, KANSAS*. **2** Currently, a private ELEMENTARY SCHOOL or HIGH SCHOOL that has no MINORITY students, staff or faculty. *See* PRIVATE SCHOOL, SEGREGATION; *compare* PUBLIC SCHOOL.

white bread (food and drink) Any soft-textured, packaged, white or light-colored bread usually made from bleached flour and precut into slices. Although it was prestigious during the nineteenth century, it has grown so widespread since the 1920s that today it is associated with "the standard", "ordinary" or "mainstream". Further, it is associated with something "white-colored" (e.g., white people) or something bland, ordinary or flat tasting. *Compare* MULTICULTURALISM.

white collar (work) Describing a person who works at an office job (i.e., not in physical labor), usually administrators, LAWYERS, teachers and other professionals. [From the business suits and 'white'-colored 'collar'ed shirts worn by these people.] *See* WHITE-COLLAR CRIME; *compare* BLUE COLLAR.

white-collar crime (economy) A kind of work-related crime (e.g., stealing office equipment, fraud) that is committed by professionals, business people or white-collar employees. *See* WHITE COLLAR.

white flight (immigration) The movement of white middle-class families from black or multicultural urban areas to largely white suburban neighborhoods. This frequently occurred in the 1970s and 1980s in those areas where BUSING was practiced. By association, any move-

ment of MIDDLE-CLASS families (e.g., black, white, HISPANIC) from urban areas to wealthier suburban areas. *See* SUBURBS, MULTICULTURALISM, ZONING REGULATIONS, FAIR HOUSING ACT.

White House, the (government) Since 1801, the official executive office and personal residence of the current PRESIDENT of the UNITED STATES OF AMERICA. It is located at 1600 PENNSYLVANIA AVENUE, NW in WASHINGTON D.C. 20090. It includes the OVAL OFFICE, the West Wing and the Rose Garden (an outdoor garden used for signing papers and greeting guests). It is a symbol of the President and/or the ADMINISTRATION[1]. It was designed by the Irishman, James Hoban (1762–1831) and is modeled on the Leinster House in Dublin, Ireland. It contains over 130 rooms, some of which are ceremonial and open to the public as a museum. [After the white-colored paint used to hide burns after the British army burned it in the WAR OF 1812.] *See* LAFAYETTE PARK, MALL.

White House Office (government) A collective name for the personal staff of the PRESIDENT and its offices, as well as the OVAL OFFICE. It includes the CHIEF OF STAFF, press secretary, communications director and Congressional liaison officer. These people are chosen by the President without the SENATE'S ADVICE AND CONSENT. [From the offices' original location in the WHITE HOUSE.]

white paper (government) The official statement from the government which gives background information (on some issue) and the government's reasons for making a decision.

white supremacy (minorities) A radical philosophy held by a minority of white people that the white race is better than the other races of people (e.g., black, HISPANIC, NATIVE AMERICAN). To support this claim and protect white interests, these individuals usually form groups and participate in GRASSROOTS-level, often illegal, activities to hurt and intimidate people from other races. *See* KU KLUX KLAN.

whites (military) The white-colored military uniforms worn by members of the US NAVY for informal occasions. *Compare* BLUES[2], KHAKIS[1].

Whitman, Walt (people) (1819–1892) An influential poet known for his unique and democratic volume of poetry *Leaves of Grass* (first published in 1855) which contains poems that praise nature, the human body, the individual and the group (e.g., "Song of Myself").

wild card (sports and leisure) Describing a team that has an irregular record of wins and losses and which one cannot predict to win or lose. [From card games in which certain 'cards', like the joker, do not follow the rules of suit in a game; they behave 'wild'ly.] By association, describing something that is unpredictable.

Wilderness Society, The (environment) An active organization and LOBBY which works to protect the special and significant areas of wilderness in the UNITED STATES. It was founded in 1935 by ALDO LEOPOLD, is headquartered in WASHINGTON D.C. and currently counts over 300,000 members.

Williams, Hank, Jr. (people) (born in 1949) Singer and songwriter of COUNTRY MUSIC. He is known for writing music with simple melodies and lyrics relating to men, none of which is as popular as those of his father, HANK WILLIAMS, SR. His nickname is "Bocephus".

Williams, Hank, Sr. (people) (1923–1953) Singer, songwriter and performer of COUNTRY MUSIC. His songs were influenced by the BLUES[1], had simple musical melodies and the lyrics told sad stories, all of which made them very popular, especially "I'm So Lonesome I Could Cry", "Your Cheatin' Heart" and "Cajun Baby". He is remembered for his flashy rhinestone costumes, severe alcohol addiction problem and for being one of the best stars ever in COUNTRY AND WESTERN MUSIC. He died while he was being driven by a chauffeur to a concert at which he was to perform. His son is HANK WILLIAMS, JR.

Williams, Tennessee (people) (1911–1983) A playwright whose works explored themes of loneliness and desire while using everyday speech. Many of his characters are normal people with unusual or intense passions, feelings and personal histories. Some of his best-known works include

A Streetcar Named Desire (1947) and *Cat on a Hot Tin Roof* (1955); he received PULITZER PRIZES for both of them.

Williamsburg (1, 2 geography) **1** A colonial settlement established by the English in 1633, which served as the capital city of Virginia (1699–1780). After falling into disrepair in the subsequent centuries, most of it was restored and returned to its former appearance during the COLONIAL PERIOD in 1926 (through funding by JOHN D. ROCKEFELLER[2]) and, today, functions as a living museum of colonial American life. **2** A section of BROOKLYN, north of BEDFORD-STUYVE-SANT; because its population is a mixture of working-class peoples from different ethnic backgrounds (e.g., AFRICAN AMERICANS, HISPANICS, Italian Americans and HASIDIC JEWS), it is known to have had racial and cultural conflicts. *Compare* JEWISH.

Wilson, Woodrow (people) (1856–1924) PROFESSOR of political science and US PRESIDENT (1913–1921). As president, he is remembered for establishing the FEDERAL RESERVE BANK SYSTEM, helping labor UNIONS[1] and passing PROGRESSIVE ERA reforms. Although he tried to keep the US out of war, he finally led the US into WORLD WAR I. He is recognized for supporting peace with the FOURTEEN POINTS speech and supporting the creation of a League of Nations (today's United Nations). *See* ISOLATIONISM, Appendix 2 Presidents.

windbreaker (clothing) A lightweight, wind-resistant, water-repellent and sportive jacket with elastic, snug-fitting cuffs and waistband. Often, it has a hood which can be rolled up and zippered into the neck collar. [From a trademark.]

Windy City, the (geography) The popular nickname for the city of CHICAGO. [Allegedly after the habit of traders and business people from talking a lot; or after the cold, strong 'winds' which blow off Lake Michigan.] *See* GREAT LAKES.

Winfrey, Oprah (people) (born in 1954) The producer and host of the popular TALK SHOW *The Oprah Winfrey Show* (started in 1986), produced by her company Harpo Studios (established 1988). She is recognized for using her successful show to address social conditions, current issues and personal relationships. She is known for having tried several weight loss programs with failures and successes. She has also worked successfully as an actress, performing the roles of strong, African-American women characters in *The Color Purple* (1985) and *Native Son* (1986).

wingtips (clothing) A type of men's dress shoe with a leather upper body which is punctured with small holes. It has laces and a hard sole and is worn with office suits or SEMIFORMAL[1] clothing. It is considered an elegant, yet CONSERVATIVE, shoe.

winner-take-all (politics) A system that divides up ELECTORAL VOTES among candidates in an election. The candidate who earns the most POPULAR VOTES in a STATE 'wins' that state and receives 'all' that state's electoral votes.

Winston Cup, the (sports and leisure) The annual prestigious prize given to the national championship of stock-car races. This title is given to the driver who has earned the most points in the WINSTON CUP SERIES. From 1949 until 1971, it was known as the champion of the "NASCAR Grand National Championships". *See* NASCAR, STOCK CAR, DAYTONA 500.

Winston Cup Series (sports and leisure) A series of 29 different stock-car races ranging from 400 miles (640 km) to 600 miles (960 km) in length which are held at 19 different speedways across the country in a given year from February to October. Each driver who wins a race, earns and accumulates points. After the racing season, the driver with the most points wins the WINSTON CUP. From 1949 until 1971, it was known as the "NASCAR Grand National Championships". *See* NASCAR, STOCK CAR, DAYTONA 500.

Winthrop, John (people) (1588–1649) LAWYER and first Governor of the MASSACHUSETTS BAY COLONY (1629–1649). He helped make the colony prosperous because of his stern, disciplined leadership and belief in a community which combined religion and politics. He is best known for giving his fellow travelers the sermon "A Model of Christian Charity" which spoke of "CITY ON A HILL". *See* CONGREGATIONALISM[1,2].

wiretapping (legal system) The action of a THIRD PARTY[2] listening in on a telephone conversation without the knowledge of those having the conversation. If the third party does not have a special warrant (i.e., permission) to do this, then this is a criminal action. *See* CRIMINAL LAW, WATERGATE.

witch trials (history) During the COLONIAL PERIOD in NEW ENGLAND, the infamous series of events held in the village of Salem in 1692 in which some 200 people were accused by other fellow, local residents of being witches; the holding of judicial trials to test these "claims"; and the following execution of those 19 villagers found guilty. By association, a "witch trial" is any accusation, legal case or the trying of people for crimes made amid much panic, hysteria and/or based on false information or without proof. *Compare* MCCARTHYISM, RED SCARE[3], HOUSE UN-AMERICAN ACTIVITIES COMMITTEE (HUAC).

Witnesses, the (religion) The popular name for those members of the religious group, JEHOVAH'S WITNESSES.

Wobblies, the (work) The popular nickname for members of the INTERNATIONAL WORKERS OF THE WORLD. [Most likely from the 'wobble'saw, a special type of circular saw, used by lumberjacks out WEST, many of whom were members of the IWW.]

Woman's Christian Temperance Union (minorities) (WCTU) The largest women's organization of the nineteenth century and one of the forces that pushed for the EIGHTEENTH AMENDMENT, PROHIBITION and total abstinence from alcoholic drinks. Its members, mostly PROTESTANT women, had an EVANGELICAL enthusiasm in prohibiting alcohol. It was founded in 1874 in Cleveland, Ohio by Frances Willard (1839–1898) who also served as its very strong president (from 1879 to 1898). It also supported women's right to vote, labor reform and the improvement of FAMILY VALUES. At its peak in 1898, the organization had 10,000 branches and 500,000 total members. In the 1920s, its influence declined. Today, it is known as the NATIONAL WOMAN'S TEMPERANCE UNION.

Women's History Month (minorities) March is designated as the month to celebrate women and what they have contributed to American history and culture. In ELEMENTARY SCHOOLS and SECONDARY SCHOOLS, special events and FIELD TRIPS are planned to teach students – female and male – about women.

Women's Lib (minorities) A rather disparaging term (it is shortened from "Women's Liberation Movement"). Today, women and the general public prefer using the terms WOMEN'S MOVEMENT or the FEMINIST MOVEMENT.

Women's Movement, the (minorities) A general term describing all or some of those organized or spontaneous efforts by women to give women the same political, economic and social rights as men. In the nineteenth century, it pushed for a woman's right to vote; in the twentieth century, it pushed for women and men receiving equal pay when they do the same or equal work as well as federal laws for DAY CARE and against SEXUAL HARASSMENT. More specifically, it consists of two major periods. The first period began in 1848 with the SENECA FALLS CONVENTION and includes the WOMEN'S SUFFRAGE MOVEMENT. The women's movement's advances in the nineteenth century were due to the successes of ABOLITION and the FIFTEENTH AMENDMENT which gave free black men the right to vote. The second period began in 1963, and it includes the FEMINIST MOVEMENT, the fight for the EQUAL RIGHTS AMENDMENT, and the right to have an abortion legally. The movement's advances in the twentieth century were greatly helped by the successes of the CIVIL RIGHTS MOVEMENT and the CIVIL RIGHTS ACT (of 1964). Also written "women's movement"; *see* NINETEENTH AMENDMENT, NATIONAL ORGANIZATION FOR WOMEN, PRO-CHOICE, AFFIRMATIVE ACTION, EQUAL EMPLOYMENT OPPORTUNITY COMMISSION, DISCRIMINATION, WOMEN'S HISTORY MONTH, SUSAN B. ANTHONY, CULTURAL STUDIES; *compare* FAMILY VALUES, PRO-LIFE.

Women's National Basketball Association (sports and leisure) (WNBA) The organization for professional women's BASKETBALL. It played its first season

(June through August) of 28 total games in 1997. It is supported by the NBA and consists of eight women's teams.

Women's Suffrage movement, the (minorities) Largely, a nineteenth-century movement organized in the 1860s to give women the right to vote in elections. Many women, known as "SUFFRAGISTS", participated in the marches and organized protests and activities. SUSAN B. ANTHONY was a strong organizing force of this movement. After it finally achieved its goal in 1920 when the NINETEENTH AMENDMENT was approved, it dissolved. It preceded the FEMINIST MOVEMENT. Also known as the "suffragist movement" or the "WOMEN'S MOVEMENT"; see LEAGUE OF WOMEN VOTERS, WOMAN'S CHRISTIAN TEMPERANCE UNION, SUSAN B. ANTHONY.

Wooden Award (sports and leisure) The annual award given to the best men's COLLEGE[1] BASKETBALL player in a given year. It is presented by the United States Basketball Writers Association, first in 1977. Formally known as the "John R. Wooden Award". [For John R. 'Wooden' (born in 1910), the winning basketball coach of the UNIVERSITY OF CALIFORNIA at Los Angeles team.]

Woodstock Festival (the arts) A large, outdoor ROCK AND ROLL and FOLK MUSIC concert held August 15 to 17, 1969, in New York STATE. Performers included JOAN BAEZ, JIMI HENDRIX, JANIS JOPLIN, BOB DYLAN, Joe Cocker and Jefferson Airplane. Some 400,000 young people attended the event, which is considered a high point of the HIPPIE and COUNTERCULTURE movement. [For the planned location of the event at 'Woodstock', New York; the event actually took place on a dairy farm in nearby Bethel in New York STATE.]

Worchester v. Georgia (minorities) The important DECISION of the SUPREME COURT (passed 1832) establishing the tenet that only the federal government (i.e., not the individual STATES) has the right to regulate affairs concerning Indian TRIBES. This decision permitted the federal government in the nineteenth century to pass the INDIAN REMOVAL ACT and enforce the TRAIL OF TEARS and ASSIMILATION; but in the twentieth century, it also helped establish a precedent for Indian rights and self-government.

work-study (education) A federally-funded student FINANCIAL AID program that employs UNDERGRADUATES enrolled full time in a COLLEGE[1] to work part time (i.e., 10–15 hours per week) in offices of that COLLEGE[1]. Students work to earn money that helps pay for their education, and study during the same TERM[2]. Usually, the work is unrelated to the student's MAJOR. See CREDIT; compare CO-OP[1], PELL GRANT.

Workers' Compensation (work) A general term referring to a monthly gift of money given by an employer to any of its employees who are injured or killed while working on the job. Regardless of the blame, the employer is required to pay the injured worker or the worker's spouse and/or family some money; usually, it is about 66% of the worker's monthly salary at the time of the accident. Injured workers continue to receive these payments until their health condition has improved. Popularly known as "Workers Comp"; compare UNEMPLOYMENT COMPENSATION.

workfare (work) A type of WELFARE program that gives individuals of working age welfare money benefits only if those people participate in some part-time public-service job or job-training course. [From 'work' + wel'fare'.]

Works Progress Administration (history) (WPA) During the GREAT DEPRESSION, the emergency federal agency established by EXECUTIVE ORDER that gave some 8.5 million people jobs in the PUBLIC SECTOR (e.g., building bridges, SCHOOLS[1], hospitals, highways and streets). It also created jobs for writers, musicians and artists (i.e., Federal Writers' Project, FEDERAL ARTS PROJECT). The WPA, active from 1935 and dissolved in 1943, was the single most important method of the NEW DEAL to help the economy and unemployed people. After 1939, its name was changed to the "Works Projects Administration"; compare PUBLIC WORKS ADMINISTRATION.

workshop (education) A method of organizing and running an educational or information session. It brings people with common concerns or interest to-

gether for a short period to learn new information and techniques. It usually entails that both the participants and the presenter talk and interact with each other.

World Series, the (sports and leisure) In BASEBALL, the annual championship competition between the best team in the AMERICAN LEAGUE and the best team of the NATIONAL LEAGUE. To win, a team must win four games out of a possible seven games. The winning team receives the title of "National Champions" and each of its players receives money and a diamond World Series ring. It is played every year, first in 1903; however, it was canceled in 1994 due to a player STRIKE[1] over player contract concerns (e.g., wanting larger salaries). It is the biggest event of the baseball season. It is held every October and is a final symbol of the end of summer. *See* PENNANT, OPENING DAY, SPRING TRAINING, FREE AGENT, LABOR DAY WEEKEND; *compare* LITTLE LEAGUE.

World Trade Center, the (economy) (WTC) A complex of five office buildings located just west of the financial district of Lower MANHATTAN[1]. It is known for containing the two tallest buildings in NEW YORK CITY, the "Twin World Trade Towers", each of which has 110 stories, which are twin replicas of each other. Tower One (with the antenna) measures 1,368 feet tall (417 m) and Tower Two measures 1,362 feet tall (415 m). By association, it represents the commerce of the city, specifically, and the entire UNITED STATES, in general. On February 26, 1993, it was damaged by the first serious terrorist bomb attack in the US by non-Americans which killed six people. It has since been repaired. *Compare* WALL STREET, SEARS TOWER, EMPIRE STATE BUILDING.

World War I (foreign policy) (WWI) The United States fought as an "associated power" with the allied forces (i.e., Great Britain, France and Italy) against Germany and Austria-Hungary in the European War from 1917 until the war's end in 1918. Originally in August 1914, PRESIDENT WOODROW WILSON declared American neutrality in the war. However, after repeated German naval attacks on ships carrying American passengers (e.g., *Lusitania*), and German promises to Mexico of a return of lands lost to the US if Mexico helped Germany in its war effort (discovered in the intercepted "Zimmermann telegram"), Wilson, with CONGRESS's approval, declared war on Germany April 6, 1917. Thereafter, the US aided its allies by supplying the fighting military front with fresh military forces (over 2 million men known as "DOUGHBOYS") who, although inexperienced, fought well in the Meuse–Argonne campaign during the Battle of Verdun (September 26 to November 11, 1918) which led to the end of the war. In total, 4.7 million Americans served in the war (including whites, blacks and INDIANS) and there were 117,000 total American deaths caused by it. In addition, the US sent its European allies money (raised by American people who bought US war bonds) and food stuffs (collected by Americans who once a week abstained from eating meat and/or wheat) which helped the war effort. During the war, the US economy experienced a boost and many jobs in US factories and offices were, for the first time, filled by AFRICAN AMERICANS, HISPANICS and women. Also, this war further encouraged the GREAT MIGRATION[2], promoted anti-German-American sentiment in civilian society and led to the INDIAN CITIZENSHIP ACT. This war and the difficult victory led to the carefree attitude of the 1920s (*see* JAZZ AGE, ROARING TWENTIES) as well as the pessimism of others (*see* LOST GENERATION). *See* VETERANS' DAY, RED SUMMER, "WAR TO SAVE DEMOCRACY", HAMBURGER.

World War II (foreign policy) (WWII) From December 1941 to 1945, the UNITED STATES fought with the Allies (i.e., Great Britain, France) against Germany and Italy in Europe and Africa; and against the Japanese in the Far East and the Pacific Ocean. When the war first broke out in Europe, the US followed a policy of ISOLATIONISM although it did participate in the LEND-LEASE ACT program. After the Japanese bombing of PEARL HARBOR, the US declared war on Japan December 10, 1941; then, Germany declared war on the US. American (and British) forces invaded occupied-Europe at the beaches of Nor-

mandy, France (June 6, 1944) and were a strong force in winning the "Battle of the Bulge", also known as the "Battle of the Ardennes" (November–December 1944). In the Pacific Ocean, the US lost the Philippines (May 6, 1942) but then won several important victories over the Japanese in the battles of: Midway (June 3–6, 1942); Guadalcanal (February 3, 1943); Saipan (July 1944), Iwo Jima (March 16, 1945) and Okinawa (June 21, 1945). The ATOM BOMB was dropped on Japan twice in August 1945 which forced the Japanese military to surrender. Over 16.3 million American troops were active in the war and over 407,000 Americans died in it. During the war and in the US, the American government sent over 110,000 Japanese-Americans to INTERNMENT CAMPS. In the US, this war ended the GREAT DEPRESSION and the creation of NEW DEAL programs. The war helped the defense industries and produced many other new jobs and many AFRICAN AMERICANS, HISPANICS and women worked in these industries and other businesses. Also, civilians contributed to the war effort by buying war bonds; collecting rubber, paper and metal; and participating in blood drives. This war and the allied victory encouraged American patriotism and nationalism during the 1950s. *See* YALTA CONFERENCE, COLD WAR, DWIGHT EISENHOWER, BABY BOOMER, OPEN DOOR POLICY.

Wounded Knee (Massacre) (minorities) The brutal killing of an entire group of SIOUX INDIAN prisoners (some 153 men, women and children) by the Seventh division of the US Cavalry on December 29, 1890. The killings only occurred after several events. First, the BIA prohibited Indians from practicing the GHOST DANCE RELIGION; however, the Sioux Indians living on the PINE RIDGE RESERVATION did continue practicing it; the US Cavalry was then sent to the reservation to prohibit the Indians from performing it. The Indians fled the Cavalry, which pursued them and after capturing them and their older leader, SITTING BULL, killed them all. Although the Cavalry claimed that the killings were accidental, this was the same Cavalry unit part of which had fought and

lost the Battle of LITTLE BIG HORN. This massacre marked the end of Indian resistance to US government demands and the end to the wars between the US government and Indian tribes of the nineteenth century. Since then, it has also become a symbol of the injustice of the federal government toward NATIVE AMERICANS. It was memorialized by the book *Bury My Heart at Wounded Knee*, Dee Brown (born 1908), book published in 1970. [After the site of the massacre near 'Wounded Knee' Creek in the present-day STATE of South Dakota.] *Compare* WOUNDED KNEE II.

Wounded Knee II (minorities) The armed, 90-day long stand-off in which RED POWER supporters were matched up against local and federal government law officers on the Lakota SIOUX'S RESERVATION, February 27 to May 1973. During this period, the PINE RIDGE RESERVATION was controlled by Chairman, Richard Wilson, a Sioux who had been picked by the US government to fill this post. The conflict began when several TRADITIONALS on the RESERVATION, suspecting Wilson's government and police force of corruption, asked members of AIM to help the TRIBE protect it against Wilson's local Indian law officers, which were supported by other federal government law enforcement officers. 200 AIM members, led by DENNIS BANKS and Russell Means, set up their camp post on the site of the WOUNDED KNEE MASSACRE as a symbolic statement that the US government was continuing to inflict injustice against Indians. Two Indians and one government agent died in the armed conflict. The stand-off only ended when the two sides agreed to negotiate a resolution. This event, which was a major event of the RED POWER Movement, serves as a symbol of Indian power and the wish of many Indians to govern themselves (i.e., not the BIA or federal government) on reservations and in INDIAN COUNTRY.

Wright Brothers, the (people) The two men, Wilbur 'Wright' (1867–1912) and his brother Orville 'Wright' (1871–1948), who built and developed the first powered airplane in Dayton, Ohio and flew it successfully at KITTY HAWK, North

Carolina, December 17, 1903. They are symbols of technology, teamwork and the birth of the airplane.

Wright, Frank Lloyd (people) (1867–1959) An architect admired for his modernity and combination of natural and man-made materials in his structures; he promoted the PRAIRIE HOUSE for suburban houses. Most of his commissions were for private residences (e.g., FALLINGWATER) although he did design large public structures (e.g., GUGGENHEIM MUSEUM, Johnson Wax factory, Tokyo Hotel). He designed his own homes TALIESIN and "Taliesin West". He is known for his modernity, unashamed self-boasting and creativeness.

Wright, Richard (people) (1908–1960) African-American writer whose works treated the themes of racism and the desire of individuals to be accepted by society. His books include *Native Son* (1940) and *Black Boy* (1945), his autobiography. He was a member of the communist party until 1942. He left the US preferring to live and work in France (1947–1960).

X (the arts) The former movie ranking of the RATINGS SYSTEM[2] indicating that the movie contained explicit scenes of sex and violence and therefore was inappropriate for children. It was replaced in 1990 by NC-17. By association, "X-rated" describes something that is sexual (e.g., erotic, pornographic) and not appropriate for children.

Xmas (customs and traditions) A secular spelling of CHRISTMAS. [From the Greek letter "X" pronounced "chi", the first letter in the Greek word *Christos*, meaning "Christ".] *See* SECULARISM.

Y2K (science and technology) The technical name for the YEAR 2000 BUG.

Yale University (education) One of the most respected, independent UNIVERSITIES in the US and an IVY LEAGUE member. It is well known for its solid UNDERGRADUATE programs and PROFESSIONAL SCHOOLS of law and medicine. It was founded in 1701 by the Congregational Church but no longer has this religious affiliation. Currently, its student body is COEDUCATIONAL: the 5,200 UNDERGRADUATES attend Yale College and the 5,700 GRADUATES[2] attend one of 11 GRADUATE SCHOOLS. It is an NCAA member and its teams compete at the INTERCOLLEGIATE level. The athletic teams are known as the "Bulldogs" or "Elis". The CAMPUS is located in New Haven, Connecticut and its buildings are made of stone: of note is the 221 feet (67.3 m) tall Harkness Tower which serves as the symbol of the university. [After Elihu 'Yale' (1648–1721), a benefactor.] *See* PRIVATE SCHOOL, HARVARD–YALE FOOTBALL GAME, CONGREGATIONALISM[1,2].

Yalta Conference, the (foreign policy) During WORLD WAR II, the meeting (held February 4–11, 1945) at which Winston Churchill (1874–1965) of Great Britain, Joseph Stalin (1879–1953) of the Soviet Union and PRESIDENT FRANKLIN ROOSEVELT of the UNITED STATES met and agreed upon plans for the post-war political situation in European areas. [After the meeting's location at the resort located on the Black Sea in the USSR.]

Yankee (1 society; 2 history; 3 society; 4 sports and leisure) **1** Any person from NEW ENGLAND; especially that traditional New Englander who is often characterized as being frugal, hard-working, very independent and conscientious and who does not speak much, usually using few words to communicate. **2** A person from the NORTH; especially during the CIVIL WAR, this term was used by Southerners to refer, in a derogatory way, to those soldiers and people who supported the UNION[3]; used in this way, this term is pejorative. **3** Any

American. When it is used by Mexicans and Latin Americans, it is often spelled "*yanqui*". **4 the Yankees** The AMERICAN LEAGUE BASEBALL team of NEW YORK CITY, the "New York Yankees". [Allegedly during the COLONIAL PERIOD, Englishmen referred to Dutch people in AMERICA[1] with the derogatory name of 'Jan Kaas', a typical Dutch name, meaning "John Cheese"; later the name became a name of pride among Americans.] *See* "YANKEE DOODLE", YANKEE STADIUM, Appendix 3 Professional Teams; *compare* BROOKLYN DODGERS.

"Yankee Doodle Dandy" (customs and traditions) A popular, proud, upbeat, patriotic song written by George Cohan (1878–1942). The first part of the refrain is: "I'm a Yankee Doodle dandy/A Yankee Doodle, do or die."

"Yankee Doodle" (customs and traditions) A lively, quick-tempo song with lyrics originating among the British as a method of making fun of the THIRTEEN COLONIES and the colonists in AMERICA[1]; however, during the AMERICAN REVOLUTION, it became popular among the colonial Americans who began singing it as a song of pride. The refrain of the traditional version is: "Yankee Doodle keep it up, Yankee doodle Dandy/Mind the music and the step/And with the girls be handy." The first verse of a second version, popularly sung by American SCHOOL[1] children, is: "Yankee Doodle went to town/Riding on a pony/He stuck a feather in his hat/And called it macaroni." *See* YANKEE[3], "YANKEE DOODLE DANDY".

Yankee Stadium (sports and leisure) The BASEBALL stadium located in the Bronx in NEW YORK CITY and the home stadium of the New York YANKEES[4] (a team member of the AMERICAN LEAGUE). It was built in 1923 to seat 75,000 people; but after remodeling in the 1970s it now seats 57,545 people and still has a grass turf. Its nickname is "The House that Ruth Built" because of the large number of fans who bought tickets to see BABE RUTH play here. *Compare* EBBETS FIELD, BROOKLYN DODGERS.

yard (daily life) The green grounds on which a house is built and which is usually decorated with trees, shrubs and gardens.

Most houses in the SUBURBS have both a "front yard" and a "back yard". *See* GARAGE SALE/YARD SALE.

yarmulke (religion) A flat, round felt JEWISH man's cap worn on the crown of the head and often affixed with straight hairpins. It is worn by members of ORTHODOX JUDAISM and CONSERVATIVE JUDAISM during religious and prayer services in the temple, on the day of the Sabbath (i.e., Saturday) and special meals and other religious events (e.g., HIGH HOLIDAYS, HANUKKAH).

Year 2000 bug (science and technology) The popular name for the computer programming deficiency in which mainframe computers created in the twentieth century were programmed with computer codes to understand dates from that century only (i.e., until December 31, 1999), meaning that they could not record or retain any information which occurred on or after January 1, 2000. This deficiency, or 'bug', had the potential of wiping out all official records (e.g., financial, business, scientific) held by all individuals and companies and therefore, in the late 1990s, caused great anxiety among investors, stock SHAREHOLDERS, CORPORATIONS, CREDIT CARD companies, banks and the INTERNAL REVENUE SERVICE. Technically known as "Y2K".

yearbook (education) An annual publication written by and for students which celebrates the events of the ACADEMIC YEAR. It includes articles about SCHOOL[1]-sponsored events and photographs of all the CLASSES of students. The "yearbook club" is an EXTRACURRICULAR ACTIVITY in many SECONDARY SCHOOLS and COLLEGES[1].

yellow journalism (media) A negative term for the sensational writing style and content in newspaper and magazine articles, used to increase sales of the periodical during the PROGRESSIVE ERA. [Shortened from "'Yellow' Kid 'journalism'" which refers to the NEW YORK CITY newspapers which carried this comic and were known for this writing style.] *See* NEW JOURNALISM[3]; *compare* MUCKRAKING, INTERPRETIVE REPORTING, YELLOW PRESS.

Yellow Kid, the (media) The first modern comic and the first to be printed in color which treated the adventures of a young, trouble-making boy. It was de-

signed by animator Richard Outcault (1863–1928) and was first published in 1895 in the NEW YORK *WORLD* which was owned by JOSEPH PULITZER and proved enormously popular with readers. Later wishing to increase sales of his own newspapers, WILLIAM RANDOLPH HEARST attempted to, and earned the rights to, publish this comic in his own newspaper, the *New York Journal.* [From the main character's 'yellow'-colored shirt/nightgown.] *See* YELLOW JOURNALISM.

Yellow Peril, the (minorities) The irrational fear of white Americans that Asians, especially the Japanese and/or Chinese, will overrun and control the culture, politics and/or economy of part or all of the UNITED STATES. This was particularly common in the STATE of California from the 1880s to the 1920s because of the aggressive, sensationalistic stories written in those newspapers practicing YELLOW JOURNALISM. It was also active during WORLD WAR II, and led to the creation of the INTERNMENT CAMPS and WAR RELOCATION AUTHORITY. [From the old, pejorative term 'yellow', used to refer to people from Asia.] Also spelled "yellow peril"; *see* NATIVISM, PEARL HARBOR, WILLIAM RANDOLPH HEARST; *compare* RED SCARE[1].

yellow press (media) Currently, a term used to describe a media organization or group which reports sensational, scandal-oriented stories especially with the goal of increasing its own sales of newspapers. [From 'YELLOW' JOURNALISM.]

yellow ribbon (customs and traditions) A small yellow-colored ribbon or thin strip of cloth pinned to a person's shirt or BLAZER as a sign that that person supports another, special individual and wishes him or her to come home safely. It was commonly worn during the GULF WAR. [After the nineteenth-century custom of young women whose sweethearts were members of the UNITED STATES Cavalry; it was popularized by the WESTERN film *She Wore a 'Yellow Ribbon'* (1949) and the 1973 TOP-40 song "Tie a 'Yellow Ribbon' Round the Old Oak Tree".] *Compare* RED RIBBON.

"Yellow Rose of Texas", "the" (customs and traditions) A lively, popular FOLK MUSIC song from the SOUTH sung in quick tempo which is a favorite song of the STATE of Texas. The first verse follows: "There's a yellow rose of Texas that I am going to see/No other fellow knows her, no fellow, only me/She cried so hard when I left her, it like to break my heart/And if I ever find her, we never more will part." It was popularized in a 1933 SINGING COWBOY movie starring Gene Autry (1907–1998).

yellow-dog contract (work) A contract for work in which the employers have the right to fire an employee who joins a UNION[1]. It is illegal according to the NORRIS–LA GUARDIA ACT of 1932. [From the belief that only a weak, easily intimidated person, that is a 'yellow dog', would sign it.]

Yellowstone (National Park) (environment) A unique natural area, encompassing hot springs, over 300 geysers (e.g., releasing steam or gaseous smells), bubbling mud pots and the Snake and Yellowstone Rivers, as well as offering camping and hiking and opportunities for outdoor recreation. Its most famous geyser is OLD FAITHFUL. In 1872, it became the world's first NATIONAL PARK.

Yippies (politics) The radical student group active during the COUNTERCULTURE movement which combined utopian ideas of promoting the ANTI-WAR MOVEMENT with a funny sense of humor. Further, it wanted to have free merchandise and free sex. It used DIRECT ACTION to catch the attention of the media for which it enacted funny public displays. For example, in the 1968 election for US PRESIDENT, it nominated its own candidate – a pig named "Pigasus". It was founded in 1968 by ABBIE HOFFMAN and Jerry Rubin (born in 1938); although it lost media attention after 1972, it remains active in small projects today. [Abbreviation of 'Y'outh 'I'nternational 'P'arty + 'ie'.] *See* CHICAGO EIGHT.

YMCA/YWCA (sports and leisure) A local, urban organization with a national administration that works to promote the health of people, especially young people, by offering health and physical education in sports, weight-lifting, SUMMER CAMPS, child care, DAY CARE and hotel/hostel facilities. The Young Men's Christian

Association (YMCA) was founded in 1851. The Young Women's Christian Association (YWCA) was founded in 1858.

YMHA/YWHA (sports and leisure) A local organization which provides services and WORKSHOPS to the community and its JEWISH populations. Its buildings usually include GYMS, exercise and fitness equipment and classrooms where special programs about physical and mental health services and programs are presented as well as information about Judaism. All the local branches are overseen by a national organization. [Abbreviation of 'Y'oung 'M'en's 'H'ebrew 'A'ssociation/'Y'oung 'W'omen's 'H'ebrew 'A'ssociation.]

Yoknapatawpha County (society) The fictional, small, rural COUNTY created by WILLIAM FAULKNER where his novels are set and his characters live. It is "located" in the SOUTH and modeled on his real home of Lafayette County, in the STATE of Mississippi where everyone knows everyone else. [From Chickasaw Indian language, meaning "ground with furrows", or "depressions".]

Yorktown (history) The last major battle of the AMERICAN REVOLUTION (held on October 17, 1781). It ended with the surrender of British General George Cornwallis (1738–1805) and his command of 8,000 troops to the French and American Army under the command of GEORGE WASHINGTON. [From the location of the battle site, 'Yorktown', Virginia.]

Yosemite (National Park) (environment) A popular NATIONAL PARK (since 1890) located in a mountainous region of central California known as the Sierra Nevada which includes unique granite rock peaks (i.e., El Capitán, the Half Dome), waterfalls (i.e., Yosemite Falls, Bridalveil Falls), water (i.e., Mirror Lake) and forests of fir trees and oversized trees (i.e., Sequoia trees). Through the efforts of JOHN MUIR, it was preserved and first established as a state park in 1864. *Compare* YELLOWSTONE.

"You have the right to remain silent..." (legal system) The first right mentioned in the *MIRANDA* WARNING.

Young Lords Organization, the (minorities) (YLO) During the CHICANO MOVEMENT, an organized GRASSROOTS group of militant Puerto Ricans which worked to decrease gang warfare and to unite neighborhoods and BARRIOS. It attempted to achieve this through organized SIT-INS and housing tenant strikes. Further, it held political ideas which did not support the system of WASP power and CAPITALISM in the US, but rather preferred communal self-help and the improved condition of all oppressed peoples. Although it was based in CHICAGO, there was another group in NEW YORK CITY. It briefly formed a coalition with the BLACK PANTHERS and the BROWN BERETS to promote "people power". They called themselves *compañeros revolucionarios*, which is Spanish, meaning "revolutionary friends/brothers". *See* PUERTO RICO.

Young, Brigham (people) (1801–1877) A religious and political leader of the MORMONS who led his followers on a long cross-country trek to establish their new (and current) "home" in SALT LAKE CITY. During his long tenure as president of the CHURCH OF JESUS CHRIST OF LATTER-DAY SAINTS (1844–1877) he helped to legitimize the organization by providing political and economic stability in that region of the WEST and, finally, forbidding male members from having more than one wife.

Young, Lester (people) (1909–1959) Musician and tenor saxophone of JAZZ MUSIC. A talented musician who performed in the big band of COUNT BASIE until he was drafted into the US ARMED FORCES. Later he played solos and in small ENSEMBLES, especially with BILLIE HOLIDAY, his close friend. Holiday gave him the nickname of "Prez" or "Pres", a clipping from 'Pres'ident. His smooth, slower style helped lead to BEBOP. He died March 15.

Your Honor (legal system) During a courtroom trial, the title used (by ATTORNEYS, witnesses) when addressing a judge. *See* BENCH[1].

yuppie (society) An individual (aged 25 through 40) who earns a large salary from working hard in a professional, white-collar job and who enjoys spending that money on expensive, fashionable, trendy products (e.g., non-American-made sports cars, hot tubs). [Acronym from 'y'oung 'u'rban 'p'rofessional + ie.] *Compare* BUPPY.

Z

ZIP code (daily life) A number used by the US Postal Service to help in mail sorting and delivery. In an address, it follows the names of the city and STATE. It consists of five digits (e.g., 12345) or nine digits (e.g., 12345-6789). In general, these numbers increase from east to west; they are lowest in Massachusetts (01000) and highest in Alaska (99500). [Acronym from the initials 'Z'one 'I'mprovement 'P'lan.] Also spelled "zip".

zone (coverage) (sports and leisure) A method of defense in which a defensive team member is assigned to an area (i.e., 'zone') of the playing field or court and is responsible for stopping all offensive actions made by any offensive player(s) while in that defending player's zone. *Compare* MAN-TO-MAN (COVERAGE).

zoning regulations (housing and architecture) Any type of CIVIL LAW[1] created and enforced by a city, village or local government concerning and permitting the development and building usages of certain architectural structures. Usually they delimit certain regions according to the following classifications: single-family homes; multi-family homes; apartment BLOCKS[3]; social/public housing; commercial (businesses), factories and industrial buildings. This system of **zoning** traditionally has supported the system of SUBURBS and separation of housing zones.

Zoot Suit Riots (minorities) The violent racial attacks and beatings of teenage Mexican-American and some black youths by newly recruited US NAVY sailors in LOS ANGELES in June 3–7, 1943. These attacks on the Mexican Americans (also known as "Zoot Suiters"), were approved of by the local and US press corps and local police. They were only stopped when the DEPARTMENT OF STATE and PENTAGON banned the sailors from LA. These riots were caused by the racial prejudice of whites and the practices of the local police officers, as well as encouragement from the press. During the CHICANO MOVEMENT, these riots were dramatized in the production by El TEATRO CAMPESINO of "Zoot Suit" (1978). Further, the BROADWAY play "Zoot Suit" (1979), the film "Zoot Suit" (1981) and the documentary film "Pachuco" were all designed to illustrate to white audiences white Americans' racism against CHICANOS. [From the 'Zoot Suit', a distinctive stylized two-piece suit popular with these Mexican-American youths in the 1940s and 1950s. It consisted of an oversized jacket that stretched long to the knees and had broad padded shoulders; the baggy pants had a high waistband and were pegged at the ankle.] *See* PACHUCO[2].

Appendixes

Appendix 1
States

State	Population	Nickname	Region
Alabama (AL)	4,273,084	Heart of Dixie; Yellowhammer State	SOUTH; SOUTHEAST
Alaska (AK)	607,007	The Last Frontier (unofficial)	Alaska
Arizona (AZ)	4,428,068	Grand Canyon State	WEST; SOUTHWEST
Arkansas (AR)	2,509,793	Land of Opportunity; Razorback State	SOUTH
California (CA)	31,878,234	Golden State	WEST
Colorado (CO)	3,822,676	Centennial State	WEST; ROCKY MOUNTAIN region; SOUTHWEST
Connecticut (CT)	3,274,238	Constitution State; Nutmeg State	EAST; EAST COAST
Delaware (DE)	724,842	First State; Diamond State	EAST; EAST COAST
Florida (FL)	14,399,985	Sunshine State	SOUTHEAST
Georgia (GE)	7,353,225	Peach State; Empire State of the South	SOUTH
Hawai'i (HI)	1,183,723	Aloha State; Paradise of the Pacific	Hawai'i
Idaho (ID)	1,189,251	Gem State	WEST; ROCKY MOUNTAIN region
Illinois (IL)	11,846,544	Prairie State	MIDWEST; Corn Belt
Indiana (IN)	5,840,528	Hoosier State	MIDWEST; Corn Belt
Iowa (IA)	2,851,792	Hawkeye State	MIDWEST; Corn Belt
Kansas (KS)	2,572,150	Sunflower State	MIDWEST; GREAT PLAINS; Corn Belt
Kentucky (KY)	3,883,723	Bluegrass State	MIDWEST; SOUTH
Louisiana (LA)	4,350,579	Pelican State	SOUTH
Maine (ME)	1,243,316	Pine Tree State	NEW ENGLAND; EAST
Maryland (MD)	5,071,604	Old Line State; Free State	EAST; EAST COAST
Massachusetts (MA)	6,092,352	Bay State	EAST; EAST COAST; NEW ENGLAND
Michigan (MI)	9,594,350	Wolverine State; Lake State	MIDWEST
Minnesota (MN)	4,657,758	North Star State; Gopher State; Land of Lakes (unofficial)	MIDWEST
Mississippi (MS)	2,716,115	Magnolia State	SOUTH
Missouri (MO)	5,358,692	Show Me State	WEST; MIDWEST
Montana (MT)	879,372	Treasure State; Big Sky Country	WEST; ROCKY MOUNTAIN region
Nebraska (NB)	1,652,093	Cornhusker State	WEST; MIDWEST; Corn Belt
Nevada (NV)	1,603,163	Silver State; Sagebrush State	WEST; SOUTHWEST; GREAT BASIN
New Hampshire (NH)	1,162,481	Granite State	EAST; NEW ENGLAND
New Jersey (NJ)	7,987,933	Garden State	EAST; MID-ATLANTIC

State	Population	Nickname	Region
New Mexico (NM)	1,713,407	Land of Enchantment	WEST; SOUTHWEST
New York (NY)	18,184,774	Empire State	EAST; MID-ATLANTIC
North Carolina (NC)	7,322,870	Tarheel State; Old North State	EAST; SOUTH
North Dakota (ND)	643,539	Sioux State; Peace Garden State; Flickertail State	WEST; MIDWEST
Ohio (OH)	11,172,782	Buckeye State	MIDWEST
Oklahoma (OK)	3,300,902	Sooner State	WEST; MIDWEST
Oregon (OR)	3,203,735	Beaver State	WEST; PACIFIC NORTHWEST
Pennsylvania (PA)	12,056,112	Keystone State	EAST
Rhode Island (RI)	990,225	Ocean State; Little Rhody	EAST; EAST COAST
South Carolina (SC)	3,698,746	Palmetto State	EAST; SOUTH
South Dakota (SD)	732,405	Coyote State; Sunshine State	WEST; GREAT PLAINS
Tennessee (TN)	5,319,654	Volunteer State	EAST; SOUTH
Texas (TX)	19,128,261	Lone Star State	EAST; WEST
Utah (UT)	2,000,494	Beehive State; Mormon State	WEST; GREAT BASIN
Vermont (VT)	588,654	Green Mountain State	EAST; NEW ENGLAND
Virginia (VA)	6,675,451	Old Dominion; Mother of Presidents; Mother of States	EAST; EAST COAST; SOUTH
Washington (WA)	5,532,939	Evergreen State	WEST; PACIFIC NORTHWEST
West Virginia (WV)	1,825,754	Mountain State	EAST APPALACHIAN MOUNTAIN region
Wisconsin (WI)	5,159,795	Badger State	MIDWEST
Wyoming (WY)	481,400	Equality State	WEST; GREAT PLAINS

State	Capital city	Entry into the US	Electoral votes	Major cities (populations)
Alabama (AL)	Montgomery	December 14, 1819	9	Birmingham (266,000)
Alaska (AK)	Juneau	January 3, 1959	3	Anchorage (226,000)
Arizona (AZ)	Phoenix	February 14, 1912	8	Tucson (405,000)
Arkansas (AR)	Little Rock	June 15, 1836	6	Little Rock (176,000)
California (CA)	Sacramento	September 9, 1850	54	Los Angeles (3.48 million)
Colorado (CO)	Denver	August 1, 1876	8	Denver (461,000)
Connecticut (CT)	Hartford	January 9, 1788	8	Hartford (140,000)
Delaware (DE)	Dover	December 7, 1787	3	Wilmington (72,000)
Florida (FL)	Tallahassee	March 3, 1845	25	Jacksonville (672, 971); Miami (358,629)
Georgia (GE)	Atlanta	January 2, 1788	13	Atlanta (395,000)
Hawai'i (HI)	Honolulu	August 21, 1959	4	Honolulu (365,000)
Idaho (ID)	Boise City	July 3, 1890	4	Boise City (126,000)
Illinois (IL)	Springfield	December 3, 1818	22	Chicago (2.78 million)
Indiana (IN)	Indianapolis	December 11, 1816	12	Indianapolis (742,000)
Iowa (IA)	Des Moines	December 28, 1846	7	Des Moines (193,000)
Kansas (KS)	Topeka	January 29, 1861	6	Wichita (304,000)
Kentucky (KY)	Frankfort	June 1, 1792	8	Lexington-Fayette (225,000)
Louisiana (LA)	Baton Rouge	April 30, 1812	9	New Orleans (497,000)
Maine (ME)	Augusta	March 15, 1820	4	Portland (64,000)
Maryland (MD)	Annapolis	April 28, 1788	10	Baltimore (736,000)
Massachusetts (MA)	Boston	February 6, 1788	12	Boston (574,000)
Michigan (MI)	Lansing	January 26, 1837	18	Detroit (1.028 million)
Minnesota (MN)	St. Paul	May 11, 1858	10	Minneapolis (369,000)
Mississippi (MS)	Jackson	December 10, 1817	7	Jackson (197,000)
Missouri (MO)	Jefferson City	August 10, 1821	11	Kansas City (435,000)
Montana (MT)	Helena	November 8, 1889	3	Billings (81,000)
Nebraska (NB)	Lincoln	March 1, 1867	5	Omaha (336,000)
Nevada (NV)	Carson City	October 31, 1864	4	Las Vegas (258,000)
New Hampshire (NH)	Concord	June 21, 1788	4	Nashua (80,000)

State	Capital city	Entry into the US	Electoral votes	Major cities (populations)
New Jersey (NJ)	Trenton	December 18, 1787	15	Newark (275,000)
New Mexico (NM)	Santa Fe	January 6, 1912	5	Albuquerque (385,000)
New York (NY)	Albany	July 26, 1788	33	NEW YORK CITY (7.3 million)
North Carolina (NC)	Raleigh	November 21, 1789	14	Charlotte (396,000); Raleigh (208,000)
North Dakota (ND)	Bismarck	November 2, 1889	3	Fargo (74,000)
Ohio (OH)	Columbus	March 1, 1803	21	Cincinnati (364,000); Cleveland (506,000)
Oklahoma (OK)	Oklahoma City	November 16, 1907	8	Oklahoma City (445,000)
Oregon (OR)	Salem	February 14, 1859	7	Portland (437,000)
Pennsylvania (PA)	Harrisburg	December 12, 1787	23	Philadelphia (1.6 million); Pittsburgh (370,000)
Rhode Island (RI)	Providence	May 29, 1790	4	Providence (161,000)
South Carolina (SC)	Columbia	May 23, 1788	8	Columbia (98,000)
South Dakota (SD)	Pierre	November 2, 1889	3	Sioux Falls (101,000)
Tennessee (TN)	Nashville	June 1, 1796	11	Memphis (610,000); NASHVILLE (511,000)
Texas (TX)	Austin	December 29, 1845	32	Houston (1.6 million); DALLAS (1 million)
Utah (UT)	Salt Lake City	January 4, 1896	5	Salt Lake City (160,000)
Vermont (VT)	Montpelier	March 4, 1791	3	Burlington (38,000)
Virginia (VA)	Richmond	June 25, 1788	13	Virginia Beach (393,000)
Washington (WA)	Olympia	November 11, 1889	11	SEATTLE (516,000)
West Virginia (WV)	Charleston	June 20, 1863	5	Charleston (57,000)
Wisconsin (WI)	Madison	May 29, 1848	11	Milwaukee (628,000)
Wyoming (WY)	Cheyenne	July 10, 1890	3	Cheyenne (50,000)

State	Name Origin
Alabama (AL)	after *Alabamas*, a local INDIAN TRIBE and language
Alaska (AK)	from ALEUT word *alakshak*, meaning "land that is not an island" or "great lands"
Arizona (AZ)	probably from Pima INDIAN word meaning "place of little springs"; less probably, from Aztec *arizuma* meaning "silver-bearing"
Arkansas (AR)	French for the name of the Quapaw, an INDIAN TRIBE
California (CA)	Spanish name and concept of a literary and figurative island of earthly paradise
Colorado (CO)	Spanish meaning "colored" and used to refer to the Colorado River
Connecticut (CT)	from the Mohican language meaning "place beside the long river"
Delaware (DE)	after Englishman and colonial governor of Virginia, Lord 'De La Warre' (1577–1618)
Florida (FL)	Spanish – full name is *Pascua Florida* – because it was discovered on Easter Sunday, 1513
Georgia (GE)	after English King 'George' II (1683–1760)
Hawai'i (HI)	derived from Hawaiian language name, '*Hawaiki*', for their traditional homeland in Polynesia
Idaho (ID)	allegedly, a new word given the meaning "gem of the mountains"; also possible, *Idaho*, the Kiowa and Apache name for the Comanche TRIBE
Illinois (IL)	French form meaning "land of the *Illini*", a local INDIAN TRIBE
Indiana (IN)	English meaning "lands of the Indians"
Iowa (IA)	name of INDIAN TRIBE meaning "beautiful land" or "here I rest"
Kansas (KS)	SIOUX meaning "people of the south wind"
Kentucky (KY)	from Iroquois INDIAN word *kenta-ke* meaning "meadowland"; Wyandot *kah-ten-tah-teh* meaning "land of tomorrow"
Louisiana (LA)	after French King 'Louis' XIV (1638–1715)
Maine (ME)	after old French province, 'Maine'; also, distinguishing the 'main'land from islands
Maryland (MD)	for English Queen Henrietta 'Maria', wife of King Charles I (1600–1649)
Massachusetts (MA)	after the INDIAN TRIBE name, meaning "large hill place"
Michigan (MI)	Chippewa '*mici gama*' meaning "great water"
Minnesota (MN)	from Dakota SIOUX meaning "cloudy water", referring to the Minnesota River
Mississippi (MS)	from Algonquin '*messippi*' meaning "great water"
Missouri (MO)	from Algonquin meaning "river of the big canoes"
Montana (MT)	Spanish meaning "mountainous"
Nebraska (NB)	from Omaha INDIAN language meaning "broad water" or "flat river"
Nevada (NV)	Spanish meaning "snow-covered"

State	Name Origin
New Hampshire (NH)	named after English county of 'Hampshire'
New Jersey (NJ)	named after England's Isle of 'Jersey'
New Mexico (NM)	after original Spanish name for this region
New York (NY)	after the English Duke of 'York', the brother of the English king
North Carolina (NC)	after Latin form, 'Carolus', in honor of English King Charles I (1600–649)
North Dakota (ND)	Sioux word *dakota* means "friend" or "ally"
Ohio (OH)	Iroquois word meaning "beautiful, fine river"
Oklahoma (OK)	Choctaw Indian word meaning "red man"
Oregon (OR)	perhaps from a French map dating to 1715 and referring to '*Ouaricon-sint*'
Pennsylvania (PA)	after English Admiral Sir William 'Penn' (1621–1670); it means "Penn's woods"
Rhode Island (RI)	from Dutch *Roode Eylandt* meaning "red-colored island"
South Carolina (SC)	after Latin form, 'Carolus', in honor of English King Charles I (1600–1649)
South Dakota (SD)	Sioux word *dakota* means "friend" or "ally"
Tennessee (TN)	from *Tanasi*, the Cherokee Indian name for villages
Texas (TX)	Indian word meaning "friends" or "allies"
Utah (UT)	from Navajo word meaning "upper" or "higher up"
Vermont (VT)	from French *vert* ("green") + *mont* ("mountain")
Virginia (VA)	after 'Virgin' English Queen Elizabeth (1533–1603)
Washington (WA)	after George Washington
West Virginia (WV)	after the 'west'ern part of Virginia which refused to leave the United States in 1863
Wisconsin (WI)	probably from Chippewa meaning "grassy place"
Wyoming (WY)	Algonquin meaning "large place", "at the big place"

Appendix 2
Presidents

President	Party	VP	Year	Platform
GEORGE WASHINGTON	FEDERALIST[2]	John Adams	1789–1792; 1792–1797	defeated WHISKEY REBELLION
John Adams (1735–1826)	FEDERALIST[2]	THOMAS JEFFERSON	1797–1801	passed ALIEN AND SEDITION ACTS
THOMAS JEFFERSON	DEMOCRATIC–REPUBLICAN	Aaron Burr; George Clinton	1801–1805; 1805–1809	JEFFERSONIAN DEMOCRACY, LOUISIANA PURCHASE, LEWIS AND CLARK
JAMES MADISON	DEMOCRATIC–REPUBLICAN	George Clinton; Elbridge Gerry	1809–1813; 1813–1817	declared WAR OF 1812
James Monroe (1758–1831)	DEMOCRATIC–REPUBLICAN	Daniel Tompkins	1817–1821; 1821–1825	ERA OF GOOD FEELING; MONROE DOCTRINE
John Quincy Adams (1767–1848)	FEDERALIST;[2] DEMOCRATIC–REPUBLICAN	JOHN C. CALHOUN	1825–1829	supported ABOLITION and very strong presidential powers
ANDREW JACKSON	DEMOCRATIC–REPUBLICAN; DEMOCRAT	JOHN C. CALHOUN	1829–1833; 1833–1837	JACKSONIAN DEMOCRACY, KITCHEN CABINET
Martin Van Buren (1782–1862)	DEMOCRAT	Richard Johnson	1837–1841	created independent treasury system
William Henry Harrison (1773–1841)	Whig	John Tyler	1841 (only 31 days long)	campaign slogan "Tippecanoe and Tyler; too"
John Tyler (1790–1862)	Whig	0	1841–1845	annexed the REPUBLIC OF TEXAS
James Knox Polk (1795–1849)	DEMOCRAT	George Dallas	1845–1849	encouraged MEXICAN-AMERICAN WAR; established northwestern border of US at 49° Parallel, MANIFEST DESTINY
Zachary Taylor (1784–1850)	Whig	Millard Fillmore	1849–1850 (only 16 months)	encouraged the SPOILS SYSTEM
Millard Fillmore (1800–1874)	Whig	0	1850–1853	believed STATES should decide for selves about legal SLAVERY
Franklin Pierce (1804–1869)	DEMOCRAT	William King	1853–1857	supported KANSAS-NEBRASKA ACT and GADSDEN PURCHASE
James Buchanan (1857–1861)	FEDERALIST;[2] DEMOCRAT	John Breckinridge	1857–1861	believed STATES should decide for selves about legal SLAVERY

President	Party	VP	Year	Platform
ABRAHAM LINCOLN	REPUBLICAN	Hannibal Hamlin; Andrew Johnson	1861–1864; 1864–1865	promoted ABOLITION; supported the CIVIL WAR
Andrew Johnson (1808–1875)	DEMOCRAT	0	1865–1869	did not support CONGRESS' RECONSTRUCTION; first president to be impeached
ULYSSES S. GRANT	REPUBLICAN	Schuyler Colfax; Henry Wilson	1869–1873; 1873–1877	supported RECONSTRUCTION; passed FIFTEENTH AMENDMENT
Rutherford B. Hayes	REPUBLICAN	William Wheeler	1877–1881	ended RECONSTRUCTION; supported CIVIL SERVICE REFORM, ended railroad strikes
James Garfield (1831–1881)	REPUBLICAN	Chester Arthur	1881 (term only 6½ months long)	shot by former campaign worker July 1881; died September 19, 1881
Chester Arthur (1829–1886)	REPUBLICAN	0	1881–1885	supported CIVIL SERVICE REFORM
Grover Cleveland (1837–1908)	DEMOCRAT	Thomas Hendricks	1885–1889	increased size of civil service
Benjamin Harrison (1833–1901)	REPUBLICAN	Levi Morton	1889–1893	approved SHERMAN ANTITRUST ACT
Grover Cleveland (1837–1908)	DEMOCRAT	Adlai Stevenson	1893–1897	did not support any government interference with business
William McKinley (1843–1901)	REPUBLICAN	Garret Hobart; THEODORE ROOSEVELT	1897–1901; 1901	started SPANISH-AMERICAN WAR; "assassinated" September 1901
THEODORE ROOSEVELT	REPUBLICAN	0; Charles Fairbanks	1901–1905; 1905–1909	supported PROGRESSIVE ERA reforms; established NATIONAL PARKS system
William Howard Taft (1857–1930)	REPUBLICAN	James Sherman	1909–1913	drafted SIXTEENTH & SEVENTEENTH AMENDMENTS
WOODROW WILSON	DEMOCRAT	Thomas Marshall	1913–1917; 1917–1921	approved FEDERAL RESERVE SYSTEM and WORLD WAR I
Warren Harding (1865–1923)	REPUBLICAN	Calvin Coolidge	1921–1923	tried to repeal high INCOME TAX
Calvin Coolidge 1872–1933)	REPUBLICAN	0; Charles Dawes	1923–1925; 1925–1929	reduced national debt; opposed League of Nations
Herbert Hoover (1874–1964)	REPUBLICAN	Charles Curtis	1929–1933	did not support government aid to individuals; BLACK TUESDAY

President	Party	VP	Year	Platform
FRANKLIN D. ROOSEVELT	DEMOCRAT	John Garner; Henry Wallace; HARRY S. TRUMAN	1933–1937; 1937–1941; 1941–1945; 1945	NEW DEAL; supported LEND-LEASE ACT and WORLD WAR II
HARRY S. TRUMAN	DEMOCRAT	0; Alben Barkley	1945–1949; 1949–1953	SQUARE DEAL; supported MARSHALL PLAN and KOREAN WAR
DWIGHT D. EISENHOWER	REPUBLICAN	RICHARD NIXON	1953–1957; 1957–1961	supported free-market system and LITTLE ROCK NINE; helped end KOREAN WAR
JOHN F. KENNEDY	DEMOCRAT	LYNDON JOHNSON	1961–1963	NEW FRONTIER, CUBAN MISSILE CRISIS, BAY OF PIGS
LYNDON JOHNSON	DEMOCRAT	0; Hubert Humphrey	1963–1965; 1965–1969	GREAT SOCIETY; WAR ON POVERTY and CIVIL RIGHTS ACT; VIETNAM WAR, GULF OF TONKIN RESOLUTION
RICHARD NIXON	REPUBLICAN	Spiro T. Agnew; GERALD FORD	1969–1973; 1973–1974	encouraged DÉTENTE and DUAL FEDERALISM; VIETNAM WAR, resigned because of WATERGATE
GERALD FORD	REPUBLICAN	Nelson Rockefeller	1974–1977	he pardoned RICHARD NIXON for any crimes committed while president;
JIMMY CARTER	DEMOCRAT	Walter Mondale	1977–1981	supported ENVIRONMENTAL MOVEMENT; hurt by Iran Hostage Crisis and MARIEL BOATLIFT
RONALD REAGAN	REPUBLICAN	GEORGE BUSH	1981–1985; 1985–1989	IRAN-CONTRA; SUPPLY-SIDE ECONOMICS
GEORGE BUSH	REPUBLICAN	Dan Quayle	1989–1993	GULF WAR; raised taxes
BILL CLINTON	DEMOCRAT	Al Gore	1993–1997; re-elected in 1996; 1997	increased MINIMUM WAGE; approved plan to change WELFARE system

Appendix 3
Professional teams

Team	Sport	Division	League or Conference	Stadium
Anaheim Angels	BASEBALL	Western	AMERICAN LEAGUE	Anaheim Stadium (1966)
Anaheim Mighty Ducks	ice hockey NHL	Pacific	Western Conference	Arrowhead Pond (1992)
Arizona Cardinals	FOOTBALL NFL	Eastern	NATIONAL FOOTBALL CONFERENCE	Sun Devil Stadium (1958)
Arizona Diamondbacks	BASEBALL	Western	NATIONAL LEAGUE	Bank One Ballpark (1998)
Atlanta Braves	BASEBALL	Eastern	NATIONAL LEAGUE	Turner Field (1997)
Atlanta Falcons	FOOTBALL NFL	Western	NATIONAL FOOTBALL CONFERENCE	Georgia Dome (1992)
Atlanta Hawks	BASKETBALL NBA	Central	Eastern Conference	Georgia Dome (1997)
Baltimore Orioles	BASEBALL	Eastern	AMERICAN LEAGUE	Oriole Park at Camden Yards (1992)
Baltimore Ravens	FOOTBALL NFL	Central	AMERICAN FOOTBALL CONFERENCE	Memorial Stadium (1924)
Boston Bruins	ice hockey NHL	Northeast	Eastern Conference	FleetCenter (1995)
Boston Celtics	BASKETBALL NBA	Atlantic	Eastern Conference	FleetCenter (1995)
Boston Red Sox	BASEBALL	Eastern	AMERICAN LEAGUE	Fenway Park (1912)
Buffalo Bills	FOOTBALL NFL	Eastern	AMERICAN FOOTBALL CONFERENCE	Rich Stadium (1973)
Buffalo Sabres	ice hockey NHL	Northeast	Eastern Conference	Marine Midland Arena
Calgary (Canada) Flames	ice hockey NHL	Pacific	Western Conference	Saddledome Stadium
Carolina Hurricanes	ice hockey NHL	Northeast	Eastern Conference	Aerial Center
Carolina Panthers	FOOTBALL NFL	Western	NATIONAL FOOTBALL CONFERENCE	Ericsson Stadium (1996)
Charlotte (North Carolina) Hornets	BASKETBALL NBA	Central	Eastern Conference	Charlotte Coliseum (1988)
Chicago Bears	FOOTBALL NFL	Central	NATIONAL FOOTBALL CONFERENCE	SOLDIER FIELD (1924)
Chicago Blackhawks	ice hockey NHL	Central	Western Conference	United Center (1994)
Chicago Bulls	BASKETBALL NBA	Central	Eastern Conference	United Center (1994)
Chicago Cubs	BASEBALL	Central	NATIONAL LEAGUE	Wrigley Field (1914)
Chicago White Sox	BASEBALL	Central	AMERICAN LEAGUE	Comisky Park (1991)

Team	Sport	Division	League or Conference	Stadium
Cincinnati Bengals	FOOTBALL NFL	Central	AMERICAN FOOTBALL CONFERENCE	Cinergy Stadium (1970)
Cincinnati Reds	BASEBALL	Central	NATIONAL LEAGUE	Cinergy Field (1970)
Cleveland Cav(alier)s	BASKETBALL NBA	Central	Eastern Conference	Gund Arena (1994)
Cleveland Indians	BASEBALL	Central	AMERICAN LEAGUE	Jacobs Field (1994)
Colorado Avalanche	ice hockey NHL	Pacific	Western Conference	McNichols Sports Arena
Colorado Rockies	BASEBALL	Western	NATIONAL LEAGUE	Coors Field (1995)
Dallas Cowboys	FOOTBALL NFL	Eastern	NATIONAL FOOTBALL CONFERENCE	Texas Stadium (1971)
Dallas Mavericks	BASKETBALL NBA	Midwest	Western Conference	Reunion Arena (1980)
Dallas Stars	ice hockey NHL	Central	Western Conference	Dr. Pepper Star Center
Denver Broncos	FOOTBALL NFL	Western	AMERICAN FOOTBALL CONFERENCE	Denver Mile High Stadium (1948)
Denver Nuggets	BASKETBALL NBA	Midwest	Western Conference	McNichols Sports Arena (1975)
Detroit Lions	FOOTBALL NFL	Central	NATIONAL FOOTBALL CONFERENCE	Pontiac Silverdome (1975)
Detroit Pistons	BASKETBALL NBA	Central	Eastern Conference	Palace of Auburn Hills (1988)
Detroit Red Wings	ice hockey NHL	Central	Western Conference	Olympia Stadium
Detroit Tigers	BASEBALL	Eastern	AMERICAN LEAGUE	Tiger Stadium (1912)
Edmonton (Canada) Oilers	ice hockey NHL	Pacific	Western Conference	Edmonton Coliseum
Florida Marlins	BASEBALL	Eastern	NATIONAL LEAGUE	Pro Player Stadium (1987)
Florida Panthers	ice hockey NHL	Atlantic	Eastern Conference	Miami Arena
Golden State Warriors	BASKETBALL NBA	Pacific	Western Conference	Oakland Arena (1977)
Green Bay Packers	FOOTBALL NFL	Central	NATIONAL FOOTBALL CONFERENCE	Lambeau Field (1957)
Houston Astros	BASEBALL	Central	NATIONAL LEAGUE	The Astrodome (1965)
Houston Rockets	BASKETBALL NBA	Midwest	Western Conference	The Summit (1975)
Indiana Pacers	BASKETBALL NBA	Central	Eastern Conference	Market Square Arena (1974)
Indianapolis Colts	FOOTBALL NFL	Eastern	AMERICAN FOOTBALL CONFERENCE	RCA Dome (1983)

Team	Sport	Division	League or Conference	Stadium
Jacksonville Jaguars	FOOTBALL NFL	Central	AMERICAN FOOTBALL CONFERENCE	ALLTEL Stadium (1995)
Kansas City Chiefs	FOOTBALL NFL	Western	AMERICAN FOOTBALL CONFERENCE	Arrowhead Stadium (1972)
Kansas City Royals	BASEBALL	Central	AMERICAN LEAGUE	Kauffman Stadium (1973)
Los Angeles (LA) Clippers	BASKETBALL NBA	Pacific	Western Conference	LA Memorial Sports Arena (1959); Arrowhead Pond of Anaheim (1992)
Los Angeles (LA) Dodgers	BASEBALL	Western	NATIONAL LEAGUE	Dodger Stadium (1962)
Los Angeles (LA) Lakers	BASKETBALL NBA	Pacific	Western Conference	The Great Western Forum (1967)
Los Angeles Kings	ice hockey NHL	Pacific	Western Conference	The Great Western Forum (1967)
Miami Dolphins	FOOTBALL NFL	Eastern	AMERICAN FOOTBALL CONFERENCE	Pro Player Stadium (1987)
Miami Heat	BASKETBALL NBA	Atlantic	Eastern Conference	Miami Arena (1988)
Milwaukee Brewers	BASEBALL	Central	NATIONAL LEAGUE	County Stadium (1953)
Milwaukee Bucks	BASKETBALL NBA	Central	Eastern Conference	Bradley Center (1988)
Minnesota Timberwolves	BASKETBALL NBA	Midwest	Western Conference	Target Center (1990)
Minnesota Twins	BASEBALL	Central	AMERICAN LEAGUE	Hubert Humphrey Metrodome (1982)
Minnesota Vikings	FOOTBALL NFL	Central	NATIONAL FOOTBALL CONFERENCE	Metrodome (1982)
Montreal (Canada) Canadiens	ice hockey NHL	Northeast	Eastern Conference	Le Centre Molson
Montreal (Canada) Expos	BASEBALL	Eastern	NATIONAL LEAGUE	Olympic Stadium (1976)
New England Patriots	FOOTBALL NFL	Eastern	AMERICAN FOOTBALL CONFERENCE	Foxboro Stadium (1971)
New Jersey Devils	ice hockey NHL	Atlantic	Eastern Conference	Continental Airlines Arena (1981)
New Jersey Nets	BASKETBALL NBA	Atlantic	Eastern Conference	Continental Airlines Arena (1981)
New Orleans Saints	FOOTBALL NFL	Western	NATIONAL FOOTBALL CONFERENCE	Louisiana Superdome (1975)
New York Giants	FOOTBALL NFL	Eastern	NATIONAL FOOTBALL CONFERENCE	Giants Stadium (1976)
New York Islanders	ice hockey NHL	Atlantic	Eastern Conference	Nassau Veterans Memorial Coliseum

Team	Sport	Division	League or Conference	Stadium
New York Jets	FOOTBALL NFL	Eastern	AMERICAN FOOTBALL CONFERENCE	Giants Stadium (1976)
New York Knick(erbocker)s	BASKETBALL NBA	Atlantic	Eastern Conference	MADISON SQUARE GARDEN (1968)
New York Mets	BASEBALL	Eastern	NATIONAL LEAGUE	Shea Stadium (1964)
New York Rangers	ice hockey NHL	Atlantic	Eastern Conference	Madison Square Garden (1968)
New York Yankees	BASEBALL	Eastern	AMERICAN LEAGUE	YANKEE STADIUM (1923)
Oakland Athletics (A's)	BASEBALL	Western	AMERICAN LEAGUE	Oakland Coliseum (1968)
Oakland Raiders	FOOTBALL NFL	Western	AMERICAN FOOTBALL CONFERENCE	Oakland-Alameda City Coliseum (1966)
Orlando Magic	BASKETBALL NBA	Atlantic	Eastern Conference	Orlando Arena (1989)
Ottawa (Canada) Senators	ice hockey NHL	Northeast	Eastern Conference	Corel Centre
Philadelphia 76ers	BASKETBALL NBA	Atlantic	Eastern Conference	CoreStates Center (1996)
Philadelphia Eagles	FOOTBALL NFL	Eastern	NATIONAL FOOTBALL CONFERENCE	Veterans Stadium (1971)
Philadelphia Flyers	ice hockey NHL	Atlantic	Eastern Conference	CoreStates Complex
Philadelphia Phillies	BASEBALL	Eastern	NATIONAL LEAGUE	Veterans Stadium (1971)
Phoenix Coyotes	ice hockey NHL	Central	Western Conference	Renaissance Square
Phoenix Suns	BASKETBALL NBA	Pacific	Western Conference	America West West Arena (1992)
Pittsburgh Penguins	ice hockey NHL	Northeast	Eastern Conference	Civic Arena
Pittsburgh Pirates	BASEBALL	Central	NATIONAL LEAGUE	Three Rivers Stadium (1970)
Pittsburgh Steelers	FOOTBALL NFL	Central	AMERICAN FOOTBALL CONFERENCE	Three Rivers Stadium (1970)
Portland Trail Blazers	BASKETBALL NBA	Pacific	Western Conference	The Rose Garden (1995)
Sacramento Kings	BASKETBALL NBA	Pacific	Western Conference	ARCO Arena (1988)
San Antonio Spurs	BASKETBALL NBA	Midwest	Western Conference	Alamodrome (1993)
San Diego Chargers	FOOTBALL NFL	Western	AMERICAN FOOTBALL CONFERENCE	Qualcomm Stadium (1967)
San Diego Padres	BASEBALL	Western	NATIONAL LEAGUE	Qualcomm Stadium (1967)
San Francisco 49ers	FOOTBALL NFL	Western	NATIONAL FOOTBALL CONFERENCE	3Com Park at Candlestick Point (1960)

Team	Sport	Division	League or Conference	Stadium
San Francisco Giants	BASEBALL	Western	NATIONAL LEAGUE	3Com Park at Candelstick Point (1960)
San Jose Sharks	ice hockey NHL	Pacific	Western Conference	San Jose Arena
Seattle Mariners	BASEBALL	Western	AMERICAN LEAGUE	The Kingdome (1976)
Seattle Seahawks	FOOTBALL NFL	Western	AMERICAN FOOTBALL CONFERENCE	The Kingdome (1976)
Seattle SuperSonics	BASKETBALL NBA	Pacific	Western Conference	KeyArena (1995)
St. Louis Blues	ice hockey NHL	Central	Western Conference	Kiel Center
St. Louis Cardinals	BASEBALL	Central	NATIONAL LEAGUE	Busch Stadium (1966)
St. Louis Rams	FOOTBALL NFL	Western	NATIONAL FOOTBALL CONFERENCE	Trans World Dome (1995)
Tampa Bay Buccaneers	FOOTBALL NFL	Central	NATIONAL FOOTBALL CONFERENCE	Houlihan's Stadium (1967)
Tampa Bay Devil Rays	BASEBALL	Eastern	AMERICAN LEAGUE	Tropicana Field (1990; 1998)
Tampa Bay Lightning	ice hockey NHL	Atlantic	Eastern Conference	Ice Palace
Tennessee Oilers	FOOTBALL NFL	Central	AMERICAN FOOTBALL CONFERENCE	Liberty Bowl Memorial Stadium (1964)
Texas Rangers	BASEBALL	Western	AMERICAN LEAGUE	The Ballpark in Arlington (1994)
Toronto (Canada) Blue Jays	BASEBALL	Eastern	AMERICAN LEAGUE	SkyDome (1989)
Toronto (Canada) Maple Leafs	ice hockey NHL	Central	Western Conference	Maple Leaf Gardens
Toronto (Canada) Raptors	BASKETBALL NBA	Central	Eastern Conference	SkyDome (1989)
Utah Jazz	BASKETBALL NBA	Midwest	Western Conference	Delta Center (1991)
Vancouver (Canada) Canucks	ice hockey NHL	Pacific	Western Conference	General Motors Place
Vancouver (Canada) Grizzlies	BASKETBALL NBA	Pacific	Western Conference	Bear Country at GM Place (1973)
Washington (D.C.) Capitals	ice hockey NHL	Atlantic	Eastern Conference	USAir Arena
Washington (D.C.) Redskins	FOOTBALL NFL	Eastern	NATIONAL FOOTBALL CONFERENCE	Jack Kent Cooke Stadium (1997)

Appendix 4 *Education levels*

EDUCATION LEVELS

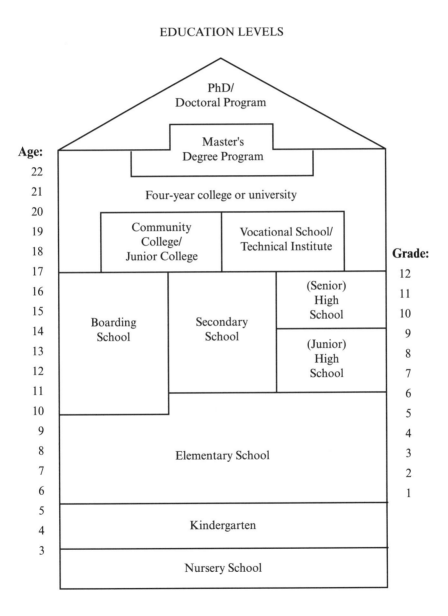

Adapted from The United States System of Education. (Washington, DC: United States Information Agency, 1984)

Appendix 5: *Grading systems*

LETTER GRADE A–F (ELEMENTARY SCHOOL)	100% SCALE (SECONDARY SCHOOL)	4.0 SCALE (COLLEGE[3] & GRADUATE SCHOOL)	EQUIVALENCE
A+	100%	4.0	
A+	99%	3.9	excellent
A+	98%		
A	97%	3.8	
A	96%	3.7	
A	95%		
A	94%	3.6	very good
A-	93%	3.5	
A-	92%		
A-	91%	3.4	
B+	90%	3.3	
B+	89%		
B+	88%	3.2	
B	87%	3.1	
B	86%		good
B	85%	3.0	
B	84%	2.9	
B-	83%		
B-	82%	2.8	
B-	81%	2.7	
C+	80%		
C+	79%	2.6	
C+	78%	2.5	
C	77%		
C	76%	2.4	average
C	75%	2.3	
C	74%		
C-	73%	2.2	
C-	72%	2.1	
C-	71%		
D+	70%	2.0	
D+	69%	1.9	
D+	68%	1.8	
D	67%	1.7	bad scores, often
D	66%	1.6	considered to be
D	65%	1.5	unacceptable
D	64%	1.4	and therefore
D-	63%	1.3	the course
D-	62%	1.2	should be
D-	61%	1.1	repeated
D-	60%	1.0	
F	59% and lower	0.9	flunking

Appendix 6 *Bowl games*

name	location	year established
Alamo Bowl	San Antonio, Texas	1993
Aloha Bowl	Honolulu, Hawaii	1982
Carquest Bowl (until 1983, Blockbuster Bowl)	MIAMI, Florida	1990
Copper Bowl	Tucson, Arizona	1989
Cotton Bowl	DALLAS, Texas	1937
Fiesta Bowl	Tempe, Arizona	1971
Florida Citrus Bowl (until 1983, Tangerine Bowl)	Orlando, Florida	1947
Gator Bowl	Jacksonville, Florida	1946
Holiday Bowl	San Diego, California	1978
Independence Bowl	Shreveport, Louisiana	1976
Las Vegas Bowl	LAS VEGAS, Nevada	1992
Liberty Bowl	Memphis, Tennessee	1959
Orange Bowl	MIAMI, Florida	1935
Outback Bowl (until 1996, Hall of Fame Bowl)	Tampa, Florida	1986
Peach Bowl	ATLANTA, Georgia	1968
Rose Bowl	Pasadena, California	1902
Sugar Bowl	NEW ORLEANS, Louisiana	1935
Sun Bowl (1989–1993, John Hancock Bowl)	El Paso, Texas	1936

Appendix 7 *Military ranks and ensignia*

US Army and Air Force

Commissioned Officers:

General of the Armies	[this title only given to George Washington and John Pershing (1860–1948)]
General of the Army/Air Force	five silver stars
Lieutenant General	four silver stars
Major General	three silver stars
Brigadier General	one silver star
Colonel	one silver eagle
Lieutenant Colonel	one silver oak leaf
Major	one gold oak leaf
Captain	two silver bars
First Lieutenant	one silver bar
Second Lieutenant	one gold bar

Warrant Officers:

Grade Five
Grade Four
Grade Three
Grade Two
Grade One

Noncommissioned Officers:

Sergeant Major of the Army/Air Force
Command Sergeant Major
Sergeant Major
First Sergeant
Master Sergeant
Sergeant First Class
Staff Sergeant
Sergeant
Corporal

Other enlisted personnel:

Private First Class
Private

US Marine Corps

Commissioned Officers:

General of the Marine Corps
Lieutenant General
Major General
Brigadier General
Colonel
Lieutenant Colonel
Major
Captain
First Lieutenant
Second Lieutenant

Noncommissioned Officers:

Sergeant Major of the Marine Corps
Sergeant Major
Master Gunnery Sergeant
First Sergeant
Master Sergeant
Gunnery Sergeant
Staff Sergeant
Sergeant
Corporal
Lance Corporal
Private First Class
Private

US Navy

Commissioned Officers:

Fleet Admiral (this title used only during wartime)
Admiral
Vice Admiral
Rear Admiral (upper half)
Rear Admiral (lower half)
Captain
Commander
Lieutenant Commander
Lieutenant
Ensign
Warrant Officer – W-4
Warrant Officer – W-3
Warrant Officer – W-2
Warrant Officer – W-1

Enlisted personnel:

Petty Officer

Appendix 8: *Baseball diamond*

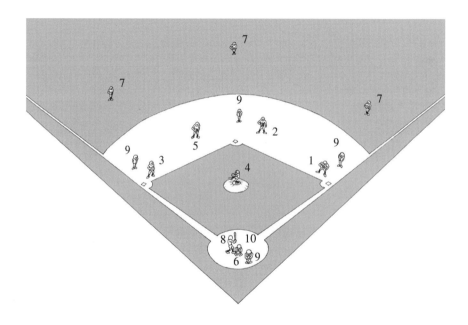

DEFENSE

INFIELD:
(1) FIRST BASE(man)
(2) SECOND BASE(man)
(3) THIRD BASE(man)
(4) PITCHER
(5) SHORTSTOP
(6) CATCHER

OUTFIELD:
(7) OUTFIELDER

OFFENSE
(8) batter

(9) UMPIRE
(10) HOME PLATE

Appendix 9 *Football field*

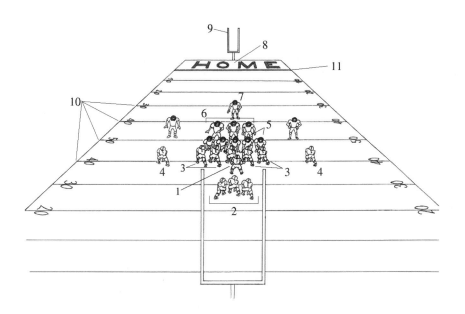

OFFENSIVE TEAM
(1) QUARTERBACK
(2) RUNNING BACKS
(3) LINEMEN
(4) receiver

DEFENSIVE TEAM
(5) LINEMEN
(6) LINEBACKERS
(7) QUARTERBACK

FIELD
(8) END ZONE
(9) goal post
(10) yard line
(11) goal line

INDEXES (ordered by field)

DAILY LIFE

ECONOMY

EDUCATION

ENVIRONMENT

FOOD AND DRINK

FOREIGN POLICY

War of 1812
"War to end all Wars"
"War to save Democracy"
World War I
World War II
Yalta Conference

GEOGRAPHY

Adirondack Mountains
Appalachia
Appalachian Mountains
Aspen
Atlanta
Atlantic City
barrio
Bay Area
Bean Town
Bedford-Stuyvesant
beltway
Berkeley
Beverly Hills
Big Apple
block
Border
borough
Boston
Bourbon Street
Bowery
Branson
Brooklyn
Cajun Country
Cape Cod
Castro
Central Park
Chicago
Chinatown
Christopher Street
Coney Island
continental divide
Cotton Kingdom
county
county seat
Dade County
Dallas
Daytona Beach
Department of the Interior
Detroit
District of Columbia
Dixie
downtown

Dust Bowl
East
Fifth Avenue
Florida Keys
Forty-Ninth Parallel
Four Corners
French Quarter
frontier
Gadsden Purchase
Georgetown
Gotham
Graceland
Great Basin
Great Divide
Great Lakes
Great Plains
Guam
Haight-Ashbury
Hamptons
Harlem
Heartland
Hollywood
Independence Hall
Indian Country
Indian Territory
Jamestown
Key West
Koreatown
Lafayette Park
land claim
Las Vegas
Little Havana
Long Island
Loop
Los Angeles
Louisiana Purchase
Lower 48
Magnificent Mile
Mall
Mall of America
Manhattan
Martha's Vineyard
Mason-Dixon Line
Miami
Michigan Avenue
Mid-Atlantic
Midwest
Mississippi River
Motown
Mrs. O'Leary's Cow
Napa Valley

Nashville
New England
New Orleans
New York City
North
Northeast
Oregon Trail
Pacific Northwest
Palm Beach
Palm Springs
parish
Pine Ridge Indian Reservation
public land
pueblo
Puerto Rico
Rodeo Drive
Rustbelt
Salt Lake City
San Francisco
Seattle
Seward's Folly
Skid Row
SoHo
South
South Side
Southwest
Spanish Harlem
state
strip
Strivers' Row
suburbs
Sunbelt
territory
Thousand Islands
Tidewater Region
Times Square
TriBeCa
Twin Cities
United States (of America)
upstate
uptown
US
Venice Beach
Washington D.C.
West
Williamsburg
Windy City

GOVERNMENT

adjournment

administration/Administration
advice and consent
Air Force One
Air Force Two
"all men are created equal"
amendment
appointment power
appropriations
Articles of Confederation
Assembly
Attorney General
balanced budget
Beltway
bicameral legislature
big government
bill
bipartisan
Black Caucus
Blair House
block grant
both sides of the aisle
"buck stops here"
budget deficit
bylaw
Cabinet
Camp David
Capitol (Building)
Central Intelligence Agency
checks and balances
chief executive
Chief of Staff
Chief of State
civil service
civil service reform
cloture
co-operative federalism
Commander in Chief
commerce clause
concurrent powers
conference committee
Congress
Congressional Black Caucus
Congressional Budget Office
Congressional caucus
Congressional committee
Congressional district
Congressional Hispanic Caucus
Congressional Record
Congressional Research Service
Congressman/woman
Congressmember

HEALTH

HISTORY

HOUSING AND ARCHITECTURE

IMMIGRATION

MILITARY

MINORITIES

tribal council
tribe
Uncle Tom
Uncle Tomahawk
Universal Negro Improvement
 Association
Vocational Rehabilitation Act
Voting Rights Act of 1866
Voting Rights Act of 1965
War Relocation Authority
Watts riots
white supremacy
Woman's Christian Temperance Union
Women's History Month
Women's Lib
Women's Movement/women's movement
Women's Suffrage movement
Worchester v. *Georgia*
Wounded Knee (Massacre)
Wounded Knee II
Yellow Peril
Young Lords' Organization
Zoot Suit Riots

PEOPLE

Abbey, Edward
Abzug, Bella
Adams, Ansel
Adams, Samuel
Alcott, Louisa May
Alger, Horatio
Ali, Muhammad
Allen, Woody
Angelou, Maya
Anthony, Susan B.
Armstrong, Louie
Arnold, Benedict
Ashe, Arthur
Audubon, John James
Baez, Joan
Baker, Josephine
Baldwin, James
Banks, Dennis
Baraka, Imamu Amari
Barnum, P[hineas] T[aylor]
Barry, Dave
Basie, Count
Bellow, Saul
Black Hawk
Boone, Daniel

Booth, John Wilkes
Bradford, William
Brady, Matthew
Brooks, Garth
Brothers, Joyce
Bunche, Ralph
Bush, George
Cajuns
Calamity Jane
Calhoun, John C.
Capone, Al
Capra, Frank
Carmichael, Stokely
Carnegie, Andrew
Carson, Rachel
Carter, Jimmy
Chávez, César Estrada
Cherokee Nation (of Oklahoma)
Child, Julia
Chomsky, Noam
Clinton, Bill
Clinton, Hillary Rodham
Cody, "Buffalo Bill"
Cole, Nat "King"
Collier, John
Coltrane, John
Columbus, Christopher
Cooper, James Fenimore
Copland, Aaron
Crazy Horse
Crèvecoeur, J. Hector St. John, de
Crockett, Davy (David)
cummings, e. e.
Cuomo, Mario
Davis, Miles
De Niro, Robert
Dean, James
Dershowitz, Alan
Dewey, John
Dickinson, Emily Elizabeth
DiMaggio, Joe
Diné
Disney, Walt
Douglass, Frederick
Du Bois, W[illiam] E[dward] B[urghardt]
Dunbar, Paul Lawrence
Dylan, Bob
Edelman, Marian Wright
Edison, Thomas Alvin
Eisenhower, Dwight D. ("Ike")
Ellington, Duke

reapportionment
redistricting
referendum
registration drive
Republican
Republican National Committee
Republican Party
right/Right
running-mate
slate
split ticket
straight ticket
straw poll
Super Tuesday
Tammany Hall
term
third party
ticket
Twelfth Amendment
Twenty-fourth Amendment
Twenty-second Amendment
Twenty-third Amendment
two-party system
voter registration
winner-take-all
Yippies

RELIGION

Abyssinian Baptist Church
"All Things Bright and Beautiful"
"Amazing Grace"
American Indian Religious Freedom Act
American Jewish Congress
Amish
Anti-Defamation League (of B'nai B'rith)
anti-Semitism
awakening
B'nai B'rith (International)
Baptist
Baptist Church
bar mitzvah
bat mitzvah
believer
Bible Belt
Bible camp
Black Jews
Black Muslims
blue laws
born-again Christian
Calvinism

cardinal
Catholic Worker Movement
Christian Coalition
Christian Right
Christian Science
church
Church of Christ, Scientist
Church of Jesus Christ of Latter-day
 Saints
civic/civil religion
commune
congregationalism
Conservative Judaism
Daughters of Isabella
denomination
ecumenism
electronic church
Engel v. *Vitale*
Episcopal Church
Episcopalian
establishment clause
evangelical
Everson v. *Board of Education of Ewing
 Township*
family values
free-exercise clause
Freemasons
Fruit of Islam
fundamentalism
fundamentalist
Ghost Dance (Religion)
gospel (music)
Great Awakening
Hasidic Jews
Hillel (Foundation)
Jewish
kiva
kosher
lay
Lutheran Church
Mason
medicine man/woman
Mennonites
Methodist Church
Moonies
Moral Majority
Moravian Church
Mormon
Mormon Tabernacle Choir
Mormon Trail
Nation of Islam

SCIENCE AND TECHNOLOGY

SOCIETY

SPORTS AND LEISURE

TRANSPORTATION

WORK